Woman in Art | Helen Rosenau's 'Little Book' of 1944

Including a new colour edition of
Woman in Art: From Type to Personality
by Helen Rosenau

With a personal memoir by Adrian Rifkin
and biographical essay on Helen Rosenau
by Rachel Dickson

Isomorph 1 Woman in Art by Helen Rosenau DrPhil PhD | 55ill 100pp 5'-

Dewey Decimal Clasification 396.7 [709]
Universal Decimal Classification (Brussels 1933) 7(09):396:7
First published February 1944 by Isomorph Ltd 3 Pitts Head Mews London W1
Printed in Great Britain by The Marshall Press Ltd Milford Lane Strand London WC2
Bound Plastoic by Nevett Ltd Colindale London NW9
Typography and cover design by Anthony Froshaug

Woman in Art

Helen Rosenau's 'Little Book' of 1944

Griselda Pollock

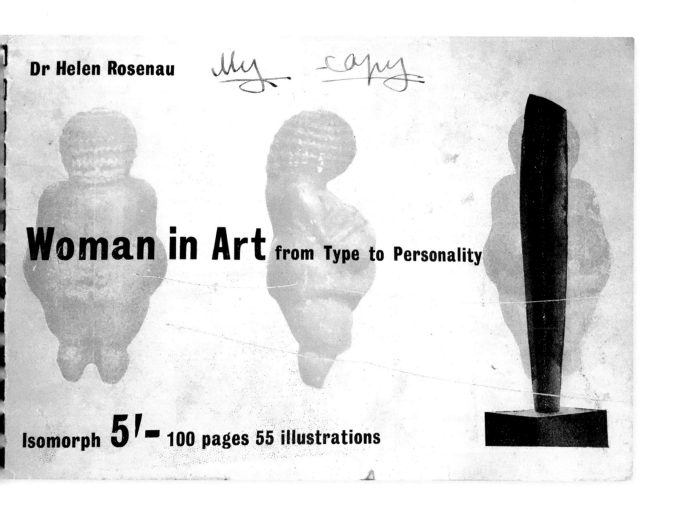

Dr Helen Rosenau

my copy

Woman in Art from Type to Personality

Isomorph 5/- 100 pages 55 illustrations

Paul Mellon Centre for Studies in British Art

Distributed by Yale University Press *New Haven & London*

A digital facsimile of *Woman in Art* (1944) can be found on the Internet Archive (archive.org)

First published in 2023 by the
Paul Mellon Centre for Studies in British Art
16 Bedford Square, London, WC1B 3JA
paul-mellon-centre.ac.uk

ISBN 978-1-913107-41-3 HB
Library of Congress Control Number: 2023941924

British Library Cataloguing-in-Publication Data
A catalogue record for this book is available from the
British Library

Designed by Robert Dalrymple
Typeset in MVB Dovetail and Solitaire
Origination by DL Imaging
Printed in Wales by Gomer Press

Frontispiece: Helen Rosenau's personal copy of
Woman in Art. Collection of Michael and Louise Carmi.

Acknowledgements

Deepest thanks must go to Helen Rosenau's son and daughter-in-law, Michael and Louise Carmi, for their permission to undertake this reprinting, for their immense generosity in sharing their knowledge and the personal collection of Helen Rosenau's books and papers, and for providing the portrait photographs of Helen Rosenau for this publication.

We want to acknowledge Professor Tamar Garb of University College London, who, prompted by Adrian Rifkin, sponsored the lecture on missing feminist memories by Griselda Pollock in 2014 that set in motion this project for a reprinting of the 'little book' and incited its newly researched framing. We want to thank Professor Jaś Elsner of the University of Oxford for his many and judicious insights into the intellectual conversations within which Helen Rosenau formed her distinctive approach to art history; these have enriched the project. Our anonymous peer reviewers also enriched the project with both their astute observations and their helpful recommendations. We additionally thank the Ben Uri Gallery Archives and also the Warburg Institute for access to the correspondence of Helen Rosenau. We especially thank Eckart Marchand for his assistance in sourcing several of the illustrations for this book.

We want to thank Mark Hallett, former director, and Sarah Victoria Turner, director, of the Paul Mellon Centre for Studies in British Art, London, for their enthusiastic welcome and continued support of the book from its proposal through to final publication. Emily Lees has been an astute and insightful editor shaping the many elements of this project into a beautiful book that combines the innovative redesigning of Rosenau's original 'little book' between its two scholarly wings. The book has been scrupulously and sympathetically copy-edited with great care by Hazel Bird, who has been attentive to ensuring the fullest representation of Helen Rosenau's multi-lingual and transdisciplinary scholarship. Finally, we acknowledge the generosity of the Paul Mellon Centre for enabling the book to be illustrated in ways not available to Helen Rosenau in 1944.

Griselda Pollock wishes to add a more personal acknowledgement to Adrian Rifkin for the introduction to Helen Rosenau and for helping to

shape her own understanding of Helen Rosenau's intellectual, political, and personal world, and for his gentle, but insistent, prompting to ensure completion of this book. She warmly thanks Dr Eva Frojmovic, director of the Centre for Jewish Studies at the University of Leeds since 1995, for three decades of stimulating conversation, shared teaching, and joint research projects that have forged a creative and self-critical dialogue between Jewish Studies and Art History. Family members who live with the genesis, impassioned writing and detailed administration involved in writing any book, let alone a heavily illustrated art history book with all its legal and technical complexities, must know how much they are appreciated for their tolerance of the writer's preoccupation and for their personal and constant intellectual support.

GRISELDA POLLOCK · ADRIAN RIFKIN · RACHEL DICKSON
Leeds & London, 2023

Preface

In 1979, in one of the ironies of history that only yield their full significance retrospectively, the proofs of the last major publication of the historian of art and architecture Helen Rosenau (1900–1984), *Vision of the Temple: The Image of the Temple of Jerusalem in Judaism and Christianity*, lay on the desk of the historian and publisher Robert Oresko (1947–2010) – who, having studied with architectural historian Rudolf Wittkower (1901–1971), a refugee from Germany and part of the Warburg circle in London, may have known Rosenau through his former tutor and was an editor at Academy Editions in 1976 for her book *Boullée and Visionary Architecture* – side by side with the manuscript of one of the first British interventions in the emerging field of feminist studies in Art History: *Old Mistresses: Women, Art and Ideology* by Rozsika Parker and Griselda Pollock. As a result of the unexpected collapse of Oresko Books in 1980, *Old Mistresses* was only published in 1981 (by Routledge & Kegan Paul). Neither Parker nor Pollock was aware that Rosenau had, in 1944, published her own book on 'woman, art, and ideology', confidently illustrating many artist-women in her grand survey of the history of imagining and imaging 'Woman' as both the concept and condition while tracking, as the book's subtitle suggests, a complex process of symbolic and representational transformation 'from Type to Personality' (fig. 0.1).

Now, on the eightieth anniversary of its original completion in November 1943, *Woman in Art: From Type to Personality* returns as a lost treasure of the History of Art, fulfilling that 'missed feminist encounter' of 1979. Overlooked or ignored maybe, but today *Woman in Art* sustains an urgency that makes it our contemporary. Published after five years of world war in a short run by a small and short-lived avant-garde imprint, Isomorph, it was both a visual symptom of the assimilation of Bauhaus or Dutch modern aesthetics in England and a vector of a dense and adventurous modern German-language Art History (*Kunstgeschichte*) that had, under conditions of forced exile and endangered lives, migrated to Britain to expand a still tiny, underdeveloped academic discipline in the field. Through Rosenau, the intellectually rich debates within well-established European Art History arrived to be transformed by her in an uniquely feminist and militant form.

Rosenau had published her dissertation, written under the direction of Erwin Panofsky (1892–1968) as *Der Kölner Dom: seine Baug-eschichte und historische Stellung* (Cologne Cathedral: Its Architectural History and His-torical Context), in 1931. This placed her at the centre of the transformation of art and architec-tural history that flowed from the life and work of Aby Warburg (1866–1929) in the intellectual environment of Hamburg, but also marked a singular intellectual history that set her apart from it in many ways. Even as, during the early 1940s, she was thinking and writing *Woman in Art* under the intellectual hospitality of another German Jewish refugee, the sociologist Karl Mannheim (1893–1947) at the London School of Economics, her frequent correspondence with the Warburg Institute in London makes no men-tion of this major work in progress – the publi-cation of articles in the journal of the Warburg Institute and borrowed slides for her lectures in adult education, yes, but *Woman in Art* not at all. Although supported by several preparatory articles, this remarkable text did not generate more studies of this order by Rosenau, who became better known for her work on eighteenth-century French art and archi-tecture, for her study of concepts of the 'ideal city', and, as her *Temple* book consolidated, the origins and dissemination of Jewish concepts in religious and denominational architecture.

The prime purpose of this new edition of *Woman in Art* is to right the wrongful neglect of Helen Rosenau and her position not merely, how-ever importantly, as an unacknowledged feminist forerunner, but as a critical link in a much longer chain of women asking questions about gender in art and art's histories. At the same time, this publication aims to present and frame the book and the ensemble of Rosenau's work in

26. II. 1982

Dear Madam,
 I wonder whether you have ever
my little book, which was published by Iso
in 1943. Its title is Woman in Art and it
immediately sold out. My friends urge me to
have it republished, perhaps with a postf
or in a new edition. Would you be at all
interested?

Yours sincerely,

(Helen Rosenau, D. Phil .)

0.1 Helen Rosenau, fragment of a typescript letter, 26 February 1982, about a new edition of her 'little book', *Woman in Art* (London: Isomorph, 1944). Collection of Michael and Louise Carmi. Addressee unknown.

The Preface is dated November 1943 and the book was pub-lished in early 1944. Looking back from 1982, Rosenau is 'remembering' her book as completed in 1943.

and with the historical and theoretical complexity that it deserves – and that generated its singular contribution to a field of feminist art histories we are mistakenly led to believe developed only after 1970. This volume reintroduces Rosenau's radically innovative 1944 book re-set with colour illustration and supplemented by a bibliography created from her learned footnotes. Rosenau's astonishing command of scholarly and political sources and unchallengeable skills as a reader in many languages are thus made available to anglophone readers. Many of her illustrations will appear again in Part 3 as Griselda Pollock both examines Rosenau's creative relationship to Warburg's incomplete *Bilderatlas Mnemosyne*, and identifies Rosenau's method for presenting images as active components of an art-historical text and not just illustrations to a wordy argument.

In Part 1, 'Helen Rosenau: Art Historian and Feminist between Two Worlds', three contemporary art historians develop a complex portrait of the author. In my personal memoir, I recall my own experience of studying with Rosenau. Rachel Dickson of the Ben Uri Gallery in London, where Rosenau lectured after she retired from the University of Manchester, sketches a biography and offers a revelatory account of Rosenau's career in Britain, documenting her still-menaced place in the culture of the Jewish refugees from Nazism after 1933. Griselda Pollock creates an intellectual portrait of Rosenau and her theoretical formation and art-historical training amid the ferment and formation of rival forms of Art History, Cultural History, and the Sociology of Knowledge in pre-1933 Germany and after, among the diaspora of Jewish refugee scholars in England.

In 1950, a mere six years after Rosenau's book's publication in 1944 – which had offered a thematic survey of art including on its cover the proof of women as artists as well as the affirmation of gender as a category of thought, culture, and social and anthropological research – Ernst Gombrich (1909–2001), a fellow refugee who would emerge as the pre-eminent public face of Art History in the second half of the twentieth century in Britain, was allowed to publish his positivist, exclusionary, and gender-exclusive survey of the history of art. Titled simply *The Story of Art*, this all-male text actively blotted out women as artists and effaced gender, class, and race as legitimate questions for cultural analysis. Through the wide and popular readership his book acquired internationally (over seven million copies sold), Gombrich's asocial, uncritical masculinism erased what Rosenau's small, radical, conceptually rich book, from the same circles of refugee art historians in Britain, so elegantly proved – that it was clearly possible to think, write, and study *inclusively* about art and culture.

Part 2 presents a new edition of Rosenau's *Woman in Art: From Type to Personality* with illustrations in colour. Concise at around twenty thousand words, the book is a brilliant nexus of wide-ranging scholarship revealing Rosenau's transdisciplinary grasp of sociology, anthropology, theology, philosophy, and international histories of art.

In Part 3, 'Reading Helen Rosenau's "Little Book" Now', Griselda Pollock offers a suite of seven essays on *Woman in Art* in its original form, engaging us in a detailed analysis of Rosenau's thinking and tracing her method as it is revealed in the selection and juxtaposition of images. She reveals Rosenau's multi-disciplinary research and theoretically informed analysis, confirming her place in what is revealed as a sustained and international feminist project between the later nineteenth century and the 1940s. This equally enables us to situate Rosenau's contribution to Art History *after* Hamburg (the Warburg–Panofsky–Cassirer circle) and, in a European academic context, to position her attention to gender *before* a revitalized women's movement and intellectual project after 1968. These essays are the result of a meticulous close reading of Rosenau's text, and of chasing clues until they become substantial knowledge, and discovering – in the unending serendipity of following up references, arguments, or the sourcing of plates – individual scholars' histories and travels, the legacies of the development of feminism in Germany, and its articulation among its refugee thinkers.

Many years ago I asked Griselda Pollock to undertake a reading of this 'little book', which had always moved me in its daring intensity. Reading it, seeing it on the shelf, my luck in having been Rosenau's student was as a flash of illumination. Building on her work with Rozsika Parker and other feminist scholars in and since the 1970s, Griselda Pollock has plumbed the invention of Helen Rosenau's book, sustaining and expanding feminist social histories of art over the past fifty years. The flash has now become a blazing flame. The outcome of her research shows in what ways *Woman in Art* is a work of consequence and, we imagine, of as yet unforeseen consequences.

ADRIAN RIFKIN
London, 2023

Helen Rosenau:
Art Historian and Feminist
between Two Worlds

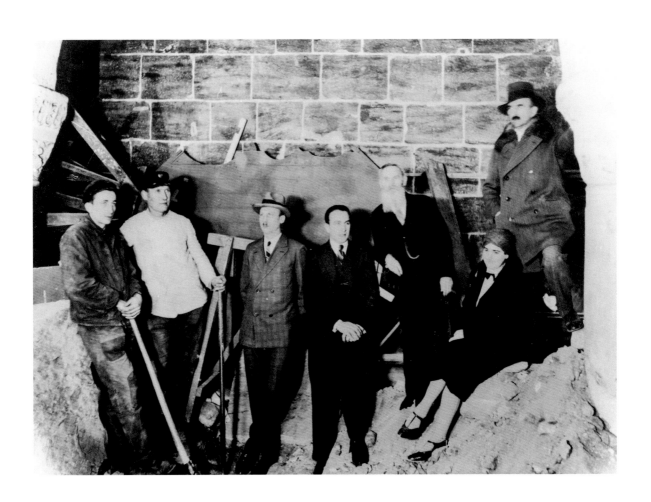

Missing Feminist Memory
Helen Rosenau, Art Historian (1900–1984)

Deep in a crypt of the medieval cathedral of Bremen, whose foundations are being excavated, six men stand for a photograph (fig. 1.1). One woman is present. She is seated on a pile of stone and dust, dressed in a dark suit and a white shirt with a small dark bow at the collar. Her legs are neatly crossed at the knee, and we note the elegant strapped and heeled shoes, hardly sturdy enough for moving among this rubble. Her head is covered with a hat or tied scarf. The men, differentiated by costume and stance, are divided between two resting workmen, wearing a beret and a cap respectively. They form the left, mirroring flank of the image with the seated woman on the right. Three men stand centrally facing the camera, wearing smart suits of different colours and cuts. One man is hatless, sporting a long beard and a waistcoat and gold watch chain. Wearing an angled fedora, a man stands at the top right alone wearing an overcoat with fur collar and a hat, a visitor perhaps. Only the bearded man appears to address the camera.

How would we read this image, sociologically, iconologically, biographically? What do we learn from it as evidence of a world of work or art history? Why is the woman alone seated? What does it mean to be a lone woman in a class-structured world of suited bourgeois scholars and administrators and labourers? What is her space here? This is a rare photographic image of Helen Rosenau at work, directing excavations during her *Habilitation* research in Germany in 1931, even rarer for showing her on the site of her archaeological-art-historical research into the symbolic, iconological meaning of architecture at its most material.

Repairing severed memories, this re-setting and supplementing of Helen Rosenau's 'little book' (see fig. 0.1) rebuilds a bridge between Art History itself and feminist contributions to the discipline. We reconfigure Rosenau's place in Art History (capitalized as the discipline versus the field, the history of art, that it studies) in the historiographical landscape of the long history of feminist thought in art and also in terms of the impact of the continentally trained art historians on the emergent discipline of Art History in Britain during the 1930s and 1940s.

1.1 Helen Rosenau with archaeologists in the eastern crypt of St Petri Cathedral, Bremen, during an excavation in 1930–31. Photograph: identified by Jannik Sachweh; Dom Archiv Bremen.

Rosenau thus wrote her 'little book' under the sociological shelter of fellow refugee and sociologist Karl Mannheim's (1893–1947) supervision in London even as the German bombers rained destruction on many British cities. Senior British politicians were advocating submission to Hitler as he massed troops for an invasion of Britain, where Jewish intellectuals had found precarious refuge and were thus in fear of their lives. Had not young British Air Force pilots fought nightly battles in the skies and died in great numbers in the defence of Britain, few British or refugee Jews would have survived the German victory. Not only had her academic career been ruptured by forced exile because of institution-alized anti-semitic persecution by her own government, but Rosenau arrived in Britain in 1933 as a foreigner, a refugee, and a woman. From 1939 on, moreover, her actual life was at risk from the constant menace of a German invasion of Britain and the latter's possible defeat in the war, and even more darkly overshadowed by the horror of the genocide of Jewish and Romani peoples of Europe that was, at that time, not yet fully known.

Furthermore, Rosenau's work traversed the decades of the 1930s to the 1980s, when it is often – mistakenly – imagined that feminist thought and activism were lulled in the wake of women's successful campaigns for emancipation from the 1850s to the 1920s and then disrupted by the initial victory of, and subsequent world war against, fascism. We now know that this was not the case. Simone de Beau-voir's post-war text *The Second Sex* (1949) was not an isolated event.[1] Undertaken at the London School of Economics with Karl Mannheim, concurrently with Rosenau's research for *Woman in Art* in the early 1940s, refugee Jewish sociologist Viola Klein's study titled *The Feminine Character: History of an Ideology* (1946) was, like Rosenau's book, both an English-language forerunner of Beauvoir's examination of the cultural myths of 'the feminine' and a counter-exploration of the lived expe-riences of women negotiating feminine subjectivity as articulated by women in art and literature.[2]

What kinds of histories of art did Rosenau write in these politi-cal-subjective conditions of war-time terror and radical rupture of her academic life? How might we understand what she produced in this book not only as feminist thinking but also as feminist–Jewish resist-ance? What model for writing art's histories did she produce? What theoretical resources did she mobilize as a scholar, a woman, a Jewish thinker, and a refugee, choosing at this moment to write a book conjoin-ing *woman* and *art*?

Biography is inseparable from history, not just of date-marked events and their repercussions but also of deep sociological, philosophical, and

cultural processes that are always shaded by and with subjective experience. These in turn are shaped across the axes of power and difference we theorize as gender, class, sexuality, and ethnic–cultural formation as well as geopolitical and historical situation. Before this book's new edition with full-colour illustration of Rosenau's war-time book, this section presents three encounters with the scholar herself that draw an intellectual portrait of the writer. 'A Personal Memoir' by Adrian Rifkin, one of her students, is followed by a documentary biography of Rosenau assembled by art historian and curator Rachel Dickson, a specialist in Jewish art, artists, and art historians and the refugee experience. Building on what Dickson has carefully culled from a range of sources about Rosenau after she came to Britain, in Chapter 3 I create an intellectual portrait of the scholar through her writing by close-reading her commentary on Rodin's sculpture titled *Thought*. I shall then develop a socio-cultural reading of the educational and intellectual formation in Germany that shaped Rosenau's entry into, and transformation of, the European academic tradition of Art History. As a refugee art historian, Rosenau introduced this tradition into British Art History as much as those other scholars whose names have been preserved as the 'fathers' of the discipline in a manner typical of patriarchal effacement of the co-production of knowledge by women and men.

Notes to Introduction

1 Simone de Beauvoir, *Le deuxième sexe* (Paris: Éditions Gallimard, 1949).

2 Viola Klein, *The Feminine Character: History of an Ideology* (London: Kegan Paul & Co., 1946).

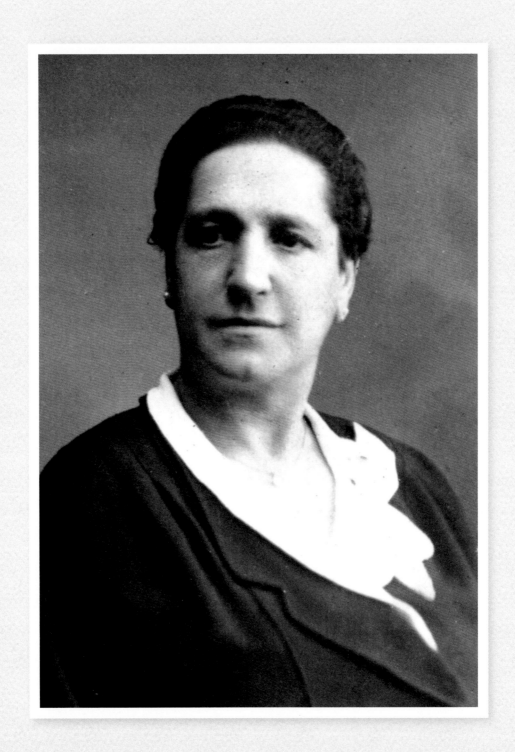

Helen Rosenau
A Personal Memoir

Though Helen Rosenau (fig. 1.2) played an immense role in my intellectual formation, my memories of her are, however, largely anecdotal. I was introduced to her in the autumn of 1967 by some cousins of my father, epidemiologists and social health experts who knew her as a colleague at the University of Manchester. They were exiles from South Africa, African National Congress supporters, and Marxists and so I met Dr Rosenau through a left-wing and family community, and certainly not via an art-historical network, in which her invisibility is now a matter of historical scandal. By chance, then, I came into contact with the scholar whose book on woman and art I now think of as the undisputed *chef d'oeuvre* of the Warburg school – or perhaps despite it? She offered to take me on as an unattached MA student, whatever that meant. But of the book, let us say that as a woman who declared herself a feminist in 1928 on realizing that the best lecture she had ever heard was by a feminist sociologist (Gertrud Kinel Simmel, who was also the wife of a more famous man – think Georg Simmel), she was well equipped to write it. Given that her letters to the editors of the *Journal of the Warburg and Courtauld Institutes* show that she did not even mention it to them in the course of arguments about another article during 1941–3, then we hardly have to speculate on her own contempt for the contempt that was offered to the women scholars of her generation.[1]

Even after the war she received nothing but discouragement from Emil Kauffmann and other historians of 'revolutionary architecture', while her tenure at Manchester persisted as an intellectual exile of kinds. In the final term of 1967, she took me into the Art History Department corridor and boomed, for all to hear, 'When I retire from here this summer there is no one left worth being taught by, so you will leave too.' And, 'You will go to my friend Noach at Leeds – he is expecting you – and you will write a thesis on Ingres.'[2] I did. Exactly as I was told.

The MA without an MA was an administrative alibi, I guess for my transfer to History of Art from a BA in English and Philosophy, which I had decided to do as a second BA after a rather battering experience with Philosophy, Politics and Economics at Oxford. But that, in its own way, had turned out to be as philosophically retrograde and provincial as had

been the moralists and the language blokes of the somnolent spires. Why had my courage failed me when I approached Iris Murdoch to ask her to be my tutor in 1965? I was so overwhelmed by her achievement that I could not even open my mouth before the puzzled novelist and, anyway, having listened to Edgar Wind earlier that year, I knew that Art History was my *seul désir* (perhaps even since seeing the Unicorn tapestry at Musée de Cluny in Paris in 1959, but certainly after being shown Botticelli as riffed by Wind). One could not but be speechless before Helen; she demanded an exposition. So I stopped postponing Art History and accepted the terms she offered me. Clearly, she liked me, she thought I was clever enough to do her justice one day, and she immediately understood my tendency to idleness. And once, while I was driving her somewhere, she said that 'it is well known that most male art historians are homosexuals', a warning that allowed me to be ever-after suspicious of straight ones. Yet a number, straight or gay, had also treated her quite badly – but in the manner of the English establishment.

Helen was as worldly as could be, and if you look at her early letters, conserved in the archive of the Warburg Institute, she had been dashing too. The beautifully and deeply engraved and rather stylish 'R' on the top right corner of her stationery speaks of ease and wealth – ease with the world and its connections, a capacity to take pleasure in her intellectual capacities and her desires, and to play them together in the library, in travel (to Dura-Europos, for example), or in writing as she wished under Panofsky's supervision. In the 1970s she returned to the Estampes in the Bibliothèque Nationale in Paris, where she wanted to review some of Jean-Jacques Lequeu's highly sexual architectural drawings, only to find that they had been classified in the *enfer* along with pornography – such were the days! The 'huissier' who was to accompany her to this classificatory hell was told that, if he could not trust her not to masturbate before them, then nor could he be certain that she would not assault him, good looking as he was.

Edgar Wind too was driven by desire to be at large in the world, and I always thought of both of them as great voluptuaries, as thinkers utterly at ease with their intellectual greed, free from any moralism, even though both were politically on the left. Think of W. H. Auden's loving critique of Wind to see that he and Rosenau were not quite like the others of the Warburg school, and to understand their enduring mutual respect.[3] Wind and she never spoke German to one another, she told me; 'When we left, we left.' She was not a 'German art historian'. It was indeed this libidinously charged attachment to the world, their *jouissance*, that flowed as a way out of the irreparable disappointment of 1933. How little this was understood as a kind of deep legacy from old Warburg days

you could see, I think, by looking at the building in Woburn Square [the London location of the Warburg Institute] after dusk, in seeing how few of the floors were lit, and how the adventure of travelling between those floors, of having made that space of thought, retracted to the more conventionally art-historical levels. You might say that *The Ideal City* or others of her works were thought as much in the transition between these floors as in the ground floor Reading Room where she sat – when not in the old North Library of the British Museum.[4]

The only thing that she told me I *had to* read in the Institute was the 'Serpent Ritual' of Aby Warburg (1866–1929), the *sine qua non* of becoming an art historian.[5] And that was in basement periodicals; otherwise I was free from any direction, other than that of losing myself in the enchantment of the floors, the oddity of the catalogue. Self-enchantment was the only pedagogy, her showing things to me as a temptation to show things to myself. Yes, for two terms at Manchester we sat side by side in a library, one afternoon every week, while she turned over the pages of the great architectural books from Alberti to Ledoux, and I watched and listened. That way of turning pages, interrogatively, was as much 'teaching' as I got – and, in the end, as much as I ever was to do. As with Wind's classes, every session was a new start.

Hatred of positivism was a baseline, as the first page of her little essay on Moses Montefiore demonstrates, and it signalled the deep enmities within the intellectual survivals of the Warburg Institute in her time, and mine.[6] So she did nothing to discourage rumours of Ernst Gombrich (1909–2001) nightly prowling the Warburg Library to destroy and snip out any signs of Wind's notorious review of his biography. Insidiously she armed me against Viennese positivism, Karl Popper (1902–1994) and Gombrich in particular, so that one day I might re-enact her own contempt. I did, noisily, in her presence, at the plenary of the Association of Art Historians conference in 1982 or 1983, referring to the work of Gombrich and Popper as intellectual triviality in the face of the philosopher Rudolf Carnap (1891–1970), a bluff to please the British. Allegorically and elliptically in the outcry that followed, she backed me up with some remarks on Rembrandt, her last and unfinished project, never to be published.

In 1982, Nicos Hadjinicolaou, whom I had met in 1978 and who had introduced me to the group Histoire et Critique des Arts in Paris – a wonderful home base in the still largely conservative frame of Art History – invited me to speak on the Paris Commune in Hamburg, where he was based at that moment. Before I set off, Helen told me that the art historians there (Horst Bredekamp, the late Klaus Herding, and others) were constantly writing to ask her to come back, to help them reconstitute the

archive of the Warburg in Hamburg. She warned me that they would ask me to persuade her, whereas she indeed had no intention even of replying to them, and that I should pass this on. The first thing they said (after greeting me) was to question her silence and I passed on her message verbatim. When I was shown the remains of a 6 × 6 cm (2.5 × 2.5 in) glass slide collection from fifty years before, I was told that some of the big gaps had been made by Wind when he fled with his materials, and they would like to see them restored. Then I understood why he and Helen had refused this reparative melancholy and decided that I would never myself be associated with it, nor with the industry that it has become. Later Helen was to learn that an unknown drawing by Claude Nicolas Ledoux (1736–1806) or Jean-Jacques Lequeu (1757–1826), both eighteenth-century architects, had turned up in Hamburg and she set off to see it, already rather unwell. Getting off the train at the Hauptbahnhof, she tripped on a planter and spent ten days in hospital, unvisited by any member of the University of Hamburg. She spoke of her relief that her unconscious had such good judgement in warning her that the station was already a step too far.

Via my cousins, Helen became a part of our family circle that included a good number of Frau Doktor refugees (women academics), from Małinowski students to linguists and philosophers. My mother became her driver elect, along with me, so some of my main memories of Helen are of her magisterial impatience with the services we happily offered her. Illegally parked on Tottenham Court Road outside Heals while she collected window blinds for us to drive down to her new apartment in Streatham, only to be dismissed on arrival so the builder could in turn do his work. Double parked for ages in Grosvenor Square shortly after the collapse of sterling against the German Mark at the end of the gold standard, while she sorted out her reparations in the German Embassy. 'Now they are worth something,' she said, 'I will move to Bloomsbury.' This reparation at least was to be accepted. Viewing flats in Bloomsbury, being totally and noisily denounced in the passage to the North Reading Room of the British Library: 'You are five minutes late for our appointment – who do you think that I am? I will never speak to you again.' 'So be it,' I said, in a moment of courage, 'It's your flat…' – but two days later we were back for our *scallopine Milanese* in the Castelletto in Bury Place, where we passed many a lunchtime. What did we talk about? 'Social Purpose in Architecture', I guess; I was always up to date after riffling through her private shelf in the North Reading Room…as I did with many another older scholar. I never paid attention – really – to those to whom I was closest; it was so everyday and anyway, my mind was very much on night life in my early London years. That she would

understand, the more so as she knew I was doing the work, so that when I offered her my article 'Ingres and the Academic Dictionary' she was as happy with the dedication as she was satisfied with her prediction that I would take my time.

A last anecdote – the most treasured, the point at which the Warburgian and Proustian axes cross in my life, our lives. Helen is just back from Paris. She has strolled through the Luxembourg Gardens. Stepping into the road, to cross over towards the Panthéon, a building laden with problems of neo-classical theoretical wrangling, she is hit by a car. Lying in the gutter, hurt, but not badly, she notes first that it is a handsome car, at least that. Then that the young man leaning over her is as handsome as his vehicle. He lifts his hat to her and says, 'Madame je m'appelle le Comte de Méras, on prononce le "s"'. She is totally won over – think 'ma cousine d'Uzès' – even before he apologizes and helps her to her feet. A delightful drive to the Hôpital Rothschild, a little patchwork, and a delicious lunch in such charming company at Le Pré Catalan. If only, if only, that could happen more often.

Apart from that she passed on, accoustically, the difference between two epochs of thinking, that between 'vorking at ze Vaarburg' (hear the vowels and consonants of the German-speaking refugee) and 'wuarking and the Worburg'.

Notes to Chapter 1

1 See copies of letters (uncatalogued but arranged by year and alphabetically by correspondent) in the Warburg Institute Archive, London.

2 Scotford Lawrence, *Arnold Noach: Biography of a Friend* (Malvern: Aspect Design, 2020).

3 W. H. Auden's poem 'The Truest Poetry Is the Most Feigning' was dedicated to Edgar Wind. See W. H. Auden, *W. H. Auden: Collected Poems*, ed. Edward Mendelson (London: Faber & Faber, 1976). It was a response to an encounter at a conference titled 'Art and Morals', held at Smith College in 1953.

4 Helen Rosenau, *The Ideal City in Its Architectural Evolution* (London: Routledge & Kegan Paul, 1959).

5 Aby Warburg, 'A Lecture on Serpent Ritual', *Journal of the Warburg Institute* 2:4 (1939), 277–92.

6 Helen Rosenau, 'Reflections on Moses Montefiore and Social Function in the Arts', *Journal of Jewish Art*, 8 (1981), 60–67.

BOULLÉE
& VISIONARY
ARCHITECTURE

including Boullée's 'Architecture, Essay on Art'

Helen Rosenau

THE PAINTER
J-L DAVID

HELEN ROSENAU

EVANS–KEMPSTER

DESIGN and MEDIEVAL
ARCHITECTURE

By

HELEN ROSENAU
Ph.D.(Hamburg)

LONDON
B. T. BATSFORD LTD.
15 NORTH AUDLEY STREET, MAYFAIR, W.1

THE IMAGE OF THE TEMPLE OF JERUSALEM
IN JUDAISM AND CHRISTIANITY

A SHORT
HISTORY OF
JEWISH ART

by Helen Rosenau

With sixty illustrations Preface by Edward Carter
B.A., A.R.I.B.A.

Dr Helen Rosenau

Woman in Art from Type to Personality

Isomorph 5/- 100 pages 55 illustrations

HELEN ROSENAU

The Ideal
City

ITS ARCHITECTURAL EVOLUTION
IN EUROPE

SOCIAL
PURPOSE IN
ARCHITECTURE

Paris and London compared,
1760–1800

HELEN ROSENAU

Some Things I Never Knew
The Rehabilitation of Dr Helen Rosenau and Her Work in England after 1933

As this republication of a sadly overlooked text from 1944 attests, Helen Rosenau has been largely forgotten since her death in 1984 as a name in the twentieth-century discipline of Art History in Britain. Indeed, her presence online (let alone her presence in the real world), beyond key publications, remains somewhat obscured. Even Griselda Pollock's lecture in 2014, 'Making Feminist Memories: The Case of Helen Rosenau and *Woman in Art*, 1944', took place without showing a single photograph of the scholar herself.[1] Nevertheless, traces of her diverse feminist and humanist interests beyond her academic remit do exist in unexpected iterations. It is these more hidden representations that I hope to explore in this brief text, which also uses archive sources to piece together an outline biography that is further analysed by Griselda Pollock in the next chapter.

Following her arrival in Britain as a refugee in 1933, Rosenau spent most of her career teaching in London and at the University of Manchester, with her research interests ranging across Jewish art and ritual architecture, French Revolutionary painters and architects, sociology of art, utopian architecture, and urban planning. Her final post was at the Leo Baeck College, London, which continues today to train Progressive rabbis and teachers of Jewish education. Her published legacy as a lecturer at English universities in the post-war period is not difficult to locate. A cursory trawl online quickly reveals a number of single-authored books over three decades – some reprinted – across her favoured research areas: *Design and Medieval Architecture* (1934), *A Short History of Jewish Art* (1948), *The Painter Jacques-Louis David* (1948), *The Ideal City: Its Architectural Evolution in Europe* (1959), *Social Purpose in Architecture: Paris and London Compared, 1760–1800* (1970), *Boullée & Visionary Architecture* (1976), and *Vision of the Temple: The Image of the Temple of Jerusalem in Judaism and Christianity* (1979) (fig. 1.3).[2]

Her initial marginality can perhaps partly be attributed to her status in 1930s Britain as a Jewish refugee and as a woman. As Margaret Olin has observed: 'Art historians of Jewish heritage were part of the intense theoretical debate that characterized art history in German-speaking countries in the 1920s and early 1930s. … Those who concentrated on

1.3 Selected covers of Helen Rosenau's publications.

Jewish topics remained marginal to the field as a whole. ... Some ... who did make important contributions to the study of Jewish monuments were ... doubly marginal. They were women.'[3] And, although her position as a German refugee may have opened the door a little way at the Warburg, her position as a woman, equally, sometimes made her situation there far from easy.

Brought up in a professional Jewish medical family between Monte Carlo and Bad Kissingen, Rosenau was initially privately tutored. After her *Abitur* in 1923, she studied art history at Munich with Heinrich Wölfflin (1864–1945), in Berlin with Adolph Goldschmidt (1863–1944), in Bonn with Paul Clemen (1866–1947), and in Hamburg with Erwin Panofsky (1892–1968), where she completed her first doctoral thesis, on Cologne Cathedral (1930).[4] With the rise of Nazism, anti-semitic laws prevented her from receiving her *Habilitation* from Münster on medieval architecture and she was removed from the university and her scholarship withdrawn. She and her mother then emigrated first to Switzerland, arriving in England in autumn 1933. Prior to her departure, Rosenau had already established links with the Warburg Institute in Hamburg and London – she thanks Professor Fritz Saxl (1890–1948) personally in the preface to her Cologne Cathedral book – and she continued a correspondence from the early 1930s with Gertrud Bing (1892–1964) and Rudolf Wittkower (1901–1971), initially writing in German on elegant monogrammed paper and signing with a flourish, as so vividly described by Rifkin in the preface to this book and the previous chapter.[5] With the outbreak of war, the letters are increasingly written in English and on plain postcards.

Rosenau's first major English publication, *Design and Medieval Architecture*, appeared in 1934, funded by a stipend from the British Federation of University Women (BFUW) – replacing one issued in 1932 by the Notgemeinschaft der Deutschen Wissenschaft (Emergency Association of German Science) (founded in 1920) but then withdrawn – which enabled her to complete research begun in Germany.[6] She subsequently continued her studies at the newly founded Courtauld Institute of Art, researching the architectural history of the synagogue for a second PhD (1940, awarded *summa cum laude*) and describing to Saxl her approach as somewhat academically risky: 'the art historians will say it may be good sociology and the sociologists: it may be good history of art'.[7] From 1935 she began contributing to a wide range of British academic publications, including *Apollo*, the *Burlington Magazine*, the *Journal of the Warburg and Courtauld Institutes*, *Adult Education*, and *RIBA Journal*, exploring art-historical topics along with wider humanist, educational, and feminist interests.

In 1936 Rosenau published 'Some Aspects of the Pictorial Influence of the Jewish Temple' in *Palestine Exploration Quarterly* and 'Note on the Relationship of Jews' Court and the Lincoln Synagogue' in *Archaeological Journal*.[8] In this year, she was also included in the list of German scholars in exile published by Notgemeinschaft deutscher Wissenschaftler im Ausland (Emergency Association of German Scholars Abroad), founded in 1933 by Philipp Schwartz, which had identified 2,600 such scholars by 1937.[9] The purpose of the list was 'to find openings for those German scholars who have lost their positions in Germany as a result of political developments since 1933'.[10] In co-operation with the Academic Assistance Council (later the Society for the Protection of Science and Learning, now the Council for At-Risk Academics) the Notgemeinschaft had transferred to London. Rosenau was identified under sections for both 'Archaeology' and 'Art History' ('Art History', with more than fifty names, a number comparable with that listed under 'History'), confirming the importance of the German refugees in developing a discipline which to date had had little profile in Britain. Those listed as having secured posts (often fractional) at the Courtauld Institute, itself formed in 1932, included Friedrich (later Frederick) Antal (1887–1954), Peter Brieger (1898–1983), Alfred Scharf (1900–1965), and Martin Weinberger (1893–1965), and at the Warburg, Otto Kurz (1908–1975), Fritz Saxl (1890–1948), and Rudolf Wittkower (1901–1971); Edith Hoffmann (1907–2016) and Nikolaus Pevsner (1902–1983) were listed as 'unaffiliated researchers'.[11]

Correspondence in the Warburg archive confirms that being published in credible journals during war time was difficult for many reasons – and Rosenau's submissions were often criticized by her male colleagues, both in letters written directly to her and in notes between themselves. During the war years, Saxl sought to reassure her, when her articles were turned down for publication, that paper shortages were partly to blame, that 'the lack of collaboration of which you complain is not institutional', and that 'any refusal on the part of the editors … is quite impersonal'.[12] Some years later, Anthony Blunt wrote caustically to the editor of the journal of the Warburg and Courtauld Institutes, when Rosenau was seeking a publisher, that 'as usual she has found something interesting and presented it in a hopeless manner'.[13]

By 1939 Rosenau (sometimes known as Rosenau-Carmi following her marriage to the Palestinian economist Dr Zvi Carmi (1883–1950)) was noted in minutes of the British Federation of University Women Refugee sub-committee under 'Special Cases' as having requested funding towards photographs for her *Women and Art* project, which she was researching at the London School of Economics under Hungarian Jewish refugee sociologist Karl Mannheim (1893–1947).[14] As with many

refugees from prosperous backgrounds, exile brought financial hardship – and, with the adoption of her infant son in 1944, Rosenau needed to secure funding and employment. The minutes further confirm that her request for £1 a month for a year was refused, noting that Rosenau had already received a Crosby Hall fellowship during 1933–4, which had provided accommodation in a historic building in Cheyne Walk. Leased by the BFUW, Crosby Hall was a residence for women students at a time when relatively few were entering higher education, and it became a refuge for scholars – many Jewish – who were fleeing Nazism. Rosenau later moved to Goldhurst Terrace, in West Hampstead, in the heart of the Jewish refugee community, and then to a flatlet on the edge of Regent's Park.

Copies of correspondence in the Warburg Institute Archive from August 1940 clearly evidence Rosenau's determined search for a suitable academic position across English universities at this time. (A Miss Jaffe at the University of Cambridge did 'not think they will bestow a fellowship upon an alien just now'.[15]) In the same year, Rosenau was classified as an enemy of the German state and placed on the *Sonderfahndungsliste GB* (The Black Book),[16] along with Gertrud Bing and Frederick (still listed as Friedrich) Antal. Although not actively political, in 1943 she wrote 'Die Kunst unter dem Nationalsozialismus' in conjunction with refugee sculptor Heinz Worner, in a small anthology, entitled *Der Fall Professor Huber*, edited by Hans Siebert, as part of the Frei Deutsch Kultur series published by the Free German League of Culture in Great Britain, whose contributors included German refugees from the fields of literature, art history, economics, history and philosophy.[17] From the mid-1940s, Rosenau also gave adult education lectures under the various auspices of the Extra-Mural Department of London University (including a series for the Ben Uri Art Society in spring 1948; a second series was presented by Anglo-Jewish curator Helen Kapp, herself of immigrant heritage, who had a particular interest in the so-called 'Continental British' school of artists).[18] Rosenau also lectured at the London County Council ('Art and Society' at the Marylebone Institute) and the Workers' Educational Association.[19]

The year 1944 finally saw the publication of Rosenau's book *Woman in Art: From Type to Personality* as the first and only volume under designer Anthony Froshaug's (1920–1984) modernist imprint, Isomorph.[20] Rosenau's subject did not arrive without precedent, but followed her short article 'Changing Attitudes towards Women', which she contributed to the literary compendium *Women under the Swastika* (which included a title piece by German feminist Marguerite Kuczynski), published in English by the Free German League of Culture in Great Britain

in 1942,[21] and an essay for *Apollo* a year later: 'Social Status of Women as Reflected in Art'.[22]

Rosenau received her certificate of naturalization in early February 1948, two days after her husband. In December, her book on painter Jacques-Louis David was reviewed in *AJR Information*, the newly launched magazine of the Association of Jewish Refugees, by fellow refugee Dr Lutz Weltmann, who had also contributed to *Der Fall Professor Huber*. A writer for Rudolf Mosse's papers in Berlin prior to emigrating in 1939, Weltmann extolled Rosenau's 'fine reputation as a historian of art in this country. … Her special subject is architecture, and her heart belongs to Jewish and women's questions.'[23] Weltmann continued in this vein the following May with a review of her *A Short History of Jewish Art*, prefaced by Edward Carter, Counsellor for Libraries and Museums at UNESCO.[24] In November 1949, Rosenau herself reviewed several exhibitions by Jewish refugee artists, observing that 'the riches of a civilisation can be gauged from the variety of the personalities who participate in it. If this test be applied to artists in the Anglo-Jewish community, then one may express satisfaction at a galaxy of varied talent.'[25] Rosenau praised a roster of Germans, including refugee sculptor Else Fraenkel (showing at the Essex Art Club), Ludwig Meidner and Else Meidner (exhibiting jointly at the Ben Uri Art Society), and Fritz Solomonski (exhibiting at the Kensington Gallery).

This was a particularly difficult period for Rosenau, whose husband had been terminally ill – he passed away in late 1950. Much of her – now handwritten – correspondence in the Warburg archive conveys a tone of anxious desperation. Her appointment as assistant lecturer in History of Art at Manchester, as announced in *AJR Information* in April 1951, must have been a huge relief, her new position enabling her to 'take a decisive part in the building up of the newly established Art Department … a task for which she has been considered particularly qualified due to her Continental experience'.[26] She achieved this post after earlier bitter disappointments regarding posts at the universities of Cambridge and Durham. Although Rosenau was thrilled, Rifkin recalls that she was, in fact, treated 'like a kitchen maid'.[27] She, of course, understood the importance of keeping up contacts in London and maintained links with the Warburg Institute and beyond. Her progressive humanist and feminist outlook saw her present more than a dozen talks to the Ethical Society between 1951 and 1972, with titles ranging from 'Art and Propaganda' and 'Modern Man as Seen in Art' to 'The Humanism of Leonardo da Vinci'.[28] She also wrote a number of columns for the *International Women's News* on linked topics with a female perspective, including articles titled 'The Institution of Marriage as Seen in Art', 'Motherhood

as Seen in Art', 'The Community of Women as Seen in Art', and 'Women Pioneers as Seen in Art'.[29]

AJR Information continued to track Rosenau's career, and in 1953 it reviewed her editing of Étienne-Louis Boullée's *Treatise on Architecture*, with 'acumen and scholarship', under the headline 'Refugee Scholar', even though the war had ended eight years earlier.[30] In July 1955, the journal highlighted 188 scholarships and fellowships worth $135,000 awarded by the latest Claims Conference to Victims of Nazi persecution. Rosenau was among thirty-one British recipients, along with the expressionist painter Else Meidner.[31] In 1965, to mark the half-century of the Ben Uri Gallery, which continued to provide an exhibition platform for many refugee artists, Rosenau wrote 'The Menorah: A Contribution to Jewish Symbol Formation' in a special anniversary volume, *Ben Uri: Fifty Years of Achievements in the Arts*, edited by Jacob Sonntag (1905–1984), co-founder of the periodical *Jewish Quarterly*.[32]

After her retirement, Rosenau resumed her support for adult education, lecturing once again for the Extra-Mural Department at London University and for the School of Architecture at the Polytechnic of Central London. After her death in 1984, several obituaries were published, including one in the *Gazette des Beaux-Arts*, written by her friend the writer and art historian Mendel Metzger (1900–2002), estranged brother of refugee artist Gustav Metzger (1926–2017).[33] In a quirk of connection so typical of informal networks in exile, Gustav was assisting Rosenau's son, Michael, in his efforts to leave his mother's library and manuscripts to the Exil Archiv in Frankfurt, where it is now kept but catalogued under the name of Gustav Metzger.

It seems appropriate to end this snapshot of an academic life under rehabilitation – and which enthusiastically embraced journeys of exploration in several unexpected directions – with an element of circularity. In June 1985, *AJR Information* proudly reviewed the reprinting of *Philo-Lexicon: Handbuch des jüdischen Wissens* (Handbook of Jewish Knowledge) – a handbook of Jewish knowledge originally published in Germany during the 1930s.[34] Recently deceased notables listed therein included distinguished rabbi Leo Baeck; *AJR Information*'s own editor, Dr Werner Rosenstock; and Dr Helen Rosenau, each described as 'part of a long roll of honour of the German Jewish intelligentsia'.[35]

Notes to Chapter 2

1 Griselda Pollock, 'Making Feminist Memories: The Case of Helen Rosenau and *Woman in Art*, 1944', University College London, London, 4 December 2014, https://www.youtube.com/watch?v=QhCLvdzPy10, retrieved 22 February 2023. A photograph has now been supplied by the family; see fig. 1.2.

2 Helen Rosenau, *A Short History of Jewish Art* (London: J. Clarke, 1948), *The Painter Jacques-Louis David* (London: Nicholson & Watson, 1948), *The Ideal City: Its Architectural Evolution in Europe* (London: Routledge & Kegan Paul, 1959), *Social Purpose in Architecture: Paris and London Compared, 1760–1800* (London: Studio Vista, 1970), *Boullée & Visionary Architecture* (London: Academy Editions, 1976), and *Vision of the Temple: The Image of the Temple of Jerusalem in Judaism and Christianity* (London: Oresko Books, 1979).

3 Margaret Olin, *The Nation Without Art: Examining Modern Discourses on Jewish Art* (Lincoln: University of Nebraska Press, 2001), 129–30.

4 Helen Rosenau, *Der Kölner Dom: seine Baugeschichte und historische Stellung* [1930] (Cologne: Creutzer, 1931).

5 See copies of letters (uncatalogued but arranged by year and alphabetically by correspondent) in the Warburg Institute Archive, London.

6 Helen Rosenau, *Design and Medieval Architecture* (London: B. T. Batsford, 1934).

7 Typescript letter from Helen Rosenau-Carmi to Dr Saxl, 6 March 1941, Warburg Institute Archive, London.

8 Helen Rosenau, 'Some Aspects of the Pictorial Influence of the Jewish Temple', *Palestine Exploration Quarterly*, 68 (1936), 157–62; Helen Rosenau, 'Note on the Relationship of Jews' Court and the Lincoln Synagogue', *Archaeological Journal* 93 (1936), 51–6.

9 The philosopher Ernst Cassirer (1874–1945), such an important presence in the Hamburg intellectual community in which Rosenau studied in the 1920s, was brought to the University of Oxford by this organization before moving to Sweden and eventually to Columbia University, New York, where he was working when he died. See Gerald Kreft, '"Dedicated to Represent the True Spirit of the German Nation in the World": Philipp Schwartz (1894–1977), Founder of the *Notgemeinschaft*', in *In Defence of Learning: The Plight, Persecution and Placement of Academic Refugees 1933–1980s*, ed. Shula Marks, Paul Weindling, and Laura Wintour (London: British Academy, 2011), 126–42.

10 'Introduction', in *Displaced German Scholars: A Guide to Academics in Peril in Nazi Germany During the 1930s* [1936] (San Bernardino: Borgo Press, 1993), 3–4: 4.

11 'List of Displaced German Scholars London, Autumn, 1936', in *Displaced German Scholars*, 8–11.

12 Copy of typescript letter from Dr Saxl to Mrs Rosenau, 24 March 1942, Warburg Institute Archive, London.

13 Copy of typescript letter from Anthony Blunt to M. D. Brown Esq, *Journal of the Warburg Institute*, 15 November 1963, Warburg Institute Archive, London.

14 British Federation of University Women Special Cases minutes, 1939, Holocaust Survivors and Victims Database, United States Holocaust Memorial Museum, Washington, DC, https://www.ushmm.org/online/hsv/wexner/cache/1678113646-2412464-RG-59.026M.0001.00000160.jpg, retrieved 6 March 2023.

15 Copy of typescript letter from Dr Saxl to Mrs Rosenau, 27 August 1940, Warburg Institute Archive, London.

16 Geheime Staatspolizei, *Die Sonderfahndungsliste GB*, Hoover Institution Library and Archives, Stanford University, 1940, https://digitalcollections.hoover.org/objects/55425/die-sonderfahndungsliste-gb, retrieved 1 March 2023.

17 Contributors included 'Die deutschen Intellektuellen in der Zeit der französischen Revolution' by Alfred Meusel; 'Wilhelm von Humboldt und die Gründung der Berliner Universität' by Arthur Liebert; 'Die Kunst unter dem Nationalsozialismus' by Helen Rosenau and Heinz Worner; 'Die Romantik und die deutsche Wissenschaft' by Herbert Sultan; 'Theater im Naziland' by Monty Jacobs; 'Zur Soziologie des deutschen Lehrers' by J. Schellenberger; 'Geopolitik und Faschismus' by Jürgen Kuczynski;

and 'Literaturwissenschaft an den Nazi-universitäten' by Lutz Weltmann. See Helen Rosenau and Heinz Worner, *Der Fall Professor Huber*, ed. Hans Siebert (London: Free German League of Culture, 1943). Kurt Huber (1893–1843) was a Swiss-born German professor of Psychology and Music in Munich, who had suffered childhood illness disabling his speaking and walking. Appalled at the rise of the Nazis, Huber joined the White Rose resistance movement against National Socialism and was arrested by the Gestapo. He was tried for insurrection and executed by guillotine on 13 July 1943.

18 See the detailed syllabus pamphlet for the 1948 University of London extension course 'The Jewish Contribution to Art', Ben Uri Archives, http://d303gnxmdhyq59.cloudfront.net/archive/BU_Pub_LectureSyll_1948.pdf, accessed 27 May 2020. Helen Kapp (1901–1978) was a Jewish curator and art critic who championed the so-called 'Continental British' school of artists (émigrés and refugees from Nazism). She was a second-generation immigrant herself, born in Hampstead to a German wine merchant father who was vice-president of the London Jewish Hospital.

19 See typescript note from Helen Rosenau to Dr Wittkower, 8 October 1942, Warburg Institute Archives, London. The Workers' Educational Association was founded in 1903 to promote the higher education of working people. The Marylebone Institute is now a campus of City University, London.

20 On Froshaug see Robin Kinross (ed.), *Anthony Froshaug: Typography and Texts* (London: Hyphen Press, 2000). Froshaug was born to a Norwegian father, working in Britain, and an English mother. After a public school education, he studied briefly at the Central School of Arts and Crafts between 1937 and 1939, and in the latter year he set up a freelance design practice. In the 1940s, he taught at the Central School. As a communist, he did not serve during the war. He founded Isomorph in part to publish books on typographic design and theory by Jan Tschichold (1902–1974), a German calligrapher who directed the visual design of Penguin Books. Froshaug later went to Germany to study the latter's design innovations. In his study of Froshaug's texts, graphic arts historian Robin Kinross suggests that Rosenau met the very young graphic designer as they moved in similar left-wing circles. There is a copy of her book preserved in the Froshaug Archive deposited at the University of Brighton.

21 The pamphlet included a foreword by Theo Naftel; 'From the Stories of Minna' by Friemut Schwarz; 'One of the Many' by Ruth Von Bueren; 'German Miner's Wife' by Honor Arundel; 'You Men are Funny People' by Hans Fladung; 'The Women of Neunkirchen' by Max Zimmering; 'On Leave' by Rita Hausdorff; 'Käthe Kollwitz' by Paul Westheim; 'Song of an Exiled Woman' by Hans Schoenfeld; 'Changing Attitudes towards Women' by Helen Rosenau; and 'German Women against the Swastika' by Marguerite Kuczynski. See *Women under the Swastika* (London: Free German League of Culture, 1942), of which there is a paper copy in Rosenau's library.

22 Helen Rosenau, 'Social Status of Women as Reflected in Art', *Apollo* 37 (1943), 94–8. For discussion of these preparatory pieces, see Griselda Pollock's analyses in Part 3, Essay 4.

23 L. W., review of *The Painter J.-L. David*, by Helen Rosenau, *AJR Information*, December 1948, 6.

24 Lutz Weltmann, 'Jewish Art', *AJR Information*, May 1949, 4.

25 Helen Rosenau, 'Current Exhibitions', *AJR Information*, November 1949, 7.

26 Anon., 'Personalia', *AJR Information*, April 1951, 7.

27 Personal communication from Adrian Rifkin.

28 See, for example, Helen Rosenau, 'The Humanism of Leonardo da Vinci', *Monthly Record* 57:8 (1952), 10–11.

29 Helen Rosenau, 'The Institution of Marriage as Seen in Art', *International Women's News* 35:1 (1940), 13; 'Motherhood as Seen in Art', *International Women's News* 35:2 (1940), 34; 'The Community of Women as Seen in Art', *International Women's News* 35:3 (1941),

55; 'Women Pioneers as Seen in Art', *International Women's News* 35:4 (1941), 74.

30 L. W., 'Refugee Scholar Honoured', *AJR Information*, August 1953, 4.

31 *AJR Information*, July 1955, 2.

32 Helen Rosenau, 'The Menorah: A Contribution to Jewish Symbol Formation', in *Ben Uri: Fifty Years of Achievements in the Arts*, ed. Jacob Sonntag (London: Ben Uri Art Society, 1965), 10–11.

33 Mendel Metzger, 'Helen Rosenau', *Gazette des Beaux-Arts* 105 (1985), 30.

34 *Philo-Lexicon: Handbuch des jüdischen Wissens* [1985] (Berlin: Suhrkamp Verlag, 1992).

35 *AJR Information*, June 1985, 4. Leo Baeck, the distinguished rabbi and leader of the Reform Jewish Community in Germany and later in Britain, had studied philosophy with Wilhelm Dilthey in Berlin and wrote a neo-Kantian account of Judaism. He survived the Holocaust in Terezin and relocated to Britain. In 1955, the Leo Baeck Institute, focussed on the study and history of German-language Jewry, was established in London with partner institutes in New York and Jerusalem.

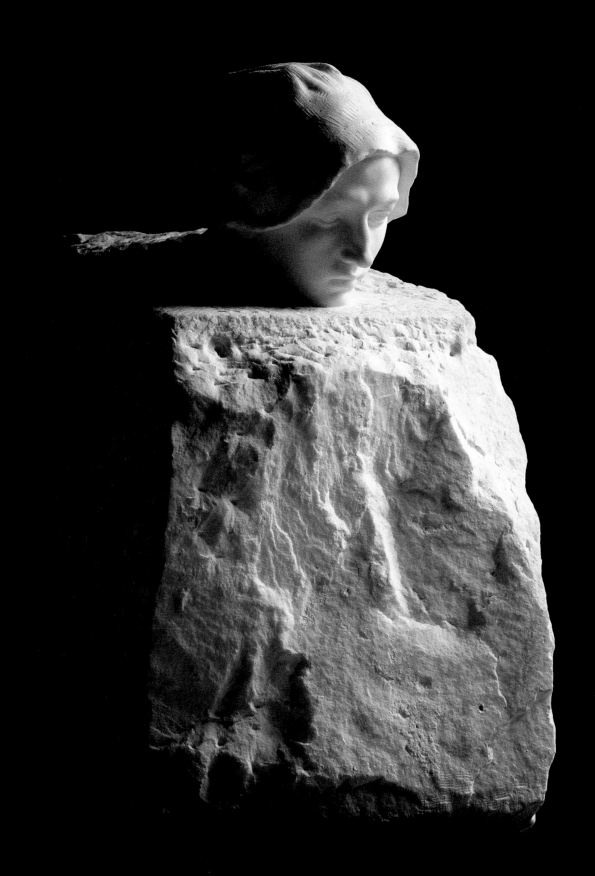

Thought in 'a Woman's Shape'
Writing as a Portrait of the Writer

Woman in Art: From Type to Personality is a dense, fully illustrated *tour de force* of art-historical and cultural analysis arising from, and situated in, its socio-political time-space, in both a gendered (woman intellectual) and an exilic (Jewish intellectual) condition. Tracing the production of *Woman in Art* as locus of social 'thought' and symbolic form from the Palaeolithic era to contemporary abstract art, Helen Rosenau demonstrates her extensive art-historical, anthropological, and sociological knowledge. Rosenau was at the centre of Hamburg's dynamic intellectual culture in the 1920s – around Aby Warburg (1866–1929), Erwin Panofsky (1892–1968), and Ernst Cassirer (1874–1945) – while in London in the 1930s she drew on the sociology of knowledge proposed by German-speaking Hungarian Jewish sociologist Karl Mannheim (1893–1947), who was equally engaged with debates in art history. Treating *Woman in Art* as a sociological concept, she aligns *preposterously* with later theories of gender as a social construct rather than a collection of essential characteristics.[1] Art-historically, she advances on both Panofsky's iconology and Warburg's *pathos formulae* (explained below). She approaches images as symbolic forms through which diverse human cultures formulate and materialize explorations of key dimensions of human life – life itself culturally organized through regulations of sex, kinship, law, and religion – and, above all, the social relationships in which desire, sexuality, and relationality were instituted, lived, and imagined.

An intellectual's biography is legible as much in what an author writes as in the information about how she came to write it. From Rosenau's footnotes, references, and arguments, I shall draw a portrait of the author in the first and second sections of this three-part chapter, while a picture of the moment of her writing is the focus of the final section.

I · LA PENSÉE

In her third chapter, 'Further Aspects of Creativeness', Rosenau illustrates a detail from Auguste Rodin's (1840–1917) *La Pensée* (Thought) (figs 1.4, 1.5a, and 1.5b). Readers may be familiar with Rodin's monumental and masculine *Le Penseur* (The Thinker) (fig. 1.6), conceived in 1880 for his *Gates of Hell* (Musée des Arts Décoratifs, Paris) as the Florentine

1.4 Auguste Rodin (1840–1917), *La Pensée* (Thought), carved *c.*1895, marble, 74.2 × 43.5 × 46.1 cm. Praticien: Victor Peter (technique). Photographer: René-Gabriel Ojéda. Musée d'Orsay, Paris. Photo © RMN-Grand Palais / Dist. Photo Scala, Florence.

poet Dante Alighieri pondering his own *The Divine Comedy*. What is the logic of Rosenau's focus on a work titled with a concept grammatically feminine: *La Pensée*?

In pages preceding the illustration, Rosenau tracks the social and cultural changes in Europe since the French Revolution that register the impact of industrial modernization on women and the ramifications of political Modernity for women, identifying individual revolutionary advocates for the rights of women in the later eighteenth century, such as the British feminist Mary Wollstonecraft (1759–1797) and the French feminist and abolitionist Olympe de Gouges (1748–1793) (see fig. 3.56). They inspired a women's revolt lasting into the later nineteenth century, promoting demands for the rights to education (a developed mind), to work (an income, economic independence, and social purpose), and to vote (civil emancipation as a political subject and citizen). Rosenau

1.5 a) Page 86 from Chapter 3 of *Woman in Art* (London: Isomorph, 1944): detail of the head in *La Pensée* (see fig. 1.4). b) Detail of the head in *La Pensée* (see fig. 1.4). Photo © RMN-Grand Palais (Musée d'Orsay) / Jean Schormans / Photo Scala, Florence.

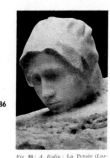

reads in translation :
" The same as a man—
Also a beast of burden !
In the dusty mine
She grew up and lived.
In body and soul
Just like him,
A beast of burden—
Just like him."

It is characteristic that the " masculine protest," first extensively studied from the psychological viewpoint, makes its appearance here and is found coupled with a conscious feeling of solidarity. The pioneer is no longer an exceptional " genius " but one of a group of dispossessed sisters. Once this idea became popular, it influenced politics, especially in the English Suffragette movement.[64]

By contrast, Rodin's sensibility and instinctive symbolism is the most revealing in modern art as regards the potential power of women. Rodin's attitude has been expressed by himself in a talk with P. Gsell, when he stated : " La réflexion très profonde aboutit très souvent à l'inaction." This in-

Fig. 50 : A. Rodin : La Pensée (Luxembourg Museum, Paris).

"*The widening of the basis for political influence by women was attempted by suffragettes and their men friends. It is worth noting, however, that the radical leader, Mrs. Emmeline Pankhurst, still*

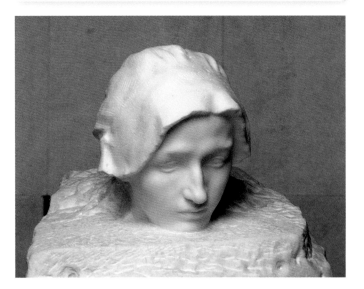

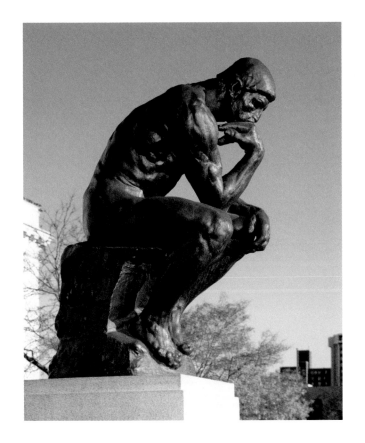

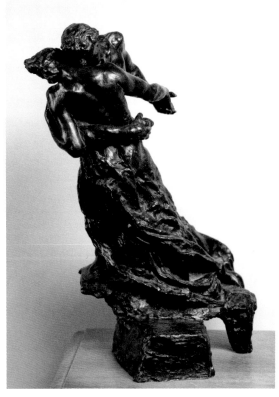

equally acknowledges working-class women defiantly engaging in typically masculine tasks such as heavy labour in coalmines (see fig. 2.49), their defiance of gender exclusion from work being as important as the political emergence of solidarity among women and collective understanding of disadvantage. Affirming a trajectory from individual dissension to mass movement, she concludes: 'The pioneer is no longer an exceptional "genius" [Mary Wollstonecraft or Olympe de Gouges] but one of a group of dispossessed sisters.' This novel solidarity not only motivated women's mass political action; it also engendered artistic activity and challenges to regimes of representation. From this brief history, Rosenau focusses on the *concept of the mind at work* proposed by Rodin's Symbolist sculpture, generally assumed to be modelled on Rodin's younger contemporary, another sculptor, Camille Claudel (1864–1943) (fig. 1.7), whose name was clearly familiar to Rosenau.

Claudel challenged the static quality of sculpture with works that evoked dynamic physical movement in daringly expressive poses, conveying psychological urgency and mutual eroticism as much through pose and treatment of her *matière* as through the pathos of both adolescent and ageing women.[2] Feminist sculpture historian Claudine

1.6 Auguste Rodin (1840–1917), *Le Penseur* (The Thinker), modelled 1880–81, cast in bronze in 1904, 200.7 × 130.2 × 140.3 cm. Detroit Institute of Arts. © Detroit Institute of Arts / Gift of Horace H. Rackham / Bridgeman Images.

1.7 Camille Claudel (1864–1943), *La Valse* (The Waltz), c.1893, bronze, 43.2 × 23 × 34.3 cm. Musée Rodin, Paris. © Philippe Galard / Bridgeman Images.

Mitchell elucidates Claudel's daring renegotiation, in her sculptural compositions, of the axis of intellectuality and sexuality central to late nineteenth-century academic sculptural theory even as officials, controlling the funds for casting sculptural ideas in bronze, severely censored any 'erotic' expression of sexuality by women.[3]

For Rosenau *La Pensée* (see fig. 1.4) *represents* an idea even as it singularizes its idea in/as *a* woman, going beyond woman as image to her being thinking itself. At first take, we might react against Rodin's encasing of the invisible body of the woman in a block of marble, as if her intellect remains contained, not yet freed into self-expression. Such is not, however, Rosenau's reading of the sculpture as an exercise in Symbolist aesthetics contemporary with the mass movement of women. For her, Rodin engages with that 'modern moment' in both women's activism and the representation of gender and feminine subjectivities as subjects to/of historical change that must be registered in innovative form. From Rodin's sculptured head – its chaste bonnet still bearing chisel marks and its finished, individualized face lost in self-contained reverie, with both emerging from roughly hewn marble – Rosenau reads a materialized formulation of an ungraspable principle: thought, cast *in and of and from the feminine* as a new, individuated force:

> By contrast, Rodin's sensibility and instinctive symbolism is the most revealing in modern art as regards *the potential power of women*. Rodin's attitude has been expressed by himself in a talk with P. Gsell, when he stated: 'La réflexion très profonde aboutit très souvent à l'inaction [Very deep reflection frequently arrives at inaction].' This intensive thought which is not manifest in overt action takes for Rodin *a woman's shape*. In his sculpture *Le Penseur* he shows a figure *bowed down* and concentrated on *the task* of thinking. His *La Pensée* illustrates the very opposite: out of an angular block the neck and head of a woman *arises* [see figs 1.4 and 2.50]. It is no longer the collective or the sexual aspect of womanhood which is expressed. In a manner which denotes no effort, thought is represented, the thought of the solitary woman as a thinker.[4] (my emphases)

Dynamically, *thinking* (activity) appears to *weigh down* a male figure – a type: the thinker – as a *task*, while, on the contrary, *thought arises* out of the roughly hewn marble block to take 'a woman's shape'. This is not Woman as allegory. Dispensing also with the classical language of heroic, muscled, bronze male nudity of *Le Penseur*, Rodin's modernist daring in *La Pensée* singularizes *a woman*, distinguished from both the pre-modern *Woman* and the modern political collectivity of 'dispossessed sisters' as *women*.[5] Freed from social, legal, mythic, and theological concepts that defined and confined women, mostly in the 'sexual aspect', Rodin's

sculpture reimagines 'the potential power of women' as intellect and reflection through rendering a solitary creative woman's head as *thought* itself – where thinking is neither burden nor labour but a state of being, and of time, as thought becomes the weighing up of many possibilities in meditative reflection. *She* can thus engender a symbolic form realizing the *modern* feminine subject. The sculpture thus realizes the potential in the grammatical gender of *La Pensée* itself. Rosenau argues that historic political movements and their concurrent changes to subjectivity have been distilled from the collective to enable a symbolic realization in the revolutionary image of 'the solitary woman', who is implicitly *this* woman, herself a creative artist, while the sculpture gives an aesthetic-symbolic form to the modern subjectivity of 'woman as thinker'.

Rodin first imagined the work as *Thought Emerging from Matter* – his own version of Genesis, form emerging from stone as metaphor for sculpture itself, the process of creating symbolic meaning by aesthetic handling of inert material. Rosenau references interviews with Rodin by Paul Gsell from 1911. Rodin defends himself from Gsell's initial perplexity, and even anguish, on encountering the plaster version (*moulage*) for the later carved marble sculpture *La Pensée*, following which Gsell described the head as inclined, the body twisted painfully as if caught in mysterious torment. Gsell felt 'she' was encased and immobilized, without limbs and deprived of movement and the potential for action. Rodin replied:

> 'What are you reproaching me for?' he said with some astonishment. 'It is by design, believe me, that I have left my statue like this. It represents *Meditation*. That is why it has neither arms with which to take action nor legs with which to walk. Have you not noticed, in fact, that reflection, when at its deepest, justifies plausible arguments for opposing decisions such that it counsels inertia?'[6]

Rosenau implies that mass action animates movement but recognizes Rodin's insight that thought is a mode of inaction, a virtuality in Bergson's terms.[7] Rodin has not, therefore, created an image of passivity but the embodiment of reflective and singular interiority for the recognition of which women have had to struggle. Gsell then understands Rodin's purpose:

> This woman, that I then understood, was the emblem of human intelligence that has been urgently animated by problems that it cannot resolve, haunted by an ideal it cannot realize, obsessed by the infinite that it cannot embrace.[8]

Thought conveys mental work of virtuality – meaning both futurity and unrealized potential. Gsell allows the woman to figure the 'emblem

of human intelligence' in a mental struggle with the hard world. Yet in a sculpture that insists on the labour of the artist in forming an image emerging from a solid piece of marble, Rodin has embodied an idea of intelligence itself as the invisible *work* of the artistic mind in general as it pauses, meditates, reflects, weighs up, or perhaps feels defeated by the enormity it seeks to comprehend through forming a sculpture. In mechanics, inertia is the state of matter before a force propels it. Inaction is not a negation but a 'state of potential'. Inertia is then the 'inspiriting-intellectual' (my neologism to capture the double meanings of the German *Geist* and French *esprit*, which translate as 'mind' or 'intellect' as well as 'spirit') condition of thought itself that Rodin has formulated to convey the pathos Gsell registered encountering the plaster form in Rodin's studio.

Rosenau's text has, however, placed this sculpture strategically. *She*, the thinker thinking, becomes the emblem of human intelligence in a world where women were struggling for the right to think, and, in Claudel's case, to think sculpturally. Rosenau opens a space for 'thought' in the historical trajectory of both women's philosophical and political protest and their desire for full realization as a subject, neither as a category defined and confined by others, nor as the other of thought – mere body.

This is innovative and confident feminist art history, so far. Then Rosenau swerves to philological and Jewish theological territory that bonds linguistic grammar with symbolic ideation:

> This bust may well remind one of the verse in *Genesis*: 'And the spirit of God moved upon the face of the waters' (*Gen.* 1: 2). It is worth noting that the original Hebrew text uses the word *ruach*, spirit in its feminine form. In this manner a gulf in time is bridged by a great artist's inspiration.[9]

Ruach is the Hebrew for 'breath'. It is also translated as 'spirit', signifying an invisible, animating force. Yet the Hebrew verb for what *ruach* is doing in *Genesis* 1 – [Me]RaCHeFet, מְרַחֶפֶת – is not strictly 'moving' as in 'moved upon the waters'; it is better translated as 'hovering', or, from the three-letter Hebrew root of the word (*Resh, Chet, Peh*) 'brooding', which comes closer to what Rodin explained to Gsell as inertia of the mind as it is thinking: brooding, hovering, suspended before action.

In her footnote beside which she has placed an image by Claudel's younger contemporary, the French painter Marie Laurencin (1883–1956) (fig. 1.8), Rosenau quotes Rodin again but adds a gloss on *ruach*:

> 'Profound thought frequently leads to inaction.' The fact that the Hebrew word *ruach* has a masculine as well as a feminine meaning provided the basis which influenced the 'Wisdom Literature' as well as Montanists and other Christian sects.[10]

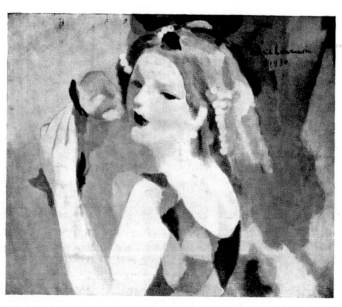

Fig. 52 : *Marie Laurencin* : Girl with Rose, *watercolour.* (*Paul Rosenberg Coll.*)

[65]*Cf. P. Gsell* : A. Rodin, *Paris,* 1911, p. 205 : " *Profound thought frequently leads to inaction.*" *The fact that the Hebrew word* ruach *has a masculine as well as a feminine meaning provided the basis which influenced the* " *Wisdom Literature* " *as well as Montanists and other Christian sects. Cf. D. Nielsen :* Der Dreieinige Gott, *Copenhagen,* 1922, *an important work, although a certain bourgeois bias and lack of acquaintance with psychological research mar some of its conclusions. Nielsen deals mainly with the later phases of Semitic thought, and does not consider Old Testament sources. Cf. also E. Jones :* Essays in Applied Psycho-Analysis, *London,* 1923, *esp.* p. 415 ff.

[66]*Cf. L. Ashton and B. Gray :* Chinese Art, *London,* 1935, passim ; *A. Waley :* An Introduction to the Study of Chinese Painting, *London,* 1922, p. 45 ff.

88

sented, the thought of the solitary woman as a thinker. This bust may well remind one of the verse in *Genesis :* " And the spirit of God moved

Referencing both the mystical Jewish Kabbalah and ecstatic and egalitarian early Christianity, Rosenau's footnote directs us to Danish scholar Ditlef Nielsen's comparative investigation into the Christian concept of a three-in-one deity (Father, Son, and Holy Ghost). He underlines its difference from other mythic and religious systems that formulate a trio of Father God (*m*), Mother Goddess (*f*), and Son (*m*). Finding Nielsen's work a little marred by 'a certain bourgeois bias', Rosenau criticizes him also for the omission of both a recent psychoanalytical interpretation by British psychoanalyst Ernest Jones and ignorance of 'Old Testament sources' – that is, Jewish theology and the Hebrew language itself. The latter does not reduce the feminine to the maternal, but does linguistically and hence symbolically *include* the feminine, and sometimes, as Bracha Lichtenberg Ettinger has suggested, a matrixial feminine, as a principle within the deity, as we see in associated terms such as *Shechinah* ('dwelling or presence of the deity', grammatically feminine) and the invocation *El Malei Rachamim* (translated as 'God full of Mercy', but literally 'of many wombs', with the root word *rehem* (womb) engendering in Hebrew the word for mercy and compassion).[11] Grammatically feminine

1.8 Page 88 from *Woman in Art* (London: Isomorph, 1944) showing *Woman with Rose* by Marie Laurencin (1883–1956). Formerly Rosenberg Collection.

but not as a goddess or divine being, the Hebrew *ruach*, an invisible force, sets things in motion even as its own source and direction are not definable. It causes movement, generating life and form, even as it is invisible and shapeless. The inertia of matter that is the void is thus 'thought' into becoming by *ruach*. As form- and later life-animating 'breath', *ruach* would also later in the twentieth century become a major topic in the relational thought of the post-Holocaust Jewish philosopher Emmanuel Levinas (1906–1995). Breath and breathing become key concepts for the aforementioned artist-theorist Bracha L. Ettinger in dialogue with Levinas, as well as for the feminist philosopher Luce Irigaray, all of whom address the concept 'in the feminine'.[12]

Rosenau references Jones's *Essays in Applied Psycho-Analysis*, specifically directing us, by page numbers, to his paper 'A Psycho-Analytic Study of the Holy Ghost'. Speculating on the psychological basis of the aberrant composition of the Christian Trinity, Jones argued that, for both psychoanalysis and anthropology, 'The Mother' is the obvious second element of divine trios of Father, Mother, and Son. Jones argues that Christian thought, however, hides the Mother within – or even represses her as – the Holy Ghost or Holy Spirit. Christian theology then makes a difficult compromise, he suggests, between the archaic and classic Mother Goddess, the feminine, and what Jones terms 'the Hebraic tendency towards an androgenic conception'.[13] Jones here demonstrates a typically Christian misunderstanding that attributes masculinity to the Judaic deity and Judaism in general rather than finding, as have Rosenau and other feminist scholars, an autonomous feminine already included in the varied words used of the deity in Hebrew scriptures, and indeed in the force of *ruach* itself, which Rosenau states combines both masculine and feminine meanings, as indicated above.

Rosenau leaps across the imaginative and historical gap between the theological concepts encoded in Hebrew and Jewish texts to Rodin's modern, Symbolist sculpture, which, unknowingly or not, but in tune with the historically emergent political movement of women, created an aesthetic formula for 'thought as force' that condenses both the most ancient pre-patriarchal acknowledgements of a feminine agency and the most contemporary post-patriarchal aspirations of a political movement, giving both a form 'in the feminine' – where feminine does not mean 'of women' or 'associated with women'. Without entrapping it in the Oedipal as Mother in the archaic Trinities, and without disappearing it into genderless abstraction as 'spirit', Rosenau has teased out an animating, becoming force: *ruach* as *the feminine*.

Unpacking just these few sentences reveals Rosenau's synthesis of a range of sources on both art and historical processes with contemporary

developments in philology, psychoanalysis, and the anthropology of religious thought and language to arrive at this one example of what her book does again and again: bringing into dialogue *Woman* and *Art* by placing woman *in* art, as always already a question and a presence, and as a figuration of a becoming force. Art becomes a site of its own forms of thinking. This passage finally is but one example of the density and range of her thought that inspired the final section of this book, where I undertake a slow unpacking of seven aspects of what is not at all a 'little book'.

II · THINKING ART HISTORY BETWEEN GERMANY AND ITS SCHOLARLY DIASPORA IN BRITAIN

Rosenau was a multi-lingual scholar, feminist intellectual, and art and architectural historian deeply engaged with both the theoretical foundations of her discipline and the major humanities and social sciences. She was an equal partner in the transformative intellectual project of the German-language and European-wide discipline of Art History, but its now well-known figures remain largely masculine and there is little recognition of her, and many other women's, originary feminist inflection. Furthermore, she belonged in the community of leftist and secular Jewish thinkers, both women and men, queer and straight, whose multiple and often outsider perspectives on the theological–cultural legacies of the dominant Classical and Christian aesthetic forms and systems of thought diversified and critically reassessed Western art's *work* in relation to thought, belief, ideology, politics, and imagination, effectively differencing the Christianocentric canon of Art History that places non-European traditions as 'other'. In that field, her gesture was both to trace the *Nachleben* (Warburg's term for the persistence, survival, and return of pagan antiquity) of Judaic symbolic forms in Christian, and later modern Jewish, architecture and identify multiple aesthetic–religious traditions from the ancient period to the modern by attending not only to classical Greek and Roman legacies but also to Middle Eastern Jewish thought-forms.[14] Finally, she was one of the diverse group of refugee scholars from Europe whose cultural impact on British intellectual culture we are belatedly recognizing.[15]

Rather than reading *Woman in Art* as an isolated or idiosyncratic text by a solitary feminist voice suspended rootless, in the mid-1940s, we can now see the book as a dense meeting point of late nineteenth-century and early twentieth-century German-, French-, and English-language sociological, anthropological, and art-historical thought. It confirms a long history of feminist interventions in all three disciplines from the late nineteenth century on, when modernization and critical analysis of

massive historical change, Modernity, affected not only relations of class (as capitalism) and race (as colonialism and imperialism) but also crucially 'the status of women' (the typical framing of the debate in many fields) across different classes, communities, and cultures of difference.

As I began my research on Helen Rosenau in 2012, I opened my battered copy of Claire Richter Sherman with Adele Holcomb's *Women Interpreters of the Visual Arts, 1820–1979*, published in 1981. Rosenau is listed there among 'Women Art Historians and Critics' for the period 1930–79. Her work on architectural history and theory is represented in detail and her entry concludes: 'Rosenau has also published on eighteenth century French painter Jacques-Louis David (1948), and, most exceptionally for the time, in 1944, *Woman in Art*.'[16] Thirty-seven years after Rosenau's book publication, there was a reference to *Woman in Art*, which I had not noted when I first read this book.[17] It has taken me another forty years of research and self-re-formation as a feminist art historian to turn that missed encounter into a substantial acknowledgement of Rosenau as a feminist art historian. No regrets. Now is the moment for me, for us, to re-encounter Rosenau and read *Woman in Art: From Type to Personality*.

Sherman and Holcomb also wrote a long paragraph on Rosenau in another section noting three names of women specializing in Jewish studies in Art History at its beginnings. Rosenau's companions were Zofia Ameisenova (1897–1967) and Rachel Wischnitzer (1885–1989).[18] This second entry is not insignificant, for the argument I shall also advance here. In addition to writing *Woman in Art* (1944), in 1948 Rosenau published *A Short History of Jewish Art* and her final published monograph (1979) would be her study of the influence of the lost Biblical Temple on concepts and forms of sacred buildings across many religions.[19] Rosenau thus also played a significant role in the developing field of Jewish studies of art and its architectural form across the twentieth century.[20] Both Jewish studies and feminist studies challenge hegemonic systems that establish their own normality, be that Christianocentrism or Patriarchy, through a figuration – often a disfiguring inclusion – of their structuring other: *the Jew* and *Woman*. Switching from cathedral (in *Der Kölner Dom*, her first doctoral thesis, in Hamburg) to the synagogue (in *The Architectural Development of the Synagogue*, her third doctoral thesis, in London), Rosenau radically expanded the historical and geopolitical frame of her investigation into the meaning of *design* – the intellectual conceptualization – in architecture as a symbolic form or *image* (in Panofsky's as well as Warburg's terms) rather than as a monument to be studied only for stylistic features indicating the evolution of style. Her work articulated archaeology with theology,

treating thought as a symbolic form, articulated through form and material. Concurrently with her architectural work, during the1930s, Rosenau was to focus on another idea-become-form, *Woman*, as it was formulated in and by the visual arts.

In patriarchal, Christianocentric culture, *Woman* and *Jew* are figures of difference.[21] With Rosenau, they become Archimedean points for analysing both the dominant structures of power and the differentiated subjective situations that dominant cultures rarely acknowledge as co-existing within them. Attention to them, however, enables the scholar, and us all, 'to pivot the centre'.[22]

Rosenau wrote her book in conditions of racist expulsion, traumatically rimmed with the slowly revealed horror of mass murder of the Jewish communities left in Europe. She encountered a cool welcome from the mostly positivist British hosts and lack of support from some fellow refugee art historians. She faced the necessity of making a living without her prestigious academic accreditations and training providing purchase on a secure university post or career. Awareness of these factors sharpens our sense of how to read Rosenau's tenacity and adaptation alongside her distinctive combination of social–historical, Jewish and feminist, architectural and utopian art histories. At both existential and political levels, it becomes clear that being a refugee, European Jewish not Anglo-Jewish, and a woman in a male-bonding discipline – despite many significant women scholars being its co-creators – offered more than substantial challenges throughout Rosenau's working life.[23] We might also have to wonder whether her lack of a secure academic position for many years resulted in part from the fact that her potential entry into the still-nascent discipline of Art History in Britain in the 1940s was a book titled *Woman in Art: From Type to Personality* that paralleled her work on Jewish histories of art and architecture. Only when she defined herself as a specialist in eighteenth-century architecture and art, with a focus on the City as concept and symbolic form, for instance in *The Ideal City in Its Architectural Evolution* (1959), did she acquire a permanent university post.[24]

The ways in which Rosenau conceptualized, across a long history, the relation of figure, concept, and symbolic form – *Woman* – interacted intellectually with her posing the question of a trio of equally charged terms – the Jew, the Temple, and the City – in a long and dispersed history. The model she proposed drew richly on forms of cultural analysis within and beyond the frontiers of Art History to participate in her own distinctive, yet still Warburg- and Panofsky-informed, emplotment of art's histories through, within, and across the *image*, theorizing the *image* neither as a repository of given meaning nor as the site of

1.9 Pictorial Press, *Simone de Beauvoir* (1908–1986), 2 November 1947, gelatin silver print, 20.3 × 25.4 cm. Photo: Hulton Archive / Stringer, Getty Images 2662847.

iconographic complexity nor as a mere vehicle of formal evolution, but as a figurative and intellectual register of thinking – and imagining – structures of social organization, processes of historical transformation, and works of imaginative dissent and desire.

— A Community of Thinkers

Rosenau is but the tip of an iceberg of many women and some men intellectuals whose work sustained her research and paralleled her writings. She was deeply engaged with the major debates on gender that were – it may well surprise some readers – already central to European and US-American intellectual culture from the later nineteenth to the mid-twentieth century under the emergent rubrics of sociology and anthropology as well as both interdisciplinary feminist thought and progressive feminist politics. Some of Rosenau's feminist and non-feminist contemporaries in the European, US-American, and international anglophone academy engaging with critical theories of gender included renowned anthropologists Ruth Benedict (1887–1948) (see fig. 3.41) and

Margaret Mead (1901–1978); sociologists Marianne Weber (1870–1954) (see fig. 3.4), Mirra Komarovsky (1905–1999), and Rosenau's co-supervisee at the London School of Economics (LSE) Viola Klein (1908–1973) (see fig. 3.33); archaeologist Jacquetta Hawkes (1910–1996); the critic of male bias in science Ruth Herschberger (1917–2014), and the French philosopher Simone de Beauvoir (1908–1986) (fig. 1.9).[25] 'Gender' is currently associated more with a sense of constructed or declared identity. In the context of art-historical, sociological, and cultural theory, however, it is understood as i) an axis of asymmetrical socio-economic–political power akin to those of class or race and ii) a symbolic representation of a hierarchy of value such that one term is valorized by the devalorization of the other.[26]

Because she was also a refugee scholar and was undertaking additional research at the LSE with Mannheim at the same time as Rosenau, it is worth pausing to learn more about Viola Klein's thesis at the LSE, which was titled *Feminism and Anti-feminism: A Study of Ideologies and Social Attitudes*. Completed in 1944, it was only published in 1946 under a slightly misleading but still Mannheimian title: *The Feminine Character: History of an Ideology* (fig. 1.10).[27] Klein undertook a critical analysis of ten modern theorists of gender: Havelock Ellis (biological approach), Otto Weininger (philosophical approach), Sigmund Freud (psychoanalytical approach), Helen B. Thompson (experimental psychology), L. M. Terman and C. C. Miles (psychometric tests), Mathias and Mathilde Vaerting (historical approach), Margaret Mead (anthropological approach), and W. I. Thomas (sociological approach). She investigated thought-models for examining the question of gender and sex differences through discourses that had sought to define femininity.

1.10 Cover of Viola Klein, *The Feminine Character: History of an Ideology* (London: Kegan Paul & Co., 1946).

As a sociologist, Viola Klein, however, displaced 'nature' by the term 'character', while her initial title makes clear that her work was not a compendium of views but a historical sociology of knowledge, examining socially situated and disciplinary mindsets that Mannheim defined as ideology. What is so striking is that the initial title, accepted at the academic institution as a study acknowledging the ideological politics of *feminism and anti-feminism*, did not make it into the printed version.

Klein's *feminine* (she had been a scholar of French literature and studied at the Sorbonne) in the published title anticipated, however, Beauvoir's first volume of *Le deuxième sexe* (The Second Sex), *Les faits et les mythes* (Facts and Myths) (1949), which was being researched at the

same time. The latter was not concerned with *feminine* character. Beauvoir deconstructed *le féminin* – myths of femininity in science, sociology, and psychoanalysis – as did Klein, whose trajectory Beauvoir traced first in the volume *Facts and Myths* under 'Destiny' – biology, psychoanalysis, and historical materialism – and then under 'History' and 'Myths'. In her second volume, titled *L'experience vécue* – newly translated in 2011 as *Lived Experience*, i.e. as situation (the existentialists took up this concept, which also echoes Mannheim's sociology of *Lagerung* (situation/location) in his theory of thought and social formation, which I shall explain more fully in the third part of this chapter) – Beauvoir drew on both women's own writings and writings about women to illuminate how, in women's lived experience, they experienced the shaping and deforming of their subjectivities and bodies by those very myths – ideological thought systems – whose impact equally generated psychological vagaries that were then attributed to the inherent weakness of women's nature and brains.[28] Beauvoir's concluding chapter, 'The Independent Woman', was written at a point when French women had only just won the vote (1944) and also were no longer required by French law to be obedient to their husbands. Yet, she argued, women still lacked economic autonomy, concluding that 'work alone can guarantee her concrete freedom'.[29] Work for Beauvoir, the philosopher, was intellectual work: thought.

In this extended company and moment of feminist intellectual interventions, Helen Rosenau represents a modern socialist, Jewish, and feminist art historian who was clearly a creative personality in her own new terms. Reprinting and framing her book is not only a critical contribution to modes of art-historical writing but also my work of intellectual politics to reclaim this valuable historical text in the history of Woman *and* art and of this woman *in* Art History and in the history of feminist thought.

— The Politics of Timing

Why did an eminent architectural historian and, so far, a medievalist, choose to write a book on *Woman in Art* at such a moment and with Mannheim at the LSE? Why did Mannheim take on an art historian? What made Rosenau's project as an art historian both possible and necessary at a specific point in history, around 1940, and how could it have been so easily lost?

I suggest that *Woman* figures as a term in anti-fascist struggle. Fascism was ravaging a modernizing world whose progressive forces, among which the women's movements worldwide must be counted, were being stalled by a world war caused by militarist totalitarianism. The fascist powers of Italy and Germany had purposely crushed the

radical modernization of the condition and subjectivity of women. The Third Reich declared its ideological war against the project of feminism itself with its ideology of *Kinder*, *Küche*, *Kirche* (children, kitchen, church). Social and feminist studies should be understood as a declaration of resistance to this reverse of a women's revolution. Rosenau's book is, itself, an anti-fascist statement.

The fate of her book – being overlooked – is, as tragically, also a result of the post-war Western powers' unacknowledged internalization of elements of fascism's gender conservatism. If the twentieth century had begun as 'the century of women' and had produced not only political activism but also a feminist cultural revolution during the 1920s, that hope was stalled in post-war Western society as it drew back from earlier gender radicalism.[30] Post-war ideologies tried to send women 'back to the home', culturally idealizing domesticity and motherhood and leaving women with an impoverished 'pop memory' of the long-since-gone 'suffragette' in place of the 150 years of sustained feminist thought and political struggle since the eighteenth century, which had as deep an intellectual and an aesthetic dimension as a political one. Finally, anglophone Art History of the post-war twentieth century *became* institutionally and ideologically sexist, falling silent about the many artist-women who had co-created modern art, and historically gender exclusive in their collecting, documenting, and celebrating.[31]

That Rosenau's feminist book was ignored and subsequently forgotten may itself have been a symptom of this double rupture in women's twentieth-century history, caused by fascism, and then the internalization of a resistance to women's progress, evident in Western post-war conservative retrenchment. As we now ponder the fate of Rosenau's books and Rosenau herself, she who responded to the challenges of Modernity and its darkest hours, we need to recover the context of her projects. It is not merely shocking but also destructive of our present that what Rosenau had proposed in her book became so completely invisible less than thirty years later, its memory lost by the early 1970s when my generation of emerging feminist scholars found itself compelled, but in ignorance of our recent and still living predecessor's work and thought, once again to pose the questions of Woman/Women in/ and Art – but so differently, and in a way impoverished by the attenuated, anti-theoretical discipline of Art History with which we first battled.

It was not just that her name and her book disappeared. It was her art-historical model – a historical–sociological hermeneutics of the image – that her work represents that got lost, to be replaced by what became the dominant 'rediscovery' mode of monographic feminist anglophone Art History. As I survey, and honour, the often-cited canon of

feminist art-historical writing post-1970 – starting from the North American art historians, such as Linda Nochlin, Ann Sutherland Harris, Eleanor Munro, Eleanor Tufts, Elsa Honig Fine, Judy Chicago, Norma Broude, Mary Garrard, Karen Petersen, and J. J. Wilson – I notice that, apart from Nochlin's sociological analysis of institutional and ideological discrimination, the format for this later twentieth-century feminist recovery was Vasarian, rather than analytical.[32] This means that these feminist books and exhibitions were largely compilations of artist-women's names with biographies and illustrated works organized in periodized sequence, inserting the missing women into the existing story of styles while defining their difference.[33] This was then consolidated by scholarly monographic studies of individual artist-women reflecting, while only challenging a little by their focus on the gender of the artist, the artist-centred mode of twentieth-century Art History, which sidelined the philosophical and theoretical German models (apart from Panofsky's philosophically muted version of iconography, which remained strong in medieval and Renaissance studies of major named artists).

The opening declaration of Ernst Gombrich's (1909–2001) influential *The Story of Art* (1950) – which I shall discuss shortly – is simply this: 'There is really no such thing as Art. There are only artists.'[34] Gombrich thus wiped away the very context of Rosenau's own intellectual formation. Her innovative book traces no story of development but a radical shift of *Woman in Art*: *From Type to Personality* that focuses on images as sites of many forms of cultural thought figured by *Woman* as type (a Panofskyan category, as we shall see) to the point at which women themselves became the thinkers and formulators of meaning, so that, under the conditions of modernization – and later Modernity – the individual artist, writer, or sociologist can realize herself as a singular personality.

Rosenau's book thus became theoretically and art-historically stranded, sadly, between the intellectual culture in which it had been formed in European thought in the 1920s–1940s and the post-war British and US-American formations of a largely anti-theoretical, positivist, and sexist brand of Art History that negatively shaped a major form of post-1968 feminist Art History in either the monographic, artist-name mode or the study of 'images of women'. Rosenau's book is neither about 'women represented in art' (iconographical image studies) nor 'women as artists' (Vasarian artist studies) – the two dominant tendencies of post-1960 feminist recovery art-historical writing – nor yet openly, though implicitly, a critique of mainstream Art History's selective and gender-exclusionary version of art's histories (my own project). In her moment of writing, Art History was not as exclusive of artist-women as it was to become post-1950.

Rosenau tracks, interculturally and over history, *Woman* not only as a member of social communities but also as a *concept*, a *figure*, an *idea*, a *formula*, and a *symbolic form*. She does so by reading the varied aesthetic formulations and inscriptions in artworks that enable her both to trace histories of social organization and to map patterns of cultural imagination around issues of socio-economic and symbolic importance in most societies: kinship, laws of property, love, desire, and subjecthood. Not offering a 'story' of artists, periods, styles, or movements that became typical of several branches of her discipline, Rosenau produced an analytical, cultural study of the representation of social, ritual, symbolic, and imaginative understandings of gender as social, erotic, legal, and cultural relations over the full swathe of human history. Thus, by attending to the visual arts, we are invited to follow historical transformations as cultural formulations – in which women's subjectivity and social subjecthood can be traced and were self-inscribed as women increasingly became what US-American historian Mary Ritter Beard (see fig. 3.32) termed 'a force in history'.[35]

To read and appreciate the intellectual force and urgency of Rosenau's book now, we need, however, to re-encounter the conditions of its emergence as more than a recovery of 'feminist memories', a title I first used for a lecture I gave on Rosenau in 2014.[36] I have come to challenge and resist more urgently the violence of decades of continuing silencing, effacing, willed ignorance, and blatant sexist indifference that have distorted the histories of art and the character of the discipline of Art History, pushing feminism and the histories of artist-women and studies of the representation of women in art into oblivion at worst, and now into a subordinate space, always deformed by the recurring necessity of having repeatedly to 'rediscover' our own pasts.

— From German *Kunstgeschichte* to Art History in Britain

Rosenau arrived in Britain with an extensive and theoretically cutting-edge art-historical education, having worked with the field's leading intellectuals. Not only, as Rachel Dickson shows in the previous chapter, had she studied at several prestigious German universities, but these were also, in fact, the centres of the new theoretical foundations for the discipline of Art History itself. She was thus at the heart of her discipline's major intellectual debates. Rosenau first studied Art History at the University of Munich with the hugely influential, still important formalist art historian Heinrich Wölfflin (1864–1945), author of three major art-historical and art-theoretical works – *Renaissance und Barock* (Renaissance and Baroque) (Munich, 1888), *Die Klassische Kunst* (Classic Art) (Munich, 1898), and *Kunstgeschichtliche*

Grundbegriffe (Principles of Art History) (Munich, 1915) – and many other studies. Then she went to Berlin to study with the medievalist architectural specialist Adolph Goldschmidt (1863–1944), who, being Jewish, also had to flee. Then she studied in Bonn with a medievalist and monuments preservation specialist, Paul Clemen (1866–1947), and finally moved to Hamburg, where she did her doctoral dissertation with the young Erwin Panofsky (1892–1968) – himself also a former student of Wölfflin and Goldschmidt and whose thesis, supervised by Wilhelm Vöge (1868–1952), focussed on the art theory of Albrecht Dürer (1471–1528) (*Dürers Kunsttheorie: vornehmlich in ihrem Verhaltnis zur Kunsttheorie der Italiener*, 1914).[37] In Hamburg, Rosenau also met art historian Dora Panofsky (born Dorothea Mosse, 1885–1965), who, like her husband Erwin, had studied with classical archaeologist Margarete Bieber (1879–1978), a student of Clemen in Berlin. In 1919, Bieber had become only the second woman to be appointed as a university professor in Germany; hitherto women had not been permitted to submit for *Habilitation*, the postdoctoral research thesis that was the requirement for a university position with the supervision of doctoral students.[38] Erwin Panofsky had hastily submitted his own *Habilitation* thesis in 1920, on Michelangelo and Raphael, once he was offered a university position at the newly founded University of Hamburg.[39] His subsequent published works included the theoretical text *'Idea': ein Beitrag zur Begriffsgeschichte der älteren Kunsttheorie* (A Historical Essay on the Concepts of Art Theory in the Ancient World), published in English as *Idea: A Concept in Art Theory* in 1968.[40] Then came *Die Perspektive als 'symbolische' Form* (Perspective as Symbolic Form) in 1927, which remained, however, untranslated into English (not an issue for Rosenau, of course) until Christopher S. Wood produced a version in 1997.[41] The book's central thesis, on perspective as a means to grasp the cultural systems of different epochs, is summarized as follows:

> Perspective in Panofsky's hands becomes a central component of a Western 'will to form', the expression of a schema linking the social, cognitive, psychological, and especially technical practices of a given culture into harmonious and integrated wholes. He demonstrates how the perceptual schema of each historical culture or epoch is unique and how each gives rise to a different but equally full vision of the world.[42]

This brief description locates Panofsky's project in the lineage of the Austrian art historian Alois Riegl's (1858–1905) *Kunstwollen*, translated as 'will to form' and sometimes as 'artistic volition' – a thesis on the shared aesthetic impulse that, detected in the interrelations between and differentiated yet cohering manifestations of the many elements

and sites within historical cultures, enables the art or cultural historian to characterize the culture or the epoch from its components.[43] The phrase 'symbolic form' indexes Panofsky's conversation with the Hamburg philosopher Ernst Cassirer, who, in his multi-volume *Philosophy of Symbolic Forms*, argued that we gain knowledge of the world we inhabit via the mediation of symbols, included within which are scientific laws, myth, religion, art, and language, which enable thought, but also engender ideology, mentalities, mindsets, and imaginaries.[44]

In the same year that Rosenau's *Woman in Art* appeared, 1944, Cassirer, also an exile (then teaching at Yale University), published in English a summary of his three-volume *Philosophy of Symbolic Forms*, his programme for an 'anthropological philosophy' (which was, in effect, a proposition for a philosophical–cultural studies), compressing and rendering accessible his majestic sweep over the history of Western philosophy, the anthropology of religion, and philosophies of science, art, and history.[45] His proposition displaces Reason as the defining attribute of humanity, and, with it, Science as pure knowledge, to argue for the significance of symbolic forms created in and as myth, religion, art, language, history, and science as profound and necessary modes of knowing and thinking. The understanding of these forms of thought – which are inescapably also subjectively and affectively coloured and creative – requires the scholar not only to produce categories of description of their operation but also to discern the unity of the creative process at any point. A symbolic form is not a fixed content, but a means of grasping, conceptualizing, and understanding elements of lived existence. Cassirer engages with nineteenth- and twentieth-century *Lebensphilosophie*, which rejects both Kantian abstraction and positivism.[46] This philosophy of life, or lived experience, was expounded by Wilhelm Dilthey (1833–1911) and sociologist Georg Simmel (1858–1918), the latter a colleague of Cassirer at the University of Berlin. Listing these names, dates, and intersections serves to elucidate Rosenau's ambition and academic positioning within this critical moment of German scholars' validation of the major issues in the arts and humanities in the face of materialist and positivist overvaluations of the natural sciences as the sole model for knowledge.

Rosenau addresses *Woman* as a symbolic form – a thinking space, a thought-form – within the cultural sites of symbolic–affective thinking such as myth, religion, language, and, for her case, visual art. What she retains is both this sense of a long history of symbolic form, evolving and changing over time and space, and the specificities of different 'formings' in space and time geo-historically. Then, as an art historian, she also attends to the singular creative modes of artists' socio-subjective

and aesthetically specific inflections of general artistic *formulations*. As an element of the 'cultural sciences', Art History also needed specialist categories of description, such as form, or style, and image. These become intelligible at the general level of symbolic meaning within a synthesis in terms of social, historical, and cultural processes that define moments of difference over time and space.

Rosenau's writing on architectural history focussed on the concept of design as a symbolic form that manifests itself in the language that buildings speak, and on a specific symbolic form – for instance, the Jerusalem Temple – that is not imitated but repeatedly mobilized as a thought-form trans*formed* in different eras and cultures. Hence there is a formula that persists and returns. In a critical but not exclusive sense, Rosenau, I suggest, works with *Woman* as a symbolic form through which an entire era or culture can be read for how it forms and formulates certain matters of urgency. For Rosenau, these are not Panofsky's spatial relations (as in his book on ways of seeing, ordering, and situating with perspective) but the social relations of gender articulated with orders of power, belief, myth, religion, and desire within different moments and societies.

In 1930, at the University of Hamburg, as a medievalist architectural historian, Rosenau completed her first doctoral thesis, *Der Kölner Dom: seine Baugeschichte und historische Stellung* (Cologne Cathedral: Its Architectural History and Historical Context), establishing her long-lived commitment to the study of architecture as idea and symbolic form whose formulation could be materially and historically traced through the analysis of its conceptual design (fig. 1.11).[47] In Hamburg she thus became part of a remarkable intellectual circle around Erwin and Dora Panofsky including philosopher Ernst Cassirer (1874–1945); art historians Edgar Wind (1900–1971), Panofsky's first doctoral student, and Aby Warburg (1866–1929), founder of the Kulturwissenschaftliche Bibliothek Warburg (Warburg Library for Cultural History) (KBW); the KBW's librarian, Fritz Saxl (1890–1948); and Warburg's assistant on his *Bilderatlas Mnemosyne*, Gertrud Bing (1892–1964), who had completed her doctorate with Cassirer. The KBW was rescued in 1933 from the threat to its existence posed by the Third Reich's anti-semitic fascism and brought to London, where it now forms the Warburg Institute Library as part of the University of London.[48] It was there that remnants of the Warburg circle reformed, including Saxl and Bing (for Rosenau's relation to Warburg's project see Part 3, Essay 3).

In Hamburg, therefore, Rosenau engaged with a deeply philosophical focus on the analysis of the concept of symbolic thought and symbolic form as well as the major uses and transformations of Wölfflinian

formalism and the debates within Kantianism in the discipline of Art History (understanding art as a form of knowledge), and of image as *pathos formula* (*Pathosformel* in German) through Warburg's modelling of the intersection between art history, cultural analysis, myth, symbolic thought, and anthropology. Warburg's theory of the image differed from Panofsky's concurrent development of what he later termed 'iconology'.[49] Warburg approached the image as a *formula* that stores up, in gestural form, and transmits primary *affects* (ecstasy, violence, depression, liveliness, deadliness): *pathos formulae*. Warburg did not treat images as hermeneutic units of interpretable meaning (iconography or signification); instead, images are affectively charged iterations of gestures, postures, and accessories at play in the dynamics of composition. Images are also migratory, transcultural transmitters of *formulations*, binding

1.11 A historical view of Cologne (Köln) Cathedral, 1841, identified as 'engraving by Munchen after a drawing by Gerhaset'. Photo: Hulton Archive / Getty Images 340982.

psychically archaic emotion with symbolic thought by creating an interval, a *Denkraum*, a thought-space, both structural and historical, affective and symbolic. Through his further concept of *Nachleben* (survival, persistence, reanimation), Warburg argued that the classical *pathos formulae* (affective formulations) can be, indeed were, remobilized as dynamic forces to reanimate the stasis afflicting late Christian medieval art, precipitating the 'revival of the antique' that gives the post-medieval period its label, *renaissance*: rebirth. Challenging that idea itself, Warburg's version of art's histories was non-linear, non-progressive, migratory, and recursive. The image is like a battery, and, in formulae, stores up intensity, passion, and anguish that may recharge artistic practices at moments of cultural, socio-cultural crisis – positively or in fact, as he witnessed with anguish in the fascist era, destructively.

When Rosenau arrived in Britain, however, academic Art History was almost a non-existent or at best a minority subject, being taught in almost no British universities.[50] Britain hardly had an art-historical culture at the time, having few dedicated institutions in which to find academic employment, and no specialist art publishing houses. The Courtauld Institute of Art had just been founded in 1932, as she arrived, and was directed and staffed mostly by non-art historians though it was soon populated by passing refugee and exiled scholars. The Warburg Institute only arrived in Britain in 1933. Some of the refugees, but not many, were lucky to find secure paid employment – eventually.[51] Others struggled with short-term appointments or gave one-off lectures or courses. Coteries of insiders and outsiders formed. Political conservatism in Britain and among the refugees themselves led to the marginalization of Marxist and left-wing thinkers, such as Rosenau or the Hungarian Jewish Marxists Frederick Antal (1887–1954) and Arnold Hauser (1892–1978) and the Dutch Jewish art historian Arnold Noach (1910–1976).[52] Being a woman, however, in a close-knit but competitive male-dominated refugee community, only increased Rosenau's precarity.

The incoming university-trained refugee European art historians had a dramatic, uneven, and politically divided impact on the development of the discipline and subject area in Britain.[53] That so many of the continentally trained art historians who taught in Britain did so as Jewish exiles forced into often damaging and precarious migration by the Third Reich also opens another dimension for understanding and reading Rosenau's book. Through its author and her fellow refugees who played a role in its development, this 'little book' touches on the ruptured histories of Jewish modernity and their complex place in, and recognition by, Art History then and now.

As Rachel Dickson shows in the previous chapter, following the promulgation of new laws by the National Socialist Third Reich (which came into being in January 1933) – such as the Law for the Restoration of the Professional Civil Service on 7 April 1933, which excluded German Jewish citizens from holding civil positions (including university posts), and other racially targeted decrees – Rosenau was prevented from submitting her *Habilitation* thesis on medieval architectural design in Bremen, which had been supervised by another medievalist, Martin Wackernagel (1881–1962), at the University of Münster. Being Jewish, she was immediately dismissed from the university, losing her scholarship. Although she later published her *Habilitation* research in English as *Design and Medieval Architecture* (fig. 1.12), the publication is a tiny paperbound book of forty-two pages that is defined as just a part of the 'original work commissioned in 1932 by the Notgemeinschaft der Deutschen Wissenschaft' (Emergency Association of German Science).[54] Her title is not descriptive. Rosenau identified the historical re-emergence (*Nachleben*) of 'architectural design' itself as the considered relation of an idea to the architecture of cathedrals in the Gothic period. Her work as excavator of the earliest imprints of these very early Christian buildings, such as the Cologne and Bremen cathedrals (see figs 1.1 and 1.11), allowed her to drill back into time to uncover the material evidence of the *Nachleben* of the Jerusalem Temple, recorded in biblical text and 'remembered' in its two incarnations before the final Roman destruction in 70 CE (fig. 1.13).

DESIGN and MEDIEVAL ARCHITECTURE

By
HELEN ROSENAU
Ph.D.(Hamburg)

LONDON
B. T. BATSFORD LTD.
15 NORTH AUDLEY STREET, MAYFAIR, W.1

1.12 Cover of Helen Rosenau, *Design and Medieval Architecture* (London: B. T. Batsford, 1934).

Why, then, in 1936 did a scholar with these credentials enrol in the newly founded Courtauld Institute of Art to undertake, in effect, a third doctoral research project? Was it a replacement for the second, namely her *Habilitation* dissertation on Bremen Cathedral, which she would have needed in Germany to gain an academic post? Might a British degree have provided accreditation for a British position, proving her ability to write academic texts in English? This replacement *Habilitation* thesis, successfully submitted to the University of London in December 1939, was, however, surprisingly – or perhaps not – titled *The Architectural Development of the Synagogue*.[55]

The subject was, I suggest, 'of the moment' on many levels. Most of the great synagogues built across the Middle East and Mediterranean islands in the earliest period of the Common Era are lost. It was only in 1932 that the most famous discovery of a synagogue – dating to 244 CE,

1.13 Thomas Hartley Cromek (1809–1873), *The Arch of Titus, Rome: Panel of Roman Soldiers Parading the Looted Treasures of the Temple Following the Sack of Jerusalem in 70 CE*, 1842, watercolour on paper, 52 × 36 cm. Private Collection / Bridgeman Images.

including its wall paintings, with revealing images of then-current architectural ideas of Solomon's Temple – was made in the former Roman garrison town of Dura-Europos in Syria, by Rosenau's contemporary the US-American archaeologist Clark Hopkins (1895–1976) (fig. 1.14). Rosenau was thus swift in taking up the challenge of writing a history of this architectural form, which itself spans the traumatic rupture in Jewish history created by the Roman conquest of Judea and final expulsion of all Jews from Jerusalem and Judea by the second century CE.[56]

Studying with some of the most well-known figures of the flourishing German art-historical community, Rosenau had been a specialist in Christian medieval architecture, even as she would trace the form behind it to the destroyed Temple in Jerusalem, known through texts and imagined 'memories' in wall paintings and later building forms. Initially, in the context of her forced exile, she perhaps felt the need to continue to work in the field of architectural history, which would have enabled her, had the Nazi nightmare been short lived, to return to anticipated progress in her profession in the German context as a medievalist and architectural art historian. Yet her topic at the Courtauld Institute in London was not the symbolic buildings of Christianity, such as the cathedrals of Cologne (her dissertation) or Bremen (her *Habilitation* topic), but the emergence of the Jewish architectural-ritual form, the synagogue, a non-sacred architectural form for a later, non-sacrificial and rabbinical, Judaism emerging before, but flourishing after, the final destruction of the Second Temple in Jerusalem in 70 CE during the First Roman–Jewish War (66–73 CE), when the Judeans resisted Roman occupation and conquest. The early synagogues contain wall paintings that visually imagine the lost Temple, and thus became the buildings of an exilic Judaism and the sites of preserved memory, instancing another kind of *Nachleben* of space and idea – the Temple – preserved in textual description in the Jewish Bible. Did Rosenau's choice of topic also signify a defiant embrace of the *Jewish* condition of her own current exile and interrupted academic career?

We cannot but ponder the political significance and emotional poignancy of this scholar devoting herself at this moment to so overtly

Jewish a topic and to publishing a book on the synagogue's early forms literally on the cusp of what was then, in 1940, an imminent Nazi invasion of the almost defenceless British Isles, especially when, as Rachel Dickson points out, Rosenau's name was on a National Socialist list of the refugees to be immediately detained and worse once the Reich had conquered Britain. Finally, the traumatic resonance with the contemporary destruction of Jewish synagogues and communal buildings across the Third Reich on Reichspogromnacht (9–10 November 1938) (fig. 1.15) – a symptom of the assault on, dispersion, and intended destruction of European Jewry – cannot be underestimated, given that these events occurred as Rosenau did her research, travelling with further grants to Egypt and Mandatory Palestine in the late 1930s to see the ancient sites and collect her primary materials.[57]

As the bombing of London became intense in preparation for an invasion in 1940, Rosenau began yet another research project – based, however, at the LSE under the mentorship of a sociologist, Karl Mannheim, who was, however, part of the conversation in Germany about the relations between elements of cultural forms (myth, religion, ritual, art), social forms, and social consciousness. Rosenau's new project,

1.14 Interior western wall painting: the Tabernacle and priests at Dura-Europos Synagogue, Syria, second century CE, tempera on plaster. Godong / Bridgeman Images.

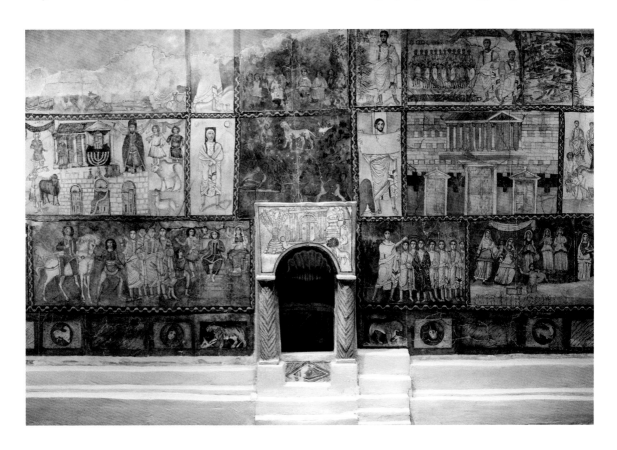

1.15 Interior view of the destroyed synagogue at Fasanenstrasse 79–80, Charlottenburg, Berlin, burnt down on Reichspogromnacht, 9–11 November 1938. Landesarchiv Berlin F REP 290(05) nr.0072034 / Photo: Wilhlem Dauss.

completed in November 1943, was published in 1944 as *Woman in Art: From Type to Personality*.

What, I must ask, is the connection between the Warburg-informed and Panofsky-inflected study of medieval architecture, Rosenau's architectural history of the synagogue as another site of cultural memory of the two destroyed Jerusalem Temples, Mannheim's sociological analysis of knowledge, ideology, generational thinking, and socio-cultural synthesis and, the book titled *Woman in Art*? Perhaps a study of the visual arts, as opposed to site-specific architectural research, could be done more easily in war-time Britain using its libraries, collections, and museums, such as the Victoria and Albert Museum, much referenced in her book. Where would it sit, however, in British Art History, still so connoisseurial or formalist with its models in John Ruskin, Roger Fry, and Bernard Berenson?[58]

Rosenau's work belongs in the tradition of the interpretation of art as content – images – that led to concurrent hermeneutic strategies – iconology and iconography, and the interpretation of the meaning of images by reference to extra-visual classical or biblical, or textual or

pictorial precedents. Images, however, store up elements for 'meaning', always already, therefore, waiting for each novel enactment in a new image whose intelligibility hovers between the current conjugation of recognizable elements and the embedded pre-text.[59] Not tied, however, to any one of the art-historical methods (from formalism to iconographic studies), yet richly using their varied potentials, Rosenau's books explored Woman or Temple or City between symbol, myth, and fantasy, which are materially articulated in visual or architectural signs and formulations of position, relationality, love, desire, revolution, and community. Her book is neither a catalogue of 'images of women' at different times in history, based on a stable definition of female persons, nor an iconographic or semiotic reading, any more than it is a simple tracing of the persistence of Warburg's *pathos formulae*. With knowledge of such models, Rosenau treats artworks as a constitutive track of social knowledge and thinking, projections and interpretations, operating on the aesthetic–symbolic level while being embedded in changing yet also persisting social arrangements, legal forms, and historical situations to which artists and cultures have given varied visual and material forms through gesture and composition.

— Rosenau and Gombrich in Britain: Contrasting Fates

Rosenau's 'little book' was published by the short-lived press Isomorph, established by a graphic designer whose plans for further publications came to naught. Why that press?[60]

The art publisher Thames & Hudson was not initiated until 1949, five years after the 'little book' appeared. The famous European art press Phaidon, founded in 1923 in Vienna as a history publishing house by Ludwig Goldscheider (1896–1973), Béla Horovitz (1898–1955), and Frederick Unger (d. 1988), was, however, partly transplanted to England in 1939 and was just beginning its art publications, which for fourteen years appeared under the auspices of the British press George Allen & Unwin. One of Phaidon's first publications in this English partnership was a large tome, *Five Hundred Self-Portraits from Antique Times to the Present Day in Sculpture, Painting, Drawing and Engraving*, compiled by Goldscheider.[61] This is the text from whose plates Rosenau may have drawn for her own book, in which appeared two images she also illustrated, namely Sophonisba Anguissola's (1532–1625) *Self-Portrait with Book* (1554, Vienna, Kunsthistorisches Museum; pl. 134) (see fig. 2.44) and Anna Dorothea Therbusch-Lisiewska's (1721–1782) *Self-Portrait* (1777; pl. 126) (see fig. 2.45).

Phaidon's biggest long-term publishing event occurred in the late 1940s when a stray research fellow at the Warburg Institute was commissioned by Horovitz, whom he had met while both were doing war work at

listening centres, to write a one-volume survey history of Western art history in English. His name was Ernst Gombrich, and he had arrived in Britain in 1936. His book *The Story of Art* appeared in 1950.[62]

The Story of Art's gendering of art as solely individual white men's creation places it in direct opposition to Rosenau's Isomorph publication in 1944. A mere six years after Rosenau's book was published in English (offering its own thematic survey of art which included on its cover the proof of women as artists as well as the affirmation of gender as a category of thought, culture, and social and anthropological research since art first emerged as a human activity), Gombrich, a fellow refugee who would emerge as the pre-eminent, knighted, public face of Art History for the second half of the twentieth century in Britain, was allowed to publish a positivist, exclusionary, and gender-exclusive survey of the history of Western art.[63] Gombrich's all-male Eurocentric text actively both blotted out women as artists and disowned gender, as well as class and race, as a legitimate question for cultural analysis. With the extensive international readership of his book, Gombrich's asocial, uncritical masculinist 'story' of artists erased what Rosenau's book had so elegantly and concisely advocated: acknowledgement of both women's creativity and the centrality of gender in art and thought.

Helen Rosenau thus had to negotiate the conservatism and positivism of British intellectual culture, which lionized Gombrich and his close intellectual allies, such as Karl Popper (1902–1994). In his essay 'Components of the National Culture' (1968), New Left thinker Perry Anderson defined Britain as 'a very conservative society' notable, and exceptional, for never having produced a classical sociology.[64] Sociology is a synthetic order of thought. Anderson argued that such structural thinking contradicted a long-standing resistance among British intellectuals to any form of synthesizing theory: 'A deep, instinctive aversion to the very category of totality marks its [British intellectual culture's] entire trajectory.'[65] Anderson profiled the exiled European refugee intellectuals who came to Britain, noting those who moved elsewhere and those who remained, and distinguishing between those remainers who were and were not embraced by the British establishment. In detailed case studies from the disciplines of Philosophy, History, Economics, Political Theory, Psychology, Anthropology, Literary Criticism, Psychoanalysis, and Aesthetics/Art History, Anderson substantiated his general analysis of who, among the European refugees, were assimilated into the British intellectual and cultural establishment, and who were left in the cold. Thus, he identified a 'Red', leftist migration, many of whom moved on to settle in the United States of

America, or tried to – Theodor Adorno, Bertolt Brecht, Herbert Marcuse – and a 'White' migration largely settling and welcomed in Britain. For the latter he lists Popper, Gombrich, Lewis Namier, Bronisław Malinowski, and Isaiah Berlin; to this we could add Nikolaus Pevsner.[66] Many were rewarded by British society with knighthoods and affection. Those scholars, often Marxists, who retained attachments to synthetic, theory-rich, social analysis, such as the historian Isaac Deutscher or the art historian Frederick Antal, were ignored and never given university positions.[67] Anderson does not cite any women refugees or trace their fates. We must name Helen Rosenau and Viola Klein, also supported by Karl Mannheim, whose theoretical sociological theories were never embraced by the British sociology community. Also feeling isolated, Mannheim later focussed on education and the formation of political personality, exploring the social and cultural crisis in mass society that accelerated the erosion of democracy and the birth of fascism, and with a small group he moved to the Institute of Education.[68]

Analysing the later canonical model produced by Gombrich in *The Story of Art* (1950) and *Art and Illusion* (1960), Anderson emphasizes Gombrich's displacement of social structuring of culture by his combination of psychologization (perception) and technique as the chief motors of stylistic change, a model that severs art from history, and history from social process. For Anderson, Gombrich's work is not even historical.[69] He presents a *story* – a narrative that is not a historical analysis – of art that, according to Anderson, 'simulates time, the better to abolish it'.[70] Given the fact that Gombrich's commission in 1950 for an accessible survey of art by Phaidon is in its seventeenth edition and has been translated into thirty languages, having sold over seven million copies worldwide, Anderson's critique is no trivial matter.[71]

Rosenau's modest, but equally erudite and very accessible, art-historical writing in *Woman in Art* is, I am proposing, the tragically less-known 'Red' feminist counter-text to Gombrich's 'White', masculinist *The Story of Art*. That her book never received its place in the history of Art History is a product of the double, if not triple, jeopardy of being written in both the inhospitable political–intellectual conditions the left-wing Rosenau encountered in Britain (so critically anatomized by Anderson's reading of British cultural conservatism and positivism) and the patriarchal sociality of the Jewish exile-refugee art-historical community, which, intellectually and theoretically, should have granted her a place among them and helped her to re-found her academic career with a British university position.[72] We know from her extant letters in the Warburg Institute Archive that Rosenau petitioned for some teaching at the Courtauld Institute, which had offered some, if intermittent,

teaching to Frederick Antal when the former Marxist Anthony Blunt (1907–1983) was director. It was eventually a British art historian, John White (1924–2021), who secured Rosenau her only full-time appointment at the University of Manchester, where she had been teaching part-time since 1951. Renowned for his book on pictorial space in Western art, White had been Blunt's student at the Courtauld and then a professor at several US-American universities before being appointed the first Pilkington Professor of Art History (1959–66) at the newly founded Department of Art History at the University of Manchester.

— Helen Rosenau and Karl Mannheim: Resources for a Method

As the third section of this chapter will elaborate, the extended context for Rosenau's analysis of 'woman' in 'art' lies in the cultural–philosophical Hamburg circle. Her work is also an elegant mobilization of sociological concepts of her fellow exile Karl Mannheim, who was himself inspired by feminist sociologists such as Marianne Weber (1870–1954) (see fig. 3.4) and Gertrud Kinel Simmel (1864–1938) (see fig. 3.5) and his own women doctoral students, evolving a sociology of gender during his teaching at the Royal University of Frankfurt am Main in the early 1930s (renamed in 1932 the Goethe Universität Frankfurt am Main). By also revisiting Mannheim's 'sociology of knowledge', we discover how art-historical theory was vital to *his* cultural sociology, notably in theorizing major socio-economic–political epochal changes that resonate through and transform all elements of a culture such that a reading of cultural forms – myth, religion, art – enables us to grasp the imaginative mentalities and subjective dimensions of structural socio-economic disruption. He was already part of the conversation with Riegl and Panofsky and the emergence of theoretical, sociological, and philosophical history of art.

Let me explain by reviewing the structure of Rosenau's book. In her 'Preface', Rosenau states the issues her project addresses (see Part 3, Essay 1). Her 'Introductory' enunciates the position of the author and her artist-women contemporaries. Rosenau considers the emergence of images of Woman, noting that the oldest images in civilization that survive are of women or animals, indicating women's importance in the evolution of society and Woman's centrality to thought and imagination. Her first two chapters explore the figurations of two couples or sets of relationships – 'husband and wife' and 'mother and child' – indicating the two key social relations, which are variously figured according to social customs and changing ideological interpretations of the sex–love relation and the creation–care–love relation. Her final chapter identifies the shift from 'type', so far identified in recurring

and changing formulations, to 'personality', which may be deciphered not only in figurative forms, such as self-portraits, but also in novel aesthetic practices, such as abstraction, with its highly individuated non-figurative signatures.

The cover juxtaposes the 11.1 cm figurine found in the Austrian village of Willendorf in 1908 (see fig. 3.2), but dated to 33,000–25,000 BCE, with a recent work by British sculptor Barbara Hepworth (1903–1975), *Single Form* (1937; see fig. 3.3). The trajectory Rosenau traces across history between these two points moves from a mythic thinking and figuring of womanhood with the power of life at a symbolic level to the differentiation of types into socio-economic–legal relations (wives) and in erotic or affective relations (lovers and mothers) to early twentieth-century modes of individualization figured in artistic self-imaging as well as in abstraction of the figure as an unmarked standing form.

This shift Rosenau equated with modern women achieving more intense degrees of political and cultural subjectivity and economic independence, as well as a sense of full human responsibility that also enables women to take part in 'objective' spheres, hitherto more limited but, as we can see in the case of anchorite abbess Hildegard of Bingen (1098–1179) (see fig. 2.35), among others, not impossible in the history of thought and art.[73] Yet Rosenau also points to the continuing social obstacles to such individual creative self-realization. For social evolution to fulfil its promise, the development of the individual woman is not enough. She concludes: 'It is only by co-operation and by the recognition of the different personal ways of approach to the social problems of their time, that women will be able to contribute fully to the historical process, no longer as a means only but also as an end of human evolution.'

Now let me review her chapter headings as the 'image' of her thinking in this book. When I first read the titles of the chapters of Rosenau's book, I honestly experienced feminist perplexity (fig. 1.16). Are not its headings – 'Wives and Lovers', 'Motherhood', and 'Further Aspects of Creativeness' – for a contemporary feminist reader all too predictable, or worse, conventional? Why were they selected? What did Rosenau mean by these categories? How shall we react to them now? What might we contemporary readers need to grasp about the intellectual and political thought of her moment of writing this book that would situate, for us, the political and intellectual grounds for her attention? Specifically:

1.16 Contents page of *Woman in Art* (London: Isomorph, 1944).

i) in 'Wives and Lovers', her attention to the *institutions* that form the socio-legal positioning of women and to the *imaginative and aesthetic formulations* that register erotic capacities and affective relationships between adults;

ii) in 'Motherhood', her attention to the *theological–mythical* investment in the idea of the maternal, in which maternity and the experience of *being a woman* are not only personally but also culturally, symbolically, and politically significant within almost every organization of human culture because maternity presents a certain 'mystery' – the creation of life and specifically a human life that encodes time for all born living beings, carrying a future and implying mortality;

iii) in 'Further Aspects of Creativeness', her attention to the impact of the key sociological–historical event, *modernization and Modernity*, and the active role of women in transforming institutions and their psychic, erotic, and intellectual–professional–productive lives through the radical expansion of means, materials, and topics in the visual arts.

No normalization of modes of erotic, personal, and legal relations or assumptions about the nature, purpose, or destiny of women are implied in Rosenau's book. The opposite is the case. Her arguments are directed against foundational and positivist theories of gender division based in models of the natural sciences: biology and physiology, and psychology, the latter offering determinations of sex and gender as instinct or physical morphology. Natural science's models were relatively recent ideological arrivals in modern culture (and indeed symptoms of the crisis Modernity initiated in patriarchal systems) and can be contrasted with deeper, and more ancient and persistent, structures of symbolic thinking about life, time, and death, encoded in myth, religion, and art which were equally urgent for modernist art and literature.[74]

Rosenau's book is built around an image track of history whereby she *reads* socio-legal relations and cultural–imaginative projections through artistic representations while also making the latter intelligible through an understanding of the historical shifts in the social formations of class and gender. Artworks are considered not merely objectifications of thought in aesthetic form and physical medium. They function as formulations and entwinings of thinking and affect even as they combine semiotic signifiers (signs that generate meaning) and produce affective pathways (aesthetic affects that inspire feelings and responses), which Art History, the discipline, was developing varied tools to interpret. In

so far as Anthropology, Sociology, and Psychology – then emerging disciplines theorizing mythic, imaginative, and social dimensions of culture – alert us to both institutions and their shaping of identities, roles, activities, and subjectivities within them, their cultural and aesthetic articulation became the object of Rosenau's concurrent social–feminist art-historical analysis. Artworks – material, aesthetically formulated, and interpretable images (from paintings to buildings) – thus function as both *topic* – what is being studied – and *resource* – the means of studying the larger domains where, in cultural representation, institutions and subjectivities collide with history.

Rosenau refuses the submission of the individual as the subject of history in Marxist terms but equally resists celebrating voluntaristic individualism within capitalist liberalism. Social production of both self and knowledge requires the production of social frameworks to sustain each singularity and more collective, or rather shared, cultural articulations. Rosenau uses art-historical knowledge in its complex interweave with sociological and anthropological resources to arrive at a formulation that still resonates with, and provides a challenge to, contemporary feminist thought. How do we acknowledge the aesthetic–expressive singularity of each woman within the *social* but also electively *political* collectivity *women*? Women had been summoned, during the nineteenth century, to become a mass movement, even, as a newly politically conscious entity, 'women' were forced to confront and acknowledge what they shared and the differences of their social, economic, and psychological existence riven by class, geopolitical situation, religion, ethnicity, and education.

I conclude that the framework for this project was shaped in dialogue with key elements of Mannheim's sociological theories that had themselves emerged in debate with both Art History and its expanded forms of Cultural Analysis. To situate Mannheim, and hence his facilitation of Rosenau's socio-art-historical engagement with 'woman' in 'art' in the early 1940s, I need to sketch a compressed overview of the varied streams of thinking about culture and art at this critical moment of modern thought.

— *Kulturwissenschaft* and *Kunstwissenschaft*

Along the major fault-lines of eighteenth-century Kantian and Hegelian philosophical divisions, the formations of both Cultural Sociology (*Kulturwissenschaft*) and Art History (*Kunstwissenschaft*) as nascent disciplines in the later nineteenth and early twentieth centuries were riven by the differences between idealist, synthesizing, and historical–materialist philosophies.[75] At one extreme, for instance, art historians sought to identify the singular internal logic of art in *form*, liberating

art from being a mere epiphenomenon of wider cultural and historical formations without its own dynamic of transformation. Formalism was a major discovery and is always a valuable, and necessary, element of art-historical analysis. Form's differing modes would then be tracked as *style*, giving rise to recognizable periods each defined by common style, or treatment of form, inflected by individual artists' singular inventions and articulations. Formalism made possible a specific and autonomous history for Art as a history of styles. Stylistic innovations are then associated with named artists in specific periods. Each artist's work is a variation of the epochal style, although it is not merely expressive of 'their time'; it elaborates a particular moment of form's general trajectory in art across history. Yet formalism excludes non-stylistic historical and social dynamics, enclosing art in its own internal, formal trajectory, an argument that would find a final articulation in the formalist theories of modern art. Formalism cannot, however, be the sole model for a study of art history.

A more cultural, Hegelian expressive and teleological thesis rendered art intelligible as the aesthetic–formal index of a permeating 'Spirit' (*Geist*), whose historical destiny is ultimate self-realization, so that art is a momentary form of the general Spirit and subject to its *telos*. This engendered a chronologically progressivist model for the history for art, moving in one direction towards an ultimate goal; for instance, art's history was traced from 'primitive origins' and paganism to its peak, for Hegel, in Prussian Christian Europe (and tragically, in the case of some art historians in the twentieth century, in post-Christian fascism).

Yet another, more synthetic thesis, drawing from Dilthey, conceived of art as a multi-media expression of *Weltanschauung*, a global outlook permeating each epoch and giving it its phenomenal appearance of consistency and conceptual unity. *Weltanschauung* is only deducible from minute and systematic study of all the different modes and sites of artistic expression (and their media) within a period or epoch, each area articulating what Riegl termed an era's distinctive *Kunstwollen* – meaning will to art, artistic volition, or aesthetic intent – according to the specificities of its own forms, sites, and media. This fostered a synthetic, non-hierarchical understanding of art's many forms and media that could be synthesized as enacting a global outlook that allowed recognition of epochal differences between, for instance, the late Roman, medieval, Renaissance, and so on.

Marxism fostered a historical–materialist inversion of the Hegelian thesis by locating the driving force shaping changing cultural and artistic practices in the historically different modes of socio-economic 'relations of production' (e.g., feudalism, capitalism) that 'in the last instance'

determined the 'superstructural' cultural forms of thought and cultural expression as ideological reflexes of their material base. Finally, at the intersection of studies of memory, psyche, and philosophy, we find Warburgian studies, which theorize the image as a *pathos formula*, formulae being carriers of often archaic affective intensities in specific configurations of bodies and accessories such that archaic emotions are stored as energies, as in batteries, by images that can be recalled to recharge later cultures when they need to be liberated from their own exhaustion.

The massive work involved in formulating and demonstrating these diverse philosophies of interconnected cultural, but specifically aesthetic, practices (the visual arts, architecture, applied arts) provided the intellectual foundations for Art History as a critical, philosophically based, and analytical discipline that was anything but unified in its approaches to its 'objects'. However varied these different strands, they also made the field central to any synthesizing theorization of culture and indeed society, including cultural mores as well as literature, music, dance, myth, religion, institutions, and a study of aesthetic formulations – a term incorporating *form* as the work of *shaping* thought and imagination in specific, historically different modes. They also made Art History a key player in the massive work that occurred in the German-language universities of the first quarter of the twentieth century developing the academic study of the arts and the humanities.

Engaging with key art historians, Riegl and Panofsky in particular (as I shall explore more fully shortly), Mannheim contributed to this field a *sociology of knowledge* (*Wissenschaftssociologie*), adding to the study of historical change in ways of understanding ourselves and our worlds his social concepts of *situation, generation, rupture*, and *destabilization* (rather than dialectics and progress (Hegel) or formal evolution). His thinking evolved in dialogue with the 'theoretical turn' in the formation of European Art History in the later nineteenth and early twentieth centuries in Europe, which also addressed key questions about general patterns of cultural thought and representation, which in turn gave phenomenal and sensual aesthetic form to structural and social–historical change, and indeed, in Warburg's studies, to the drama of affective intensities and psychological crisis.[76] The interface between the social and the subjective was Mannheim's focus. This includes the sociology of personality and the social systems that form it not only individually but socially, as in mass movements that create and disseminate a fascist personality as opposed to social forms that foster a democratic personality.

By selectively canonizing only some famous men in histories of our discipline, we have overlooked the reverse influence of art and the emerging discipline of Art History on the concurrent intellectual

projects of key thinkers, such as Mannheim, who, in his theorizing of major issues of cultural formation, social change, and social subjectivity fully included gender as much as race and class in his deep sociological analysis of thought alongside experience. Modern feminist theory has appropriated the term 'patriarchal' for a system that also produces its own personalities (as indeed does feminism). For Mannheim, sociology identifies the categories societies create and with which they classify their members, with the effect of producing personalities – what I might term 'subjectivities' – that are classed and classing, raced and racing, gendered and gendering.

In the 1930s, Mannheim had witnessed Hitlerian fascism and observed Stalinist totalitarianism and then encountered a constitutional and imperial monarchy in a Britain whose democracy was 'at risk' from what he termed 'mass society'. During the years he was supporting Rosenau's project, Mannheim was deeply involved in urgent debates about social planning and social education for democracy and also expanding accessible adult education. He gave numerous lectures at the Institute of Education in London.[77] The politics of the material form and indeed the language and economy of Rosenau's 'little book' comes into new focus in relation to Mannheim's campaign outside the academy for democratic education to deflect the dangers of fascism and the dire effects, and attractions of, mass movements.

Was Rosenau's publication of this book with an avant-garde press in experimental visual presentation part, therefore, of this wider engagement with shared interests in the need for accessible but rigorous texts not aimed only at the academic community but nonetheless inspired by contemporary academic thinking?

— Gender

Researching Rosenau's intellectual formation revealed that debates about gender ran through the intricately entangled fields of medical, psychological, biological, sociological, psychoanalytical, historical, and philosophical analysis. In the 1930s and 1940s these debates were – and still are – symptoms of the centrality and the transformations of gender both in modernizing societies and to the modern humanities and social studies. The interpretation and contestation of constructions of gender roles – and the resulting social, political, legal, and cultural meanings, subject positions, and psychological formations – are anything but self-evident. They are deeply entangled with economy, social systems, religion, myth, and art. In European thought, what has come to be articulated as 'gender' was, in fact, a hotly debated issue from the late eighteenth century, throughout the nineteenth century, and into

the early twentieth century across many disciplines, long before post-1968 feminist theory made it central – and agonizingly complex – to the feminist theoretical revolution of which I am a product. For many fields and for over two centuries, however, the term 'woman' functioned as a synonym for a disturbance – and at times a radical, even revolutionary, destabilization – in both the intellectual systems of knowledge and the real systems determining social experience itself around 'gender'.

The very complex theoretical and political developments since 1968 have theorized and politicized gender through concepts such as 'the sex–gender system' and relations of sex–race–gender–class hierarchy, as well as radically changing understandings of gender identity and sex roles, often positing only a *social* construction of gender – a position contested by psychoanalytical theories of the psychic formation of sexuated subjectivity and sexual difference. In this light, I refer readers to three historic texts of post-1968 feminist theory by anthropologist Gayle Rubin, philosopher of science Donna Haraway, and historian Joan Scott. Rubin built on the theory of Claude Lévi-Strauss (1908–2009) – that culture and society are founded on exchange, which produces a structural division of people into exchangers (men) and exchanged (women) – to identify the many different forms of such a 'sex–gender system' that effectively creates as a 'traffic in women', with 'woman' being produced as a sign within a communication system, a system also installed in each psyche, which is effectively sexed by a socio-sexual formation that psychoanalysis subsequently theorized.[78]

Haraway pointed to the theoretical difficulties that arise because of the absence of corresponding nouns for the English word 'gender' in so many languages, while also tracing the history of its difficult relation with, and difference from, the more widespread term 'sex', the latter emerging in medical and psychological as well as sociological theories of sex role and gender role as well as in the concept of 'gender identity' within medical and psychological fields.[79] Scott critically examined pre-1968 meanings of gender, while herself defining gender as an axis of socially instituted power difference that is then imaginatively iterated across a range of symbolic forms. Her article also enables us now to understand the history of post-1968 feminist retheorizations of gender.[80]

Addressing gender through *woman* as a *concept* and a *symbolic form*, situates Rosenau at the forefront of theoretical debates in the development of both Art History, or *Kunstwissenschaft* (specifying and negotiating the difficult condition of art as a historical–cultural, a symbolic, and an aesthetic topic), and *Kulturwissenschaft* (exploring the non-causal correlations between art, myth, religion, images, forms, and modes of

their analysis in their different configurations in different epochs and civilizations). She also prefigures, without psychoanalysis and structuralism, some post-1968 feminist theory. Since the formation of the modern university in the nineteenth century, what had been included in *Kulturwissenschaft* had been in the process of being divided up into separate disciplines: Theology, History, Anthropology, Philosophy, and Art History. The last of these cannot but engage with all the others. As a discipline that could not remain discrete even as some tried to specify form or style as art's singular essence, Art History faced very particular questions about the interplay of many modes of materialization (different media) and the historical transformations of imaginative forms such as art, myth, religion articulated in image, form, and style in historical time – always at the recurring core, which the later twentieth-century literary theorist Julia Kristeva has defined psychoanalytically and anthropologically as *the hinge between life and meaning*. Anthropologically not religiously, Kristeva named this unthinkable hinge 'the sacred', to which 'the feminine' is central.[81] I suggest that Rosenau named this hinge *Woman* when she took it as her topic.

Woman, like Kristeva's conjoining of 'the sacred and the feminine', poses for both Kristeva and Rosenau the question of thinking, representing, imagining, and imaging human life, death, desire, and the body and their psycho-subjective resonances in the context of sexual difference – all compulsively explored in ancient as much as in modern thought – at what Kristeva defines as 'the crossroads of sexuality and thought, body and meaning, which women feel intensely but without being preoccupied by it, and about which there remains much for us – for them – to say'.[82] I stress this because even with a half-century of 'feminist art history', there are many who still see the feminist issue as only a matter of naming 'women artists' or women as a subset, a minority question. Rosenau's book makes clear that the concept *Woman* is the locus of what *women* have latterly become the historical agents for, namely exploring this profound question that suspends us all at this hinge of physical–material–corporeal existence and the symbolic life of thought, imagination, and representation.

III · HELEN ROSENAU THINKING WITH KARL MANNHEIM: THE SUBJECTIVE POSITION AND THE SOCIOLOGY OF KNOWLEDGE IN ART HISTORY

> The art historians will say it may be good sociology and the sociologists it may be good history of art.
>
> — Helen Rosenau-Carmi to Fritz Saxl, 6 March 1941[83]

The considerable scope of Rosenau's undertaking in *Woman in Art: From Type to Personality* clearly belies its original compact form as a hundred-page paperback, plastic-bound book that had been boldly designed in red, black, and white by the innovative graphic designer Anthony Froshaug for his short-lived avant-garde publishing company Isomorph.[84] Both intellectually rich and concise, Rosenau's text can be enriched by historical framing and theoretical elaboration. Let me now closely read and situate the following statements in Rosenau's two-page 'Preface' (fig. 1.17):

> Another necessary limitation is the subjective approach of the writer. No doubt a book written by some other person in a different period would yield a different approach. At the same time it has to be remembered that only from a subjective standpoint can the concept of history be realised, and that it is a personal point of view which enables us to grasp the order in a seemingly chaotic sequence of events.

What does Rosenau mean by 'limitation' and 'subjective approach'? Surely scholarship seeks to be objective, verifiable, and impersonal? Does her suggestion that her position in time shapes her approach invalidate its significance? Why is 'history … realised' only from a specific standpoint, not from an Archimedean position that surveys it all

1.17 Preface (pages 7 and 8) of *Woman in Art* (London: Isomorph, 1944).

Preface

THE PURPOSE OF THIS STUDY ON WOMAN IN ART is threefold: firstly, to show the close interrelation which exists between the visual arts and the society to which they belong; secondly, to suggest the changing attitudes held regarding womanhood in the course of human evolution. The third problem to be considered is whether there may be found some permanent features which repeat themselves in varying social conditions, and may be regarded as typically feminine. It need not be added that completeness cannot be attempted in a book of this kind, either with regard to the examples selected or to the periods studied, especially since owing to war conditions it has to appear in an abridged form. The main emphasis is laid on the Mediterranean and European civilisations, whilst civilisations outside this sphere can only be dealt with as enlightening contrasts or corroborating evidence. Another necessary limitation is the subjective approach of

the writer. No doubt a book written by some other person in a different period would yield a different approach. At the same time it has to be remembered that only from a subjective standpoint can the concept of history be realised, and that it is a personal point of view which enables us to grasp the order in a seemingly chaotic sequence of events. The picture thus conveyed should be checked by the reader perusing the selection of illustrations, thereby testing the evidence and the conclusions suggested.

I am greatly indebted to the Authorities of the Victoria and Albert Museum for facilitating my work in every way; to Dr. Karl Mannheim for reading the original draft of this book and making some valuable suggestions; to Miss V. Douie, of the Women's Service Library for her constant interest in the progress of the manuscript; and finally to my publisher, for his understanding and enterprise, as well as for the care and taste with which he has given to this study its external form.

H. R.

London,
November, 1943.

dispassionately? Why is the 'chaotic' nature of history only graspable from 'a personal point of view'?

When I first read these words in Rosenau's preface, I was puzzled. The preface reads as a confident, theoretical statement about theories of knowledge and positionality in historical writing, not an apology. The author firmly declares her advocacy of what we now recognize as *situated* scholarship, with all its ethical and creative possibilities. She anticipates contemporary feminist point-of-view theory advanced by both bell hooks and Donna Haraway, with their idea of 'situated knowledge', and Lorraine Code's work on feminist epistemology.[85] I suggest, however, that Rosenau's words knowingly endorse and mobilize her feminist elaboration of the 'sociology of knowledge', a project advanced by Mannheim.

I need, therefore, to elaborate the theoretical framework – it may be unfamiliar – and explain, by way of a long digression, Mannheim's sociology of knowledge, which is critical to our understanding of why, and with what effects, *Woman in Art* was hosted at the LSE and not at the relocated Warburg or the newly founded Courtauld Institute, and why the preface makes such a decisive statement about its 'situated' theoretical position.[86] Moreover, remembering how deeply Mannheim was already involved with theoretical developments within Art History (by Riegl and Panofsky in particular) will expand our understanding of the formation of the discipline and make more visible the feminist turn Rosenau performed, supported by Mannheim, who was equally engaged with feminist developments in his own discipline of Sociology.

The history of a social history of art has largely been written by Marxist writers. Mannheim's project, which is in effect a social analysis of art and culture, was, however, neither Marxist nor anti-Marxist, even as he acknowledged the Marxist position on the ultimate structuring force of class relations. His sociology of culture allowed, therefore, for other social groupings than class and other fracture lines, women being a major social group that he studied through developing a sociology of women. In addition, Mannheim's concept of *situation* insisted on the subjective dimension of social experience and called for the acknowledgement of the subjective positioning of the investigator. As well as elaborating a sociology of gender, Mannheim academically supported many women scholars.

It is thus possible to situate theoretically Rosenau's affirmation of a 'sociological-subjective' position in her preface. She composed a book that traces a long historical trajectory of change indicated by the two prepositions 'from … to …' in which, in place of art-historically defined epochs and style-defined periods, she maps out 'group outlooks' at different historical moments, while developing a hermeneutic strategy

through reading visual representations of the changing representational modes of 'concrete groups' (these are all Mannheimian concepts and will be introduced below) that constitute societies at different moments in history and place. She treats women and men as social subjects inflected by class, religion, ethnicity, sexuality, and geopolitical and generational historical experience. She acknowledges a personal relevance, alongside historical urgency, of women analysing *Woman* both as a category of human thought articulated across the imaginative and visual arts and as a social subject acting in history to transform both the practice and the space of representation.

Read from a feminist perspective, artworks thus studied reveal the placement and experience of women as a differentiated component of the 'concrete' and 'generational' groups out of which the larger social formations are historically composed, and which mutually inflect the distinct registers of situation and experience. Rosenau reads artworks for aspects that pertain particularly but not exclusively to the regimes of sexual difference that societies institute and that individuals must negotiate subjectively. These form the substance of myth, religion, language, and art. She analyses modes in the visual arts that refract them in representations that themselves change historically, in ways that are often marked by ruptures, traumas, and massive cultural changes or are, in turn, fissured by class, race, gender, sexuality, and generational difference as they are historically reformulated.

By grasping the possibilities offered by Mannheim's key sociological–cultural theses on *social situation*, *generation*, and *destabilization*, Rosenau's art-historical project produced a distinctive contribution still rich with methodological possibilities.[87] This is especially clear when we seek to resist normative assumptions and grasp both art and its histories as inscriptions of multiple difference, disruption, and locatedness rather than the unidirectional unfolding of a single or privileged ethnicity's, culture's, religion's, gender's, or class's destiny of mastery.

— Karl Mannheim (1893–1947)

Writing in the foreword to his study of Mannheim, Peter Hamilton applied Mannheimian sociology of knowledge to Mannheim himself (fig. 1.18), enacting the sociologist's own principles of situation and social–subjective formation:

> Thus, a sociology of knowledge applied to Mannheim's principal works would emphasise his upbringing and education as a German-speaking Jew in the last years of the Austro-Hungarian empire: his brief involvements in the liberal Soviet regimes which ruled Hungary in 1918–19, and his friendship with

Béla Kun's minister of culture Geörgy Lukács; subsequent exile in Weimar Germany until the advent of the Nazi state in 1933, when, because he was a Jew, he lost his chair in sociology at the University of Frankfurt; and finally a further very difficult period of exile in Britain until his death in 1947, during which he exemplified the refugee European scholar, painfully aware of the gulf between his own *speculative and philosophically sophisticated sociology* which was culturally rooted in Germanic intellectual life, and the *sturdy pragmatism* of his hosts [my emphases].[88]

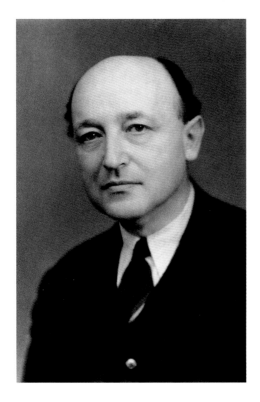

1.18 Elliott & Fry Studios, *Karl Mannheim* (1893–1947), 1943, half-plate negative. National Portrait Gallery (x82148), London.

Let me add a gloss. Mannheim was born just seven years before Rosenau, but in Budapest, then one of the two capitals of the Austro-Hungarian Empire. Both of his parents were Jewish, his father Hungarian and his mother German. He studied philosophy and literature in Budapest, moving later to continue his studies in Berlin with sociologist Georg Simmel and the feminist philosopher Gertrud Kinel Simmel, who published as Marie Luise Enckendorff and who also influenced Rosenau's own discovery of feminism when she attended a lecture by Gertrud Simmel.[89] After a period in Paris, Mannheim completed his doctorate in Budapest and *Habilitation* in social sciences at the University of Heidelberg in 1926. He 'beat' Walter Benjamin to a post there before teaching sociology and political economy at the recently founded University of Frankfurt. He had been a youthful member of the famous Sontagskreis (Sunday Circle) in Budapest with key left-wing thinkers such as literary cultural theorist György Lukács (1885–1971), Marxist art historians Frederick (Frigyes) Antal (1887–1954) and Arnold Hauser (1892–1978), and film theorist Béla Balázs (1884–1949).[90]

This intellectual portrait plots out the conditions of Mannheim's life experience, with its potential areas of sensitization, trauma, political awareness, and generational dissonance. Let me give one example. Consider, psychologically as well as sociologically, the unimaginable gulf between three generations. Glorying in militarist and imperialist conviction, the first generation sent Europe into a world war that a second generation, specifically young men, had to fight in the novel conditions of industrialized trench warfare, while the general population experienced mass bereavement from twenty million dead and, post-war, witnessed the after-effects of the wounding and traumatization of the twenty-one million (many disfigured and disabled) who survived the trench warfare. Both generations then faced the ensuing pandemic,

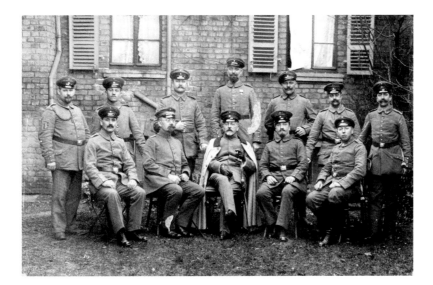

1.19 Recto and verso of post-card sent by Dr Albert Rosenau to his daughter, Helen Rosenau, during the First World War. Collection of Michael and Louise Carmi.

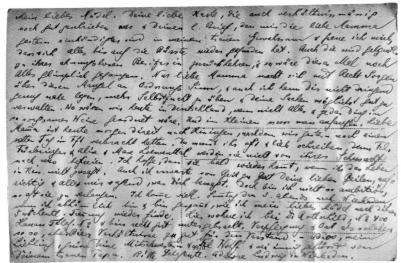

which infected one third of the world's population and had an estimated death toll of 50 million, while the second generation saw their children, a third generation, born into a world marked by these legacies of catastrophic, brutal rupture, and the transmitted trauma from their elders.

Both Mannheim and Rosenau were old enough to live through and witness the effects of the First World War on their parents and subsequently on their own generation as they witnessed the rise of fascism. Rosenau's father, Albert Rosenau, was a doctor who served in the Bavarian Medical Corps during the First World War.[91] Helen Rosenau's son, Michael Carmi, has allowed us to show a photograph of Dr Rosenau in his military Medical Corps uniform, on the back of which Dr Rosenau wrote a postcard message to his 'dear little girl' (fig. 1.19).[92] Behind this

tiny document we need to imagine what witnessing the mutilations and traumas of war did to Dr Rosenau, who died only five years after its end, in 1923, and to his daughter, bereaved at the age of twenty-three, having lived with a father who had witnessed such atrocity in the effects of that war on fragile human bodies.[93]

Mannheim's European speculative and philosophically sophisticated sociology, articulated in German (the language of traditions of speculative thought) during the 1920 and 1930s, was written by a political refugee from, and witness to, the failed Hungarian revolution of 1918. He was displaced to post-war Germany, where he witnessed the slow corruption and ultimately the terrifying collapse of the Weimar Republic (1918–33) and the rise and electoral success of a fascist, militarist, racist, ultra-sexist, anti-semitic regime. This regime installed itself on 30 January 1933 and shortly thereafter proclaimed a Third Reich, whose aggressive conquests and alliances precipitated a second world war while the regime pursued a policy of racist genocide of all Jewish and Romani Europeans.[94]

Such events would certainly count as moments of radical interruption, of both historical *destabilization* for his *generation* (both key Mannheim concepts) as well as disillusionment and psychological *fragmentation* in which massively contrasting cohorts of thought and affect, and politics and rhetoric clashed. The events informed the later work Mannheim undertook in London seeking to analyse and forestall the fascist tendencies he saw emerging within mass society and to advance the need for social education to sustain democracy.

Becoming a refugee is not just a biographically noted fact; as a prolonged condition of precarity and outsiderness, it would shape the kind of knowledge brought to bear on major questions and the insights that 'desituated situatedness' (my neologism for this condition) and subjective experience of disruption introduce into the general field of 'knowledge' as the act of seeking to understand and analyse by means of disciplined and disciplinary 'thought'. In perspectivist terms, generationally different life conditions stimulate creative sensitization to structures and conditions invisible to those not wrenched from their normalities.

— *Wissenssoziologie*

With his major work, *Ideologie und Utopie* (Ideology and Utopia) (1929), Mannheim made his name academically by elaborating a *sociology* of knowledge (*Wissenssoziologie*) to critical acclaim and widespread review, including a substantial critique by a young philosophy student, Hannah Arendt (1906–1975).[95] Traditionally, the discipline of Philosophy

investigates how and what we know and theorizes the subject's relation to a world that becomes an object of knowledge via varied disciplines, from the natural sciences to the humanities. What would sociological analysis of these central questions be? Would knowledge be inseparable from ideology as a set of socially determined ways of thinking that misrecognizes partial interests as reality?

Seeking to create a thinking space between the natural sciences' claim to objective knowledge of the world and philosophy's tortured examination of subject–object foundations for any knowledge – sociologically, therefore, rather than philosophically – Mannheim theorized the following question: how do we, subjects, grasp the world we seek to understand as an object of knowledge even as that world is forming us as its thinking subjects? He argued that, rather than determination (in the Marxist sense) by the economic system, social situatedness or location (*Lagerung* in German) – being in and of the world, but a world that involves difference, hierarchy, class, race, gender, geopolitics, power, and history, all factors that sociological thought identifies – shapes both our knowing of the world and how we produce 'knowledge' of it, and this knowledge can either be trapped in fixed thinking – ideology – or, utopianistically, might imagine other worlds.[96] The utopian represents the element of incongruity with the status quo, which can go either way, as an ideological misrepresentation of the future still aligned with and dominated by the ruling classes or an imagined future.

Socializing, as a sociologist would, the individualized consciousness of philosophical modelling of the self-sufficiency of thought – Descartes' *cogito ergo sum* ('I think therefore I am') being a founding shibboleth – Mannheim, however, equally refused the historicist–Marxist view that consciousness and thought are the overdetermined and merely *ideological* reflexes of the socio-economic structure of class (the social relations of production). He rejected both conventional and Marxist understandings of ideology – sets of ideas, beliefs, and attitudes – as either false understanding (a matter of arbitrary beliefs) or totalizing (a product of class formation). Without dismissing Marxist insights into social pressures and limits, however, he sought to analyse thinking and beliefs as socially situated and socially inflected, shared and public rather than individual, even as each individual makes this real or realizes this subjectively. As Edward Shils explains:

> The sociology of knowledge was intended to go beyond Marxism. Although he [Mannheim] regarded it as a mark of superiority of the sociology of knowledge that it regarded 'not merely classes, as a dogmatic type of Marxism would have it,' as the determinant of 'thought-models' but went beyond Marxism

to include 'generations, states, groups, sects, occupational groups, schools, etc.', he immediately went on to say: 'We do not intend to deny that of all the above-mentioned social groupings and units, class stratification is the most significant, since in the final analysis all the other social groups arise from and are transformed as parts of the more basic conditions of production and domination.'[97]

Social existence thus signifies both shared and unshared historical changeability in contrast to given facts, such as life or death, between which any existence is lived. Mannheim argued that the organization of social existence that occurs between these two points (life and death) is *social*, which includes both public and private dimensions that alter both subjects and their ways of knowing. In *Ideologie und Utopie*, he proposed that everyone's beliefs, including those of the investigating scholar, are subject to, and shaped by, the social, political, economic, and historical context in which they are *situated*. This does not make the acts of seeking knowledge, thinking, writing, and so forth only ideological; it does not constitute, as for classic Marxism, false consciousness and ideological limitation. It necessitates sociological sensitivity to one's own activity and position as thinker, a view embraced in feminist viewpoint theory in the 1980s, and to the analysis of histories of thinking and consciousness to which cultural forms are our access. Far from rendering the critical act of research and analysis limited by time and place, it enables self and other understanding of a *sociology* of knowledge in which we are all involved, often unknowingly but also critically as scholars.

There are indeed, as Rosenau states, limitations that we must recognize, and, in doing so, we become attuned to that which shapes all ways of thinking and representing in other situations, generations, genders, and classes than our own, and especially the dominant mode thinking and representation that, when it is not acknowledged as one of many possible modes, functions as the ideology, presenting thought as autonomous and objective.

— Theorizing Generations

In 1927–8 Mannheim wrote 'Das Problem der Generationen', only translated posthumously in 1952 as 'The Problem of Generations'.[98] Not alone in recognizing the idea of the generation as an issue, Mannheim reviewed his contemporaries' diverse attempts to theorize 'generation' – understood as differences, within the larger social blocks (e.g. class, race, gender, etc.), shaped by historical rupture – defining them as either positivist or romantic before advancing his own thesis on the key concept of *social* location (*Lagerung*): 'the unity of generations is constituted

essentially by a similarity of location by a number of individuals within a social whole', itself composed, however, of 'concrete groups' such as *family*, *tribe*, *sect*, and then *class*.[99] Positivists had defined generation through the biological fact of mortality, namely human time-span. That will not do for sociology, even as such factors must be considered. They are not determining in themselves. Social relations are what matter:

> Were it not for the existence of social interaction between human beings – were there no definable social structure, no history based on a particular sort of continuity, the generation would not exist as a social location phenomenon; there would merely be birth, ageing, and death. The *sociological* problem of generations therefore begins at that point where the sociological relevance of these biological factors is discovered. Starting with the elementary phenomenon itself, then, we must first of all try to understand the generation as a particular type of social location.[100]

Mannheim significantly expanded the fractions of social groupings defined by economic relations of production and domination with the dynamic of historically formed *generational difference*, in which major historical events dislocate social ages because of novel, disruptively formative experiences. As social location, generation determines both *negatively* – what cannot be thought and will not be felt – and *positively* – indicating certain new tendencies in thought and behaviour. Our normative thinking, attitudes, orientations, and assumptions are not only socially situated but also historically divergent within the larger social blocs. In this condition, varied positions such as class, gender, sexuality, ethnicity, ableness, and crucially geopolitical histories become unevenly subject to critical articulation – that is, to awareness of our social shaping in changing times within which there are diverse cohorts of belonging and difference who experience *variously and differently* the major changes, such as industrialization or modernization:

> It may be said in general that the experiential, intellectual, and emotional data which are available to the members of a certain society are not uniformly 'given' to all of them; the fact is rather that each class has access to only one set of those data, restricted to one particular 'aspect'. Thus, the proletarian most probably appropriates only a fraction of the cultural heritage of his society, and that in the manner of his group. Even a mental climate as rigorously uniform as that of the Catholic Middle Ages presented itself differently according to whether one were a theologizing cleric, a knight, or a monk. But even where the intellectual material is more or less uniform, or at least uniformly accessible to all, the approach to the material, the way it is assimilated or applied, is determined in its direction by social factors.[101]

Mannheim analyses change as the coming of the new in the sense of the capacity for change and difference that is not uniform but is registered subjectively, and is inherently socially and historically situated in relation to 'contact' with what precedes the new arrivals, defined not just as new births – hence distinct from Arendt's philosophy of natality (birth as the promise of cultural newness); this connection is perhaps worth mentioning nevertheless. Mannheim thus allows for a cultural history and transmission and change that is not progression, because generational newness is the product of the dialectic in, and the historicity of, the social:

> In all these cases, however, the fresh contact is an event in one individual biography, whereas in the case of generations, we may speak of 'fresh contacts' in the sense of the addition of new *psycho-physical units* who are in the literal sense beginning a 'new life'. Whereas the adolescent, peasant, emigrant, and social climber can only in a more or less restricted sense be said to begin a 'new life', in the case of generations, the 'fresh contact' with the social and cultural heritage is determined not by mere social change, but by fundamental biological factors. We can accordingly differentiate between two types of 'fresh contact': one based on a shift in social relations, and the other on vital factors (the change from one generation to another). The latter type is *potentially* much more radical, since with the advent of the new participant in the process of culture, the change of attitude takes place in a different individual whose attitude towards the heritage handed down by his predecessors is a novel one.[102]

Generational difference occurs not only because of the birth of new people in the biological cycle of life and death, but also because the emergence of new thinking and feeling happens *between* transmitted or adopted cultural memory and radical rupture, *between* persistence (what the existing communities hold on to) and the new urgencies as events change the formative conditions the newcomers negotiate. Mannheim rejected a biological definition of 'generation' as simply the natural fact of a lifespan, and with it the notion of inevitable cultural progression and possible reaction against the past that is typical of the chronological modelling of unidirectional historical change, and, finally, the thesis of history as reaction (often deployed in Art History to account for periodic stylistic changes). In doing so, he introduced the dynamics of 'the *actuality of generation*', which is not simply determined by shared social location in time but also by differing senses of time and experiences of time across an internally differentiated, stratified, classed, and gendered society that are realized in practice, action, or thought.[103]

— Destabilization

Mannheim thus conceives the 'process of culture' as dynamic, two-way, mediated, and inter-mediated, and in it social remembering, forgetting, and reimagining occur, their dialectic shaping what cultural heritage is accumulating that may be adopted or displaced. This is the space for difference both epochally and within an epoch. Yet this too must be refined. Cultural heritage is not general, but geopolitically and socio-economically differentiated because of forces of interruption – *destabilization*. For instance, urbanization affects social subjectivity in different geo-economic locations, and modernization affects different classes of women, and urbanization affects workers differently in terms of town and country:

> We can speak of a generation as an actuality only where a concrete bond is created between members of a generation by their being exposed to the social and intellectual symptoms of a process of dynamic de-stabilization. Thus, the young peasants ... only share the same generation location, without, however, being members of the same generation as an actuality, with the youth of the town.[104]

Further disowning any remaining naturalism from biological lifespans, *generation* as a significant *actuality* depends on the *realization of its potential*: entelechy. This is conditional on what Mannheim terms 'the tempo of change' – that is, historically variable forces of 'de-stabilization'.[105] Removing the contrary risk of misreading his thesis as a sociological version of *Zeitgeist* (spirit of the age), Mannheim argues:

> The biological fact of the existence of generations merely provides the *possibility* that generation entelechies [realization of potentialities] may emerge at all – if there were no different generations succeeding each other, we should never encounter the phenomenon of generation styles. But the question of which generation locations will realize the potentialities inherent in them, finds its answer at the level of the social and cultural structure – a level regularly skipped by the usual kind of theory which starts from naturalism and then abruptly lands in the most extreme kind of spiritualism.[106]

Mannheim here refutes Hegelianism in general and the looser notions of 'the spirit of the age' that became absorbed also in certain kinds of Art History. Finally, after all this clarification, Mannheim offers the social-feminist art historian a gift:

> In this field, however, we need a finer differentiation. It will have to be shown how far the various social and generation impulses and formative principles have peculiar affinities to this or that art form, and also whether they do not

in certain cases bring new art forms into existence. … *The phenomenon of generations is one of the basic factors contributing to the genesis of the dynamic of historical development.* The analysis of the interaction of forces in this connection is a large task, without which the nature of historical development cannot be properly understood. The problem can only be solved on the basis of a strict and careful analysis of all its component elements.[107] (my emphasis)

Rosenau's art-historical project developed the legacies of the major German models for art-historical research. She embraced the challenges posed by the Hamburg circle of Warburg and Panofsky to theories privileging form and style, nationalism, and individual genius by the analysis of the meanings of images and transmission. Her unique dialogue with Mannheim's cultural sociology then put the potential of Mannheim's thought to work on the conjunction of two socio-historical ensembles – *Woman* and *Art*. This enabled her to cover sweeps of time, almost epochal, by means of her situating specific generational configurations across a selection of telling artworks that register socio-subjective events in lived experience and social systems as images. She thus reads the reconfigurations of pose, gesture, bodies, spaces, and environments as concrete 'actualizations' of dynamically changing – generational (even epochal) – modes of thinking and feeling that are socially located, yet psycho-physically enacted in representational habits and formulae that are preserved and objectivized as 'images'. 'Reading' rather than 'decoding' images produced an understanding of socio-historically shaped generational shifts, even ruptures, in cultural thinking. It also enabled her to perceive what had been invisible to male-centred sociologies – for instance, erotic as well as socially legislated relationships, affective and psychological as well as symbolic concepts of life-making (with its figures of mothers and children), and the potential, in changing artistic and symbolic forms, for representations of the subjectivities of women. Within the generational unit as a time-space, the forces of destabilization have an impact (according to, for instance, gender) that may coincide with or differ from the class or geopolitical situatedness of the generation as a temporal unit alone. Thus, as sociologist Jane Pilcher argues, for instance: 'There has not been a "Wall Street Crash" in women's lives; the changes in women's lives have not occurred in a sharp, easily delineated manner, although there have been a number of key events (such as the Second World War) which have punctuated the gradual change.'[108]

Ways of thinking become, therefore, resources for refined and subtle understanding of difference and change. While generational patterns are discernible, they are neither normative nor homogeneous;

they entangle class, location, language, gender, religion, and ethnicity within the same structures of the images and their circulation. Mannheim traced an ideological history grounded in material processes but semi-independently created and inflected by the subjective reflexivity of the always temporally and socially situated thinker or dreamer. We can see how this thesis has significance for Art History, notably when several major schools of thought at the time were seeking to identify a distinct realm for art whose internal motor of persistence and variation was a defining, transhistorical, internal element – *form*, with its periodic variations defined as styles. Mannheimian generational modelling requires careful analysis of patterns of shared thinking, situated and differentiated but also temporally coherent and grouped. Critically understood, generational thinking is shaped by the ways that class, gender, time, and space sensitize our subjective experience and inflect our particular insights. For example, as modernization differentially affects men and women, city and country people, and working class and bourgeois, knowledge of the phenomenon is filtered subjectively through the lived experience of the unequal distribution and impact of capitalist Modernity's potentiality for its emergence into visual or cultural representation. This, in turn, depends upon the artists who, as subjects of historical destabilization, become aware of the need for sometimes radical change in artistic practice, media, materials, and formulation that only some within their generational cohort will be able to create or embrace.

In terms of understanding differentiation, Mannheim characterized pre-capitalist systems as societies in which social, cultural, and economic activities were not distilled into separate compartments. Instead, thought, belief, fantasy, and sociality were integrated. Their forms offered or created communal cohesion. In capitalist societies, however, characterized by the increasing hegemony of the economic sphere of production, fantasy and thought are driven into separate *ideological* compartments and split into different sub-realms, while also agitating the specialist domain of thinking to generate rigorous theorizing, namely critical reflexivity, such as in the discipline of Sociology. Mannheim's innovative argument that knowledge is a sociologically analysable process of production of thought and self-understandings thus supports new ways of thinking about art's histories and artistic practices as specialized, aesthetically formulated, and materialized 'knowledge' that is subject to both historical study and generational analysis of patterns singularly articulated that are not timeless repetitions of codes nor impersonal enactments of form in successive styles.

Mannheim's thesis also enables us to analyse what we now name 'sex', 'gender', 'woman', 'class', and 'race' as concepts that were beginning

to have conceptual identity in modern thought and lived experience, precisely because the social and imaginative experiences of men and women – life, death, sex, desire, relations, oppression, and their institutions – were also becoming, under historical and generational change within capitalizing, modernizing, and imperializing societies in the later nineteenth and early twentieth centuries, both the site of actual transformation and the topic of political theorizing and sociological analysis.

Generation makes us attend to psycho-socially situated affects that register the social–historical as ways of both thinking and imagining. For Mannheim, therefore, knowledge is *socio-subjectively* constituted. Furthermore, formal knowledge, as in philosophy or sociology or art history, is fostered with a degree of subjective awareness of the conditions of knowledge by those who form the *intelligentsia(s)*, the artists as much as the thinkers. Hence, by reflecting on, even mobilizing consciously and imaginatively, the situated conditions of their research or creative practice, the intellectuals and artists produce knowledge rather than ideology, while also critically studying the earlier formations of knowledge as articulated in literature, art, and formal thinking. Yet they do so in conditions of being socially and temporally situated in, and subjectively responsive to, the larger social and historical patterns to which academic discourse or artistic representation gives a form.

Sociology is a discipline situated in and articulating this nexus of society and subject. Sociology also emerged historically as a product of the generational model of reflections on Modernity, becoming a reflexive tool for understanding the social processes of knowledge production themselves as historical. Art History itself becomes a point of major access to the *cultural elaboration* of thought patterns that, in Mannheim's model of groups and generations, historicizes women as such a group, and generation as a register of socio-historically differently situated women. This counters any tendency to 'add' women back as an undifferentiated collective. They already form a generationally differenced, socio-historical location but also one not solely aligned with the big socio-economic category of class alone.

Unsituated situationality thus defines not only the thinker, the academic, the artist – but also another critically 'concrete social group': women. It is through this Mannheimian turn, with a generation of German-language Sociology behind her, that Rosenau's focus on *Woman in Art* becomes a feminist social history of the social relations of gendered, socio-subjective situatedness and not primarily a catalogue of imaged gender difference. *Woman* signifies a social but also subjective *situation* as opposed to an *idea* or a 'difference from…', the latter formulation

consigning Woman to a subcategory of Human normatively identified with/as Man.

Mannheimian sociology added to typical historical thinking in terms of periods or epochs a nuanced *generational* dissonance within the socio-psycho-biography of the *intelligentsia* in general, and artists in particular, and of thinking (namely, how we conceptualize the world, classically defined as Reason, or as Mind or Spirit in other philosophies) that does not suspend the thinker or scholar between asocial individualism or social–biographical overdetermination. As a sociological concept, *generation* modifies and supplements the big blocks of class, race, and gender with the impacts of specific historical disruptions and eruptions, such as fascism or communism, that radically alter the subjective life-worlds of the co-existing but different generations. Between theories of the mind, philosophy, and theories of history, Mannheim's sociological theses grounded and differentiated 'knowing' in terms of the co-existing time-spaces to which certain subjects give forms – intellectual, aesthetic, scientific, theological, mythic, political, and so forth.

— Reading Rosenau with Mannheim's Sociology

In this vein, a non-reductive, situated reading of Rosenau, born in 1900, would highlight her as a thinker generationally formed, like Mannheim, in the presence of the major intellectual developments in European sociological, feminist, and art-historical thought, and also, like Mannheim, a Jewish thinker exiled into a British culture profoundly at odds with her intellectual and political formation, most notably in terms of feminist interventions in Sociology and theoretical formations and debates in Art History. In a British context, the theoretical complexity on which she was drawing for her 'little book' had to be reformulated to be read by a largely positivist – 'pragmatic' – British readership with an almost non-existent academic base for Art History. This may mislead current readers as to its rich theoretical resources and its internal conversations with fellow/sister intellectuals. Her book's necessary directness of address, modernist design, and inexpensive paperback format were also inflected by her socialist desire to reach beyond academic debate and the specialized, and sometimes narrow, conversations within academia.

Nominally at the LSE (displaced by bombing from London to Cambridge for the duration of the war), where Rosenau wrote her 'little book', Mannheim's supervision provided a space – apart from the tight and often exclusive art-historical clique at the migrated Warburg Institute – for her to think art, society, history, and gender in terms aware of the big debates in German Art History and of a sociological but not strictly Marxist methodology. As a result we can also reintroduce Mannheim

into the conversations between sociologists, philosophers, and art historians, which were as intense in Warburg's and Panofsky's Hamburg as in Mannheim's Frankfurt. If we grasp the possibilities offered to her by Mannheim's theses on *social situation*, *generation*, and *destabilization* as a triple axis, the kind of art history Rosenau practised, which may not be so immediately visible in its subtlety and continuing relevance, becomes a distinctive contribution rich with possibilities for us now.

Rosenau assumes that art constitutes one form of knowledge *both socially grounded and imaginatively utopian*, overdetermined yet capable of transformation, so we also need a sociological reading of the way we produce knowledge of art's work. This avoids the containment of art within formal and stylistic categories and allows both form and style to function as an index of changing and even radically new possibilities even while deeper, conceptual elements persist even as they are being dynamically changed by historical events. In her architectural analyses, concepts such as the Ideal City or the Temple, like Woman, persist and recur as symbolic forms, yet their formulations differ through the course of history, necessitating a method of reading this dialectic that acknowledges the insights of Aby Warburg about persistence and memory but also grasps the Marxist and the Mannheimian understanding of the impact of radical rupture or destabilization.

— A Sociology of Gender

Before his forced exile from Germany, when Mannheim was teaching at the University of Frankfurt though was not a member of the Marxist grouping at the Institute of Social Research (better remembered now as the Frankfurt School), he was delivering courses on the sociology of culture and specifically offering lectures on women in society, a growing field in Sociology.[109] He supervised several women as doctoral scholars in both areas. In their study of Mannheim's role in the fostering of women intellectuals, David Kettler and Volker Meja perceive parallels between Mannheim's thinking on *women* and on *intellectuals*, neither fitting neatly into the existing system of social class. Thus, they identify in Mannheim's work a parallel 'sociology of women'.[110]

Women struggle against imposed modes of domination and ideologies of gender hierarchy that exile them from thought and thinking at all – often through lack of education compounded by definitions of femininity as intrinsically mindless. Unlike the proletariat, however, women, challenging such real limitations and disqualifying definitions, seek neither reverse domination nor overthrow as the solution to their subordination and exclusion and, riven by class and other divisions, women are neither politically nor socially unified except in their

common, yet class- and race- and sexually-differentiated, subjugation to heteronormative patriarchal systems. Mannheim's lectures in Frankfurt addressed the *destabilization* effect of Modernity on gender situation, gender relations, and their social institutions – 'the woman question' being the shorthand for this. Kettler and Meja quote Mannheim's observation of a widespread anxiety and the need for sociological analysis of these symptoms of destabilization presenting as a number of crises:

> Everyone knows – because everyone talks about – that the family is in crisis; that sexual morality is in crisis, that the frequency of divorce is a problem; that there is talk of an uprising of women, an uprising of youth … that one can speak of a reproductive strike: that widespread psychic emiseration is being traced to the family (psychoanalysis); that there is hope of forming an altogether new human being. To be entitled to talk about these things, to form a judgement, one must know many things, one must be able to distinguish the essential from the accidental, and, in general, one must have given the matter much thought.[111]

This means that a specific area of human activity – erotic relations and the production of new people (sexuality, reproduction, and their subjectivities) – requires sociological analysis independently of the general study of the social relations of production. Gender, formulating women as both prime victims of the legal systems of the family and agents of transformation, takes its sociological place, and its institutions – family, marriage, prostitution, rape, divorce, resentment, poverty, aspiration for education or work, and revolt – require sociological interpretation. Mannheim identified critical disparities where persistent ideologies confining women to domesticity and notions of womanliness – in which no person can find full human fulfilment (his words, according to Kettler and Meja) – come into conflict with Modernity's opening of women's entry into industrial labour and the professions, Modernity equally inciting among women a desire for knowledge (an intellectual life) and engendering a demand for both political subjecthood and an erotic life of their own. Equally, new forms of class-based gender emerge as, in the course of changes in early modern Europe, for instance, the privileged woman becomes more and more economically functionless in the outsourced domestic economy – enslavement of people and use of servants make the privileged woman's 'work' redundant in the aristocracy and bourgeoisie – thus engendering a specific mode of femininity (the lady, *die Dame*) and, thereafter, inciting psychological afflictions articulated by the desperate boredom and psycho-sexual distress associated with hysteria, with which Freud so interestingly interacted.[112] To dismiss Freud's afflicted women patients as 'middle-class women' is to miss the

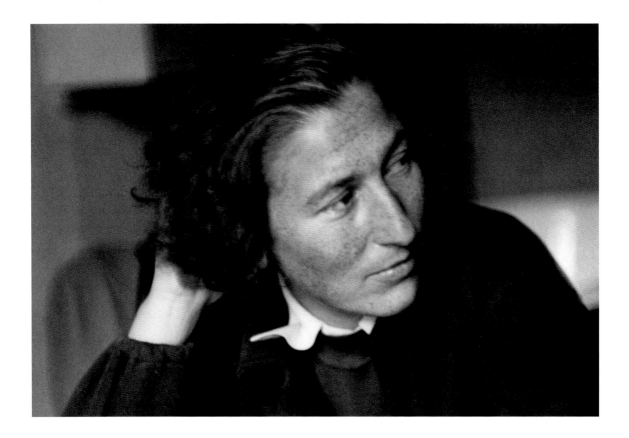

1.20 Adrienne Monnier (1892–1955), *Gisèle Freund* (1908–2000), pictured as a student in Paris, 1936, gelatin silver print, 40 × 30 cm. L'Institut Mémoires de L'édition Contemporaine (IMEC), France. © Estate Gisèle Freund / IMEC Images. Photo: © Adam Rzepka / Centre Pompidou, MNAM-CCI / Dist. RMN-GP.

historico-sociological, generational, and disrupted basis of their psychic distress and emotional dysfunction (which was, in part, symptomatic of social transformation in terms of value-creating work and social function) and to overlook what makes possible a kind of consciousness that could, and did, engender intellectual self-awareness – literature, philosophy, sociology – or political feminism as revolt.

Socialist feminism also emerged among working-class women to articulate and contest the gendered, double burden on proletarian women in capitalist, industrialized societies in terms of obligatory waged work and unwaged domestic labour, poverty, and vulnerability to sexual violence and exploitation. Anti-slavery feminism, led by women of colour and supported by some white women, articulated a desire for every woman to be considered the subject and owner of her own labour, and to be recognized as a sovereign body over which, under enslavement, she had had no control or even rights to its sexual product, her children. Equally, the anti-slavery feminist project demanded a human status for all with equal dignity free from the epidermal racism that sustained the psychic assault on enslaved peoples' humanity as profound as the brutalization of their labouring bodies.

As the research of Kettler and Meja reveals, during his time teaching in Frankfurt, Mannheim was not only delivering lecture courses on the sociology of women, drawing heavily on Marianne Weber's foundational feminist sociology.[113] (See Part 3 for more discussion of Weber's work.) He was also offering supervision to a cohort of feminist scholars, two of whom significantly began with studies in Art History. One was Margarete Freudenthal (1894–1984), who worked on the changing role of women in the household economy.[114] The other was Nina Rubinstein (1908–1996), who developed a sociological analysis of the *émigrés* during the French Revolution, a thesis she was unable to defend as a Jewish scholar forced into exile in France. She finally defended her doctorate and it was awarded retrospectively in 1989 by the University of Frankfurt.

Another, in the sociology of art, was the later-renowned photographer Gisèle Freund (1908–2000) (fig. 1.20), who studied Sociology and Art History at the University of Freiburg in 1931 and continued her studies in Art and Sociology under Mannheim, and with Theodor Adorno and Norbert Elias at the Institute for Social Research, University of Frankfurt. Freund was also a member of the socialist student organization at the university. In 1933 she fled to Paris, where she completed her dissertation at the Sorbonne in 1936 on the commercialization of photography during the nineteenth century. Feminist publisher Adrienne Monnier (1892–1955) assisted in its publication. Freund's later book *Photographie et société*, translated as *Photography and Society* by David R. Godine, takes up the same themes.[115] Freund escaped from France to Buenos Aires, returning only after the former's liberation in 1945. During the 1930s, however, she also worked for *Life* magazine, and was commissioned in 1936 to photograph the dire effects of the Depression in northern England. While in London, Freund created a series of exquisite portraits of queer women, most famously of Virginia Woolf (fig. 1.21) and Vita Sackville-West. Perhaps Rosenau, Freund, and Mannheim met up. Imagine a meeting also with Woolf, whose feminist texts *Orlando* (1928) and *A Room of One's Own* (1929) Rosenau read and cited.

1.21 Gisèle Freund (1908–2000), *Virginia Woolf* (1882–1941), 1939, gelatin silver print, 24.1 × 18 cm. IMEC, Saint-Germain-La-Blanche-Herbe, France. Grand Palais-RNM/Dist.Photo SCALA, France.

— Mannheim, Art History, and Panofsky

Before we leave Mannheim, I need to introduce the larger frame for his generational thinking and his sociology of knowledge as they pertain to

Art History and Rosenau's own circle. Mannheim's thesis, *Beiträge zur Theorie der Weltanschauungsinterpretation* (1923), translated as 'On the Interpretation of *Weltanschauung*', engages with the work of Riegl and clearly contributed to the genesis of iconology by Panofsky.[116]

Literally 'global perspective' or 'worldview', *Weltanschauung* refers to 'a largely unconscious but generally coherent set of presuppositions and beliefs that every person has which shape how we make sense of the world and everything in it. This in turn influences such things as how we see ourselves as individuals, how we interpret our role in society, how we deal with social issues, and what we regard as truth.'[117] Its significance for Art History, as much as for sociology of culture and knowledge, lies in the proposition that we might discern relationships between if not identities within the many different components of a culture, and that these relationships or identities enable us to discern a shared character or disposition of an epoch or speak of a 'civilisation', as in the English translation of Jacob Burckhardt's *Die Kultur der Renaissance in Italien: Ein Versuch* (1860) as *Civilization of the Renaissance in Italy*, where the author traces his concept of the Renaissance across literature, dance, architecture, visual art, and related humanities:

> Burckhardt sought to capture and define the spirit of the age in all its main manifestations. For him 'Kultur' was the whole picture: politics, manners, religion … the character that animated the particular activities of a people in a given epoch, and of which pictures, buildings, social and political habits, literature, are the concrete expressions.[118]

At one end of the spectrum is the notion of a single entity – a spirit or Hegel's Spirit – sustaining a synthesis of many elements, associated with Hegel's version; at the other is the materialist idea of economic determination of the superstructural elements, culture being the ideological expression of the social relations of production (a brute Marxist position). All analysts of culture and cultural change face the question of what diverse aesthetic forms and media have in common that enables us to group them as symptoms, products, or indices of a specific location, time, place, culture, or moment – even as they are realized in different material forms that provoke different modes of engagement. Is there a common element that generates the affinities or produces common features across the whole array and thus indicates a common 'outlook' even in different practices or forms?

Riegl was one of the influential proponents of the latter view, in his radical study of the late Roman cultural production, across whose most magnificent structures and tiniest decorative features he identified a common will to form, *Kunstwollen*.[119] Mannheim analysed both

Dilthey's *Weltanschauung* and Riegl's extension, proposing a schema for interpretation by arguing that an object in the world – including a worldview or spirit of an epoch – is not given 'immediately'. It is mediated by two other mediators: *expression* and *documentation* or evidence. So, he concluded that all cultural products operate on three levels of meaning that anticipate and differ from the now famous tripartite scheme that Panofsky later developed as his basis for his iconological scheme.[120]

Mannheim introduces his tripartite schema with an event, or a story. He and a friend are walking in the street. They meet a beggar asking for alms. The friend gives the beggar some money. Mannheim proposes that 'every cultural product in its entirety will, on this showing, display three distinct "strata of meaning": (a) its objective meaning, (b) its expressive meaning, (c) its documentary or evidential meaning'.[121] Giving money to a man asking for alms might be objectively interpreted as 'assistance', but that can also be expanded *expressively* as 'mercy' or 'compassion'. I think these overlap with intentional meaning on the part of the giving subject. Yet that reading is in turn inseparable from the subject – what it means 'authentically' is what it meant to that subject in the 'intimate universe' of a 'world of experience' that each subject inhabits.[122] At the same time, its meaning is also dependent on the subject who witnessed the exchange and interprets the character of the gesture with which the money was passed from he who had to the beggar who lacked. It is this that makes it a historical fact and sociological event.

Mannheim recognizes intentionality (what the giver meant) but that is not relevant for interpretation of the cultural act or, in the case of art, the cultural object. That finally requires documentary interpretation, evidence. This is where his critique of a general worldview emerges since we cannot link this situation to something general. We cannot deduce from a general worldview because that homogenizes and typifies, suppressing differentiations that denote the situation of the interpreter as well. So, in the following statement by Mannheim we can recognize the position being advanced in Rosenau's 'Preface':

> In historical understanding, the nature of the subject has an essential bearing
> on the content of knowledge, and some aspects of the object to be interpreted
> are accessible only to certain types of mind – the reason for this being that
> historical understanding is not timeless like mathematical or scientific
> knowledge but itself shaped by the historic process in philosophical self-
> reflection. Just as one admits this, one will also admit the temporal process
> of historical understanding, which does not add one item of knowledge to

another but reorganizes the entire image around a new centre in each epoch, has positive cognitive value – this type of cognitive knowledge, in fact, being the only one a dynamically changing subject can have of a dynamically changing object.[123]

Documentary knowledge or meaning, the third element, lies in this situatedness.

— Panofsky and Mannheim on Interpretation and *Weltanschauung*

Recent art-historical research has clarified the parallels and the differences between Mannheim's and Panofsky's proposals for interpretation at the intersection of social acts which are also symbolic (have meaning) and represented acts in images, the former instancing Mannheim's attention to and interpretation of a situation and the latter Panofsky's iconology of gesture. Around ten years after Mannheim's exploration of socio-cultural interpretation in his *Weltanschauung* paper, in 1932 Panofsky published 'Zum Problem der Beschreibung und Inhaltsdeutung von Werken der bildenden Kunst', translated only in 2012 by Jaś Elsner and Katharina Lorenz as 'On the Problem of Describing and Interpreting Works of the Visual Arts'.[124] Rosenau would have known both in their original German forms.

In exile in the United States of America, Panofsky recast his original German text as 'Iconography and Iconology: An Introduction to the Study of Renaissance Art', which introduced his influential collection *Meaning in the Visual Arts: Papers in and on Art History*, which in turn would consolidate iconography as a major strand in art-historical study but without its original intellectual context from German academic debates in the 1920s.[125] Elsner and Lorenz trace the transformation of Panofsky's philosophically rich German text into this less theoretically charged presentation of his thesis on interpretation of meaning in the image.[126] In 1993, Joan Hart also examined the dialogue between Mannheim and Panofsky, identifying critical differences as well as debts of the latter to the former:

> [Mannheim's] objective was to create a sociology of meaning or knowledge. His anecdote [his friend and the beggar] revealed his concern that worldviews (discerned through personalities and social situations) served as a summary of social knowledge and his awareness of the practical social value of interpreting human interrelationships. He focussed on the human and social rather than the aesthetic treatment of Weltanschauung. As we shall see, Panofsky's theory of interpretation arose from a rather rarefied consideration of Alois Riegl's theory of art, and his desire to purify it, remove its psychological aspects, and eliminate the genetic fallacy implicit in historical

interpretations that are based on the scientific method. Mannheim's and Panofsky's theories of interpretation were very similar, but their objectives were very different.[127]

Panofsky's example is how we interpret a man in the street meeting another and doffing his hat.[128] Hart concludes:

> From this brief encounter, Panofsky divulged the whole of his interpretive strategy that became the art historian's most important tool for recovering meaning from the art of the past. In dissecting this deceptively simple event, Panofsky revealed the tripartite, hierarchical but circular structure of iconological interpretation. First, we extract the basic factual and formal meaning of the two gentlemen and the action of hat removing, then we discern the expressional meaning that gives nuance to the action – the friendliness, hostility, or neutrality of the hat remover – and, finally, we delve more deeply into the philosophical meaning of the event by examining the context of the greeting in terms of the hat remover's class, nationality, intellectual traditions and so forth.[129]

Panofsky subjects this tiny event to a tripartite analysis that takes him from one level of meaning (a gesture of hat removing at a meeting) to the next level of interpretation (such a gesture conveys friendliness within a hat-wearing social class) to the historical legacy from social customs of medieval chivalry where the removal of a helmet conveyed the warrior's peaceful intent (lingering unknown as the source for this male bourgeois custom) (fig. 1.22).

Mannheim's original story about his friend and the beggar, however, concerned a chance event when walking in the street. Hart glosses Mannheim's interpretative strategy to show that psychology and politics are the issue in his analysis of another three-levelled event:

> Mannheim's story is about injustice. His interpretation emphasized the differences in social class and power between the beggar, himself as observer and his friend, and turned, at the third level of interpretation, on the motivation and personality of the friend who gave the alms. His friend's motive was impure and 'hypocritical'. His essential character was immoral, which he communicated in his body language as he gave the charity. … Mannheim's interpretation focussed on social differences and personality, while Panofsky's revolved around the historical meaning of a gesture that was independent of culture and period – the hat raising.[130]

Hart then argues that Panofsky's aim for an interpretative art history established 'relations between objects and gestures' and their culturally determined changes over time, while Mannheim's sociology of

1.22 Anonymous, *Erwin Panofsky* (1892–1968), photograph. Photo: Courtesy of the Warburg Library, London.

knowledge proposed a social interpretation of meaning. Thus Panofsky's iconography can enable the art historian to trace a meaning in an image over time, while Mannheim's thesis about social actions and their encoded representation requires interpretation of meaning within historically situated social interaction and the social foundations of what become gestures, rituals, and their meanings.

Panofsky writes that documentary meaning references

> the unintentional and subconscious self-revelation of *a fundamental attitude towards the world* which is characteristic in equal measure of the individual producer, the individual period, the individual people, and the individual cultural community. The magnitude of an artistic achievement in the end depends upon the extent to which the energy of such a particular worldview has been channelled into moulded matter and radiates towards its viewer.[131]

By this means, Panofsky refutes the division of form from content by making 'style' the locus of the historically specific and variable modes of the 'moulding of matter' that are directed at situated and enculturated viewers, who can decode what they are seeing in ways shaped by the specifics of artistic handling while exceeding the latter's purely formal histories because any decoding requires several registers of interpretative activity at the same time. The effect of this argument is to imply a situated viewer while also suggesting that a study of these worldviews – these larger shared communities of knowledge, sensibilities, and historical change – is also required. These worldviews then become the objective correctives to free-floating subjective interpretation, necessary as that is. For there to be a *history* of art's 'moulding of matter' and 'radiating' potential significance to a viewer, there has to be a *history* of worldviews (no universalism) and hence worldviews become historically variable at the triple level of intellectual culture, aesthetic practices, and imaginations. What sets apart Panofsky's implicit dialogue with Mannheim as he refashions it to meet art-historical debates from Mannheim's writing – which shared major questions with emerging Art History, notably Riegl's propositions on *Weltanschauung* – is sociology as an additional analytic to that of historical variation.

In 'On the Problem of Describing and Interpreting Works of the Visual Arts', Panofsky creates three columns, headed 'Object of interpretation', 'Subjective source of interpretation' (this second one posits a situated reader/interpreter with certain knowledges available to her), and then 'Objective corrective of interpretation'. This third dimension involves three kinds of historical knowledge that need to be mobilized: a history of styles ('what it is possible to represent' at any moment that will be legible as a representation); a history of types ('the quintessence of what is it possible to imagine at any given moment'); and general intellectual history ('the quintessence of what is possible within a given world view'). Under 'Object of interpretation' we find three categories: phenomenal meaning (composed of factual and expressive meaning); meaning dependent on content; and documentary meaning (intrinsic meaning). Of the third of these Panofsky writes:

> The source of interpretation of intrinsic meaning is effectively the worldview of the interpreter … that is, the source of knowledge is fundamentally subjective and one may say that its absolutely personal nature is even more in need of objective corrective that either the vital experience of living (with which we grasp the phenomenal meaning) or the literary knowledge (with which we uncover the meaning dependent on content). Such a corrective does exist, and it belongs to the sphere of historically situated factuality which provides

the boundary that must not be crossed by any interpretative violence in order to turn it into 'roving arbitrariness'. It is a sense of general intellectual history which clarifies what was possible within the worldview of any specific period and any specific cultural circle, just as the history of style delimits the sphere of what kind of representation was possible in a given context at any time, and the history of types clarifies what was imaginable.[132]

Panofsky draws his conclusion:

> In summary we might say, the *history of types* instructs us about how pure form coalesces with specific factual and formal meaning within the process of historical change; finally, a general sense of intellectual history instructs us about how meanings dependent on content (for example the concepts of language or the melismas of music) are redolent of the outlook of a specific worldview with the process of historical change.[133] (my emphasis)

The word 'types' leaps out. Is this the source of Rosenau's own historical reading of a movement 'from type to personality' as itself a historical–cultural trajectory, recognized by Rosenau because she is also a historically positioned subject of knowledge? Panofsky identifies the knowledges the art historian needs as both an understanding of a history of styles (modes of representation familiar to the makers and viewers at the time of representation that ensure intelligibility of the signs) and a lexicon of types, *Typenlehre*: by this he means that what we might describe factually or from ordinary knowledge will need to be related to 'a content', a meaning dependent on those phenomenal elements already being articulated as a signifying composite that exceeds an untutored deciphering.

A painting or etching of a man and a lion in a scholar's room may be deciphered from the visual signs in a picture as man and animal. What is not spontaneous, however, is our understanding of the intended meaning: the scene represents a specific scholar, St Jerome, a learned Christian saint being watched over (hence not menaced) by a lion (not dangerous) in order to produce a didactic meaning: the saint's compassion and kindness for a wounded but dangerous creature forever tamed by its gratitude for having earlier had a thorn removed from his paw by the saint. Another example can be found in the sequence of frescoes created by Carpaccio in 1502 for the Scuola di San Giorgio degli Schiavoni in Venice, which shows a scene of terror among a community of monks when St Jerome arrives at their monastery followed by his leonine companion. The next scene in the sequence by Carpaccio shows the saint's funeral. Untutored in the legend of St Jerome and his peaceful passing, untouched by the loyal lion, a viewer might unfortunately assume a causal connection foreseen by the fleeing monks.

In this early essay by Panofsky, 'types' also stands for a condensation of iconography and formal realization shaped by historically specific representational strategies. Thus a Catholic medieval manuscript's rendering of this scene would be indifferent to the kind of deep space and distribution of illumination we will find in Rembrandt's Baroque, Protestant oil paintings or etchings of the scholarly Jerome with his leonine companion sleeping at his feet.

With her subtitle, Rosenau identifies historical shifts in representational languages that moved from a culturally shared typology (such as wives, lovers, and mothers) to a sociologically different kind of subjectivity that would engender novel representational forms to articulate the no longer typical but rather *personality*, itself a socio-historical effect of Modernity's individualizing impact on women's subjectivities as much as representations of women. *Woman* is not, therefore, a given, a constant, an essence, a sex. The study of *Woman* as *type* must mobilize several levels of simultaneous 'interpretation' to produce a historically sensitive and socially situated hermeneutics of the materialized image requiring historical, formal, and cultural analysis enhanced by Warburg's thesis of image as *formeln*, 'formulae' of socio-historically grounded conceptions of changing ways of being in the world in relation to life, sex, social identity, relationality, and ultimately modern socio-economic and political individualization.

In so far as Panofsky references Mannheim in a parenthesis when giving his explanation of documentary meaning, we can acknowledge that the latter's key concepts of the subjective and the situated character of our knowledge – and hence our capacity to make sense of the world – are being folded into, and adapted to, Art History's core investigation into style, form, and content in Panofsky's argument.[134] But, even more, we can discern Mannheim's own critique of Riegl, in which Mannheim elaborates a complex thesis on historical communities of subconscious as well as consciously mobilized knowledge as dispositions within a worldview, *Weltanschauung*.[135] This enables Rosenau to devise a selection of images by which to trace major shifts in thinking about those elements of human society where class and gender, race and difference, belief and thought, create what Mannheim termed 'cultural objectifications'.

I suggest, therefore, that Rosenau's *Woman in Art* is itself a critical text in these early twentieth-century negotiations of fundamental questions of interpretation of specific image formulations, concepts of type, and the geosocial, epochal mentalities being explored in terms of Mannheim's social grounding and modification of *Weltanschauung*, a concept posing but not solving the question of the intricate relays between the specifics of each image or building, and the patterns permeating several

distinct forms across a cultural whole, a culture itself being also a socio-economic–political–mythic entity. Rosenau is in neither camp; nor is she a follower. Her book demonstrates her range and confidence as an intellectual equal engaging with these formative debates traversing Cultural Sociology and hermeneutic Art History.

Woman as *type* necessitates a reading simultaneously of how *woman* is thought as a social history; how Woman (sic) is imagined within a history of myth, religion, literature, and latterly psychoanalysis; and how Woman is represented within a history of representational systems, their materialities, and their propositional address to viewers.

CONCLUSION

Drawing in Mannheim's concepts of interpretation and his dialogue with Panofsky's earliest essay on he what would later term 'iconology', in 1940 Helen Rosenau conceived her innovative and unique study, *Woman in Art: From Type to Personality*. She deployed her wide-ranging knowledge of the history of art from the most ancient materials to trace radical change, epochal ruptures, and shorter 'generational' shifts, discernible over the long cultural history of the *sex/gender* systems (Gayle Rubin's term[136]) that Modernity retrospectively enabled her to articulate in the aesthetic figuration of *Woman* as a social and imaginative concept becoming latterly, in the fragmenting conditions of Modernity, an individual person, and in certain artworks being conceptualized and materialized as a 'solitary thinker' (as in the case of *La Pensée*). She did this by studying the different image-concepts of *Woman* in social (marriage) and sexual–affective (erotic, maternal, and religious–mythical) interrelations throughout materially recorded history using examples from European, Middle Eastern, and Mediterranean cultures and societies, although she referred to examples from India and China as well.

Shifts in the visual–affective formulation of this critical index of human thought – woman–life–sex–death–love–other–time – enabled her to chart both continuities and innovations in thought while demonstrating a new way to read any image as the site of cultural ideologies (beliefs) and knowledges (new thinking) and their changes – situated ways of understanding the world – in a Mannheimian reformulation of ideology. By studying changing formulations of *Woman*, Rosenau both traced historical difference across societies and temporalities and revealed *Woman* as a social–imaginative, symbolic form that, in the shift from ancient and pre-capitalist to early mercantile and then modern industrial capitalist societies under industrial and political modernization, would become increasingly articulated in art and literature as a socio-subjective situation.

In theorizing such questions, *women* as intellectuals, artists, and social agents were themselves taking both a theoretical and a political lead in registering the historically changing conditions for their self-understanding and challenging of roles in reshaping in intellectual culture, namely thought. Hence it was necessary, at this critical historical moment of 1940 as a war with fascism threatened all of Europe and indeed the world, to chart how such an imagined subjectivity might be represented and equally how the subject, herself a woman with diverse personal, familial, social, and erotic situatedness and connections, might represent her situations. This, in turn, and, notably in Modernity, initiated new pressures that had to be formulated aesthetically to register shifts in ways that exceeded inherited mythic formulation, classical figuration, or religious iconic images, all of which Art History was canonizing as *The History of Art*. For an art historian mobilizing Mannheimian possibilities for thinking a gender-sensitized social history of art, the history of images therefore unfolded for Rosenau the conceptual move and historical shift *from type to personality*, and did so historically, sociologically, symbolically, generationally, and radically. In the same process, operative but without comment within the text, the changing artistic modes were explored as diverse cultural sites for the articulation of *Woman* – from monumental ancient political sculpture to European genre scenes of bourgeois family life, from religious icons and works of devotional theology to the emergence of self-portraiture, from prints of executed revolutionaries to Chinese medicinal dolls, each work being given the space to speak. Let me, therefore ask you to reread Rosenau's 'Preface' through and beyond a Mannheimian lens, with new emphases:

> Another necessary limitation is the subjective approach of the writer. *Recognition of personal and social situatedness.* No doubt a book written by some other person in a different period would yield a different approach. *Recognition of generationality.* At the same time it has to be remembered that only from a subjective standpoint can the concept of history be realised, and that it is a personal point of view which enables us to grasp the order in a seemingly chaotic sequence of events. *Integration of both the above into the hermeneutic activity of research conditioned by its own historical moment for the possibility of new knowledge when understanding history neither as a flow nor a progression but a series of ruptures.*

Recognizing her engagement with Mannheim's thought enables a historically situated, generational, and gender- and ethnicity-sensitive reading of Rosenau's intellectual formation as an art historian, deeply engaged in a very fertile moment of the intellectual history of

German-language Art History and Sociology with its many Jewish scholars contributing new methods and conceptualizations of cultural processes and aesthetic formulations through their doubled perspectives. Her formation in that intellectual community collides with the devastating, traumatic rupture Nazism inflicted on this young scholar, poised to take her place within these circles. Severed by racist fascism and under increasing threat of death, her Jewish and intellectual community was scattered to different locations, notably Britain and the United States of America, where, as a refugee, she was obliged to think, write, and teach in her fourth language and in a radically different culture.

Rosenau is, therefore, not just a symptom of a historical moment but a key intellectual player. In her book, she explored the trajectory of myth, religion, art, and language in relation to a central and structural symbolic form, *Woman*. Neither asking for admission to a boys' club nor adding a roster of 'women artists' nor creating a subset of iconography such as 'images of women', Rosenau elegantly and compactly wrote, in English, an accessibly brilliant 'little book' whose riches require firsthand encounter (see Part 2) and then a fuller analysis in our present (see Part 3) to ensure we have indeed recognized the thought of the art historian Helen Rosenau: *La Penseuse*.

Notes to Chapter 3

1 *Preposterous*, a term that inverts temporality, was taken up by Mieke Bal in *Quoting Caravaggio: Contemporary Art, Preposterous History* (Chicago: University of Chicago Press, 1999). Bal 'argues for a notion of "preposterous history" where works that appear chronologically first operate as an aftereffect caused by the images of subsequent artists' (from the book's marketing summary).

2 See *La Valse* (*c.*1893, bronze), *L'Age Mûr* (1894–1900, bronze), and *Clotho* (1893, plaster).

3 I am indebted to Claudine Mitchell, 'Intellectuality and Sexuality: Camille Claudel, Fin de Siècle Sculptress', *Art History* 12:4 (1989), 419–47. Mitchell documents the official censorship of Claudel's work by the sculptural establishment, which forbade her from completing her original concept for her work *The Waltz* because she had created a male/female couple whose bodies touched.

4 Rosenau is quoting from [Paul Gsell] Auguste Rodin, *L'Art: entretiens réunis par Paul Gsell* (Paris: Bernard Grasset, 1911), ch. 8.

5 For a detailed study of this type of male body in art at the intersection with science, medicine, and sexual politics see Anthea Callen, *Looking at Men: Art, Anatomy and the Modern Male Body* (New Haven and London: Yale University Press, 2018).

6 '"Quel reproche me faites-vous?" me dit-il avec quelque étonnement. "C'est à dessein, croyez-le, que j'ai laissé ma statue dans cet état. Elle représente la *Méditation*. Voilà pourquoi elle n'a ni bras pour agir, ni jambes pour marcher. N'avez-vous point noté, en effet, que la réflexion, quand elle est poussée très loin, suggère des arguments si plausibles pour les déterminations les plus opposées qu'elle conseille l'inertie?"' ([Gsell] Auguste Rodin, *L'Art*, 196). In nineteenth-century sculptural practice, the original work of the artist is the plaster or terracotta work. Carving in marble was later done by *practiciens/practiciennes*, the sculptor's students or professional studio assistants, while casting in bronze was done from the plaster in professional foundries.

7 In his study *Bergsonism* (trans. Hugh Tomlinson and Barbara Habberjam, New York: Zone Books, 1996), French philosopher Gilles Deleuze (1925–1995) identified the concept of virtuality from the philosophy of Henri Bergson (1859–1941), who in *Matière et mémoire* (Paris: Félix Alcan, 1896) developed a materialist thesis for the foundations of memory that created a distinction between the real and the actual, when the real, in fact, opposed the possible. Thus, the virtual represents a creative dimension.

8 'Cette femme, je le comprenais maintenant, était l'emblème de l'intelligence humaine impérieusement sollicitée par des problèmes qu'elle ne peut résoudre, hantée par l'idéal qu'elle ne peut réaliser, obsédée par l'infini qu'elle ne peut étreindre' ([Gsell] Auguste Rodin, *L'Art*, 196).

9 The Hebrew reads: וְרוּחַ אֱלֹהִים מְרַחֶפֶת עַל־פְּנֵי הַמָּיִם.

10 The Montanists were a second-century Christian sect in modern-day Turkey (Phrygia) who believed in continuing prophecy inspired by the Holy Ghost (Paraclete) that included women being recognized as bishops and presbyters as well as visionaries. They had an ecstatic form of worship and observed some Judaic dates, such as 14 Nisan for Easter. They were eventually crushed by the official, Roman apostolic church.

11 On the suppression of the feminine within the Hebrew through translation, and the implications of conceptualizing the deity in 'the matrixial feminine', see Bracha Lichtenberg Ettinger's 'The Becoming Thresholds of Matrixial Borderlines', in *Travellers' Tales: Narratives of Home and Displacement*, ed. Jon Bird, Barry Curtis, Melinda Mash, Tim Putnam, George Robertson, and Lisa Tickner (London: Routledge, 1994), 38–62 and 'Transgressing with-in-to the Feminine', in *Differential Aesthetics: Art Practices, Philosophy and Feminist Understandings* (Aldershot: Ashgate, 2000), 185–209.

12 Bracha Lichtenberg Ettinger and Emmanuel Levinas, *Time Is the Breath of the Spirit* (Oxford: Museum of Modern Art, 1993); Luce Irigaray, 'The Age of the Breath', in *Key Writings* (London: Continuum,

2004), 165–70; Michael Marder, 'Breathing "to" the Other: Levinas and Ethical Breathlessness', *Levinas Studies* 4 (2009), 91–110; Lenart Škof, 'Ethics of Breath: Derrida, Levinas and Irigaray', in *Breath of Proximity: Intersubjectivity, Ethics and Peace* (Dordrecht: Springer, 2015), 127–56.

13 Ernest Jones, 'A Psycho-Analytic Study of the Holy Ghost', in *Essays in Applied Psycho-Analysis* (London: Psycho-Analytical Press, 1923), 415–30: 429. He also analysed the idea of conception by breath in his essay 'The Madonna's Conception through the Ear' [1923], in *Essays in Applied Psycho-Analysis* (London: Hogarth Press, 1951), 260–359.

14 Aby Warburg, *The Renewal of Pagan Antiquity: Contributions to the Cultural History of the Renaissance* [1932], introduced by Kurt Forster, trans. David Britt (Los Angeles: Getty Research Institute for the History of Art and Humanities, 1999); Ulrich Raulff, 'Nachleben: A Concept and Its Legacies', 150th Anniversary Conference at the Warburg Institute, London, 13–15 June 2016, https://warburg.sas.ac.uk/podcasts/ulrich-raulff-nachleben-a-warburgian-concept-and-its-origins, retrieved 15 March 2023.

15 Daniel Snowman, *The Hitler Émigrés: The Cultural Impact on Britain of Refugees from Nazism* (London: Chatto & Windus, 2002).

16 Claire Richter Sherman (ed.) with Adele M. Holcomb, *Women Interpreters of the Visual Arts, 1820–1979* (Westport: Greenwood Press, 1981), 69.

17 Rozsika Parker and Griselda Pollock, *Old Mistresses: Women, Art and Ideology* (London: Routledge, 1981).

18 Rachel Wischnitzer fled Germany as late as 1938 to work in Paris with one of the French excavators of the newly discovered Dura-Europos synagogue, a field she further pursued when she moved to New York, achieving an MA at the Institute of Fine Arts with her thesis *The Messianic Theme in the Paintings of the Dura Synagogue* in 1948. She died aged 104 in 1989. See Katharina Feil, *A Scholar's Life: Rachel Wischnitzer and the Development of Jewish Art Scholarship in the Twentieth Century* (New York: Jewish Theological Seminary, 1984).

19 Helen Rosenau, *A Short History of Jewish Art* (London: J. Clarke, 1948); Helen Rosenau, *Vision of the Temple: The Image of the Temple of Jerusalem in Judaism and Christianity* (London: Oresko Books, 1979).

20 For her research on the synagogue, she was widely recognized among other exiled European Jewish scholars such as Mendel Metzger (1900–2002) and Theresa Metzger (dates not known), Mendel writing Rosenau's obituary in the *Gazette des Beaux-Arts*. Mendel's brother, Gustav Metzger (1926–2017), the artist, also a friend of Rosenau, took her archive for preservation to Frankfurt Exil Archiv, where it is conserved, but under his name.

21 The other is not just different, but is structurally created as the negative to the positive meaning of the central term, Man or Christian.

22 Bettina Aptheker, *Tapestries of Life: Women's Work, Women's Consciousness and the Meaning of Daily Life* (Amherst: University of Massachusetts Press, 1989), 12. Seeking to develop an inclusive model for the feminist analysis of the ensemble of social relations as multi-racial, cross-cultural, and shaped by class, religion, work experience, age, and sexual preference, Aptheker's concept displaces centre/margin hierarchies by creating a polyrhythmic understanding of history with multiple centres of experience and meaning.

23 The Jewish communities of Britain have a complex and broken history. Present in the Middle Ages, Jews were expelled, having had their resources forcibly appropriated, by Edward II in 1290. Although Jews were officially not readmitted until the mid-seventeenth century, small communities developed, from German Jewish merchants to major waves of migration from areas of Eastern Europe, termed the Pale of Settlement under the Russian Empire, in the wake of violent pogroms during the nineteenth and early twentieth centuries. Anglo-Jewry thus contains and obscures very different migrations, communities, and classes – and indeed is divided by major theological splits within the Jewish world shaped by the impact of Modernity, which produced both Orthodox and Reform/Progressive Judaism. So someone arriving from German Reform Judaism encountering British Jewish worlds arrives also as a potential foreigner within some Jewish communities in Britain.

24 Helen Rosenau, *The Ideal City in Its Architectural Evolution* (London: Routledge & Kegan Paul, 1959).

25 Shira Tarrant, *When Sex Became Gender* (New York: Routledge, 2006). Tarrant states of her selected five post-war thinkers (Mead, Komarosky, Klein, Herschberger, and Beauvoir) that they 'collectively gave us the *vocabulary* for understanding how society creates and enforces the ideals of *femininity* and the tools for analysing the political dimensions of *sex-role ideology*. These basic concepts paved the way for the later second-wave feminists to grapple with the social and political dynamics of gender' (3).

HELEN ROSENAU

26 The classic 'feminist' text is Joan Scott, 'Gender: A Useful Category of Historical Analysis', *American Historical Review* 91:5 (1986), 1053–75.

27 Viola Klein, *The Feminine Character: History of an Ideology* (London: Kegan Paul & Co., 1946); second edition introduced by Janet Sayers (London: Routledge, 1989).

28 Simone de Beauvoir, *Le deuxième sexe* (Paris: Éditions Gallimard, 1949). The complete text was retranslated and published in 2011: *The Second Sex* [1949], trans. Constance Borde and Sheila Malovany-Chevalier (London: Vintage Books, 2011).

29 Beauvoir, *The Second Sex*, 737.

30 On the feminist cultural revolution and its dispersion with the rise of fascism and war see Andrea Weiss, *Paris Was a Woman: Portraits from the Left Bank* (London: Pandora Books, 1995). Betty Friedan coined the phrase 'the problem that has no name' as she researched the post-war discontent of college-educated women forced into obligatory domesticity and unpaid childcare that would erupt as a second feminist revolt in the later 1960s; see *The Feminine Mystique* (New York: W. H. Norton, 1963). On political, economic, and psychoanalytical debates in post-war Britain about ending war-time state-funded nurseries, see Denise Riley, *The War in the Nursery* (London: Virago, 1983).

31 For my concept of co-creation (side by side not collaborative) see Griselda Pollock, 'Abstraction? Co-creation?', in *Women in Abstraction*, ed. Christine Macel and Karolina Ziebinska-Lewandowska (Paris: Centre Pompidou, 2021), 25–30. On gender exclusion see Griselda Pollock, *Killing Men and Dying Women: Imagining Difference in 1950s New York Painting* (Manchester: Manchester University Press, 2022).

32 In 1550 and then in an enlarged edition in 1558, the Florentine artist Giorgio Vasari (1511–1574) compiled essays on the lives of his artistic contemporaries in three volumes as *Le vite de' più eccelenti pittori, sculptori et architettori* (Florence: Giunti, 1558). In the 1558 enlargement he compiled one chapter specifically on his artist-women contemporaries, including Suor Plautilla Nelli (1524–1588), Properzia de' Rossi (1490–1530), and Sophonisba Anguissola (1532–1625), whose home he personally visited. The Vasarian model produces a 'subject' for art; see Griselda Pollock, 'Artists, Media and Mythologies, or Genius, Madness and Art History', *Screen* 21:3 (1980), 57–96. See also the essay Linda Nochlin developed as 'Why Are There No Great Women Artists?', in *Woman in Sexist Society: Studies in Power and Powerlessness*, edited by Vivian Gornick and Barbara K. Moran (New York: Basic Books, 1971), 480–510; 'Why Have There Been No Great Women Artists?', *Art News*, January 1971, reprinted in *Art and Sexual Politics Why Have There Been No Great Women Artists?*, edited by Thomas B. Hess and Elizabeth C. Baker (New York: Macmillan, 1973), 1–43; *Why Have There Been No Great Women Artists?*, 50th anniv. ed. (London: Thames & Hudson, 2021).

33 The curators of one of the first exhibitions to begin the feminist recovery in 1972, *Old Mistresses: Women Artists of the Past* (Walters Art Gallery, Baltimore), Ann Gabhart and Elisabeth Broun, identified sexism encoded in Art History's linguistic canonization of artists as Old Masters, pointing out the lack of a 'feminine equivalent' term to recognize major artist-women; see Elisabeth Broun and Ann Gabhart, 'Old Mistresses: Women Artists of the Past', *Walters Art Gallery Bulletin* 24:7 (1972). This inspired Rozsika Parker and me to critique the discourse of Art History itself, taking up Gabhart and Broun's title for our book subtitled *Women, Art and Ideology* (London: Routledge, 1981). The term 'women artists' itself, however, disqualifies women as artists, for the unqualified term 'artist' remains by default masculine, white, straight, Western, and so on. So I propose *artist-women* and *artist-men* as a necessary remedy.

34 Ernst Gombrich, *The Story of Art* [1950] (London: Phaidon, 1962), 5. See also David Carrier, 'Gombrich and Danto on Defining Art', *Journal of Aesthetics and Art Criticism*, 54:3 (1996), 279–81.

35 Mary Ritter Beard, *Women as a Force in History: A Study in Traditions and Realities* (New York: Macmillan, 1946). See Part 3, Essay 4 for a discussion of Beard's book of that title.

36 Griselda Pollock, 'Making Feminist Memories: The Case of Helen Rosenau and *Woman in Art*, 1944', University College London, London, 4 December 2014, https://www.youtube.com/watch?v=QhCLvdzPy1o, retrieved 22 February 2023.

37 It was published as *Die theoretische Kunstlehre Albrecht Dürers* (Berlin: G. Reimer, 1914).

38 Emily J. Levine, 'PanDora, or Erwin and Dora Panofsky and the Private History of Ideas', *Journal of Modern History*, 83:4 (2011), 753–87. Erwin's elder, Dora Panofsky was also a medievalist and former student of Goldschmidt. Erwin and Dora later collaborated on a study of the Pandora myth, their scholarly partnership earning them the nickname *PanDora*, an uneven collaboration Levine analyses in critical detail.

39 This manuscript was thought to have been lost. It was rediscovered in 2012 by chance in a safe in the

basement at the Zentralinstitut für Kunstgeschichte (Central Institute for Art History) in Munich, was published in German in 2014, and was translated into English as Erwin Panofsky, *Michelangelo's Design Principles Particularly Those in Relation to Raphael* [1920], edited and introduced by Gerda Panofsky-Soergel, trans. Joseph Spooner (Princeton: Princeton University Press, 2020). See Uta Nitschke-Joseph, 'A Fortuitous Discovery: An Early Manuscript by Erwin Panofsky Reappears in Munich', Institute for Advanced Study, 11 June 2013, https://www.ias.edu/ideas/2013/nitschke-joseph-panofsky, retrieved 22 February 2023.

40 Erwin Panofsky, *'Idea': ein Beitrag zur Begriffsgeschichte der älteren Kunsttheorie* (Leipzig: Teubner, 1924) and *Idea: A Concept in Art Theory* [1924] (Colombia: University of South Carolina Press, 1968).

41 Erwin Panofsky, *Perspective as Symbolic Form* [1927], trans. Christopher S. Wood (Princeton: Princeton University Press, 1997).

42 Panofsky, *Perspective as Symbolic Form*, blurb.

43 Alois Riegl, *Stilfragen: Grundlegungen der Ornamentik* (Berlin: G. Siemens, 1893) and *Die spätrömische Kunst-Industrie nach den Funden in Österreich-Ungarn im Zusammenhange mit der Gesamtentwicklung der Bildenden Künste bei den Mittelmeervölkern* (Vienna: Kaiserlich und Königlichen Hof- und Staatsdruckerei, 1901). See Jaś Elsner: 'From Empirical Evidence to the Big Picture: Some Reflections on Riegl's Concept of *Kunstwollen*', *Critical Inquiry* 32 (2006), 741–66. For a corrective reading of Riegl's work and his relevance to contemporary art-historical debates, see Margaret Iverson, *Alois Riegl: Art History and Theory* (Cambridge, MA: MIT Press, 2003).

44 Ernst Cassirer, *Philosophie der symbolischen Formen*, 4 vols (Berlin: Bruno Cassirer, 1923), trans. Steve G. Lofts as *Philosophy of Symbolic Forms*, 3 vols (London: Routledge, 2020).

45 Ernst Cassirer, *An Essay on Man: An Introduction to a Philosophy of Human Culture* (New Haven: Yale University Press, 1944).

46 *Lebensphilosophie* was a European, but largely German, philosphical tendency that countered mechanistic and materialist philosophies by focussing on life (*Leben*). It also reacted against the dominance of rationalism and theoretical knowledge by valuing life experience. Inspired by Arthur Schopenhauer (1788–1860), its major exponents included Wilhelm Dilthey (1833–1911), Henri Bergson (1851–1941), and Friedrich Nietzsche (1844–1900).

47 Helen Rosenau, *Der Kölner Dom: seine Baugeschichte und historische Stellung* [1930] (Cologne: Creutzer, 1931). Erwin Panofsky, her supervisor, had researched as a possible *Habilitation* topic the cathedral at Minden, which had Carolingian origins. Cologne Cathedral is the tallest twin-spired cathedral in the world and the third tallest church in the world, with the largest façade of any church worldwide. The building was initiated in 1268 but was halted in the early sixteenth century, not being completed until 1880. The site includes a Roman temple, early Christian structures from the fourth century CE, and a seventh-century cathedral completed in 818 and destroyed by fire in 1248. It is significant for its unusual equilateral cruciform design, also known as square or balanced and, indicating its pre-Christian origins, a Greek cross. Key issues are orientation (from the Latin *oriens*, 'east') – namely orienting the altar in the East End and worship in relation to the East, with the literal meaning of the sun and sunrise and all its metaphorical as well as geopolitical associations with Jerusalem – and its symbolic form.

48 On the British rescue of the library see Eric M. Warburg, 'The Transfer of the Warburg Institute', in Warburg Institute, October 1953, https://warburg.sas.ac.uk/about-us/history-warburg-institute/transfer-institute, retrieved 15 March 2023.

49 Erwin Panofsky, 'Zum Problem der Beschreibung und Inhaltsdeutung von Werken der bildenden Kunst', *Logos* 21 (1932), 103–19, trans. Jaś Elsner and Katharina Lorenz as 'On the Problem of Describing and Interpreting Works of the Visual Arts', *Critical Inquiry* 38:3 (2012), 467–82. In his exile in the United States, Panofsky had recast his original German article as Erwin Panofsky, 'Iconography and Iconology: An Introduction to the Study of Renaissance Art', in *Meaning in the Visual Arts: Papers in and on Art History* (Garden City: Doubleday, 1955), 26–54. In their paper 'The Genesis of Iconology' (*Critical Inquiry* 38:3 (2012), 483–512), Jaś Elsner and Katharina Lorenz trace the transformation of Panofsky's philosophically rich German text into a less theoretically charged presentation. I discuss this later in the context of the relation of Panofsky's *Logos* text to Karl Mannheim's work.

50 Griselda Pollock, 'Art History and Visual Studies in Great Britain and Ireland', in *Art History and Visual Studies in Europe: A Critical Guide*, ed. Matthew Rampley, Charlotte Schoell-Glass, Andrea Pinotti, Kitty Zijlmans, Hubert Locher, Thierry Lenain (Leiden: Brill, 2012), 355–78.

51 Pollock, 'Art History and Visual Studies in Great Britain and Ireland', 336.

52 On Antal's observations on the backward, formalist, or connoisseurial state of art history in Britain that militated against the acceptance of his work on a Marxist social history of art, see Frederick Antal, 'Remarks on the Method of Art History' [1949], in *Classicism and Romanticism, with Other Studies in Art History* (London: Routledge & Kegan Paul, 1966), 175–89. See also Maria Teresa Costa and Hans Christian Hönes (eds.), *Migrating Histories of Art: Self-Translations of a Discipline* (Berlin: De Gruyter, 2018); Snowman, *The Hitler Émigrés*. On Arnold Noach, who was in the Dutch Resistance and survived the German occupation of the Netherlands, see Scotford Lawrence, *Arnold Noach: Biography of a Friend* (Malvern: Aspect Design, 2021). Hauser and Noach both taught at the University of Leeds. Noach was a close friend of Rosenau.

53 Griselda Pollock, 'Art History and Visual Studies in Great Britain and Ireland'.

54 Statement on the title page of Helen Rosenau, *Design and Medieval Architecture* (London: B. T. Batsford, 1934). We do not have the original title of her *Habilitation*, but this publication implies its topic was the same, 'design in architecture', and her research focussed on the cathedrals of Bremen and Cologne and the Grossmünster in Zürich.

55 Helen Rosenau, *The Architectural Development of the Synagogue* (PhD thesis, Courtauld Institute, University of London, 1939); the award was published in 1940. Arising from this work were later articles such as Helen Rosenau, 'The Architecture of the Synagogue in Neoclassicism and Historicism', in *The Visual Dimension: Aspects of Jewish Art* [1977], ed. Clare Moore (London: Routledge, 1993), 82–104, a paper presented at the First International Conference on Jewish Art at the University of Oxford Centre for Postgraduate Hebrew Studies (23–5 October 1977), although the papers were only published in 1992, long after her death in 1984.

56 See Helen Rosenau, review of *The Excavations at Dura-Europos, Conducted by Yale University and the French Academy of Inscriptions and Letters; Preliminary Report of Sixth Season of Work, October 1932–March 1933*, by M. I. Rostovtzeff, A. R. Bellinger, C. Hopkins, and C. B. Welles, *Burlington Magazine* 73:424 (1938), 43. An earlier text, E. L. Sukenik, *Ancient Synagogues in Palestine and Greece* (London: British Academy, 1934), is cited in the syllabus for a University of London extension course taught by Helen Rosenau in 1948

titled 'The Jewish Contribution to Art'. The first lecture was titled 'The Palestinian Background' and focussed on the trajectory from Temple to Synagogue. Thanks to Rachel Dickson for discovering this document, now in the archives of Ben Uri Gallery and Museum: 'The Jewish Contribution to Art', Ben Uri Archives, http://d303gnxmdhyq59.cloudfront.net/archive/BU_Pub_LectureSyll_1948.pdf, accessed 27 May 2020.

57 Originally termed Kristallnacht by the National Socialist authorities in 'honour' of the broken glass created in the violent mob's assaults across Nazi Germany on Jewish shops or businesses (7,000 were destroyed) and synagogues (1,000 were burnt) and other community buildings and houses – through which they rampaged arresting 30,000 Jewish men and killing 91 – the event has since been redefined by the Jewish world as a pogrom, and hence is now termed Reichspogromnacht (Night of the Pogrom). *Pogrom* is a Russian word for a violent assault on an ethnic and religious group that came into use with the widespread assaults, massacres, and attempted expulsions of Jewish communities during the nineteenth and early twentieth centuries across the Russian Empire.

58 The *Burlington Magazine* was founded in 1903 by Roger Fry, Bernard Berenson, Charles Holmes, and Herbert Horne. Roger Fry was editor from 1909 to 1919 and was followed by a polymath with greater involvement in modernism, Herbert Read. It contrasted to *The Connoisseur*, initiated in 1901, which serviced the art trade by offering archival and serious art-historical articles drawing on German academic models while remaining in touch with the art market.

59 For a critique and revision of iconography see Mieke Bal, 'Recognition: Reading Icons, Seeing Stories', in *Reading Rembrandt: Beyond the Word–Image Opposition* (Cambridge: Cambridge University Press, 1991), 177–215.

60 Her *Design and Medieval Architecture* was published by B. T. Batsford, a niche press founded in 1843, and her *A Short History of Jewish Art* appeared in 1948 from James Clarke & Co., a well-established theological press.

61 Ludwig Goldscheider, *Five Hundred Self-Portraits from Antique Times to the Present Day in Sculpture, Painting, Drawing and Engraving*, trans. J. Byam Shaw (Vienna: Phaidon; London: George Allen & Unwin, 1937).

62 I discuss this text in more detail shortly. See Vardan Azatyan, 'Ernst Gombrich's Politics of Art

History: Exile, Cold War and *The Story of Art*, *Oxford Art Journal* 33:2 (2010): 129–41.

63 It is significant that all artist-men in the index are listed by surname alone, the patronym being sufficient.

64 Perry Anderson, 'Components of the National Culture' [1968], in *Student Power: Problems, Diagnosis, Action*, ed. Alexander Cockburn and Robin Blackburn (Harmondsworth: Penguin, 1969), 214–86.

65 Anderson, 'Components', 226.

66 Anderson, 'Components', 231. Two left-wing scholars, Eric Hobsbawm and Ralph Miliband, both achieved academic posts in Britain, in the fields of history and politics respectively. From reviewing the biographies of both of these left-wing intellectuals and academics, it is clear they belong to a younger generation than those Anderson was describing. Hobsbawm was born in Egypt of a British Jewish father and an Austrian Jewish mother and was always an English speaker. After both his parents died, he came to Britain as a schoolboy in 1933 and went to the University of Cambridge in 1936. His advanced studies were suspended by the war and in 1947 he joined Birkbeck and progressed there to Professor of History in 1970. Miliband arrived in Britain in 1940 and began undergraduate studies at the London School of Economics (LSE). He did war service and resumed in 1946, achieved his doctorate in 1956, was appointed to a lectureship at LSE in 1949, and subsequently became Professor of Politics at Leeds in 1972, alongside Zygmunt Bauman in Sociology when the former Tory cabinet minister Edward Boyle (then chancellor at Leeds) decided, apparently, that his university needed more Marxist thinkers to ensure intellectual balance (Bauman was my source for this last point in a personal communication). Boyle appointed the Marxist T. J. Clark to the Chair of Fine Art in 1974 and in 1977 sat on the interview panel board that appointed me, then evidently a left-wing feminist. See Michael Newman, *Ralph Miliband and the Politics of the New Left* (London: Merlin Press, 2002); Richard J. Evans, *Eric Hobsbawm: A Life in History* (London: Little, Brown, 2019).

67 On Antal's increasingly anxious and frustrated attempts to get a university post and to receive serious reviews of his major work, see Jennifer Cooke, 'Frederick Antal: Connoisseur Turned Social Historian', in *Migrating Histories of Art: Self-Translations of a Discipline*, ed. Maria Teresa Costa and Hans Christian Hönes (Berlin: De Gruyter, 2018), 99–110; see also Jim Berryman, 'Frederick Antal and the Marxist Challenge to Art History', *History of the Human Sciences* 35:2 (2022), 55–7.

68 Yoshiyuki Kudomi, 'Karl Mannheim in Britain', *Hitotsubashi Journal of Social Studies* 28:2 (1996), 43–56.

69 Ernst Gombrich, *Art and Illusion: A Study in the Psychology of Pictorial Illusion* (London: Phaidon Press, 1960).

70 Anderson, 'Components', 257.

71 See Azatyan, 'Ernst Gombrich's Politics'. On Phaidon see Anna Nyburg, *Émigrés: The Transformation of Art Publishing in Britain* (London: Phaidon, 2014).

72 Viola Klein, also supervised by Mannheim at this time, with her three doctorates from major European universities only achieved a post at the University of Reading in 1964.

73 Rosenau references Hildegard of Bingen, an enclosed Benedictine abbess, the founder of two major monastic complexes, a composer of sacred music, and the author of theological, botanical, and medicinal works (including health advice for women). Her three volumes of religious writings were admitted to the canon of the Catholic Church. Her visions were transcribed and illuminated for a manuscript known as *Scivias* (1151), from *Sci vias Domini* ('Know thy ways O Lord'). For the most recent range of scholarly studies see Jennifer Bain (ed.), *The Cambridge Companion to Hildegard of Bingen* (Cambridge: Cambridge University Press, 2021).

74 I take my inspiration for this assertion from the work of literary and cultural analyst Julia Kristeva.

75 Hegel's idealism positions the material world as the symptomatic site of the expression of the Spirit. Kant posed questions about how the mind appropriates the objects of knowledge in the sensual and material world as concepts.

76 Thanks to Jaś Elsner for this insight. See Elsner and Lorenz, 'The Genesis of Iconology'; Jeremy Tanner, 'Karl Mannheim and Alois Riegl: From Art History to the Sociology of Culture', *Art History* 32:4 (2009), 755–84.

77 Kudomi, 'Karl Mannheim in Britain'. The lectures were also delivered to a group of social thinkers called 'The Moot' in the early 1940s, and were published as Karl Mannheim, *Diagnosis of Our Time* (London: Kegan Paul, 1943).

78 Gayle Rubin, 'The Traffic in Women: Notes on the "Political Economy" of Sex', in *Toward an Anthropology of Women*, ed. Rayna R. Reiter (New York: New Monthly Press, 1975), 157–210.

79 Donna J. Haraway, 'Gender for a Marxist Dictionary', in *Simians, Cyborgs and Women: The Reinvention of Nature* (London: Free Association Books, 1991), 127–48.

80 Scott, 'Gender: A Useful Category'.

81 Catherine Clément and Julia Kristeva, *Le féminin et le sacré* (Paris: Éditions Stock, 1988), trans. Jane Marie Todd as *The Feminine and the Sacred* (New York: Cornell University Press, 2001).

82 Kristeva in Clément and Kristeva, *The Feminine*, 1. Kristeva offers her working definition of 'the sacred', which she distinguishes from religion: 'What if the sacred were the unconscious perception the human being has of its untenable eroticism: always on the borderline between nature and culture, the animal and the verbal, the sensible and the nameable? What if the sacred were not the religious *need* for protection and omnipotence that institutions exploit but the *jouissance* of that cleavage – of that power/powerlessness – of that exquisite lapse?' (27).

83 Typescript letter from Helen Rosenau-Carmi to Dr Saxl, 6 March 1941, Warburg Institute Archive, London.

84 Paperback publishing began only in 1935, by Allen Lane. See 'Company History', Penguin, n.d., https://www.penguin.co.uk/company/about-us/company-history.html, retrieved 21 September 2021.

85 bell hooks, *Talking Back: Thinking Feminist – Thinking Black* (Boston: South End Press, 1989); Donna J. Haraway, 'Situated Knowledges: The Science Question in Feminism and the Privilege of Partial Perspective', in *Simians, Cyborgs and Women: The Reinvention of Nature* (London: Free Association Books, 1991), 183–202; Lorraine Code, *What Can She Know? Feminist Theory and the Construction of Knowledge* (Ithaca: Cornell University Press, 1991).

86 The London School of Economics (LSE) was founded in 1895, the brainchild of Fabian Society (founded in 1884) socialists Beatrice Webb (1858–1943), Sidney Webb (1859–1947), George Bernard Shaw (1856–1950), and Graham Wallas (1858–1932). It joined the University of London in 1900 to grant full degrees; by 1914 a third of its students were women and a third from outside Britain. During the Second World War the LSE was evacuated to Cambridge. See Ralf Dahrendorf, *LSE: A History of the London School of Economics and Political Science 1895–1995* (Oxford: Oxford University Press, 1995).

87 Karl Mannheim, *Ideologie und Utopie* (Bonn: Friedrich Cohen Verlag, 1929), trans. Louis Wirth and Edward Shils as *Ideology and Utopia: An Introduction to the Sociology of Knowledge* (London: Routledge & Kegan Paul, 1936). I also reference the English translations of texts Rosenau would have known in their original German publications: Karl Mannheim, 'The Problem of Generations' [1927–8], in *Essays on the Sociology of Knowledge*, ed. Paul Kecskemeti (London: Routledge & Kegan Paul, 1952), 276–320; Karl Mannheim, *Essays on the Sociology of Knowledge*, ed. Paul Kecskemeti (London: Routledge & Kegan Paul, 1952).

88 Peter Hamilton, 'Editor's Foreword', in *Karl Mannheim*, by David Kettler, Volker Meja, and Nico Stehr (Chichester: Ellis Harwood; London: Tavistock, 1984), 8.

89 Personal communication from Helen Rosenau to Adrian Rifkin.

90 Antal and Hauser were both forced to seek refuge in Britain, the latter teaching at the University of Leeds during the 1950s and later at Hornsey College of Art (now Middlesex University). I discuss Antal's experience as a Marxist in Britain shortly.

91 Michael Carmi has supplied this information from the archives in Bad Kissingen. Per his communication on 17 June 2020, Albert Rosenau was born in Bad Kissingen and also lived in Munich and Monte Carlo (he lost his possessions in the latter because of his war service). After serving in the war and being appointed to the Royal Bavarian Medical Council, he was offered a professorship in medicine at the University of Munich on condition of conversion to Catholicism; he refused. He ran the renowned Spa Kurhaus in Bad Kissingen with his wife, Klara Lion (1874–1940), whom he married in 1898. Their daughter, originally named Helene, was born in 1900. After Albert's death in 1923, Klara Rosenau continued to direct the Kurhaus, but she was subsequently forced to sell it for a price below its real value by the Nazi laws. She moved to Switzerland and then Britain with her daughter but returned to her home town, where she died in 1940. She is buried in the Jewish cemetery in Bad Kissingen.

92 My colleague Dr Eva Frojmovic kindly transcribed and translated this message, which is itself rich in social–historical material.

93 I am prompted to reflect on this detail because of my research into the work of Charlotte Salomon (1917–1943), whose father was a surgeon and mother a nurse at the front during that war. This artist not only painted images of bloody field-station surgeries but also began a series of paintings from the memoirs of a teenaged German soldier who was deeply traumatized by his war experiences, including lying beneath the bodies of his dead comrades, playing dead to avoid

detection as still living. The man became suicidally depressed. His recovery story became the philosophy Salomon then translated into her own major artwork, *Leben? Oder Theater?* (1941–2). See Griselda Pollock, *Charlotte Salomon in the Theatre of Memory* (New Haven and London: Yale University Press, 2018).

94 Hitler was ahistorically invoking succession to the Holy Roman Empire established by Charlemagne in 800 CE and the relatively recent establishment of a Second German Empire, founded in 1871 with a unification of German states under the rule of one of them (Prussia).

95 Hannah Arendt, 'Philosophie und Soziologie: Anlässlich Karl Mannheim, *Ideologie und Utopie*', *Die Gesellschaft* 7:1 (1930), 1631–76; Hannah Arendt, 'Philosophy and Sociology', in *Essays in Understanding 1930–1954*, ed. Jerome Kohn, trans. Robert Kimber and Rita Kimber (New York: Harcourt Brace, 1994), 28–43. See also Peter Baehr, 'Sociology and the Mistrust of Thought: Hannah Arendt's Encounter with Karl Mannheim and the Sociology of Knowledge', https://www.bard.edu/library/archive/arendt/kettler-mannhiem/SocioMistrust.pdf, retrieved 18 February 2023. Knowledge, in German *Wissenschaft*, is closer to a specific sense of intellectual knowledge or even research. The term Mannheim used was *Geistigkeit*, *Geist* meaning both 'spirit' and 'mind' in German. Mannheim was addressing a philosophical question – of knowing and thinking, and of consciousness and mentalities – that he considered to be caught between ideology (existing ways of thinking) and utopia (imaginative, projective thinking). Both were grounded not in the singular thinking subject addressed at the same time by the philosophers Martin Heidegger (*Dasein*, 'being') or Karl Jaspers (*Existenz*, 'existence') but in social or public thinking. In Arendt's closely argued critique one can see the seeds of her own anti-philosophical political theory about singularity and her opposition to social thinking that, without the singular, risks descent into ideological totalitarianism, or totalitarianism as the logical conclusion of ideology and the notion of the socially determined grounded nature of thought. The debate the young Arendt addressed concerned two disciplines' definitions of the means to understand what is real and what is reality.

96 The Marxist term 'determination' combines two meanings of the verb 'determine'. The first suggests intent and also pressure. The second implies limits. Thus social relations are determined by economic structures in that the latter shape the former and also set limits to their operation. I draw on Raymond Williams, *Marxism and Literature* (Oxford: Oxford

University Press, 1977), 83–90. 'Overdetermination' refers to situations in which a specific social formation is shaped by several different sets of pressures and limits, as well as happening as a result of the compound force.

97 Edward Shils, '*Ideology and Utopia* by Karl Mannheim', in 'Twentieth-Century Classics Revisited', ed. Stephen R. Graubard, special issue, *Daedalus* 103:1 (1974), 83–9.

98 Karl Mannheim, 'The Problem of Generations' [1927–8], in *Essays on the Sociology of Knowledge*, ed. Paul Kecskemiti (London: Routledge & Kegan Paul, 1952), 276–320.

99 Mannheim, 'The Problem of Generations', 290. Generational theories were also developed in the following works on which Mannheim comments: François Mentre, *Les générations sociales* (1920); José Ortega y Gasset, *El tema de nuestro tiempo* (1923) and *En torno a Galileo* (1933); Wilhelm Pinder, *Kunstgeschichte nach Generationen* (1926); Edward Wechssler, *Die Generationen als Jugendgemeinschaft* (1927) and *Das Problem der Generationen in der Geistesgeschichte* (1929); and Julius Peterson, *Die Literarischen Generationen* (1930). They were applied to art history by Wilhelm Pinder in *Das Problem der Generation in der Kunstgeschichte Europas* (Berlin: Frankfurter, 1926), this work also cited by Rosenau.

100 Mannheim, 'The Problem of Generations', 290.

101 Mannheim 'The Problem of Generations', 291–2.

102 Mannheim, 'The Problem of Generations', 290.

103 Mannheim, 'The Problem of the Generations', 303. See also Jane Pilcher, 'Mannheim's Sociology of Generations: An Undervalued Legacy', *British Journal of Sociology* 45:3 (1994), 481–95.

104 Mannheim, 'The Problem of Generations', 290. The pace of change and hence subjectivity is more intense in the cities than in rural society, so that young peasants may continue living similar lives to their parents, whereas 'youth' as a social group is typically an urban cultural phenomenon, and were the young rural workers to move to the cities to work in factories for wages, they would then participate in this generational difference.

105 Mannheim, 'The Problem of Generations': 'the tempo of change', 302; 'de-stabilization', 295, 303.

106 Mannheim, 'The Problem of Generations', 311.

107 Mannheim, 'The Problem of Generations', 319–20.

108 Pilcher, 'Mannheim's Sociology of Generations', 487. See also Jane Pilcher, *Social Change and Feminism: Three Generations of Women, Feminist Issues and the*

Women's Movement (PhD thesis, University of Wales, 1992).

109 Rolf Wiggershaus, *The Frankfurt School: Its History, Theories and Political Significance* (Cambridge: Cambridge University Press, 1994); Martin Jay, *The Dialectical Imagination: A History of the Frankfurt School and the Institute for Social Research* (Los Angeles: University of California Press, 1973).

110 David Kettler and Volker Meja, 'Their "Own Peculiar Way": Karl Mannheim and the Rise of Women', *International Sociology* 8:1 (1993), 5–55: 7.

111 Kettler and Meja, 'Their "Own Peculiar Way"', 11, citing Karl Mannheim's unpublished papers.

112 Sigmund Freud with Josef Breuer, 'Studies on Hysteria' [1893–5], *The Standard Edition of the Complete Psychological Works of Sigmund Freud*, ed. James Strachey with Anna Freud (London: Hogarth Press and the Institute of Psychoanalysis, 1953). For an analysis of the Freudian theories of hysteria see Elisabeth Bronfen, *The Knotted Subject: Hysteria and Its Discontents* (Princeton: Princeton University Press, 1998).

113 Kettler and Meja, 'Their "Own Peculiar Way"'.

114 Margarete Freudenthal, *Gestaltwandel der städtischen, bürgerlichen und proletarischen Hauswirtschaft zwischen 1760 und 1910* [1933] (Frankfurt: Ullstein, 1986).

115 Gisèle Freund, *Photographie et société* [Photography and Society] (Paris: Éditions du Seuil, 1974), trans. David R. Godine as *Photography and Society* (Boston: David R. Godine, 1980).

116 Karl Mannheim, *Beiträge zur Theorie der Weltanschauungsinterpretation* (Vienna: E. Hölzel, 1923), trans. and ed. by Paul Kecskemeti as 'On the Interpretation of *Weltanschauung*', in *Essays on the Sociology of Knowledge* (London: Routledge & Kegan Paul, 1952), 33–83. See also Karl Mannheim, *From Karl Mannheim*, ed. Kurt Wolff, introduced by Volker Meja and David Kettler (New York: Routledge, 1971), 8–58; Joan Hart, 'Erwin Panofsky and Karl Mannheim: A Dialogue on Interpretation', *Critical Inquiry* 19:3 (1993), 534–66; Elsner and Lorenz, 'The Genesis of Iconology'.

117 'Worldview', Oxford Reference, n.d., https://www.oxfordreference.com/display/10.1093/oi/authority.20110803124830471, retrieved 3 May 2023.

118 Denys Hay, 'Burckhardt's Renaissance: 1860–1960', *History Today*, 10:1 (1960), 14–23: 14. See also Jacob Burckhardt, *Die Kultur der Renaissance in Italien: Ein Versuch* (Basel: Schweighauser 1860) and *Civilization of the Renaissance in Italy*, trans. S. G. C. Middlemore (London: George Allen & Unwin, 1878).

119 Alois Riegl, *Die spätrömische Kunst-Industrie*, trans. Rolf Winkes as *Late Roman Art Industry* (Rome: Giorgio Bretschneider, 1985).

120 Panofsky, 'Iconography and Iconology'. See below for elaboration of this thesis.

121 Mannheim, 'On the Interpretation of *Weltanschauung*', 44.

122 Mannheim, 'On the Interpretation of *Weltanschauung*', 46.

123 Mannheim, 'On the Interpretation of *Weltanschauung*', 61–2. In his introduction to the English collection of Mannheim's essays, Paul Kecskemeti glosses this as follows: 'The subject who *knows* history is the one who *participates* in history as an active being, sharing the dominant aspirations of his [her] epoch.' See Paul Kecskemeti, 'Introduction', in *Essays on the Sociology of Knowledge*, by Karl Mannheim (London: Routledge & Kegan Paul, 1952), 1–32: 14.

124 Panofsky, 'Zum Problem der Beschreibung' and 'On the Problem of Describing'.

125 Panofsky, 'Iconography and Iconology'.

126 Elsner and Lorenz, 'The Genesis of Iconology'.

127 Hart, 'Erwin Panofsky and Karl Mannheim', 536–7.

128 Francesco Ventrella, 'Under the Hat of the Art Historian: Panofsky, Berenson and Warburg', *Art History* 34:2 (2011), 310–31.

129 Hart, 'Erwin Panofsky and Karl Mannheim', 536.

130 Hart, 'Erwin Panofsky and Karl Mannheim', 536.

131 Panofsky, 'On the Problem of Describing', 479.

132 Panofsky, 'On the Problem of Describing', 480.

133 Panofsky, 'On the Problem of Describing', 480.

134 Panofsky, 'On the Problem of Describing', 478.

135 Karl Mannheim, '*Weltanschauung*: Its Mode of Presentation', in *Essays on the Sociology of Knowledge*, ed. Paul Kecskemeti (London: Routledge & Kegan Paul, 1952), 33–83.

136 Gayle Rubin, 'The Traffic in Women'.

Woman in Art:
From Type to Personality

Dr Helen Rosenau

A new edition with colour
illustrations of the book first
published by Isomorph Ltd in
February 1944

A digital facsimile of the original
publication can be found on the
Internet Archive (archive.org)

Note on the New Edition

FULFILLING HELEN ROSENAU'S DESIRE TO SEE *WOMAN IN ART* republished, what follows is a newly designed edition that is in tune aesthetically with the original.

Rosenau's 'little book' is now illustrated in colour, to current standards of art-history publication. Wherever possible, a colour version of the exact original image has been used. Where one was not available, or where the original source could no longer be traced, a suitable substitute has been chosen. Two supplementary images have been included: 9a is a contemporary photograph of a satī stone *in situ*, and 16a, contemporary with 16, is a portrait of the Soviet sculptor who made the monument.

The original text has been lightly edited with a view to retaining Rosenau's exact text where possible but imposing consistency of spelling, punctuation and formatting for modern readers. Minor inaccuracies of date, etc., have been corrected.

Page numbers in the Table of Contents have been amended to reflect the pagination of this new edition.

The List of Illustrations has been updated with the latest information on title, date, medium, dimensions and location of the works of art, as well as with the credits for the new photography. Some additional explanatory comments on a number of the images are also now included.

When *Woman in Art* was originally published, it did not include a bibliography; one has now been compiled to make visible Rosenau's sources, methods, references and interlocutors. This can be found on pp. 159–63.

Page references in the Index of Artists now reflect the pagination of the new edition, and Hildegard of Bingen, whose work was illustrated in the original, is now included in this index. A full index of this entire publication can be found on pp. 369–86. This general index includes a more thorough indexing of Rosenau's original publication, references to which are indicated there in bold.

Contents

Foreword

THIS BOOK CONTAINS MORE INFORMATION, ANALYSIS AND reflection than many a volume twice or thrice its size. The illustrations are chosen from such a wide field that even experts may find something that is new to them. It is far more, however, than an annotated collection of feminine types and attitudes in chronological order. Dr Rosenau's approach is sociological. Her aim is to relate the representation of women in art to their position during the various stages through which *Homo Sapiens* has passed in his long and painful ascent from primitive times to the differentiations and complexities of the twentieth century. Her text, enriched and fortified by elaborate bibliographical notes, reveals her as a thinker no less than as a narrator of social evolution.

The story, which in these pages begins about 25,000 BCE, is summarised in the second half of the title: *from Type to Personality*. Beginning as a mere biological phenomenon, the symbol of fertility, the instrument and often the slave of the stronger sex, woman gradually advances to a position in which she claims and receives recognition as an individuality with a mind and will of her own. History is the record and interpretation of the life of humanity, and the emergence of woman forms one of its most thrilling chapters. This immense and beneficent change, expressing itself in law, politics, economics and social life, ranks with the most significant transformations of the modern age. It is the author's achievement to have studied this revaluation of values from the relatively unfamiliar angle of the history of art.

G. P. GOOCH

London, 1944

Preface

THE PURPOSE OF THIS STUDY ON WOMAN IN ART IS THREEFOLD: firstly, to show the close interrelation which exists between the visual arts and the society to which they belong; secondly, to suggest the changing attitudes held regarding womanhood in the course of human evolution. The third problem to be considered is whether there may be found some permanent features which repeat themselves in varying social conditions, and may be regarded as typically feminine. It need not be added that completeness cannot be attempted in a book of this kind, either with regard to the examples selected or to the periods studied, especially since owing to war conditions it has to appear in an abridged form. The main emphasis is laid on the Mediterranean and European civilisations, whilst civilisations outside this sphere can only be dealt with as enlightening contrasts or corroborating evidence. Another necessary limitation is the subjective approach of the writer. No doubt a book written by some other person in a different period would yield a different approach. At the same time it has to be remembered that only from a subjective standpoint can the concept of history be realised, and that it is a personal point of view which enables us to grasp the order in a seemingly chaotic sequence of events. The picture thus conveyed should be checked by the reader perusing the selection of illustrations, thereby testing the evidence and the conclusions suggested.

I am greatly indebted to the Authorities of the Victoria and Albert Museum for facilitating my work in every way; to Dr Karl Mannheim for reading the original draft of this book and making some valuable suggestions; to Miss V. Douie, of the Women's Service Library for her constant interest in the progress of the manuscript; and finally to my publisher, for his understanding and enterprise, as well as for the care and taste with which he has given this study its external form.

H. R.

London, November 1943

List of Illustrations

IN THE FOLLOWING LIST ARE MENTIONED THE sources from which the illustrations were taken. I wish to express my gratitude to the Trustees of the British Museum for *Figs. 4*, *5* and *51*; to the Director of the Victoria and Albert Museum for *Figs. 26* and *41*; to the Warburg Institute for *Fig. 8*; to Messrs George Allen & Unwin, Ltd for *Fig. 9*, which is reproduced from Edward Thompson's *Suttee*; to Sir Humphrey Milford, the Oxford University Press, for *Fig. 25*, which is reproduced from S. Kramrisch's *Indian Sculpture*; to the London School of Economics for *Fig. 15*; and to Miss Barbara Hepworth, both for the cover illustration, and for her kindness in providing a photograph of a hitherto unpublished work, *Fig. 55*. I regret that owing to the War, permission to reproduce some of the works could not be obtained, and the present location of the private collections cannot be stated.

Cover: Barbara Hepworth (1903–1975), *Single Form*, 1937, 89.8 × 28 × 17.6 cm, holly wood. Collection: Herbert Read; now in the Leeds Museums and Art Galleries. © Bowness. Photo: Bridgeman Images.

Willendorf 'Venus', thought to be *c.*25,000 BCE but now dated to 33,000–25,000 BCE, oolitic limestone, 11.1 cm tall. Natural History Museum, Vienna.

Fig. 1: Back, side and front views of the *Willendorf 'Venus'*, 33,000–25,000 BCE, oolitic limestone, 11.1 cm tall. Natural History Museum, Vienna. Photo: © Natural History Museum, Vienna.

Fig. 2: *Santhal* mantra, contemporary (Bihar). The original photograph is taken from *Axis: A Quarterly Review of Abstract Painting and Sculpture* 7 (1936), p. 27.

Fig. 3: *Seneb and His Wife and Children*, found at the Giza Acropolis, Old Kingdom, Late Dynasty 5 to Early Dynasty 6 (twenty-fourth to twenty-third century BCE), limestone, 34 × 22.5 cm. Egyptian National Museum, Cairo. © Sandro Vannini / Bridgeman Images.

Fig. 4: *The Family of Epichares* (grave relief), marble stela with pediment: a seated woman clasps the hand of her daughter Aristeis while Epichares looks on, *c.*375–350 BCE, 111.76 × 73.66 cm. 1910.0712.1AN244301001 © The Trustees of the British Museum.

Fig. 5: *Dextrarum Junctio*, second century CE, Parian marble, Proconnesian relief from the front of a sarcophagus: a Roman marriage ceremony, 98.4 × 75 × 11 cm. 1805,0703.143AN241199003 © The Trustees of the British Museum. [*Editor note*: Rosenau identifies the additional figures (apart from bride and groom) in the British Museum sculpture as: woman, *pronuba* (for the bride), and man, *paranymphus* (ceremonial assistant or coach at a ceremony), or best man. Of the maiden supporting the bride, only one hand remains (on the right edge, touching the bride's arm). This indicates a lost figure that balanced the best man, or coach, on the the left side of the sculpture.]

Fig. 6: *Ekkehard and Uta*, 1245–50, painted stone, two life-sized sculptures by the Naumburger Meister showing Uta von Ballenstedt (*c.*1000–1046), known worldwide as Uta von Naumburg, and Ekkehard II (*c.*985–1046), Margrave of Meissen (Naumburg Cathedral) / Bridgeman Images: Andrea Jemolo.

Fig. 7: Hans Holbein the Younger (1497/8–1543), *Madonna of the Burgomaster Meyer*, *c.*1526, oil on wood, 146.5 × 102 cm. Schlossmuseum, Darmstadt / Bridgeman Images.

Fig. 8: Master of the Rolls, *Fight for the Trousers*, fifteenth century, engraving (after Warburg). Photo: Interphoto Fine Arts / Alamy Stock Photo.

Fig. 9: *Satī* (Hampi), illustration from Edward Thompson (1886–1946), *Suttee: A Historical and Philosophical Inquiry into the Hindu Rite of Widow Burning* (London: George Allen & Unwin, 1928), pp. 32–3.

Fig. 9a: *Satī Memorial Stone* (Madhya Pradesh, Panna National Park). © John Warburton-Lee

Photography / Alamy Stock Photo. [*Editor note*: Satī stones are memorial stelae dating from *c*.900 CE either showing an upraised hand or a couple in life. Hampi is a UNESCO World Heritage Site in Karnataka, India. On the Tungabhabra River, Hampi was once capital of the Vijayanagara Empire.]

Fig. 10: Titian (Tiziano Vecellio, 1490–1576), *Venus with an Organist and Dog*, *c*.1540–45, oil on canvas, 138 × 222.4 cm. Prado Museum, Madrid, Spain / Bridgeman Images. [*Editor note*: Interpretations of this painting vary from erotic to an allegory of the senses, and also to the matrimonial, since this recognizable female figure is without Cupid and wears a wedding ring.]

Fig. 11: Peter Paul Rubens (1577–1640), *Helena Fourment ('The Little Fur Coat')*, *c*.1636/38, oil on wood, 176 × 83 cm © Kunsthistorisches Museum, Vienna / Bridgeman Images.

Fig. 12: Rembrandt van Rijn (1606–1669), *The Jewish Bride (Portrait of a Couple as Isaac and Rebecca)*, 1665–9, oil on canvas, 121.5 × 166.5 cm. Rijksmuseum, Amsterdam.

Fig. 13: Francisco de Goya (1746–1828), *No hay quien nos desate?* (Can't Anyone Untie Us?), 1779, from *Los Caprichos* (The Caprices) plate 75, 21.6 × 15.2 cm; sheet 28.7 × 18.9 cm. Washington National Gallery of Art (open access). Gift of Ruth B. Benedict.

Fig. 14: Henri de Toulouse-Lautrec (1864–1901), *À la mie* (At the Café Mie), *c*.1891, oil paint on millboard, mounted on panel, 53 × 67.9 cm. Museum of Fine Arts, Boston. All rights reserved. S. A. Denio Collection-Sylvanus- / Bridgeman Images.

Fig. 15: William Nicholson (1872–1949), *Sidney and Beatrice Webb: The Authors at Home*, 1928, oil on canvas, *c*.120 × *c*.80 cm. London School of Economics and Political Science. Lebrecht History / Bridgeman Images.

Fig. 16: Vera Mukhina (1889–1953), *Worker and Girl Collective Farmer* [also known as *Worker and Kolkhoz Woman*], stainless steel, first shown in Paris in the Pavilion of the USSR at the Exposition Internationale, 1937, then moved to Moscow, 24.5 metres tall. Russian Exhibition Centre, Moscow. © CCI / Bridgeman Images.

Fig. 16a: Mikhail Nesterov (1862–1942), *Portrait of Vera Mukhina*, 1937, oil on canvas. State Tretyakov Gallery, Moscow. Photo © Fine Art Images / Bridgeman Images.

Fig. 17: Pablo Picasso (1881–1973), *The Kiss* (now titled *Lovers in the Road*), 1900, pastel, 59 × 35 cm. Originally Museu d'Art de Catalunya, now Museu Picasso de Barcelona. Bridgeman Images / DACS, London 2023.

Fig. 18: *Hathor Protecting Psammetichus* (Psamtik), 26th Dynasty, 664–525 BCE, schist stone. Egyptian National Museum, Cairo. © Andrea Jemolo / Bridgeman Images.

Fig. 19: *Artemis Ephesia*. Collection: Helbing, Munich. No longer traceable. Replaced by *Artemis of Ephesus*, Roman, second century CE, bronze and alabaster (head, hands, and feet restored in bronze by Valadier (1762–1839); restoration in alabaster by Albacini (1734–1813)), height 130 cm. Museo Archeologico Nazionale, Naples, Campania, Italy / Bridgeman Images. [*Editor note*: Hugo Helbing was a gallerist in Munich, but, after the introduction of the Third Reich's Aryanization laws affecting the art market and Jewish-owned auction houses, he was unable to trade. He was severely beaten during Reichspogromnacht (9–10 November 1938) and died on 30 November 1938 from his injuries aged 75.]

Fig. 20: *Matronae Aufaniae*, second century CE, Vosges sandstone, excavated in Bonn Minster. Rheinisches Landesmuseum, Bonn. Interfoto/Alamy Stock Photo.

Fig. 21: *Kongo Maternity Figure*, from Cabinda Region, Democratic Republic of Congo or Angola, wood. Photo © Heini Schneebeli / Bridgeman

Images. This is a replacement image for the untraceable original.

Fig. 22: *Relief of the Virgin Holding Christ* (after Steinberg), *c.*1180, at Ottrott Convent of Mont Sainte-Odile, Odilienberg, formerly a pillar in the cloister showing the Abbesses Relinde (d. 1176) and Herrade at the foot of the Virgin. Photo: Bernard Couturier. © Région d'Alsace – Inventaire général 1986. [*Editor note*: S. H. Steinberg (1899–1969), born in Germany, emigrated to Britain in 1936 with a research fellowship at the Courtauld Institute.]

Fig. 23: *Vierge Ouvrante*. Cathedral Museum, Vienna. Replaced by *Mother of Mercy: Opening Virgin, c.*1390, German School, wood and gold leaf, 93 × 54.7 cm. © Germanisches National Museum, Nuremberg / Bridgeman Images.

Fig. 24: *Annunciation*, Tympanum, early fifteenth century (Church of St. Mary, Wurzburg). Photo: Zvonimir Atlelic / Alamy Stock Photo.

Fig. 25: *Buddha's Birth* (after Kramrisch), now titled *The Birth of Siddartha*, Pala, tenth century CE, basalt, 37.8 × 24.2 × 10 cm. Indian Museum, Kolkata. Photo: Biswarup Ganguly under Creative Commons.

Fig. 26: Bartolomeo Buon (d. after 1564), *Mater Misericordiae* (*Virgin and Child with Kneeling Members of the Guild of the Misericordia*), Italian, *c.*1445–50, Istrian stone, 251.5 × 208.3 × 50 cm. Victoria and Albert Museum, London. Photo: Universal History Archive / Bridgeman Images.

Fig. 27: Nicolas de Largillière (1656–1746), *Portrait of the Artist and His Family, c.*1704, oil on canvas, 128 × 167 cm. Kunsthalle Bremen. Photo: Lars Lohrisch ARTOTEK.

Fig. 28: Ernesto de Fiori (1884–1945), *Die Engländerin* (The English Girl), 1924, bronze, 137 cm tall. Collection: Buchholz; now in the Georg Kolbe Museum, Berlin. Photo: Markus Hilbich, Berlin.

Fig. 29: Paula Modersohn-Becker (1876–1907), *Self-Portrait on the Sixth Anniversary of Marriage*, 1906, tempera on canvas, 102.8 × 70.2 cm. Paula Modersohn-Becker Museum, Bremen. Photo © Fine Art Images / Bridgeman Images

Fig. 30: Käthe Kollwitz (1867–1945), *The Mothers*, 1919, lithograph, 43.6 × 57.7 cm; sheet 52.7 × 70.1 cm. Metropolitan Museum of Art, New York. Harris Brisbane Dick Fund, 1928, 28.68.3. Scala Images.

Fig. 31: Albrecht Dürer (1471–1528), *Portrait of the Artist's Mother at the Age of 63*, 1514, 42.1 × 30.3 cm, charcoal. Kupferstichkabinett, Berlin, Germany / Bridgeman Images.

Fig. 32: Anselm Feuerbach (1829–1880), *Henriette Feuerbach*, 1877, 86.5 × 69.8 cm, oil on canvas (Nationalgalerie, Berlin). bpk /Nationalgalerie, SMB / Andres Kilger. [*Editor note*: Henriette Feuerbach (1812–1892) was the author of *Gedanken über die Liebenswürdigkeit von Frauen* (Thoughts on the Amiability of Women), subtitled *Kleiner Beitrag zur weiblichen Charakteristik* (A Little Contribution to the Characteristics of Women) (Nürnberg: Campe Verlag, 1839).]

Fig. 33: *Dancing Group*, from the Los Moros Caves of El Cogul, Catalonia/Catalunya, Palaeolithic period, paint on rock, figures 25–30 cm tall. Mary Evans Picture Library. © Mary Evans / AISA Media.

Fig. 34: Erich Wolfsfeld (1884–1956), *Moroccan Mothers, c.*1934, untraced. Replaced by *Family with a Goat*, no date, oil on paper laid in card, 94 × 64.8 cm. Private Collection. Photo © Christie's Images / Bridgeman Images.

Fig. 35: *Hildegard of Bingen and Monk Gottfried* (after Steinberg), now titled *Hildegard of Bingen Receiving the Light from Heaven, c.*1151, vellum (later colouration), plate from Hildegard of Bingen (1098–1179), *Scivias* (*Know the Ways*) (1142–51), known as the *Rupertsberger Scivias-Kodex*. Landesbibliothek Wiesbaden. The original manuscript is a missing artwork since its evacuation to Dresden in 1945. The images are known through a painted facsimile made in the 1920s. Private Collection / Bridgeman Images.

Fig. 36: *Chinese Medicinal Doll*. Collection: Mr and Mrs How-Martyn. Replaced by *Chinese Ivory Diagnostic Doll*, length *c.*10 cm. Wellcome Collection, London. Creative Commons Attribution (CC BY 4.0).

Fig. 37: Martial d'Auvergne (1420–1508), *Les vigiles du roi Charles VII* (The Vigils of King Charles VII): miniature of Joan of Arc chasing prostitutes from her army's camp, *c.*1484, illumination on parchment, miniature. Bibliothèque Nationale de France, Paris.

Fig. 38: Diego Rodríguez de Silva y Velázquez (1599–1660), *Las Hilanderas* (The Carpet [Tapestry] Weavers, also known as *The Fable of Arachne*), 1655, oil on canvas, 220 × 289 cm. Prado Museum, Madrid. Luisa Ricciannini / Bridgeman Images.

Fig. 39: Pieter de Hooch (1629–1684), *Mother with a Child in a Pantry*, 1656–60, oil on canvas, 65 × 60.5 cm. Rijksmuseum, Amsterdam.

Fig. 40: Frans Hals (1582–1666), *The Women Regents* (also known as *The Regentesses*), c.1664, oil on canvas, 170.5 × 249.5 cm. Frans Hals Museum, Haarlem. Art Heritage / Alamy Stock Photo.

Fig. 41: Edward Francis Burney (1760–1848), *An Elegant Establishment for Young Ladies*, 1805, watercolour, 77.3 × 105.2 cm. © Victoria & Albert Museum Images.

Fig. 42: Jacob Cornelisz van Oostsanen (1472–1533), *Salome with the Head of John the Baptist*, 1524, oil on panel, 72 × 53.7 cm. Mauritshuis, The Hague / Bridgeman Images.

Fig. 43: Carl E. Weber (1806–1856), *Rahel Levin Varnhagen*, 1834, stipple engraving later coloured from a pastel portrait by Michael Moritz Daffinger (1790–1849), 1817. From *Rahel: Ein Buch des Andenkens für ihre Freunde* (Rachel: A Book of Memories for Her Friends) (Berlin: Trowitsch & Sohn, 1833), frontispiece. Scan: Petra Dollinger, public domain.

Fig. 44: Sophonisba Anguissola (c.1532–1625), *Self-Portrait with Book*, 1554, oil on panel, signed and dated, 19.5 × 14.5 × 0.8 cm, framed: 32.5 × 26.5 × 4 cm. Kunsthistorisches Museum, Vienna / Bridgeman Images.

Fig. 45: Anna Dorothea Therbusch-Lisiewska (1721–1782), *Self-Portrait*, 1777, oil on canvas, 151 × 115 cm. © Staatliche Museen zu Berlin, Gemäldegalerie / Jörg P. Anders.

Fig. 46: Francisco de Goya y Lucientes (1746–1828), *Quo valor* (What Courage!), plate 7 of *Los desastres de la guerra* (Disasters of War), 1810–20, depicting Augustina of Aragon firing a cannon in defence of Saragossa, 1808. Private Collection. Index Fototeca / Bridgeman Images.

Fig. 47: Jacques-Louis David (1748–1825), *Théroigne de Méricourt(?)*. Collection: Poniatowski. Unknown location, reproduced from *Woman in Art*.

Fig. 48: Marcellin Pellet (1849–1942), *Théroigne de Méricourt*, 1816, sketch done at the Salpêtrière Hospital on the request of Etienne Esquirol, also known as *Théroigne de Méricourt à la Salpêtrière en 1816* (Théroigne de Méricourt at the Salpêtrière in 1816). Engraving (plate) by Ambroise Tardieu published in Jean-Étienne Esquirol, *Des maladies mentales* (Mental Illnesses) (1838), then reproduced in Marcellin Pellet, *Étude historique et*

biographique sur Théroigne de Méricourt: avec deux portraits et un fac-similé d'autographe (Historical and Biographical Study on Théroigne de Méricourt: With Two Portraits and a Facsimile of an Autograph) (Paris: Maison Quantin, 1886), p. 126.

Fig. 49: Constantin Meunier (1831–1905), *Hiercheuse à la lanterne* (Woman Pitbrow Worker with a Lantern), c.1886, plaster, 72 × 30.2 × 25.3 cm. Royal Museums of Fine Arts of Belgium, Brussels. Photo: J. Geleyns / Ro scan.

Fig. 50: Auguste Rodin (1840–1917), *La Pensée* (Thought), c.1895, praticien: Victor Peter, marble head, rough-hewn base, 74.2 × 43.5 × 46.1 cm. © RMN-Grand Palais (Musée d'Orsay) / Jean Schormans.

Fig. 51: Ku K'ai-Chih (now known as Gu Kaizhi) (c.344–406), attributed, *Admonitions of the Instructress to the Court Ladies*, Tang Dynasty, Six Dynasties (between 400 and 700 CE), painting in nine scenes (originally 12), height 26 cm, length 343.75 cm, width 24.60 cm (in brocade wrapper). British Museum, London. Replaced by a different scene. © Trustees of British Museum, London. [*Editor note*: The scroll depicts a poetic text composed by writer, poet, and politician Zhang Hua (c.232–300).]

Fig. 52: Marie Laurencin (1883–1956), *Jeune femme à la rose* (Young Woman with a Rose), 1930, lithograph, 45 × 54 cm, sold at auction 23 February 2014. Replaced by *Femme en rose* (Woman in Pink), 1932, watercolour over pencil on paper, 34 × 24.8 cm. Photo © Christie's Images / Bridgeman Images / DACS.

Fig. 53: Elisabet Ney (1833–1907), *Bust of Arthur Schopenhauer*, 1859, marble. Elisabet Ney Museum, Austin. The History Collection / Alamy Images or Elisabet Ney Museum, Austin, Texas.

Fig. 54: Renée (Renata) Sintenis (1888–1965), *Self-Portrait*, 1933, mask in terracotta, 30.5 × 10.5 cm. Leicester German Expressionism Collection. Gift of Mr N. E. B. Elgar (on behalf of his late wife). National Art Collections Fund. © 2021 Renée Sintenis / DACS, London.

Fig. 55: Barbara Hepworth (1903–1975), *Conoid, Sphere and Hollow*, 1937, white marble, 30.5 × 40.6 cm. Bequest of Virginia C. Field, New York, Museum of Modern Art 22.2004. Photo: Original supplied to Helen Rosenau by Barbara Hepworth. London: Tate Archives © Bowness.

Fig. 1 Back, side and front views of the
Willendorf 'Venus', 33,000–25,000 BCE,
oolitic limestone, 11.1 cm tall. Natural History
Museum, Vienna. Photo: © Natural History
Museum, Vienna.

Introductory

THE POSITION OF WOMAN IN THE EARLIEST PHASES OF HUMAN evolution is unknown, and any theories on the subject are based on indirect evidence drawn from much later sources, or from field work among primitive tribes.[1] E. Grosse's suggestion, however, that a biological differentiation between the sexes became reinforced by cultural influences may well hint at the solution of the problem.

The earliest representations of women (*Fig.* 1) imply a form of society in which they were considered as basically important. Since the facts of biological paternity are not known by instinct, but only by experience, they must have been ignored at an early stage of civilisation, and the mother have possessed a considerable social prestige.

On the other hand, it is true to say that the physical strength of the male is marked in the 'society' of apes, and gives him power over a group of females; and there is no reason to suppose that this situation was entirely different from primitive man. But to imagine that such an 'order' had no exceptions and that it always worked in the same direction is all the more unlikely, since as Zuckerman has shown, a varying behaviour may be due to reasons of strength and domination and not to direct sexual causes.[2]

The term *gynaecocracy* has been coined in Greece for the rule of women, but it would be more correct to speak of a 'gynaecodynamic' character in primitive civilisations, in which the possession of the offspring may have contributed to the woman's influence, and the force of her magic *mana* found expression in veneration and taboos, as Jane Harrison and Gilbert Murray have so abundantly shown in regard to the Greek world. A similar state of affairs is shown by Tacitus in describing the ancient Germans, so that it would seem that influence rather than rule constituted originally the woman's sphere.[3] To this age-old influence the palaeolithic figures give a significant clue.

Although a matrilocal manner of living, in which the husband lives in the wife's clan, favours monogamy, the matrilineal system as such is frequently consistent with the right of the husband to take a plurality of wives. But, at the same time, these relationships are not necessarily exclusive, and admit, on the part of the wife, of open sexual relations with males other than the husband. Well-known

1 Bachofen and his followers, among them Briffault, stress the maternal aspect of primitive civilisation; an opposite view is held by the Darwinian-Freudian school, emphasising the patriarchal outlook. The two views are combined in a third theory of W. Koppers and Thurnwald, who show how certain changes in agriculture facilitated a matriarchal stage as a possible but not a necessary precursor of patriarchy. They believe that at an earlier stage a more equalitarian type of family, with little division of labour between the sexes, and based on monogamy and a primitive type of food-gathering, was usual. Cf. E. Grosse: *Die Formen der Familie*, Freiburg and Leipzig, 1896; J. J. Bachofen: *Das Mutterrecht*, Stuttgart, 1861; R. Briffault: *The Mothers*, London, 1927; S. Freud: *Totem and Taboo*, Harmondsworth, 1940 [1938]; P. W. Schmidt and W. Koppers: *Voelker und Kultur*, Regensburg, 1924; R. Thurnwald: *Die Menschliche Gesellschaft*, Berlin and Leipzig, 1931–5; J. G. Frazer: *The Golden Bough*, London, 3rd ed., 1935–6; Cf. also R. Benedict: *Patterns of Culture*, London, 1934. Varying and contradictory male and female characteristics of behaviour are here compared, without however considering the causation of such behaviour patterns. Cf. also G. Bateson: *Naven*, Cambridge, 1936.

2 The classificatory system is, as Thomson in accordance with Morgan's theory points out, best explained by the reality of 'group marriage'; and the matrilineal way of counting descent may be derived from the fact that in the society of apes the mother and children constitute the family. The monogamy prevailing with primitive peoples is explained by Zuckerman as due to the scarcity of food supply, or, as one might say, to conditions of environment; in this sense Bachofen's ideas of the importance of the mother-child family relationship are given a basis in the economic structure of the society of primates. To sum up, it may therefore be said that all these theories are not contradictory, but complementary: the women and children, the first nucleus of the family, were related to one or more headmen acting as fathers, possibly passing from one man to the other, and being as such an important unit to be transmitted. Differing individual propensities as well as economic necessities may stress the one or the other aspect, and especially in a sedentary type of civilisation the matrilineal tendencies may be reinforced by matrilocality of domicile, as Lowie has pointed out. Cf. S. Zuckerman: *The Social Life of Monkeys and Apes*, London, 1932, esp. p. 308 ff; R. H. Lowie: *Primitive Society*, London, 2nd ed., 1929; G. D. Thomson: *Aeschylus and Athens*, London, 1941.

3 J. E. Harrison: *Ancient Art and Ritual*, Home University Library, London and New York, 2nd ed., 1918; G. Murray: *Five Stages of Greek Religion*, Thinkers' Library, London, 1935; Tacitus: *Germania*, chaps. 18 and 19.

4 G. A. de C. de Moubray: *Matriarchy in the Malay Peninsula*, London, 1931; L. T. Hobhouse, G. C. Wheeler, M. Ginsberg: *The Material Culture and the Social Institutions of the Simpler Peoples*, London School of Economics III, 1914, p. 142 ff.

5 Santhal house-painting, Singhbhum district of Bihar, India. Cf. W. G. and M. Archer: *Santhal Painting*, *Axis* 7, Henley-on-Thames, 1936. These signs are *mantras* having originally a meditative meaning. Cf. also F. Boas: *Primitive Art*, Oslo, 1927.

examples of this – commonly called 'sacred prostitution' – can be found in the cults of the mother goddesses in Babylonia, Crete and ancient Greece, as well as in the Indian literary tradition. It is essential that these relations were not in any way personal ones, neither were they intended to favour the development of individual love.

The matriarchal tendencies were fostered by division of labour, the invention of primitive agricultural implements by women, and thus hoe-culture is generally considered to be the basis of this type of civilisation. Furthermore, it is clear from Spartan tradition that the marked influence of the women led to a warlike attitude on the part of the men, a fact which is corroborated by de Moubray when he speaks of the virile qualities of the Malay men living in a matriarchal society.[4] The tentative explanation which this author gives may well hold good generally: he thinks that the women, who possess the soil, thereby force the men to 'go out' and to develop a spirit of initiative and adventure. In this way the culture pattern of matriarchy may itself be instrumental in its own overthrow, since the men, growing more and more independent, master new techniques and ultimately acquire rights over the womenfolk. From this point of view the rise of the influence of the mother's brother and the ultimate power of the husband and father may be explained.

It is worth noting that the man, who in the earliest periods could not have known the facts of fatherhood, had to claim his children by some ritual acts. He therefore must have favoured the patriarchal marriage institution as a safeguard of his rights, and the means of obtaining not only a partner in life but also legitimate offspring for himself. In the course of the development of the marriage relationship, however, the situation became reversed, since it was found advantageous for the woman to be kept by the man and her children cared for. The woman, as well as her family, would therefore acquiesce in a restriction of rights which ensured to her the protection and care of a husband. Such a situation presupposes the knowledge of physical paternity as well as the existence of a division of labour which bound the woman to her biological functions, to the house or to the tent.

The influences on art in primitive civilisations are as varied as these civilisations themselves. Two facts appear, however, particularly striking in this connection. The one is that women, who are commonly assumed to have little or no power of abstraction, invent patterns of abstract art (*Fig.* 2) (as with the Esquimaux and the Santhals);[5] the other, that the earliest representations of human beings are of the female sex.

Palaeolithic art is the only historical source in existence for the earliest periods of human evolution, and strikingly enough it shows two prevailing subjects, the animal and the female figure in the nude. The rarer representations of the male, as found for example in Eastern Spain, are not sculptures in the round, but so-called *pictograph* paintings, showing mostly hunters, dancers and magicians, and emphasising not so much their sex as their occupation. The whole interest is in the active and mobile side of men's lives, whilst the interest in the less mobile woman centres around sex and fertility.

The palaeolithic female figures of the 'Venus' type are most frequently sculptures in the round. They concentrate on the sexual and reproductive aspects and are presumably the work of men. No indication of the faces is given, but the hair is carefully curled, and the breasts, the belly and the buttocks are shown. The best known and, at the same time, the most revealing example is perhaps the 'Venus' of Willendorf (c.25,000 BCE). The characteristics of this type have been interpreted either from a sexual point of view – as the name 'Venus' indicates – or they have been understood as naturalistic representations of pregnancy or illness. The solution of the problem may well be that the figure is meant to be ambivalent, sexual and maternal at the same time. The same is true also in another respect: one cannot say whether the figures represent human beings or goddesses, since in most cases no attributes are given. Indeed, the lack of clear distinctions is characteristic of the whole group. A magic meaning may well be correlated to these works, which express a subconscious notion of the potential powers of woman.[6]

6 It is worth noting that from these figures no direct evolution can be traced to ancient Egyptian or Sumerian Art. Owing to geological reasons which produced climatic changes, the centre of civilisation shifted from the West to the East in Neolithic times, and an artistic evolution set in, starting from primitive pottery and culminating in works of art of the highest aesthetic significance. Cf. F. Boas: *Op. cit.*, p. 181; also H. Kuehn: *Kunst und Kultur der Vorzeit Europas*, Berlin, 1929; H. G. Spearing: *The Childhood of Art*, London, 1930; H. Obermaier: *Urgeschichte der Menschheit, in Geschichte der führenden Völker I*, Freiburg, 1931.

Fig. 2 *Santhal* mantra, contemporary (Bihar). The original photograph is taken from *Axis: A Quarterly Review of Abstract Painting and Sculpture* 7 (1936), p. 27.

1 | Wives and Lovers

7 E. A. Westermarck: *The History of Human Marriage*, I, 5th ed. London, 1921, p. 72; [Pastor D. Jansen is cited by] Th. H. Van de Velde: *Die Fruchtbarkeit in der Ehe*, Horw-Luzern, Leipzig and Stuttgart, 1929, p. 103.

8 It is not without significance that the civilisation which first developed the portrait of the married couple should be one favouring the habit of brother–sister marriage. It is equally characteristic that the legal provisions of marriage were fixed by documents establishing the wives' and children's rights, especially the rights of the chief wife (*nebt pa*). This may be partly explained by the fact that the chief wife, who at the same time was frequently the sister, could not be deprived of her family status; descent and inheritance being reckoned according to the matrilineal system, the children belonged to the mother's group, and so it was to the interest of the father to emphasise the stability of the marriage relation. In the case of the slave girls and their children, the situation remained different, since there the master could dispose at will. Cf. H. Ranke: *The Art of Ancient Egypt*, Vienna and London, 1936, fig. 74; M. Murray: *Journal of the Anthropological Institute* 45, 1915, p. 307 ff; J. Nietzold: *Die Ehe in Aegypten*, Leipzig, 1903, passim. Mar. Weber's valuable work *Ehefrau und Mutter in der Rechtsentwicklung*, Tuebingen, 1907, has not been superseded, although some of the author's conclusions with regard to matriarchy require revision.

9 Cf. A. Moret: *Kings and Gods of Egypt*, New York and London, 1912, esp. p. 16 ff. The story of the god visiting the queen has been deprived of its magical and ritual meaning in Molière's *Amphytrion*, and is even alive today in Jean Giraudoux' modern version *Amphytrion*, 38.

MARRIAGE IS ONE OF THE BASIC INSTITUTIONS OF MANKIND, and seems to exist in one form or another at all times and places. Its function is determined from an anthropological point of view by Westermarck when he says: 'Marriage is rooted in the family rather than the family in marriage.' The individualistic view of its basis in love is expressed equally well by D. Jansen: 'Children are the blessing but not the true purpose of marriage.'[7] Between these two extreme opinions a place can be found for the views held on marriage in the most divergent civilisations. Since visual art gives form to emotional attitudes and valuations, the human relationships of marriage and love are reflected by it and can be studied with its help.

The earliest representation of the married couple is found in Egypt, and goes back to the third millennium BCE; the husband usually sits erect with his wife at his side and is generally shown with one arm around her shoulders. There is only one wife, the chief wife, to be seen, and she is of slightly smaller size than her partner.[8] This difference is even more marked when the figures are seen in profile, the male represented on a larger scale, whilst the smaller woman is seated behind him. Another type shows the man seated and the woman standing at his side. In each case the dominant or more leisurely position is allotted to the male. It is characteristic of masculine preponderance that even if the husband is a dwarf, like Seneb, *c.*2500 BCE, he is seated on a higher stool in order to appear taller than his wife (*Fig.* 3).

Love scenes in a naturalistic style are usually not described in the Egyptian reliefs where the hierarchic character is strongly marked. In the case of the union of the god Amon and the queen Ahmasi, god and queen are seated in profile, joining hands and with legs crossed, the ritual character being stressed by the identity of their position and their rigid posture.[9] It is only the revolutionary Amenophis IV who favours family scenes rendered in an intimate manner.

In ancient Sumeria, Babylonia and Assyria, under rigid patriarchal civilisations in communities ruled by warriors, the act of sexual

union was omitted from art. The dominant female figure, Ishtar, frequently appeared in the nude, holding forward her breasts and symbolising sex and fertility. The *hierodoulai*, slave girls dedicated to the gods, expressed religious ritual through sexual acts.[10] The group of the married couple, occurring on rare occasions, shows the husband reclining and the smaller wife sitting in attendance, as in Ashurbanipal's relief in the British Museum. This type cannot be compared either in frequency or in intimacy with the Egyptian scenes. The contrast between the nude figure of Ishtar and the ceremonially robed group of husband and wife in Babylonia is derived from the fact that sacred prostitution was permissible, whilst elaborate laws ruled over marriage and divorce. Thus a circumscribed although inferior position was allotted to women, both sexes being placed under the law.[11]

The Old Testament, although negative in attitude towards pictorial representations, reflects in many ways the Babylonian background. It differs from it, however, in its particular emphasis on individual love, well exemplified in Elkanah's words to his barren

10 Cf. G. Contenau: *La Déesse Nue*, Paris, 1914; S. Kramrisch: *Indian Sculpture*, Calcutta, 1933, esp. pp. 97 & 190; L. J. Delaporte: *Mesopotamia*, London, 1925, and Briffault, passim, where many bibliographical references are given.

11 It is in India that the fusion of the male and female principle has found a symbolic representation in art in the Maithuna groups. But this is not synonymous with a positive attitude towards individual love or equality of women in the social sphere. Cf. Rūpam [Gongoly], 1925, and T. A. Gopinatha Rao: *Elements of Hindu Iconography*, Madras, 1914.

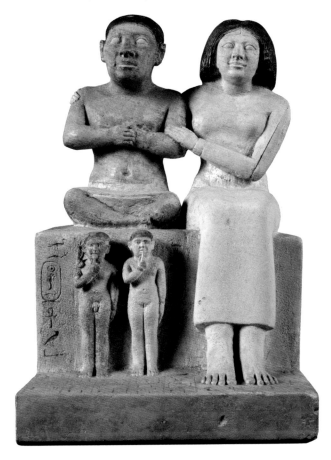

Fig. 3 *Seneb and His Wife and Children*, found at the Giza Acropolis, Old Kingdom, Late Dynasty 5 to Early Dynasty 6 (twenty-fourth to twenty-third century BCE), limestone, 34 × 22.5 cm. Egyptian National Museum, Cairo. © Sandro Vannini / Bridgeman Images.

12 The Talmudic texts imply monogamy as well by prescribing that a High Priest should marry a second subsidiary wife for the Day of Atonement in order to be able to pronounce a blessing over 'his house' even in the case of the death of his first wife. This custom shows that a priest normally possessed one wife only (*Yoma I*, 13 a/b). It is also stated that a priest should marry a virgin. Since this word appears in the singular the notion of monogamy is again implied, *Leviticus* 21: 13. All Biblical quotations are from the Authorised Version.

13 A. Conze: *Die Attischen Grabreliefs*, Berlin, 1890 ff [1893–1922]; A. Hekler: *Greek and Roman Portraits*, London, 1912.

14 Even Plato's *Republic* reflects a higher valuation of men, in so far as no particular aptitude is attributed to women, who on the whole are considered similar to though weaker than men. It may be added that in Plato's *Timaeus*, where the doctrine of reincarnation is adopted, mankind is interpreted as first created from a star, and according to merit, man returns to the star after death or is reborn either as a woman or as an animal. For Aristotle, there is a difference of virtue for men and women as there is between the child and the slave; in his *Politics* he enlarges on the function of the family, the ruling factor of which is the father, so that for Plato as well as for Aristotle the place of the woman is a secondary one. An extreme opinion on women is found in the *Eumenides* by Aeschylus, since the male seed is considered all important, the woman not contributing towards the child but only housing it in her womb. Cf. A. E. Zimmern: *The Greek Commonwealth*, Oxford, 1922, passim; F. A. Wright; *Feminism in Greek Literature*, London, 1923; H. Licht: *Sexual Life in Ancient Greece*, London, 1931, gives subjective valuations, but useful bibliographical references. Also G. D. Thomson: *Op. cit.*, p. 387 ff; J. E. Harrison: *Prolegomena to the Study of Greek Religion*, 3rd ed., Cambridge, 1922, p. 300 ff.

15 In the classic art of Greece goddesses like Aphrodite – powerful fertility symbols of an earlier age expressed in the form of the *Bearded Aphrodite* – became personified representations of the beauty of women, devoid

wife: 'Hannah, why weepest thou? … Am not I better to thee than ten sons?' (1 *Samuel* 1: 8). From the Old Testament it is easy to understand that the idea of monogamy also had a germ in Israel. Zion and Israel were regarded as the Bride of God (*Isaiah* 61: 10; *Jer.* 2: 32), ideas which (based on *Eph.* 5: 23–32 and *Rev.* 21: 2 and 22: 17) were later taken up when the Church was considered the Bride of Christ. In *Proverbs* also the description of the Jewish wife is taken from a monogamous household.[12]

A new world opens itself in Greece, both with regard to form and to iconography. Among funerary family monuments, the warrior with his horse, the housewife with her maid holding the jewel-box, and other scenes including two, three or more figures are found.[13]

Generally it is the seated figure that is mourned by relatives. Mostly the wife is thus seen, linking hands with her husband who stands before her, ruefully looking up at him. But the same scene can also be used in the opposite way. This arrangement was however less frequent, since the scene centring around the seated woman in her chamber so clearly expressed the secluded home atmosphere in which the wives and mothers spent their lives (*Fig.* 4).

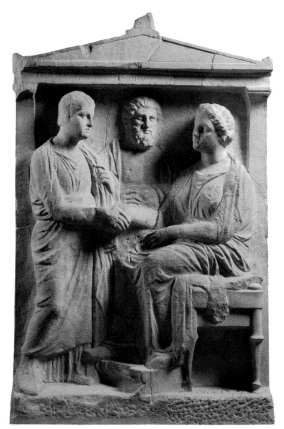

Fig. 4 *The Family of Epichares* (grave relief), marble stela with pediment: a seated woman clasps the hand of her daughter Aristeis while Epichares looks on, *c.*375–350 BCE, 111.76 × 73.66 cm. 1910.0712.1AN244301001 © The Trustees of the British Museum.

In classical Greek art the women were typified in a specific way, such as the goddess, the nymph, the amazon, the *hetaira*, the married woman. The famous saying attributed to Demosthenes: 'We have *hetairai* to give us pleasure, concubines for daily bodily comfort, wives to bear us legitimate children and to care for the house' well expresses the differentiation into types as seen from the point of view of the wealthy citizen.[14]

Monogamy for the Greek was a mark of distinction between himself and the barbarian, although this monogamy was qualified. The marked differentiation between the freedom of the female strangers, the *hetairai*, and the seclusion of the Athenian-born woman was expressed in social and artistic life.[15]

Contrasting with the Greek attitude further to the West, Etruscan sarcophagi frequently show the married couple; the reclining man is seen in an easier position than his smaller wife, and although the type does not appear identical with its Egyptian counterparts, the social attitude implied is similar. The Republican Roman sepulchral reliefs develop a more equalitarian tendency. The naturalistic busts of husband and wife, sometimes linking hands, are of equal height. Frequently their children are joined to them, and in all cases the degree of individualisation is a remarkable feature. For the patricians it was usual to place the wife by the marriage ritual of *confarreatio* entirely under the power, in the *manus* of the husband. However, in late Republican times, the less rigid forms of marriage between plebeians, which safeguarded the wife's independence, were introduced into the higher classes of society, and so patriarchy was gradually abolished.[16]

The great importance of the ideals of *ordo* and *dignitas* permeated not only the Roman family, but also the Roman Empire and its hierarchy. The careful fixing of the husband's prerogative by law is characteristic of Roman society; at the same time the enforcement of monogamy and the right of divorce for both sexes may be regarded as a compensation for the loss of freedom of the woman, obtained through the influence of her family group. Thus the idea of social equality – a tendency especially strong in Stoic circles during late Republican and early Imperial times – found its counterpart in the practice of family life.

When the ancient discipline of marriage was relaxed in Rome, men as well as women accordingly indulged in frequent marriages and divorces. It was consistent with the freedom generally allowed to women that brothels and prostitution were frowned upon. The term 'immoral' frequently applied to this period by modern writers

of the ancient *mana* formerly attributed to them. A rationalisation of the world took place in the socially leading circles, depriving women of their mysterious powers and ancient rites. But this society found as yet no place for women outside their homes, and it is against this popular attitude that Euripides holds out his challenge. In Athena, the City goddess of Athens, the sexless character is emphasised and a value attached to virginity, revealed artistically in the close drapery and the armour of her figure. Beauty was valued for its own sake in the classic age, and under the influence of this valuation the woman's individual characteristics were not considered a fit subject for the visual arts. The separation of the male from the female sphere also precluded emphasis on the intimate relationship of marriage. Therefore the artistic representation of married life is mainly reduced to farewell scenes in Greek art, the classic example being the well-known relief of Orpheus and Eurydice, the two partners mournfully trying to bridge their separation.

16 Briffault draws attention to the matriarchal influences underlying Roman society, and retained by the plebeians. Rostovtsev describes the economic independence and the civic pride of the Roman citizen, whilst Max Weber has pointed out that in a society of patrician citizens monogamy was an adequate form of marriage. Cf. the excellent article on *Marriage* in the *Dictionnaire de théologie catholique*; M. I. Rostovtsev: *The Social and Economic History of the Roman Empire*, Oxford, 1926; and Briffault passim. Also Panofsky in the *Burlington Magazine* 64, 1934, p. 117 ff; Rodenwaldt in *Abhandlungen der Prüssischen Akademie der Wissenschaften*, 1935, Phil. Hist. Kl. Nr. 3, p. 13 ff; H. Rosenau: *Apollo*, Nov., 1942, p. 125 ff; M. Weber: *Wirtschaft und Gesellschaft*, Tuebingen, 1921, p. 207; also Mar. Weber, *Op. cit.* Fuller references are given in: P. G. Elgood: *The Ptolemies of Egypt*, Bristol, 1938 and H. Rosenau: *Journal of the Warburg and Courtauld Institutes* 3, 1939–40, p. 155. A contemporary *dextrarum junctio* is to be seen in the decoration of Kensington Palace, a sign of the importance attached to the scene during the classical revival [John Michael Rysbrack (1693–1770), *Roman Marriage*, completed *c*.1772–3 (Royal Collection Trust, Kensington Palace)]. Cf. A. H. Smith: *A Catalogue of Sculpture*, *III*, London, 1904, p. 318.

Fig. 5 *Dextrarum Junctio*, second century CE, Parian marble, Proconnesian relief from the front of a sarcophagus: a Roman marriage ceremony, 98.4 × 75 × 11 cm. 1805,0703.143AN241199003 © The Trustees of the British Museum.

[*Editor note*: Rosenau identifies the additional figures (apart from bride and groom) in the British Museum sculpture as: woman, *pronuba* (for the bride), and man, *paranymphus* (ceremonial assistant or coach at a ceremony), or best man. Of the maiden supporting the bride, only one hand remains (on the right edge, touching the bride's arm). This indicates a lost figure that balanced the best man, or coach, on the the left side of the sculpture.]

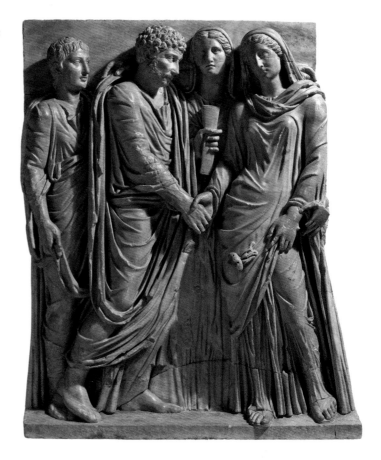

omits to point out this equalitarian aspect. This social evolution towards marriage between equals is paralleled in the creation of a new artistic type: busts or full-length representations of husband and wife joining hands and being united by a female deity (*Fig.* 5). This ceremonial linking of right hands as a token of marriage, the *dextrarum junctio*, expresses the meaning of the solemn sanctification of the wedding. Since husband and wife are treated as ceremonial equals, the Roman principle of *condominium* finds its expression, not only in the state, but also in the family sphere. It is not by chance that when the Italian Renaissance emphasised the equalitarian character of contemporary sex relationships it revived the type of the *dextrarum junctio* for the sacramental wedding scene of Mary and Joseph in the *Sposalizio* [Raphael, 1504, Pinacotera di Brera, Milan].

Interest in the feminine personality as distinct from an ideal of youthful freshness is also made clear by studying the age of the leading women of the period: Cleopatra was *c.*twenty-eight when she first met Antony, and the Jewish princess Berenice had attained

her thirty-eighth year before meeting the Emperor Titus. A high regard for the individuality of the wife in Roman society is revealed by G. Misch in his interesting book on the development of autobiography.[17] The author explains the importance of the *laudatio* delivered by a Roman Republican officer in honour of his deceased wife (end of 1st century BCE), and shows how this type of posthumous honour was later revived in the Renaissance in the form of a letter by Giovanni Bembo.

During the Middle Ages great changes occurred in the valuation and the position of women in the West. It is only in the Byzantine Empire that the relationship with the classical world is closely maintained. The status of the Byzantine Empress can thus be derived from that of the Roman Empress. In art it is not only a direct iconographic derivation but also a similarity of subject-matter which denotes this relationship. The well-known mosaics in Ravenna of the Empress Theodora with her female attendants form a symmetrical counterpart to the Emperor Justinian and his male followers. On Byzantine ivories the hieratic representations of Christ, blessing or crowning the Emperor or Empress, are numerous. This indicates not only the high regard in which the Emperor's consort was held, but also illustrates her constitutional responsibilities. This position of the Empress is reflected in the German Empire, especially under the influence of a Byzantine princess, the Empress Theophano, married to the Emperor Otto II in 972 CE. But it should be noted that such representations of official and ceremonial character throw no light on the situation of the members of more humble strata of society. In fact it is at a later stage of evolution only that socially inferior classes were regarded as artistic subject matter.

Romanesque art was hieratical, instructional, and it turned away from the facts of secular life. During the 12th century, however, the sphere of the feudal courts strongly influenced the visual arts. It found perhaps its clearest expression towards love and marriage during the middle of the 13th century in the famous sculptures in Naumburg Cathedral (*Fig.* 6). They include male and female members of the Wettin family in perfect equality, and among them are two married couples, Ekkehard & Uta, and Hermann & Regelindis. This 'gallery of ancestors' in sculpture cannot be considered as portraits, since the chief donors lived as far back as the 10th century. It is all the more interesting to see how the directing sculptor was not satisfied by reproducing types, but formed individualised visions of the lady and the knight of his time. He was particularly interested in contrast of temperament: thus

17 G. Misch: *Geschichte der Autobiographie*, Leipzig and Berlin, 1931, esp. p. 131 ff. By contrast, it is characteristic of the Hellenistic 'comedy of manners', such as Menander's and the Roman plays influenced by him, that the main figures belong to the sphere of prostitution. This fact finds its equivalent in contemporary naturalistic figurines, which are less characteristic of the sphere of art than of craftsmanship. Official Roman art is, however, free from such forms of realism and expresses the religious and ethical valuations held by Roman society. Since these valuations were of an abstract quality, it is significant that Roman art, other than portraits, possesses the same austere and representational characteristics. The Stoic pronouncement, attributed to Metellus Numidius: If 'we can neither live with nor live without them (women) we had better seek one permanent union' well expresses this attitude of regulated monogamy. Cf. P. Elgood: *Op. cit.*, p. 203.

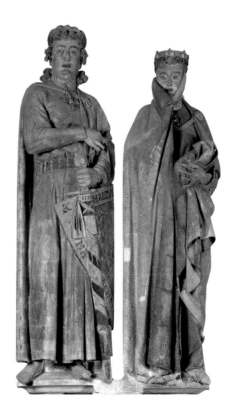

Fig. 6 *Ekkehard and Uta*, 1245–50, painted stone, two life-sized sculptures by the Naumburger Meister showing Uta von Ballenstedt (c.1000–1046), known worldwide as Uta von Naumburg, and Ekkehard II (c.985–1046), Margrave of Meissen (Naumburg Cathedral) / Bridgeman Images: Andrea Jemolo.

18 Cf. W. Pinder: *Der Naumburger Dom*, Berlin, 1925.

19 Cf. H. Rosenau: *Der Kölner Dom*, Cologne, 1931, p. 224 ff.

20 Cf. note 16 above, esp. *Apollo*, 1942.

21 Signs of the fusion of love & marriage are, e.g., found in Wolfram von Eschenbach's *Parsival* where married love is extolled. The story of Eliduc, characteristically written by a woman poet, Marie de France, at about the same period, emphasises even more strongly the ideal of married love. 'Loyaument se main-tiendrait' [Loyalty would continue], Eliduc has sworn to his wife, and he is therefore unhappy when a young princess falls in love with him. But later he returns the maiden's love and takes her with him to his own country. When his wife discovers the truth she refuses to share her husband, and states 'qu'il ait celle qu'il aime tant, car n'est pas bien ni avenant qu'à la fois on ait deux épouses' [Let him have the one he loves so much, for it is not good or pleasant to have two wives at the same time]. She therefore retires into a convent and is followed later on by Eliduc's second wife, whilst Eliduc on his part enters a monastery. So renunciation and retirement triumph over love and its complications, and by these means the ideal of monogamy is maintained. Cf. L. Petit de Julleville: *Histoire …* , Paris 1896–1900; Cf. M. Borodine: *La Femme et l'Amour*, Paris, 1909, esp. p. 22 ff; A. Wulff: *Frauenfeindlichen Dichtungen*, Halle, 1914; E. Wechssler: *Das Kulturproblem des Minnesangs*, Halle, 1909; C. S. Lewis: *The Allegory of Love*, Oxford, 1936; G. Paris: *La Légende du Mari aux Deux Femmes*, in *La Poésie du Moyen Age, II*, Paris, [1895] 1906, p. 109 ff; *Speculum* 12, 1937, p. 3 ff; N. Elias: *Über den Prozess der Zivilisation*, Basle, 1939. The idea of two lovers in complete harmony may well be considered an archetype. Its universality invites comparison with J. K. Folsom's study of 'subcultural' patterns. Cf. *The Family*, New York and London, 1934, p. 91 ff, and note 74 below.

Gerburg is represented as a refined lady, whereas Gepa is seen in an attitude of mournful loneliness, enhanced by her widow's garb. The expression of sorrow gives a touch of distinction to her face, a face characterised by broad Slavonic cheekbones. In the group of Ekkehard & Uta the sturdy husband is opposed to his delicate wife. Uta's slender hands hold her cloak, in which she seems to hide from him and from the crudities and contradictions of her age. On the opposite side, Regelindis is depicted as a robust and humorous housewife, whereas her partner Hermann looks melancholy and sad. Significantly within each couple, husband and wife are placed at divergent angles, and by this means the lack of community between them, already expressed in their contrast of temperament, is emphasised.[18]

By contrast, the early 14th century ideal of beauty consciously discards any notions of age, individualisation or sex differentiation. For example, in the Cathedral of Cologne the sculptures of the Virgin Mary, Christ and the Twelve Apostles are given in the same linear and ornamental manner, and a similar attitude prevails in contemporary scenes of courtly love.[19] It can be truly said that St. Paul's statement 'there is neither male nor female' (*Gal.* 3: 28) has found full expression in the art of this period.

On Medieval sepulchral monuments, from the 13th century onwards, husband and wife are generally seen in isolation, mostly in the gesture of prayer. The Roman linking of hands is discarded as a motive, except in one country and places influenced from there. In England on brass slabs and monuments the *dextrarum junctio* appears frequently from the 14th century onwards, uniting the two partners in marriage into a formal and iconographic unit. This exceptional type reflects English social conditions, the welding together of bourgeois and feudal valuations. The linking of hands was not, as Prior and Gardner take it to be, a 'romantic suggestion'. The contract for the 'counterfeits' of Richard II and Anne of Bohemia specifies that they are to hold each other's right hand. But this is anything but a romantic arrangement. The 'hand-fasting', the solemn clasping of right hands, means betrothal or marriage, *beweddung*, and this legal concept is expressed in the English monuments.[20]

It has to be remembered that the fusion of the concepts of love and marriage was a slow process taking place during the Middle Ages and coming to fruition during the Renaissance and later periods. This happened especially under the influence of Puritan valuations, and through the importance attached to family life.[21]

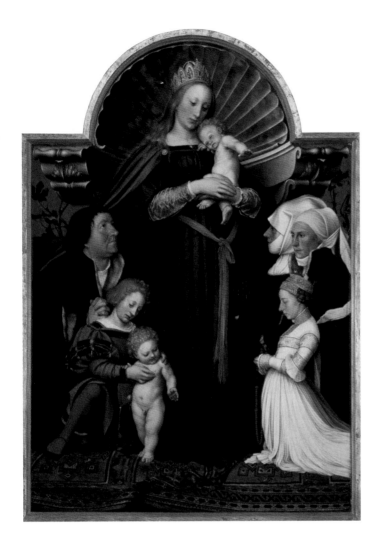

Fig. 7 Hans Holbein the Younger (1497/8–1543), *Madonna of the Burgomaster Meyer*, c.1526, oil on wood, 146.5 × 102 cm. Schlossmuseum, Darmstadt / Bridgeman Images.

During the Middle Ages courtly love found its object outside the family circle, and childbearing leading to early death meant the possibility of 'consecutive polygamy' for the husband. Holbein's famous Meyer Madonna (*Fig.* 7) in Darmstadt combines Renaissance and medieval features. The Madonna – an earthly mother – infolds in her mantle of protection the mayor, his two wives and his children, a representation of the family, frequently found all over Europe. This type shows the wives and many children – some of them still-born – taking their place with the husband and father in the position of donors kneeling before the representations of saints or other religious scenes.

But that women have not always been willing to share their husbands or lovers is expressed in art by the numerous classical representations of the jealous Medea, contemplating the murder

22 Cf. A. Warburg: *Gesammelte Schriften*, Leipzig, 1932, p. 179 ff. A few more references to the prevalence of jealousy in polygamous households may be added. Westermarck (*Op. cit.*, *III*, p. 92) states that in the Thonga language there is a special term for co-wives' jealousy; and in S. Leith-Ross's book on *African Woman*, London 1939, it is explained that little peace exists in the polygamist's house. A Chinese poem of 769 BCE expresses the misery of jealousy:

'It is for her he shames me.
I sit and think apart.
I wonder if the Sages knew
A woman's heart.'

(Helen Waddell: *Lyrics from the Chinese*, London, 1913, p. 12)

Fig. 8 Master of the Rolls, *Fight for the Trousers*, fifteenth century, engraving (after Warburg). Photo: Interphoto Fine Arts / Alamy Stock Photo.

of her children, and in the later Middle Ages by the *Fight for the Trousers*, a popular engraving of the 15th century (*Fig.* 8), showing women fighting for the possession of the trousers, symbolising the male.[22]

The lack of strictness in the medieval marriage relationship as compared with the Christian ideal is easily understood when considering the ancient Germanic custom of polygamy as practised by their chieftains. Furthermore, intimate contact with the Islamic world was established by the Crusades, and therefore the legal possession of a plurality of wives became a well-known fact.[23] It should be noted that the love poetry as well as the stories of Islam describe the affection of one man for one woman, regardless of the legal status of wives. The same attitude is seen in Persian miniatures and paintings, which illustrate the romance of two lovers only. It is true that, on the Java reliefs of Boro Budur, Buddha appears in the midst of his women. But he remains lonely and isolated in spite of his surroundings. The representations of *Suttee* (*Figs* 9 and 9a) [Rosenau uses here the transcription from the title of Thompson's

book] (the voluntary sacrifice of the wives' lives) in Vijayanagar describe polygamy and 'virtuous attitudes' of Indian wives, but not love, whilst in the representations of the god Siva with his two wives the symbolic side of this subject should not be overlooked.[24] It is in modern times that the community of veiled women attracted attention. E. Wolfsfeld, in his *Moroccan Mothers*, hints at the life and suffering behind the veil (see *Fig.* 34).

A popular subject derived from medieval tradition but gaining in importance during the Renaissance is the group of a mistress with her attendant lover. The woman forms the main centre of attention. The meaning of the whole situation is clearly expressed by the fact that she is seen in the nude, whereas the man appears elaborately dressed, frequently playing a musical instrument and thus acting as a noble *dilettante*. The different standard of morals and behaviour for men and women noted above finds here a new and striking illustration (*Fig.* 10).

It is during the 17th century that the antagonism between Catholic and Protestant conceptions of what should be regarded as art deepens, and leads to a 'Protestant' as distinct from a 'Catholic' sphere in this field. Rubens, the Catholic court painter and diplomat of the Baroque age, describes the raptures of the flesh in allegorical representations of women in the nude. It is true that the models are represented according to a personal ideal of beauty which remained almost unchanged during Rubens' artistic

Fig. 9 *Satī* (Hampi), illustration from Edward Thompson (1886–1946), *Suttee: A Historical and Philosophical Inquiry into the Hindu Rite of Widow Burning* (London: George Allen & Unwin, 1928), pp. 32–3.

Fig. 9a *Satī Memorial Stone* (Madhya Pradesh, Panna National Park). © John Warburton-Lee Photography / Alamy Stock Photo.

[*Editor note*: Satī stones are memorial stelae dating from c.900 CE either showing an upraised hand or a couple in life. Hampi is a UNESCO World Heritage Site in Karnataka, India. On the Tungabhabra River, Hampi was once capital of the Vijayanagara Empire.]

23 But the story of Eliduc is worldwide and exists even in countries allowing polygamy. Thus in the Nō Drama of Japan, Seami tells of Hotoke No Hara, who herself retires after having driven her predecessor into conventual life. On the concept of monogamy in Germany, cf. H. Naumann: *Deutsche Kultur im Zeitalter des Rittertums*, Potsdam, 1938, p. 149 ff. This opinion is contrary to the one held by G. Paris in the work cited above (note 21). Equally important is D. de Rougemont: *Passion and Society*, London, 1940. For Japan, A. Waley: *The Nō Plays of Japan*, London, 1921, p. 291.

24 Cf. E. Thompson: *Suttee*, London, 1928; T. A. Gopinatha Rao: *Op. cit*.

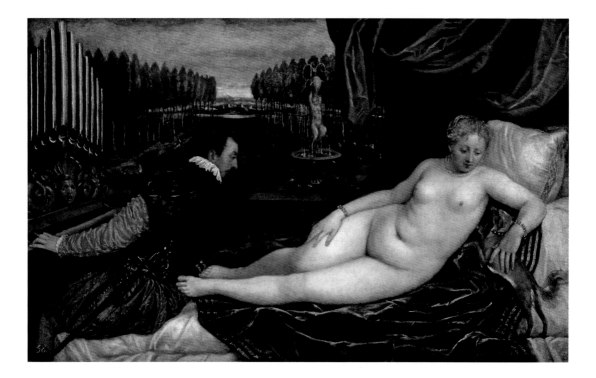

Fig. 10 Titian (Tiziano Vecellio, 1490–1576), *Venus with an Organist and Dog*, c.1540–45, oil on canvas, 138 × 222.4 cm. Prado Museum, Madrid, Spain / Bridgeman Images.

[*Editor note*: Interpretations of this painting vary from erotic to an allegory of the senses, and also to the matrimonial, since this recognizable female figure is without Cupid and wears a wedding ring.]

25 Cf. W. Weisbach: *Der Barock als Kunst der Gegenreformation* [corrected], Berlin, 1921; W. Haller: *The Rise of Puritanism*, New York, 1938, p. 121 ff, a book which not only gives an up-to-date presentation of the problems involved, but also excellent bibliographical references for further study. Cf. also the penetrating analysis of English society in L. L. Schuecking: *Die Familie im Englischen Puritanismus*, Leipzig and Berlin, 1929. On Rembrandt, J. Zwarts: *The Significance of Rembrandt's* The Jewish Bride, Utrecht, 1929; L. Goldscheider: *Five Hundred Self-Portraits*, Vienna and London, 1937.

development. It is not yet clear in his youthful joyous portrait of himself and his first wife, Isabella Brandt, holding hands – a survival of the *dextrarum junctio* – but is seen in his later works and is most clearly expressed in the representations of his second wife, Helena Fourment (*Fig.* 11). She was thirty-seven years his junior and only sixteen years old when she married him. Characteristic of Rubens' art is the sexual aspect of his feminine figures, the brightness of his flesh tints, the curved outlines of the bodies and the youthful grace of the figures. In Boucher this treatment of the nude finds its culmination in Rococo style.

Rembrandt's so-called *Jewish Bride* (*Fig.* 12) – in reality the portrait of Don Miguel de Barrios and his wife – shows husband and wife as equals, thus resuscitating unconsciously the classical representation of the joining of hands in a new and highly personal form.[25] The husband touches the wife's breast and she lays her hand on his. Both are seen in a tender and at the same time protective gesture. The value laid on the inner life expressed in the faces and hands reveals intensity of feeling and a new emphasis on individualisation. The two people united here are no longer hieratical types. They are understood in the intimacy of their lives, differentiated as man and woman, and, although the wife is smaller in size than the husband, of equal importance in the balance of the picture and in

their mutual relationship. A long development of the iconography of the married couple finds expression in this work. It is as characteristic of the ideals of the Western world – personal fulfilment within life – as the symbols of renunciation are under Indian influence of the East.

With the bourgeois influence, a critical attitude towards marriage finds its voice in art, such as in the well-known series by Hogarth, *Marriage à la Mode*. Frankly didactic in its purpose, the artist tries to express a moral attitude in the description of a transitory moment, but only succeeds in illuminating in a direct way the particular social wrongs with which he is dealing. With Goya, on the other hand, the simplification of a particular scene stands for the timeless symbol of the event; this fact is clear in his impressive study of the unwilling pair tied together in marriage and overshadowed by the bespectacled owl, in the *Los Caprichos* (*Fig.* 13). It

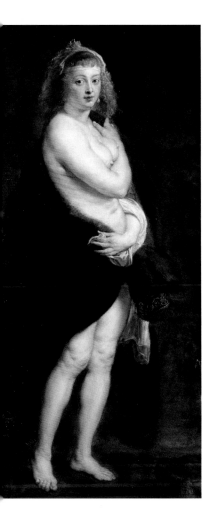

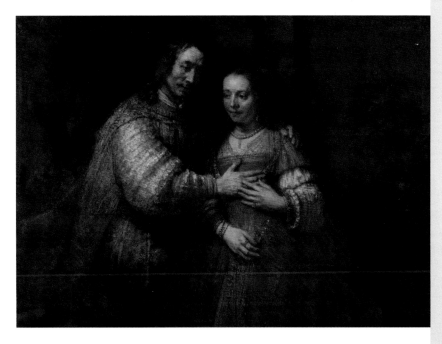

Fig. 11 Peter Paul Rubens (1577–1640), *Helena Fourment ('The Little Fur Coat')*, *c.*1636/38, oil on wood, 176 × 83 cm © Kunsthistorisches Museum, Vienna / Bridgeman Images.

Fig. 12 Rembrandt van Rijn (1606–1669), *The Jewish Bride* (*Portrait of a Couple as Isaac and Rebecca*), 1665–9, oil on canvas, 121.5 × 166.5 cm. Rijksmuseum, Amsterdam.

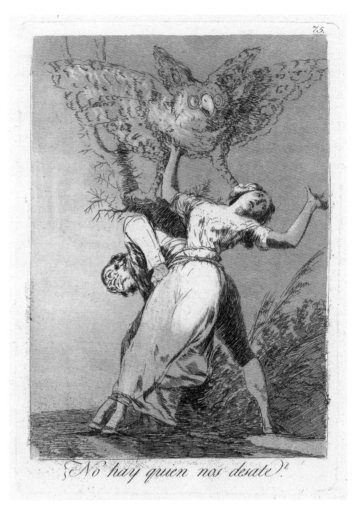

¿No hay quien nos desate?

shows the Roman Catholic Church as a symbol of reaction, a strong and moving plea for permission to divorce. The caption '*No hay quien nos desate*?' [Can't Anyone Untie Us?] enhances and explains the meaning of the scene.[26]

The Romantic age and its ideas on the individual soul, companionship and erotic fulfilment within life for both sexes, led to a deeper understanding of women.[27] Friedrich Schlegel's *Lucinde* expresses in literature a doctrine which was not only preached but also lived by his age. Men should develop their feminine traits and women their masculine ones; thus androgyny was the ideal. As usual with equalitarian periods in regard to the sexes, it is no longer the young woman only who is considered attractive. This tendency goes so far with the Romantics that they frequently marry women older than themselves. For instance, Elizabeth Barrett Browning, born 1806, married Robert Browning in 1846, when his age was 34.

26 J. Hofmann: *F. de Goya*, Vienna, 1907, p. 33.

27 The common interest and happiness of the marriage partners finds expression in numerous works belonging to the 19th century. Cf. H. von Tschudi: *Ausstellung Deutscher Kunst, 1775–1875*, Berlin and Munich, 1906.

She had her child at forty-three years of age. Rahel Levin, 1771–1833, married Varnhagen von Ense in her forty-third year. Varnhagen was fourteen years her junior (see *Fig.* 43).[28]

In France the development followed different lines: erotic culture is expressed by Rococo artists like Boucher, and even in the works of the classicists, as in Ingres' and Delacroix' harem scenes, the study of the nude in women is characteristic. The bourgeois conventionality of two common people bound together in a relationship without any inner meaning is seen in the works of Toulouse-Lautrec, as in *À la mie*, where a man seeks his enjoyment with a prostitute (*Fig.* 14). In such works are found the roots of the present-day trends in contemporary art.[29] This realism is in opposition to the bourgeois way of life and a challenge to current conventions; it is therefore 'social' in its intentions and political in its implications.[30]

To deal with contemporary trends, one word should be added about the Russian woman, as personified for example in the wife of Lenin, Nadeshda Krupskaya. A teacher and an intellectual, she

28 The Schlegels illustrate the same point. Dorothea, the daughter of the German-Jewish philosopher Mendelssohn, first lived with and then married in second marriage Friedrich Schlegel, who was nine years younger. Caroline Boehmer married in her third marriage F. W. Schelling, who was her junior by twelve years. Madame de Stael married Count Rocca at the age of forty-five in second marriage, he being about twenty-three years younger. Cf. on the period F. Schlegel: *Lucinde*, first published 1799; F. Schleiermacher: *Vertraute Briefe ueber F. Schlegel's Lucinde*, published anonymously 1800; also his *Catechismus der Vernunft fuer Edle Frauen*. On Rachel, cf. L. Assing: *Aus Rahels Herzensleben*, Leipzig, 1877; O. Berdrow: *Rahel Varnhagen*, Stuttgart, 1902.

29 Cf. M. Joyant: *H. de Toulouse-Lautrec*, Paris, 1927, p. 50, 1926, p. 83 and p. 271.

30 On the problems of realism, cf. G. V. Plekhanov: *Art and Society*, New York, 1937; W. Pinder: *Das Problem der Generation*, Berlin, 1926, pp. 83, 271, has some suggestions to make as to style and age of artists.

Fig. 15 William Nicholson (1872–1949), *Sidney and Beatrice Webb: The Authors at Home*, 1928, oil on canvas, c.120 × c.80 cm. London School of Economics and Political Science. Lebrecht History / Bridgeman Images.

sacrificed her own independence to be his wife in a traditional manner. Her type is particularly important, when contrasted with the heroines of the books of Alexandra Kollontai, who profess 'free love', in explaining the most recent developments in Russia with regard to marriage. Already in the early days of the Bolshevik Revolution, the attitude sketched in Kollontai's *The Way of Love*, emphasising sexual pleasure and promiscuity, was combated by Lenin when he wrote in 1920 to Clara Zetkin:

> The notorious theory that in Communist society the gratification of sexual passion is … as simple and commonplace an act as drinking a glass of water … has been the doom of many a young lad and lass. … The proletariat is a rising class. It has no need of intoxicants as narcotics or as stimulants. Self-control, self-discipline, is not slavery. No! even in love it is not that.[31]

The portrait of *Sidney and Beatrice Webb*, by William Nicholson (*Fig.* 15) [see also fig. 3.46], shows these great social research workers in their old age, and is full of restrained intimacy. The

fireplace and the little dog enhance the cosy home atmosphere of this childless and devoted couple, whose 'two typewriters … click as one'. The portrait of the Webbs stands for a type of marriage in which the partners are bound together in a common task, merging their individuality. Here the division of labour has been superseded by comradeship in an all-inspiring duty. The Curies [see fig. 3.26] are perhaps the best-known example of this type.[32]

The sculpture *Worker and Girl Collective Farmer* (*Figs* 16 and 16a), on the Soviet Pavilion, by Vera Ignatievna Mukhina, in the Paris Exhibition of 1937, is of a dynamic character, which expresses not so much love as the moving forward of the man and woman in a spirit of comradeship, an indication perhaps of a future development towards a 'social humanism'.

But Picasso's early works revealed deeper psychological levels, in producing a challenge, not only with regard to style, but also in subject matter, by introducing into art without sentimentality the embrace of a worker couple (*Fig.* 17). A rising social class makes its appearance, and stakes its claim in all spheres of life. The faces are not important in this scene, indeed they are almost hidden away; it is the eternal aspect of love, permeating all classes and peoples, which is represented in a realist as well as a profoundly moving document.

32 Cf. E. Curie: *Madame Curie*, Paris and London, 1938. The best formulation of this attitude is perhaps G. B. Shaw's pithy article in *Picture Post* 12, Sept. 13th, 1941, p. 21. The opposite point of view is equally well expressed by J. E. Harrison: *Ancient Art*, p. 216: 'Spiritual creation *à deux* is a happening so rare as to be negligible.' It may be pointed out, however, that in recent years an ideal of companionship and joint responsibility is developing. It is based on a new division of labour, which is not founded on sex but is entirely personal in character. This new approach has as yet found no expression in art.

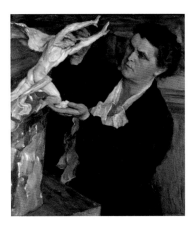

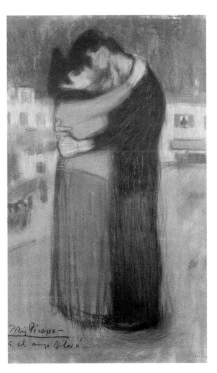

Fig. **16** FAR LEFT Vera Mukhina (1889–1953), *Worker and Girl Collective Farmer* [also known as *Worker and Kolkhoz Woman*], stainless steel, first shown in Paris in the Pavilion of the USSR at the Exposition Internationale, 1937, then moved to Moscow, 24.5 metres tall. Russian Exhibition Centre, Moscow. © CCI / Bridgeman Images.

Fig. **16a** ABOVE Mikhail Nesterov (1862–1942), *Portrait of Vera Mukhina*, 1937, oil on canvas. State Tretyakov Gallery, Moscow. Photo © Fine Art Images / Bridgeman Images.

Fig. **17** LEFT Pablo Picasso (1881–1973), *The Kiss* (now titled *Lovers in the Road*), 1900, pastel, 59 × 35 cm. Originally Museu d'Art de Catalunya, now Museu Picasso de Barcelona. Bridgeman Images / DACS, London 2023.

2 | Motherhood

Fig. 18 *Hathor Protecting Psammetichus* (Psamtik), 26th Dynasty, 664–525 BCE, schist stone. Egyptian National Museum, Cairo. © Andrea Jemolo / Bridgeman Images.

IN THE FIRST BOOK OF THE ILIAD, HOMER SPEAKS OF THE 'cow-eyed mighty Hera'. This is a definite expression of an ideal of femininity which emphasises in women the fertility aspect, the animal side of life as opposed to a more individualistic notion of beauty. It stands for nutritive abundance and placid calm. In Egypt this attitude is expressed by the goddess Hathor being frequently represented (*Fig.* 18) in the guise of a cow.

The roots of this conception lie far back in human history. As stated above, in the earliest representations of women – the palaeolithic 'Venus' figures – the sexual characteristics are shown in conjunction with those of fertility. The buttocks, the belly and the breasts are described, whereas the treatment of the face is neglected. It is typical of this early stage of human development that sex and fertility are not distinguished.

There exists a gap between palaeolithic and Egyptian monumental art, a gap best explained by geological considerations; the new beginning in the Nile valley, about 5000 BCE, led from pottery and primitive clay figures to representations of spiritualised motherhood which are best exemplified in the group of Isis and Horus.

In the Egyptian pantheon the protecting goddesses play an important role, especially the goddess Isis, frequently seen in a hieratic stiff position, holding the boy Horus across her knees.[33] Another important mother goddess is the one venerated as Diana of Ephesus (*Fig.* 19). In her case the symbols of fertility are particularly apparent: the reduplication of breasts, the representation of animals and fruit.[34]

With the Celts of the Roman period the figure of the mother goddess was especially popular. The interpretation of motherhood according to a patriarchal civilisation is found in Republican Rome, well illustrated in the story of a Roman matron, Cornelia, mother of the Gracchi [see fig. 3.47]. According to the well-known story, when asked by a friend what her greatest treasures were, she replied that these were her sons. (This in spite of the fact that she also had a daughter at that time.)

[33] Cf. H. Rosenau: *Burlington Magazine*, London, September 1943, p. 228 ff.

[34] Cf. H. Thiersch: *Artemis Ephesia*, Berlin, 1935, passim.

Oriental influences, especially the cults of Isis and of Diana of Ephesus, further enhanced the position of the Roman mother. Portraits of women reflect this fact. Among them were the Emperors with their mothers represented on coins, such as Caracalla with his mother Julia Domna, wife of the Emperor Septimus Severus. It is significant that the title mother was used ceremonially on inscriptions, such as *Mater Augustorum, Mater Patriae, Mater*

35 Cf. *Journal of the Warburg and Courtauld Institutes* 3, 1939–40, p. 155. Whilst the position of the married woman was slowly raised in Roman society, the unmarried mother's status underwent no significant changes. Since she had no claims against the father of her children, the illegitimate child practically lived under mother-right. It is in line with the consistent development of patriarchy that as late as the 19th century the Code Napoléon and laws derived from it laid down that the unacknowledged and illegitimate children legally have no parents, not even a mother. They were *filii nullius*, although, as is well known, 'la recherche de la paternité est interdite', whereas 'la recherché de la maternité est admise'. This means that to look for the father is forbidden, but that it is permitted and sometimes encouraged to look for the mother.

36 In Bonn especially, not only peaceful donors are represented, but even a victorious Roman soldier striking down an oriental enemy (2nd century CE). Cf. H. Lehner: *Roemische Steindenkmaeler*, in *Bonner Jahrbuecher* 135, Bonn, 1930, p. 1 ff. The most usual representations of the Matrons, discussed by H. Lehner: *Op. cit.*, describe them as carrying flowers or fruit as symbols of fertility, but they are also seen with children as their attributes, especially in the South of France. A variation of this type at Bonn, showing the youthful central figure with open hair and carrying a basket of fruit, may be due to the fact that it was a dedication to the goddesses in honour of the bride. The two goddesses are treated as counterparts, so that the ideas of motherhood and protection are not only expressed singly but collectively.

Senatus (although women were not actually admitted to the Senate), *Mater Castrorum*.[35]

The *Matronae* were greatly venerated, not only on the Rhine, but also in England, France and Northern Africa. Apart from women, men also dedicated altars to them, as is clear from many inscriptions.[36] In the beautiful monument from Bonn (*Fig.* 20), two older Matrons, wearing their native headgear, reminiscent of a halo, are seated to right and left of a young girl, presumably a bride. It need hardly be mentioned that artistically these figures are based on classical influence, whereas their subject matter is Celtic. The distinctive quality of the monument lies in the artistic unification of native beliefs with imported forms.

Fig. 20 *Matronae Aufaniae*, second century CE, Vosges sandstone, excavated in Bonn Minster. Rheinisches Landesmuseum, Bonn. Interfoto/Alamy Stock Photo.

Fig. 21 OPPOSITE *Kongo Maternity Figure*, from Cabinda Region, Democratic Republic of Congo or Angola, wood. Photo © Heini Schneebeli / Bridgeman Images. This is a replacement image for the untraceable original.

The universal appeal of the concept of motherhood is also clear from works of primitive art, especially in African sculpture (*Fig.* 21). How such works are ultimately derived from Egyptian influences deserves discussion, but the plastic qualities and compact proportions are contributions of a specific native character.[37]

The valuation of motherhood is clearly expressed in the case of the Empress Matilda by the inscription placed on her tomb:

Ortu magna, viro major, sed maxima partu, hic jacet Henrici filia, sponsa, parens.
(From Matthew Paris' *Chronica Majora*, 1185 CE)[38]

But that motherhood could be used as a political weapon for an ambitious woman is seen in the case of Constance (1152–1198), Queen of Sicily in her own right and wife of the Emperor Henry VI of Germany. Her son the Emperor Frederick II was born when she had reached the age of forty-two, and this fact became not only the fulfilment of her private life, but also of her political career. Through her son she could secure for herself the rule over Sicily, of which she had been Queen in her own right before her marriage. Dr S. Steinberg has shown that this historic situation found expression on a wooden column from Salerno, now in the Victoria and Albert Museum. The scene shows the Queen kneeling before St. Stephen, the saint on whose day her son was born.[39]

The scene of the Pietà, Mary sorrowfully clasping her dead son in her arms, was widespread during the Middle Ages. It shows Christ sometimes as a small child and on other occasions as a grown man. It expresses the Christian valuation of the nobility and the redeeming power of suffering.

But it was not only the classical but also the Egyptian type which influenced the later, and especially the early medieval, development. An outstanding example is a relief in Odilienberg (*Fig.* 22) belonging to the 12th century, in which the madonna, a feudal maiden with long plaited hair, holds the boy Christ seated across her knees, in an attitude reminiscent of the numerous statues of Isis holding Horus.[40]

But the great liturgical importance of the Virgin Mary is perhaps best expressed in the *Vierges Ouvrantes* (*Fig.* 23), madonnas forming a shrine, which when opened frequently reveal the *mater misericordiae* holding in her hands the Trinity, symbolised by God the Father, the Dove, and the Son on the cross.[41]

The naturalism of the Pietà is applied to other mystical scenes in the late Middle Ages. The Annunciation at Wurzburg (*Fig.* 24) shows

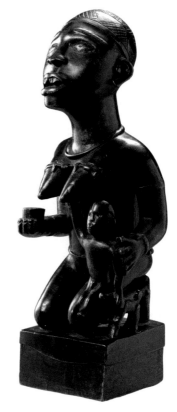

37 E. L. R. Meyerowitz: *Burlington Magazine*, 82, 1943, p. 35. These Egyptian influences will be seen in a door from Northern Yoruba, now in the Middle School of Ilorin, photographed by Mrs Meyerowitz, showing a pair of lovers reminiscent of the representation in Deir-el-Bahari of the god Amon visiting the queen Ahmasi. Cf. also note 9 above.

38 'By father much, spouse more, but son most blest, here Henry's mother, daughter, wife doth rest.' Translation from the Earl of Onslow: *The Empress Maud*, London, 1939, p. 196.

39 *Journal of the Warburg Institute* 1, 1937–8, p. 249 ff.

40 Cf. note 33 above, and S. H. Steinberg and Chr. von Pape-Steinberg: *Die Bildnisse geistlicher und weltlicher Fuersten*, Leipzig and Berlin, 1931.

41 I am indebted to Dr Kurz for providing Fig. 23 and for making some valuable suggestions. Cf. *Pages d'Art Chrétien, V*, p. 101 ff; *Marburger Jahrbuch* 5, 1929, p. 285 ff. Mrs V. Sussmann-Jentzsch is in a position to prove the classical antecedents of the *Mater Misericordiae*. Dr F. Grossmann kindly draws my attention to a medieval reference regarding the Egyptians' worship of a virgin with child in the *Speculum Humanæ Salvationis*, chap. 11, verses 15 & 16.

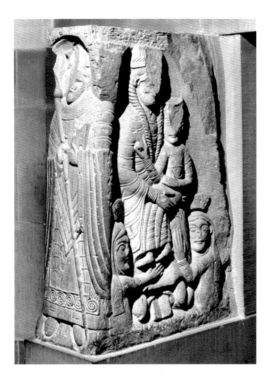

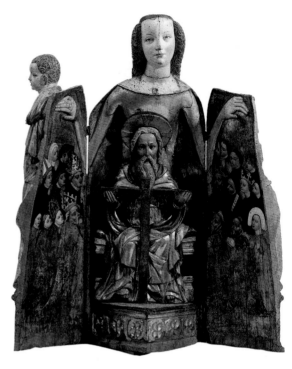

Fig. 22 *Relief of the Virgin Holding Christ* (after Steinberg), *c.*1180, at Ottrott Convent of Mont Sainte-Odile, Odilienberg, formerly a pillar in the cloister showing the Abbesses Relinde (d. 1176) and Herrade at the foot of the Virgin. Photo: Bernard Couturier. © Région d'Alsace – Inventaire général 1986. [*Editor note*: S. H. Steinberg (1899–1969), born in Germany, emigrated to Britain in 1936 with a research fellowship at the Courtauld Institute.]

Fig. 23 *Vierge Ouvrante*. Cathedral Museum, Vienna. Replaced by *Mother of Mercy: Opening Virgin*, *c.*1390, German School, wood and gold leaf, 93 × 54.7 cm. © Germanisches National Museum, Nuremberg / Bridgeman Images.

Fig. 24 *Annunciation*, Tympanum, early fifteenth century (Church of St. Mary, Wurzburg). Photo: Zvonimir Atlelic / Alamy Stock Photo.

42 Cf. T. A. Gopinatha Rao: *Op. cit.*, p. 379 ff; S. Kramrisch: *Op. cit.*, with excellent bibliography.

43 A similar type has been alluded to above with regard to the Meyer Madonna. Cf. *Catalogue of the Victoria and Albert Museum, Italian Sculpture*, London, 1932, p. 100; L. Planiscig: *Venezianische Bildhauer*, Vienna, 1921, p. 26.

44 Cf. the portrait of the Jabach family of Cologne by Charles Lebrun, or the *Family Reunion* by Johann Zoffany.

the infant Jesus penetrating into his Virgin Mother through her ear, the ear being connected to God the Father's mouth by means of a symbolic 'umbilical' cord.

Thus the concept of immaculate birth finds expression in art. The interest in the miraculous birth of gods and heroes is not however confined to the Christian world. These are fundamental human concepts connected with the birth of exceptional personalities, and are for instance found reflected in scenes of the birth of Buddha (*Fig.* 25).[42]

The transition from the Middle Ages to the Renaissance and the Reformation is generally conceived as a strengthening of individualism. In the North as well as in the South of Europe a veil appears suddenly lifted, the main difference being that in Italy the emphasis is laid on the beauty of form, whereas in the Northern countries the features of everyday life arouse the greatest pictorial interest. But even in Italy naturalistic elements are dominant in the early Renaissance, although realism belonged to the sphere not of detail but of the artistic creation as a whole. The child, symbolised by his head, which in the Byzantine type of *platytera* is not clearly described in its physical relation to the Virgin, but seems somehow to be hovering before her, is now incorporated in a clasp, of the mandorla shape, which fastens her cloak. To this type belongs the *mater misericordiae* (*Fig.* 26) attributed to Bartolommeo Buon in the Victoria and Albert Museum.⁴³

With the rise of the middle classes, the English conversation pieces and the French family portraits gain in importance.⁴⁴ It is interesting here to see how the unity of the family is frequently broken up in the sense of a differentiation between a distinctly masculine and a feminine sphere, since the women are more particularly related to the children, especially the babies, whilst the men are portrayed in dignified repose. For example, Nicolas de Largillière's self-portrait with his family shows the artist holding his palette against the background of a classical statue, whilst his buxom wife receives an apple from one daughter – the symbol of fruitfulness – and uncovers with her other hand the figure of a sleeping baby in the nude with a coquettish gesture (*Fig.* 27).

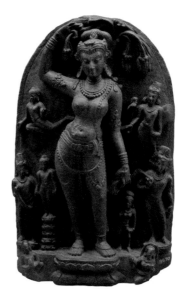

Fig. **25** *Buddha's Birth* (after Kramrisch), now titled *The Birth of Siddartha*, Pala, tenth century CE, basalt, 37.8 × 24.2 × 10 cm. Indian Museum, Kolkata. Photo: Biswarup Ganguly under Creative Commons.

Fig. **26** Bartolomeo Buon (d. after 1564), *Mater Misericordiae* (*Virgin and Child with Kneeling Members of the Guild of the Misericordia*), Italian, c.1445–50, Istrian stone, 251.5 × 208.3 × 50 cm. Victoria and Albert Museum, London. Photo: Universal History Archive / Bridgeman Images.

Fig. **27** Nicolas de Largillière (1656–1746), *Portrait of the Artist and His Family*, c.1704, oil on canvas, 128 × 167 cm. Kunsthalle Bremen. Photo: Lars Lohrisch ARTOTEK.

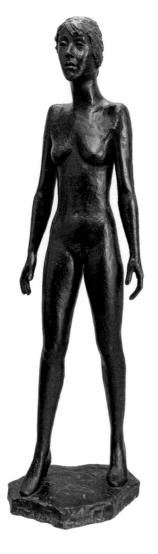

Fig. 28 Ernesto de Fiori (1884–1945), *Die Engländerin* (The English Girl), 1924, bronze, 137 cm tall. Collection: Buchholz; now in the Georg Kolbe Museum, Berlin. Photo: Markus Hilbich, Berlin.

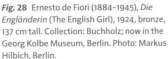

Fig. 29 Paula Modersohn-Becker (1876–1907), *Self-Portrait on the Sixth Anniversary of Marriage*, 1906, tempera on canvas, 102.8 × 70.2 cm. Paula Modersohn-Becker Museum, Bremen. Photo © Fine Art Images / Bridgeman Images

The change in the ideal of female beauty in the inter-war period (1918–39) with the consequent fall in the birth rate, may well be exemplified by a work called *The English Girl*, by the Italian sculptor Ernesto de Fiori (*Fig. 28*). This work is all the more interesting in that it shows a type of English womanhood seen through an alien temperament. Although the sexual characteristics cannot be completely eliminated in a woman in the nude, as far as possible all distinctly feminine traits are suppressed. The breasts and hips are small, expressing the contrast to the formerly established ideal of fertile beauty. The high-heeled shoes which cover the feet tend to emphasise the fact that the prudish figure wears no clothes, and the whole atmosphere is rather more frigid than sexual, more sterile than fertile.

Thus a type of sexlessness in woman finds expression, a type as remote as possible from the primitive. This sexless ideal, based on bourgeois and Puritan traditions, has its antecedents in English art, especially in Reynolds and Gainsborough, where the court atmosphere of refined loveliness gives women a fleeting and dreamlike, but not a pronouncedly sexual, maternal or individual attraction.[45]

In pre-Nazi Germany, where the tendency towards expression in the most personal sense was characteristic of artistic life until the Nazi revolution, two women artists have left a strong mark by emphasising the specific character of motherhood. Paula Modersohn-Becker (1876–1907), who died shortly after giving birth to a baby girl, found in maternity the deepest fulfilment of her nature, and was quite ready to sacrifice her life and work to this end. She was conscious of the problem 'work versus children' and preferred the latter. This highly gifted artist foreshadowed, in the monumental simplicity of her style, the future development of German expressionism. One of her paintings represents a mother in the nude suckling her child, a picture of almost painful intensity. She also painted her self-portrait (*Fig.* 29) in the nude foreshadowing pregnancy, the first portrait of its kind in the history of art, and of special significance in its emotional sincerity and simplicity.[46]

Another German artist, Käthe Kollwitz (b. 1867), has a more popular appeal. The medium of her work, largely book illustrations, woodcuts and posters, made it social in the widest sense. It appealed to the masses and was meant for them. She shows the woman worker, careworn and aged before her time, playing happily

45 Romney's work appears as an exceptional instance of a more erotic approach to womanhood, whilst the active gesture in Reynolds' portrait of *Georgiana, Duchess of Devonshire*, with her daughter, skilfully avoids any expression of maternal emotion. Reminiscence of the French artists Boucher and Greuze clarifies the English, as opposed to the French attitude. Cf. T. Ashcroft: *English Art and English Society*, London, 1936.

46 Cf. G. Pauli: *Paula Modersohn-Becker*, [Leipzig], 1919, with useful bibliography. It is characteristic of Paula Modersohn-Becker's attitude that she is doubtful about the emancipation of women. Her work has the 'earth-like' quality of the primitive, and the scenes she prefers are the simple ones such as mother and child groups, flower pieces, still lifes of every kind. Her self-portraits emphasise this character of stillness. She never questioned her own, a woman's ability for artistic creation, and regarded her difficulties as individual ones, without any bearing on the woman's question generally. This may be accounted for by the tolerant middle-class atmosphere in which she passed her youth, her introvert character, and the friendly fellow artists who surrounded her during maturity. Had she lived longer she might have developed to an even greater form and more mature rendering of genuine emotions. But she died young, happy and radiant to the last moment. She well illustrates the type of artist to whom belongs a balanced personality, a type best personified by Raffael and Bach in the male sphere and unfortunately overlooked in discussing 'the artist' by the majority of psychologists. Cf. O. Rank: *Art and Artist*, New York, 1932; S. D. Gallwitz: *Briefe und Tagebuchblater*, Munich, 1920.

Fig. 30 Käthe Kollwitz (1867–1945), *The Mothers*, 1919, lithograph, 43.6 × 57.7 cm; sheet 52.7 × 70.1 cm. Metropolitan Museum of Art, New York. Harris Brisbane Dick Fund, 1928, 28.68.3. Scala Images.

47 One of Käthe Kollwitz' latest sculptures, executed *c.*1939, is a torso showing the two hands of the mother protecting the quiet ageless head and the smaller hand of the child [see fig. 3.49]. The rhythm of the composition, enclosed in an almost square piece of wood, is impressive, and the lack of any detailed naturalistic rendering enhances the beauty and significance of the hands and the quiet stillness of the child's face. The appeal of this art is as universal as motherhood.

48 It seems an argument against the overpowering urge of the maternal instinct that the European ruling classes are able and willing to regulate births by means of contraception. The childless spinsters, who do not break social *tabus* in order to have children, seem to point to the same conclusion. Perhaps the maternal instinct is most closely related to social inclinations and emotions generally and can therefore be readily diverted. Thus McDougall relates the protective to the parental and maternal instincts, from which it is derived. Be this as it may, the study of the mother in art shows how in all periods motherhood has been the honoured function of the wife, and has been the responsibility and joy of women. Individualised and diverted in modern times, it has not lost its appeal, as is seen especially in the work of women artists. A social force, it has included the childless woman, as in the case of Henriette Feuerbach. Cf. W. McDougall: *An Outline of Psychology*, 4th ed., London, 1928, esp. p. 135 ff and *An Introduction of Social Psychology*, 23rd ed., London, 1936, p. 142 ff. A. Feuerbach: *Briefe an seine Mutter*, Munich, 1920, is the best tribute to his stepmother and a significant expression of the artist's feelings by himself. No adequate biography does Feuerbach full justice yet. The importance of a spiritual as opposed to a biological interpretation of motherhood is found already in the Old Testament (*Is.* 54: 1, and *Ps.* 113: 9): 'Sing, O barren, thou that didst not bear; break forth into singing, and cry aloud, thou that didst not travail with child: for more are the children of the desolate than the children of the married wife, saith the Lord.' In *Psalms*, 'He maketh the barren woman to keep house, and to be a joyful mother of children…'

with her child; she describes the timid knock at the doctor's door of the sullenly determined pregnant woman who, encumbered by too many children, wishes to be relieved of her newest burden: the pathetic joys and sorrows of motherhood are equally clear (*Fig.* 30).[47]

It is by no means strange that two women have introduced this specific emphasis on motherhood into art, stressing it in a more direct manner, giving it from within, and not only from the point of view of the spectator, however sympathetic.

By contrast, the male artist has frequently rendered the portrait of his own mother in a highly individualised sense. Some examples have been mentioned before. Dürer's (*Fig.* 31), Rembrandt's, Whistler's and many other artists' mothers, and Feuerbach's stepmother (*Fig.* 32), are known to us intimately and personally, seen through the medium of their sons' affection.[48]

Fig. **31** Albrecht Dürer (1471-1528), *Portrait of the Artist's Mother at the Age of 63*, 1514, 42.1 × 30.3 cm, charcoal. Kupferstichkabinett, Berlin, Germany / Bridgeman Images.

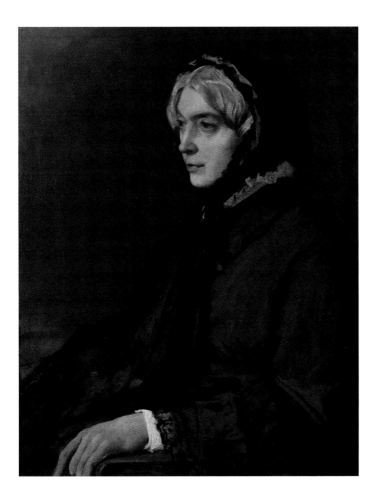

One difference seems to emerge from the study of the man and the woman artist in this field. The woman usually shows mother and child in a typical way and is interested in motherhood as such; the man frequently represents his own family, even if the subject-matter is religious, which means that his approach is more individualistic. This is not to say that there are no typical madonnas executed by male artists, or individual portraits by women, but in a broad generalisation this differentiation of approach between men and women makes itself felt in the representation of motherhood.

3 | Further Aspects of Creativeness

49 Boswell, quoted by J. Langdon-Davies: *A Short History of Women*, Thinkers' Library, London, [1927] 1938, p. 234.

50 The more the social position of women is considered unsatisfactory, the more a trend to move in this direction appears, and it is a problem worth studying whether the special appeal which religion has for women may not be closely related to such conditions. In any case it is true to say that movements of religious revival and social betterment of suffering lower classes, such as Buddhism, Christianity, heretic and Protestant sects, have been actively supported by women. The stress laid on spiritual equality between all human beings may well have attracted women especially, and this in spite of the fact that the leading and directing positions belonged to men. Conservative though women are popularly supposed to be, they have all the same taken an active part in revolutionary movements: the wars of the Albigenses, the French and Russian Revolutions, so that consideration must be given to the problem of what social conditions influence women either towards reactionary or towards revolutionary attitudes. Cf. C. Buecher: *Die Frauenfrage im Mittelalter*, Tuebingen, 1882.

'SIR, A WOMAN'S PREACHING IS LIKE A DOG'S WALKING ON HIS hind legs. It is not done well; but you are surprised to find it done at all.' Dr Johnson's words to Boswell and the astonishment they imply at the achievements of women outside the biological sphere is characteristic of the transition towards a new attitude towards women, still characteristic of the present day, if we are to believe the contemporary newspaper reports with their amazement at 'what women are able to do in wartime'.[49]

This transition goes back to the Renaissance, where the personality of the woman was valued, not only in the highest and princely classes of society as had been formerly the case, but also in a growing stratum: the circles of the rising middle-class.

Thus the personality of woman was a 'discovery' which can be compared to other discoveries of the Renaissance. It led to a new perspective, not in space but in human psychology.

Indeed the great mistresses of the French kings, the romantic women of Germany, the suffragettes of England stood on a platform which was first erected for them in Italy. Only to a people whose senses were quick and whose spirit was uncrushed by asceticism could the belief in women become an inspiration. Only here could they form a vital part of society without a sense of conflict.

When considering the place of woman in society, it has to be remembered that a number of people of both sexes escape the normal routine of everyday life by becoming recluses, monks or nuns or celibate priests and priestesses, in most if not in all civilisations. In the case of women this abnegation is frequently correlated to the idea of a god-like lover, who is the centre of their lives and towards whom their activities are directed.[50]

The division between the male and female spheres, together with a legal discrimination against women, is most clearly stated in the Code of Manu. Here it is specifically laid down that the woman's husband is her god. The ideal of self-abnegation rules the woman's life. It is characteristic that the ethical code is a different one for the two sexes. Only a small distance separates such a wife from the

nunnery or the temple, since the impersonal husband-god is replaceable by a deity functioning as a symbolic bridegroom or husband.

The Delphian Pythia is inspired by a god, Apollo. The Roman Vestals, who were represented in numerous statues in a ceremonial and individualised manner, stood under the direction of a male priest, the Pontifex Maximus. They appear closely draped in formal robes, such as befits dignitaries performing significant state functions. The chief of the Vestals, the *Virgo Vestalis Maxima*, was frequently represented in art. The *Virgo Vestalis* had to be a virgin sanctified to Vesta for at least thirty years, starting her career at the early age of between 6 and 10 years. Thus the main years of female fertility were covered by sexual restrictions.[51]

Only superficially opposed to this type of womanly chastity are the Nautch girls and Devadasis. Women, who as sacred prostitutes live in the temples of their gods and goddesses, give themselves to the worshippers as a religious duty. A counterpart to the lives of anonymous devotion is the secluded existence of the married woman in *purdah*. In Babylonia, as well as in India, the latter type is symbolised by the veil, which is considered a mark of distinction. Especially in Babylonia, the temple prostitutes, although honoured in their own spheres, were debarred from being thus distinguished. The Vestals as well as the wives were heavily draped or veiled, the veil signifying the consecration to a mortal, or to a god, a feature resuscitated in the Middle Ages with regard to nuns.[52] This seclusion leads to solidarity among women.

But the feeling of solidarity between women inside their family is also considered as an appropriate attitude in patriarchal as well as matrilocal civilisations. The biblical story of Ruth and Naomi corroborates this fact. When Naomi wishes her daughters-in-law to return to their mothers' houses, as she herself is no longer able to bear sons who might become their husbands, she hints at a stage in which Levirate marriage and matrilocality formed the background of a patriarchal civilisation. It is not without significance, as regards the change of outlook, in later periods, that Ruth's reply: 'Entreat me not to leave thee … for whither thou goest I will go, and where thou lodgest I will lodge … thy people shall be my people and thy God my God' (*Ruth* 1: 8-17), has now found its place in the marriage service. [William] Blake with his unusual grasp of the symbolic meaning of traditional subjects has described this rarely rendered scene in a drawing of dramatic vigour, contrasting the meek daughter-in-law Orpah with the heroic intensity of Ruth, and the matronly dignity of Naomi with the youthful grace of the two younger women [see fig. 3.51].

51 Cf. W. H. Roscher: *Ausfuehrliches Lexikon der Griechischen und Rœmischen Mythologie VI*, 1924-37, p. 241 ff.

52 Cf. J. B. Horner: *Women under Primitive Buddhism*, London, 1930; L. Eckenstein: *Women under Monasticism*, Cambridge, 1896; E. Power: *Medieval English Nunneries*, Cambridge, 1922; J. H. Leuba: *The Psychology of Religious Mysticism*, London, 1925, p. 100 ff; F. Hauswirth: *Purdah*, London, 1932, p. 23 ff.

53 Cf. Juan Cabre: *El Arte Rupestre en Espana*,
Madrid, 1915.

54 A sense of spiritual solidarity between
women is expressed in the Roman monument
erected in honour of the *Matronae*, referred
to above (note 36). The function of these god-
desses is protection, a spiritual motherhood,
expressed by the duplication or triplication of
the figures.

55 Cf. J. P. Schmelzeis: *Das Leben und
Wirken der Hl. Hildegardis*, Freiburg, 1879;
H. Liebeschuetz: *Das Allegorische Weltbild der
Hl. Hildegard*, Studien der Bibliothek Warburg
XVI; F. Werfel in his penetrating psychological
study: *The Song of Bernadette*, London,
1942, p. 328, p. 336 ff, draws attention to
Bernadette's gift for painting and considers it
likely that artistic creation replaces on a more
conscious level the visions of the primitive
mind.

56 Cf. M. Hirschfeld: *Women East and West*,
London, 1935, p. 162. On the change in modern
China, cf. Hsieh Ping-Ying: *Autobiography*,
London, 1943, esp. p. 93 ff.

The earliest representation of a group of women hovering around
a small central figure of a man in the nude is found in Cogul (*Fig.*
33) and belongs to prehistoric times (15,000–10,000 BCE).[53] The
exact meaning of the scene is unknown, but so much is obvious:
there is a striking contrast between the solitary male figure, whose
genital organs are proportionately bigger than is necessitated by
a naturalistic rendering, and the women. These are clothed and
grouped together, their long hanging breasts appearing strongly
marked. They seem to be in attendance on the man. The scene may
have a ritual or a ceremonial, religious or magical meaning. In any
case it implies clearly a differentiation between the man's and the
women's sphere, the women being collectively treated when juxta-
posed to the male.

A contemporary painting by Erich Wolfsfeld, taken from inspi-
ration in Moroccan surroundings, has admirably expressed this
attitude (*Fig.* 34). He shows two deeply veiled women, and hints at
the life behind the veil. The children, one to the left and one to the
right of their elders, give a contrast of cheerful liveliness against
the background of hidden and anonymous womanhood. It is thus
possible to illustrate the position of the veiled woman of the past
by a contemporary painting, since the subjects represented still live
according to such standards in the East.[54]

In the lives of medieval abbesses, the solidarity of women may
be seen in their concern for their nuns, as in the case of Herrad
of Landsberg (2nd half of the 12th century). Her work *Hortus
Deliciarum* was primarily directed towards the education of her
convent. Drawings of cosmic visions (*Fig.* 35) by the great Hildegard

of Bingen (1098–1179) were included in her writings and inspired by her, revealing her striking power of imagery; her political gifts were recognised in her time, and her devotion to her nuns permeates her work.[55]

The life of the nuns was comparatively rich in outside contacts, as compared to that of the women in purdah, in a harem, or in similar places of seclusion. For a doctor to communicate with these women, medicinal dolls were used. On them the ailing inmates could mark the place of their illness, and by these means the unseen patient communicated with the physician. Although strictly speaking not works of art but of craftsmanship, the aesthetic value of these figures (*Fig.* 36) is nevertheless considerable, and their sociological meaning obvious.[56]

Fig. 34 Erich Wolfsfeld (1884–1956), *Moroccan Mothers*, *c*.1934, untraced. Replaced by *Family with a Goat*, no date, oil on paper laid in card, 94 × 64.8 cm. Private Collection. Photo © Christie's Images / Bridgeman Images.

Fig. 35 *Hildegard of Bingen and Monk Gottfried* (after Steinberg), now titled *Hildegard of Bingen Receiving the Light from Heaven*,*c*.1151, vellum (later colouration), plate from Hildegard of Bingen (1098–1179), *Scivias* (*Know the Ways*) (1142–51), known as the *Rupertsberger Scivias-Kodex*. Landesbibliothek Wiesbaden. The original manuscript is a missing artwork since its evacuation to Dresden in 1945. The images are known through a painted facsimile made in the 1920s. Private Collection / Bridgeman Images.

Fig. 36 *Chinese Medicinal Doll*. Collection: Mr and Mrs How-Martyn. Replaced by *Chinese Ivory Diagnostic Doll*, length *c*.10 cm. Wellcome Collection, London. Creative Commons Attribution (CC BY 4.0).

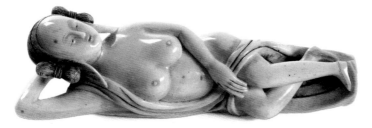

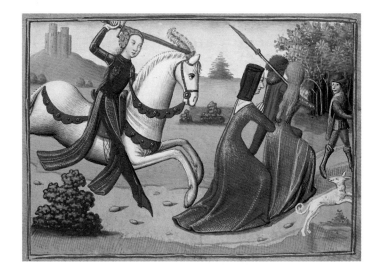

The rigid division of labour between the sexes in patriarchal civilisations finds its counterpart in an equally rigid division in the sphere of female activities itself, restricting further the position of women.

In this connection the type of female 'Vices' and 'Virtues' so popular during the Middle Ages is revealing, since the marked difference between types of women may here be found treated in an allegorical manner. When Joan of Arc is represented (*Fig.* 37) in *Les Vigiles du roi Charles VII* by Martial D'Auvergne, she still appears according to this ancient division, representing Virtue, the courtesans representing Vice. Thus even in the late 15th century, it is not portraiture but a type which is rendered – an essentially medieval concept.[57]

The contrast in women's occupations is found on a naturalistic basis in Velázquez' *Carpet [Tapestry] Weavers*. There the workers fill the dark foreground, whereas the noble ladies watch the finished tapestry in a room in the background flooded with light (*Fig.* 38). The differentiation between the social spheres of life is thus clearly marked and illustrated by the occupation of the women.

But it is in the Dutch school, as exemplified by Pieter de Hooch, that the sphere of activity and co-operation of the bourgeois woman is perhaps most clearly seen: the description of the home of which she is the maker, and in which she takes pride (*Fig.* 39). It is her specific creation, contrasted with the alehouses and inns, populated by servants and loose-living prostitutes, seen characteristically in the works of Jan Steen.[58]

Women as directors of an alms house form the subject of Frans Hals' remarkable and justly famous picture in Haarlem, dated 1664

57 Of the questionably authentic portraits of Joan, nothing has been preserved for posterity. Cf. Vita Sackville-West: *Saint Joan of Arc*, London, 1936. In the early Renaissance fresco in the Palazzo Schifanoia at Ferrara, studied by A. Warburg, and showing the planets and the human beings ruled by them, the sphere of the Weavers appears in the field of Mars, that of the Lovers in the field of Venus. Thus the occupations are markedly separate. The attitude implied demands that women should be either weavers or lovers, but that the combination of differing functions is not the woman's task. This fact is also clear in many languages, e.g., English, where the 'spinsters' used to spin and were unmarried, the occupation of the women being thus linked to their status. Cf. A. Warburg: *Gesammelte Schriften*, Leipzig, 1932, p. 459 ff.

58 Shopkeeping, buying and selling, belongs equally with weaving to the woman's traditional work; [African] tribes have their women traders, and in Proverbs the good wife is described not only as spinning and planting amongst other occupations, but also she 'perceiveth that her merchandise is good' (*Proverbs* 31: 18).

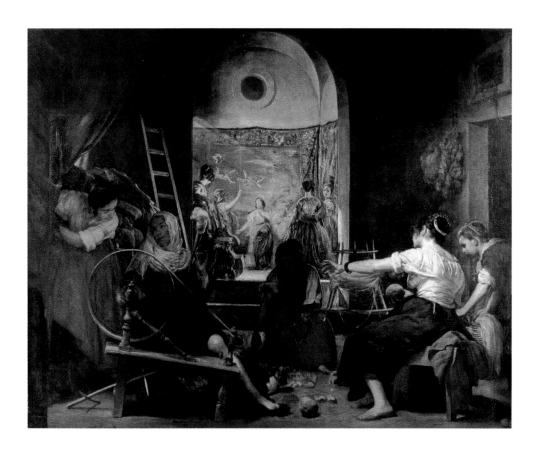

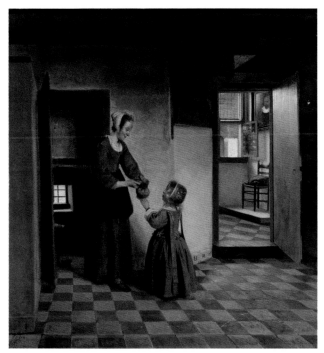

Fig. **38** Diego Rodríguez de Silva y Velázquez (1599–1660), *Las Hilanderas* (The Carpet [Tapestry] Weavers, also known as *The Fable of Arachne*), 1655, oil on canvas, 220 × 289 cm. Prado Museum, Madrid. Luisa Ricciannini / Bridgeman Images.

Fig. **39** Pieter de Hooch (1629–1684), *Mother with a Child in a Pantry*, 1656–1660, oil on canvas, 65 × 60.5 cm. Rijksmuseum, Amsterdam.

59 Cf. F. D. Klingender: *Hogarth and English Caricature*, London, 1944, passim; S. Sitwell: *Narrative Pictures*, London, 1937; and *Conversation Pieces*, London, 1936.

(*Fig.* 40). Here the women are seen highly differentiated and individualised, the counterpart to the more frequent representations of men directors. The spirituality of faces and hands is emphasised, and the dignity of old age coupled with distinction of personality. It seems that the artist, then an old man, was less in sympathy and accord with the men directors, who are represented in a more conventional manner.

Only at a later stage of evolution, and particularly in England's 'Narrative Pictures', was a detached attitude of mockery with regard to a subject like women's education possible. E. F. Burney's *An Elegant Establishment for Young Ladies* may be dubious as a work of art, but it is unsurpassed as a piece of educational satire, and makes abundantly clear the background whence sprang the modern 'masculine protest' (*Fig.* 41). English pictures have often to be 'read' and not apprehended in one instantaneous intuition. Hogarth's paintings are the best-known example of this fact.[59] By 'reading' Burney's picture the indictment of a useless and superficial education is perfectly understood. From holding one's back straight, from stretching one's neck in a torturing manner, hung high up from the ceiling, all the necessary accomplishments for

Fig. **40** Frans Hals (1582–1666), *The Women Regents* (also known as *The Regentesses*), c.1664, oil on canvas, 170.5 × 249.5 cm. Frans Hals Museum, Haarlem. Art Heritage / Alamy Stock Photo.

acquiring a husband are described. That this type of education was doomed is clear from the painter's criticism. Although many young girls are assembled there is no expression of dignity or relationship between them.

The importance of the woman warrior and leader in warfare is expressed in the Old Testament with regard to Deborah, the wife of Lapidoth, i.e., the prophetess who judged and delivered Israel (*Judg.* 4: 4). Deborah was not a consecrated virgin, but a woman in public life, and the fact of her prophecies appeared as unexceptional to the Old Testament writer. It is, however, characteristic of patriarchal civilisation that her figure has been almost forgotten; thus when outstanding Jewish women find representation in art, it is generally Judith and Salome who are selected. Judith stands for freedom and independence, as a counterpart to the male figure of David, as in Florence. Salome shows the demonic power of woman engendering evil. But this subject can also appear alluring to a bourgeois painter as in Cornelisz van Oostsanen's picture (*Fig.* 42). In both cases the women are instrumental in killing the man they love, thus forming a part of, and strongly influencing, an historical

Fig. 41 Edward Francis Burney (1760–1848), *An Elegant Establishment for Young Ladies*, 1805, watercolour, 77.3 × 105.2 cm. © Victoria & Albert Museum Images.

Fig. 42 Jacob Cornelisz van Oostsanen (1472–1533), *Salome with the Head of John the Baptist*, 1524, oil on panel, 72 × 53.7 cm. Mauritshuis, The Hague / Bridgeman Images.

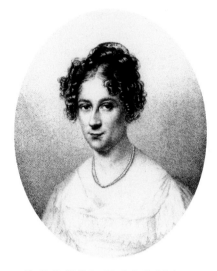

Fig. 43 Carl E. Weber (1806–1856), *Rahel Levin Varnhagen*, 1834, stipple engraving later coloured from a pastel portrait by Michael Moritz Daffinger (1790–1849), 1817. From *Rahel: Ein Buch des Andenkens für ihre Freunde* (Rachel: A Book of Memories for Her Friends) (Berlin: Trowitsch & Sohn, 1833), frontispiece. Scan: Petra Dollinger, public domain.

60 In the bourgeois world the prejudice against the exceptional woman died out slowly. When in the 19th century the sphere of the men was invaded by women artists: Georges Sand, Rosa Bonheur and others, it is not only characteristic that they frequently worked under the male *noms de plume*, like George Eliot in England and Georges Sand herself, but many wore trousers, symbolic of their desire to transcend the limits set by their sex.

61 Cf. H. Hildebrandt: *Die Frau als Künstlerin*, Berlin, 1928; L. Goldscheider: *Five Hundred Self-Portraits*, Vienna and London, 1937. All the same, the attitude remained primarily human not professional, as seen for example in the portrait of Madame Vigée-Lebrun embracing her daughter, who forms an attribute to the mother's feminine charm. Cf. C. E. Vullamy: *Aspasia*, London, 1935, p. 195. With regard to Angelica Kauffman, Mrs Delany writes: 'my partiality leans to my sister painter; she certainly has a great deal of merit, but I like her history still better than her portraits'.

process. The two spectacular heroines with their sensational fate have inspired the imagination of many artists, including a woman painter, Artemisia Gentileschi, whose *Judith* is a contribution to the Baroque movement in Italian art [see fig. 3.58]. Deborah, the greater and more austere figure, has, however, been neglected for the most part, since her heroic figure made no emotional or 'romantic' appeal.

The poetess, Annette von Droste-Hülshoff, is seated with quietly folded hands in J. Sprick's portrait, but this cannot hamper the penetrating look of her eyes and the fullness of expression of her vivid mouth [see fig. 3.53]. 'If only I were a man', she exclaims in one of her poems. This woman, who constantly fought the limits set to her sex, was a pioneer like her contemporaries, Rahel Levin Varnhagen in Germany (*Fig.* 43) and Elizabeth Barrett Browning in England [see fig. 3.54].[60]

Rahel Levin, who was a society leader and one of the romantic lovers of her time, also acted as a social worker in Berlin during the Napoleonic era. She expressed her attitude towards women's work when she asked whether the philosopher Fichte's work would lose in value had it been written by Mrs Fichte. She thus demonstrated her confidence in the creativeness of women, a creativeness also explicitly acknowledged in Elizabeth Browning's poem *Aurora Leigh*.

The foremost woman artist of the Renaissance, Sophonisba Anguissola (b. *c*.1532), specialised in portraits, especially self-portraits (*Fig.* 44). She discovered in herself new aspects of life and of interest. Highly honoured, she died blind at the age of about ninety-three. Her case is significant; her fame was not only based on these pictorial talents but also on the charm of her personality, her humanistic education and her musical aptitude. Like many of her successors, Artemisia Gentileschi (1597–1653), and Rosalba Carriera (1675–1757), who also became blind in her old age, she occupied a highly honoured position in society and the world of art. The Academies of Paris and Vienna opened themselves to Anna Dorothea Therbusch-Lisiewska (1721–1782), as did the London Royal Academy to Angelica Kauffman (1741–1807). In the former's self-portrait, she looks at us in a coquettish way through her monocle, her instrument of work as a miniaturist (*Fig.* 45). She is serious, self-conscious and inquisitive, and at the same time convinced of her own charm.[61] Although women artists were primarily considered as *dilettantes*, women none the less established themselves professionally, and created precedents.

It was left to the early 19th [the Romantic period] and the 20th century [the Modern period] to give a new artistic form to the

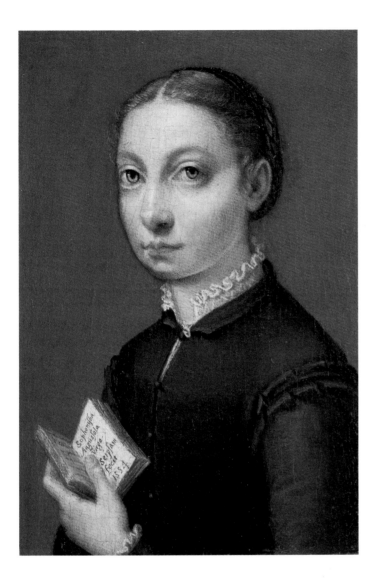

Fig. **44** Sophonisba Anguissola (*c.*1532–1625), *Self-Portrait with Book*, 1554, oil on panel, signed and dated, 19.5 × 14.5 × 0.8 cm, framed: 32.5 × 26.5 × 4 cm. Kunsthistorisches Museum, Vienna / Bridgeman Images.

heroine and to look for her in the lower strata of society. In poetry this aim has been achieved in Lord Byron's romantic poem of the *Maid of Saragossa*, a theme treated more poignantly and realistically in one of Goya's significant etchings of the *Disasters of War* (*Fig.* 46). The maiden's floating robes enhance her fragility; whilst firing she turns her back on the spectator, thus expressing concentrated and relentless action. It is not the mannish but the feminine woman whom Goya considers heroic. At the present time the process has found a significant new development in Spanish and Russian war posters showing the proletarian heroine.[62]

In France, the high place of the court lady is based on sensual charm. However, in spite of her social achievements, she remained

62 The Romantic attitude towards women, and the new emphasis and understanding for their long-repressed potential powers of personality, are perhaps best expressed in the German philosopher Schleiermacher's *Ten Commandments for Wise Women*, from which some extracts are here translated:

 I. Thou shalt have no lover beside him. But thou shouldst be capable of being a friend …
 III. Thou shalt not misuse even the smallest of the tokens of love.
 IV. Heed the Sabbath of thy heart, and when they hold thee back, make thyself free or perish.
 V. Honour the individuality of thy children.
 VII. Thou shalt conclude no marriage which should be broken.
VIII. Thou shalt not want to be loved when thou lovest not.
 IX. Thou shalt not bear false witness for the men … (nor) condone their barbarity …

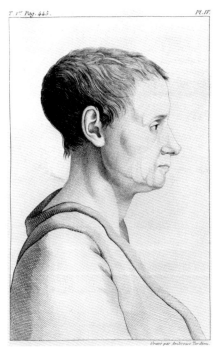

under the domination of a man, the King. Mlle de Scudéry represents the force of the woman's personality in the French *grand siècle*. She started her work under the name of her brother, since aristocratic circles still frowned on a noble lady who wrote. Her portrait shows that character rather than beauty was the basis of her charm. Olympe de Gouges was an exponent of contemporary feminist views in her *Declaration of the Rights of Women* [see fig. 3.56]. Her demands that women should have the right to ascend the tribune since they were free to ascend the scaffold, express the heroism of her personality. Her tragic death by the guillotine finds a parallel in the fate of her contemporary, Théroigne de Méricourt, who ended in the Salpêtrière as a lunatic, thus illustrating the tragic fate of the pioneer.[63] Her portraits reflect her features in a naturalistic manner from young womanhood (*Fig.* 47) to the worn profile of the mad woman (*Fig.* 48).

The best expression of the attitude of protest, full of revolutionary vigour and intense naturalism, was created by Constantin Meunier (1831–1905) in his *Woman Truck Pusher* [now titled *Woman Pitbrow Worker*], who is seen in heavy boots wearing breeches and bereft of all feminine charm (*Fig.* 49). Ellen Key in the German edition of her *Woman's Movement* quotes a poem about this statue, which reads in translation:

Fig. 47 Jacques-Louis David (1748–1825), *Théroigne de Méricourt(?)*. Collection: Poniatowski. Unknown location, reproduced from *Woman in Art*.

Fig. 48 Marcellin Pellet (1849–1942), *Théroigne de Méricourt*, 1816, sketch done at the Salpêtrière Hospital on the request of Etienne Esquirol, also known as *Théroigne de Méricourt à la Salpêtrière en 1816* (Théroigne de Méricourt at the Salpêtrière in 1816). Engraving (plate) by Ambroise Tardieu published in Jean-Étienne Esquirol, *Des maladies mentales* (Mental Illnesses) (1838), then reproduced in Marcellin Pellet, *Étude historique et biographique sur Théroigne de Méricourt: avec deux portraits et un fac-similé d'autographe* (Historical and Biographical Study on Théroigne de Méricourt: With Two Portraits and a Facsimile of an Autograph) (Paris: Maison Quantin, 1886), p. 126.

Fig. 49 Constantin Meunier (1831–1905), *Hiercheuse à la lanterne* (Woman Pitbrow Worker with a Lantern), *c*.1886, plaster, 72 × 30.2 × 25.3 cm. Royal Museums of Fine Arts of Belgium, Brussels. Photo: J. Geleyns / Ro scan.

63 Cf. H. Rosenau: *Apollo*, April, 1943, p. 94 ff. Cf. J. E. D. Esquirol: *Des maladies mentales*, Paris, 1838.

64 The widening of the basis for political influence by women was attempted by suffragettes and their men friends. It is worth noting, however, that the radical leader, Mrs Emmeline Pankhurst, still appeared first and foremost, a 'lady' in spite of her political agitation. Cf. note. 61 above, and Helen Waddell: *Op. cit.*, p. 24 from which is quoted this poem (675 BCE):

> I would have gone to my lord in his need,
> Have galloped here all the way,
> But this is a matter concerns the State,
> And I, being a woman, must stay …
> I may walk in the garden and gather
> Lilies of mother-of-pearl.
> I had a plan would have saved the State.
> But mine are the thoughts of a girl …

> The same as a man –
> Also a beast of burden!
> In the dusty mine
> She grew up and lived.
> In body and soul
> Just like him,
> A beast of burden –
> Just like him.

It is characteristic that the 'masculine protest', first extensively studied from the psychological viewpoint, makes its appearance here and is found coupled with a conscious feeling of solidarity. The pioneer is no longer an exceptional 'genius' but one of a group of dispossessed sisters. Once this idea became popular, it influenced politics, especially in the English Suffragette movement.[64]

By contrast, Rodin's sensibility and instinctive symbolism is the most revealing in modern art as regards the potential power

Fig. 50 Auguste Rodin (1840–1917), *La Pensée* (Thought), *c.*1895, praticien: Victor Peter, marble head, rough-hewn base, 74.2 × 43.5 × 46.1 cm. © RMN-Grand Palais (Musée d'Orsay) / Jean Schormans.

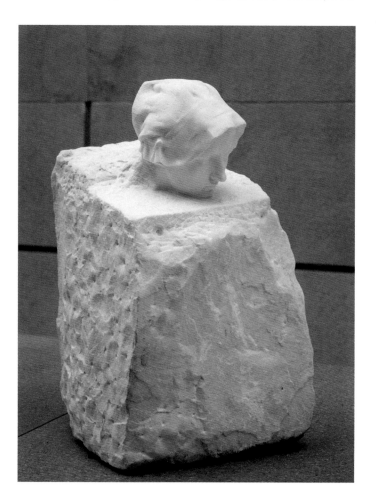

of women. Rodin's attitude has been expressed by himself in a talk with P. Gsell, when he stated: 'La réflexion très profonde aboutit très souvent à l'inaction' [Very deep reflection very often leads to inaction]. This intensive thought which is not manifest in overt action takes for Rodin a woman's shape. In his sculpture *Le Penseur* he shows a figure bowed down and concentrated on the task of thinking. His *La Pensée* illustrates the very opposite: out of an angular block the neck and head of a woman arises (*Fig.* 50). It is no longer the collective or the sexual aspect of womanhood which is expressed. In a manner which denotes no effort, thought is repre- sented, the thought of the solitary woman as a thinker. This bust may well remind one of the verse in *Genesis*: 'And the spirit of God moved upon the face of the waters' (*Gen.* 1: 2). It is worth noting that the original Hebrew text uses the word *ruach*, spirit in its feminine form. In this manner a gulf in time is bridged by a great artist's inspiration.[65]

Having reached this point, it should be remembered that such a type of representation is non-existent in the Far East. Thus in the Chinese painting of the *Admonitions of the Instructress to the Court Ladies*, by or after Ku K'ai-Chih (344–406 CE), an attitude of appreci- ation of the graceful and charming side of women's life is seen (*Fig.* 51). A similar valuation also finds expression in Hellenistic terra- cottas, in Japanese woodcuts, in Rococo paintings, where women exert their charms, in a man-made world, and still permeates the art of a modern and sensitive woman painter like Marie Laurencin (*Fig.* 52).[66]

Fig. 51 Ku K'ai-Chih (now known as Gu Kaizhi) (*c*.344–406), attributed, *Admonitions of the Instructress to the Court Ladies*, Tang Dynasty, Six Dynasties (between 400 and 700 CE), painting in nine scenes (originally 12), height 26 cm, length 343.75 cm, width 24.60 cm (in brocade wrapper). British Museum, London. Replaced by a different scene. © Trustees of British Museum, London.

[*Editor note*: The scroll depicts a poetic text composed by writer, poet, and politician Zhang Hua (*c*.232–300).]

65 Cf. [Paul Gsell] Auguste Rodin: *L'Art*, Paris, 1911, p. 205: 'Profound thought frequently leads to inaction.' The fact that the Hebrew word *ruach* has a masculine as well as a feminine meaning provided the basis which influenced the 'Wisdom Literature' as well as Montanists and other Christian sects. Cf. D. Nielsen: *Der Dreieinige Gott*, Copenhagen, 1922, an important work, although a certain bourgeois bias and lack of acquaintance with psychological research mar some of its conclusions. Nielsen deals mainly with the later phases of Semitic thought, and does not consider Old Testament sources. Cf. also E. Jones: *Essays in Applied Psycho-analysis*, London, 1923, esp. p. 415 ff.

66 Cf. L. Ashton and B. Gray: *Chinese Art*, London, 1935, passim; A. Waley: *An Introduction to the Study of Chinese Painting*, London, 1922, p. 45 ff.

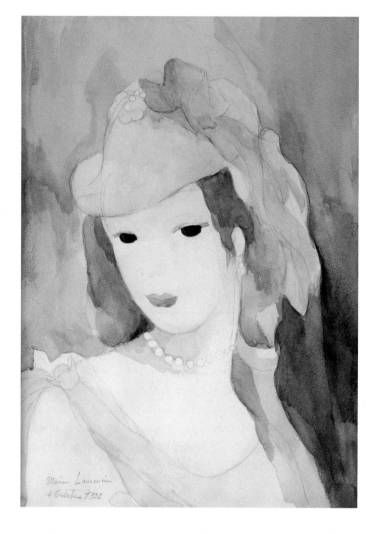

67 Cf. *Das Schoene Muenster* 5:2, 1933. Women being only partly *enosh* (Hebrew), *anthropos* (Greek), *homo* (Latin), *man*, had their tasks assigned to them in a limited field. German is perhaps the only language where the word *Mensch* covers equally men and women. To be productive meant under such traditions to break away from tradition and to be lonely and without precedent. The loneliness, which explains some of the homoerotic aspects of the Women's Movement, was coupled frequently to an attitude characteristic of parvenus, e.g. unwarranted pride in minor achievements. As long as a woman is judged by male standards, and has to be 'as good in her work as a man' she is not really considered free in self-expression; freedom of expression is correlated to productivity. Cf. H. Rosenau: 'Towards a New Synthesis', *International Women's News* 35:5, London, 1941, p. 97, especially with regard to a unified mode of address which obtains in progressive countries, e.g., *tovarich* (Russia), *gwereth* (Jewish, Palestine), *bayan* (Turkey) for married as well as for unmarried women. Cf. the term *ma'am* in the British Armed Forces.

68 Cf. R. Crevel: *Renée Sintenis*, Paris, 1930. Renée Sintenis was born in Glatz.

An interesting case psychologically and artistically is that of Elisabet Ney (1833–1907) [see fig. 3.21], who was born in Münster, the daughter of a sculptor, and herself developed a considerable talent for sculpture (*Fig.* 53). Married to Dr Montgomery, she refused to share his name and preferred to be known under the title of Miss Ney, under which description she migrated to the United States of America.[67]

The inspiration of motherhood as a powerful factor in the work of the woman artist has been alluded to above (p. 137 ff) with regard to Paula Modersohn-Becker (see *Fig.* 29) and Käthe Kollwitz (see *Fig.* 30). By contrast, Renée Sintenis (b. 1888) [see fig. 3.22], the German sculptor (of Huguenot extraction as denoted by the derivation of her name from St. Denis), represents in her self-portrait (*Fig.* 54) the ideal of self-consciousness and an almost masculine appeal.[68]

From such works the distinct feminine traits as well as the special problems of women are entirely omitted. This type of art, therefore, reveals the wide range of expression attainable for women artists, an expression of a human, not of a sexually determined, attitude.[69] It is characteristic of the present time that wide divergences are represented by women artists. Marie Laurencin (b. 1885), standing in the age-honoured feminine tradition of sensitiveness and delicacy, while Barbara Hepworth's (b. 1903) approach to her abstract art is one which transcends the limitations set by her sex.

Barbara Hepworth's *Conoid, Sphere and Hollow* is suggestive in its precision, and the very simplicity and austerity of the forms enhance their spatial pattern (*Fig.* 55). Such works should be reproduced from diverging angles, since they, although motionless, express a motion of their own. Like all true sculptures in the round they do not represent one, the frontal view only, but a variety of views, each of these being three-dimensional and of a dynamic character.

In Rembrandt's *Jewish Bride* (see *Fig.* 12), indeed in Rembrandt's work as a whole, the inner, spiritual life is such as to make impossible

69 Virginia Woolf's description of 'Judith', William Shakespeare's supposed sister, in *A Room of One's Own*, London, 1929, is one of the most imaginative creations of contemporary literature, and only paralleled by the same writer's *Orlando*, London, 1928. In this context it is worth noting that Virginia Woolf was a convinced feminist, a fact not singular in contemporary English literature. Dame Ethel Smyth [see fig. 3.23] forms a parallel in music, and Winifred Holtby and Vera Brittain [see fig. 3.29], the writers, as well as Stella Bowen [see fig. 3.24], the painter, to quote diverse examples, share a similar point of view. Cf. also Otto Weininger: *Sex and Character*, London, 1906, a study which greatly influenced the typifying of 'male' and 'female' characteristics.

Fig. **53** Elisabet Ney (1833–1907), *Bust of Arthur Schopenhauer*, 1859, marble. Elisabet Ney Museum, Austin. The History Collection / Alamy Images or Elisabet Ney Museum, Austin, Texas.

Fig. **54** Renée (Renata) Sintenis (1888–1965), *Self-Portrait*, 1933, mask in terracotta, 30.5 × 10.5 cm. Leicester German Expressionism Collection. Gift of Mr N. E. B. Elgar (on behalf of his late wife). National Art Collections Fund. © 2021 Renée Sintenis / DACS, London.

Fig. 55 Barbara Hepworth (1903–1975), *Conoid, Sphere and Hollow*, 1937, white marble, 30.5 × 40.6 cm. Bequest of Virginia C. Field, New York, Museum of Modern Art 22.2004. Photo: Original supplied to Helen Rosenau by Barbara Hepworth. London: Tate Archives © Bowness.

a division with regard to masculine or feminine attitudes. An understanding of the individual is reached, which makes the subject, the expression of personality, of primary concern. By contrast, for Barbara Hepworth and the abstract artists of the present period it is rather the 'absolute form' which represents the aim of their inspiration. But in both cases, two factors are identical: the endeavour to reach a level where the accidental is left behind, and the expression of the transient in forms of timeless character.

Conclusion

HAVING MADE THIS RAPID SURVEY OF THE DIFFERENT REPRE-sentations of WOMAN IN ART in varying civilisations, a few concluding words may seem appropriate. From an undifferentiated form of womanhood, as found in the prehistoric 'Venus', a differentiation into types has set in, whilst the process of individualisation has been understood more consciously during the last few centuries. Women have striven for a more subjective approach to the problems of life, wishing to make their own decisions with a sense of full human responsibility. At the same time they have taken an ever-increasing part in the 'objective' spheres: law, science, politics.[70]

Three main conditions seem necessary for creative activity, whether in men or women. They are especially difficult for women to attain. Firstly, they must have enough vitality to pour out into the work; secondly, their intensity of feeling must be such as to demand expression; and thirdly, the processes of form require power of concentration, an attitude diametrically opposed to the education of the average girl, who is trained to diffuse her attention on various matters with a view to keeping her future house in order. Indeed, housekeeping is perhaps a real education in the diffusion of thought; looking after the kitchen, the sewing, illnesses or children, and innumerable other minor tasks which crop up during the day. One of these functions is 'to be at home', to be in attendance, to listen. It is a constant strain which is frequently not even relieved on Sundays or holidays, since even then the family requires care. On the other hand, the processes of form demand concentration, and only through this means can the productivity of women come into its own.[71]

Stella Bowen is a case in point: she has poignantly described the constant strain on the woman artist by an exacting husband, and her revival of strength when living on her own. At the same time, the artist recognises that these difficulties form the basis of her inspiration, and makes her understand and appreciate more deeply the human and artistic values in life.[72]

70 Cf. G. W. F. Hegel (trans. W. Wallace): *Philosophy of Mind*, Oxford, 1894, p. 103 ff.

71 Cf. H. Rosenau: *Contemporary Review*, April, 1939, p. 480 ff and August, 1941, p. 111 ff.

72 Stella Bowen: *Drawn from Life*, London, 1941, passim. On the woman at the present time falls the task to choose her way of life for herself – a task new to her, since in the past it was mainly the man who made the decisions. This possibility of choice may entail sacrifice, since no individual life is limitless in its scope. A 'handsome husband' may seem a more enjoyable goal than a doctor's thesis. But there might be a moment of frustration, even when the work is not given up, or when the husband seems less handsome than before. Not only outside work but also housework means drudgery. Although the same problems apply to the male sex, men are biologically and sociologically less limited, and have a wider range of choice.

73 Ève Curie: *Op. cit.*, p. 361 ff, p. 372.

74 Cf. Ch. Bühler: *Der Menschliche Lebenslauf*, Leipzig, 1933; A. Adler: *The Practice and Theory of Individual Psychology*, London, 1924; S. Freud: *Introductory Lectures on Psycho-analysis*, London, 1922; and especially *Sammlung Kleiner Schriften zur Neurosenlehre II*, p. 181, and Jones: *Op. cit.*, p. 381 ff; C. G. Jung: *Contributions to Analytical Psychology*, London, 1928; also: *Psychology of the Unconscious*, New York, 1916; and *The Integration of the Personality*, London, 1940, where, however, sociological implications are entirely omitted. M. E. Harding: *The Way of All Women*, New York, 1933, follows closely Jung's ideas while A. Ruehle-Gerstel's important book *Das Frauenproblem der Gegenwart*, Leipzig, 1932, is the most comprehensive study of modern womanhood, based on Adler's approach. I wish to thank Mrs T. Sussmann for valuable suggestions with regard to Jung's psychology. Freud's concept of *sublimation* has taken a wider meaning in Jung's stress on *transformation*. The latter bases his psychological approach on a wider conception of *libido*.

It is, for instance, illuminating to see how few 'self-made women' exist at the side of self-made men. The women who rise in the social sphere mostly do it as wives and lovers (cf. the classical *La Serva Padrona* by Pergolesi) which means that their essential functions are not changed. The same is true of motherhood. Laetitia Ramolini stays 'Madame Mère' whether to an Emperor or to a sub-lieutenant. Social reasons have strengthened this biological necessity; in fact, women, historically and socially, are less mobile than men.

It is worth noting Madame Curie's statement, made in the midst of universal recognition: 'I have given a great deal of time to science because I wanted to, because I loved research.' 'In science we must be interested in things, not in persons.' The new interest of women in the factual side of life has never been more clearly expressed. But Madame Curie explained further that the combination of wifehood, motherhood and professional work is overtiring to the average woman.[73]

The present transitional moment is full of conflicts, women frequently substituting external action for inner contentment. They strive for a 'completeness' which cannot permanently be obtained in life, and which is akin to dilettantism, exchanging diversity of interests for concentrated achievement. However, like a work of art, a human life can and should have its own style. By transforming necessary limitations into means of self-expression, by transcending from the concept of procreation to creation, woman is developing from Type to Personality.[74]

But for this evolution to fulfil its promise, the development of the individual woman is not enough. It is only by co-operation and by the recognition of the different personal ways of approach to the social problems of their time, that women will be able to contribute fully to the historical process, no longer as a means only but also as an end of human evolution.

A Reconstructed Bibliography

Compiled by Griselda Pollock

ARISTOTLE. *Politics* [suggested edition: translated by Benjamin Jowett (Oxford: Clarendon Press, 1905)].

PLATO. *Timaeus* [suggested edition: *The Dialogues of Plato*, vol. 3, edited and translated by Benjamin Jowett (Oxford: Clarendon Press, 1871)].

TACITUS. *Germania* [suggested edition: edited by J. C. G. Anderson (Oxford: Clarendon Press, 1938)].

ADLER, Alfred. *The Practice and Theory of Individual Psychology*, translated by P. Radin (London: K. Paul Trench, 1924).

ARCHER, W. G. and Archer, M. 'Santhal Painting', *Axis* 7 (1936), 27–8.

ASHCROFT, T. *English Art and English Society* (London: Peter Davies, 1936).

ASHTON, Leigh and Basil Gray. *Chinese Art* (London: Faber & Faber, 1935).

ASSING, Ludmilla. *Aus Rahels Herzensleben: Briefe und Tagebuchblätter* (Leipzig: Verlag Brockhaus, 1877).

BACHOFEN, J. J. *Das Mutterrecht: Eine Untersuchung über die Gynaikokratie der alten Welt nach ihrer religiosen und rechtlichen Natur* (Stuttgart: Von Kreis und Hoffman, 1861).

BATESON, Gregory. *Naven: A Survey of the Problems Suggested by a Composite Picture of the Culture of a New Guinea Tribe Drawn from Three Points of View* (Cambridge: Cambridge University Press, 1936).

BENEDICT, Ruth. *Patterns of Culture* (London: Routledge & Kegan Paul, 1934).

BERDROW, Otto. *Rahel Varnhagen: Ein Lebens – und Zeitbild* (Stuttgart: Greiner und Pfeiffer, 1902).

BOAS, Frans. *Primitive Art* (Oslo: Institute for Comparative Research and Harvard University Press, 1927).

BORODINE, Myrrha. *La femme et l'amour au XIIe siècle d'après les poèmes de Chrétien de Troyes* (Paris: Picard, 1909).

BOWEN, Stella. *Drawn from Life* (London: Collins, 1941).

BREITENBACH, Edgar (ed.). *Speculum Humanæ Salvationis: eine typengeschichtliche Untersuchung* (Strasbourg: Heitz, 1930).

BRIFFAULT, Robert. *The Mothers: The Matriarchal Theory of Social Origins* (London: Chapman Hall, 1927).

BUECHER, Karl. *Die Frauenfrage im Mittelalter* (Tuebingen: Laup, 1882).

BÜHLER, Charlotte. *Der Menschliche Lebenslauf als psychologisches Problem* (Leipzig: Herzel, 1933).

CABRE, Juan. *El arte rupestre en Espana* (Madrid: Museo Nacional de Ciencias Naturales, 1915).

CONTENAU, Georges. *La déesse nue babylonienne: étude d'iconographie comparée* (Paris: P. Guenthner, 1914).

CONZE, Alexander. *Die Attischen Grabreliefs* (Berlin: W. Spemann, 1893–1922).

CREVEL, René. *Renée Sintenis* (Paris: Gallimard, 1930).

CURIE, Ève. *Madame Curie* (Paris and London: Heinemann, 1938).

DE MOUBRAY, G. A. de C. *Matriarchy in the Malay Peninsula* (London: Routledge, 1931).

DE ROUGEMONT, Denis. *Passion and Society* (London: Faber & Faber, 1940).

DELAPORTE, L. J. *Mesopotamia: The Babylonian and Assyrian Civilization* (London: Kegan Paul & Co., 1925).

ECKENSTEIN, Lina. *Women under Monasticism* (Cambridge: Cambridge University Press, 1896).

ELGOOD, Percival G. *The Ptolemies of Egypt* (Bristol: Arrowsmith, 1938).

ELIAS, Norbert. *Über den Prozess der Zivilisation* (Basel: Haus zum Falken, 1939).

ESQUIROL, J. E. D. *Des maladies mentales* (Paris: Chez-Baillière, 1838).

FABRE, Abel. *Pages d'Art Chrétien, V* (Paris: Maison de la Bonne Presse, 1914).

FEUERBACH, Anselm. *Briefe an seine Mutter* (Munich: Kurt Wolff, 1920).

FOLSOM, J. K. *The Family: Its Sociology and Social Psychiatry* (New York and London: John Wiley & Sons, 1934).

FRAZER, J. G. *The Golden Bough: A Study in Comparative Religion*, 3rd ed. (London: Macmillan, 1935–6).

FREUD, Sigmund. *Sammlung Kleiner Schriften zur Neurosenlehre I: Aus den Jahren 1893–1906* (Vienna: Franz Deuticke, 1911). See *Totem und Tabu: Einige Übereinstimmungen im Seelenleben der Wilden und der Neurotiker* (Leipzig and Vienna: Hugo Heller, 1913), translated by Abraham Brill as *Totem and Taboo* (Harmondsworth: Penguin, 1938).

——. *Introductory Lectures on Psycho-analysis* (London: Hogarth Press, 1922).

GALLWITZ, S. D. (ed.). *Paula Modersohn-Becker: Briefe und Tagebuchblätter* (Munich: Kurt Wolff, 1920).

GIRAUDOUX, Jean. *Amphytrion 38* (Paris: Bernard Grasset, 1929).

GOLDSCHEIDER, Ludwig. *Five Hundred Self-Portraits*, translated by J. Byam Shaw (London: Phaidon, 1937).

GONGOLY, O. C. 'The Mithuna in Indian Art', *Rūpam*, April–July, 1925, p.6ff [source suggested for Rosenau's incomplete reference].

GOPINATHA Rao, T. A. *Elements of Hindu Iconography* (Madras: Law Printing House, 1914).

GROSSE, Ernst. *Die Formen der Familie und die Formen der Wirthschaft* (Freiburg and Leipzig: J. C. B. Mohr, 1896).

[GSELL, Paul] Rodin, Auguste. *L'Art: entretiens réunis par Paul Gsell* (Paris: Bernard Grasset, 1911).

HALLER, William. *The Rise of Puritanism* (New York: Columbia University Press, 1938).

HARDING, M. Esther. *The Way of All Women* (New York: Longmans, 1933).

HARRISON, Jane. *Ancient Art and Ritual* (London and New York: Home University Library, 1918).

——. *Prolegomena to the Study of Greek Religion*, 3rd ed. (Cambridge: Cambridge University Press, 1922).

HAUSWIRTH, Frieda. *Purdah: The Status of Indian Women* (London: Kegan Paul & Co., 1932).

HEGEL, G. W. F. *Philosophy of Mind*, translated by W. Wallace (Oxford: Oxford University Press, 1894).

HEKLER, Anton. *Greek and Roman Portraits* (London: Heinemann, 1912).

HILDEBRANDT, Hans. *Die Frau als Künstlerin: mit 337 Abbildungen nach Frauenarbeiten bildender Kunst von den frühesten Zeiten bis zur Gegenwart* (Berlin: Mosse, 1928).

HIRSCHFELD, Magnus. *Women East and West* (London: Heinemann, 1935).

HOBHOUSE, L. T., G. C. Wheeler, and M. Ginsberg. *The Material Culture and the Social Institutions of the Simpler Peoples* (London School of Economics Series of Studies III, 1914).

HOFMANN, Julius. *Francisco de Goya: Katalog seines graphisches Werkes* (Vienna: Gesellschaft für vervielfältigende Kunst, 1907).

HORNER, I. B. *Women under Primitive Buddhism* (London: White Lotus Press, 1930).

JONES, Ernest. *Essays in Applied Psycho-analysis* (London: International Psychoanalytical Library, 1923).

JOYANT, Maurice. *H. de Toulouse-Lautrec* (Paris: Jean Boussod, Manzi, Joyant et Cie, 1927).

JUNG, C. G. *Psychology of the Unconscious*, translated by Beatrice M. Hinkle (New York: Kegan Paul & Co., 1916).

——. *Contributions to Analytical Psychology*, translated by H. G. and Cary F. Baynes (London: Kegan Paul & Co., 1928).

——. *The Integration of the Personality*, translated by Stanley M. Dell (London: Kegan Paul & Co., 1940).

KELLY, Amy. 'Eleanor of Aquitaine and the Courts of Love', *Speculum* 12:2 (1937), 3–19.

KEY, Ellen Karolina Sofia. *Die Frauenbewegung* (Frankfurt am Main: Literarische Anstalt and Rütten & Loening, 1909), translated by Mamah Bouton Borthwick as *The Woman Movement* (New York

and London: G. P. Putnam & Sons, 1912). [Rosenau references the German original.]

KLINGENDER, F. D. *Hogarth and English Caricature* (London: Curwen Press, 1944).

KRAMRISCH, Stella. *Indian Sculpture* (Calcutta: YMCA Publishing House; London: Oxford University Press, 1933).

KUEHN, Herbert. *Kunst und Kultur der Vorzeit Europas* (Berlin: Walter de Gruyter, 1929).

LANGDON-DAVIES, John. *A Short History of Women* [1927] (London: Thinkers' Library, 1938).

LEHNER, H. *Römische Steindenkmäler*, in *Bonner Jahrbücher* 135 (1930), 1–48.

LEITH-ROSS, Sylvia. *African Woman: A Study of the Ibo, Nigeria* (London: Faber & Faber, 1939).

LEUBA, J. H. *The Psychology of Religious Mysticism* (London and New York: Harcourt, Brace and Co.; London: Kegan Paul & Co., 1925).

LEWIS, C. S. *The Allegory of Love: A Study in the Medieval Tradition* (Oxford: Oxford University Press, 1936).

LICHT, Hans. *Sexual Life in Ancient Greece*, translated by J. H. Leese (London: Routledge, 1931).

LIEBESCHÜTZ, Hans. *Das allegorische Weltbild der Heiligen Hildegard von Bingen*, in *Studien der Bibliothek Warburg XVI* (Leipzig: Teubner, 1930).

LOWIE, Robert H. *Primitive Society*, 2nd ed. (London: London School of Economics, 1929).

MACLAGAN, Eric and Margaret LONGHURST. *Catalogue of the Victoria and Albert Museum: Italian Sculpture*, vol. 1 (London: Victoria and Albert Museum, 1932).

MANGENOT, E. and A. Vacant. *Dictionnaire de théologie catholique contenant l'exposé des doctrines de la théologie catholique, leurs preuves et leur histoire*, vols. 1–5 (Paris: Letouzey et Ané, 1909).

MAYER, J. P., R. H. S. Crossman, P. Kecskemeti, E. Kohn-Bramstedt, and C. J. S. Sprigge. *Political Thought*. Introduction by R. H. Tawney (London: J. M. Dent & Sons, 1939).

MCDOUGALL, William. *An Outline of Psychology*, 4th ed. (London: Methuen & Co., 1928).

——. *An Introduction to Social Psychology*, 23rd ed. (London: Methuen & Co., 1936).

MEYEROWITZ, Eva L.-R. 'The Stone Figures of Esie in Nigeria', *Burlington Magazine* 82:479 (1943), 31–6.

MISCH, Georg. *Geschichte der Autobiographie* (Leipzig and Berlin: Teubner, 1931).

MOLIÈRE [Jean-Baptiste Poquelin]. *Amphytrion* [no edition cited] (1668).

MORET, Alexandre. *Kings and Gods of Egypt* (New York and London: Putnam, 1912).

MORGAN, Lewis H. *Systems of Consanguinity and Affinity of the Human Family*. Washington, DC: Smithsonian, 1871).

MÜLLER, Eugen. 'Elisabeth Ney zum 100. Geburtstag am 26. Januar 1933', *Das schöne Münster* 5:2, (1933), 17–21.

MURRAY, Gilbert. *Five Stages of Greek Religion* (London: Thinkers' Library, 1935).

MURRAY, Margaret. 'Royal Marriages and Matrilineal Descent', *Journal of the Anthropological Institute* 45 (1915), 307–25.

NAUMANN, Hans. *Deutsche Kultur im Zeitalter des Rittertums* (Potsdam: Athenaion, 1938).

NIELSEN, Ditlef. *Der Dreieinige Gott* (Copenhagen and London: Gyldenaske Boghandel, 1922).

NIETZOLD, J. *Die Ehe in Aegypten zur Ptolemäisch: Römischen Zeit* (Leipzig: Metzger & Wittig, 1903).

OBERMAIER, H. *Urgeschichte der Menschheit, in Geschichte der führenden Völker I* (Freiburg: Herder Verlagsbuchhandlung, 1931).

ONSLOW, R. W. A. *The Empress Maud* (London: James Clark, 1939).

PANOFSKY, Erwin. 'Jan van Eyck's Arnolfini Portrait', *Burlington Magazine* 64:372 (1934), 117–19, 122–7.

PARIS, Gaston. *La légende du mari aux deux femmes* (Paris: Firmin-Didot, 1887).

——. *La poésie du Moyen Age, II* (Paris: Hachette, 1906).

PAULI, Gustav. *Paula Modersohn-Becker* (Leipzig: Kurt Wolff, 1919).

PETIT DE JULLEVILLE, L. *Histoire de la langue et de la literature française des origines à 1900* (Paris: Armand Colin, 1896–1900).

PINDER, Wilhelm. *Der Naumburger Dom* (Berlin: Deutsche Kunstverlag, 1925).

——. *Das Problem der Generation in der Kunst-geschichte Europas* (Berlin: Frankfurter, 1926).

PING-YING, Hsieh [now transliterated as Xie Bing-ying]. *Autobiography of a Chinese Girl: A Genuine Autobiography*, translated by Tsui Chi and intro-duced by Gordon Bottomley (London: George Allen & Unwin, 1943).

PLANISCIG, L. *Venezianische Bildhauer* (Vienna: Kunst Verlag Anton Schroll, 1921).

PLEKHANOV, G. V. *Art and Society* (New York: Critics Group, 1937).

POWER, Eileen. *Medieval English Nunneries* (Cambridge: Cambridge University Press, 1922).

PRIOR, Edward and Arthur Gardner. *An Account of Medieval Figure Sculpture in England* (Cambridge: Cambridge University Press, 1912).

RANK, Otto. *Art and Artist* (New York: Knopf, 1932).

RANKE, H. *The Art of Ancient Egypt* (Vienna and London: Phaidon Press, 1936).

RODENWALDT, Gerhart. *Abhandlungen der Prüssischen Akademie der Wissenschaften*. Philos-ophisch-Historische Klasse No. 3 (Berlin: Verlag der Prüssischen Akademie der Wissenschaften, 1935).

ROSCHER, W. H. *Ausführliches Lexikon der Griechischen und Römischen Mythologie VI* (Leipzig: Teubner, 1924–37).

ROSENAU, Helen. *Der Kölner Dom: seine Baug-eschichte und historische Stellung* (Cologne: Creutzer, 1931).

——. 'The Portrait of Isabella of Castille on Coins', *Journal of the Warburg and Courtauld Insti-tutes* 3:1/2 (1939/40), 155.

——. 'Women's Portraiture', *Contemporary Review* 155 (1939), 480–84.

——. 'The Institution of Marriage as Seen in Art', *International Women's News* 35:1 (1940), 13.

——. 'Motherhood as Seen in Art', *International Women's News* 35:2 (1940), 34.

——. 'The Community of Women as Seen in Art', *International Women's News* 35:3 (1941), 55.

——. 'Creativeness in Women', *Contemporary Review* 160 (1941), 111–15.

——. 'Towards a New Synthesis', *International Women's News* 35:5 (1941), 97–9.

——. 'Women Pioneers as Seen in Art', *International Women's News* 35:4 (1941), 74.

——. 'Some English Influence on Jan van Eyck', *Apollo* 36 (1942), 125–8.

——. 'The Prototype of the Virgin and Child in the Book of Kells', *Burlington Magazine* 83:486 (1943), 228–31.

——. 'Social Portraits of Princess Mary', *Burlington Magazine* 83:486 (1943), 207.

——. 'Social Status of Women as Reflected in Art', *Apollo* 37 (1943), 94–8.

——. 'A Study in the Iconography of the Incarna-tion', *Burlington Magazine* 85:496 (1944), 172–9.

ROSTOVTSEV, M. I. *The Social and Economic History of the Roman Empire* (Oxford: Clarendon Press, 1926).

RÜHLE-GERSTEL, Alice. *Das Frauenproblem der Gegenwart: eine psychologische Bilanz* (Leipzig: Hirzel, 1932).

SACKVILLE-WEST, Vita. *Saint Joan of Arc* (London: Cobden Sanderson, 1936).

SCHLEGEL, Friedrich. *Lucinde: ein Roman* (Berlin: Heinrich Frölich, 1799).

SCHLEIERMACHER, F. *Idee zu einem Katechismus der Vernunft für edle Frauen* [1798] (Heidelberg: Weissbach, 1938). Translated as 'Ten Command-ments for Wise Women' in Helen Rosenau, 'Changing Attitudes towards Women', in *Women under the Swastika* (London: Free German League of Culture in Great Britain, 1942), 26–7, https://jewish-history-online.net/source/jgo:source-234, retrieved 9 May 2022.

——. *Vertraute Briefe über F. Schlegel's Lucinde* (Lübeck and Leipzig: Friedrich Bonn (published anonymously), 1800).

SCHMELZEIS, J. P. *Das Leben und Wirken der Hl. Hildegardis* (Freiburg: Her'sche Verlagshandlung, 1879).

SCHMIDT, P. W. and W. Koppers. *Völker und Kulturen* (Regensburg: Josef Habbel, 1924).

SCHÜCKING, L. L. *Die Familie im Englischen Puri-tanismus* (Leipzig and Berlin: B. J. Teubner, 1929).

SCHÜRER, Oskar. 'Romanische Doppelkapellen: Eine Typengeschichtliche Untersuchung', in *Marburger Jahrbuch für Kunstwissenschaft V* (Marburg: Verlag des Kunstgeschichtlichen Semi-nars der Universität Marburg an der Lahn, 1929).

SHAW, G. B. 'Two Friends of the Soviet Union' [Beatrice and Sidney Webb], *Picture Post* 12, 20–23, 1941).

SITWELL, Sacheverell. *Conversation Pieces: A Survey of British Domestic Portraits and Their Painters* (London: B. T. Batsford, 1936).

——. *Narrative Pictures: A Survey of British Genre Paintings and Their Painters* (London: B. T. Batsford, 1937).

SMITH, A. H. *A Catalogue of Sculpture in the Greek and Roman Antiquities in the British Museum*, vol. 3 (London: British Museum, 1904).

SPEARING, H. G. *The Childhood of Art or the Ascent of Man* (London: Kegan Paul & Co., 1930).

STEINBERG, S. H. 'A Portrait of Constance of Sicily', *Journal of the Warburg Institute* I (1937–8), 249–51.

—— and Chr. von Pape-Steinberg. *Die Bildnisse geistlicher und weltlicher Fürsten* (Leipzig: B. G. Teubner, 1931).

THIERSCH, Herman. *Artemis Ephesia* (Berlin: Weidmann, 1935).

THOMPSON, Edward. *Suttee* (London: George Allen & Unwin, 1928).

THOMSON, G. D. *Aeschylus and Athens* (London: Lawrence and Wishart, 1941).

THURNWALD, R. *Die Menschliche Gesellschaft in ihren ethnosoziologischen Grundlagen* (Berlin and Leipzig: Walter de Gruyter & Co., 1931–5).

VAN de Velde, Th. H. *Die Fruchtbarkeit in der Ehe und ihre wunschgemässe Beinflussing* (Leipzig and Stuttgart: Horw-Luzern, 1929).

VON Eschenbach, Wolfram. *Parsival* [no edition cited] (*c*.1200).

VON Tschudi, Hugo. *Ausstellung Deutscher Kunst, 1775–1875* (Munich: F. Bruckmann, 1906).

VULLAMY, C. E. *Aspasia: The Life and Letters of Mary Granville, Mrs Delany 1700–1788* (London: Geoffrey Bles, 1935).

WADDELL, Helen. *Lyrics from the Chinese* (London: Constable, 1913).

WALEY, Arthur. *The Nō Plays of Japan* (London: Allen & Unwin, 1921).

——. *An Introduction to the Study of Chinese Painting* (London: Benn Brothers, 1922).

WARBURG, Aby. *Gesammelte Schriften: die Erneuerung der Heidnischen Antike* (Leipzig: Teubner, 1932).

WEBER, Marianne. *Ehefrau und Mutter in der Rechtsentwicklung* (Tübingen: J. C. B. Mohr, 1907).

WEBER, Max. *Wirtschaft und Gesellschaft* (Tübingen: J. C. B. Mohr, 1921).

WECHSSLER, Edouard. *Das Kulturproblem des Minnesangs* (Halle: M. Niemeyer, 1909).

WEININGER, Otto. *Sex and Character* (London: William Heinemann, 1906).

WEISBACH, Werner. *Der Barock als Kunst der Gegenreformation* (Berlin: Bruno Cassirer, 1921).

WERFEL, Franz. *The Song of Bernadette* (London: Hamish Hamilton, 1942).

WESTERMARCK, E. A. *The History of Human Marriage* [1891], 5th ed., 3 vols (London: Macmillan, 1921).

WOOLF, Virginia. *Orlando: A Biography* (London: Leonard and Virginia Woolf at the Hogarth Press, 1928).

——. *A Room of One's Own* (London: Leonard and Virginia Woolf at the Hogarth Press, 1929).

WRIGHT, Frederick A. *Feminism in Greek Literature from Homer to Aristotle* (London: G. Routledge & Sons, 1923).

WULFF, August. *Die Frauenfeindlichen Dichtungen in den romanischen Literaturen des Mittelalters bis sum Ende des XIII Jahrhunderts* (Halle: Ehrhardt Karras, 1914).

ZIMMERN A. E. *The Greek Commonwealth* (Oxford: Oxford University Press, 1922).

ZUCKERMAN, Solly. *The Social Life of Monkeys and Apes* (London: Kegan Paul & Co., 1932).

ZWARTS, Jac. *The Significance of Rembrandt's* The Jewish Bride. No publisher. Printed by J. G. van Amerongen & Co., Amersfoort, 1929).

Index of Artists

Isomorph Prospectus 1944

With this volume commences a series of monographs on science, technics, sociology and art. It is intended that these shall consist of a general text of some 10,000 words, a concurrent text of notes, amplifications and bibliographical references approx. 5,000 words, and equal presentation of the argument in visual form.

The following publications are scheduled:

ELECTRONICS IN INDUSTRY by Geoffrey Bocking, comprising Introduction, Social Relations of Industry, Effects of a new Technic, Historical Background and conditions necessary for its practical development, Explanation of concepts, Electronics as a Technic, Structure and organisation of Industry, Analysis in terms of social value, Applications, inter-relations and functional synthesis, Future development (*Isomorph 2*).

PERPETUAL MOTION by a young scientist at present engaged on Government research: History and nature of the idea, Categorical analysis, Practical development, Influence of Physics, Entrophy of the universe, Value of perpetual motion, Conclusion in retrospect, Anthropocentric philosophical background, Perpetual motion and metaphysics, Exceptions to conservation of energy, Evolution and auto-evolution, Relation to Art and Philosophy, Conclusion and Miscellany (*Isomorph 3*).

ORIGIN OF JAZZ by Ken Hawkes: Introduction, Sources of Jazz, Background, New Orleans, Storyville, Early musicians as a social caste, Function of Jazz and environmental influence, Conclusion (*Isomorph 4*).

In course of preparation are: PREFABRICATION IN THE BUILDING INDUSTRY; RELATIVE GROWTH; PRIMITIVE MUSIC; MONOGRAMS AND THE ABACUS; POWER JETS; NEOTECHNIC FORMS. The series will be uniform in typography and binding.

Trade distribution is from 26 Manchester Square, London, W.1.

3

Reading Helen Rosenau's 'Little Book' Now

Seven Essays on *Woman in Art*

Griselda Pollock

Preface

I selected seven aspects for a close reading of Helen Rosenau's text to view the intellectual moment from which it sprang through its reception 'now'. I start by creating a historical context for the images Rosenau selected for the cover in order to develop an interpretation of their juxtaposition. I then explore the timescale between the two images conveyed by the subtitle, which, prepositionally, indicates the historical scope of the 'little book' while tracing the transformation of both the concept of Woman and the nature of art between the Palaeolithic and the modern periods. This involves situating Rosenau's art-historical vision in conversation with her contemporary feminist sociologists, who also offered a long view of the institutions shaping women's lives and concepts of Woman. In the second essay, I focus on the 'Foreword' and 'Preface' and on Rosenau's proposition for a social history of art, which I contrast to the anti-Marxist and positivist position of her contemporary Ernst Gombrich. I also introduce the correspondence of Barbara Hepworth, discussing Rosenau's book and its resonances with her creative responses in sculpture as an artist and a young mother of triplets in precarious economic conditions and later war time. In the third essay, we shall understand how the image sequences – 'plates' – function as a method, akin to, yet following, logics of connection distinct from Aby Warburg's *Bilderatlas Mnemosyne*. In the fourth, I explore Rosenau's preliminary publications initially laying out the territory of her published book. In the fifth, I have reconstructed and annotated the 'missing bibliography'. In the sixth essay, I undertake my own 'situated' reading of the little book, chapter by chapter. I reveal Rosenau's place in a network of scholars and discuss the dialogues between Rosenau in art history and the scholars, women and men, in archaeology and anthropology, also investigating gender historically and theoretically. I conclude, in the seventh essay, with thoughts about 'time' in Rosenau's project in relation not only to Warburg's *persistence* (*Nachleben*) but also to Michel Foucault's 'archaeology of knowledge'. I also propose a 'preposterous' resonance with Julia Kristeva's thesis in 1979 on 'women's time'. My personal afterthoughts place Rosenau's 'little book' in dialogue with my generation's attempt, after 1970, to engender what I call 'feminist interventions in art's histories'.

Essay 1

The Cover and the Title

Paper-covered, ring-bound in clear plastic, *Woman in Art* measures only 13 × 19 cm (fig. 3.1), a scale hardly conveying the monumental significance of its contents. Priced at 5 shillings (£18–20 or $22–5 in today's currency), it was published in February 1944 by Isomorph, an experimental press established by British typographer Anthony Froshaug (1920–1984), and was Isomorph's only publication. Froshaug planned a series on science, technics, sociology, and art: proposed titles included *Electronics in Industry*, *Perpetual Motion*, *Origin of Jazz*, *Primitive Music*, *Power Jets*, and *Prefabrication in the Building Industry*, all unexpected companions to *Woman in Art*, some topics so clearly proto-masculine and solely industrial or scientific. The prospectus specifies a typical word limit for Isomorph books – Rosenau's was twice as long – but Froshaug required both footnotes – the author is academically identified as DrPhil PhD Helen Rosenau – and 'presentation of the argument in visual form'. Rosenau's argument was indeed structured, rather than illustrated, by the images. How eloquent is Isomorph's embrace of her topic in such a modernist, experimental, and progressive series so distinct from the academic weight of Phaidon or its British followers. I want to explore the main title and the subtitle, but first, the images on the cover.

— The Images and Their Placement

In faded red, the cover prints free-floating views of a tiny (11 cm) carved stone figurine that is currently dated to between 33,000 and 25,000 years ago (fig. 3.2). It is small enough to nestle in the palm of a hand. What is it? How was it used? Was it a burial ornament to be laid in a grave on its back or was it a charm to nestle in the hand? Why is the head bowed and decoratively carved? Is this plaited hair, a hat, a crown, a veil? Why are the arms so long and thin and crossed, curving over the breasts? Did the figure once have feet? Could it have stood? Why is the figure's front more fully realized and anatomically detailed than the back? Why are parts tinted with ochre? If we ponder who made it and for what purpose, we must avoid projections from the modern world that misrepresent, or fail to imagine, the purposes for which this figurine was made and the uses to which it was put by the society that created a tiny, detailed, accurate

Isomorph 1 Woman in Art by Helen Rosenau DrPhil PhD | 55ill 100pp 5'-

Dewey Decimal Clasification 396.7 [709]
Universal Decimal Classification (Brussels 1933) 7(09):396:7
First published February 1944 by Isomorph Ltd 3 Pitts Head Mews London W1
Printed in Great Britain by The Marshall Press Ltd Milford Lane Strand London WC2
Bound Plastoic by Nevett Ltd Colindale London NW9
Typography and cover design by Anthony Froshaug

image of a mature woman that could be both an image of life-giving and a symbolic figuration of a goddess of life or of death.

The figurine was excavated in 1908 at a Palaeolithic site – Willendorf, Austria – by a Johann Veran or Josef Veram during an excavation led by archaeologists Josef Szombathy, Hugo Obermaier (1877–1946), and Josef Bayer.[1] It is carved from an oolitic limestone that is not found in this region. Recent research identified its geological origins near Lake Garda, Italy, 965 km away, suggesting a considerable migration of the Gravettian people or their goods.[2] A sculpted figure evoking a mature woman who has carried and nourished children, it has been termed a fertility symbol. The epithet *Venus* is anachronistic and inappropriate. Both identifications fly in the face of what Rosenau was exploring in *Woman in Art*, proclaimed on the cover by overlaying one of the three views of the ancient figurine, placed upright, with an abstract sculpture by Barbara Hepworth (1903–1975), created just seven years before this book's publication.

The unearthing of the Willendorf figure introduced the figurine into twentieth-century Art History at the point when the back-limits of the

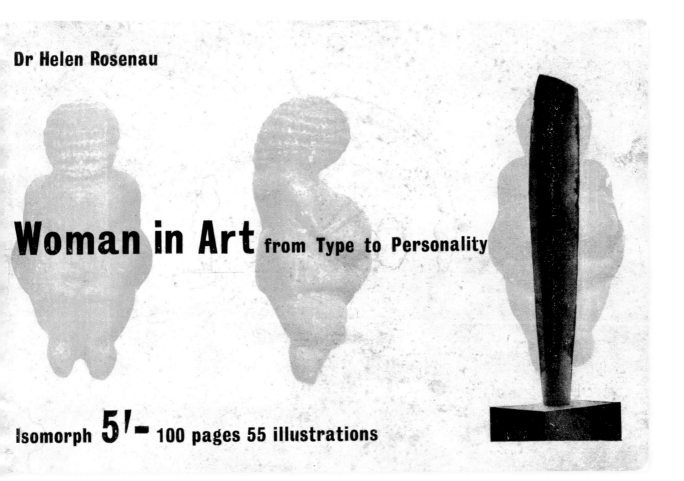

Dr Helen Rosenau

Woman in Art from Type to Personality

Isomorph **5/-** 100 pages 55 illustrations

history of European cultures were being extended by new discoveries of Stone Age artefacts. These challenged then-current understandings of the history of *Homo sapiens* and indeed of our species' capacity for imagining and making aesthetic objects. Only in 1946, with carbon dating, could archaeologists confirm the long history of such elaborately conceived symbolic objects created 33,000–25,000 years ago.[3]

The revelations of the paintings in the cave complex of Altamira in Cantabria, Spain, through their discovery in 1879 by the non-professional archaeologist Marcelino Sanz de Sautuola (1831–1888) and his daughter and the presentation in 1880 of the find as 'palaeolithic' had been a sensation at the time. Immediately, archaeologists disputed the dating, naming the find a fake for it was unimaginable that sophisticated work like these painted cave complexes could have been made in the period to which the paintings were attributed by Sautuola and the archaeologist Juan de Vilanova y Piera (1821–1893), with whom he published the discovery in 1880. Only further cave finds in France and Spain forced the academic establishment to acknowledge this shattering possibility of such aesthetic skills and imaginative mentalities in Stone Age

3.1 *Woman in Art* (London: Isomorph, 1944).

3.2 Four views of the Willendorf 'Venus', 33,000–25,000 BCE, oolitic limestone, 11.1 cm tall. Natural History Museum, Vienna. Photo: © Natural History Museum, Vienna.

peoples. By 1902 the dating of Altamira's paintings was affirmed; sceptical voices were finally silenced. The caves were then studied by several scholars, including, in 1924–5, Hugo Obermaier, who had been involved in the discoveries at Willendorf in 1908.[4]

Both finds and hesitancies were symptoms of a *modern* consciousness being challenged by the discoveries of extended geological, historical, cultural time in the emerging disciplines of Archaeology, History, and Art History. Being moderns – endpoints of evolution and a linear concept of history as progression – predetermined how these art historians, anthropologists, and archaeologists perceived and represented the pasts they were writing for a humanity of which they felt themselves the culmination. Yet proofs of the longevity of aesthetic artefacts with symbolic meanings shattered that assumption. It inspired modernist culture, equally contesting colonialist projections of primitivism onto co-existing cultures across the globe – from Amazonia to the Australian continent – that were, are in fact still, vivid instances of hunter-gatherer societies and their aesthetic–symbolic systems.

Dr Helen Rosenau was an *archaeologically* trained art historian, studying in the era immediately after these finds. In her doctoral studies of the origins of built forms – such as cathedral and synagogue – she analysed aesthetic and symbolic spaces – like the caves – shaped by active construction, decoration, and use, with mythic, symbolic, social, cultural, and theological significance. Her first PhD was on the origins and meaning of Cologne Cathedral, initiated in 1248 on the ruins of an even earlier

cathedral and ancient ruins and completed only in 1880 (see fig. 1.11); her second was on Bremen Cathedral, with older origins in the eleventh century; while her third doctoral dissertation, in London, focussed on the second-century synagogue, early remains of which had emerged only recently with the excavations of the painted synagogue at Dura-Europos in Syria as recently as 1932 (see fig. 1.14) – these place Rosenau in the academic community that was redefining the historical time of the Western and indeed Middle Eastern present through these 'diggings' into the past.[5] The disorienting effect of uncovering hitherto unknown and even unthinkable pre-histories on the modern present cannot be underestimated. The enigma of the imaginative worlds of the eras, cultures, and societies to which archaeology was giving access with these material remains was itself a critical foundation for Art History.

In addition to Archaeology, Anthropology was developing propositions about the formations of humanity and social and symbolic systems. Both disciplines elaborated relays between contemporary notions of society, family, gender, religion, and myth and what were, for the most part, hypothetical interpretations of remains and of actual practices, some still operative in contemporary cultures, being projected back into ancient pasts and vivid aesthetic–symbolic life-worlds that peoples still inhabited, even if long since overlaid (but never erased) by modernizing Europe.

Placing the Willendorf figurine on the cover of *Woman in Art* was to participate visually, therefore, in a *contemporary* cultural process of reconfiguring a long history of humanity and art and to engage with vivid debates about symbolic representation of life, begetting, desire, fear, and death across unimaginable stretches of human life-worlds. The cover thus poses *woman* in *art* not as a subcategory, but as a central signifier of human social relations and imagination from the beginnings of humanity's conceptual activity. Paradoxically, however, placement also lodges Rosenau's argument in the space of modernism in the visual arts. The expansion of histories of art under the influence of archaeologically incited interest in remains of earlier aesthetic modes directly fertilized the anti-Classical, post-academic developments of modern art drawing inspiration from other 'aesthetic–symbolic practices', in Cuban art historian Gerardo Mosquera's postcolonial, inclusive term.[6] An urgent search for new pathways for Western art was being fertilized in encounters with the rich pasts and creative presents of world cultures in Asia, Oceania, and the Latin American and the African continents that were, in European art-historical terms, located falsely in the childhood of aesthetic humanity. Cultures outside Europe were thus deformed through the racist and Eurocentric lens of Western ideas of a line from the most archaic (the others) to the most sophisticated (the Western).

Instead of imagining that, in their search for ways to revitalize the Greco-Christian tradition in art, modern European sculptors and painters were *going back* in human history and time to archaic, less sophisticated eras and cultures, we can acknowledge the rich diversity of *concurrent* aesthetic–symbolic systems and their formulations. As a source for formal and aesthetic–symbolic art-making, prehistoric art became, alongside the colonially looted booty from the contemporary and historical cultures of the world, a resource for the needs of a modern art in capitalist industrial Modernity. It is no surprise to find the advocates of modern art in the twentieth century also being the art historians writing about prehistoric art as a reverse validation for modern art, for instance in the case of Herbert Read, advocate of abstraction.[7]

The stunning combination of the Willendorf figure and a modernist sculpture by Rosenau's contemporary the British sculptor Barbara Hepworth on the cover of *Woman in Art* visually refutes a linear journey *from* archaic *to* the present. Any simple temporal traverse across time moving from left to right on the page is displaced strategically and conceptually by *overlaying* the third view with a second sculpture that visually encapsulates the modern present.

The other sculpture is Hepworth's *Single Form* (1937) (fig. 3.3). Its vertical axis formally echoes, however, a possibly anachronistic reading of the Willendorf figure as a standing figure. This choice is itself significant. The years 1936–7 were transformative in the career of Hepworth. During the later 1920s and early 1930s, the sculptor's work was figurative, exhibiting her engagement with non-Western resources for imagining sculptural form *emerging* from its substance (the catchphrase was 'truth to materials') while sculpturally remaining 'true' to stoniness or woodiness (through direct carving). Hepworth was balancing the emergence of sculpted figures from the stone or wood with the resulting image's inseparability from the physical properties of its material. Works such as her *Mother and Child* of 1929 in brown Hornton stone (now lost) and *Kneeling Figure* (rosewood, 1932) retain the geometry of their original blocks, while in *Torso* (1929), in African ivory wood, the evocation of a standing female body mimics the verticality of the tree from which the wood derives. *The Figure of a Woman* (1929–30, Corsehill stone) and *Figure in Sycamore* (1931, sycamore) animate the former monumentality with movements of the head and the gestures of the hands. Working in marble in the early 1930s, Hepworth slowly effaced figuration by highly polishing marble in sculptures that still evoke a potential figure without becoming a figuration. For instance, Hepworth's interest in relations between small and large begins to separate the typical iconography of such a relation, the mother and child, into two differentiated forms

3.3 Barbara Hepworth (1903–1975), *Single Form*, 1937, holly wood, 89.8 × 28 × 17.6 cm. BH 102. Leeds Museums and Art Galleries. © Bowness. Photo: Bridgeman Images.

interlocking more abstractly in their intuited shaping as formulations of protectiveness, vulnerability, difference, and dependence.

In her *Mother and Child* of 1934, after earlier work that bears some relation to her interest in groups, two forms become relational without iconographic implications. Relationality and difference dispense with that frame and are explored formally. *Single Form* is one of several engagements in 1937 with this most challenging of projects that, in a sense, digs deepest into the questions Hepworth was exploring. Direct carving and materials alone had to do the work of enabling a form to 'stand for' uprightness as an exercise in verticality, while the modernist sculpture, nonetheless, rhetorically stages a drama of both the singular (individuation) and the solitary (separation). Rising on a vertical axis from its narrowest point on its offset, squared cube base, with expanding roundness at the top, the sculpture presents different linear profiles that are undone by subtle swells of fullness perceptible to the viewer moving around the form in space.

A tiny statuette with swelling hips and breasts, footless legs, and a decorated head with no face had discovered indexical anatomy as a language of symbolic representation even if we can no longer decipher its meaning and must avoid patriarchal projection. Barbara Hepworth's abstract sculpture has moved from the highly developed legacy of the discovery of the body as signifier (which passed from Egypt to Greece to found the Western academic tradition) to bring forth from wood a modernist *pathos formula*. The single form appears to be without bodily identifiers, yet is rich with resonances that produce a standing form that is non-phallic. Is this, abstractly, a modern reformulation of a woman as the figure of the human adumbrated by the sculptor of the Willendorf figure?

Single Form was shown in October 1937 in Barbara Hepworth's exhibition at her London dealers, Alex Reid & Lefevre Gallery, at a time when the sculptor hardly enjoyed name recognition. The chances are that Rosenau saw this work there. Tracking the early critical reception of the artist, sculpture historian Penelope Curtis reminds us that it was only in 1943 that, after mostly dealer exhibitions, Hepworth finally had her first solo museum show, at Temple Newsam, then part of the Leeds City Art Gallery, curated by art historian and later director of the National Gallery Philip Hendy (1900–1980). Books on Hepworth's work only appeared after 1945.[8] Thus, Rosenau's selection in the early 1940s of this young British sculptor was absolutely in advance of the wave of the critical recognition of Hepworth still to come. It indicates Rosenau's interest in both cutting-edge modern art and art by women who belonged to a circle of intellectuals and writers forming a still marginal cultural avant-garde in London in the 1930s.

Hepworth's 1937 catalogue essay was written by the Irish scientist and Marxist J. D. Bernal (1901–1971), who was Professor of Physics at Birkbeck College, University of London – the adult education arm of London University, known to Rosenau, suggesting further possible encounters, political intersections, and intellectual relays between Rosenau, the artistic modernists, and radical social, engaged, scientific–cultural thought in London in this critical decade. Bernal was in addition of Sephardi Jewish ancestry although raised in Catholicism.

Bernal suggested that first impressions of Hepworth's new work prompted associations with Neolithic culture, namely with 'the art of builders of stone monuments which, in the second millennium, stretched along the coasts from Sweden to Assam'. Neolithic is not 'primitive' but represents 'extreme formalism'.[9] It is 'sophisticated and expresses the realization that important ideas can be conveyed by extremely limited symbolic forms'. At the same time, Bernal also discovered intriguing affinities between Hepworth's recent abstract sculptures and contemporary science and mathematics: 'There is an extraordinary intuitive grasp of the unity of a surface even extending to surfaces which though separated in space and apparently disconnected yet belong together both to the mathematicians and the sculptor.' Hepworth had approved of this association. In her study of Hepworth drawing on the sculptor's correspondence, Eleanor Clayton assesses Bernal's evocations of Neolithic menhirs that 'represented the centre of a ritual' and his contemporary social theory of relations between art and society, suggesting that Hepworth's sculptures call for 'some form of social utilisation'.[10]

Surely read by Rosenau, Bernal's catalogue essay resonates with the juxtaposition on her cover, which served two purposes. Signifying an enormous span of both human history and its record inscribed in materials and forms indicative of symbolic thought and imagination, the placement of an ancient and a contemporary work of art effectively affirmed a contemporary affinity that modern artists were feeling for the formal and symbolic character of the most ancient artworks currently known, many of which had only recently been excavated and were only then shaping a modernist aesthetic imagination. These ancient forms from pre-classical cultures further endorsed modernist abandonment of classical and Christian European traditions based on anthropomorphism or incarnation theology, and, latterly, social realism. Significantly, Rosenau's cover not only binds this long history of art-making to a modernism but also represents the latter with an artist-woman whose abstract sculpture speaks across time to one of the earliest representations of 'woman in art'.

On Rosenau's cover are *sculptures*, spanning thousands of centuries of creative ingenuity and the materialization of symbolic meaning in matter and by hand-carving. Stone and wood have been shaped by thoughtful hands to form two, apparently very different yet deeply related, images. Each evokes a figure whose formal elements model the human body as a signifier even as each sculptor has rendered 'the human body' as a female body because it can signify *life*, be that in the outward signs of a female body's generative and sustaining capacity – not to be confused with notions of fertility – or in a vertical figure of individuated aspiration and declared singularity and autonomy. From type to personality? As equal possibilities both for art and for women, these terms indicate change across historical systems and different mytho-poetic and philosophical emphases with which Rosenau announced and framed her study – for Art History and via a history of art – of a major question posed by early twentieth-century feminist, gender-sensitive social theory.

— The Subtitle

From Type to Personality does not imply a historical trajectory or temporal progression arriving in the present. Prepositionally, it promises a cultural analysis of historical shifts in the formulations of *Woman* as a figure, a position, and a partner in different relationships. Rosenau analyses social and cultural definitions of the key sociological and anthropological relational frames – the couple formed as partners or the couple parent and child – within which Woman is a subject – in the senses of both a topic and a person. The *from/to* is premised on sociological, cultural, and historical changes that were finding concurrent formulation in the early twentieth century in the work not only of modern artists but also of anthropologists, sociologists, and feminist thinkers.

Rosenau formulates a movement *from/to* as change, shift, or struggle rather than as linear development whose destiny is the present. The endpoint – *personality* – references, on the one hand, recent sociological theses about individuation in modern societies and, on the other, the psychological human subject proposed in psychoanalysis in its several forms. The idea of change in that movement *from/to* also encompasses the massive collective revolt through which women became *political* subjects contesting patriarchal traditions and authority that had hitherto determined their social roles and fixed their social identities in the asymmetrical hierarchy of gender.[11] Rosenau's subtitle thus lays out the frame for a history of art that is embedded as much in social formations as in figuration, symbol, image, and form that are interwoven. All demand interpretation in the relay between concurrent but distinct discursive formations.

Personality is not an end point but a historical condition and a moment in continuing historical and social processes. This book is itself not only a symptom of the Modernity of its author – her consciousness of time and change in the domain of both art and gender – but also a site of the inscription of sociological modernism into, and as, art-historical thought – thinking art and society as an inseparable couple. Rosenau centres such an examination of art, society, history, and the definition of the subject in and of gender, on herself, her position, and her embodied place in a gendered, patriarchal world as the site of a grand historical inquiry. Gender is neither a limit nor a destiny. A historical relation, it becomes a theoretical question, a historically precipitated position of revolt, and a theme in aesthetic–symbolic practices of art.

With chapters on marriage, parenthood, and creativity, Rosenau's book explores *Woman* as the product of socially regulated but also psychologically inhabited relationships with others and the world that, in each society, each generation of artists addressed with their own artistic singularity but within socio-cultural–historical–theological–mythological terms not of their own choice. She anticipates what the structuralist anthropologies of Margaret Mead (1901–1978) and Claude Lévi-Strauss (1908–2009) would soon reveal: that the symbolic systems – myth, customs, rituals, beliefs, laws, religions, art – are both social forms and communication systems that we can read, one through the other, asymmetrically and non-hierarchically. Art is thus not derived from or determined totally by pre-existing social relations external to it. Yet art does not simply express the world in either pure forms of its own or an individual artist's invention.

At the beginning of the twentieth century, the German-language academic world in which a middle-class Jewish European woman – Helen Rosenau, born 1900 – had been formed as an intellectual, a social thinker, and art historian was a ferment of investigation into these profound and difficult questions of systems, relations, and specificities spanning from the sciences to the arts and humanities and particularly evident in the emerging social sciences of Anthropology and Sociology. Behind Rosenau's subtitle we might glimpse the shadow of the most widely known nineteenth- to early twentieth-century founders of sociology – Karl Marx (1818–1883), Max Weber (1864–1920), and Georg Simmel (1858–1918) – and Karl Mannheim (1893–1947), as much as art/cultural historians such as Jacob Burckhardt (1818–1897), Alois Riegl (1858–1905), Aby Warburg (1866–1929), or Erwin Panofsky (1892–1968). We should, equally, recognize that a socialist and feminist thinker such as Helen Rosenau was as familiar with, and indeed more deeply drawing upon, the writings of the founding women sociologists, such as

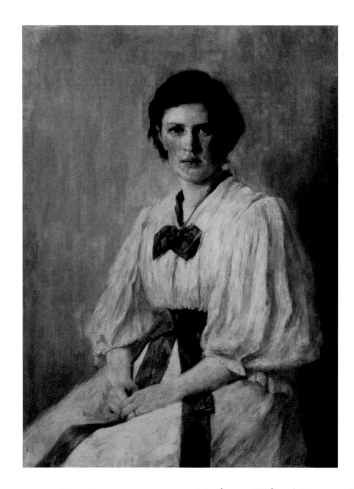

3.4 Marie Davids (1847–1905), *Portrait of Marianne Weber* (1870–1954), 1896, oil on canvas, 97.7 × 71.6 cm. © Kurpfälzisches Museum, Heidelberg. Photograph: K. Gattner.

3.5 Jacob Hilsdorf (1872–1916), *Gertrude Kinel Simmel* (1864–1938), *c*.1905. Photo: Zuri Swimmer / Alamy Stock Photo.

Marianne Weber (1870–1954) (fig. 3.4) and Gertrud Kinel Simmel (1864–1938) (fig. 3.5), as well as British cultural theorist of the origins of ancient art Jane Harrison (1850–1928) (see fig. 3.42).[12]

These brilliant women contested *ab initio* the masculinization of their fields of study and the core theorization of 'the social' itself that was taking place even as women, benefitting from the social and economic changes these very theorists termed *Modernity* – industrialization, urbanization, emergence of new class formations, widening education, travel, publishing, and new political representation and its forms, such as elected parliaments – were questioning both traditional and emerging forms of social life and theoretical understandings of their underpinnings. If the social, as social systems and the social subject, is theorized in such a way that the masculine is the norm and what men do and experience is identified as the social, then women and the feminine, by default, are posited as either *asocial* or radically distinct from *human* norms. Hence, we find heated discussions that link the analysis of the social with the promotion of newly dichotomous

theories of *gender*. Who and what *Woman* is exercised the theorists, who often made absolute declarations from a position of authoritative masculinity appropriating to itself the norms that these writers valued only for themselves.

Modernity produced a class of educated, politicized intellectual women who would use the new tools of sociological as well as philosophical, theological, and aesthetic analysis to challenge such a gender *hierarchy* that was emerging in modern theorizing by men. Women aimed to establish that it was the systems, such as law, religion, social practices, identities, and ideologies – the elements of the social that Sociology emerged to analyse – that produced historically varying arrangements to manage those areas in which sexuality and procreation were socially, economically, and legally organized. Marriage, the family, inheritance, and the division of labour were to be grasped as legal and social arrangements with histories and diversities. Traditional/residual or modern and emerging ideologies about men and women, the masculine and the feminine, had to be contested by insisting on their social rather than natural characters. The title of a major twenty-first-century study of this question is significantly titled *Engendering the Social*, playing on the semantic load of the concepts of gender and the verb 'to engender' within this word itself.[13]

The publications of Marianne Weber and Gertrud Simmel, co-founders of sociological theory, resonate with the framework that feminist social historian of art Helen Rosenau established in her book and its concurrent, but original, exploration of the gender question across the field of visual images. Equally, Rosenau read images as articulations of legal arrangements, social ideologies, lived experiences, and, equally relevant, sources for this 'sociological' study of mentalities or mindsets.

Thus, nineteenth-century and early twentieth-century thinkers were exploring what we now conceptualize as *gender*, which they wrote as Women/Woman through an analysis of the social forms of erotic and domestic relations between men and women – marriage, family, the home – on the one hand, and, on the other, in terms of intellectual and political emancipation and hence access to individuality in the form of being an intellectual or creative personality that chime directly with the chapter divisions of Rosenau's book.

Marianne Weber's contribution to Sociology, a discipline that was being thought from liberal or socialist but also strongly masculinist points of view, was to propose rethinking the social as *centred on women* and thus using *women* to 'map and explain the construction and reproduction of the social person and the social world', as Patricia Madoo Lengermann and Gillian Niebrugge argue in their chapter on women

founders of sociology such as Marianne Weber.[14] They argue that she 'takes women's experiences as the starting point for her sociological investigation, and makes women's subjectivity the frame by which social experiences are to be perceived and evaluated. Her sociology was woman-centred both in the issues she studied and from the angle of vision from which she studied.'[15] They identify four themes in Marianne Weber's Sociology: 'groundedness in women's experience, a focus on marriage as the paradigm for patriarchy, a use of women's work to map the social world, and the sensitivity to differences among women'.[16]

Marianne Weber also took issue with one of the more progressive of the 'founding fathers', Georg Simmel, who might appear as a radical thinker on gender and society. Instead of a crude use of the masculine as the norm and yardstick for the human, relegating women to secondary status, Simmel attributed equally valuable qualities to women. He thus appears to valorize the feminine as a concurrent model for human beings even as, being different, women for him 'lacked' certain qualities of rationality that gave men the socio-political edge in the public realm. While welcoming the relief offered from the more overtly sexist philosophers, Weber rejected Simmel's metaphysics of gender because it denied to any person of each sex the qualities identified as the essence of the other. Simmel had identified modernization with objectivity, which he attributed to men, leaving modern society at the mercy of masculinity. To escape this, he advocated the input from femininity, defined as not part of 'objective culture'. Femininity was needed to rescue the modern world from rational masculinism. While he positively endorses certain aspects of the supposed feminine 'character', all women are then trapped within his negative concept of femininity, making women unable to exercise intellect, leadership, or genius without deviating from their gender typology. Under this dichotomy, however positivizing it appeared, any diversion from Simmel's gender categories – for instance that men *do* sexuality while women *are consumed* by it, or men *do* rationality while women *think only with caring sensitivities* – would make any person not so normatively consistent with Simmel's opposing masculine or feminine categories deviant, intersex, inauthentic. If rationality is a masculine attribute, the intellectual woman is a hybrid and unfeminine, and vice versa. Accepting there are differences between men and women, but not as absolutes, Marianne Weber thus proposes a way of valuing potential differences as overlapping capacities shared between men and women that stand above the typical or general tendencies. These overlaps constitute for both men and women an access to what she defined as 'a full human being'.[17] Marianne Weber furthermore argued that what also stands in the way of women fully realizing

themselves is lack of education and the unpaid burden imposed on them of domestic and caring responsibilities. Hence the legal as well as ideological idea of marriage (what the later twentieth century in part redefined as partnership) becomes a critical place for renegotiation not of masculine and feminine natures, but of the distribution of economic resources, responsibilities, education, and life choices to ensure equal access via singular and perhaps also gender-difference-enhancing and differentiated pathways to all that is possible for any human being. She analysed the legal, economic, and social status of women from antiquity while defining contemporary marriage as 'a complex and ongoing negotiation over power and intimacy, in which money, women's work, and sexuality are key issues'.[18] Marianne Weber's publications are indicative:

> *Beruf und Ehe* (Occupation and Marriage; 1906)
>
> *Ehefrau und Mutter in der Rechtsentwicklung*
> (Wife and Mother in the Development of Law; 1907)
>
> *Die Frage nach der Scheidung* (The Question of Divorce; 1909)
>
> *Autorität und Autonomie in der Ehe*
> (Authority and Autonomy in Marriage; 1912)
>
> *Über die Bewertung der Hausarbeit*
> (On the Valuation of Housework; 1912)
>
> *Frauen und Kultur* (Women and Objective Culture; 1913)
>
> *Die Frauen und die Liebe* (Women and Love; 1935)
>
> *Erfülltes Leben* (The Fulfilled Life; 1942, republished 1946)

Such texts fill out the context for the categories we find in *Woman in Art*, shaped in a later nineteenth-century and pre-war feminist intellectual and political moment.

Like so many disciplines, twentieth-century academic Sociology actively has erased from its canon its many women co-founders, both telling its history through male scholars and persisting in centring social studies on masculinity and on men as *the* social subject – white, heterosexual, even if both bourgeois and working class. In their major study, *The Women Founders: Sociology and Social Theory, 1830–1930; A Text/ Reader*), Lengermann and Niebrugge argue:

Despite their work in sociology and social theory and their visibility to their contemporaries, the women founders disappeared as a significant presence from sociology's record, surviving in marginalized positions. [Harriet] Martineau is remembered as Comte's translator; [Marianne] Weber, as handmaiden to genius: [Beatrice] Webb, as Sydney's partner; [Jane] Addams, as secular

saint; [Charlotte Perkins] Gilman, as the eccentric genius of *The Yellow Wallpaper*; and the Chicago Women's School of Sociology (15 named authors including Florence Kelley), as social workers and reformers. [Anne Julia] Cooper is quoted by DuBois but acknowledged only as a 'woman of the race'.[19]

The massive feminist debates from Japan to the United States of America generated by women active in emancipatory, socialist, and socially and intellectually feminist programmes and theory during the nineteenth and early twentieth centuries have been effaced just as women's modern artistic co-creativity has been. Both were international. For instance, Marianne Weber, visiting the United States of America in 1904 with Max Weber, met the social theorists and activists Jane Addams (1860–1935) and Florence Kelley (1859–1932). Helen Rosenau was the inheritor of this centring of key debates on women's experience and on social institutions and ideologies demarcating the social world by gender, positively or negatively.

Rosenau attended lectures in Germany by Gertrud Simmel and told Adrian Rifkin, when he was studying with her in Manchester, that this experience had made her a feminist.[20] In 1910, Gertrud Simmel published *Realität und Gesetzlichkeit im Geschlechtsleben* (Reality and Law in Sex/Gender Life), which, like Marianne Weber's work on marriage, love, and divorce as indicated in her publications listed above, was also a study of women and men in marriage.[21] These two women's publications reveal that the feminist debates in the German cradle of Sociology focussed on the legal and economic institutions of marriage, divorce, and gender being transformed structurally by economic modernization and challenged politically by women – middle-class women in terms of education, economic independence, and sexual self-determination and working-class women in terms of working conditions and wages, and all desiring freedom from violence, forced sexual *corvée*, and sexual predation.

As an original exercise in feminist thinking in Art History, Rosenau's book was not stranded in the mid-twentieth century, passively awaiting a feminist reawakening after 1968. Politically and intellectually, it was the inheritor and elaborator of the urgent modern engagements with gender, sex, patriarchal institutions, and socio-legal relations that animated the emerging and modernist social sciences attending to their origins (Archaeology and Anthropology) or analysing their function (Sociology) or advocating for their current transformations (Politics). When an art historian as deeply engaged with this array of radical debates as Helen Rosenau chose to undertake this study of *Woman in Art* at the London School of Economics, and advised by a sociologist, Karl

Mannheim, she did so as a younger contemporary of Gertrud Simmel and Marianne Weber and other feminist thinkers of the widespread women's movements and political, social, and theoretical activisms – especially in the German-speaking world in which she was first educated. She was, however, original in forging her own transdisciplinary moves to animate the field of art's histories and the study of images as a concurrent site for these same modern, feminist investigations into the long, not always patriarchal, histories of thought, society, and imag(in)ing. We hear the theoretical resonances with the intellectual debates in German sociology and feminism in the statements in the opening 'Preface', to which I now turn.

Notes to Essay 1

1 The term 'Palaeolithic', referring to an era from three million to 12,000 years ago, was coined in 1865 by John Lubbock and is based on the Greek words for 'old' and 'stone'; it also translates as 'the Old Stone Age', referencing the era of hominids (*Homo habilis* and *Homo sapiens*) when stone tools were forged. The Neolithic is dated from about 12,000 to about 2,000 years ago. The former is characterized by stone tools (the Stone Age) while the latter arises from agriculture. Tool and resource uses differ in terms of cultures arising around life dependent on hunting and the cultures arising from farming and the use of domesticated animals. The figuration of the female body directly or abstractly predominates. See Marija Gimbutas, *The Language and the Goddess: Unearthing the Hidden Symbols of Western Civilization* (San Francisco: Harper & Row, 1989). The life dates of Veran/Veram, Szombathy, and Bayer are unknown.

2 Gerhard W. Weber *et al.*, 'The Micro-structure and the Origins of the Venus from Willendorf', *Scientific Reports* 12 (2022), 2926.

3 Radio-carbon dating of organic materials by measuring the content of carbon-14 was initiated in 1946 by Willard Libby.

4 Hugo Obermaier, *Urgeschichte der Menschheit, in Geschichte der führenden Völker I* (Freiburg: Herder Verlagsbuchandlung, 1931) is cited in Rosenau's footnotes, which I have compiled as a bibliography in Essay 5.

5 Helen Rosenau, *Der Kölner Dom: seine Baugeschichte und historische Stellung* [1930] (Cologne: Creutzer, 1931); *Design and Medieval Architecture* (London: B. T. Batsford, 1934); *The Architectural Development of the Synagogue* (PhD thesis, Courtauld Institute, University of London, 1939).

6 In a verbal symposium presentation at the Centre for Curatorial Studies, Bard College, New York, in 1993, Mosquera proposed the inclusive term 'aesthetic–symbolic practices' instead of the narrowed Western concept of art, the latter creating a hierarchy favouring Western art-making materials such as paint, stone, and wood over those used in many other cultures, such as textiles or ceramics, thus confining the concept of art to Western practices and classing others as 'crafts'.

7 Herbert Read, 'Art and the Evolution of Consciousness', *Journal of Aesthetics and Art Criticism* 12:2 (1954), 143–55.

8 Penelope Curtis, *Barbara Hepworth* (London: Tate Publishing, 1998), 49. Curtis mentions William Gibson, *Barbara Hepworth* (London: Faber, 1946); Herbert Read, *Barbara Hepworth: Carvings and Drawings* (London: Lund Humphries, 1952); and A. M. Hammacher, *Barbara Hepworth* (Amsterdam: DeLange, 1958).

9 J. D. Bernal, 'Foreword' to *Catalogue of Sculpture by Barbara Hepworth* [1937], in *Barbara Hepworth: A Pictorial Biography* [1970] (London: Tate Gallery, 1993), 36.

10 Bernal, 'Foreword', 36; Eleanor Clayton, *Barbara Hepworth: Art & Life* (London: Thames & Hudson, 2021), 108.

11 In her book *Am I That Name? Feminism and the Category of 'Women' in History* (Basingstoke: Macmillan, 1988), feminist historian Denise Riley tracked the increasing degree of sexualisation by which, during the nineteenth century, social identity became saturated 'by the empires of gender over the entirety of the person' (14).

12 Patricia Madoo Lengermann and Gillian Niebrugge, *The Women Founders: Sociology and Social Theory, 1830–1930; A Text/Reader* (Boston: McGraw-Hill, 1998).

13 Barbara L. Marshall and Anne Witz (eds.), *Engendering the Social: Feminist Encounters with Sociological Theory* (Maidenhead: Open University Press, 2004). On the masculinization effect and the gender in and of Modernity itself, see Anne Witz, 'Georg Simmel and the Masculinity of Modernity', *Journal of Classical Sociology* 1:3 (2001), 353–70; on the questioning of Simmel and gender, see Janet Wolff, 'The Feminine in Modern Art: Benjamin, Simmel and the Gender of Modernity', *Theory, Culture & Society*

17:6 (2000), 33–53. See also Theresa Wobbe, 'Elective Affinities: Georg Simmel and Marianne Weber on Gender and Modernity', in *Engendering the Social: Feminist Encounters with Sociological Theory*, ed. Barbara L. Marshall and Anne Witz (Maidenhead: Open University Press, 2004), 54–68.

14 Patricia Madoo Lengermann and Gillian Niebrugge, 'Marianne Weber (1870–1954): A Woman-Centered Sociology', in *The Women Founders: Sociology and Social Theory, 1830–1930; A Text/Reader* (Boston: McGraw-Hill, 1998), 193–228: 203. See also Tabea Tiertz, 'Marianne Weber and the Status of Women in Patriarchal Societies', in *SciHi Blog*, 2 August 2017, http://scihi.org/marianne-weber, retrieved 18 February 2023.

15 Madoo Lengermann and Niebrugge, 'Marianne Weber', 203. See also Tiertz, 'Marianne Weber and the Status of Women in Patriarchal Societies'.

16 Madoo Lengermann and Niebrugge, 'Marianne Weber', 203.

17 Marianne Weber, 'Die Frau und die objective Kultur', in *Frauenfrage und Frauengedanke: Gesammelte Aufsätze* (Tübingen: J. C. B. Mohr, 1919), 95–133: 132, responding to Georg Simmel's paper 'Das Relative und das Absolute im Geschlechter-Problem' [1911], in *Georg Simmel: Schriften zur Philosophie und Soziologie der Geschlechter*, ed. H. J. Dahme and K. C. Köhnke (Frankfurt am Main: Suhrkamp, 1985), 200–23. This interpretation and reference are from Lieteke van Vucht Tijssen, 'Women and Objective Culture: Georg Simmel and Marianne Weber', *Theory, Culture & Society* 8 (1991), 203–18: 210. See also her 'De plaats van de vrouw in de moderne cultuur: Marianne Weber contra Georg Simmel', *Sociale wetenschappen* 31:8 (1988), 83–101.

18 Tiertz, 'Marianne Weber and the Status of Women in Patriarchal Societies'.

19 Madoo Lengermann and Niebrugge, *The Women Founders*, 10.

20 Personal communication from Adrian Rifkin to Griselda Pollock, 1996.

21 Gertrud Simmel publishing as Marie Louise Enkendorff, *Realität und Gesetzlichkeit im Geschlechtsleben* (Leipzig: Dunker & Humblot, 1910).

Essay 2

The Foreword and the Preface

The 'Foreword' is by George Peabody Gooch (1873–1968) (fig. 3.6). From a privileged (Eton and Cambridge) English family, Gooch sat as a Liberal Member of Parliament (1905–10), supporting the 1908 bill to grant women's suffrage. He was editor of the Liberal *Contemporary Review* and a world-renowned historian of international relations with a long-term interest in Germany. Married also to a German woman, Gooch was specialist in German history, abhorring and denouncing the Third Reich. He was known for the active assistance he offered to exiled refugee scholars from Germany, sufficiently to have his name, alongside one of those he helped – Helen Rosenau – put on Himmler's infamous Black Book for England (the list named those to be captured and destroyed following the planned conquest of Britain).[1] Gooch became one of the pre-eminent historians of his day, lending his full academic standing to Rosenau's book. Significantly, he defined her project in the following terms:

> Dr Rosenau's approach is sociological. Her aim is to relate the representation of women in art to their position during the various stages through which *Homo Sapiens* has passed in his [sic] long and painful ascent from primitive times to the differentiations and complexities of the twentieth century. Her text, enriched and fortified by elaborate bibliographical notes, reveals her as a thinker no less than as a narrator of social evolution.

Characterizing her approach as sociological, Gooch places Rosenau in the debates about gender and society that Marianne Weber (1870–1954) undertook with/against Georg Simmel (1858–1918), terming it a study of 'social evolution'; it is also linked to evolutionary and anthropological studies, although Rosenau's book fiercely contests the ideology of an 'ascent from primitive times to the differentiations and complexities of the twentieth century'. Gooch defines 'the emergence of woman' as 'one of [the] most thrilling chapters' in the history of humanity, by which we must assume he implies *woman* as both a subject and a distinct mode of human being. He thus praises Rosenau for her innovative study of the 'revaluation of values' (by which he means the changing valuation of woman legally, politically, socially, and economically) through the 'relatively unfamiliar angle of the history of art'. Gooch acknowledges

3.6 Walter Stoneman (1876–1958), *George Peabody Gooch* (1873–1968), 1930, bromide print on card, 15 × 11.2 cm. National Portrait Gallery, London.

189

the methodological and thematic–cultural debates that indicate the breadth of Rosenau's foundational research and her unique perspective on the grand sweep of social evolution by means of studying images historically.

Rosenau's 'Preface' follows immediately.

> The purpose of this study on Woman in Art is threefold: firstly, to show the close interrelation which exists between the visual arts and the society to which they belong; secondly, to suggest the changing attitudes held regarding womanhood in the course of human evolution. The third problem to be considered is whether there may be found some permanent features which repeat themselves in varying social conditions, and may be regarded as typically feminine.

The visual arts have clear priority, while social evolution and 'the emergence of woman' are also highlighted. (Was Gooch borrowing from her 'Preface'?) She has, however, added a psychological dimension that bespeaks a specifically feminist questioning of history and of art.

Let me parse her three purposes as i) *interrelations*: art and society; ii) *attitudes*: womanhood in history; iii) *findings*: permanent or typical feminine characteristics. They can also be analysed as different research questions that indicate a multi-threaded project alert to concurrent fields of inquiry into sex and gender in Modernity. 'Interrelations of art and society' pose a structural question. 'Attitudes of and in womanhood in history' focusses on a historical question of lived experience and social identities. Gender, however, is also an anthropological, psychological, and linguistic question. More philosophical is the interrogation of the existence (or not) of typical features of the feminine – *Weiblichkeit* in Rosenau's and indeed Freud's German and *feminité* or *le féminin* in Beauvoir's French, neither of which are assimilable directly to the connotations of femininity, womanhood, or womanliness in English, but are bundled into and put under stress between the terms *Woman* and *women*. Rosenau continues:

> It need not be added that completeness cannot be attempted in a book of this kind, either with regard to the examples selected or to the periods studied, especially since owing to war conditions it has to appear in an abridged form.

The conditions of war-time production (notably a massive paper shortage among other obstacles) have vouchsafed to us not a *magnum opus*, however, but a brilliantly clear and acute condensation of a very major engagement in current debates, which the following essays' close readings will expand. Rosenau admits to the limited arena of her study: 'The main emphasis is laid on the Mediterranean and European civilisations,

whilst civilisations outside this sphere can only be dealt with as enlightening contrasts or corroborating evidence.' She is already alert to the question of the full geopolitical scope of the 'history' of art she will cover, her work resonating in advance with the necessity for a more global history of art that is, as of 2023, being debated in contemporary art history.

Rosenau acknowledges the world-scale and multi-national framing of her questions by including instances from Africa, China, and India. These references index her personal connections with leading scholars and collectors then studying the art of these major civilizations.[2] It is clear she consulted researchers and museum collections to ensure a widened and inclusive perspective, however merely indicative her comments were forced to be at this point of war time. Then we come to the passage on which I focussed in Part 1, Chapter 3:

> Another necessary limitation is the subjective approach of the writer. No doubt a book written by some other person in a different period would yield a different approach. At the same time it has to be remembered that only from a subjective standpoint can the concept of history be realised, and that it is a personal point of view which enables us to grasp the order in a seemingly chaotic sequence of events.

My discussion in that chapter of the statement that a 'concept of history' can only be grasped from 'a subjective standpoint' indicates Rosenau's mobilization of Karl Mannheim's (1893–1947) sociology of knowledge, and his insistence on the socio-historical, generational, and existential situatedness of the intellectual. Rosenau's theoretical framework itself is situated not only historically but also methodologically. The final sentence prior to Rosenau's brief acknowledgements – 'the picture thus conveyed should be checked by the reader perusing the selection of illustrations, thereby testing the evidence and the conclusions suggested' – necessitates its own essay, which follows this one (on the images she selected). The 'evidence' for Rosenau's conclusions is offered by the artworks forming the image track of an argument. Not a typical art-historical survey with its textual narrative reducing artworks to illustration, Rosenau's book structurally plots out an analysis as much *with* as *of* the images, the visual formulations of historical processes revealed to us as we also trace their relations and note persistent structures and transformations at both the level of the social – culture and history – and the level of the individual – artistic mode and singular interpretation.

Rosenau proposes, therefore, that 'history' is 'formulated' – evoking Aby Warburg's (1866–1929) term *formel*/formula – and that human

cultures and societies find aesthetic and imaginative formulation with, but not solely through, Heinrich Wölfflin's (1864–1945) attention to form and focus purely on style. Her mode of analysis evokes the immensely complicated history of hermeneutics and its tool philology, the former being the study of interpretation itself, the latter the historical study of language as a means of grasping the historical itself in its words, texts, language, and – we can add – visual representations. Rosenau articulates a concept of history and a methodology in Art History that is both a theoretical framework and a mode of analysis. The text is, however, not burdened by the theoretical and philosophical elaborations that nevertheless underpin its project. Her footnotes speak to the author's anticipation of a community of knowing readers while her writing offers a deceptively accessible text even as she deploys current theories and new methods by building an argument through the plates.

For Rosenau, art's history is not segmented into national school, region, period, movement, style, oeuvre, master – the conventional classifications into which artistic practices are typically fragmented. Instead, images sustain the flow of an argument that traverses cultural activity from the Palaeolithic and Neolithic to the productions of but a few years before the publication of the book itself. In a work that is situated and richly referenced, Rosenau is not the god-like guide telling a 'story' as we find in the classic survey texts by the 'masculinizers' Ernst Gombrich (1909–2001) or H. W. Janson (1913–1982).

Neither idiosyncratic nor unscholarly, Rosenau's 'little book' is a confident feminist exercise of the epistemology proposed by Mannheim. It invokes, but liberates, the practice of socio-historical–symbolic image analyses developed by Warburg and Erwin Panofsky (1892–1968) in Hamburg during the 1920s. Both were also informed by later nineteenth- and early twentieth-century neuro-psychological theories of memory and psychic life as well as philosophical theories of the symbolic and imaginative–symbolic thought. Invoking these names situates Rosenau's project at the heart of a shared project arising in the German-language academy, where European art-historical theory was formed along divergent and contested paths (formalist versus hermeneutic) while engaging, as did the humanities in general, with the tension between culture's formation within society and culture's transformation across history (structure and process). Placing the author of this book in such a context – one she also brought to Britain and extended – affirms her wide-ranging transdisciplinary intellectual formation as an art historian who, as a feminist thinker, also transmitted the distinctive feminist sociological tradition in German represented by Gertrud Kinel Simmel (1864–1938) and Marianne Weber. Her book formulates a model for feminist analysis

of art and its histories: 'to show the close interrelation which exists between the visual arts and the society to which they belong'. This declares, without a lot of theoretical trumpeting, that the author offers a 'social history of art'. Rosenau, however, *differenced* that model.

Explicit in the Marxist perspectives of several art historians – Arnold Hauser (1892–1978), who had studied with Georg Simmel, and Frederick Antal (1887–1954), from the dispersed Budapest Sonntagkreis (Sunday Circle, a meeting of leftist intellectuals in Budapest between 1915 and 1918), which included Mannheim himself – a social history of art also came to Britain. It also arrived with Rosenau but she inflected it structurally with feminism. Hauser and Antal were fellow refugees in Britain without secure academic positions. Hauser gleaned some teaching from the newly founded Department of Fine Art at the University Leeds during the 1950s, while he completed *The Social History of Art* in two volumes: *From Prehistoric Times to the Middle Ages/Renaissance, Mannerism and Baroque* (volume one) and *Rococo, Classicism and Romanticism /Naturalism, Impressionism and the Film Age* (volume two), which appeared in 1951 as a contestant in terms of depth of knowledge and extent of coverage to the one-volume *The Story of Art* (1950) by Ernst Gombrich, who reviewed Hauser's social history of art at length and negatively, as would be expected from an anti-Marxist.[3]

Gombrich allowed a social history of art to be a 'desideratum' only when it pertained to certain aspects of artistic production, such as training or commissioning and contracts. He refuted Hauser's vision of a social history of art as an integration of artistic practices with history itself. There was thus a gulf between a psychological–stylistic storying of art such as Gombrich promoted and the complex, theoretically informed social-historical study of art, and indeed of social being and social process, in which collectivities such as classes (and genders and sexualities) are formed and operative. Individualistically, Gombrich declares:

> Those of us who are neither collectivists believing in nations, races, classes or periods as independent entities, nor dialectical materialists untroubled by the discovery of 'contradictions', prefer to ask in each *individual case* how far *a stylistic change* may be used as an index to changed *psychological attitudes*, and what exactly such a correlation might imply.[4]

This leads Gombrich to conclude:

> His [Hauser's] theoretical prejudices may have thwarted his sympathies, for to some extent they deny the very existence of what we call the 'humanities'. If all human beings, including ourselves, are completely conditioned by the

3.7 Dedication page of *Woman in Art* (London: Isomorph, 1944).

to Z C

economic and social circumstances of their existence, we cannot 'understand' the past by ordinary sympathy. The 'man of the Baroque' was almost a different species from us whose thinking reflects 'the crisis of Capitalism'.[5]

Gombrich thus annuls the very basis of historical–materialist and indeed all sociological constructivist positions, and theories of ideology, from which our theories of gender, class, race, and capacity derive, and equally indirectly silences the Mannheimian sociology of knowledge that allocated a grounded but not pre-determining social positioning to thinkers themselves. Mannheim's non-class-aligned but socially situated intelligentsia produces knowledge that is subjective, but not psychologistically so. 'Subjective', in Mannheim's terms, allows for the inflection of a subjectivity as a condition or lens without being reduced to the autonomous, asocial individualist psychology espoused by Gombrich. For Marxists, class formation and the socio-economic arrangements of relations of production determine what is produced and equally determine the subjectivity of the producers in the form of class consciousness and ideology. Mannheim's break with his mentor György Lukács (1885–1971) led him to a modified, but still dynamic, thesis on ideology that clearly retained too much sense of the social for the psychological individualists such as Gombrich. Here indeed the sociology of knowledge indicates precisely that ideology is not consistently reflexive of class position but creates different, situated perspectives that are neither reducible to individual choice nor without intellectual affiliation and political critique. Mannheim did, however, more than Gombrich or even Gooch, perceive feminism, and shall we say a feminist

intelligentsia and its generations, both as creating a critique of normative patriarchal ideology by reframing Woman as *women*, and making that condition, being women, social, subjective, and intellectually and imaginatively articulated.

I finally want to note Rosenau's acknowledgements. She thanks the Victoria and Albert Museum for 'facilitating [her] work', referring no doubt to its remarkable Art Library and the expertise of the scholars working in the collections. She thanks 'Dr Karl Mannheim for reading the original draft of this book and making some valuable suggestions'; Miss V. Douie of the Women's Service Library 'for her constant interest in the progress of the manuscript'; and finally her publisher for 'the care and taste with which he has given this study its external form'.[6] The aesthetics of the book as a form, which we can only show in pages reproduced from it, clearly mattered a great deal to the author.

On an otherwise empty red page of the preliminaries, we find a discrete dedication 'to Z C' (fig. 3.7). This refers to Dr Zvi Carmi (1883–1950), a Palestinian economist whom Helen Rosenau had married in 1939. In 1944, the couple adopted a son, Michael Carmi.

In the list of illustrations, I note the author's specific thanks 'to Miss Barbara Hepworth, both for the cover illustration, and for her kindness in providing a photograph of a hitherto unpublished work, *Fig. 55*'. Hepworth specialists Sophie Bowness, the sculptor's granddaughter and guardian of the estate, and curator and sculpture historian Eleanor Clayton directed me to the letters written by Hepworth concerning Rosenau's request for this photograph. Hepworth was unhappy with the quality of the reproduction of *Conoid, Sphere and Hollow* in *Woman in Art*. Following its publication, she wrote: 'pity they made such a mess of my blocks!'[7] And if we compare the printed page (fig. 3.8) with the supplied photograph (block) in the Tate Archives (fig. 3.9), we see her point.

This letter was to critic and art historian E. H. (Hartley) Ramsden (1904–1993), with whom Hepworth established a long correspondence and friendship following Ramsden's inclusion of her sculpture in her important study *An Introduction to Modern Art* (1940). Hepworth wrote that she had been contacted by 'Dr Helen Rosenau' to 'feature in a book on "*Women* and art theory through the ages", she wants a photo of mine and a few notes'. This is a fascinating paraphrase by Hepworth that tantalizes us with conjectures about the content of Rosenau's letter to her. Hepworth's reference to 'art theory' reveals that Rosenau presented her project to Hepworth as a work of interpretation and not a mere survey of images or a narrative, endorsing my reading of this book for its theoretical infrastructure drawn from Philosophy, Sociology, and Art History. Hepworth further wrote to Ramsden:

92

> I like Dr Rosenau's little book (pity they made such a mess of my blocks!) because it represents a difficult subject in an easy manner. Of course, the whole idea touches very close on my own personal problems that I have been up against since I was 16.[8]

This is a telling comment, acknowledging Rosenau's insight and style. It also evidences the sculptor's struggle with the social norms and discriminatory structures that affected women in art education and the social and economic chances of surviving as a professional artist. We must also hear Hepworth's subjective investment in affirming the validity of women's experiences, desires, choices, and contributions to their chosen fields.

In an earlier letter dated 24 June 1943, Hepworth had written to the art patron and collector her friend Margaret Gardiner (1904–2005), whose partner was J. D. Bernal (1901–1971), the author of the commentary on Hepworth's exhibition in 1937 (see Part 3, Essay 1). Gardiner was a co-founder with Bernal of the Society for Intellectual Liberty, which aimed to unite intellectuals in the fight against war, injustice, and the rising tide of fascism.[9] To Gardiner, Hepworth wrote often about her own complex juggling of triplets (born in 1934), war-time conditions, and her need to keep making art. In this letter she insisted on the richness of her way of life despite its many responsibilities and time demands. 'I've always felt that if I renounced responsibilities, I should lose something.

3.8 Figure 55 of *Woman in Art* (London: Isomorph, 1944), illustrating Barbara Hepworth (1903–1975), *Conoid, Sphere and Hollow*, 1937, white marble, 30.5 × 40.6 cm. Bequest of Virginia C. Field, New York, Museum of Modern Art 22.2004.

3.9 Barbara Hepworth, *Conoid, Sphere and Hollow*, 1937, original 'block' photograph supplied to Helen Rosenau by Barbara Hepworth. London: Tate Archives © Bowness.

I have always believed in doing *everything*.' Hepworth then explained that having Rachel, Sarah, and Simon (her triplets) should have been a 'knock-out blow' but, in fact, it 'improved and *matured*' her work. She argued that her philosophy of 'doing *everything*' despite tiredness not only prepared her well for the post-war world but also enabled her to surmount even exhaustion and sustain her creative life.[10] This echoes Hepworth's comments, forty years later, in speaking to US-American critic Cindy Nemser in an interview for her hugely important book of conversations with 'twelve women artists', where Hepworth affirmed her method for working through the challenges of daily life and explained how she welcomed the opportunities for resolving them through her formal processes and by producing strong work.[11]

Barbara Hepworth's (1903–1975) positive response to Helen Rosenau's request and the sculptor's extended reflections on combining life and work, revealed in her letters to contemporary intellectual women, and touching on the very questions Rosenau explored specifically in her final chapter on modern women's individuality and creativity, further deepen the significance of the choices for the cover and indeed the modernity and contemporaneity of the book itself. This exchange also confirms Helen Rosenau's own place in the culture of British intellectual and creative women.

Notes to Essay 2

1 See Felix E. Hirsch, 'Biographical Article: George Peabody Gooch', *Journal of Modern History* 26:3 (1954), 260–71. See also Geheime Staatspolizei, *Die Sonderfahndungsliste GB* [The Black Book], Hoover Institution Library and Archives, Stanford University, 1940, https://digitalcollections.hoover.org/objects/55425/die-sonderfahndungsliste-gb, retrieved 1 March 2023.

2 We see this in the book sources of some of her illustrations.

3 Arnold Hauser, *The Social History of Art* (London: Routledge & Kegan Paul, 1951); Ernst Gombrich, *The Story of Art* [1950] (London: Phaidon, 1962); Ernst Gombrich, 'Arnold Hauser, *The Social History of Art*, 2 Volumes', *Art Bulletin* 35:1 (1953), 79–84. For a French response to Hauser's work see Alberto Tenenti, 'Hauser, Arnold: art, histoire sociale et méthode sociologique', *Annales: Économies, Sociétés, Civilisations* 12:3 (1957), 474–81. The 1951 two-volume edition, at 500,000 words, has subsequently been issued as four volumes.

4 Gombrich, 'Arnold Hauser', 82.

5 Gombrich, 'Arnold Hauser', 82. See also Tenenti, 'Hauser, Arnold'.

6 Vera Douie (1894–1979) was librarian of the Women's Service Library at Marsham St, London, founded in 1926 and part of the London National Society for Women's Service. In 1953 this library became the Fawcett Library and in 2002 it was renamed the Women's Library at the London School of Economics. Douie, born in Lahore to a British Civil Service family working in British India, was educated in England and studied at Oxford without being able to be awarded a degree. She was librarian of the Women's Service Library between 1926 and her retirement in 1967. An active feminist, in around 1940 she published *The Lesser Half: A Survey of the Laws, Regulations and Practices Introduced during This Present War that Embody Discrimination against Women* (London: Women's Publication Planning Association, n.d.). After the war, she also published *Daughters of Britain:*

An Account of the Work of British Women during the 2nd World War (Oxford: Vincent Baxter Press, 1950).

7 Letter from Barbara Hepworth to E. H. Ramsden, 8 March 1944, Tate Gallery Archive, London, 9310.1.1.25, cited in Eleanor Clayton, *Barbara Hepworth: Art & Life* (London: Thames & Hudson, 2021), 108.

8 Clayton, *Barbara Hepworth*, 108.

9 Clayton, *Barbara Hepworth*, 90.

10 Letter from Barbara Hepworth to Margaret Gardiner, 24 June 1943, Tate Gallery Archive, London, cited in Clayton, *Barbara Hepworth*, 108.

11 Cindy Nemser, 'Barbara Hepworth', in *Art Talk: Conversations with 12 Women Artists* (New York: Charles Scribner's Sons, 1975), 13–34.

The Plates and the Method

The small scale of Helen Rosenau's book was no doubt determined by war-related economic factors as well as the political project of making such studies available to general readers. Rosenau also taught in adult education even as she rightly aspired to, and did ultimately secure, an academic position, almost in line with her prestigious education and extensive research. Her politics, however, inspired a commitment to the widest participation in education. Scholarly in an 'easy manner',[1] her 'little book' balances both ambitions, satisfying the publisher's requirement for rigour and a strong visual argument. I now focus on Rosenau's art-historical method by analysing the images as the structural backbone of the book's argument, which almost suggests a beautifully illustrated lecture.

While preparing the original book for the reprint and checking the figure numbers, it became evident how radically Rosenau's book was not illustrated so much as woven around a spine of artworks. *Woman in Art* projects a novel form of Art History *written in images*, rather than an art-historical text supplemented by illustrations. The 'little book' was designed in landscape format with wide gutters, enabling the placement of a work of art on almost every page, the images as visible as the footnotes, which are also placed in the running gutter. Working closely with typographer Anthony Froshaug (1920–1984) produced an innovative visual format corresponding to Rosenau's art-historical writing that enables the running visual track to perform its own unspoken relays of meaning and difference (fig. 3.10). This not like Heinrich Wölfflin's (1864–1945) technical innovation using two projectors to compare and contrast two images in order to discern formal deviations or stylistic innovations; nor are these pages typologies of recurring themes.[2] Each image is doing real work as the ground of the argument as well as the evidence for the interpretations being drawn out from their configurations.

What is the logic of placement and sequence of what Rosenau termed her 'plates' (registering the physical and material processes of producing illustrated books at the time of typeset printing) and their function as the architecture of that argument? This takes us back to Germany, to Hamburg, and Rosenau's doctoral studies in a remarkable environment

56

[42] *Cf. T. A. Gopinatha Rao: Op cit., p. 379 ff ; S. Kramrisch : Op. cit., with excellent bibliography.*

[43] *A similar type has been alluded to above with regard to the Meyer Madonna. Cf.* Catalogue of the Victoria and Albert Museum, Italian Sculpture, *London,* 1932, p. 100 ; *L. Planiscig :* Venezianische Bildhauer, *Vienna,* 1921, p. 26.

Thus the concept of immaculate birth finds expression in art. The interest in the miraculous birth of gods and heroes is not however confined to the Christian world. These are fundamental human concepts connected with the birth of exceptional personalities, and are for instance found reflected in scenes of the birth of Buddha[42] (*Fig. 25*).

The transition from the Middle Ages to the Renaissance and the Reformation is generally conceived as a strengthening of individualism. In the North as well as in the South of Europe a veil appears suddenly lifted, the main difference being that

where Art History was being shaped as the work of interpretation based on what an image does and how a symbolic form becomes a visual representation.

Rosenau studied for her doctorate in Art History at the University of Hamburg with Erwin Panofsky (1892–1968). She was, therefore, familiar with the major centre for art-historical studies in Hamburg led by the private scholar Aby Warburg (1866–1929), who had established a private library after 1900 subsequently known as the Kulturwissenschaftliche Bibliothek Warburg (Warburg Library for Cultural History) (fig. 3.11). The foundation of the library lay in the personal library Warburg had accumulated – over 6,000 books by 1900. By 1905 there were 9,000 books, thousands of photographs, and some hundreds of glass slides. After he purchased a house at 114 Heilwigstrasse, Warburg had to house his private library and administer it on professional lines with documentation and a librarian, so in 1926 the library was installed next door at 116 Heilwigstrasse. There it became an intellectual hub hosting lectures and seminars, publishing proceedings, and being used by many scholars from the University of Hamburg and other visitors. Figure 3.12

in Italy the emphasis is laid on the beauty of form, whereas in the Northern countries the features of everyday life arouse the greatest pictorial interest. But even in Italy naturalistic elements are dominant in the early Renaissance, although realism belonged to the sphere not of detail but of the artistic creation as a whole. The child, symbolised by his head, which in the Byzantine type of *platytera* is not clearly described in its physical relation to the Virgin, but seems somehow to be hovering before her, is now incorporated in a clasp, of the mandorla shape, which fastens her cloak. To this type belongs the *mater misericordiæ* (*Fig.* 26) attributed to Bartolommeo Buon in the Victoria and Albert Museum.[43]

With the rise of the middle classes, the English conversation pieces and the French family portraits gain in importance.[44] It is interesting here to see how the unity of the family is frequently broken up in the sense of a differentiation between a distinctly masculine and a feminine sphere, since the women are more particularly related to the children, especially the babies, whilst the men are portrayed in dignified repose. For example, N. de Largillière's self-

57

Fig. 25 : Buddha's Birth (*Indian Museum, Calcutta, after Kramrisch*).

[44]*Cf. the portrait of the Jabach family of Cologne by C. Lebrun, or the* Family Reunion *by J. Zoffany.*

documents how the Reading Room was used for lectures, and we see as a display the composite layout of the image track for Warburg's lecture on antique resonances in a painting by Rembrandt. The library's design formally elaborated Warburg's 'law of good neighbourliness', meaning that the organization of the books had to foster correspondences and mutual fertilizations between different ways of thinking culture and memory – *Mnemosyne* (Greek goddess of memory) was the title of the library – that conventional libraries divided by subject area.[3]

At the centre of the building was the Reading Room, with its elliptical design demonstrating Warburg's conception of the dynamic interrelation between and mutual intellectual 'charging' (in the electrical sense) of many disciplines.[4] The Warburg scholar and social historian of art Kurt Forster declares that Warburg's original library must be understood firstly as itself a mental construct, hence a symbolic if not ritual space, that paralleled, in its ordering and formulation, the deepest insights Warburg's scholarship attempted to generate about human culture through a transcultural and transdisciplinary practice: 'The library, which demanded a building of its own, and the scholar's desk, which

3.10 Pages 56 and 57 of *Woman in Art* (London: Isomorph, 1944) showing the image placement.

as the *mensa* of mental labour signifies a ritual site of mental sacrifice, present positive analogies with the world of primitive religious ritual.'[5] An encounter with Hopi rituals in 1895 was foundational for Warburg's project.[6] Forster concludes his comparison with the symbolic form of the library and the orientations of the Hopi people's altar, which articulate their sense of cosmic forces:

> In the same way, Warburg sought to create, by way of experiment, a precise ordering of reified ideas that would set up a flow of thinking, like a galvanic current. The library becomes a battery, an accumulation of thinking in which, through books connected in parallel by Warburg's ordering principle, the current of ideas is induced to flow. The scholar's desk is the site of ritual invocation of those forces that impel, and those that assail, human beings within their culture. Not only the scholar's desk, but also the painter's paper and canvas can serve to invoke forces far older than the practice of Western art.[7]

More recently, Daniel Sherer has argued that the library's elliptical form and specifically its elliptical glass ceiling were symbolically significant actualizations of Warburg's intellectual engagement with philosopher Ernst Cassirer's (1874–1945) investigations into the astronomy of Johannes Kepler (1571–1630), where rational analysis was 'pierced by esoteric themes'.[8] Sherer extends this discussion of geometries of space as symbolic forms and thought systems to his analysis of Panofsky's interpretation of architecture, a dimension that has been overlooked in the focus on his later work on the image in visual arts, which has direct

3.11 Reading Room, Warburg Library, Hamburg, 1927. Photo: © Warburg Institute Archives, University of London.

READING HELEN ROSENAU'S 'LITTLE BOOK' NOW

3.12 Installation of photographs for Aby Warburg's (1866–1929) lecture 'Italian Antiquity in the Age of Rembrandt', delivered in the Reading Room of the Warburg Library, Hamburg, May 1926. Photo: © Warburg Institute Archives, University of London.

relevance to Rosenau, who as mentioned studied with Panofsky. Her first doctoral dissertation, on Cologne Cathedral, was produced under the latter's supervision in the Hamburg–Warburg circle. Thus, as the physical form enacted conceptual intervention into differing modes of thought, the Warburg library modelled a process of cultural analysis that Rosenau then extended and elaborated with a finesse that avoids the often laboured mobilizations of the Warburg–Cassirer–Panofsky circle and that explores a question these male scholars did not address – life–death–desire 'in and of and from the feminine' (as I argue in Part 1, Chapter 3).[9]

By the time that the library was rescued from Nazi Germany in 1933 and removed to London, becoming the Warburg Institute, it consisted of 60,000 books and 25,000 photographs. The library was organized into four levels:

i) orientation (philosophy, religious studies, and history of science);

ii) image (art history, archaeology, and early cultures);

iii) word (mainly ancient and post-medieval literature);

iv) action (history, social history; history of festivals, theatre, and technology).

The first librarian, Fritz Saxl (1890–1948), defined the objectives of this library in the following terms:

> The Bibliothek Warburg is both a library and a research institute. It is dedicated to working on a single problem, which it addresses in two ways: firstly, by representing it through the selection, acquisition and arrangement of books and images, and secondly by publishing the outcome of research that concerns itself with this problem. The problem is that of the afterlife of antiquity. European and Middle Eastern civilisations of the Christian era have adopted the heritage of antique prototypes, and they have done so in all areas; in art, in science and in the fields of religious and literary forms. Our task is, on the one hand, to examine the historical facts of this transmission and to illustrate, as completely as possible, the migratory routes of this tradition. *On the other hand, we aim to draw general conclusions with regard to the function of human social memory: what kind of ancient prototypes are these to be able to have such an afterlife?* Why do certain periods have a 'Renaissance' of antiquity and why do others, while sharing the same cultural heritage, not make this heritage part of its active living culture?[10]

I have highlighted with italics the second objective: the study of the function of human social memory and its transmission through prototypes that persist: *Nachleben*, living on. The intellectual community in Hamburg in its newly founded university, and in the Warburg circle that interconnected with it, was a crossroads of Art History (*Kunstgeschichte*), which had emerged as an academic discipline in German universities as early as 1813 (in Göttingen) with *Kulturwissenschaft*. This transdisciplinary model had emerged in Germany at the intersection of the philosophy of culture associated with sociologist Georg Simmel (1858–1918) and philosopher Ernst Cassirer, cultural history and historical anthropology, and the sociology of Max Weber (1864–1920). Its remit was to study the material and symbolic dimensions of culture as a memory storehouse in its most extended forms, from medicine to music to art. Without an adequate translation into English, philosophically informed 'cultural studies' approximates most closely to *Kulturwissenschaft*, although today Cultural or Visual Studies has tended to disown Art History in favour of the term 'visual culture'. Art historian Aby Warburg, however, chose *Kulturwissenschaft* over *Kunstgeschichte* to pursue his anti-formalist and de-aestheticizing study of the image.

The method Warburg adopted in relation to the visual arts themselves culminated in his unfinished project titled *Bilderatlas Mnemosyne*. This was a physical compendium of images, created by means of seventy-nine panels of black canvas-covered screens with photographs of images in many media attached. Photographs of paintings, buildings,

coins, engravings, and more were assembled under titles such as 'Pathos of Destruction', 'Pathos of Suffering', 'Kosmos', 'Battle', 'Rape', 'The Great Mother', 'The Pathos of Victory', 'Child Murder', 'Mass', 'Ascension', and 'Descent'. What kind of logic of connection was proposed or discovered by Warburg? What kinds of visual neighbourliness arise from placing different forms and media and variations of a concept rather than a theme on a single panel? The typical logics of influence, descent, and stylistic development are irrelevant. Yet the combinations, once deciphered, plumb both psychological and historico-political depths.

In 2020, the Haus der Kulturen der Welt (House of the World's Cultures) in Berlin hosted the exhibition of a project generated by the Warburg Haus, Hamburg, and the Warburg Institute, London, to reconstitute Warburg's project from the original photographs in his huge collection, now at the Warburg Institute in London. The originals were rephotographed and enlarged in the assemblages Warburg had created, of which only photographic records remain. The exhibition of the monumentally enlarged panels was accompanied by an outsized volume that reproduced all the reconstituted assemblages as well as supplementary ones (fig. 3.13).

Each panel traces the persistence and migration of a *pathos formula*, a formula of affect, arranged by topics identified by Warburg as originating in classical antiquity, travelling via different media and across cultures and being reclaimed and revivified during the Italian Renaissance. Warburg's project challenged a logic of the inevitable succession

3.13 Installation shot of Aby Warburg's (1866–1929) *Bilderatlas Mnemosyne* (last version, 1929), reconstruction from the original plates and enlarged by Axel Heil and Roberto Ohrt for an exhibition at Haus der Kulturen der Welt, Berlin, 2020. Photo: Tobias Wotten. © Warburg Institute.

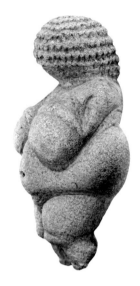

3.14 a) Profile view of the Willendorf figure (see figs 2.1 and 3.2).
b) Barbara Hepworth, *Single Form* (see fig. 3.3).

to the heritage of classical antiquity of Italian art of the fifteenth and sixteenth centuries by exposing a profound and perplexing contradiction. Why had a medieval Christianized European culture turned to a pagan visual repertoire?

As methodology, Warburg's *Bilderatlas* project, tracing the afterlife of antiquity via visual formulae, is, however, not directly a model for Rosenau's visual plotting in her own book. Its counter-logic, however, granted permission for her different logic of association across images. Warburg's discovery of *patterns* in cultural history *through* the images is not without significance for reading *Woman in Art*. Assembling Rosenau's images chapter by chapter I ask, therefore, what logic of association emerges if we study images in conversation and in the light of the sociological, cultural, art-historical, and feminist framework of Rosenau's thought? She was not following Warburg and Panofsky because she posed questions neither of the men contemplated.[11]

— **The Cover, Take Two**

Let me start by returning to the cover and its two sculptures, which cross millennia (fig. 3.14). Their relationship is clearly neither about revival nor persistence. Both are, however, hand carved, one from stone and one from a block of wood. One is tiny and figurative. The other is neither tiny in scale nor yet monumental, and it is on the vertical axis. In Hepworth's *Single Form* we encounter singularity and verticality sufficient to evoke, but not represent, both a human form and its abstract other, a column, both conveying rising but also risking what feminist philosopher Adriana Cavarero has critiqued as rectitude.[12] The Willendorf figure was imagined on a horizontal axis. These two forms, reaching across thirty millennia, illustrate the persistence of thinking in form, the will to make forms, and the unexpected revelations about form that the modernist moment made visible just as the prehistoric objects emerged from the earth through excavation to enter modernist consciousness and to locate the questions of human consciousness and embodiment at the deepest levels of imagination that art's material forming preserves.

— **The Introductory**

The introductory chapter also has only two images. The Willendorf figure (see fig. 2.1), aligned across time on the cover to be overlaid with Barbara Hepworth's sculpture of 1937 (see fig. 3.1) now finds itself situated in the chapter with only one other image, a contemporary photograph from the mid-1930s of a Santhal *mantra*, a painted house from the Bihar region of India (see fig. 2.2).[13] The image is taken from a copy of a photograph accompanying an article by two British specialists in Indian art under

Santhal Painting By W. G. and M. Archer

Smooth brown walls brought to a sharp edge, a plaster surface of sun-dried mud stiffened with cow-dung, sharp rectangular courtyards, precise doorways, finally the geometric basis enhanced by wall paintings.

These houses and paintings are made by a section of the Santhals living in the Singhbhum district of Bihar. The houses are constructed for a strict utility but are plastered and painted every year to give them a finish, an exhilaration, which is much more than useful in intention. The paintings themselves are done by the women in terracotta and ochre, obtained from oxides in the soil, in black from burnt straw, and in white from rice; and are put on with an easy obviousness as if they were part of housekeeping. With their common style, the paintings form part of a tribal stock, developed by family sensibilities and matured by repetition. The process of their growth is similar to the formation of ballads and in the same way it has produced a regional style which tribal experience has sanctioned.

The necessity of these paintings in Santhal life—a life based on agriculture and with no margins, a bare " rice " culture—would prove, if any proof were needed, the " naturalness " of an abstract style. And from this, one might draw the corollary that the abstract movement in Europe is not a mere sophistication, a doctrinaire research. It is simply returning to a natural need.

It will be obvious that the character of the materials coupled with the meagre level of living means a certain coarseness, a certain lack of precision in the painting; just as the mud walls would appear coarse beside the new architecture. And this is both a technical and, in the last analysis, a cultural weakness. But, working through this coarseness, the paintings indicate a sensibility utterly non-literary—a vital interest in the relations of geometric forms—and a pleasure in their construction. Even when the material is an object from the natural world such as a woman, an elephant or a bicycle, the tribal

sensibility presses the forms into the standard geometric style. The woman becomes identical with a triangle and the bicycle as important as a circle. It is this pressure of sensibility, breaking through the coarseness, which gives the value.

As a style, the affinity of the purest paintings is with Mondrian—an identity of direction which minimises the difference of culture level. And as house paintings, they afford an Indian parallel on a village plane to Ben Nicholson's reliefs—" the best kind of painting to go with the new architecture " (Herbert Read).

Finally, as Indian art, they form part of a living tradition—a tradition which escaped the books of Havell, Brown, and Vincent Smith and is only now being recognised as in the centre of Indian sensibility. They are part of the body of " submerged " painting which for our generation will define Indian art.

Henry Moore
by S. John Woods
Exhibition : Leicester Galleries, October 31– November 21

" It is the natural beauty of proportion of the phallic consciousness, contrasted with the more studied or ecstatic proportion of the mental or spiritual consciousness we are accustomed to."

D. H. Lawrence meant the Cerveteri tombs but the passage applies with equal relevance to sculpture. Sculpture to-day has been forced into the place of a rather younger and less important sister of painting—a place which has caused its individuality to suffer and its specific qualities to dwindle from sight.

Sculpture is more primitive, in the purest sense, than painting; it is more solidly bound to earth and less capable of becoming sophisticated. Its materials, stone and wood, existed before man and existed *as sculpture*; its formal basis, the pebble fashioned by the sea, or the tree-trunk; are phallic and, subsequently, tactile. This phallic-tactile quality both marks the main difference between

27 28

the British Empire, William G. Archer (1907–1979) and Mildred Archer (1911–2005). The article 'Santhal Painting', cited by Rosenau, appeared in issue seven of a British journal, *Axis* (1936). *Axis: A Quarterly Review of Abstract Painting and Sculpture* was edited by Myfanwy Evans (1911–1997) for six issues (fig. 3.15).[14] In 1948, William Archer would collaborate with Herbert Read, Roland Penrose, and Robert Neville on an exhibition, *40,000 Years of Abstract Art*, at the Institute of Contemporary Arts, itself just founded in 1946. He later became Keeper of Indian Art at the Victoria and Albert Museum.

Paintings of the external walls of villagers' houses in Bihar were created by women using a range of motifs, some derived from vegetation, others purely abstract, and many images 'abstracted', such as two triangles signifying a woman's figure. Archer compares these artist-women's work to that of Piet Mondrian (1872–1944) and makes the case for abstraction's long history and indeed 'naturalness'.[15] Rosenau thus aligns herself with Read and the co-founders of the ICA in their expanded understanding of abstraction in many cultures, noting the affinity between contemporary abstraction and some of the most ancient and persistent forms of known human art, which had elsewhere

3.15 William G. Archer (1907–1979) and Mildred Archer (1911–2005), 'Santhal House Painting', *Axis* 7 (1936), 27–8.

been dismissed by conservative and colonial minds as mere geometric pattern-making.[16] Even while herself reiterating Western terminology, Rosenau wrote:

> The influences on art in primitive civilisations are as varied as these civilisations themselves. Two facts appear, however, particularly striking in this connection. The one is that women, who are commonly assumed to have little or no power of abstraction, invent patterns of abstract art (*Fig. 2*) (as with the Esquimaux and the Santhals); the other, that the earliest representations of human beings are of the female sex. Palaeolithic art is the only historical source in existence for the earliest periods of human evolution, and strikingly enough it shows two prevailing subjects, the animal and the female figure in the nude.

Hence, if we juxtapose colour images of both the most ancient unearthed artefact from Willendorf and the relatively recent example of Santhal house-painting, we see in fact two images of related ideas – body, home, and woman – that equally signify space and, indirectly, the creation and sheltering of life and the creation of meaning by means of visual thought in two differing idioms (fig. 3.16).

— Chapter 1: Wives and Lovers

3.17 Images from Chapter 1 of *Woman in Art* (London: Isomorph, 1944), 'Wives and Lovers', assembled as a single panel.

The first numbered chapter is about relationships – legal, marital, erotic. It plots out the 'figure' of the couple from Pharaonic Egypt to the newly instituted Union of Socialist Soviet Republics (30 December 1922). The socio-legal and institutional form of the couple is marriage, although marital arrangements can vary from brother–sister marriage (as in the

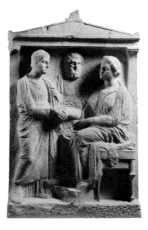
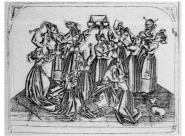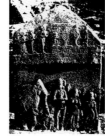
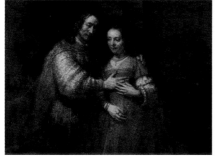
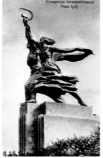

Pharaonic Egyptian dynasties) to same-sex couples (as long as the bride price is paid).[17] Marriage formed the topic of the canonical texts of early twentieth-century sociology, such as E. A. Westermarck's (1862–1939) *The History of Human Marriage* (1921) and Marianne Weber's (1870–1954) *Ehefrau und Mutter in der Rechtsentwicklung* (Wife and Mother in the Development of Law) (1907), cited by Rosenau in her first two footnotes of this chapter.[18] Following such key works, it is not surprising to find the image track of this chapter showing few images of the family but several of the forms of visual inscription of the legal form of marriage articulated by gesture, posture, and ceremonies that inscribe or redefine any form of hierarchical gender division of the contracted state (fig. 3.17).

This assemblage of images enables us to study compositional issues and ways of formulating two figures and twoness itself. These visually represent institutional and legal construction of the social coupling of distinct human beings who have either been subject to or resisted the hierarchies of gendered differentiation. The gestures of the figures in the images 'speak' the social laws governing bodies and property. Images also signify erotic connection or desire. In the modern period, they may also articulate companionship and political solidarity and the underside of legal marriage, namely divorce or prostitution. The range, historically varying in focus and configuration rather than persistent, and yielding social and political diversity, religious culture, and the emergence of a secular articulation, requires us not to be concerned with differences of style so much as the changing pattern of configurations of the two elements.

— Chapter 2: Motherhood

The images in this section move from the Egyptian cow goddess Hathor, with the moon between her uterine horns (see fig. 2.18), to what Rosenau terms the 'highly individualised' treatment by Anselm Feuerbach (1829–1880) in his portrait of his widowed, childless, bourgeois stepmother (see fig. 2.32). They also travel via Buddhist art from India and carvings from the Lower Congo in Africa across the veneration of the Northern European cult of the female deities known in Latin as *Matronae* through the various representations of the single mother and child. The cult of the Virgin, sanctioned by the Council of Ephesus in 431 CE in Christianizing Europe, poses the theological paradox of virginity as maternity so at odds with the Neolithic concept of the maternal sexual body we might think we see in the Willendorf figure and the Egyptian representation of Isis and Horus, thought to be a shadow source for the visual typology of the Christian Madonna and Child. This chapter's plates (all compiled in figure 3.18 as a single overview or *Bilderatlas*) plot out the expansion of

3.18 Images from Chapter 2 of *Woman in Art* (London: Isomorph, 1944), 'Motherhood', assembled as a single panel.

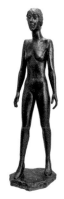

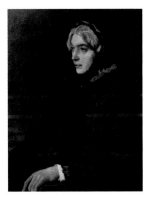

the twoness of mother and child, to mother with children in the European family as well as the single figuration of the 'woman with child' – pregnancy – moving towards the mother as site of loss and the mother as herself the figuration of age and death. Works by artist-women are included. Rosenau illustrates Paula Modersohn-Becker's (1876–1907) fictive, half-nude self-portrait as a pregnant woman (see fig. 2.29) and the lithograph by Berlin sculptor Käthe Kollwitz (1867–1945) (see fig. 2.30) of working-class mothers fearing the destruction of their children in war, in industrial accidents, or from starvation. Thus, Rosenau captures both the socialization of mothering and the psychologization of the maternal subject. In the final sequence, she invites the viewer and reader to contrast both with the masculine gaze, in the case of Albrecht Dürer (1471–1528) upon the face of the elderly woman from whom he was born (see fig. 2.31), indicating a questioning of how the mother, motherhood, and the temporalities these signify are figured by both women and men. This creates a situatedness of perspective that privileges neither while de-normalizing the masculine as much as the Western and Christian imaginations.

— Chapter 3: Further Aspects of Creativeness

This chapter, whose image track is compiled in figure 3.19, has a long textual introduction before the first plate is introduced. This illustrates dancing figures painted on the walls of caves from the Roca dels Moros, also known as the Caves El Cogul, in Catalonia/Catalunya, north-western Spain, which were discovered only in 1908 by the local rector. The system of forty-five caves, with scenes of hunters and animals, includes this remarkable composition, dubbed a 'dance scene', with nine female figures dressed in skirts surrounding a single naked man and a single female animal potentially carrying twin young in her transparent uterus (see fig. 2.33). This echoes the time range established by the cover and introduces Rosenau's discussion of women in groups, alongside selections of images of women as individuals, as workers and as figures of fiction, as political revolutionaries and courtiers, and as artists.

Individuation is marked by two self-portraits: by the long-lived Italian painter Sophonisba Anguissola (1532–1625) (see fig. 2.44) and the Polish artist Anna Dorothea Therbusch-Lisiewska (1721–1782) (see fig. 2.45).[19] Rosenau also mentions Artemisia Gentileschi (1593–1653), referencing her *Judith* as 'a contribution to the Baroque movement' (see fig. 3.58); Rosalba Carriera (1673–1757); Angelica Kauffman (1741–1807) (see fig. 3.47); and Élisabeth Vigée-Lebrun (1755–1842), mentioning *Self-Portrait with Her Daughter, Julie*, in the Louvre. These names of artist-women are introduced with the expectation of general recognition, reminding us now that the almost total effacement, or downgrading of familiarity

3.19 Images from Chapter 3 of *Woman in Art* (London: Isomorph, 1944), 'Further Aspects of Creativeness', assembled as a single panel.

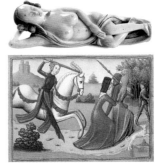

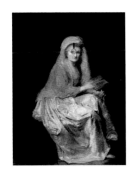

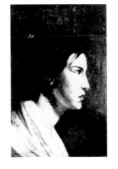
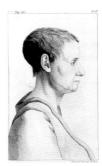
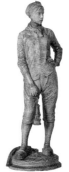
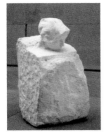

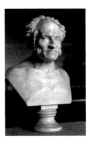
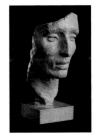

with, women as artists occurred in the decades *after* Rosenau's publication with the all-male one-volume surveys of the history of art by Ernst Gombrich (1909–2001) in *The Story of Art*, 1950.[20] Gombrich's exclusion was compounded by the émigré scholar in the United States of America H. W. Janson (1913–1982), also a student of Panofsky in Hamburg, who was not forced to flee but enabled to move to the United States by museum director Alfred H. Barr (1902–1981). Janson's one-volume *History of Art*, first published in 1962, contained no mention of any artist-woman, an exclusionist position Janson openly defended over twenty-nine printings of his survey, which became the standard textbook for Art History across the United States.[21] It was only in 1986 that a revision by his son included a few artist-women in the chapter on artistic uses of photography – one of whom was the artist Joanne Leonard (b. 1940), with her work *Romanticism Is Ultimately Fatal* (1972).[22] *The Artist Joanne Leonard* (fig. 3.20), from 2022, is a painting from a photograph of Leonard by US-American artist Coral Woodbury (b. 1971) as part of her project titled *Revised Edition*. This is an ongoing series of 617 portraits in sumi ink made from existing images, often self-portaits of artist-women, which Woodbury paints over each page of her own copy of Janson's women-less *History of Art*, still in use when she was at university in the 1990s, effectively denying her knowledge of women in the past and of herself as an artist in the present.

Then Rosenau introduces Jewish women in art, Salome (see fig. 2.42) and Judith (see fig. 3.58) being the most widely represented, while noting that the judge and poet Deborah had been neglected since she had 'no emotional or "romantic" appeal'. In the context of poets such as Annette von Droste-Hülshoff (1797–1848) (see fig. 3.53) and Elizabeth Barrett Browning (1806–1861) (see fig. 3.54) both contesting restrictions imposed on them by cultural assumptions about women and by class, Rosenau references and illustrates the Jewish German intellectual and salonnière Rahel Levin Varnhagen (1771–1833) (see fig. 2.43), the *Habilitation* topic of Rosenau's fellow exile and refugee, the political philosopher Hannah Arendt (1906–1975).

The face becomes an increasingly significant feature of this chapter, establishing thereby the singularity of each woman and moving 'from type to personality'.[23] Sculpture concludes the chapter with three works. The first is a sculpted bust by Elisabet Ney (1833–1907) (see fig. 2.53) of the renowned and influential German philosopher Arthur Schopenhauer (1788–1860), a white supremacist who, however, disowned slavery and was known for both his assertive and disfiguring anti-Judaism and his misogynist views on women as fit only for the nursery – being themselves child-like and frivolous – a view articulated in his essay 'On Women' (1851).[24] Having sat, aged seventy-two, in 1859 for the portrait

bust by the twenty-six-year-old Ney (fig. 3.21), Schopenhauer encountered a woman of independence and intelligence and wrote to the German Nobel Prize-nominated Malwida von Meysenbug (1816–1903): 'I have not spoken my last word about women. I believe that if a woman succeeds in withdrawing from the mass, or rather raising herself above the mass, she grows ceaselessly more and more than a man.'[25] Ney married but always retained her surname. This fact incites a long footnote from Rosenau on gender and language. The words for 'human being' in Hebrew (*enosh*), Greek (*anthropos*), and Latin (*homo*) only partially encompass, if at all, women. German's *Mensch* apparently does so. Rosenau elaborates:

> To be productive meant under such conditions to break away from tradition and to be lonely and without precedent. The loneliness, which explains some of the homoerotic aspects of the Women's Movement, was coupled frequently to an attitude characteristic of *parvenus*, e.g. unwarranted pride in minor achievements. As long as a woman is judged by male standards and has to be 'as good in her work as a man', she is not really considered free in self-expression: freedom of expression is correlated to productivity.

3.20 Coral Woodbury (b. 1971), *The Artist Joanne Leonard* (b. 1940) from the series *Revised Edition*, 2022, sumi ink on a book page of H. W. Janson's (1913–1982) *History of Art* (1962), 22 × 28 cm. Private Collection.

3.21 Friedrich Kaulbach (1822–1903), *Elisabet Ney with Her Bust of George V of Hanover*, 1860, oil on canvas. Niedersächsisches Landesmuseum, Hannover. Photo: The Picture Art Collection, Alamy Stock Photo.

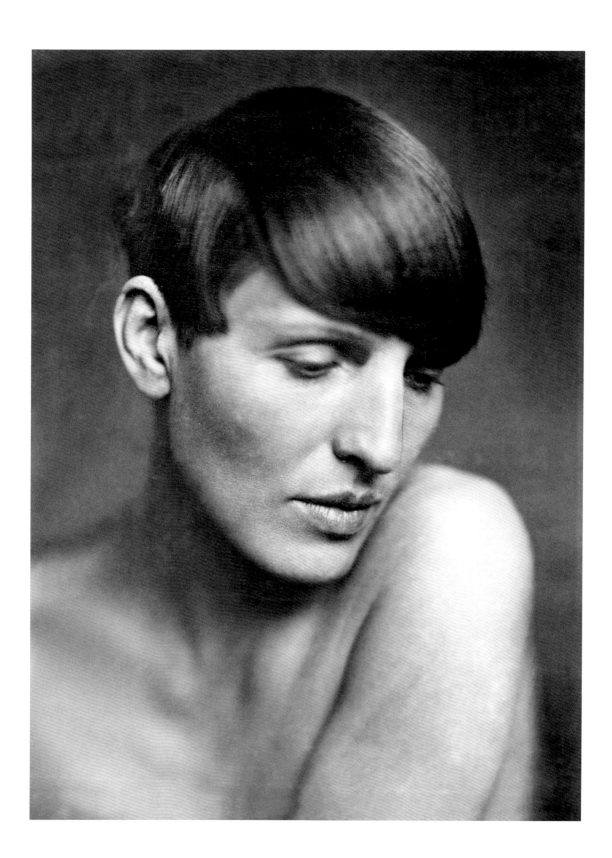

This final comment is referenced to an article by Rosenau, 'Towards a New Synthesis', published in *International Women's News* in 1941. Integration of women and men into a single concept of human being will, she argues, require linguistic change, specifically to modes of address that should no longer distinguish married from unmarried women.

Countering Ney's monumental classical bust representing masculine, patriarchal thought rendered by a woman sculptor, Rosenau chose to position the intense, roughly handled, and introspective modern self-portrait of the queer German sculptor Renée Sintenis (1888–1965) (see fig. 2.54), who also posed for the renowned Berlin photographic portraitist Frieda Gertrud Riess (1890–1957) (fig. 3.22). Sintenis was a major presence in Berlin, where she was also, alongside Kollwitz, professor of sculpture at the Berlin Academy until, in 1934, she was forced to leave, being decreed half-Jewish because she had one Jewish grandmother. Her sculptures were regularly exhibited by the influential Flechtheim Gallery. She exhibited internationally and received critical recognition for her animal sculptures and also for her athletic figures in motion. Rosenau references a 1930 catalogue essay on Sintenis by French surrealist, communist novelist, and art critic René Crevel (1900–1935). Sintenis was herself frequently sought as a photographic model and by other sculptors. Rosenau writes of the sculptor's own works and those of her generation:

> From such works the distinct feminine traits as well as the special problems of women are entirely omitted. This type of art, therefore, reveals the wide range of expression attainable for women artists, an expression of a human, not of a sexually determined, attitude.

This reads as a classic statement of modernist feminist consciousness – the ambition to escape the sex–gender stereotyping typically dressed up as science and philosophy in the legacies of nineteenth-century thought, which attributed totally divergent humanities to women and men, backing the division up with economic, political, social, and sexual constraints. Rosenau invokes Virginia Woolf's (1882–1941) *A Room of One's Own* (1929), commending Woolf's brilliant conceit of imagining a sister for Shakespeare, Judith, whose desperate fate – sexual exploitation, poverty, and suicide – her brother Will never encountered in his ambition to become a writer. Rosenau names Judith 'one of the most imaginative creations of contemporary literature, and only paralleled by the same writer's *Orlando*' (1928). Rosenau affirms that Woolf was 'a convinced feminist' and aligns her in such conviction with the suffragist composer Ethel Smyth (1858–1944) (fig. 3.23) and writers Winifred Holtby (1898–1935) and Vera Brittain (1893–1970) (see fig. 3.29) as well as

3.22 Frieda Gertrud Riess (1890–1957), *The Sculptor Renée Sintenis*, 1925 or 1928, gelatin silver print, 22.6 × 17.3 cm. © Photo: sz Photo / Bridgeman Images.

Bassano Ltd., *Dame Ethel Smyth* (1858–1944), composer and suffragette, half-page negative, *c*.1927. Photo: Sasha / Hulton Archive / Getty Images.

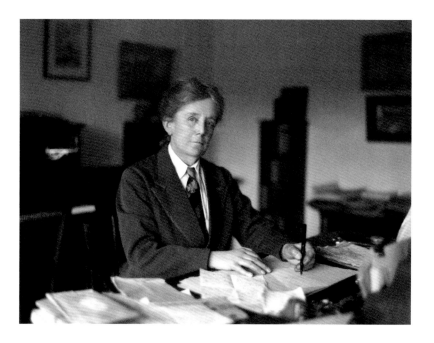

the Australian painter Stella Bowen (1893–1947) (fig. 3.24).[26] Bowen lived in Britain, Paris, and the United States of America and published her very well-received autobiography *Drawn from Life* in 1941, just six years before her early death from cancer.[27] The text is a critically important historical document of modernist feminist writing, a rich complement to Woolf's more well-known *A Room of One's Own*. Bowen negotiated several marriages and, after 1918, lived with a British novelist, Ford Madox Ford (1873–1939), with whom she had a daughter. They moved in literary and artistic circles in both England and then Paris.[28] Leaving Ford in 1927, Bowen travelled to the United States in 1932 before returning to England, seeking to sustain herself and her daughter through her painting and journalism. During the war she was appointed a war artist by the Australian government.

Rosenau draws from Bowen's autobiography to make her own observation of the 'constant strain on the woman artist by an exacting husband, and her revival of strength when living on her own. At the same time, the artist recognizes that these difficulties form the basis of her inspiration, and makes her understand and appreciate more deeply the human and artistic values in life.' In a long footnote in her 'Conclusion', Rosenau writes:

> On the woman at the present time falls the task to choose her way of life
> for herself – a task new to her, since in the past it was mainly the man who
> made the decisions. This possibility of choice may entail sacrifice, since no

individual life is limitless in its scope. A 'handsome husband' may seem a more enjoyable goal than a doctor's thesis. But there might be a moment of frustration, even when the work is not given up, or when the husband seems less handsome than before. Not only outside work but also housework means drudgery. Although the same problems apply to the male sex, men are biologically and sociologically less limited, and have a wider range of choice.[29]

Painter Stella Bowen's younger contemporary was sculptor Barbara Hepworth (1903–1975), whose *Conoid, Sphere and Hollow* (1937) is the third of the sculptures that concludes Rosenau's chapter. Hepworth mirrored the contemporary intellectual individuality of scholar Helen Rosenau herself, both artist and academic benefitting from the modernization of social relations and from the new identities of women as singular *personality* no longer economically totally confined to *type*. It is

3.24 Stella Bowen (1893–1947), *Self-Portrait*, 1928, oil on plywood, 45 × 36.8 cm. Art Gallery of South Australia, Adelaide, 991P3.

significant that Rosenau chose to conclude her text with Bowen's vivid literary self-portrait, an autobiographical text published in 1941 that is of profound sociological significance as a reflection on the complex relations of modernity, individuality, artistic practice, and gender.

The footnote that begins with Woolf ends with a reference to Otto Weininger's (1880–1903) notorious thesis in *Sex and Character* (1906) asserting an absolute and hierarchically valued differentiation of 'male' and 'female' characteristics. If *A Room of One's Own* itself was a feminist tracing of the historical fate of women intellectually stunted, sexually silenced, and creatively strangled by rigidly divided gender definitions and norms, Woolf's historical novel *Orlando*, referenced by Rosenau, is a glorious reimagining of that same historical trajectory. In the novel, Orlando time-travels from the Renaissance to the present time, as a poet-writer inhabiting mobile possibilities of both masculine and feminine bodies, sexualities, and subjectivities. Through Orlando's experience, Woolf shows that these possibilities for fluidity became increasingly narrowed and typed as eighteenth- and nineteenth-century European societies imposed more fixed and heteronormative, bourgeois notions of both the feminine and the masculine. The modern women of the twentieth century challenged these Victorian norms, freeing themselves to desire whom they desired and to explore ways of being a woman as they defined their own erotic and intellectual humanity. Thus Rosenau concludes: 'It is characteristic of the present time that wide divergences are represented by women artists. Marie Laurencin (b. 1885), standing in the age-honoured feminine tradition of sensitiveness and delicacy, while Barbara Hepworth's (b. 1903) approach to her abstract art is one which transcends the limitations set by her sex.'

The visual thinking across this set of images arrives at the modernist moment in visual art and literature still marked by struggle against disadvantageous gender norms that had hardened during the nineteenth century and were defended by the masculinist reaction against emerging feminist challenges.[30] Rosenau has, however, woven creativity by women as creators of images of women over time following the dialectic of social situatedness, generationality, individuation, professionalization, and relationality. Each image becomes a strategic element of an argument that cannot be made without the evidence of many of the images being made by women as counter-images to the ideologies that sought to *type* woman versus man, and, later inspired by the feminist project, to defy all typing in the name of open, individualizing, and elective self-discovery via work, alone or together.

Notes to Essay 3

1 Letter from Barbara Hepworth to E. H. Ramsden, 8 March 1944, Tate Gallery Archive, London, 9310.1.1.25, cited in Eleanor Clayton, *Barbara Hepworth: Art & Life* (London: Thames & Hudson, 2021), 108.

2 Wölfflin's method involved comparing and contrasting stylistic features and so he introduced the use of two projectors side by side to enable his audience to see two images at the same time. Prior to this, art historians beginning to use the new technology of projected images, often from large glass plates, typically screened one image alone. Wölfflin installed a formal-stylistic model that became standard for teaching Art History. See, for example, Bethany Farrell, 'How Our Tools Shape Us: Technology's Impact on Art History', Scholars Studio (Temple University), 19 February 2019, https://sites.temple.edu/tudsc/2019/02/19/how-our-tools-shape-us-technologys-impact-on-art-history, retrieved 27 April 2023.

3 Claudia Wedepohl, 'Mnemonics, Mneme, and Mnemosyne: Warburg's Theory of Memory', *Bruniana & Campanelliana* 20:2 (2014), 385–402: 389. Wedepohl references Warburg's assistant, Gertrud Bing (1892–1964), who explained this system as follows: 'The classification is anything but indifferent. The manner of shelving the books is meant to impart certain suggestions to the reader who, looking on the shelves for one book, is attracted by the kindred ones next to it, glances at the sections above and below, and finds himself involved in a new trend of thought which may lend additional interest to the one he was pursuing.'

4 Daniel Sherer, 'Panofsky on Architecture: Iconology and the Interpretation of Built Form, 1915–1956', *History of the Humanities* 5:1 (2020), 189–224.

5 Kurt W. Forster, 'Aby Warburg: His Study of Ritual and Art on Two Continents', trans. David Britt, *October* 102:77 (1996), 5–24: 11. *Mensa* (Latin for 'table') is the single piece of stone that forms the tabletop of the Christian altar.

6 Uwe Flecker, *The Snake and the Lightning: Warburg's American Journey*, trans. Kevin Cook (Berlin: Hatje Cantz, 2023).

7 Forster, 'Aby Warburg', 12.

8 Sherer, 'Panofsky on Architecture', 217.

9 This phrase was coined by Catherine de Zegher in her edited work *Inside the Visible: An Elliptical Traverse of Twentieth Century Art in, of, and from the Feminine* (Cambridge, MA: MIT Press, 1996), borrowing from the title and argument in my chapter in that publication, 'Inscriptions in the Feminine' (67–87). I in turn had drawn on artist Mary Kelly's definition of feminist practice as 'visual inscriptions' in which 'the feminine is, metaphorically, set on the side of the heterogeneous, the unnameable, the unsaid' and 'in so far as the feminine is said, or articulated in language, it is profoundly subversive'. See Mary Kelly, 'Sexual Politics and Art' [1977], in *Framing Feminism: Art and the Women's Movement 1970–1985*, ed. Rozsika Parker and Griselda Pollock (London: Pandora Books, 1995), 303–12: 310. For this psychoanalytical and semiotic definition of 'the feminine', Kelly references Julia Kristeva, 'Signifying Practice and the Mode of Production', trans. Geoffrey Nowell-Smith, *Edinburgh Magazine* 1 (1976), 64–76.

10 Quoted in Michael Thimann and Thomas Gilbhard (curators), 'The Library of Aby Warburg', trans. Eckart Marchand, Warburg Institute, n.d., https://warburg.sas.ac.uk/library/about-library/library-aby-warburg, retrieved 17 March 2023 (my emphasis).

11 In a personal communication to me, Adrian Rifkin expressed the view that a stronger case can be made for Rosenau's closer affinity with her contemporary Edgar Wind (1900–1971) than with Warburg or Panofsky, of whom Wind was the first doctoral student. Wind worked with Warburg at the library and was instrumental in its transfer to London and in the founding of the *Journal of the Warburg Institute* (later the *Journal of the Warburg and Courtauld Institutes*). Having achieved teaching posts in the United States after 1939, he returned to Britain in 1955 to be the first Professor of Art History at the University of Oxford, where, without there being a degree in this subject, he was able to give lectures in his field.

12 Adriana Cavarero, *Inclinations: A Critique of Rectitude*, trans. Adam Sitze and Amanda Minervini (Stanford: Stanford University Press, 2016). Tracing the trope of rectitude across Western philosophy, Cavarero makes the argument for inclination as an ethical and political posture.

13 The Santhals are a Munda ethnic group who speak an Austroasiatic language and are settled in West Bengal. Their original homeland is not known, though they arrived on the subcontinent 3,500–4,000 years ago. They are protected under the Indian Constitution as one of the Scheduled Tribes.

14 *Axis* no. 7 included a review of the major exhibition 'Cubism and Abstract Art', curated by Alfred H. Barr at the Museum of Modern Art. See Stuart Carey Welch and Diane M. Nelson, 'William G. Archer (1907–1979): Bibliographical Note', *Archives of Asian Art* 33 (1980), 109–11. See also Karen Anne Hiscock, *Axis and Authentic Abstraction in 1930s England* (PhD thesis, University of York, 2005).

15 W. G. Archer and M. Archer, 'Santhal Painting', *Axis* 7 (1936), 27–8: 27.

16 Herbert Read, *The Meaning of Art* (London: Faber & Faber, 1931).

17 Gayle Rubin, 'The Traffic in Women: Notes on the "Political Economy" of Sex', in *Toward an Anthropology of Women*, ed. Rayna R. Reiter (New York: Monthly Review Press, 1975), 157–210. Defining the sex–gender system, Rubin explores the kinship systems that determine the social relations between families and social groups mediated by exchange, 'women' being the name of that which is exchanged and 'men' not-exchanged. Arrangements can be matrifocal or patrifocal. Although heteronormativity is institutionalized in most kinship systems for social regulation of reproduction of the species, the rules are structural, not physical, and thus Rubin identifies examples of transgendering and same-sex coupling condoned, but subject to the economics of exchange.

18 Edward Westermarck, born in Swedish-speaking Finland, became one of the founders of British sociology and was the first Martin White Professor of Sociology at the University of London in 1907.

19 Over two hundred works by Therbusch-Lisiewska are documented including at least eighty-five portraits. Her sister Anna Rosina de Gasc, née Lisiewska (1713–1783) was also a professional and court painter.

20 Ernst Gombrich, *The Story of Art* [1950] (London: Phaidon, 1962).

21 H. W. Janson with Dora Jane Janson, *History of Art* (New York: Abrams, 1962).

22 H. W. Janson, *History of Art*, 3rd edition, revised and expanded by Anthony F. Janson (Englewood Cliffs, NJ: Prentice Hall, 1986). Elizabeth Sears and Charlotte Schoell-Glass, 'An Émigré Art Historian and America: H. W. Janson', *Art Bulletin* 95:2 (2013), 219–42. Janson was from a Lutheran family and left Germany in 1935 when his PhD supervisor moved to the United States. On feminist critique of Janson and his impact, see Jeffrey Weidman, 'Many Are Culled but Few Are Chosen: Janson's History of Art, Its Reception, Emulators, Legacy, and Current Demise', *Journal of Scholarly Publishing* 38:2 (2007), 85–107. See also Patricia Hills, 'Art History Textbooks: The Hidden Persuaders', *Artforum* 14:10 (1976), 58–61; Sylvia Moore, 'An Interview with That Man Janson!', *Women Artists News* 4:1 (1978), 1, 8; and Eleanor Tufts, 'Beyond Gardner, Gombrich, and Janson: Towards a Total History of Art', *Arts Magazine* 55:8 (1981), 150–54.

23 Rosenau references Ludwig Goldscheider, *Five Hundred Self-Portraits*, trans. J. Byam Shaw (London: Phaidon, 1937), the first book published by the exiled Phaidon Press in London. Its German edition had appeared in 1936. It illustrates the following artist-women: Properzia de' Rossi (1490–1530), Sophonisba Anguissola (1532–1625), Marietta Robusti (c.1560–1590), Rosalba Carriera (1673–1757), Anna Rosina de Gasc, née Lisiewska (1713–1783), Anna Dorothea Therbusch-Lisiewska (1721–1782), Angelica Kauffman (1741–1807), Adélaïde Labille-Guiard (1749–1803), Élisabeth Vigée-Lebrun (1755–1842), Marie Bouliard (1763–1825), Käthe Kollwitz (1867–1945), Paula

Modersohn-Becker (1876–1907), and Renée Sintenis (1888–1965). Rosenau illustrates the same images by Anguissola, Therbusch-Lisiewska, and Sintenis.

24 Arthur Schopenhauer, 'On Women', in *Parerga and Paralipomena: Short Philosophical Essays* [1851], vol. 2, edited and trans. Adrian del Caro (Cambridge: Cambridge University Press, 2015), 550–61: 'Women are suited to be nurses and governesses of our earliest childhood precisely by the fact that they themselves are childish, silly and short-sighted, in a word, big children their whole life long, a sort of intermediate stage between a child and a man, who is the actual human being. Just look at a girl as she dawdles, dances around with and sings to a child for days, and then imagine what a man doing his utmost could achieve in her stead!'

25 Cited in Rüdiger Safranski, *Schopenhauer and the Wild Years of Philosophy*, trans. Ewald Osers (London: Weidenfeld & Nicolson, 1989), 348. On the encounter between Elisabet Ney and Schopenhauer during the making of the bust see Sandra Salser Long, 'Arthur Schopenhauer and Elisabet Ney', *Southwest Review* 69:2 (1984), 130–47.

26 Virginia Woolf and Ethel Smyth had a long friendship, erotic on Smyth's side. Woolf wrote to Smyth: 'I was thinking the other night that there's never been a woman's autobiography. Nothing to compare with Rousseau. Chastity and modesty I suppose have been the reason. Now why shouldn't you be not only the first woman to write an opera, but equally the first to tell the truths about herself? Isn't the great artist the only person to tell the truth?' Virginia Woolf to Ethel Smyth, 24 December 1940, cited by Christopher Wiley, '"When a Woman Speaks the Truth about Her Body": Ethel Smyth, Virginia Woolf, and the Challenges of Lesbian Auto/Biography', *Music & Letters* 8:3 (2004), 388–414: 401.

27 Stella Bowen, *Drawn from Life: Reminiscences by Stella Bowen* (London: Collins, 1941). Bowen's complex life is retold and analysed in Drusilla Modjeska, *Stravinsky's Lunch: Two Women Painters and Their Claims of Life and Art* (New York: Farrar, Straus and

Giroux, 1999). I acquired my own copy of Bowen's book when it was reprinted in 1984 by Virago Books, the feminist press dedicated (among other things) to recovering the literary works of nineteenth- and twentieth-century women that had gone out of print and fallen out of cultural memory. It included a preface written by Julia Loewe, Bowen's daughter.

28 Ros Pesman, '*Drawn from Life*: Stella Bowen and Ford Madox Ford', *International Ford Madox Ford Studies* 2 (2003), 221–38.

29 For similar attitudes see Stella Bowen, *Drawn from Life* (London: Virago Books, 1984), 160–63. Rosenau's footnote provides her own commentary, possibly taking the phase in quotation marks – 'handsome husband' – from an uncited source in Bowen's book.

30 Rosenau notes the use of male pseudonyms (Georges Sand and George Eliot) and trousers worn by Georges Sand and Rosa Bonheur at a time when 'male prejudice' against the exceptional woman refused to die and obliged these women to use the subterfuge of costume as statements of defiance.

Essay 4

The Process and Its Feminist Context

All of us know that the greatest oppression in history is not that of the slaves, serfs or wage-earning labourers, but that of women in patriarchal societies. And yet the sufferings and the resentment of these women remained meaningless throughout the many thousand years as long as they were the sufferings of the millions of individual women in isolation. But their resentment at once became creative and socially relevant when in the movement of the suffragettes these sufferings and sentiments were integrated, thus contributing to the recasting of our views concerning the place and function of women in modern society.

Karl Mannheim, *Diagnosis of Our Time* (1943)[1]

In a series of articles published in the *International Women's News*, produced since 1930 by the suffragist organization the International Woman Suffrage Alliance (founded in 1902), we can trace the various elements Helen Rosenau combined to formulate the book *Woman in Art*. Among papers provided to me by Louise and Michael Carmi, Rosenau's daughter-in-law and son, are Rosenau's own copies of four one-page articles published in the early 1940s and directed not at an academic audience but at a readership of educated, politically active women. They are titled 'The Institution of Marriage as Seen in Art', 'Motherhood as Seen in Art', 'The Community of Women as Seen in Art', and 'Women Pioneers as Seen in Art'.[2] 'As seen in art' was, perhaps, also the original title for her book, which, in the published form, compiled these four themes into three chapters. In another British art magazine, *Apollo*, founded in 1925, Rosenau published 'Social Status of Women as Reflected in Art'.[3]

I want to examine the arguments and additional examples as well as the sources we find in these essays as preliminary sketches for the book that were first made available to a readership of politically active educated women through these magazines, making a history of visual representation relevant to their promotion of women's consciousness and struggle for change.

We can situate Rosenau's feminist project in the community of feminist thinking during the 1940s and understand the currency of the term 'feminine' in these debates. We can locate Rosenau's project firstly

within the emerging subdiscipline of History – 'women's history', which both recognized 'women' as having a history and initiated new historiographical procedures for its elaboration. Then a sociological context is explored through the analysis of the formation of the ideology of femininity in recent Western thought in *The Feminine Character: History of an Ideology* (1946), written by a second Jewish refugee scholar working with Karl Mannheim (1893–1947) at the London School of Economics in the 1930s and 1940s, the sociologist Viola Klein (1908–1973).[4] Klein has also been belatedly recovered and reinstated as a founder of feminist sociology in Britain by post-1968 feminist scholars. I complement Klein's analytical work with a political document that indicates the currency of the term 'feminine' – uneasy for readers today, but clearly situated critically within feminist thinking in the 1940s – as much in British studies as in a French context in *The Second Sex* (1949) by philosopher Simone de Beauvoir (1908–1986), or later in the US-American Betty Friedan's (1921–2006) *The Feminine Mystique*, published in 1963.[5] Hailed as the founding text of the post-1968 Women's Movement, the latter can better be seen, as indeed Rosenau's book must also be recognized, as part of a continuum of feminist thinking across the mid-twentieth century.

— Rosenau's Articles

As a note at the end of Rosenau's article for the *International Women's News* titled 'Motherhood as Seen in Art', we read:

> These articles are intended only as an introduction to the important sociological researches on women in which she is now engaged. She is also giving a series of lectures on Art and Society, Central Square NW 11 on Saturday afternoons.[6]

The outcome of the 'sociological researches' was, of course, *Woman in Art* being undertaken at the London School of Economics.[7] The preliminary presentations in article form aid reading of her 'little book' for its multiple addressees indicate a political commitment. At once immensely scholarly and interdisciplinary, the writing is direct, accessible, and aimed at both feminist and general art readers.

The recurring phrase (amended, I suspect, by editors for the *Apollo* version by the term 'reflected') 'as seen in art' expands the meaning of the preposition in the title, *Woman in Art*, to position art – understood as artistic representation – as both a perspective and an archive. *Perspective* allows for differing ways of seeing, defining, and understanding the experience and categorization of women and their lives. *Archive* indicates the historical density of different perspectives. Together these terms constitute a 'sociology of knowledge', in Mannheim's terms, for ways of knowing

the world and our positions and experience that are at once subjective, perspective, and historically inflected, with institutions, social practices, agency, and change being the critical elements to track and analyse.[8]

In her article on marriage in art, Rosenau references two contrasting anthropological interpretations of the marital institution. The functionalist argument relates it to the creation of family, already a complex concept, while the individualistic approach focusses on the relations between the adult partners. The two possibilities yield both an institution universally found in human cultures and a vast diversity between those cultures in how the marital institution is defined or practised and enters into representation, myth, and the shaping of the identities and statuses of the couple's members. Rosenau accompanies this broad anthropological framing by suggesting that the history of art is also a source for understanding the history of the institution of marriage as both a cultural form – 'since art expresses the general trend of a period' – and a site of agency – 'as well as the particular feelings of an individual artist'. She can then conclude that 'it is possible to understand, through this *medium*, how a certain culture appeared to its contemporaries'.[9]

As a historical formulation, therefore, art is shaped by individualized articulations that introduce singular instances of historically changing forms of subjectivity, while as *medium* – a transmitter – art performs the cultural function of enabling later scholars to enter the mindset of a past culture. For Rosenau, art forms a complex of society and individual, of cultural institutions and agents of representation. Artworks also archive, for later outsiders, but also for their own society, the features that project and then form a society's understanding of itself.

Rosenau thus reviews the most ancient representations of Woman from Neolithic times, referencing unnamed her later cover image, passing through ancient Egypt, Babylonia, and Assyria, where polygamy was recorded, in contrast to biblical examples of affectionate monogamy in ancient Judaism. She moves on to Greece, Rome and the Christian European world, where she argues that Christian influence notably shifted from the sixteenth century onwards (the Renaissance and the Reformation) to foster individuation, culminating in European images, by the later nineteenth and early twentieth centuries, that represent marriage as a joint intellectual–affective partnership. Rosenau mentions three couples by name: a painting by Pre-Raphaelite Ford Madox Brown (1821–1893) of suffragist leader Millicent Garrett Fawcett (1847–1929) and political economist Henry Fawcett (1833–1884) (fig. 3.25); a photograph of scientists Marie Skłodowska Curie (1867–1934) and Pierre Curie (1859–1906) in their shared laboratory (fig. 3.26); and a painting of Beatrice Webb (1858–1943) and Sidney Webb (1859–1947) (see fig. 2.15), economists and founders of

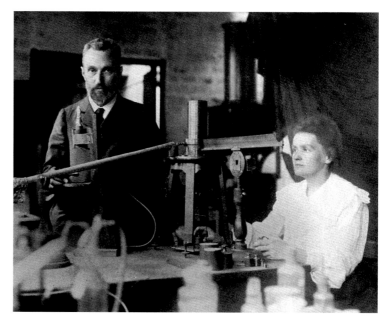

3.25 Ford Madox Brown (1821–1893), *Henry Fawcett and Dame Millicent Garrett Fawcett*, 1872, oil on canvas, 108.6 × 83.8 cm. Bequeathed by Sir Charles Wentworth Dilke, 2nd Bt, 1911. National Portrait Gallery, London.

3.26 Anonymous, *Marie Skłodowska Curie and Pierre Curie in Their Laboratory*, 1905, gelatin silver print. Photo: Alamy Stock Photo.

3.27 William Hogarth (1697–1764), *Portrait of David Garrick and His Wife Eva Maria Feigel*, 1757–64, oil on canvas, 132.7 × 104.2 cm. Royal Collection Trust, London. © His Majesty Charles III 2023 / Bridgeman Images.

3.28 Rembrandt van Rijn (1606–1669), *Portrait of the Mennonite Preacher Cornelis Claesz Anslo and His Wife*, 1641, oil on canvas, 207.6 × 173.7 cm. Gemäldegalerie, Berlin. Photo: © Fine Art Images / Bridgeman Images.

the London School of Economics. Of these only the last is illustrated in the final chapter of her book.

In her article for *Apollo* in 1943, 'Social Status of Women as Reflected in Art', Rosenau mentioned two other works that tantalize us in terms of her missing archive of images from which she derived her analyses. The works in question were *Portrait of David Garrick and His wife Eva Maria Feigel* (1757–64) by William Hogarth (1697–1764) (fig. 3.27) and Rembrandt's (1606–69) *Portrait of the Mennonite Preacher Cornelis Claesz Anslo and His Wife* (1641) (fig. 3.28).

Once we add in the images, the massive arc of this survey, identifying both emotional attachment and social forms, discloses Rosenau's skills of visual analysis, shaped by several then newly emerging modes of image analysis. These render the institution of social–erotic–affective (largely heterosexual) relations between men and women visible as both *type* – the marital couple – and *personality* – two individuals in a companionate and intellectual relationship. Rosenau concludes in the recent present of revolutionary Russia's political experiment and the impact of the emancipation movement of women:

> With the emancipation of women and the emphasis laid on individual development a *new type of marriage* seems to develop in our time. The *personalities* of the wife and husband are no longer merged one into the other. A *division of labour*, and not solely based on sex, but on *individual attitudes* obtains. A well-known woman writer, like Vera Brittain, has a husband working in a different field, and such examples could be multiplied.[10]

The breadth of historical perspective on the shifts within a structural social relation serves to identify contemporary directions through a concrete exemplar. British writer Vera Brittain (1893–1970) (fig. 3.29) – volunteer nurse during the First World War, Oxford scholar before women were given degrees, married to political scientist George Catlin (1896–1979) – is pertinent and of the minute in so far as Brittain's creative and autobiographical writings address the changing ambitions for, and experiences of, both heteronormative love relations and close friendships as well as divisions between women, in the wake of major events – world war and women's suffrage struggle. In 1933, Brittain published the work for which she became famous, *Testament of Youth*, which was followed by *Testament of Friendship* in 1940, her tribute to and biography of novelist and journalist Winifred Holtby (1898–1935).[11] Brittain's first novel, *The Dark Tide* (1923), explored the complexity of love and friendship while *Honourable Estate* (1936) is also a reflection on contemporary marriage and generations as the site of conflicting social mores, as well as of the personal and intellectual ambitions of women, and of the men who might be able to adjust to women's desire for subjecthood.

3.29 Howard Coster (1885–1959), *Vera Brittain* (1893–1970), 1936, photograph, 25.4 × 21.8 cm, film negative. National Portrait Gallery, London.

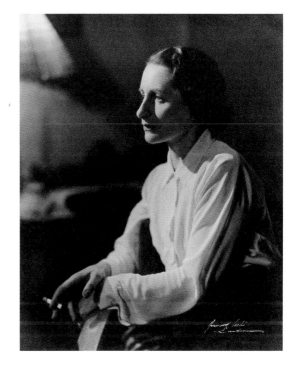

The bibliography for this dense and brilliantly concise article includes key publications still considered canonical studies:

E. A. Westermarck, *The History of Human Marriage* ([1891] 1921); Finnish anthropologist.

Th. H. Van de Velde, *Fertility and Sterility in Marriage* [subtitled *Their Voluntary Promotion and Limitation*] (1931); Dutch physician.

J. K. Folsom [and Marion Bassett], *The Family* [*and Democratic Society*] (1934); US-American sociologist.

E. Panofsky, 'Jan van Eyck's Arnolfini Portrait', *Burlington Magazine*, 64:372 (March, 1934), 117–19, 122–7; German art historian.

J. P. Mayer, *Political Thought* [subtitled *The European Tradition*] [written with R. H. S. Crossman, P. Kecskemeti, E. Kohn-Bramstedt, and C. J. S. Sprigge with an introduction by R. H. Tawney] (1939).[12]

In Rosenau's article on women pioneers 'as seen in art', the historical spread ranges from Queen Hatshepsut (*c.*1507–1458 BCE) (fig. 3.30) of Egypt, who claimed the Pharaoh's throne in *c.*1478 BCE, to the Holy Roman Empress Maria Theresa (1717–1780) (fig. 3.31). It concludes with contemporary women workers in the Belgian coalmines (see fig. 2.49).[13] Within this category of the *pioneer* – defined as 'women who transcend the limits set them by their age, and thereby reveal new potentialities in themselves, and for other women' – Rosenau places women as artists.[14] During the Renaissance, individual artist-women emerged from the medieval veil of invisibility in the scriptoria of convents to claim a public presence, demonstrated specifically through the new genre of artistic self-portraiture. Sophonisba Anguissola (1532–1625) – 'highly honoured by her contemporaries' – is mentioned by name while the increasing numbers of artist-women are invoked as becoming 'serious competitors with men' who then have to struggle not only against male resistance but as artists having to manage a range of expectations according to the existing sexual divisions of labour as both mothers and workers. Rosenau concludes: 'this short survey shows how the representation of women tends to reflect their *social position* and the *division of labour* between the sexes' (my emphasis), both concepts stressed by Marianne Weber (1870–1954) and Mannheim.[15] In the published book *Woman in Art*, pioneers are incorporated into the third section, 'Further Aspects of Creativeness'. Rosenau creates a diverse array of exemplars through a combination of self-portraiture with images from French revolutionaries (see fig. 2.47), Hildegard of Bingen's (1098–1179) visions (see fig. 2.35), Ku K'ai-Chih's (*c.*344–406 CE) *Admonitions of the Instructress to the Court Ladies* (see fig. 2.51), Frans

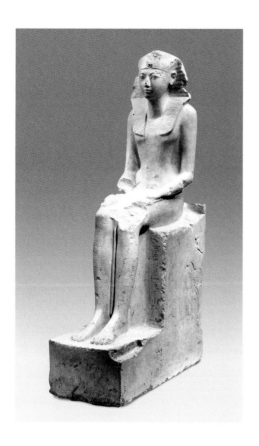

Hals's (1582–1666) painting *The Women Regents* (see fig. 2.40), and Jacob Cornelisz van Oostsanen's (1472–1533) biblical *Salome* (see fig. 2.42) to Carl E. Weber's (1806–1856) portrait of the salonnière Rahel Levin Varnhagen (see fig. 2.43). They create a diverse array of exemplars.

Rosenau's distinctiveness lies in both her way of identifying social relations of gender 'in art' and in her reading of art as the site of the diverse inscriptions of social subjectivities (self-portraiture) as well as social positions across portraiture, prints, genre paintings, and mythological paintings. Her combinations neither follow typical art-historical logics of period, style, artist, genre, subject matter, or theme, nor explore the Warburgian notion of the migration of *pathos formulae*. Not formally or stylistically connected, the images plot out a historical sociology across disparate artworks that would be segregated in most art-historical narratives.

— Women's History

Underlying Rosenau's sociological–art-historical intervention is the concurrent emergence not only of a historiography of women in history. She also marks the emergence of women, and indirectly sex and gender,

3.30 *Seated Statue of Queen Hatshepsut*, fifth pharaoh of the Eighteenth Dynasty, ruled *c.*1478–58 BCE, indurated limestone, painted, 195 × 49 × 114 cm. New York: Metropolitan Museum of Art (Rogers Find 1929), USA / Bridgeman Images.

3.31 Martin van Meytens (1695–1770), *The Holy Roman Empress Maria Theresa*, 1759, oil on canvas, 232.7 × 172 cm. Academy of Fine Arts, Vienna. © NPL-DeA Picture Library / Bridgeman Images.

as topics for historical analysis. Rosenau references the study by the leftist, pacifist, and anti-racist South African-born writer John Langdon-Davies (1897–1971, incidentally the founder of the still operative children's charity Plan International). In 1927 he published a thick volume titled *A Short History of Women* (Rosenau cites a 1938 edition), making the case for a historical study of women as a perspective through which to grasp foundational aspects of human societies.[16] Virginia Woolf (1882–1941) herself mentions his work in her study of women and literature *A Room of One's Own* (1929).[17]

Langdon-Davies's substantial volume opens with a 'Biological background to Women's History' – posing the following questions: What is the meaning of sex in the universe? What is sex? Why is sex? – before plotting out the following chapters: 'Women in Primitive Society: The Birth of Fear and Contempt', 'The Ancient Civilizations: Asia, Egypt, Greece, Rome', 'Women and the Early Christian Church', 'The Middle Ages: The Witch, the Virgin and the Chatelaine', 'Modern Times: From Womanly Woman to Intelligent Being', and 'Epilogue: The Future'. Social organization and social typing are underpinned by economic, sexual, and ideological organization of lives and minds. His conclusion is that, when viewed through this question of why 'sex' (gender) became a defining element in social organization and belief, the problem, which had begun with mistaken notions of biology, can be undone once we recognize that differences are sociologically instituted and imaginatively reproduced. Education and economic emancipation, he argues, have begun to 'right' this wrong, yet deeply held ideological beliefs obstruct 'emotional emancipation'. This has been inhibited by the recalcitrance of 'facts' of desire (sexuality and its outcomes) and the division of labour, which created social institutions such as 'the family', originally in a domestic economy and now in capitalist industrialization. The latter have led to separation of home and work even as, under differing class situations, many women have to work, some women choose to work, and some are afflicted with enforced worklessness. These impact unevenly on men and women, causing continuing challenges around women being full participants in all aspects of life or requiring wholesale reconfiguration of the management of the reproduction of daily life and of generations to come, leading to the so-called crisis of the family. Communist experimentation with socialization of both childcare and daily life needs becomes relevant to his argument but at a price not all are prepared to pay. If the originating cause lies in misreading biology and the creation of 'sex' and then 'gender' as key dividers of the human community, Langdon-Davies concludes that:

Men and women are purely relative terms, and long before the tendencies of our times work to their logical conclusions, men and women, as we know them, will have ceased to exist; and human nature will have forgotten the 'he' and the 'she'. According to our own personal feelings we may regret that we shall not live to see that time, or congratulate ourselves on living at a time that antedates it.[18]

The pertinence of this text does not lie in its influence on Rosenau. I discern none directly. It is in the shared nature of the inquiry, which required a sweep of history by which the present emerges as a moment of radical interrogation of its own destabilization. This destabilization – remember Mannheim's thesis on generationality (see Part 1, Chapter 3) – in sociological and historical terms renders available for intellectual reflection as well as political challenge the sequencing of *men, women, desire, the family, rational being, political rights*, and *creativity* as well as the conditions and uneven distribution of the results of *procreativity as sex and gender questions*. Women thus become a topic in general – but also a necessary lens for understanding both the present and the future.

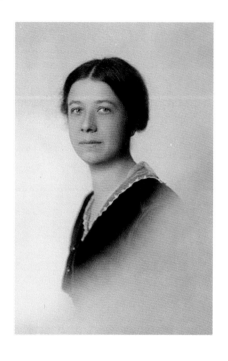

In this context, I introduce the US-American leftist, suffragist, and historian Mary Ritter Beard (1876–1958) (fig. 3.32), whose *Women as a Force in History: A Study in Traditions and Realities*, published in 1946, just postdates Rosenau's work even as it is deeply relevant in its approach.[19] Beard argued for 'women's history' as a specific area of research and worked to foster the creation of women's historical archives at major universities in the United States of America to facilitate it. She challenged the then-current feminist over-emphasis only on the negative, and seemingly unending, burden of women's legal and economic and hence subjective subordination. Instead, she encouraged recognition of an always-occurring counter-record of women's agency in history: 'The strongest argument living women can make in their quest for equality is the *fact* of their historic force.' By a recovery of the historical record that balanced what oppressed women with the traces of their long history of being a 'force', Ritter Beard argued: 'We cannot know how our own society has been built up without knowing women's share in establishing free speech, free assembly, freedom of worship, all civil liberties, all humanism, all the branches of learning and everything else we value.'[20]

3.32 Anonymous, *Mary Ritter Beard* (1876–1958), photograph published in *The Suffragist* 3:30 (1915), gelatin print. Women's Party National Records, Library of Congress, Washington, DC.

In this dialectic, I recognize my own position as a feminist art historian who has resisted the argument that past institutional discrimination is the sufficient explanation for women's relative absence from, or

relative scarcity in, the history of art. Without much digging, we find a history of art with women constantly present, co-creating culture while negotiating conditions, often not of their own making, and creating their work as much *because of* their specific situations *as despite* the restrictive conditions that, however, never stopped so many women from becoming artists. This is not to deny real obstacles and limitations on creative practice; it is instead to offer the consistent, counter-balancing evidence of women's persistent creativity.

We can characterize Helen Rosenau's 'little book' as women's history, a history of women's varied conditions, and of women's significant negotiations of those conditions, to which we have access through the record of art. Art is a culture's representational 'face' – the site of negotiations of conflicting interests and power relations, ideologies, and fantasies. It is also a space for representational activity, for developing, transforming, and inventing. Writing and teaching the history of women 'as seen through art' (Rosenau's model in this series of articles) and creating a history of art that recognizes *in art* much more complex, negotiated, and often surprising representations and formulations of gender, sexual difference, agency, and sexualities – both strategies foster and enable egalitarian social transformation. Unknown to each other, yet indicative of a generational shift, earlier twentieth-century feminist scholars, women and men, redefined *Women* as a lens for the rewriting of history. When *Women* are studied in and through art, art itself is also challenged and changed by the way it can become both face of culture and record of agency and change.

Thus, Rosenau's chapters on socially instituted and gendering forms of relations, work, sexuality, self-realization, and the trajectory *from type to personality*, concluding with pioneers of the modern situation, resonate, I suggest, with the concurrent texts (explored in this essay and the previous) from John Langdon-Davies, Virginia Woolf, Stella Bowen, Mary Ritter Beard, and, as we shall see now, Viola Klein.

— The Sociological Context

The book by fellow refugee Viola Klein (fig. 3.33) titled *The Feminine Character: History of an Ideology*, also prepared with the support and supervision of Mannheim at the London School of Economics in the early 1940s, provides an expanded context for the concerns and issues that shape Rosenau's work. Klein's book sociologically framed a history of ideological representations of women by major male thinkers in relation to sexuality, marriage, and maternity.[21]

Viola Klein was a Czech, Jewish, and adopted British scholar who was one of Britain's first sociologists of women.[22] Born in Vienna, she

studied in Prague and Paris before graduating from the University of Vienna in philosophy and psychology. Her doctoral research was, however, in French Literature on the controversial modern writer Louis-Ferdinand Céline (1894–1961) (also later studied by Julia Kristeva). During the 1930s, Klein visited the Soviet Union and critiqued the contradictions she observed between official ideology and social practice within that society in regard to women. Although she and her brother had escaped from Europe in 1938, her mother did not and was murdered in Auschwitz and her father died in the ghetto camp of Terezin, in Czechoslovakia. Surviving in Britain by working as a domestic, Klein

was awarded a scholarship from the Czech government that enabled her to enrol at the London School of Economics, where she completed her *Habilitation* doctorate supervised by Mannheim. Initially titled *Feminism and Anti-feminism: A Study in Ideologies and Social Attitudes*, her thesis was published in 1946 as *The Feminine Character: History of an Ideology* (see fig. 1.10). 'Ideology' references Mannheimian sociology of knowledge as articulated in his book *Ideology and Utopia*, while the address to 'the feminine character' echoes the third purpose stated in Rosenau's 'Preface': 'The third problem to be considered is whether there may be found some permanent features which repeat themselves in varying social conditions, and may be regarded as typically feminine.'[23]

In her study of Klein, E. Stina Lyon suggests that Klein might have initially considered the topic of anti-semitism for her research, mentioning Mannheim's recommendation of a project being led by Max Horkheimer (1895–1973) in New York, while concluding: 'In her final thesis the parallels between the social and scientific construction of women and that of Jews are stated though never explicitly addressed.'[24] Not only did Klein produce a Mannheimian reading of ideological statements by several thinkers on femininity but also, as Lyon reminds us, Klein has precedence in such an undertaking: 'The first case-study in Britain based on Mannheim's conception of the sociology of knowledge, it [Klein's book] preceded Simone de Beauvoir's *The Second Sex* (1949) as a theoretical challenge to prevailing male conceptions of femininity.'[25] Lyon concludes:

> For her it seemed as sociologically absurd, and ethically dubious, to ask questions about the universal nature of 'women' as about the inherent collective characteristics of Jews. Such attempts were in her view invariably coloured by expedient demands for social control of 'the other' and a means of avoiding the hard slog of empirical research about the needs and aspirations of real persons in all their variety and complexity.[26]

What is significant in terms of a history of ideas and of concepts is that the book addressed *femininity* and the potentially essentializing ascription of a *feminine character*. These French-derived English words resonate differently, I suggest, from what is evoked in the French, German, or Czech versions of the concept. As a concept, not an attribute, 'feminine' (*le féminin*) is an invented French formulation that does not carry the same associations as 'femininity', a condition and an attribute – in English (still carrying a French and Latin origin), or *Weiblichkeit*, which has the word for 'woman in it' – that is distinct from what its direct English translation, 'womanliness', conveys to an English-speaking ear, where it suggests not a condition, but an approved attribute. It is interesting in

3.34 Contents page of Viola Klein, *The Feminine Character* (London: Kegan Paul & Co., 1946).

CONTENTS

this context to note that Rosenau chose to write of Woman in art and not 'the feminine', even as she invoked the term in her 'Preface'. Coming from her literary studies in France on the modernist and infamously anti-semitic and homophobic Céline, undertaken at the Sorbonne, Klein's francophone intellectual experience would make the terms *le féminin* and *feminité* resonate as they would for her contemporary Beauvoir as the linguistic site of what needed to be systematically unpacked as a series of congealed ideologies, working as much for as against feminist thought, which itself was divided between those seeking to disown any of the stereotypical versions of *le féminin* and those who valued what we would now term the sexual difference of women as a counterforce to phallocentric subjectivity.

As mentioned in Part 1, Chapter 3, Klein critically analyses the ideologies of ten theorists (fig. 3.34) and plots out a historical trajectory in three parts. She concludes that no theory/theorist exhausts the question.

MEMBERS OF THE CONFERENCE
which issued this Report

Miss E. Alexander	Lady Allen of Hurtwood
Miss Roxanne Arnold	Miss Bertha Bracey
Mrs Billington Grieg	Miss Clare Campbell
Mrs Olwen W. Campbell	Miss E. Clarke
Mrs Corbett Ashby	Miss A. M. Daniel
Miss Mary Field	Miss Juanita Frances
Miss Marie Grulter	Dame Florence Hancock
Miss A. Haigh	Miss J. Hilton
Miss Rachel Hubbock	Professor Kathleen Lonsdale
Miss D. M. Moore	Mrs M. Nicholson
Miss O. M. Potts	Miss Pratt
Lady Simon of Wythenshawe	Mrs Mary Stocks
Mrs E. Stone	Miss Ann Temple
Hon. Mrs D. Wedgwood	Dr. Helena Wright

The Report of a Conference
drafted by
OLWEN W. CAMPBELL

3.35 a) Front cover of the conference report *The Feminine Point of View* (London: Williams and Norgate, 1952) and b) the list of conference members.

Considering theorists as, in fact, ideologists in Mannheim's term, they confuse theory (as pure knowledge) for ideology (as situated, generational attitudes). A sociological approach such as Klein chose must arrive at the relationship between social forms and social identities. Dismissing the stereotype of women's inherent incapacity for thought or inherent destiny determined by sexuality or body, Klein concludes with a digression on the psychological effects of the consistent discouragement of women by a world dominated by the feminine stereotype and its instituted social limitations on women. She also discusses the psychological 'distortion' imposed upon social groups othered by gender, race, religion, enslavement, migrancy, and marginality – returning us to the parallel between the positions, social and psychic, of women, Jewish people, and people of colour in patriarchal, anti-semitic, and/or racist or colonial societies respectively, the latter later explored in 1952 by Frantz Fanon.[27] She opens the feminine stereotype to the larger system of both social *typing* and *psychological* othering, anticipating the entangled questions with which we are still currently battling theoretically

as much as socially and politically. Her analysis also echoes the terms between which Rosenau situated her concurrent research but 'as seen through art' rather than philosophical writings.

A final book, postdating Rosenau's text, further confirms the continuities of feminist inquiry across the twentieth century that included the visual arts as a site of thinking of *the feminine* as a resource of transformation. Dating from 1952, this short conference report, *The Feminine Point of View* (fig. 3.35), situates socially progressive feminist *thought* in Britain contemporary with Rosenau's publication, reminding us of the longer, non-militant legacies of the more (in)famous feminist agitation for the vote culminating in the limited Representation of the People Act in 1918, which was extended to full emancipation of all women over age twenty-one in 1928.[28] Feminist thinking during the middle decades of the twentieth century tends to be forgotten even as it remained active in less spectacular ways.

The conference 'The Feminine Point of View' had been initiated in 1947. The report was edited by Olwen W. Campbell, a novelist, literary scholar, and women's rights campaigner who self-defined in the flyleaf as a 'housewife and writer'.[29] The standing conference included among its participants Teresa Billington-Greig (1876–1964) (fig. 3.36), the British suffragette who had critiqued and then dissociated herself from the autocratic leadership and militant tactics of the Pankhursts' Women's Social and Political Union, leaving it to found the Women's Freedom League, which replaced militant action with a revolutionary feminist programme that Billington-Greig outlined in her subsequent publications. In 1937, the League was renamed Women in Westminster and it campaigned to have women in Parliament with a feminist agenda.

3.36 Hemming (?), *Teresa Billington-Greig* (1876–1964), *c*.1950, photograph. The Women's Library Collection, London School of Economics (7TGB/3/4/6/).

3.37 Elliott & Fry Studios, *Dame Mary Danvers Stocks* (1891–1975), 1952, quarter-plate glass negative. National Portrait Gallery, London.

Billington-Greig was also a member of the Six Point Group, founded in 1921 by former suffragette Margaret Haig Thomas, Lady Rhondda (1883–1958), whose platform included i) satisfactory legislation on child assault; ii) satisfactory legislation for the widowed mother; iii) satisfactory legislation for the unmarried mother and her child; iv) equal rights of guardianship for married parents; v) equal pay for teachers; and vi) equal opportunities for men and women in the civil service.

Billington-Greig argued for a radical feminist revolt, rather than mere inclusion in the existing order. She proposed an evolving feminist programme for changing the whole edifice of society. Her collected writings, *The Non-violent Militant: Selected Writings of Teresa Billington-Greig*, were edited by Carol McPhee and Ann Fitzgerald, who felt that sadly she lived to see her work fall into oblivion among a generation unaware of the continuing work and thinking she contributed throughout the 1940s to the 1960s.[30] Another member of the conference was the suffrage campaigner and academic economic historian Dr Mary Danvers Stocks (1891–1975) (fig. 3.37), principal of Westfield College, University of London (1939–51), and then an independent parliamentary candidate and later a cross-bench peer in the House of Lords and a radio broadcaster. An economics graduate from the London School of Economics (1913), Stocks was an advocate of the vote, family allowances, and birth control, as well as equal pay, non-restrictive clothing, flat shoes, and short hair for women, and was deeply involved with the Workers' Educational Association (WEA), of which she wrote a history in 1953.[31] Rosenau regularly taught for the WEA in London.

Reflecting the trauma of the recent world war and the genocide of Jewish, Roma, and Sinti people that was perpetrated by the Third Reich, the conference report opens with the statement that 'the discussion here summarised originated less in dissatisfaction with the position of women than in dissatisfaction verging on despair with the present state and future prospects of human society' and proposes that any human future must include 'a feminine point of view'.[32] This does not assume a universal, singular, and radical position among all women, but a shared condition, created in societies that they do not control, but that do control what women can and cannot do, and determine what they are obliged to do and are prevented from doing. So the first question for a future is this: Is there a 'feminine point of view'?

Acknowledging that 'women' are shaped, often negatively, by their societies and thus as participants, the report questions: 'What defects in society and in women themselves prevent the Feminine Point of View from being more effective?'[33] Then strategic thinking must emerge from the enquiry: 'What can be done to increase the influence of the Feminine

Point of View?'[34] The answers include education (in the home and in the school); adaptation of society to women's needs and abilities (work in the house and paid work); the financial position of women ('nothing has so lowered women's position in society as the gradual accumulation of nearly all wealth and the means for producing it in the hands of men'); taxation; and marriage patterns (including divorce, companionate marriage, premarital sexual experience, removal of stigma for unmarried mothers and their children, the right to birth control, and the denunciation of prostitution).[35] Resonating with Rosenau's choices for her chapters, there is a long discussion of marriage, because it was a condition that, according to the report's most recent statistics, included ninety percent of women and hence was the legal institution by which the majority were most affected and was, in its current state, 'both cramping and unrealistic'.[36]

In what, according to this group of educated and politically active women, does 'the feminine point of view' consist? Firstly, they examined the characteristics *attributed* to women and tested out their validity as 'generalizations'. They used statistics relating to criminality to explore if women were less cruel, more compassionate, and more selfless. They asked what evidence exists that such qualities are 'characteristically feminine'? Accepting implicitly that they might be, the final section explored the 'relevance of these qualities to contemporary problems regarding World Peace: rescue of the Individual, Social Legislation, Education, Religion'. In terms of the 'defects' that inhibited women's 'point of view' being effective, the conference identified lack of self-confidence and lack of scope – economically and professionally. The authors cited the poverty of unmarried women and the limitations of women's double jobs (home and profession).[37]

What is interesting in the section on education is the necessity to change the curriculum to include histories and specifically the biographies of women in the past in terms of their significant actions while also including evidence of the oppression of women:

> A very wise teacher would be needed to teach girls something about the oppression their sex has suffered in the past and still suffers in many parts of the world. Yet unless they learn something about this side of social history, they cannot be expected either to co-operate with other women and men to bring about reforms, or even to exert an influence in their own circle by expression of informed opinion. Knowledge and vigilance are necessary to guard against the clock being put back; new customs are easily undermined, and history shows that in the matter of the position of women the clock has been put back quite often, even in this country.[38]

In a section on literature and the arts, it is roundly stated that 'in the Arts, which exert a great influence over the minds of a nation, there are no sex barriers', and this is followed by the question: 'But is there a sex point of view?' While it may be so in music (the text assumes), 'it is certainly less true of painting', and of literature even more so.[39] Mary Webb (1881–1927) and Virginia Woolf (*A Room of One's Own* is cited) are the two exemplars of writers opening the world's eyes to the lives and experiences of women, and indeed understanding of the conflicts and misapprehensions that lead to tragedy.

The conclusion advocates for education of the mind, hence transformation of women's as much as men's socially influenced mindsets and inherited attitudes to effect changes that address economic and financial disadvantage on the one hand, while, on the other, promoting inclusive education and equal valuing of the attributes of women arising from their experiences and indeed their relationships of care as necessary for creating societies not only equal, but equally as fit for the needs of women as for those of men.

This report of formal conversations convened among educated, middle-class, mostly white British women who continued the nineteenth-century feminist struggle for emancipation via education, economic independence, and revised self-evaluation (confidence, opinions, and positive sense of identity as women) further consolidates feminist thinking and questioning in the inter-war and post-war periods in Britain. Women benefitting from, and like, Stocks and Billington-Greig, having been active in the suffragist movement and even the militant activities of the Women's Social and Political Union, as well as from women's education and entry into the professions, were still actively engaged in these questions in the 1940s and 1950s. In their own terminology, they were posing questions that still ripple through and even disturb contemporary feminism – as well as non- or anti-feminist discussions.

The organizers openly defined themselves as feminists and humanists, confidently valuing what has been ascribed, non-essentially but socio-psychologically, to women. They embraced positively the subjective effects of aspects of women's lived experience resulting from their relationships of care, elective, enforced, or as a result of maternity, none of these being natural but situational, with equally positive and negative effects. They aimed to mobilize more equitably *on behalf of society* those social and affective qualities 'more common' among women as a result of what they either chose or were obliged to undertake. Hence, rather than equality, their project was a radical social transformation of all based on the recognition, and fully compensated contribution, of

women, a project that, paradoxically, involves valuing certain legacies of difference while removing all discriminatory obstacles to women's as yet untapped and incompletely known social and political contribution to society as a whole:

> Discussing ways in which women differ from men we at once came up against the obstacle that some of us thought that any differences (other than the physical ones) were likely to have been caused by social factors, and might ultimately disappear if women ceased to be treated as a class apart; while others thought that biological factors, particularly those which related to the maternal role of women, were likely to have an effect on women's minds, values and characters. We agreed that the answer to these questions of causation depended on expert knowledge which is not at present sufficient; but that we need not attempt to decide them since our concern was simply with the effect of these various combined forces in giving women characteristics of which the world today stands in need.[40]

In her essay for *International Women's News* titled 'The Community of Women as Seen in Art', Rosenau also broached political solidarity among women. She is critical of the 'Suffragette Movement' (her term) for the assertion of a singular and uniform ideal for all women; she also queried its denial of any sex differentiation at all, a position that, she felt, resulted in regret if not hostility among the following generation and even inspired longing for old 'chivalries'. This reaction also risked what Rosenau terms 'a dangerous sign of reversion to barbarism' – an extreme statement justified by the very recent example she cites of Nazi ideology and its oppressive sex differentiation, which she introduces to weigh up the potential for women's groupings and organizations as the basis for a Women's (political) Party.[41] Not convinced of this project, because women are so different among themselves due to class and other differences, as a socialist and feminist, Rosenau nevertheless stresses the importance of art and culture as a process of discovery among women about themselves of what lies beyond prevailing ideological statements about what women are:

> But they are the nuclei of a potential feminine culture, arising out of the potential energies of a sex which has not yet found its own balance and its own possibilities. After having attained equality, women will want more justice and liberty, social conditions which will allow them to be themselves. Where will this lead?[42]

Rosenau values the specificity of women's existentially shaped experience as a basis for a culture, while crucially allowing that this requires time to negotiate, assess, and to come to self-understanding beyond

the psychological deformities inflicted on women that Virginia Woolf defined with such anguish in her writings. Rosenau's preparatory studies of women addressed to a feminist readership reveal what she, a contemporary feminist thinker of the 1940s using art-historical research, could offer to the post-emancipation debates about women, even posed as they were under the sign of a very unstable signifier – *the feminine* – that could be either an ideology (as Klein exposed in her Mannheimian terminology) or the unknown territory that women must reveal for themselves once they have liberty and justice. Rosenau terms this future not 'a feminine point of view' but 'a feminine culture' that is still to be created and is already emerging, as her book shows by illustrating artists who are women and concluding with Virginia Woolf, Stella Bowen, and Barbara Hepworth.

Notes to Essay 4

1 Karl Mannheim, *Diagnosis of Our Time* (London: Kegan Paul, 1943): 34. Was Mannheim being historically imprecise in the use of the term 'suffragette' instead of 'suffragist'? Or was he intending to support the militant feminists dubbed 'suffragettes' by a hostile British press in contrast to the groups campaigning for the vote, who did not approve of the tactics of the Women's Social and Political Union (1903–18), led by Emmeline and Christabel Pankhurst – they who adopted the term, naming their journal *The Suffragette*? There is frequent confusion of the two very different campaigns, the suffragist movement being led by Millicent Fawcett at the National Union of Women's Suffrage Societies.

2 Helen Rosenau, 'The Institution of Marriage as Seen in Art', *International Women's News* 35:1 (1940), 13; 'Motherhood as Seen in Art', *International Women's News* 35:2 (1940), 34; 'The Community of Women as Seen in Art', *International Women's News* 35:3 (1941), 55; and 'Women Pioneers as Seen in Art', *International Women's News* 35:4 (1941), 74.

3 Helen Rosenau, 'Social Status of Women as Reflected in Art', *Apollo*, 37 (1943), 94–8.

4 Viola Klein, *The Feminine Character: History of an Ideology* (London: Kegan Paul & Co., 1946).

5 Simone de Beauvoir, *Le deuxième sexe* (vol. 1: *Les faits et les mythes*; vol. 2: *L'expérience vécue*) (Paris: Éditions Gallimard, 1949); Betty Friedan, *The Feminine Mystique* (New York: W. H. Norton, 1963).

6 Rosenau, 'Motherhood as Seen in Art', 34.

7 Rosenau applied unsuccessfully for a research fellowship at Girton College, Cambridge, perhaps because of the displacement of the London School of Economics and her supervisor to Cambridge.

8 For my discussion of Karl Mannheim's sociology of knowledge, first advanced in 1925, and its use by Helen Rosenau see Part 1, Chapter 3. For collected texts in English see Karl Mannheim, *Essays on the Sociology of Knowledge*, ed. Paul Kecskemeti (London: Routledge & Kegan Paul, 1952).

9 Helen Rosenau, 'The Institution of Marriage as Seen in Art', 13 (my emphasis).

10 Rosenau, 'Social Status of Women as Reflected in Art', 97–8 (my emphases).

11 Vera Brittain, *Testament of Youth* (London: Victor Gollancz, 1933) and *Testament of Friendship: The Story of Winifred Holtby* (London: Macmillan, 1940).

12 J. P. Mayer was a German-born political theorist and an active anti-Nazi social democrat who fled to Britain in 1936 and later became a specialist in Toqueville studies at the University of Reading, publishing his *Political Thought in France from the Revolution to the Fifth Republic* in 1943.

13 This performs an interesting crossover with my own work on Vincent van Gogh (1853–1890), one of whose earliest drawings includes images of the Belgian women coal-miners, and my reading of the photographic collection created by Arthur Munby (1828–1910). See Griselda Pollock, '"With My Own Eyes": Fetishism and the Colour of the Labouring Body', *Art History* 17:2 (1994), 342–82.

14 Rosenau, 'Women Pioneers as Seen in Art', 74.

15 Rosenau, 'Women Pioneers as Seen in Art', 74; Marianne Weber, *Ehefrau und Mutter in der Rechtsentwicklung* (Wife and Mother in the Development of Law) (Tübingen: J. C. B. Mohr, 1907). On Mannheim's sociology of gender see Part 1, Chapter 3.

16 First published by Viking Press, New York, in 1927, the book was republished in Britain by Jonathan Cape in 1928. Rosenau cites an edition from Thinker's Library (London, 1938).

17 Virginia Woolf, *A Room of One's Own* [1929] (London: Penguin, 1945), 110.

18 John Langdon-Davies, *A Short History of Women* [1927] (New York: Viking Press, 1938), 381–2.

19 Mary Ritter Beard, *Women as a Force in History: A Study in Traditions and Realities* (New York: Macmillan, 1946).

20 Both quotations cited in Catherine E. Forrest Weber, 'Mary Ritter Beard: Historian of the Other Half', *Traces of Indiana and Midwestern History* 15:1 (2003), 5–13: 11.

21 Viola Klein, *The Feminine Character: History of an Ideology*.

22 E. Stina Lyon, 'Viola Klein: Forgotten Émigré Intellectual, Public Sociologist and Advocate of Women', *Sociology* 4:5 (2007), 829–42: 829.

23 Karl Mannheim, *Ideologie und Utopie* (Bonn: Friedrich Cohen Verlag, 1929) and *Ideology and Utopia: An Introduction to the Sociology of Knowledge* [1929], trans. Louis Wirth and Edward Shils (London: Routledge & Kegan Paul, 1936).

24 Lyon, 'Viola Klein', 833.

25 Lyon, 'Viola Klein', 840.

26 Lyon, 'Viola Klein', 840.

27 Frantz Fanon, *Peau Noire, Masques Blancs* (Paris: Éditions du Seuil, 1952).

28 Olwen W. Campbell (ed.), *The Feminine Point of View* (London: Williams and Norgate, 1952).

29 Campbell had played an active role in the peace movement, sustaining a long tradition of women's opposition to militarism and war that was especially strong in the aftermath of the First World War, as expressed notably in Virginia Woolf's epistolary essay *Three Guineas* (London: Hogarth Press, 1938) and studied in deep historical detail in Jill Liddington's *The Road to Greenham Common: Feminism and Anti-militarism in Britain since 1820* (Syracuse: Syracuse University Press, 1989). Woolf's anti-war book is not referenced by Rosenau even as she was clearly aware of Woolf's text *A Room of One's Own* (1929), quoting with approval Woolf's tragic fiction of the dark fate of Judith, Shakespeare's imagined sister, who also aspired to write.

30 Carol McPhee and Ann Fitzgerald (eds.), *The Non-violent Militant: Selected Writings of Teresa Billington-Greig* (London: Routledge & Kegan Paul, 1987). Billington-Greig's concept of feminism as revolt is linked to modernist aesthetic experimentation and political imagination by the literary theorist Ewa Płonowksa Ziarek in her *Feminist Aesthetics and the Politics of Modernism* (New York: Columbia University Press, 2013).

31 Mary Stocks, *The Workers' Educational Association: The First Fifty Years* (London: Allen & Unwin, 1953).

32 Campbell, *The Feminine Point of View*, 13.

33 Campbell, *The Feminine Point of View*, 22–33.

34 Campbell, *The Feminine Point of View*, 34–59.

35 Campbell, *The Feminine Point of View*, 51, 53, 55.

36 Campbell, *The Feminine Point of View*, 55.

37 Campbell, *The Feminine Point of View*, 23, 28.

38 Campbell, *The Feminine Point of View*, 42.

39 Campbell, *The Feminine Point of View*, 42.

40 Campbell, *The Feminine Point of View*, 15.

41 Rosenau, 'The Community of Women as Seen in Art', 55.

42 Rosenau, 'The Community of Women as Seen in Art', 55.

Essay 5

The Missing Bibliography

Why write an essay about a bibliography? A bibliography lists the author's sources and situates her topic academically. A bibliography is the cornerstone of academic research, confirms the range and depth of the scholar's knowledge of her field, and substantiates the scholar's claim to be recognized as an equal participant in the collective production of verifiable knowledge. Validity (we know the field), significance (we identify a lack within it), originality (we make a contribution to it), usefulness (of the discoveries or analyses), and rigour (of the argumentation) – these are the axes of research. Through their bibliographies, scholars speak to the academic community, indicating intellectual affiliations and theoretical alignments even while meeting the obligation to 'cover the field'.

There is, however, no bibliography in *Woman in Art* – probably because of the specific context of its war-time publication, its small scale, and its price, with the author seeking a general readership even as every argument or comment is supported by wide-ranging multi-disciplinary research. So I have compiled a bibliography by extracting from the footnotes, completing references with fuller bibliographical details, and following up the contents of referenced texts and learning more about the authors of many. My analysis of Helen Rosenau's references and footnotes illuminates how she constituted her field of research, defined her topic, and placed herself in dialogue with the established field and with her peers. Her footnotes demonstrate a staggering range of scholarship – theoretical, art-historical, sociological, anthropological, psychoanalytical, linguistic, and political – and they are placed strategically to amplify each page. Their location does not, however, allow us easily to grasp the range and depth of her sources, nor the breadth of her research. This bibliography can be found at the end of Part 2, and in addition this essay ends with a listing of the bibliography by date and categorizations of both women scholars and publications on the topics of psychoanalysis and social psychology.

Analysing what I assembled consolidates the portrait of Rosenau as art historian, transdisciplinary feminist cultural analyst, and thinker of the left, equally revealing her intellectual companions and specifically

introducing to me the many women scholars of her own and earlier generations. Some of these scholars engaged directly or indirectly with gender in both European and art histories for the arts of Africa, China, and India, even as the latter were still being viewed from the perspective of the Western art historians, although their understanding of these civilizations was being extended through their collaboration with their colleagues in these countries and continents.

Analysing Rosenau's bibliography in terms of what was available, what authors she consulted, and what date range her choice of sources covers, we can trace the communities of knowledge and the formations of disciplines, and identify the scholars, themes, and historical concentration. Her bibliography is itself an object of research and analysis, becoming a resource for feminist art historiography. As intellectual portrait of the author, the bibliography affirms the 'grandeur' of the project contained in her modest book.

What theory and research did Rosenau consider necessary for the study of Art as the site of her study of Woman? Here references underscore the many materials for such a study. The breadth of her references delineates, however, the distinctive character of her intervention in around 1940 because she was addressing major cultural and sociological debates from the perspective of Art History and vice versa. Given that the book was produced after she had completed two doctorates (Hamburg and London), worked on an incomplete *Habilitation* thesis (Münster), and begun this additional postdoctoral research project at the London School of Economics, both the location and the project itself become more legible once her sources become indices of her arena of thought, her intellectual conversations, and her own discoveries. The bibliography models an extended form of transdisciplinary art-historical practice placing questions of gender at the heart of art's histories and the discipline of Art History.

I catalogued the references into two lists, by author and by date of publication. Both were cross-checked with language of publication, allowing me to visualize Rosenau's multi-lingual research in German, French, and English, let alone Latin and Greek. The chronological list revealed some interesting insights. Apart from the Greek classics she cites, her earliest reference is to a book of 1798. Works from the nineteenth century increase, clustering in the last two decades of more intensive discussion of the major issues in Anthropology and historical studies. The references grow incrementally as we pass from 1900 to the recent past of her writing, with a major cluster in the 1930s, an index of still intense attention but from increasingly modern sociological and philosophical perspectives. This reflects the slow but significant

beginning of modern engagements with issues relevant to the book in the second half of the nineteenth century – the family, marriage, sexuality, gender – and the increasing range of research and publication by the fifth decade of the twentieth century, when politically activist feminism may have waned with the winning of the vote but scholarly research into gender and society had not.

Analysing the bibliography by name documented Rosenau's extended range in historical and art-historical studies from the Neolithic and ancient worlds to contemporary India or post-war Britain. Anthropology and Sociology rub shoulders with studies of medieval monasticism, Psychoanalysis with Sexology and other branches of Psychology, Philosophy with Archaeology. There is, interestingly relatively little Art History, except in the substantiation of art created by women, and certain focussed works of interpretation. Finally, I have identified within her bibliographical references a rebalancing presence of works by women scholars alongside the selections of now more famed male contemporaries. I shall look at some of these in more detail below.

Rosenau's choices also picture a much wider debate illuminating issues of what we, in the wake of later twentieth-century feminist theory, term 'gender', but which, from the mid-nineteenth century, was expressed in equally theoretical investigations by terms such as 'woman', 'la femme' in French, and 'Geschlecht' in German (literally meaning 'sex') – neither French nor German having a word for gender.[1] Gender was clearly being interrogated through hotly contested studies of institutions such as family and marriage – often through Law and Theology – and, in a more subtle and indirect way, sexuality was a topic in Psychoanalysis and Social Psychology. Gender was at the forefront of analysis and contention in Anthropology, Psychology, and Sociology. Indirectly, gender was also present in the discipline of Art History, even as it is secreted behind the study of iconography. Iconography focusses on the interpretation of the image in distinction from what formalist art history defines as visual art's specificity in either the 'will to form', as articulated by Alois Riegl (1858–1905), or style, as defined by Heinrich Wölfflin (1864–1945) (see Part 1, Chapter 3). The hermeneutic question 'what do images mean?' inevitably opens onto extended visual and extra-visual sources in Theology, Philosophy, or Literature.

Aby Warburg (1866–1929) and Erwin Panofsky (1892–1968) engaged with contemporary philosophical debates around the symbol, or rather symbolic thinking, being concurrently explored notably by Ernst Cassirer (1874–1945) in his *Philosophy of Symbolic Forms* (1923), as well as with philosophical and psychological theories of memory from philosopher Henri Bergson (1859–1941) and zoologist Richard Semon (1859–1918) to

psychoanalyst Sigmund Freud (1856–1939).[2] Art History alone seems to have been disengaged from both what art could tell us about the social meanings and histories of gender and thought or gender in the image. That Art History, in museum and academic form, became, however, a more and more gender-exclusionary, mono-sexed discourse, silent about gender yet installing a gendered hierarchy of value through the wilful exclusion of the historic and historically increasing creative participation of women in artistic production, is one of the major indictments of the discipline in its twentieth-century forms made by and in turn inciting feminist studies after 1970.[3]

During the nineteenth century in European thought, many disciplines focussed on the question of gender as a synonym for social order, morality, and hierarchy. These issues were posed via terms such as 'man' and 'woman' (referencing difference, status, situation) or sex (referencing bodies, minds, potentials, pleasures, sexual practices, social institutions, and social regulations of sexual relations) even as doing so placed gender at the foundations of the social, political, and moral order, at the very moment of the radically destabilizing transformations of Modernity, which was equally engendering these academic disciplines themselves. Emerging disciplines – the *-ologies* – addressed symbolic meanings enacted in and articulated through social forms, studying gestural as well as verbal, visual, ritual, and performance languages, and the social investment in, and legal management of, the continuation of the species via procreation, which was the focus as much of Sociology and Anthropology (family and division of labour) as in Theology, Zoology, and Biology (species existence, law and sexuality). Being thus debated, these issues were, in effect, the stimulus for the very emergence of the social sciences, which studied these human activities and raised them to the level of social and symbolic analysis.

Those scholars who investigated the past through Archaeology interpreted their finds, however, through emerging anthropological modelling. It was as if European colonizers imagined they were meeting their *past* in *still-present* and long-lived social forms – rituals and systems that the mid-twentieth-century anthropologist Claude Lévi-Strauss (1908–2009) would characterize as treasuring the complex primary human modes of thought that he termed *la pensée sauvage* (i.e., *wild* thinking).[4] Furthermore, the anthropologists' interpretation of what silent archaeological remains of earlier cultural ways of thinking revealed was often coloured (sometimes literally in terms of racialization) by contemporary anxieties about Modernity as the cause of what some experienced as the current destabilization of patriarchal gender relations and social organization, and others welcomed as progressive changes. Thus,

intense theoretical and political scrutiny of gender was being incited by the impact of modernization, industrialization, urbanization, and increasingly imperializing colonialism, whose significance and effects were being contested by both conservative and progressive social forces, igniting equally fiery debates. All the texts attest to the destabilizing effect of the changing condition of women resulting from reconfigured industrial and domestic divisions and locations of labour and expanding sexual practices. The latter were challenging definitions of *men* as much as of *women* and, as a result, of society itself increasingly understood, beyond Marxist theories, as systematically structured by social relations of gender and sexuality. Such social relations were already legible in aesthetic–symbolic practices of all societies that art historians, as much as anthropologists, were beginning to decipher.

Scholars began searching the newly emerging archaeological record *anthropologically* for the origins and varieties of socio-legal-economic institutions such as marriage or the family (sites of sex, production, reproduction, law, and cult) precisely because, in their religiously and politically legislated forms, they were currently under pressure from socio-economic forces such as professionalization and industrialization. Women were working outside the home in offices and factories, while the use of domestic servants rendered privileged middle-class women's lives functionally emptied of role-derived value. Individuation fostered new consciousness of intellectual needs and pressure for participation in all areas of labour, including academic, and of course this provoked questions of the body and desire, sexuality and choice.

As Modernity radically challenged the diverse but often theologically determined ordering of humanity and society, the new social sciences were anxiously exploring their pasts and presents. Thus, the date range of the majority of Rosenau's cited publications of almost a century (1850s–1940s) becomes significant because, within that century, we can also map the formation of the disciplines that are still key to thinking about gender – and art, or what Gerardo Mosquera termed more inclusively and in less purely Western terms as *aesthetic–symbolic forms* (Archaeology, Sociology, Anthropology, Comparative Religious Studies, and Art History) while also noting the emergence of colonially inflected, nationalist, and imperialist research into ancient cultures as well as the art histories of modern societies.

This led me to discern another pattern in Rosenau's bibliography when it is analysed by the area or discipline for each book or source. This pattern not only underlines the transdisciplinary range of Rosenau's research but also indicates a tentative but sustained international and multi-cultural perspective. India, China, and Africa are referenced

although the core of her study remains lodged in the Mediterranean–European tradition of art. Non-European imaginative, aesthetic, and symbolic systems both confirm the existence of patriarchal cultures and unsettle the Christian version consolidated in the Western world.

Using the bibliography as a lens, I came to understand Rosenau's selected chapters and categories: marriage and love. The date range of the publications she consulted affirms that these issues were being examined *anthropologically* as the primary legal and erotic relations that had organized heteronormative social kinships systems, and, in effect, produced the two-sex heterosexual couple as social institution (marriage) and site of the intercommunal exchange of value and goods.[5] Yet they also stage the forces of desire, affection, and respect, and how they are contained within or challenge dominant theological frames and social agencies. By focussing on parenting as activity not destiny, the primary visible bond between mother and child (paternity being sometimes not recognized, or in patriarchal forms paternity being established by naming and possession of the child as the property of the father), from which life and the family are constituted, becomes a focus of imaginative representation. These complex societal structures are explored in the two central chapters titled 'Wives and Lovers' and 'Motherhood', which are, in turn, preceded by the 'Introductory' (which references the most ancient sources – artefacts and sculptures excavated from the deep past, which at the time some key thinkers considered had been matriarchal and matrilineal, thus not automatically assuming an eternal patriarchy). The final chapter ('Further Aspects of Creativeness'), on the contemporary situation, demonstrated where modernization had fostered women as individuals, workers, or citizens who can choose their own sexuality, procreative practice, and partnerships. Hence, far from working with static categories, Rosenau's investigation of the *-ologies* – through the lens of the image as an aesthetic–symbolic practice – introduces the dynamic dimension of historical change not as progress but as trans*form*ation.

Rosenau thus introduces both the visual arts (types and materials) and the image into this extended field as the register of the trans*form*ation of the social, religious, ideological, and historical structures that she articulated as 'from *type* to *personality*'. She also places art itself within these larger cultural and theoretical debates, which were indicative of the consciousness of colonizing European intellectual culture being conditioned by, but also as analytical response to, modernization, whose lineaments involved radical reconfigurations of gender across the entire social and intellectual fabric and sense of humanity's pasts and varied presents. Hence the distinction between *type* and *personality*. This

shift becomes historical while grounded in contemporary anthropological, sociological analyses of the social relations of gender and sexuality. Rosenau integrated these trends in thought into Art History and into art's visual image histories as a prime site for their exploration – while both iconographic and stylistic-formalist Art History ignored art as such a resource in its pursuit of theological, philosophical priorities or autonomous stylistic trajectories for art.

We now better understand and acknowledge, as a response to his present, which witnessed the emergence of fascism, the concurrent deconstruction of Christianocentric and 'aestheticizing' Art History (style, form, and adulation of the artist-genius) that we find in Warburg's analysis of the inexplicable embrace by Christian Europe from the fifteenth century onwards of the passion-formulations stored up by the arts of pagan antiquity.[6] We can recognize the links with his exploration of real, projected, and imagined violence directed against a Jewish other while witnessing the dangerous emergence of officially sanctioned and public anti-semitism in his own moment.[7] I discern, therefore, a difference but also a significant concurrence between Rosenau's address to the centrality of *Woman* as a pathway into the analysis of Western thought and art and Warburg's also structural, often oblique, and anxious analysis of the othering of the *Jew*.

Although it includes many examples, *Woman in Art* is not about women as artists. Rosenau was not inquiring into a difference in women's aesthetics or perspectives. Her focus is structural, sociological, and anthropological, hence her references both to the big guns in anthropological thinking about *mother-right* and *mothers* (such as Johann Jakob Bachofen and Robert Briffault) as well as to detailed historical studies of women in monasticism and in the political and cultural work of medieval court politics and culture. Nevertheless, I want now to consider a puzzling absence from her bibliography. Asking myself why led me to understand the book's project better.

One missing text is by the French journalist and supporter of women's professional activity in the visual arts of painting and sculpture Marius Vachon (1850–1928), whose *La femme dans l'art: les protectrices des arts; les femmes artistes* was published in 1893 (fig. 3.38).[8] Vachon published monographs on French *juste milieu* painters such as William-Adolphe Bouguereau (1825–1905), for whom Vachon sat, and Pierre Puvis de Chavannes (1824–1898). He also became deeply involved with the Union des Femmes Peintres et Sculpteurs (Union of Women Painters and Sculptors), founded in 1881 by artist Hélène Pilate Bertaux (1825–1909) (fig. 3.39).[9] Vachon placed this initiative to gain access for women to prestigious art training at the École des Beaux-Arts in Paris and admission to

3.38 Title page of Marius Vachon (1850–1928), *La femme dans l'art: les protectrices des arts; les femmes artistes* (Paris: J. Rouam & Cie, 1893).

3.39 Etienne Carjat (1828–1906), *Hélène Bertaux* (1825–1909), *c.*1864, photograph, 10 × 6 cm. Musée d'Orsay, Paris. Photo © RMN-Grand Palais (Musée d'Orsay) / Hervé Lewandowski.

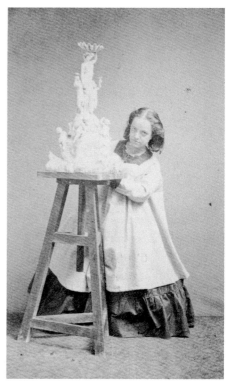

the Jury of the Paris Salon in a historical context that reached back to the classical world. He traced representations of *la femme* in Western art, setting it beside a concurrent history of women as patrons and collectors, *protectrices des arts*, and also as artists, notably as painters.

Richly illustrated with fine engravings, the book is divided into five volumes: *Antiquity*, *The Middle Ages*, *The Renaissance*, *The Seventeenth and Eighteenth Centuries*, and *The Nineteenth Century*. Vachon is primarily interested in art as a history of images/imaginings of concepts of the feminine and in the role of women as patrons shaping artistic culture, but, only thirdly, in women as artists. Yet, not only does he reference many of the names of artist-women that we now know well, but his listing also affirms that they were well known in the nineteenth century. Some others are named who are not so familiar, then or now, indicating his specialist documentation of instances of women's creativity. Vachon illustrates the art-historical and art-journalistic engagement with the theme of *La Femme*/Woman in later nineteenth-century France, a time of some women's participation in the egalitarian society of independent artists dubbed 'the Impressionists' (1874–1886), namely Berthe Morisot (1841–1895) and Mary Cassatt (1844–1926), as well as more conservative women's organizations, such as Bertaux's Union. Both of these groups

aimed to secure access to official recognition based on an argument asserting women's different, and hence special, contribution to culture and society.

I want now to offer expanded entries on some authors and their texts, and, in addition to the analytics of names and dates, to draw attention to the women scholars Rosenau cites, adding information about the authors who are less known so as to draw portraits of women and Jewish intellectuals, feminists, psychologists, sociologists, anthropologists, and socialist, psychoanalytical, legal, and historical researchers. Researching these names repopulated my own imaginary library with many women scholars, who, like artist-women, had progressively disappeared from general knowledge in the reactionary, masculinizing culture of the twentieth century. The brief portraits of intellectuals and key ideas contribute to a deepened understanding of what Helen Rosenau has done in *Woman in Art* because they necessitate rethinking her moment of both consciously feminist scholarship and widespread, if sometimes anxiety-driven, attention to the social, legal, theological, sexual, and interpersonal relations and politics embedded in the term 'Woman' at that time. Rosenau's 'little (Art History) book' takes its place beside Simone de Beauvoir's (1908–1986) canonical text in philosophy and in feminist thought, *Le deuxième sexe* (The Second Sex) (1949),[10] because both authors posed the same question: what is this figure, *La Femme/Woman*, fabricated across mythologies and the sciences? What is this figure as a project, to be lived in and made sense of, in the Existential sense, for those living under this sign? Working concurrently at the London School of Economics with Rosenau, Viola Klein (1908–1973) also parallels and precedes Beauvoir. The following vignettes will, I hope, animate the bibliography as mere lists of names and titles and dates.

— Brief Portraits

JOHANN JAKOB BACHOFEN (1815–1887) was a Swiss philologist and anthropologist as well as being professor of Roman Law at the University of Basel for five years. In 1861 he published 'an investigation into the religious and juridical character of matriarchy in the Ancient World' under the lead title *Mutterrecht* (Mother-Right). His thesis was that motherhood was the foundation of human society, religion, and morality. His analysis divided cultural evolution into four phases: Haeterism, Mother-Right, the Dionysian, and the Apollonian. The last was a patriarchal solar phase that obliterated traces of both the Dionysian and the Mother-Right (matriarchal) eras. If Haeterism was symbolized by the figure of and early type of Aphrodite, the matriarchal, lunar, and agricultural era produced chthonic mystery cultures whose deity was Demeter. Despite

the complexity of its writing, Bachofen's book had an immediate influence on anthropology and social theory, being taken up by Lewis Henry Morgan and Friedrich Engels, the latter notably in his proto-Marxist work *The Origin of the Family, Private Property and the State* (1884). Resonances of his work are to be found in the writings of Thomas Mann, JANE ELLEN HARRISON (focussing on the Dionysian) (see fig. 3.42), Walter Benjamin, Carl Jung, Rainer Maria Rilke, Robert Graves (*The White Goddess*), and Erich Fromm. Further support for the hypothesis through archaeology was advanced by Marija Gimbutas in her excavations and interpretation of remains of the matristic, agriculturalist culture 'old Europe', Neolithic Europe from 7000 to 1700 BCE. According to sociologist Émile Durkheim, Bachofen shocked by challenging the deeply held belief in paternal authority as the sole foundation for the family. Bachofen's thesis of a pre-matriarchal, polyamorous culture that was replaced by matriarchy and monogamy was a product of a still patriarchal, nineteenth-century ideological framing of his thesis. In her study of the nineteenth-century debates, Cynthia Eller positions Bachofen as a leading figure in the struggle to sustain the patriarchal model of the family as a higher level of development, even as this positing of a matriarchal phase inspired a range of new research, such as the work of Jane Harrison or Marija Gimbutas, that unsettled such a view, rendering patriarchy a 'historical' organization, not a natural form.[11] These propositions of a matriarchal phase are disputed, and even discredited. They were explored in feminist thinking post-1970. Citing Bachofen, Rosenau's book made its contribution to the afterlife and further research into these contested theses on the origins of society studied through the origins of the family, its institution and forms, and hence gender.

GREGORY BATESON (1904–1980) was a polymath English anthropologist and social scientist who was involved with cybernetics and participated in the Macy conferences (1940–61). He drew on this anthropological research to propose an influential thesis of 'the double-bind' in the analysis of schizophrenia. His first major work, titled *Naven* (1936) after a ritual he observed among the Iatmul communities of New Guinea, was as much a reflection on anthropological observation and the process of writing as it was a study of a specific ritual. Bateson analysed the ritual from three perspectives: *sociological* (how did this ritual, which involved reversal of gendered costuming and performance as well as spectatorship inverting gender positions, incite or maintain social cohesion?); *ethological* (what was the ritual doing to and with, by inversion, the norms of masculine and feminine behaviour?); and *eidological*, i.e., the study of mental imagery (how did the ritual correspond with or disorder

the normative patterns of thought in this society?). His book is valued for its self-reflexivity – that the modes of analysis and interpretative frameworks shape the interpretation. This is now situated knowledge that echoes the Mannheimian framework in Rosenau's 'Preface' about the inevitable 'subjectivity' of knowledge, not as a limitation but as a dialectical condition that dethrones myths of objective understanding. As both an exploration of gender and rituals in one culture and a 'sociology of knowledge', its presence in Rosenau's bibliography is indicative of her deployment of several frames of interpretation. It is, however, significant that neither Margaret Mead's *Coming of Age in Samoa* (1928) nor her *Sex and Temperament in Three Primitive Societies* (1935) was included. Mead, a student and close friend of RUTH BENEDICT, in 1936 married Bateson, a fellow anthropologist in the field.

RUTH BENEDICT (1887–1948) (see fig. 3.41) was a US-American anthropologist who studied with founding anthropologist Franz Boas at Columbia University, and taught and later worked closely with Margaret Mead, becoming president of the American Anthropological Association. In her influential book *Patterns of Culture* (1934), where she did a comparative study of Zuñi, Dobu, and Kwakiutl cultures on the North American continent, she argued for cultural relativism. Her thesis is that a relatively limited range of possible human behaviours is incorporated by any one culture. She put forward the idea of the 'personality' being produced by the complex of traits and attitudes of a culture, which then defines the individuals within it as successes, misfits, or outcasts according to the presence or absence of those traits and attitudes. In 1940 she used her work to refute racist thinking in *Race: Science and Politics*.

MYRRHA BORODINE (1882–1954) (known as Lot-Borodine) was born in Russia and worked in France as a specialist in medieval French and Anglo-Saxon literature. Rosenau's inclusion of her work *La femme et l'amour au XIIe siècle d'après les poèmes de Chrétien de Troyes* (Women and Love in the Twelfth Century According to the Poems of Chrétien de Troyes) (1909) under the shortened title *La femme dans l'œuvre de Chrétien de Troyes* heightens the focus on *Woman* as topic. Rosenau was a medievalist and there is a significant presence of research into medieval culture and notably several books on one of the most famous thinkers and artists of the period, Hildegard of Bingen (see fig. 2.35), alongside studies of women in convents and monasticism in general in Britain, France, and German lands.

ROBERT BRIFFAULT (1874–1948) was a French surgeon, social anthropologist, and novelist. Born in either France or Britain, he studied

medicine at the University of Otago, New Zealand, and served during the First World War before returning to England to study social anthropology. In his major study, *The Mothers* (1927), advancing the matrilineal group motherhood thesis on the origins of the social family proposed by Lewis Henry Morgan and Friedrich Engels, Briffault argued that 'the female, not the male, determines all the conditions of the animal family. Where the female can derive no benefit from association with the male, no such association takes place.'[12] Briffault's communal-mother thesis was contested by the anti-Marxist and anti-communalist anthropologist Bronisław Malinowski, who insisted that 'marriage in single pairs – monogamy in the sense in which Westermarck [also cited by Rosenau] and I are using it – is primeval'.[13] In the context of recent socialist and notably Soviet experiments, Malinowski also believed that marriage and the family were pivotal in avoiding social catastrophe even as studies of many cultures produced evidence that did not support the patrilineal, or patriarchal and monogamous, concept of family and descent networks. Briffault, BACHOFEN, and Morgan are in Rosenau's bibliography.

CHARLOTTE BÜHLER (1893–1974) was a psychologist born in Berlin to the Jewish family of the architect Herman Malachowski and his wife Rose Kristeller. She studied Natural Sciences and Humanities at the universities of Freiburg and Berlin, was awarded her doctorate in 1918 from the University of Munich on 'experimental studies in the psychology of thought', and completed her *Habilitation* in child psychology in Dresden. She taught at the University of Vienna (Vienna Psychological Institute) and developed her own school of Child Psychology, now commemorated in the Charlotte Bühler Institute, founded in 1992. The family fled to the United States of America via a brief period at the University in Oslo after the German annexation of Austria in 1938. Bühler held positions as a psychologist and psychiatrist at several US-American university hospitals. In addition to her innovative work on the development of thought and personality in infants and children, she was one of the first to consider age and ageing as both a psychological and a continuing developmental issue. Her publications number 168 and have been translated into many languages. She also pioneered the use of autobiographical methods in psychology.

RENÉ CREVEL (1900–1935) was a bisexual communist French novelist and art writer initially associated with Dada, acting in a play by Romanian Dadaist Tristan Tzara (1896–1963), and who became part of the Paris Surrealist circle around André Breton. He wrote short books on artists such as Paul Klee and Renée Sintenis for Gallimard in its series Peintres

Allemands. Key works are *Mon corps et moi* (My Body and Me) (1925), *La mot difficile* (The Difficult Word) (1926), and *Babylone* (Babylon) (1927).

Lina Dorina Johanna Eckenstein (1857–1931) was a British historian and archaeologist, born the daughter of a Jewish socialist refugee from the Deutsche Revolution (German Revolutions) of 1848–9. She is known as a British polymath who was acknowledged as a philosopher and scholar in the Women's Movement. She joined a radical organization called the Men and Women's Club and published a radical and feminist analysis of women under monasticism over a thousand years, *Women under Monasticism* (1896). She took part in excavations with Hilda and Flinders Petrie in Egypt and was active in the suffrage movement with her long-term partner Marjory Pearson.

Norbert Elias (1897–1990) was a sociologist, born into a German Jewish family in Breslau/Wrocław. He initially studied medicine and philosophy before following his supervisor Karl Mannheim to Frankfurt, where he submitted his *Habilitation* thesis, which was not awarded for reasons of the establishment of the Third Reich. Titled *The Courtly Man*, it was later published as *The Court Society* (1969). Elias fled to Paris in 1933 and in 1935 to Britain, where he was supported by a relief organization for Jewish refugees in completing the book for which he is best known, *Über den Prozess der Zivilisation* (1939). In 1939, he became a senior research assistant for Mannheim at the London School of Economics before being interned by the British authorities as an alien in camps in Liverpool and the Isle of Man. He later taught at the Workers' Educational Association and at the University of Leicester, as well as being involved in the development of Group Analysis and founding the Group Analytic Society.[14] He finally achieved a full-time academic post at Leicester in 1954, and there he created one of the most influential sociology departments, which he oversaw until his retirement in 1962. His reputation was enhanced in 1969 when the first volume, *The History of Manners*, of his two-volume *Über den Prozess der Zivilisation* was translated into English as *The Civilizing Process*.[15] After his retirement from Leicester, he added to his small number of publications to date by writing a further fifteen books and 150 essays. Elias was the first laureate of the Theodor W. Adorno Prize (1977) and of the Amalfi Prize for Sociology and Social Sciences (1987). Thus his inclusion in Rosenau's bibliography in 1944 indicates two elements of historiographical significance: she was one of the early readers of his German text on the civilizing process and she referenced his German work in an English-language publication while her personal and intellectual connection with him ran through the Mannheim circle at the London School of Economics.

LUDWIG GOLDSCHEIDER (1896–1973) was a poet, translator, and publisher. His wife was the sister-in-law of Anne Frank's mother. Having studied Art History in Vienna under Julius Schlosser, in 1923 he co-founded Phaidon Verlag (later Press) with Béla Horovitz and Frederick Ungar in Vienna as a publishing house for literature, notably German classics but also including Shakespeare. It slowly became known for also producing high-quality illustrated books on art. He escaped to Britain in 1938 following the annexation of Austria to the Third Reich. There Phaidon began producing its large-format books on artists such Vincent van Gogh and Sandro Botticelli, but he is also known as the author of the Phaidon publications on Michelangelo's drawings, paintings, and sculptures. He commissioned Ernst Gombrich's *The Story of Art* (1950).

T. A. GOPINATHA RAO (1872–1919) was an Indian archaeologist who became the first superintendent of the Travancore Archaeology Department (in 1908) and in 1914 authored *Elements of Hindu Iconography*, in which he sought to refute the concept of the religion's origins in Buddhism and establish a form of analysis of the function of the image in Hindu thought and practice.

MARY ESTHER HARDING (1888–1971), who went by the name Esther, was born in England and later lived in New York. She studied medicine at the London School of Medicine, graduating in 1914. She worked in London in medical practice as a cardiologist before being introduced to Jungian psychoanalysis. In 1922 she moved to Zürich to study psychoanalysis with Carl Jung. After meeting her life partner, Eleanor Bertine, in Zürich, Harding moved with Bertine to New York in 1924 and became a major exponent of Jungian psychoanalysis in the United States of America. Her two books, *The Way of All Women* (1933) and *Women's Mysteries* (1935), examined many aspects of women's lives and relationships from a feminist-inflected Jungian perspective that was endorsed by Jung himself.

JANE ELLEN HARRISON (1850–1928) was a Yorkshire-born British classical scholar and professional academic, one of the first women to be so, who was taught Greek, Hebrew, and Latin by governesses and later acquired facility in sixteen languages, including Russian. In 1874 she began her studies in classics at Newnham, the women's college at the University of Cambridge founded in 1871, and later studied Greek art and archaeology at the British Museum (1880–97) with the renowned archaeologist Charles Newton, who from 1860 was the museum's Keeper of Greek and Roman Antiquities. She returned to Newnham as a fellow in 1898 and taught there until shortly before her death in 1928. She is the 'ghost' of a woman scholar, 'J. H.' invoked in Virginia Woolf's *A Room*

of One's Own (1929). Her own original readings of early Greek culture and art, published as *Prolegomena to the Study of Greek Religion* (1903), *Themis: A Study of the Social Origins of Greek Religion* (1912), *Ancient Art and Ritual* (1913), and *Epilegomena to the Study of Greek Religion* (1927), placed her at the heart of a radical group, the Cambridge Ritualists, who contested the post-Winckelmann and Victorian projection of calm gravity onto Greek art and culture by proposing the foundations of Greek drama and literature in the violence and precarity of life articulated in ritual.[16] Rosenau also lists one other Cambridge Ritualist, Gilbert Murray, whose *Five Stages of Greek Religion* (1935) was first published in 1925.

FRIEDA HAUSWIRTH (1886–1974) was a Swiss scholar and painter who graduated from Stanford University in 1910 and subsequently from the California School of Fine Arts in San Francisco. Following her marriage to an Indian political activist who helped to shape India's constitution, Sarangadhar Das, she lived in Calcutta, later travelling extensively and also living in Mexico. She painted and wrote on many feminist topics including *Purdah: The Status of Indian Women* (1932).

MAGNUS HIRSCHFELD (1868–1935) was a leading German Jewish physician and sexologist, and an advocate for minority, homosexual, and transgender rights. He founded the Scientific-Humanitarian Committee to campaign for homosexual rights and to repeal the criminalization of homosexuality. He joined the feminist organization founded by Helen Stöckler Der Bund für Mutterschutz (League for the Protection of Mothers), which campaigned to decriminalize abortion. Under the Weimar Republic, in 1919 he established his Institut für Sexualwissenschaft (Institute for the Study of Sexuality). Forced into exile in France by Nazism, he published his book on racism, *Rassismus*, in 1935, identifying National Socialist racism as a symptom of a longer history of racism founded on the pseudo-scientific theories of the German Enlightenment.

ISALINE BLEW HORNER (1896–1981) studied Moral Sciences (Philosophy) at Newnham College, Cambridge, where she later became a fellow and librarian. She was one of the presidents of the Pali Text Society, Oxford, and an honorary fellow of the International Association of Buddhist Studies. She published her first work, *Women under Primitive Buddhism*, in 1930. Her second major publication, *The Early Buddhist Theory of Man Perfected* (1936), was a study of the 'Arahant'. Horner was respected by Newnham College throughout her life. Between 1946 and 1966 she had to her credit among other works a series of translations of the Pali texts, major ones being *The Book of the Discipline* (translation of

Vinaya Pitaka), *Middle Length Sayings* (translation of *Majjhima-Nikaya*), *Milinda's Questions* (translation of *Milindapanha*), *Buddhavamsa: Chronicle of Buddhas*, and *Cariyapitaka: Basket of Conduct*. From 1926 to 1959, Horner lived and travelled with her partner Dr Eliza Marian Butler (1885–1959), Schröder Professor of German at the University of Cambridge, who had learned German from JANE HARRISON. Publishing as E. M. Butler, Eliza Butler published an article in the first volume of the *Journal of the Warburg Institute*.[17]

STELLA KRAMRISCH (1896–1993) was an Austrian scholar who studied art history in Vienna with Max Dvořák and Josef Strzygowski and turned to the study of Indian art, becoming Professor of Indian Art at the University of Calcutta in 1924 and remaining there until 1950, when she moved to the United States of America and became a curator at the Philadelphia Museum of Art and professor of Indian Art at the University of Pennsylvania. She published *Grundzüge der Indischen Kunst* (Principles of Indian Art) (1924) and in English, *Indian Sculpture* in the Heritage of India Series (Oxford University Press, 1933). She made regular visits to lecture on Indian Art at the Courtauld Institute during the later 1930s, and presented an exhibition on Indian Art in photographs at the Warburg Institute, then housed in the Imperial Institute in Kensington, before moving to the University of London in 1944.[18] She is personally thanked in Rosenau's book.

SYLVIA LEITH-ROSS (1884–1980) was born in France of British and US-American parents. In 1907, she went as the bride of a transport officer to Zungeru, in what had become, in 1900, the Colony and Protectorate of Nigeria under British Crown colonial rule. Her husband died within a year. Leith-Ross had interested herself sufficiently in the people of Nigeria to publish a book on West African produce and cooking. In 1919, in London, she became the first honorary secretary of the newly founded Tavistock Clinic. She studied languages at the École des Langues Orientales (School of Oriental Languages) in Paris and produced a grammar of the Fulani language in 1921. She returned to Nigeria in 1920 with her brother and was involved with establishing schools for girls. She was then awarded a Leverhulme Fellowship with Margaret Green to research women's culture and history, from which came her remarkable study of Ibo women, their lives, and their societies in the wake of the Women's War, Ogu Umunwanyi in Igbo and Ekong Iban in Ibibi, the effective mass movement of protest by thousands of women from six ethnic communities against the colonial imposition of patriarchal and masculinist authority and institutions on their societies, which had long traditions of women's political and economic agency and influence. Her book has

also been called the first 'psychoanalysis of anticolonial insurgency', deflecting the political impulse of resistance to patriarchal domination into the psychological explanation.[19] Later in life she returned to Nigeria and travelled widely to research and write a study of Nigerian pottery and potters and establish a major collection at Jos Museum. More recent scholars equivocally evaluate her writing, books, and positions under the rubric of white women in colonialism while identifying her innovations in anthropology through uses of narrative, autobiography, and conversation.

HANS LIEBESCHÜTZ (1893–1978) was a Berlin-born medieval historian who studied in Berlin and after his war service obtained his doctorate in 1920 before teaching Latin in schools. He founded the B'nai B'rith Lodge in Hamburg in 1922 and was a member of the Warburg Institute, where he met Fritz Saxl. Imprisoned in Sachsenhausen in 1938 he escaped, and with the help of Saxl fled to Britain in 1939 only to be detained on the Isle of Man, eventually gaining an academic post in 1946 in medieval history at the University of Liverpool. He helped to found Leo Baeck College in London. His study of Hildegard of Bingen was his *Habilitation* thesis, completed in 1929 (cited by Rosenau).

GUSTAV PAULI (1866–1938) was a German art historian and curator who studied Art History with Renaissance specialist Jacob Burckhardt. In 1899 he took up a post at the Bremen Kunsthalle, where he developed a collection of modern German and French art, supporting the artist Paula Modersohn-Becker (1876–1907) (see fig. 2.29), who had spent several years living in Paris. After her untimely death aged 31 from a postpartum embolism, Pauli organized the first retrospective of Modersohn-Becker, wrote the first monograph on her work in 1922, and edited her *Letters and Diaries* in 1926. He then became director of the Hamburg Kunsthalle, developing its French modern collection. He delivered a speech at the funeral of Aby Warburg, being also a close friend of Erwin Panofsky. He did not refuse to sign the allegiance to the Third Reich required of all civil servants by that regime but was dismissed, living to see the notorious *Degenerate Art Exhibition* (1937), which exhibited modern art that was being systematically withdrawn from public collections to public denigration and ridicule. He died in Munich in 1938.

HSIEH PING-YING/XIE BING-YING (1906–2000) was a Chinese soldier and author. She joined the Nationalist Revolutionary Army in 1926 and began writing and publishing in newspapers. When her unit was disbanded in 1927, she was forced home and into an obligatory marriage, which she left to take teaching jobs before entering the Shanghai

Academy of Art to study Chinese Literature, living off royalties from her publication *War Diaries* (1938 and 1943). Moving between Shanghai and Japan she published her second book, *Woman Soldier's Own Story*, in 1936, followed by *Girl Rebel: The Autobiography of Hsieh Ping-ying, with Extracts from Her New War Diaries* (1940) and *Autobiography of a Chinese Girl: A Genuine Autobiography* (1943), the latter being the volume cited by Rosenau. She went to Taiwan in 1948 and taught at the National University. Following her retirement, she died in California.

ALICE RÜHLE-GERSTEL (1894–1943) was a Jewish socialist–feminist philosopher and educationalist who engaged with Adlerian individual psychology, socialist education, and the condition of women. Born in Germany, she escaped to Prague in 1932 and then to Mexico in 1936, where she was part of the circle of Frida Kahlo (1907–1954), Diego Rivera (1886–1957), and Leon Trotsky (1879–1940) in exile. Her focus was on working women and working-class education. She tried to reconcile Marxism and Adlerian individual psychology. The work cited by Rosenau also appeared in 1973 under the title *Die Frau und der Kapitalismus* (Woman and Capitalism).

MARIANNE WEBER (1870–1954) was a German sociologist and women's rights advocate. She undertook philosophical studies at the University of Freiburg in 1894 and became involved in the Women's Movement. In 1893, she had married the sociologist Max Weber (1864–1920), a distant relation, who suffered a serious breakdown in 1898, withdrawing from public life and his teaching. Marianne Weber published her first book, on Fichte's socialism, in 1900. Touring the United States of America with Max Weber, she made contact with leading US-American sociologists Jane Addams (1860–1935) and Florence Kelley (1859–1932) and went on to publish her major study of women, marriage, and law in 1907. Working on her own projects and publications, Marianne Weber became a delegate elected to the state parliament in Baden for the German Democratic Party and in 1919 was leader of the League of German Women's Associations. Bereaved in 1920 by the death of her husband and having taken on the care of four children when her husband's sister died by suicide, she wrote a biography of her husband and held an intellectual salon while also being a major public speaker. Her political and public career was halted by Hitler's dissolution of the League, but she went on to publish two further books: *Women and Love* (1935) and *The Fulfilled Life* (1942). In her sociological studies, Marianne Weber addressed the sphere of daily life as a subjective and social space of the formation of the self while also being acutely sensitive to the radical differences of age, sexuality, class, and religion between women and to the significance of such differences

in women's lives and their resulting sense of social self. Her focus on the twin effects of marriage as a *legal and erotic situation* and an occupation as a *condition* for a gendered self yielded subtle sociological explorations based on attention to women's specific and differential experiences in modernizing societies, rural as well as urban. She attributed significance to women's roles and contributions to the larger spheres of social and moral life.

Kurt Wolff (1887–1963) was a German Jewish writer and publisher who founded Kurt Wolff Verlag in Leipzig in 1908, publishing the works of Franz Kafka. With the help of Varian Fry (1907–1967), Wolff and his wife Helen Mosel Wolff (1906–1994) were able to escape from Europe for New York, where they founded Pantheon Books in 1942 and later the Helen and Kurt Wolff imprint at Harcourt Brace Jovanovich publishers.[20] Wolff is listed as the publisher of several works cited by Rosenau.

— Analysis of the Missing Bibliography

Pages 266–75 provide a listing of Helen Rosenau's bibliography for *Woman in Art*, first by date of publication and then by subject area. The listing by date allows us to track the emergence across many old and some new disciplines, from ancient texts to the most current scholarship, of a literature on the core questions of woman, art, and society. It also reveals both the long history and the increasing attention to these questions during the nineteenth century and notably in the immediate moment of Rosenau's writing.

The listing by name populates the field of her research with individuals whose works contributed to the foundation of new disciplines or new directions within established modes of study. These include a significant number of women scholars, to be recognized not only as co-founders of many of these disciplines in their modern forms but also as major theorists expanding their fields by a specific focus on gender, shared with their male colleagues, and on cultural difference.

Compiled Bibliography by Date of Publication and Subject Area

BY DATE OF PUBLICATION

Pre-1900

c.360 BCE	Plato	*Timaeus* [suggested edition: *The Dialogues of Plato*, vol. 3, edited and translated by Benjamin Jowett (Oxford: Clarendon Press, 1871].
384–22 BCE	Aristotle	*Politics* [suggested edition: translated by Benjamin Jowett, Oxford: Clarendon Press, 1905].
c.98 CE	Tacitus	*Germania* [suggested edition: edited by J. C. G. Anderson, Oxford: Clarendon Press, 1938].
c.1200	Von Eschenbach, Wolfram	*Parsival* [no edition cited].
1668	Molière [Jean-Baptiste Poquelin]	*Amphytrion* [no edition cited].
[1798] 1938	Schleiermacher, F.	*Idee zu einem Katechismus der Vernunft für edle Frauen*. Heidelberg: Weissbach. Translated as 'Ten Commandments for Wise Women' in Helen Rosenau, 'Changing Attitudes towards Women', in *Women under the Swastika* (London: Free German League of Culture in Great Britain, 1942), 26–7, https://jewish-history-online.net/source/jgo:source-234, retrieved 9 May 2022.
1799	Schlegel, Friedrich	*Lucinde: ein Roman*. Berlin: Heinrich Frölich.
1800	Schleiermacher, F.	*Vertraute Briefe ueber F. Schlegel's Lucinde*. Lübeck and Leipzig: Friedrich Bonn (published anonymously).
1838	Esquirol, J. E. D.	*Des maladies mentales*. Paris: Chez-Baillière.
1861	Bachofen, J. J.	*Das Mutterrecht: Eine Untersuchung über die Gynaikokratie der alten Welt nach ihrer religiosen und rechtlichen Natur*. Stuttgart: Von Kreis und Hoffman.
1871	Morgan, Lewis H.	*Systems of Consanguinity and Affinity of the Human Family*. Washington, DC: Smithsonian.
1877	Assing, Ludmilla	*Aus Rahels Herzensleben: Briefe und Tagebuchblätter*. Leipzig: Verlag Brockhaus.
1879	Schmelzeis, J. P.	*Das Leben und Wirken der Hl. Hildegardis*. Freiburg: Her'sche Verlagshandlung.
1882	Buecher, Karl	*Die Frauenfrage im Mittelalter*. Tuebingen: Laup.
1887	Paris, Gaston	*La légende du mari aux deux femmes*. Paris: Firmin-Didot.
[1891] 1921	Westermarck, E. A.	*The History of Human Marriage*, 5th ed., 3 vols. London: Macmillan.
1893–1922	Conze, Alexander	*Die Attischen Grabreliefs*. Berlin: W. Spemann.

1894	Hegel, G. W. F.	*Philosophy of Mind*, translated by W. Wallace. Oxford: Oxford University Press.
[1895] 1906	Paris, Gaston	*La poésie du Moyen Age*, II. Paris: Hachette.
1896	Eckenstein, Lina	*Women under Monasticism*. Cambridge: Cambridge University Press.
1896	Grosse, Ernst	*Die Formen der Familie und die Formen der Wirthschaft*. Freiburg and Leipzig: J. C. B. Mohr.
1896–1900	Petit de Julleville, L.	*Histoire de la langue et de la literature française des origines à 1900*. Paris: Armand Colin.

1900–1919

1902	Berdrow, Otto	*Rahel Varnhagen: Ein Lebens – und Zeitbild*. Stuttgart: Greiner und Pfeiffer.
1903	Nietzold, J.	*Die Ehe in Aegypten zur Ptolemäisch: Römischen Zeit*. Leipzig: Metzger & Wittig.
1904	Smith, A. H.	*A Catalogue of Sculpture in the Greek and Roman Antiquities in the British Museum*, vol. 3. London: British Museum.
1906	Von Tschudi, Hugo	*Ausstellung Deutscher Kunst, 1775–1875*. Munich: F. Bruckmann.
1906	Weininger, Otto	*Sex and Character*. London: William Heinemann.
1907	Hofmann, Julius	*Francisco de Goya: Katalog seines graphisches Werkes*. Vienna: Gesellschaft für vervielfältigende Kunst.
1907	Weber, Marianne	*Ehefrau und Mutter in der Rechtsentwicklung*. Tübingen: J. C. B. Mohr.
1909	Borodine, Myrrha	*La femme et l'amour au XIIe siècle d'après les poèmes de Chrétien de Troyes*. Paris: Picard.
1909	Key, Ellen Karolina Sofia	*Die Frauenbewegung*. Frankfurt am Main: Literarische Anstalt and Rütten & Loening. Translated by Mamah Bouton Borthwick as *The Woman Movement* (New York and London: G. P. Putnam & Sons, 1912). [Rosenau references the German original.]
1909	Mangenot, E. and A. Vacant	*Dictionnaire de théologie catholique contenant l'exposé des doctrines de la théologie catholique, leurs preuves et leur histoire*, vols. 1–5. Paris: Letouzey et Ané.
1909	Wechssler, Edouard	*Das Kulturproblem des Minnesangs*. Halle: M. Niemeyer.
1911	Freud, Sigmund	*Sammlung Kleiner Schriften zur Neurosenlehre I: Aus den Jahren 1893–1906*. Vienna: Franz Deuticke. See *Totem und Tabu: Einige Übereinstimmungen im Seelenleben der Wilden und der Neurotiker* (Leipzig and Vienna: Hugo Heller, 1913), translated by Abraham Brill as *Totem and Taboo* (Harmondsworth: Penguin, 1938).
1911	[Gsell, Paul] Rodin, Auguste	*L'Art: entretiens réunis par Paul Gsell*. Paris: Bernard Grasset.

1912	Hekler, Anton	*Greek and Roman Portraits*. London: Heinemann.
1912	Moret, Alexandre	*Kings and Gods of Egypt*. New York and London: Putnam.
1912	Prior, Edward and Arthur Gardner	*An Account of Medieval Figure Sculpture in England*. Cambridge: Cambridge University Press.
1913	Waddell, Helen	*Lyrics from the Chinese*. London: Constable.
1914	Contenau, Georges	*La déesse nue babylonienne: étude d'iconographie comparée*. Paris: P. Guenthner.
1914	Fabre, Abel	*Pages d'Art Chrétien, V*. Paris: Maison de la Bonne Presse.
1914	Gopinatha Rao, T. A.	*Elements of Hindu Iconography*. Madras: Law Printing House.
1914	Hobhouse, L. T., G. C. Wheeler, and M. Ginsberg	*The Material Culture and the Social Institutions of the Simpler Peoples*. London School of Economics Series of Studies III.
1914	Wulff, August	*Die Frauenfeindlichen Dichtungen in den romanischen Literaturen des Mittelalters bis sum Ende des XIII Jahrhunderts*. Halle: Ehrhardt Karras.
1915	Cabre, Juan	*El arte rupestre en Espana*. Madrid: Museo Nacional de Ciencias Naturales.
1915	Murray, Margaret	'Royal Marriages and Matrilineal Descent', *Journal of the Anthropological Institute* XLV, 307–25.
1916	Jung, C. G.	*Psychology of the Unconscious*, translated by Beatrice M. Hinkle. New York: Kegan Paul & Co.
1918	Harrison, Jane	*Ancient Art and Ritual*. London and New York: Home University Library.
1919	Pauli, Gustav	*Paula Modersohn-Becker*. Leipzig: Kurt Wolff.

1920–1929

1920	Feuerbach, Anselm	*Briefe an seine Mutter*. Munich: Kurt Wolff.
1920	Gallwitz, S. D. (ed.)	*Paula Modersohn-Becker: Briefe und Tagebuchblätter*. Munich: Kurt Wolff.
1921	Planiscig, L.	*Venezianische Bildhauer*. Vienna: Kunst Verlag Anton Schroll.
1921	Waley, Arthur	*The Nō Plays of Japan*. London: Allen & Unwin.
1921	Weber, Max	*Wirtschaft und Gesellschaft*. Tübingen: J. C. B. Mohr.
1921	Weisbach, Werner	*Der Barock als Kunst der Gegenreformation*. Berlin: Bruno Cassirer.
1922	Freud, Sigmund	*Introductory Lectures on Psycho-analysis*. London: Hogarth Press.
1922	Harrison, Jane	*Prolegomena to the Study of Greek Religion*, 3rd ed. Cambridge: Cambridge University Press.
1922	Nielsen, Ditlef	*Der Dreieinige Gott*. Copenhagen and London: Gyldenaske Boghandel.
1922	Power, Eileen	*Medieval English Nunneries*. Cambridge: Cambridge University Press.

1922	Waley, A.	*An Introduction to the Study of Chinese Painting.* London: Benn Brothers.
1922	Zimmern A. E.	*The Greek Commonwealth.* Oxford: Oxford University Press.
1923	Jones, Ernest	*Essays in Applied Psycho-analysis.* London: International Psychoanalytical Library No. 5. Printed in Vienna.
1923	Wright, Frederick A.	*Feminism in Greek Literature from Homer to Aristotle.* London: G. Routledge & Sons.
1924	Adler, Alfred	*The Practice and Theory of Individual Psychology,* translated by P. Radin. London: K. Paul Trench.
1924–37	Roscher, W. H.	*Ausführliches Lexikon der Griechischen und Römischen Mythologie VI.* Leipzig: Teubner.
1924	Schmidt, P. W. and W. Koppers	*Völker und Kulturen.* Regensburg: Josef Habbel.
1925	Delaporte, L. J.	*Mesopotamia: The Babylonian and Assyrian Civilization.* London: Kegan Paul & Co.
1925	Gongoly, O. C.	'The Mithuna in Indian Art', *Rūpam: An Illustrated Quarterly Journal of Oriental Art Chiefly Indian,* April–July, p.6ff [source suggested for Rosenau's incomplete reference].
1925	Leuba, J. H.	*The Psychology of Religious Mysticism.* London and New York: Harcourt, Brace and Co.; London: Kegan Paul & Co.
1925	Pinder, Wilhelm	*Der Naumburger Dom.* Berlin: Deutsche Kunstverlag.
1926	—	*Das Problem der Generation in der Kunstgeschichte Europas.* Berlin: Frankfurter.
1926	Rostovtsev, M. I.	*The Social and Economic History of the Roman Empire.* Oxford: Clarendon Press.
1927	Boas, Frans	*Primitive Art.* Oslo: Institute for Comparative Research and Harvard University Press.
1927	Briffault, Robert	*The Mothers: The Matriarchal Theory of Social Origins.* London: Chapman Hall.
1927	Joyant, Maurice	*H. de Toulouse-Lautrec.* Paris: Jean Boussod, Manzi, Joyant et Cie.
[1927] 1938	Langdon-Davies, John	*A Short History of Women.* London: Thinkers' Library.
1928	Hildebrandt, Hans	*Die Frau als Künstlerin: mit 337 Abbildungen nach Frauenarbeiten bildender Kunst von den frühesten Zeiten bis zur Gegenwart.* Berlin: Mosse.
1928	Jung, C. G.	*Contributions to Analytical Psychology,* translated by H. G. and Cary F. Baynes. London: Kegan Paul & Co.
1928	McDougall, William	*An Outline of Psychology,* 4th ed. London: Methuen & Co.
1928	Thompson, Edward	*Suttee.* London: George Allen & Unwin.

1928	Woolf, Virginia	*Orlando: A Biography*. London: Leonard and Virginia Woolf at the Hogarth Press.
1929	Giraudoux, Jean	*Amphytrion 38*. Paris: Bernard Grasset.
1929	Kuehn, Herbert	*Kunst und Kultur der Vorzeit Europas*. Berlin: Walter de Gruyter.
1929	Lowie, Robert H.	*Primitive Society*, 2nd ed. London: London School of Economics.
1929	Schücking, L. L.	*Die Familie im Englischen Puritanismus*. Leipzig and Berlin: B. J. Teubner.
1929	Schürer, Oskar	'Romanische Doppelkapellen: Eine Typengeschichtliche Untersuchung', *Marburger Jahrbuch für Kunstwissenschaft V*. Marburg: Verlag des Kunstgeschichtlichen Seminars der Universität Marburg an der Lahn.
1929	Van de Velde, Th. H.	*Die Fruchtbarkeit in der Ehe und ihre wunschgemässe Beinflussing*. Leipzig and Stuttgart: Horw-Luzern.
1929	Woolf, Virginia	*A Room of One's Own*. London: Leonard and Virginia Woolf at the Hogarth Press.
1929	Zwarts, Jac.	*The Significance of Rembrandt's* The Jewish Bride. No publisher. Printed by J. G. van Amerongen & Co., Amersfoort.

1930–1939

1930	Breitenbach, Edgar (ed.)	*Speculum Humanæ Salvationis: eine typengeschichtliche Untersuchung*. Strasbourg: Heitz.
1930	Crevel, René	*Renée Sintenis*. Paris: Gallimard.
1930	Horner, I. B.	*Women under Primitive Buddhism*. London: White Lotus Press.
1930	Lehner, H.	*Römische Steindenkmäler*, in *Bonner Jahrbücher* CXXXV, 1–48.
1930	Liebeschütz, Hans	*Das allegorische Weltbild der Heiligen Hildegard von Bingen*, in *Studien der Bibliothek Warburg XVI*. Leipzig: Teubner.
1930	Spearing, H. G.	*The Childhood of Art or the Ascent of Man*. London: Kegan Paul & Co.
1931	de Moubray, G. A. de C.	*Matriarchy in the Malay Peninsula*. London: Routledge.
1931	Licht, Hans	*Sexual Life in Ancient Greece*, translated by J. H. Leese. London: Routledge.
1931	Misch, Georg	*Geschichte der Autobiographie*. Leipzig and Berlin: Teubner.
1931	Obermaier, H.	*Urgeschichte der Menschheit*, in *Geschichte der führenden Völker I*. Freiburg: Herder Verlagsbuchhandlung.
1931	Rosenau, Helen	*Der Kölner Dom: seine Baugeschichte und historische Stellung*. Cologne: Creutzer.
1931	Steinberg, S. H. and Chr. von Pape-Steinberg	*Die Bildnisse geistlicher und weltlicher Fürsten*. Leipzig: B. G. Teubner.

1931–5	Thurnwald, R.	*Die Menschliche Gesellschaft in ihren ethnosoziologischen Grundlagen*. Berlin and Leipzig: Walter de Gruyter & Co.
1932	Hauswirth, Frieda	*Purdah: The Status of Indian Women*. London: Kegan Paul & Co.
1932	MacLagan, Eric and Margaret Longhurst	*Catalogue of the Victoria and Albert Museum: Italian Sculpture*, vol. 1. London: Victoria and Albert Museum.
1932	Rank, Otto	*Art and Artist*. New York: Knopf.
1932	Rühle-Gerstel, Alice	*Das Frauenproblem der Gegenwart: eine psychologische Bilanz*. Leipzig: Hirzel.
1932	Warburg, Aby	*Gesammelte Schriften: die Erneuerung der Heidnischen Antike*. Leipzig: Teubner.
1932	Zuckerman, Solly	*The Social Life of Monkeys and Apes*. London: Kegan Paul & Co.
1933	Bühler, Charlotte	*Der Menschliche Lebenslauf als psychologisches Problem*. Leipzig: Herzel.
1933	Harding, M. Esther	*The Way of All Women*. New York: Longmans.
1933	Kramrisch, Stella	*Indian Sculpture*. Calcutta: YMCA Publishing House; London: Oxford University Press.
1933	Müller, Eugen	'Elisabeth Ney zum 100. Geburtstag am 26. Januar 1933', *Das schöne Münster* V:2, 17–21.
1934	Benedict, Ruth	*Patterns of Culture*. London: Routledge & Kegan Paul.
1934	Folsom, J. K.	*The Family: Its Sociology and Social Psychiatry*. New York and London: John Wiley & Sons.
1934	Panofsky, Erwin	'Jan van Eyck's Arnolfini Portrait', *Burlington Magazine* 64:372, 117–19, 122–7.
1935	Ashton, Leigh and Basil Gray	*Chinese Art*. London: Faber & Faber.
1935–6	Frazer, J. G.	*The Golden Bough: A Study in Comparative Religion*, 3rd ed. London: Macmillan & Co.
1935	Hirschfeld, Magnus	*Women East and West*. London: Heinemann.
1935	Murray, Gilbert	*Five Stages of Greek Religion*. London: Thinkers' Library.
1935	Rodenwaldt, Gerhart.	*Abhandlungen der Prüssischen Akademie der Wissenschaften*. Philosophisch-Historische Klasse No. 3. Berlin: Verlag der Prüssischen Akademie der Wissenschaften.
1935	Thiersch, Herman	*Artemis Ephesia*. Berlin: Weidmann.
1935	Vullamy, C. E.	*Aspasia: The Life and Letters of Mary Granville, Mrs Delany 1700–1788*. London: Geoffrey Bles.

1936	Archer, W. G. and Archer, M.	'Santhal Painting', *Axis* 7. Henley-on-Thames.
1936	Ashcroft, T.	*English Art and English Society*. London: Peter Davies.
1936	Bateson, Gregory	*Naven: A Survey of the Problems Suggested by a Composite Picture of the Culture of a New Guinea Tribe Drawn from Three Points of View*. Cambridge: Cambridge University Press.
1936	Lewis, C. S.	*The Allegory of Love: A Study in the Medieval Tradition*. Oxford: Oxford University Press.
1936	McDougall, W.	*An Introduction to Social Psychology*, 23rd ed. London: Methuen & Co.
1936	Ranke, H.	*The Art of Ancient Egypt*. Vienna and London: Phaidon Press.
1936	Sackville-West, Vita	*Saint Joan of Arc*. London: Cobden Sanderson.
1936	Sitwell, Sacheverell	*Conversation Pieces: A Survey of British Domestic Portraits and Their Painters*. London: B. T. Batsford.
1937	Goldscheider, Ludwig	*Five Hundred Self-Portraits*, translated by J. Byam Shaw. London: Phaidon.
1937	Kelly, Amy	'Eleanor of Aquitaine and the Courts of Love', *Speculum* 12:2, 3–19.
1937	Plekhanov, G. V.	*Art and Society*. New York: Critics Group.
1937	Sitwell, Sacheverell	*Narrative Pictures: A Survey of British Genre Paintings and Their Painters*. London: B. T. Batsford.
1937–8	Steinberg, S. H.	'A Portrait of Constance of Sicily', *Journal of the Warburg Institute* I, 249–51.
1938	Curie, Ève	*Madame Curie*. Paris and London: Heinemann.
1938	Elgood, Percival G.	*The Ptolemies of Egypt*. Bristol: Arrowsmith.
1938	Haller, William	*The Rise of Puritanism*. New York: Columbia University Press.
1938	Naumann, Hans	*Deutsche Kultur im Zeitalter des Rittertums*. Potsdam: Athenaion.
1939	Elias, Norbert	*Über den Prozess der Zivilisation*. Basel: Haus zum Falken.
1939	Leith-Ross, Sylvia	*African Woman: A Study of the Ibo, Nigeria*. London: Faber & Faber.
1939	Mayer, J. P., R. H. S. Crossman, P. Kecskemeti, E. Kohn-Bramstedt, and C. J. S. Sprigge	*Political Thought*. Introduction by R. H. Tawney. London: J. M. Dent & Sons.
1939	Onslow, R. W. A.	*The Empress Maud*. London: James Clark.
1939/40	Rosenau, Helen	'The Portrait of Isabella of Castille on Coins', *Journal of the Warburg and Courtauld Institutes* 3:1/2, 155.

1940–1943

1940	de Rougemont, Denis	*Passion and Society*. London: Faber & Faber.
1940	Jung, C. G.	*The Integration of the Personality*, translated by Stanley M. Dell. London: Kegan Paul & Co.
1941	Bowen, Stella	*Drawn from Life*. London: Collins.
1941	Shaw, G. B.	'Two Friends of the Soviet Union' [Beatrice and Sidney Webb], *Picture Post* XII, 20–23.
1941	Rosenau, Helen	'Towards a New Synthesis', *International Women's News* 35:5, 97–9.
1941	Thomson, G. D.	*Aeschylus and Athens*. London: Lawrence and Wishart.
1942	Rosenau, Helen	'Some English Influence on Jan van Eyck', *Apollo* XXXVI, 125–8.
1942	Werfel, Franz	*The Song of Bernadette*. London: Hamish Hamilton.
1943	Meyerowitz, Eva L.-R.	'The Stone Figures of Esie in Nigeria', *Burlington Magazine* LXXXII:479, 31–6.
1943	Ping-ying, Hsieh [now transliterated as Xie Bing-ying]	*Autobiography of a Chinese Girl: A Genuine Autobiography*, translated by Tsui Chi and introduced by Gordon Bottomley. London: George Allen & Unwin.
1943	Rosenau, Helen	'The Prototype of the Virgin and Child in the Book of Kells', *Burlington Magazine* LXXXIII: 486, 228–31.
1943	—	'Social Status of Women as Reflected in Art', *Apollo* XXXVII, 94–8.
1944	Klingender, F. D.	*Hogarth and English Caricature*. London: Curwen Press.

WOMEN SCHOLARS AND WRITERS

Archer, W. G. and Archer, M.	1936	'Santhal Painting', *Axis* 7. Henley-on-Thames.
Assing, Ludmilla	1877	*Aus Rahels Herzensleben*: *Briefe und Tagebuchblätter*. Leipzig: Verlag Brockhaus.
Benedict, Ruth	1934	*Patterns of Culture*. London: Routledge & Kegan Paul.
Borodine, Myrrha	1909	*La femme et l'amour au XIIe siècle d'après les poèmes de Chrétien de Troyes*. Paris: Picard.
Bowen, Stella	1941	*Drawn from Life*. London: Collins.
Bühler, Charlotte	1933	*Der Menschliche Lebenslauf als psychologisches Problem*. Leipzig: Herzel.
Eckenstein, Lina	1896	*Women under Monasticism*. Cambridge: Cambridge University Press.
Harding, M. Esther	1933	*The Way of All Women*. New York: Longmans.
Harrison, Jane	1918	*Ancient Art and Ritual*. London and New York: Home University Library.

—	1922	*Prolegomena to the Study of Greek Religion*, 3rd ed. Cambridge: Cambridge University Press.
Hauswirth, Frieda	1932	*Purdah: The Status of Indian Women*. London: Kegan Paul & Co.
Horner, I. B.	1930	*Women under Primitive Buddhism*. London: White Lotus Press.
Kelly, Amy	1937	'Eleanor of Aquitaine and the Courts of Love', *Speculum* 12:2, 3–19.
Kramrisch, Stella	1933	*Indian Sculpture*. Calcutta: YMCA Publishing House; London: Oxford University Press.
Leith-Ross, Sylvia	1939	*African Woman: A Study of the Ibo, Nigeria*. London: Faber & Faber.
Meyerowitz, Eva L.-R.	1943	'The Stone Figures of Esie in Nigeria', *Burlington Magazine* LXXXII:479, 31–6.
Murray, Margaret	1915	'Royal Marriages and Matrilineal Descent', *Journal of the Anthropological Institute* XLV, 307–25.
Power, Eileen	1922	*Medieval English Nunneries*. Cambridge: Cambridge University Press.
Rosenau, Helen	1931	*Der Kölner Dom: seine Baugeschichte und historische Stellung*. Cologne: Creutzer.
—	1939/40	'The Portrait of Isabella of Castille on Coins', *Journal of the Warburg and Courtauld Institutes* 3:1/2, 155.
—	1941	'Towards a New Synthesis', *International Women's News* 35:5, 97–9.
—	1942	'Some English Influence on Jan van Eyck', *Apollo* XXXVI, 125–8.
—	1943	'Social Status of Women as Reflected in Art', *Apollo* XXXVII, 94–8.
—	1943	'The Prototype of the Virgin and Child in the Book of Kells', *Burlington Magazine* LXXXIII: 486, 228–31.
Rühle-Gerstel, Alice	1932	*Das Frauenproblem der Gegenwart: eine psychologische Bilanz*. Leipzig: Hirzel.
Sackville-West, Vita	1936	*Saint Joan of Arc*. London: Cobden Sanderson.
Waddell, Helen	1913	*Lyrics from the Chinese*. London: Constable.
Weber, Marianne	1907	*Ehefrau und Mutter in der Rechtsentwicklung*. Tübingen: J. C. B. Mohr.
Woolf, Virginia	1928	*Orlando*. London: Leonard and Virginia Woolf at the Hogarth Press.
—	1929	*A Room of One's Own*. London: Leonard and Virginia Woolf at the Hogarth Press.

Adler, Alfred	1924	*The Practice and Theory of Individual Psychology*, translated by P. Radin. London: K. Paul Trench.
Bühler, Charlotte	1933	*Der Menschliche Lebenslauf als psychologisches Problem*. Leipzig: Herzel.
Freud, Sigmund	1911	*Sammlung Kleiner Schriften zur Neurosenlehre I: Aus den Jahren 1893–1906*. Vienna: Franz Deuticke. See *Totem und Tabu: Einige Übereinstimmungen im Seelenleben der Wilden und der Neurotiker* (Leipzig and Vienna: Hugo Heller, 1913), translated by Abraham Brill as *Totem and Taboo* (Harmondsworth: Penguin, 1938).
—	1922	*Introductory Lectures on Psycho-analysis*. London: Hogarth Press.
Harding, M. Esther	1933	*The Way of All Women*. New York: Longmans.
Jones, Ernest	1923	*Essays in Applied Psycho-analysis*. London: International Psychoanalytical Library No. 5. Printed in Vienna.
Jung, C. G.	1916	*Psychology of the Unconscious*, translated by Beatrice M. Hinkle. New York: Kegan Paul & Co.
—	1928	*Contributions to Analytical Psychology*, translated by H. G. and Cary F. Baynes. London: Kegan Paul & Co.
—	1940	*The Integration of the Personality*, translated by Stanley M. Dell. London: Kegan Paul & Co.
McDougall, William	1928	*An Outline of Psychology*, 4th ed. London: Methuen & Co.
—	1936	*An Introduction to Social Psychology*, 23rd ed. London: Methuen & Co.
Rühle-Gerstel, Alice	1932	*Das Frauenproblem der Gegenwart: eine psychologische Bilanz*. Leipzig: Hirzel.
Zuckerman, Solly	1932	*The Social Life of Monkeys and Apes*. London: Kegan Paul & Co.

Notes to Essay 5

1 In French *genre*, from Latin *genus*, serves now as the translation of the English term 'gender', even as its etymology indicates that *genre* means 'kind', as in 'of a kind'. Hence genre was typically used in literary criticism and art history for the kind of writing – a novel, a short story, a romance – or, in art, for the areas of painting – such as portrait, landscape, or history painting.

2 Ernst Cassirer, *Philosophie der symbolischen Formen*, 4 vols (Berlin: Bruno Cassirer, 1923), trans. Steve G. Lofts as *Philosophy of Symbolic Forms*, 3 vols (London: Routledge, 2020).

3 The evidence for women as artists is there in all the records from Classical art to the present. Major dictionaries listing artists' names, works, careers, and so on had been compiled by the end of the nineteenth century, the best known being Ulrich Thieme and Felix Becker's *Allgemeines Lexikon der bildenden Künstler von der Antike bis zur Gegenwart*, 37 vols (Leipzig: Verlag von Wilhelm Engelmann/Verlag E. A. Seemann, 1907–50) and Emmanuel Bénézit's *Dictionnaire des peintres, sculpteurs, dessinateurs, et graveurs* (Paris: Éditions Gründ, 1911). Artist-women are to be found in these major tomes. A major compilation of 1904 was published by Clara Clement, *Women in the Fine Arts from the Seventh Century B.C. to the Twentieth Century A.D.* (Boston: Houghton Mifflin, 1904), with more than one thousand entries. In *Old Mistresses: Women, Art and Ideology* (Routledge & Kegan Paul, 1981, 3–6), Rozsika Parker and I noted that it was only in the twentieth century that museum and scholarly Art History systematically evacuated artist-women, as exemplified by the contrast between women's presence in the dictionaries cited above and their total absence in Ernst Gombrich's *The Story of Art* [1950] (London: Phaidon, 1962) and H. W. Janson's *History of Art* (New York: Abrams, 1962).

4 Claude Lévi-Strauss, *La pensée sauvage* (Paris: Librairie Plon, 1962); *The Savage Mind* (London: Weidenfeld & Nicolson, 1966). *Sauvage* means 'uncultivated' or 'undomesticated', as in wild as opposed to farmed strawberries.

5 In 1975 US-American anthropologist Gayle Rubin articulated psychoanalytical and anthropological theory to clarify that society as an exchange system *constituted* the differentiations that *produce* 'men' and 'women' as signifiers in the system such that 'man' means *not-exchanged and exchanger* and 'woman' *exchanged/not-exchanger*. The imposition of heterosexuality and often, though not always, foreclosure of other sexualities follows from the logic of society formed as exchange system and kinship networks. Psychoanalysis becomes the lens through which to track the *psychological installation* of the system into individuals, who are demarcated by their designated places in the system. See Gayle Rubin, 'The Traffic in Women: Notes on the "Political Economy" of Sex', in *Toward an Anthropology of Women*, edited by Rayna R. Reiter (New York: Monthly Review Press, 1975), 157–210.

6 Aby Warburg, *The Renewal of Pagan Antiquity: Contributions to the Cultural History of the Renaissance* [1932], introduced by Kurt Forster, trans. David Britt (Los Angeles: Getty Research Institute for the History of Art and Humanities, 1999).

7 Charlotte Schoell-Glass, *Aby Warburg and Antisemitism: Political Perspectives on Images and Culture* (Detroit: Wayne State University Press, 2008).

8 Marius Vachon, *La femme dans l'art: les protectrices des arts; les femmes artistes* (Paris: J. Rouam & Cie, 1893).

9 For an analysis of the organization and artistic ambitions of this significant and long-lived body see the major study by Tamar Garb, *Sisters of the Brush: Women's Artistic Culture in Late Nineteenth-Century Paris* (New Haven and London: Yale University Press, 1994).

10 Simone de Beauvoir, *Le deuxième sexe* (Paris: Éditions Gallimard, 1949).

11 Cynthia Eller, *Gentlemen and Amazons: The Myth of Matriarchal Prehistory 1861–1900* (Berkeley: University of California Press, 2011); Marija Gimbutas, *The Language and the Goddess: Unearthing the Hidden*

Symbols of Western Civilization (San Francisco: Harper & Row, 1989).

12 See, in the *Woman in Art* bibliography, Robert Briffault, *The Mothers* (London: Chapman Hall, 1927), 21–2. The 1937 edition was a one-volume compression of his three-volume *The Mothers: A Study of the Origin of Sentiments and Institutions* (1927; new edition 1931).

13 M. F. Ashley Montagu, *Marriage, Past and Present: A Debate between Robert Briffault and Bronisław Malinowski* (Boston: Porter Sargent, 1956), 42.

14 Stephen Mennell, 'A Sociologist at the Outset of Group Analysis: Norbert Elias and His Sociology', *Group Analysis* 30:4 (1997), 489–513.

15 Norbert Elias, *The Civilizing Process*, vol. 1: *The History of Manners*, trans. E. Jephcott (Oxford: Blackwell, 1969).

16 Johann Joachim Winckelmann (1717–1768) valued Greek art for its noble simplicity and quiet grandeur. He published *The History of the Art of Antiquity* [1764], trans. Harry Francis (Los Angeles: Getty Research Institute, 2006).

17 E. M. Butler, 'Alkestis in Modern Dress', *Journal of the Warburg Institute* 1:1 (1937), 46–60.

18 On a 2022 event celebrating this exhibition see 'Rediscovering Stella Kramrisch's 1940 Photographic Exhibition of Indian Art at the Warburg Institute', Warburg Institute, n.d., https://warburg.sas.ac.uk/blog/rediscovering-stella-kramrischs-1940-photographic-exhibition-indian-art-warburg-institute, accessed 27 April 2023; 'Stella Kramrisch as Curator: Calcutta 1922 – London 1940 – Philadelphia 1968', Warburg Institute, 11 March 2022, https://www.youtube.com/watch?v=p2a0bB7Lny4, accessed 27 April 2023. See also Jo Ziebritzki, *Stella Kramrisch: Kunsthistorikerin zwischen Europa und Indien: Ein Beitrag zur Geschichte der Kunstgeschichte* [Stella Kramrisch: Art Historian between Europe and India: An Essay on Depatriachalizing Art History] (Marburg: Büchner, 2021).

19 Glenn Gossling, 'Sylvia Leith-Ross', Tavistock and Portman NHS Foundation Trust, 2019, https://100years.tavistockandportman.nhs.uk/sylvia-leith-ross, accessed 27 April 2023.

20 My personal connection runs through the fact that Pantheon was the US-American publisher of Rozsika Parker's and my *Old Mistresses* (1981) and that Kurt and Helen Wolff were the first publishers of a book, *Charlotte: A Diary in Pictures* (1964) on the artist Charlotte Salomon (1917–1943), on whom I wrote the first major art-historical monograph, combining Jewish and feminist studies: *Charlotte Salomon in the Theatre of Memory* (New Haven and London: Yale University Press, 2018).

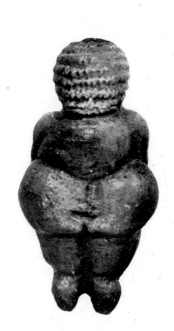
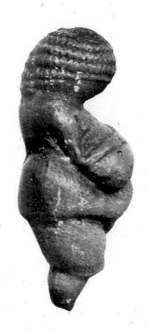
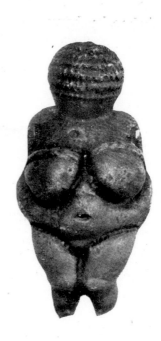

Fig. 1 : Willendorf "Venus," c. 25,000
B.C. (Natural History Museum, Vienna)

Essay 6

Situated Readings

In the spirit of Karl Mannheim's (1893–1947) theory of situated knowledge and intellectual generationality, deployed art-historically by Helen Rosenau, in this essay I offer a set of situated readings of each chapter of *Woman in Art* informed by the developments in feminist thinking after 1968.

— The Introductory

The two-page, theoretically substantial 'Introductory' declares the author's intellectual alignments and her cultural and gender politics. Beginning with a second illustration of three views of the Willendorf figure (fig. 3.40), Rosenau situates the book within key developments in the previous half-century in anthropology and the discoveries of key artefacts of palaeolithic societies and cultures.

The first sentence endorses a socio-cultural interpretation of human culture that opens the study of the representation of men and women in documented, historical–cultural forms – art – to subtle scrutiny of the changing modes of attribution and incorporation of roles of – and, critically, social relations between – women and men in historically varying situations. The 'Introductory' states that Rosenau's work is aligned with the distinction between human evolution, with its biological theories of the origins of sexual dimorphism (and 'the position of *Woman* in the earliest phases'), and the history of *societies* and social organization, the earliest of which scholars agree attributed a high degree of significance to *women* as social and indeed mythic subjects. Rosenau emphasizes the critical space between *woman* – an idea – and *women* – social subjects – that plays out across her text as a dynamic. So, when we read the phrase 'the earliest representations of women', we are to imagine already a social structure that valued those termed women and what *woman* symbolically represented as a result. Thus biology, even as complexly thought as Darwin's evolutionary theory, is not the starting point. The characters of different forms of society are the first locus of investigation.

Rosenau's first footnote identifies the rich debate in social–cultural anthropology arising from evolutionary theories applied to culture

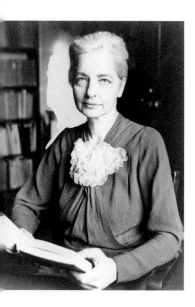

3.41 World Telegram staff photographer, *Ruth Benedict* (1887–1948), 1937, gelatin silver print. Photo: Library of Congress, Washington, DC.

– and their refutation. Using its provocation, Rosenau references the founding texts that located gender within human social organization, drawing on recent publications appearing in the late 1920s and early 1930s. She has to start with the classic nineteenth-century work of Swiss anthropologist J. J. Bachofen (1815–1887), who, in 1861, published *Das Mutterrecht: Eine Untersuchung über die Gynaikokratie der alten Welt nach ihrer religiosen und rechtlichen Natur* (Mother-Right: An Investigation of the Religious and Juridical Character of Matriarchy in the Ancient World), a book that influenced both the founder of US-American anthropology, Lewis Henry Morgan (1818–1881), and Karl Marx's (1818–1883) collaborator and social theorist Friedrich Engels (1820–1895), notably in the latter's proto-materialist but gender-sensitive book *Der Ursprung der Familie, des Privateigenthums und des Staats im Anschluss an Lewis H. Morgan's Forschungen* (1884), translated only in 1902 as *The Origin of the Family, Private Property and the State: In the Light of the Researches of Lewis H. Morgan*. The latter is not referenced in Rosenau's notes. She also mentions the contemporary social anthropologist Robert Briffault (1874–1948), author of *The Mothers: The Matriarchal Theory of Social Origins* (1927). These are linked to German scholars such as Ernst Grosse (1862–1927), who wrote *Die Formen der Familie und die Formen der Wirthschaft* (The Forms of the Family and the Forms of the Economy) (1896); Sigmund Freud, who wrote *Totem and Taboo* (Rosenau cites the English translation from 1940); and the British J. G. Frazer's (1854–1941) *The Golden Bough* (1890; Rosenau used the third edition, of 1935–6).

In terms of models for thinking culture's social origins and variability, Rosenau also references her contemporary the US-American anthropologist Gregory Bateson (1904–1980), whose recent publication on a ritual of the Iatmul people in New Guinea, *Naven: A Survey of the Problems Suggested by a Composite Picture of the Culture of a New Guinea Tribe Drawn from Three Points of View* (1936), recast anthropology as a methodologically self-reflexive and epistemological project by proposing a triple model of sociological, ethological, and eidological analysis. As importantly, Bateson's equally famous contemporary the US-American anthropologist Ruth Benedict's (1887–1948) (fig. 3.41) influential and earlier text *Patterns of Culture* (1934) is also cited by Rosenau.

Benedict argued that culture *patterns* human action and thought, and indeed human actions and thoughts are registered as the varied patterns that constitute the diversity of cultures, each of which is as complex and significant as any other. This argument is deeply anti-biologistic and allows for the creativity of each society and culture equally as modes of thought and action. Associated with the anti-racist stance of Franz Boas (1858–1942) and taking a similar position, Benedict's anthropology

consciously refuted the biological determinism on which racist and indeed colonialist ideologies rested, and this is also true for patriarchal sexism. Why this matters for the art historian is that Benedict identified patterns of cultures that need to be deciphered for the characteristics that create constellations of their values and their thoughts through both practices and aesthetic–symbolic artefacts.[1]

Reading from such a standpoint and introducing, while upending, a psycho-cultural view such as Freud offered in seeking to identify the psychic underpinnings of historical cultures, Rosenau argued that while 'matriarchal tendencies were fostered by division of labour [and] the invention of primitive agricultural implements by women', thus producing a civilization shaped by their centrality, that very centrality of women could have paradoxically fostered a psychological reaction within the masculinities such societies equally produced, inciting even this reversal:

> In this way the culture pattern of matriarchy [Benedict's terminology] may itself be instrumental in its own overthrow, since the men, growing more and more independent, master new techniques and ultimately acquire rights over the womenfolk. From this point of view the rise of the influence of the mother's brother and the ultimate power of the husband and father may be explained.

Rosenau brings in evidence from George Alexander de Chazal de Moubray (1888–1975/7), who 'speaks of the virile qualities of the Malay men living in a matriarchal society' in his *Matriarchy in the Malay Peninsula* (1931). Marriage based on the assertion of father right – patriarchy – also arises socially, Rosenau argues, because of the mystery of fatherhood and hence as a cultural–psychological reaction to men's 'apparent' irrelevance to reproduction. Hence:

> It is worth noting that the man, who in the earliest periods could not have known the facts of fatherhood, had to claim his children by *some ritual acts*. He therefore must have favoured the *patriarchal marriage institution* as a safeguard of his rights, and the means of obtaining not only a partner in life but also legitimate offspring for himself. (my emphasis)

Rosenau's sentence endorses a socio-cultural interpretation of biological differentiation that is enacted in historically and culturally varying social relations between women and men. Moreover, she is also allowing for psychological – that is, subjective – dimensions in cultural patterning, such that might account for patriarchy as a reactive social tendency in the face of the self-evident significance of women in terms of creating new life.

Rosenau's footnotes reveal the rich debate responding to and contesting evolutionary theories applied to culture that reflected, and supported with 'biological data', only the sexual hierarchies of current society. The imagined origins of social institutions were but the ideological foundations of nineteenth-century European theories of a natural division of the sexes. Feminist critique questioned all ideologies as well as religious beliefs that appeal to nature and defend patriarchal hierarchy and the asymmetry of sexual identities and functions. Denaturalizing characterization of societies as *matriarchal* and *patriarchal* made available analytical terms that historicized and socialized the relations, roles, and identities of women and men.

Certain scholars are cited in support of evidence for an egalitarian family and division of labour in the earliest societies, which were neither matriarchal, as Bachofen and Briffault argued, nor patriarchal, as Darwin and Freud postulated. Matriarchal and patriarchal types were shown to arise from different economic practices, such as the development of agriculture (crop growing) versus pastoral animal husbandry (sic!). Rosenau furthermore introduces another mediating term to describe early societies – 'gynaecodynamic' rather than 'gynocracy' – bypassing issues of rule and domination by either men or women in favour of thinking about value, veneration, respect, and influence evident specifically in the language of rituals and taboos.

Such possibilities are reinforced by her important reference to the work of the Cambridge Ritualist school of classicists, such as Jane Harrison (1850–1928) (fig. 3.42) and Gilbert Murray (1866–1957). Harrison published six meticulously researched books, using inscriptions, texts, and artefacts to argue that ancient, pre-classical Greek art and myth arose from ritual. These rituals were imaginative modes of negotiating the vulnerability of humans before the forces of nature on which life depended. What were originated as performed rituals, *dromenon*, were eventually distilled into staged cultural forms such as *drama* while projections about forces ensuring food (sun, earth, seasons) or threatening life (storms, drought, disease) eventually took on the form of personified gods.

Harrison's books include *Prolegomena to the Study of Greek Religion* (1903), *Themis: A Study of the Social Origins of Greek Religion* (1912), *Ancient Art and Ritual* (1913), and *Epilogomena to the Study of Greek Religion* (1921). Her non-Frazerian Ritual Theory of the origins of Greek myth, drama, the pantheon, and art resonated with, and left its impact on, modernism in contemporary art and literature, engaging many writers, such as Virginia Woolf (1882–1941), and relating to the ideas about myth and literature of both W. B. Yeats (1865–1939) and James Joyce (1882–1941).[2]

I want to draw out these references to deepen our understanding of Rosenau's self-positioning and her project. As older contemporaries of a scholar such as Helen Rosenau, the British classicist Jane Harrison and the US-American anthropologist Ruth Benedict provided strong, intellectual women's voices in the formation of the cultural disciplines that investigated the most archaic *social organizations*, including the family as a *social* organization and not a *biological* unit. As cultural anthropologists, they equally valued and explored the most archaic forms of imagination and representation relating to human precarity, life, and death.

Not a back-projection of art's unbroken history to its farthest known regions, Rosenau's use of the Willendorf figure situates thinking about art and women in the present moment of intellectual, and effectively political, debate, challenging the very grounds for any attempted retrospective naturalization of patriarchal hierarchies and their social

3.42 Augustus John (1878–1961), *Portrait of Jane Harrison* (1850–1928), 1909, oil on canvas, 62 × 75 cm. Newnham College, Cambridge. Artepics / Alamy Stock Photo.

sex–gender systems. In a very swift move, Rosenau sets up the imaginative and the aesthetic, the thoughts and actions, as it were, that identify women with both appearance in figurative sculpture and capacity for abstract art-making, using one of the oldest artefacts and a contemporary example of persistence of long-standing relations of women to creativity, aesthetics, and imagination. She writes:

> The influences on art in primitive civilisations are as varied as these civilisations themselves. Two facts appear, however, particularly striking in this connection. The one is that women, who are commonly assumed to have little or no power of abstraction, invent patterns of abstract art (*Fig. 2*) (as with the Esquimaux and the Santhals); the other, that the earliest representations of human beings are of the female sex. Palaeolithic art is the only historical source in existence for the earliest periods of human evolution, and strikingly enough it shows two prevailing subjects, the animal and the female figure in the nude.

Noting the epithet 'Venus' attached to the Willendorf figure, which superimposes a Western classical reading of her 'nudity' that can be countered by other interpretations that project notions of illness or pregnancy onto this tiny, sculpted form, Rosenau reads this figuration of a female body as an *ambivalent* representation, and intended as such – condensing *ideas* of the sexual and the maternal rather than descriptions of fertility or mere erotic fantasy. As a result, she will also speculate:

> The same is true also in another respect: one cannot say whether the figures represent human beings or goddesses, since in most cases no attributes are given. Indeed, the lack of clear distinctions is characteristic of the whole group. A magic meaning may well be correlated to these works, which express a subconscious notion of the potential powers of woman.

To this is attached another significant footnote:

> It is worth noting that from these figures *no direct evolution can be traced to ancient Egyptian or Sumerian Art*. Owing to geological reasons which produced climatic changes, the centre of civilisation shifted from the West to the East in Neolithic times, and an artistic evolution set in, starting from primitive pottery and culminating in works of art of the highest aesthetic significance. Cf. F. Boas: *Op. cit.*, p. 181; also H. Kuehn: *Kunst und Kultur der Vorzeit Europas*, Berlin, 1929; H. G. Spearing: *The Childhood of Art*, London, 1930; H. Obermaier: *Urgeschichte der Menschheit, in Geschichte der führenden Völker I*, Freiburg, 1931. (my emphasis)

Remnants of cultures we still cannot decipher surfaced in the later nineteenth and early twentieth centuries. Rosenau is arguing that we cannot

smooth over the rupture in the archaeological record between the Palae-olithic and Neolithic cultures and those with a firmer evidential record deriving from a shifted 'centre' of culture in the Middle Eastern area from the Euphrates to the Nile. No derived history of art or of society is offered. Instead fragments and hypotheses form a battlefield for contemporary social and cultural theory itself, articulating debates about gender that emerged with academic as well as political force in the era of Modernity and notably as the university disciplines were formed. They too are necessarily subject to a reading for 'the sociology of knowledge'.

Unknowable to Rosenau, the later work of Lithuanian archaeologist Marija Gimbutas (1921–1994) focussed on the study of what she termed 'Old Europe' (the regions of Austria eastwards to modern-day Turkey) and on the shifts from Neolithic to Bronze Age cultures. These might well have been relevant for Rosenau in so far as the massive body of evidence about gynaecodynamic societies has been sidelined in favour of the master narrative of empires that created Europe's patriarchal foundations in Babylonian, Sumerian, Egyptian, and Greek societies. Gimbutas's many publications on the goddesses and resulting civilization documented in detail the archaeological existence of a gynaecodynamic Old Europe violently supplanted by patriarchal social organizations during the Bronze Age, brought to Old Europe by Kurgan (the Russian word for Turkic) invaders from the East. Gimbutas's interpretations have, inevitably, been dismissed by the masculinist scholarly establishment, which has erased or ignored the earlier scholarship that Rosenau herself cited. Gimbutas is respected by later twentieth-century feminist anthropologists, artists, and art historians, and indeed aligned with the issues that Rosenau left rightly open for further evidence such as that which Gimbutas, in the tradition of Jane Harrison and Ruth Benedict, continued to collect and assess.[3]

— Chapter 1: Wives and Lovers

In keeping with the anthropological and both feminist and non-feminist sociological literature, the opening proposition of Rosenau's study of women in society and cultural representation addresses the legal and social institution of marriage. She neither favours the form nor endorses heteronormativity. Anthropologically, marriage is a social institution and a formal act instituted in most cultures, and not only as the marriage of men and women, although scholars diverge in their explanations for the apparently universal incidence of a ritual, some linking its origins to the sometimes unknown 'facts' of reproduction and fertility (i.e., children and family) and with the making of new humans being mysterious in ways that enhanced the 'manna' of the women who carry and give birth.

Other scholars focus interpretation on the economic and social organization of relations within and between primary social groupings – the family as a unit of both production and reproduction. The now-classic text *The Elementary Structures of Kinship* was published in 1949 by Rosenau's contemporary refugee the Jewish French anthropologist Claude Lévi-Strauss (1908–2009).[4] His work postdates but complements her book.

With his use of the US-American anthropology of Franz Boas and the literary theory of Roman Jakobson (1896–1982) – encountered as a fellow refugee in New York in the 1940s – Lévi-Strauss developed a structuralist reading of the foundations of society and of culture itself in the social relations of exchange and kinship rather than, as had Engels and Marx, in the primacy of social relations of production and labour. For Lévi-Strauss, 'society' is built from the exchanging by family groups of their young, creating kinship as social bonding and establishing tables of affinity and difference for such bonding, via the passage of things of value between unrelated groups. Exchange builds, and is articulated as, kinship systems that are widely variable but, as sets of rules, are universal. Kinship organizes two processes. The first is transfer of some children, either boys or girls, from their birth families to becoming 'wives' or 'husbands' in other families, and this is compensated by the transfer of goods passing in the reverse direction. The 'gift' or exchange of the young person who will create 'kin' through reproduction, paternal or maternal, furthermore initiates social bonds between families, these developing, in layers of complexity, into social networks dividing kin from non-kin, friend from foe, while also producing larger units: tribes, communities, societies.[5]

One effect of the exchange-based kinship systems is a formal and social investment in gender differentiation between those who are exchanged and those who are not exchanged for the purposes of the social regulation of the sexual production of children. Kinship thus operates as a 'language' with its designated asymmetrical positioning of the non-exchanged versus the exchanged, these social–economic positions being signified by words. These words, *man* and *woman*, *husband* and *wife*, do not describe, but prescribe and signify, asymmetrical positions in the kinship exchange system. *Woman* is, thus, a signifier in a 'communication' system for that which is exchanged. It then signifies that which has no property in its own sexual body. This distinction creates or sustains the condition that differentiates human children sexually for the purposes of exchange in the social institution of kinship. Mostly, but not always, *Men*, being non-women, signify the *not-exchanged* even as both parties, their positions and sexual lives, are equally regulated by the overall system and, in some cases, it is the husband who moves to relocate to his wife's family; this is termed a 'matrilocal family system'. In some

cases descent and property are never alienated from the woman's family but pass through the maternal uncle. I have introduced this compressed account of structural kinship theory to ensure that, while approaching this chapter, we remain at the anthropological, hence structural, level.

This was the social foundation for what Helen Rosenau tracked through sociological, legal, and cultural scholarship in order then to ascertain the specific and the different ways in which non-natural – that is, socially determined – legal relations governing sexuality and gender alter and shift over the world and more specifically down European history *as these changes are inscribed in visual formulae*. The changes the art historian notes reveal how erotic desire, personal love, and psychological individualization slowly emerge in different societies, in ways shaped, however, both by class in material terms in relation to their resulting visibility in cultural representation, and by religion/culture – she considers examples from Buddhist, Hindu, Egyptian, Judaic, Sumerian, Greek, Roman, Christian (both Catholic and Protestant), and modern atheistic as well as political communist post-religious ideologies.

While Rosenau introduces the theoretical and political framework that specifically does not assume the origins of a social institution (marriage) in biologically derived purposes (reproduction), she also identifies, within the social and legal structuring of kinship, degrees of affective connection: 'Since visual art gives form to emotional attitudes and valuations [Warburg?], the human relationships of marriage and love are reflected by it and can be studied with its help.' *Human* relationships, characterized by emotions and values, generate representations that exceed the organizational focus of anthropological and sociological analyses of underlying systems alone. Art, as inscription of 'emotional attitudes' – might be read, therefore, as producing something akin to cultural *pathos formulae* of 'the couple'. Perhaps, however, we are dealing with something more consciously conceived such as values – registers of meaning, the qualifier 'human' signifying another purposeful distinction that might be related to a more Mannheimian sense of ideology as both systemic and psychological, social and affective.

Rosenau starts with Egyptian visual formulae for the legal couple composed of a man and a woman, shown, she stresses, standing or seated side by side, although some visual arrangements use higher or lower positioning to produce a minimal man/woman hierarchy while equalizing the couple in frontality. This already inscribes 'gender' not as absolute difference but as a placement in a system of social signification. Rosenau also notes the incidence of sister–brother marriage in Egypt and the presence in their legal documents of rights of wives

and children that indicate older traditions of matrilineal inheritance in Egyptian society as the key principle determining both. Indicating the sources and debates on which she draws, she references Marianne Weber's (1870–1954) 'valuable work' – *Wife and Mother in the Development of Law* (1907) – linking this chapter directly with Marianne Weber's analysis of the institution of marriage as a historically complex development, allowing gender to be viewed historically through the prism of its variable legal formulations.

Not all societies represent marriage, notably warrior cultures such as Sumeria, Babylonia, and Assyria, where Woman appears more often as a goddess or a slave (*hierodoulai*), both conveying a primacy of erotic desirability, potency, or service. The key figure here is a sexually explicit nude, often representing the deity Ishtar, that contrasts with the robed figures representing the married couple.[6] In the latter, hierarchy is established by the relative sizes of the male and female figures, producing none of the intimacy sometimes present in Egyptian representations of couples. Here the footnotes include the work of the leading European scholar of Indian art, and Rosenau's fellow refugee scholar, who delivered lectures on Indian art at the Courtauld Institute and Warburg Institute in London between 1937 and 1940, Stella Kramrisch (1896–1993), citing her book on Indian sculpture of 1933.[7] Further references are made to Indian scholars on the fusing of male and female principles ideally represented in Hindu artforms, without, Rosenau stresses, reflecting any recognition of female desire or granting women social equality. The next examples are drawn from the texts of the Hebrew Bible that correspond more to the Babylonian models because they acknowledge individual love in stories of Isaac and Rebecca, Jacob and Rachel, Hannah and Elkanah. Rosenau's concise journey through the centres of ancient art from the Indian subcontinent through the Euphrates basin down to Egypt registers her expanded and comparative method.

Rosenau moves on to radically different Greek, Etruscan, and Roman exemplars. Chasing down the footnotes took me to Frederick Adam Wright's *Feminism in Greek Literature* (1923), which opens with a question: how did Greek civilization fall so quickly to an inferior one (e.g., Roman)? His answer is the Greeks' low ideal of womanhood and degradation of women in its art and literature, which was so widespread and consistent that the author muses: 'it is hard to say how far current opinions of women's disabilities are not unconsciously due to the long line of writers, Greek and Latin … who used all their powers of rhetoric and literary skill to disparage and depreciate womankind.'[8] Wright's book allows for variations in the Greek city-states' valuation of women, for instance women's higher status in Spartan society and women's voices

articulated passionately in Euripides' plays. He concludes, sadly, that Aristotelian misogyny prevailed and was passed on as the dominant legacy. Wright traces the genealogy of this legacy and identifies the repressed counter-representations of women as subjects in the diverse city-states of ancient Greece. This same footnote ends with a reference to Jane Harrison's *Prolegomena to the Study of Greek Religion* (first edition 1903; Rosenau cites the 1922 third edition), which uncovers, through the study of ritual, a pre-classical imaginary attributing a high degree of *mana* (mystery, power) to women, and indexing valuation of the feminine retained in some degree in the later Greek myth and its pantheon of deities even as this was contradicted by women's actual, subordinated status in many a Greek *polis*.

Rosenau turns to the Jewish Bible as source for yet another ancient Middle Eastern society to suggest 'that the idea of monogamy also had a germ in Israel. Zion and Israel were regarded as the Bride of God (*Isaiah* 61: 10; *Jer.* 2: 32), ideas which (based on *Eph.* 5: 23–32 and *Rev.* 21: 2 and 22: 17) were later taken up when the [Christian] Church was considered the Bride of Christ.' In *Proverbs* there is also the description of the Jewish wife being taken from a monogamous household. Rosenau's footnote reads:

> The Talmudic texts imply monogamy as well by prescribing that a High Priest should marry a second subsidiary wife for the Day of Atonement in order to be able to pronounce a blessing over 'his house' even in the case of the death of his first wife. This custom shows that a priest normally possessed one wife only (*Yoma I*, 13 a/b). It is also stated that a priest should marry a virgin. Since this word appears in the singular the notion of monogamy is again implied, *Leviticus* 21: 13. All Biblical quotations are from the Authorized Version.

Rosenau returns to Greek society and culture using funerary monuments as a source. In classical Greek art the women were typified in a specific way, such as the goddess, the nymph, the amazon, the *hetaira*, the married woman. The *hetairai*, often non-Greeks, functioned as the permitted sites of heterosexuality and a degree of sexual self-determination but are the reverse mode of the feminine to the incarcerated Greek wife, whose function was to bear legitimate children while concubines provided daily sexual services. This fracturing of women into different services provided to the man defines the character of Greek patriarchy, which used monogamy as a mark of distinction of the Greeks from its other polygamous societies, while 'authorizing' the sexual use of concubines and *hetairai* as well as sexual–affective relations between men. A lengthy footnote negotiates two other aspects of Greek concepts of the feminine revealed through visual representations of Greek

3.43 *Orpheus, Eurydice and Hermes*, relief, Roman copy of the Augustan Age from a Greek original of the second half of the fifth century BCE by Alcamenes, disciple of Phidias. Marble. Inv. No. 6727. Naples: National Archaeological Museum / Bridgeman Images.

deities. The eroticization and aestheticization of what were formerly revered fertility deities in the form of Aphrodite indicate the waning of projections of mysterious powers on women, *mana*, while the City goddess Athena, a 'sexless character' with 'a value attached to virginity' (Rosenau's description), was also portrayed with body-revealing clinging drapery. The Greek separation of *oikos* and *polis*, private and public, masculine and feminine spheres, tended not to produce images of intimate relations between husbands and wives. Rosenau notes, however, the affecting case of love and mourning in the myth of Orpheus and Eurydice (fig. 3.43), demonstrated in a 'well-known relief' where 'the two partners mournfully [try] to bridge their separation'.

Briefly noting the grave monuments of Etruscan society, which represent the married couple together in reclining form but differentiated by size, Rosenau devotes several pages to the contradictions in Roman law and society, where arrangements are complex (fig. 3.44). Using

sepulchral reliefs, Rosenau first identifies a more egalitarian tendency even as Roman law placed the wife entirely in the power of the husband. Yet, a practice enshrined in monumental form, the *dextrarum junctio* – the joining of hands overseen by a deity – was a sanctification of marriage whose visual form implies the ceremonial equality of the woman and the man. This model, Rosenau suggests, was revived in the Renaissance for the representation of the 'sacramental wedding' of Joseph and Mary, notably in Raphael's (1438–1520) painting *Sposalizio* (1504, Pinacoteca di Brera). Furthermore Rosenau notes that class differences in Roman society between the patrician and plebeian practices with regard to women's independence were such that the latter infiltrated the former and led to the abolition of 'patriarchy', a claim substantiated in a lengthy footnote that directs the reader to Robert Briffault, Max Weber, Marianne Weber, Erwin Panofsky, and Rosenau herself, specifically her research for this book, published in 1939–40.

3.44 *Sarcophagus of the Spouses*, 530–510 BCE, terracotta, 1.14 × 1.9 m. Rome: National Etruscan Museum / Bridgeman Images.

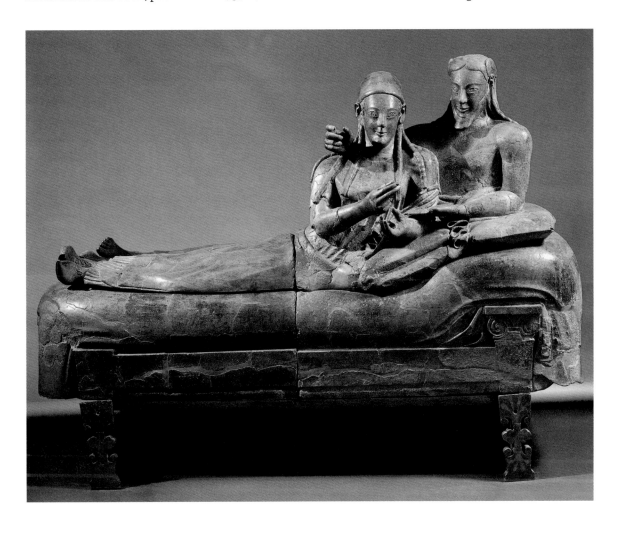

Rosenau passes via the renowned and individually recorded empresses of the Byzantine Empire, such as Theodora, to the Romanesque period of Western Europe, where religious concerns dominated the arts even as the feudal courts produced new forms of art that focussed on relationships, a tendency she identifies in the representation of two married couples in Naumburg Cathedral. These are sculptured with attentive detail differentiating the personalities, ages, and physical and psychological dispositions of the individualized women, a tendency abandoned in the later Middle Ages. Noting a singular continuation of the *dextrarum junctio* in English funerary slabs combining both members of a couple, Rosenau explains it as a 'welding together of bourgeois and feudal valuations' and not an affectionate but a legal state. Rosenau draws a complex picture of new tendencies and survivals, including traces of Germanic polygamous customs as well as the exposure of Western Christian culture to Islamic culture during the Crusades, extending her discussion of ideas of monogamy, love, and polygamy and jealousy to comparative examples from Buddhist culture and concluding with the Indian custom of 'Suttee', as well as the representation of the deity Siva and his two wives. It is in this context that Rosenau references two works that acknowledge the pain – jealousy – experienced by women in polygamous cultures: E. A. Westermarck's (1862–1939) monumental comparative study of human marriage and the focussed recent study by her contemporary Sylvia Leith-Ross, *African Woman: A Study of the Ibo, Nigeria* (1939). Chinese and Japanese examples are mentioned, as well as Gaston Paris's (1839–1903) nineteenth-century study of the husband with two wives, *La légende du mari aux deux femmes* (1887), and a very recent and monumental publication by the prolific Swiss and Christian author Denis de Rougemont (1906–1985), analyst of totalitarianism and European federalist, *L'amour et l'Occident* (1939), translated in the United States of America as *Love in the Western World* and in Britain as *Passion and Society*. De Rougemont's book offers a model for a long and speculative history of ideas about passionate love and a sermon on the nuptial idea in Christian theology and modern secular thought – tracked through their cultural inscriptions in myth, literature, and art. I pause to note this text since it introduces contemporary (1930s) debates about marriage and passion, being tracked by Rosenau in the register of the visual arts, situating her book's structure and allowing her move from the medieval period to the emergence of distinctive visual formulae in sixteenth-century Italian or rather Venetian art, notably in Titian's representation of what Rosenau terms 'a mistress with her attendant lover' (see fig. 2.10). Contemporary art historians working on Titian's painting remain undecided as to the meanings of such erotic paintings and their complex negotiations of visuality and Catholic

censorship of concupiscence (desire incited by looking) denounced by the Counter-Reformation at the Council of Trent of 1545.[9]

Different theologies begin to play their part, with the Protestant Reformation and the Counter-Reformation introducing distinct visual cultures in the representation of marriage and desire. Rosenau sets up a contrast between the Flemish Catholic diplomat-painter Rubens (1577–1640) (see fig. 2.11) and his voluptuous painting of his sixteen-year-old bride and a painting by the sombre Amsterdam Protestant Rembrandt (1606–1669) (see fig. 2.12), a work that had been thought to have biblical overtones (Isaac and Rebecca, perhaps) but that had recently, in 1929, been identified as the marriage portrait of a Jewish merchant, Don Miguel de Barrios, and his second bride, Abigail de Piña. This identification is not accepted. Rosenau's interest lies in how such paintings replace 'hieratic types' and, while still 'using' the formula of the joining of hands, elaborate intensity of feeling, individuality of expression, and a combination of gestures of protection with a compositional balance between the man and the woman suggestive of an affective equality.[10] This 'serene' image of the married couple is disturbed by Rosenau's next two examples, one of the anguish of forced bondage in Catholic marriage, which does not allow divorce – Francisco de Goya (1746–1828) (see fig. 2.13) – and the other of mercenary marriage and its attendant corruption, as presented by William Hogarth (1697–1764), works that Rosenau attributes to 'bourgeois influence', that leads on to a discussion of the impact of Romanticism.

Finally, women become the protagonists in this era and Rosenau turns to literature for the model, curiously introducing, as a feature of Romanticism, men's marriage to older women, citing the examples of the English poet Elizabeth Barrett Browning (1806–1861) (see fig. 3.54) and the German Jewish salonnière Rahel Levin Varnhagen (1771–1833) (see fig. 2.43) as indicative of individual love. For the nineteenth century, perhaps where we might expect more detailed study of the impact of bourgeois society from a feminist social historian of art, the sole image selected is a sombre work by Henri de Toulouse-Lautrec (1864–1901) (see fig. 2.14), interpreted rather bitterly as a scene indicative of 'bourgeois conventionality of two common people bound together … without any inner meaning'. Rosenau reads the couple as estranged, playing on both a slang phrase for a male customer with a working woman whom he will not pay, and the café's possible name, both creating a Baudelairean, prostitutional image. The Russian Revolution against 'the bourgeois way of life' breaks into the study of marriage at this point with the writings of the Russian revolutionary Marxist and feminist Alexandra Kollontai (1872–1952), still alive at Rosenau's time of writing as the Russian

46

3.45 Page 46 of *Woman in Art* (London: Isomorph, 1944); see also figs 2.16 and 2.16a.

ambassador to Sweden in 1943. Kollontai's radical philosophy of free love attracted the conventional bourgeois husband Lenin's personal denunciation of any suggestion that in Communist society 'gratification of sexual passion is [like] drinking a glass of water' – a direct citation of Lenin writing to Clara Zetkin in 1920. Having opened the recent debates about radical social theories and sexual moralities, Rosenau focusses on three images of the couple. In a domestic portrait of the two intellectuals who founded the London School of Economics, Beatrice Webb (1858–1943) and Sidney Webb (1859–1947) (see fig. 2.15), the social researchers are represented in old age with 'restrained intimacy'. In this visual formulation of a long partnership, marriage signifies a shared purpose in a life of intellectual comradeship comparable to that of the scientist couple of Marie Skłodowska Curie (1867–1934) and Pierre Curie (1859–1906) (see fig. 3.26), which erodes the bourgeois division of labour and the division of women into wife–mother or sexual companion. Rosenau cites the recent book (1938) on Marie and Pierre Curie by their daughter focussing on the intellectual and affective partnership of these great scientists. A sculpture by Vera Ignatievna Mukhina (1889–1953), dominating the

massive modernist Soviet Pavilion and the skyline at the World's Fair in Paris of 1937, is read as imagining a possible 'social humanism' through the placement of a male industrial worker and a female agricultural worker moving forwards side by side (see fig. 2.16).

In a footnote, George Bernard Shaw (1856–1950), famous for his views on marriage, is referenced in a recent article in the *Picture Post* in 1941 that I identified by buying a copy of the original issue.[11] Termed editorially as 'a tribute to two wonderful lives' of Shaw's friends and allies, Beatrice and Sidney Webb, the long article on their socialism is illustrated by a photograph of the couple in a domestic setting that, unlike the more hierarchical and differentiated painting by William Nicholson (1872–1949) (see fig. 2.15), places them on the same level, both seated, with Beatrice Webb working on some papers. Another photograph offers a frontal portrait of an elderly Beatrice Webb alone and is titled 'The Face of a Thinker'; I insert a counter-image in the form of a portrait of the younger intellectual by Fabian artist Jessie Holliday (1884–1915) (fig. 3.46). The freight of these images of the couple, including socialist couples, is

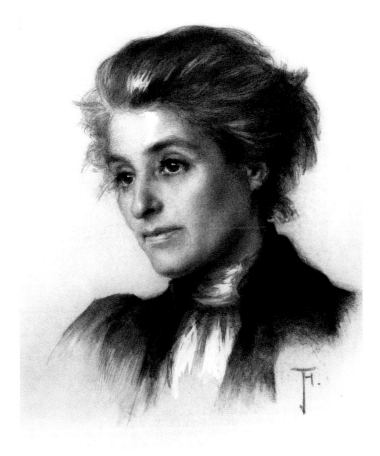

3.46 Jessie Holliday (1884–1915), *Beatrice Webb* (1858–1943), *c.*1909, gelatin silver print, 46 × 37.8 cm. National Portrait Gallery, London. Given by John Parker on behalf of the Trustees of the Beatrice Webb House, 1987.

qualified by citing classicist Jane Harrison's scepticism: 'Spiritual crea-
tion *à deux* is a happening so rare as to be negligible.' Rosenau comments
that even as joint companionship and responsibility are emerging, the
'new approach has as yet found no expression in art'.[12]

The juxtaposition in the original setting (fig. 3.45), on the double-page
spread, of the domestic setting of the Webbs at home with Soviet Social-
ist Realism at its most monumental, is complemented by a tiny image by
a young Picasso (1881–1973) (see fig. 2.17), in his still-post-Impressionist
phase, who reworks the stark realism of Lautrec to very different effect.
Rosenau defines as a 'profoundly moving document' Picasso's pastel of
a working-class couple embracing in a simple act of affectionate desire
that is presented without mythic or legal, theological or social-critical
framing, and with neither bourgeois sentimentality nor Stalinist pomp.
'A rising social class makes its appearance, and stakes its claim in all
spheres of life.'

The titling of the chapter, 'Wives and Lovers', might predispose the
reader to interpret both as the objects of the assumed normative posi-
tion of the man/husband. The trajectory of the chapter makes it clear
that this has been a social history of an institution – marriage – and an
idea – love. I suggest that this chapter is strategically woman-centred. At
its conclusion, we can hear the voice of the author, writing from the posi-
tion of women. 'Wives and Lovers' are not the possessions of the 'Hus-
bands and Men'; they are positions women occupy or negotiate, or resist,
and which Rosenau's feminist politics seek to liberate in ways closer to
Picasso's image of freely experienced mutual desire.[13] Rosenau's text
was clearly written about the early 'Picasso', whose painting of a working
couple would be her full-stop to this chapter and to a sweeping but inci-
sive historical overview of law, custom, and affects in relation to what
the anthropologists and sociologists identified as a key social condition
and relationship that itself produced and defined gendered, sexual, and
social experience.

— Chapter 2: Motherhood

Rosenau's second chapter effectively mounts an argument against fun-
damentalist or biological notions of maternity as an instinct or function.
Her approach is to trace the cultural evidence for what she terms the
'spiritualization of motherhood' across a wide range of cultures. She
tracks certain key differences between, on one hand, the few examples
of Palaeolithic art such as the Willendorf figure where 'sex and fertility'
appear not to be distinguished, thus rejecting the terminology for the
figure as a Venus type while refusing to see it solely as a fertility object
– it is clearly an imaginative condensation – and, on the other hand, the

emergence of deification of the mother to be found in the legacies of the flourishing of culture in the Nile Valley after 5000 BCE.

The Egyptian representation of Isis shown with her child Horus on her lap becomes the prototype that is later reprogrammed in the Christian image of Virgin and Child. Rosenau advanced the argument of this genealogy in an article in the *Burlington Magazine* in 1943 illustrating several Egyptian prototypes for the images found in the Celtic Book of Kells.[14] Intervening in this genealogy of adult woman and child, Rosenau contrasts two other sites of cultural investment in the spiritualized mother: the Celts and the Romans. The 'patriarchal' character of Roman society is exemplified by the story of Cornelia, mother of the Gracchi (*c*.190–115 BCE). Married to an elderly Roman, Cornelia bore twelve children, six of each sex. Only three survived. She remained a widow, educating her children by herself becoming a scholar of both Latin and Greek. The political lives of two of her sons, Tiberius and Gaius, were recorded by Plutarch. It appears that letters written by Cornelia have survived, rendering her the first woman in antiquity to leave such a record. Some historians consider the letters inauthentic, created as part of a political polemic. A comment recorded by Valerius Maximus (a Roman author of the first century CE) captured artistic attention, notably in eighteenth-century art: the story where Cornelia, being questioned about her modest dress, supposedly replied, touching the heads of her sons, that they were her true jewels.[15] Swiss artist and founder member of the Royal Academy in London Angelica Kauffman (1741–1807) painted one version in 1785 (fig. 3.47). Rosenau also points to Oriental influences from Isis and notably the many-breasted Near Eastern goddess known as Diana of Ephesus (see fig. 2.19), which she states 'enhanced' the social position of the Roman mother as evidenced by the presence of Imperial mothers on coins with their emperor sons.

Returning to the Celts, Rosenau traces another form of investment of meaning in the spiritualized mother. She illustrates one of many representations of the *Matronae* (the double mother goddesses), where Celtic subject matter is formally influenced by Roman monumental sculpture. *Matronae* (see fig. 2.20) are to be found in Northern Europe, Britain, and France, and as far south as Northern Africa, a fact that opens a pathway to a brief discussion of the imagery of a mother holding a child on her lap from the Lower Congo (see fig. 2.21). The terminology in this passage bears all the hallmarks of early twentieth-century colonialist vocabularies that are now rightly disowned but shaped the often distorting enthusiasm of a generation of artists and thinkers for non-classical aesthetics they discovered in the arts and traditions of sculpture in West and Central Africa.[16] The reference for this passage led me to an article

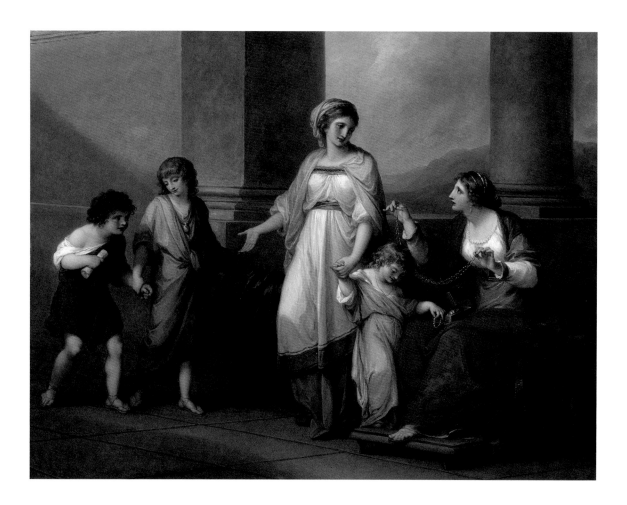

3.47 Angelica Kauffman (1741–1807), *Cornelia, Mother of the Gracchi, Pointing to Her Children as Her Treasures*, c.1785, oil on canvas, 110 × 127 cm. Virginia Museum of Fine Arts, Richmond. Adolph D. and Wilkins C. Williams Fund 75.22 © Virginia Museum of Fine Arts. Photo: Travis Fullerton.

by the anthropologist and photographer Eva Lewin Richter Meyerowitz (1899–1994). Born in Berlin, Eva Lewin Richter married sculptor Herbert Meyerowitz (1900–1945) in 1925 and moved to South Africa, where her husband taught at the University of Cape Town and opened the School of Art. They both travelled extensively in the Gold Coast, now Ghana, where Herbert founded an Institute for West African Art. After her husband's unexpected death in 1945, Eva Lewin Richter Meyerowitz moved to Ghana for the rest of her life and was awarded the title of Queen Mother.[17]

Political motherhood is the next topic and two examples are Matilda (1102–1167) (fig. 3.48), a Norman queen of England who succeeded her father, Henry I, and Constance (1154–1198), Queen of Sicily. Matilda, also known as Empress Maud from her marriage to the Holy Roman Emperor Henry V, was her father's only surviving heir. Although he declared her his successor, the Anglo-Norman barons backed a cousin, Stephen. The period is known as 'The Anarchy' as a result of the civil war between two rulers contesting the single throne: Matilda and Stephen. Matilda

left England but eventually her son with Geoffrey of Anjou succeeded as Henry II, establishing the Angevin dynasty and empire, which, during the twelfth and thirteenth centuries, ruled England, half of Ireland, and most of Western France from Normandy to the Pyrenees. Leaving the truncated parts of the British Isles to Stephen, Matilda herself ruled Normandy for the rest of her life.

Rosenau's reference is tantalizingly brief to such a major political and military leader, but she introduces another powerful woman of Norman origin, Constance, Queen of Sicily, in her own right. Following another conquest in 1061, the Normans controlled Sicily and southern Italy. She became the wife of Holy Roman Emperor Henry VI, the son and successor of the Holy Roman Emperor Frederick Barbarossa. Rosenau references a short article by her contemporary Sigrid H. Steinberg (1899–1969) for the newly founded *Journal of the Warburg Institute* in 1938. This article interprets an unexpected (in terms of iconography) sculptural group of a kneeling woman in prayer on the fourth of four columns for a church in Salerno, preserved in the Victoria and Albert Museum, offering a portrait of the Empress Constance, who gave birth at the age of forty-two to a son who would become Frederick II, 'the most powerful and splendid of medieval Emperors' in the words of Steinberg.[18] Steinberg and his co-author, Christine von Pape-Steinberg, had earlier published the major study on portraits of both spiritual and secular rulers from which Rosenau selected her next illustration. Also a Jewish art historian escaping from Germany, Steinberg was appointed research fellow at the Courtauld Institute in 1936 and lived the rest of his life in London, later working for publishing houses on popular historical studies.

3.48 *Great Seal of Empress Matilda* (1102–1167), engraving after the original seal made in the nineteenth century, 29.6 × 28.9 cm. Private Collection / Bridgeman Images.

Rosenau then addresses Christian elaborations of the spiritualization of motherhood with the evolution of two other dimensions that shape the iconography and the *pathos formula* of Catholic art. In *The Pietà*, the adult mother does not cradle her newborn son but struggles to hold across her knees her dead, adult son, while the *mater misericordiae*, the Mother of Mercy, appears to reveal within the interior of her body both God the Father and the crucified Son.[19] A footnote about the classical precedents for the *mater misericordiae* opens yet another link within the refugee scholarly community displaced from Germany to London through the reference to Vera Sussmann-Jentsch (1904–1973). Pursuing information about this author, I found her recorded via the United States Holocaust Memorial Museum's Holocaust Survivors and Victims Database in the minutes of the British Federation of University Women,

an organization that, according to the database, received applications for financial assistance from over two thousand women scholars. In this case, Vera Sussmann-Jentsch is recorded as giving a donation for a 'Christmas present for a refugee'. This listing led me to search for Helen Rosenau, where I discovered a remarkable entry, mentioned by Rachel Dickson in Part 1, Chapter 2. Rosenau had applied for the sum of £1 (currently worth c.£53) a month for a year to 'enable her to buy the necessary photos for her book on the Position of Women as shown in Art'.[20] Not realizing the real costs of images and permissions faced by art historians, the committee did not deem this help 'absolutely necessary' and refused the application as the Federation had already supported her with a six-month residential scholarship. This entry is interesting for it refers to the earlier proposed title of the series of short articles published in *International Women's News* using the phrase 'as seen in art': 'Position of Women as Shown in Art' (see Essay 4).

Rosenau's comparative, intercultural perspective is evidenced not only in tracing the mother and child trope in European art back to Egyptian deities such as Isis and Hathor but also in suggesting that the concurrent trope of spiritualizing the child of a miraculous birth is found in the account of the Buddha's birth as much as in the miracle of conception, often by the ear, in the Christian theology of the Annunciation. A photograph from a book by the specialist in Indian art who taught at the Courtauld in the late 1930s, Stella Kramrisch, provides the image of Buddha's birth, which literally lies across the page from an early fifteenth-century German tympanum of an *Annunciation* – a sub-Warburgian insight of the migration of formulae and cultural coincidence that thinks art history globally.[21]

Rosenau then addresses the shift during the Renaissance and the Reformation towards individualization – the chapter's starting point and the hinge between the deep anthropological dive and the historical trajectory moving 'from type to personality' – which subsumes as well as displaces the sacred forms of both mother and child. Rosenau 'historicizes' – not articulating, but producing as an effect – the emergence of both the possibility for personality for women – individuality – and the counterforce, through the focus on the family and the everyday, of prescriptive economic positions and domestic social labour for women, which, justified by false appeals to a biological base, created separated spheres of masculinity and femininity. Rosenau anticipates later twentieth-century feminist analyses of the correlations between the emergence of capitalism and a new regulatory structure imposed on women by the new class formation of the bourgeoisie, which was backed by a kind of violence some scholars define as a femicide enacted through the widespread

phenomenon in early modern Europe (sixteenth and seventeenth centuries) of 'witch' burning.[22] In art, this bifurcated, however, into two distinct tendencies, one Italian, focussing on beauty of form (a cryptic reference to the refocussing of European art on the erotic nude?), the other Northern, focussing on the everyday, expressed in genre painting and portraiture. A very compressed analysis moves swiftly into representations of the family as a social unit in eighteenth-century portraiture – the note referencing Johann Zoffany (1733–1810) and Charles Lebrun (1619–1690) as specialists in painting the often multi-generational family group – and then leaps to the present inter-war years, where Rosenau perceives an ideal of female beauty that becomes leaner, if not 'sexless'. Ernesto de Fiori's (1884–1945) *The English Girl* is as far as one can imagine from the Willendorf figuration of the female body with which this chapter began. This sculpture's troubling peculiarity lies in a combination of nudity and high heels. Rosenau comments: 'Thus a type of sexlessness in woman finds expression, a type as remote as possible from the primitive.'

In pre-Nazi Germany, two artist-women are singled out for their different engagements with the topic of motherhood, observed in both the rural and the urban working class, and, in the case of Paula Modersohn-Becker (1876–1907), in her own body (see fig. 2.29). Despite her tragically shortened life, she was always recognized as a modernist artist. Hamburg art historian and museum director Gustav Pauli (1866–1938) published a monograph on her work in 1919, having curated a retrospective of her work at the Kunsthalle in Bremen in 1908, just one year after the artist had died from an embolism resulting from being advised, after the birth of her daughter, to lie in bed for some weeks because of feeling pain in her legs. As she rose and walked for the first time, she collapsed into a chair, asked to hold her child, and died immediately, reputedly with the words 'Wie Schade!' ('What a pity!') on her lips. Between 1900 and 1907, Modersohn-Becker had defied bourgeois social convention for a young married woman and left her husband in Germany to develop her artistic career in Paris alone, absorbing the amazing concurrence of an exhibition of Picasso's pre-Cubist works and retrospectives of Gauguin and Cézanne. Of this period, she reported: 'I am becoming somebody – I'm living the most intensively happy period of my life.'[23]

Rosenau chose to illustrate one of Modersohn-Becker's more perplexing images of the maternal body, a favoured topic. In a half-nude self-portrait she imagines her non-pregnant body as if expectant with both hands cradling a swelling belly (see fig. 2.29). Rosenau defines this work of 'special significance' in the history of art for its 'emotional sincerity and simplicity'. Rosenau would have had access only to Pauli's account of an artist he knew well and supported, so different to the literature

created in the wake of feminist art history, which has drawn on Moder-
sohn-Becker's diaries and letters to produce a more nuanced account of
an ambitious modernist painter negotiating her own desires and social
conventions.[24] Perhaps reading Pauli influenced Rosenau's rather
maternalist reading of the artist. For example, 'she [Modersohn-Becker]
found in maternity the deepest fulfilment of her nature', 'was quite ready
to sacrifice her life and work to this end', and 'conscious of the problem
"work versus children" … preferred the latter'. In the footnote, we read:
'She died young, happy and radiant.'

It is hard to reconcile such assumptions about maternity as deepest
fulfilment on the basis of a woman who died from an embolism eighteen
days after the birth of her daughter, conceiving whom she had purposely
delayed for a decade by being separate from husband for long periods.
In the lengthy footnote, Rosenau offers an unusually engaged reading
of this artist's choices and work, noting that the artist was not 'doubt-
ful about the emancipation of women' even as she never questioned a
woman's artistic abilities. The artist's letters and diaries, however, reveal
a woman anxious to be somebody, and specifically an artist, delaying
conceiving until she was thirty-one (by my calculation she must have
conceived her child on or near her thirty-first birthday). The notion of
type appears here to be undergoing initial modification in Rosenau's
final characterization of Modersohn-Becker as a 'balanced personality', a
balance between work and family Rosenau insists is to be found in many
artist-men, thus challenging the fevered ideas of masculine genius and
artistic creativity.

Käthe Kollwitz (1867–1945) was still living at the time of Rosenau's
publication and is portrayed as a social artist, engaging with the anxious
experiences of proletarian motherhood, poverty, and the precarity of
life in times of war. Not illustrated but referenced in a long footnote is
a recently executed (in 1939) grave monument by Kollwitz that Rosenau
describes as being carved from a wooden block. The nearest work I can
find is cast in bronze and dated c.1936 (fig. 3.49) and there is a related
lithograph showing a different composition – the head of a child held
gently by the hands of the unseen mother.

These works concern maternal grief, a secular *mater dolorosa*. The
mother's loss of a child was, at times in Kollwitz's work, formulated as
a truly ravaging and rageous form of grief, as we witness in the devast-
ing image *Woman with Dead Child* (1903) (fig. 3.50). It was drawn before a
mirror holding her seven-year-old son in a powerful embrace; tragically,
he would be killed in the early months of the First World War, in October
1914, not quite seventeen. The print and its associated versions perform
a radical rewriting of the Isis and Horus/Virgin and Child-Pietà, which

3.49 Käthe Kollwitz (1867–1945), *Rest in the Peace of His Hands*, c.1936, bronze, 35.24 × 32.1 × 8.9 cm. National Museum of Women in the Arts, Washington, DC. Gift of Wallace and Wilhelmina Holladay.

3.50 Käthe Kollwitz (1867–1945), *Woman with Dead Child*, 1903, seventh-state soft ground etching and engraving with green and gold wash, 41.5 × 48 cm. British Museum, London. © Trustees of the British Museum, London.

Kollwitz reworked in many forms and media, notably during the early 1930s, as she processed her unbearable grief.

The section 'Motherhood' concludes by balancing the focus on artist-women and their engagements with the maternal theme by intriguingly reversing the perspective to consider the maternal viewed by the son-artist. Rosenau's suggestion is that 'the mother', in the case of 'the male artist', is *my* mother, a specific woman, and hence she is treated as a portrait, and often with affection. Albrecht Dürer (1471–1528), Rembrandt (1606–1669), and James Abbott McNeill Whistler (1834–1903) are cited but, interestingly, Rosenau focusses on the German classicist Anselm Feuerbach (1829–1880), whose portrait of his stepmother, Henriette Feuerbach (1812–1892), honours a woman who did not bear a child (see fig. 2.32). In her footnote Rosenau argues that the use of contraception among the European ruling classes and the acceptance in those classes of the childless spinster serve as the arguments against ideas of an inbuilt maternal instinct. 'Perhaps the maternal instinct is most closely related to social inclinations and emotions generally and can therefore be readily diverted.' She references the problematic figure of British 'social' psychologist William McDougall (1871–1938), whose work was as well known, almost, as William James's (1842–1910) in theories of psychology at the time. A eugenicist and a Jungian intrigued by paranormal events, McDougall advanced an instinct-based psychology. Rosenau's mention serves, I suspect, as a foil. Her argument, presented concisely in this footnote, is that the study of motherhood *through art* produces two conclusions. The first is that, at the level of culture and meaning, motherhood has been *honoured* and is also honoured as the function of the *wife* – a social position and an affective relation as revealed in the previous section, on wives and lovers. It has also been a source of both *responsibility* – again a social as well as a psychological action – and of *joy* for women. Hence it is psychologically and affectively meaningful. Tracking the image as index of differences between type and personality, mytheme and psychology, Rosenau has also managed to situate motherhood as a meaning, culturally variable but with certain recurring figurations that add up to a massive rejection of the biological argument in instinct or body. Procreativity is subjectivized and acculturated, 'spiritualized', in the religious and intellectual senses of the German word *Geistig*. She can now move on to a study of 'further aspects of creativity'.

— Chapter 3: Further Aspects of Creativeness

Rosenau begins with a major statement. The discovery of the personality of a woman, at first in elite and subsequently in middle-class societies, was one of the discoveries of the Renaissance. She will use this moment

of the early modern period as a pivot to explore the proposition that women are psychological and social beings, not a figure determined by biology. Rosenau will identify different episodes in the psychological creation of women, distinguishing the change during the Renaissance to a sense of human psychology from theological notions of the core of the person being a soul often served by asceticism as in the case of religious women of the Middle Ages. The recluse, if a woman, tends to create the image of a god-lover or, in some religious systems, a husband as her god. Rosenau swings through a range of cults and cultural modes that situate women in service to a god or god-idea from Vestal Virgins to temple prostitutes to women in purdah. A side effect of their segregation may be solidarity among women such as is found in texts such as the biblical story of Moabite Ruth's elective affiliation to her foreign, Israelite mother-in-law – for which story Rosenau instances the representation of this moment by William Blake (1757–1827) in a print of 1795 (fig. 3.51).

From the early nineteenth century, the idea of a group of women leads Rosenau back to a prehistoric epoch through painted figures on the cave

3.51 William Blake (1757–1827), *Naomi Imploring Ruth and Orpah to Return to Moab*, 1795, fresco print with watercolour, 43 × 58.5 cm. London: Victoria and Albert Museum. Photo © V&A Images.

walls of Roca dels Moros, or Caves of El Cogul, in Catalonia/Catalunya, only discovered in 1908 (see fig. 2.33). This image prompts her reading of the isolation of the single male figure within the circle of differently rendered female figures in skirts with a hind apparently bearing twins in a transparent womb, the whole indicative of a separate sphere of women's activity that may be religious, magical, or part of a ritual. A footnote recalls the Roman *Matronae* (see fig. 2.20) illustrated earlier in the chapter 'Mothers', to whom a sense of spiritual solidarity is attributed, their divinity emphasized not by being merely a group of women but by doubling or tripling. The fluency with which Rosenau precipitates us into a ritual reading of what can be misread as a normative replication of women as mother is reflected in her phrase 'a spiritual motherhood', signifying protection. From prehistoric to Roman, Rosenau moves to contemporary societies in Morocco in a painting by a German Jewish artist, Erich Wolfsfeld (1884–1956), in around 1934 (see fig. 2.34). Wolfsfeld was a fellow refugee, having been the Professor of Painting at the Berlin Academy from 1920 to 1936, during which time he travelled extensively in Morocco and the Middle East. Sacked in 1936 by the Nazi regime for his Jewishness, he arrived in Britain in 1939 and was promptly interned as an alien on the Isle of Man, and finally settled in Sheffield. He exhibited at the Royal Academy in 1943. The Ben Uri Gallery gave him a memorial exhibition in 1958 and his work has been collected by several national collections. At an auction of rediscovered drawings in 2009, the auctioneer, Nick Hall, stated: 'Erich Wolfsfeld would have been one of the great 20th century artists, had it not been for the intervention of the war and his Jewish faith.'[25] The image Rosenau selects of two women, heads and hair covered with a striped veil worn by Maghrebi women in the 1920s, serves to enclose the women in their veiled world while their children confidently gaze outwards (this image has not been traced and has been replaced by a similar subject). Rosenau's comment projects an ahistorical, orientalizing timelessness onto non-European cultures by suggesting that the deep history back to Cogul rituals and Roman *Matronae* she has so far been discussing can still be illustrated by a contemporary scene observed by a European artist 'since the subjects represented still live according to such standards in the East'.[26]

On the other hand, the Warburgian notion of *Nachleben* (see Part 1, Chapter 3) operating at the level of cross-cultural migratory myth and formula counters colonial ahistoricity with recognition of the deeper levels of correspondence more akin to Julia Kristeva's sense of monumental time she identifies as women's time, the cultural temporality of sexual difference that intersects with but is not bound by the time of nations on father's time (see Part 3, Essay 7).[27] Rosenau continues the

theme of women's groups and solidarities with further examples for medieval Europe including the named abbesses Herrad of Landsberg (1130–1195) and Hildegard of Bingen (1098–1179), the latter an anchorite and author of many works on women's health as well as accounts of her visions, these imaged in a tiny manuscript illustration (see fig. 2.35). The footnote to a German text on Hildegard dating to 1879 underscores the fact that such women were fully part of available scholarship. The following illustration, of a Chinese medicinal doll (see fig. 2.36), exemplifies another kind of enclosure of women – as an anchorite, Hildegard lived her entire life from the age of seven in a single cell connected only to the world by speaking her ideas and visions to a scribe outside – within codes of modesty and purdah. The dolls existed to enable Chinese women screened from male doctors to point to the place on the doll's body where their own bodies suffered. The owner of the doll illustrated by Rosenau was Marilyn How-Marten (1875–1954), a suffragette with a degree in physics and mathematics, an advocate for birth control, a member of the Independent Labour Party, a friend of Margaret Sanger, and a candidate for Parliament in 1918. Having a collection of medicinal dolls from China is partially explicable in terms of this array of intellectual and feminist interests. The footnotes for this discussion of the dolls' aesthetic but also sociological significance include references to both Magnus Hirschfeld's (1868–1935) 'impressions of a sex expert', the subtitle of his book *Women East and West*, and a just published (1943) autobiography of the Chinese soldier – she became a major-general – and writer Hsieh Ping-ying (Xie Bing-ying) (1906–2000). Hirschfeld, the pioneering sexological theorist and a campaigner for gay and transsexual rights, had been ruthlessly targeted and beaten up by the Nazis and driven into exile in France, where he had died in 1935.

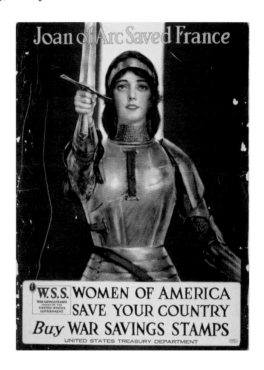

3.52 William Haskell Coffin (1878–1941), *Joan of Arc Saved France. Women of America, Save Your Country – Buy War Savings Stamps*, World War I Posters Collection, 1918, offset lithograph, 81.6 × 55.72 cm. Washington, DC: Library of Congress.

Rosenau's next point concerns the imposition, in patriarchal societies, of divisions between women according to the opposition of virtue and vice. Her example is a medieval representation of Joan of Arc menacing the courtesans following and serving the armies she led. Even as the image portrays a historical figure, the image creates the opposition of women by 'type'. A source for her discussion of Joan is Vita Sackville-West's extensively researched study *Saint Joan of Arc*, published in 1936, which formed part of a renewed interest during the First World War and throughout the 1920s and 1930s in the cross-dressing but saintly woman warrior (fig. 3.52). Cecil B. de Mille directed the epic film *Joan the Woman*

(1916), based on Friedrich Schiller's play *Der Jungfrau von Orleans* (1801), while Joan figures in both Radclyffe Hall's first novel, *The Unlit Lamp* (1924), and her semi-autobiographical lesbian novel *The Well of Loneliness* (1928).

In an unexpected change of gear, Rosenau's next image is a major painting of a mythical subject in the European canon, *The Fable of Arachne: The Carpet [Tapestry] Weavers*, or *Las Hilanderas* (see fig. 2.38) by seventeenth-century Spanish court painter Diego Velázquez (1599–1660). It represents a weaving competition between Arachne (a mortal) and the goddess Athena that resulted in the punishment of Arachne by her being turned into a spider. Superficially, Rosenau focusses on the social division enacted in the painting between its two spaces, with the workers in the foreground and the ladies in the background; women are divided and distinguished by occupation. Rosenau refers to Aby Warburg's (1866–1929) famous lecture in 1922, where he analysed the astrological schema of frescoes in the Palazzo Schifanoia in Ferrara, where the sphere of the Weavers is differentiated from that of the Lovers.[28] She writes in a footnote, 'The attitude implied demands that women should be either weavers or lovers, but that the combination of differing functions is not the woman's task.' That many languages use a word such as 'spinster' for an unmarried woman serves to underline the point and reveal how embedded such divisions with the category women have become.

Remaining in the seventeenth century but moving northwards to the concurrent trends in Dutch painting, Rosenau again identifies *typing* in her overview of the contrast in Dutch paintings of bourgeois society. The main axis is between the domestic housewife and home-maker (Pieter de Hooch; see fig. 2.39) and the 'servants and loose-living' women by Jan Steen. But type is beginning to yield to personality (as the opening of this section implied post-sixteenth century) in the highly differentiated and individualized portraits painted by Frans Hals (1582–1666) of the Regentesses of the Haarlem Almshouse (1664) (see fig. 2.40), where the impoverished painter was living at the end of his life. This monumental and 'spiritualized' representation is contrasted to an eighteenth-century satirical drawing by British artist Edward Francis Burney (1760–1840), which, in a manner milder but related to William Hogarth's more searing visions of British society, parodies the chaotic unruliness of an educational establishment for high-born young ladies that teaches them only deportment and dress.

Making a link back to the earlier discussion of Joan of Arc and the issue of type, Rosenau then introduces a new distinction, between the warrior woman and the leader in warfare, that is illustrated by Renaissance and Baroque artists' paintings of biblical heroines such as the

judge and general Deborah and the political assassin Judith, and the indirect assassin Salome.

Rosenau does not illustrate the portrait of German poet, novelist, and composer Annette von Droste-Hülshoff (1797–1848) (fig. 3.53), whom she mentions, but now creates a space for individuated women, poets and authors such as Rahel Levin Varnhagen and Elizabeth Barrett Browning, author of the epic poem *Aurora Leigh* (1856) (fig. 3.54), a dense first-person poem in a novel form whose references and models range from the biblical stories of heroic women cited above to mythology and Romantic fiction by Madame de Stael (1766–1817) and Georges Sand (1804–1876).[29] We see Rosenau weaving a complex tapestry of women's creativity. The individualized portrait of Aurora Leigh in this poem forms a bridge to the following confirmation of the opening proposition, that it was in the Renaissance that the idea of the personality of women emerged to reveal itself not only in individuals with professional careers but also through women's self-inscription as artists, as we see in the many self-portraits by Sophonisba Anguissola (1532–1625) – for instance one of the earliest,

3.53 Johann Sprick (1806–1842), *Annette von Droste-Hülshoff* (1797–1848), 1842, oil on canvas. Location unknown. Photo: Ullstein Bild / Getty Photos.

3.54 Thomas Barlow (1824–1889), *Elizabeth Barrett Browning* (1806–1861), inscribed Rome, February 1859, engraved frontispiece portrait of E. B. Browning from a photograph by Louis-Cyrus Macaire (1807–1871), Le Havre, September 1858. New York Public Library (Carl P. Forzheimer Collection of Shelley and His Circle).

Self-Portrait with Book (1554) (see fig. 2.44), in which the sitter holds up a book on which is inscribed her name and the words that grammatically defined the maker as a woman: *se ipsam fecit* – 'she herself made this'.[30] The mention of Anguissola introduces a string of names of artists who were women well documented and widely known to Rosenau's contemporaries: the Roman Artemisia Gentileschi (1593–1653) (see fig. 3.58), the Venetian Rosalba Carriera (1675–1757), the German Anna Dorothea Therbusch-Lisiewksa (1721–1782) (see fig. 2.45), and the Swiss Angelica Kauffman (1741–1807) (see fig. 3.47).[31] Rosenau's footnote references a recent German-language publication by Hans Hildebrandt (1878–1957) titled *Die Frau als Künstlerin: mit 337 Abbildungen nach Frauenarbeiten bildender Kunst von den frühesten Zeiten bis zur Gegenwart*

3.55 Cover of Hans Hildebrandt (1878–1957), *Die Frau als Künstlerin* (Berlin: Rudolf Moss Verlag, 1928).

(Woman as Artist with 337 Images of Women's Work in the Visual Arts from Earliest Times to the Present) (1928) (fig. 3.55).[32] His wife was the artist and journalist Lily (Uhlmann) Hildebrandt (1887–1974), who apparently received little support from him for her own artistic career, which she sustained through close contact with the artists of the Bauhaus, even as he wrote this book about women as artists, promoting his thesis that woman's role is support of her husband. Giving with one hand by documenting the continuous history of women as artists, he removed with his other by promoting type and role over the individual agency that Lily Hildebrandt herself demonstrated in her own career.

Rosenau constantly identifies class differences in women's situations. Once more pulling the thread of women as warriors, her attention now turns to women participating in rebellion and resistance: the women who take up arms in revolution or use revolutionary discourse to declare the rights of women, as in the case of Olympe de Gouges (1748–1793) (fig. 3.56), author of the *Déclaration des droits de la femme et de la citoyenne* (Declaration of the Rights of Woman and the Citizenness) in 1791, a year before Mary Wollstonecraft's (1759–1797) *Vindication of the Rights of Women* (1792). For challenging the revolutionary failure in terms of gender equality, Gouges was one of the relatively few women executed during the Reign of Terror for her writings. Her text presented this challenge:

> Man, are you capable of being just? It is a woman who poses the question; you will not deprive her of that right at least. Tell me, what gives you sovereign empire to oppress my sex? Your strength? Your talents? Observe the Creator

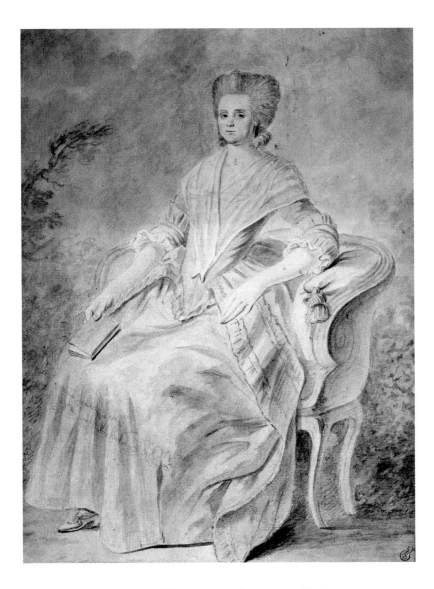

3.56 Anonymous, *Olympe de Gouges* (1748–1793), undated, watercolour, 28 × 21.3 cm. Paris: Louvre. Photo: Josse / Bridgeman Images.

in his wisdom; survey in all her grandeur that nature with whom you seem to want to be in harmony, and give me, if you dare, an example of this tyrannical empire.[33]

The radical challenge to invested power articulated by Gouges extended to the condemnation of racism and slavery and to her demand for taxation of capital.

These final pages of analysis of 'aspects of creativeness' pay more attention to the effects created by modernist engagement with formal process and the character of materials. The concluding paragraph brings together the painting *The Jewish Bride* by the seventeenth-century Dutch painter Rembrandt (see fig. 2.12) and Barbara Hepworth's (1903–1975)

sculpture *Conoid, Sphere and Hollow* (1937) (see fig. 2.55) to argue that in Rembrandt's early modern case, 'an understanding of the individual is reached, which makes the subject, the expression of personality, of primary concern'. In Hepworth's work as abstract artist, this has devolved into the articulation of an idea through form alone. Modern art may exceed the trajectory this chapter has plotted out – from type to personality. This, perhaps unexpectedly formalist, turn in her argument registers, even if it does so too briefly, a deeper shift that art historians might need to acknowledge, but could only do so by having the widest historical and cultural range. Helen Rosenau's art-historical method refused limitations of specialization in period or nation, culture or topic. This book reveals how she used a breadth of knowledge to track deep structural shifts, mostly indeed in Western Art, but not without reference to concurrent cultures, in which socio-economic, political, and ideological processes were entangled. No one level predetermines the other. Yet historical formations and processes of change can be read off each other in different relations and proportions at different moments. Modernism is not the destiny of art but presents a new challenge for reading, in its increasingly 'absolute form', changing inscriptions in the histories of class, race, and gender that may not produce figurative formulations so much as affirmations of the personality of this artist-woman no longer countering imposed concepts of difference. But personality is not itself neutral; it is perhaps in Hannah Arendt's (1906–1975) terms the site of singularity within plurality.[34]

— The Conclusion

Helen Rosenau's conclusion is a reflection in her present, the moment of writing during a world war, but before anyone could discern what would soon be revealed as having been happening between 1941 and 1944 – racialized industrial genocide – or could grasp the horror of the invention and dropping of the atomic bomb, and the terror of the subsequent installation of a world order called the Cold War. This was also to be the era of violent struggles for decolonization. Post-1945, there would additionally be temporary set-backs to the advance of women's rights and citizenship. Writing after almost a century of women's political, and indeed intellectual, activism, Rosenau was able to trace a long history of cultural habits with regard to women – typing the feminine – to a Modernity in which social individualization and psychological individuality had fostered women's participation in both the scientific pursuit of objective understanding of the real world and the aesthetic and creative contribution to understanding 'a more subjective approach to the problems of life' and decision-making as responsible human

subjects. Creativity requires, she argues, vitality, intensity of feeling, and concentration – which is fundamentally conditional on having time, which in turn translates into an indirect commentary on the continuing inequality in the division of labour, notably the continued assumption of women's sole domestic labour. Naming the present moment 'transitional', full of conflicts external and internal, women need, she implies, to fashion a style and form for their lives – very art-historical terms. Such styles or forms will dissolve the bond of women only to procreation and facilitate creative activity. This is what she means by the transition from type (mother, wife, lover) and counter-type (warrior, recluse, revolutionary) to personality. The final footnote references psychological theorists such as Alfred Adler (1870–1937), Sigmund Freud (1856–1939), and Carl Jung (1875–1961) and those who put these ideas to work, such as Esther Harding (1888–1971), who makes queering uses of Jungian ideas. These references are tantalizingly brief to sublimation (Freud), transformation (Jung), and libido (both). Psychoanalysis, taken up twenty years later by British and French feminists such as members of Psychanalyse-Politique in France and Juliet Mitchell in Britain, enters only at the end of Rosenau's book.[35] After 1968, personality and the individual will be replaced by the psychoanalytical terminologies of subjectivity and the subject within an articulated critique of patriarchy as phallocentrism that is no longer an anthropological concept.

The final paragraph of the book deflects a purely psychological end-point. Rosenau's political commitments assert the necessity for solidarity and co-operation between women different in their 'approach to … social problems'. This political and historical agency as an internally differentiated human force means that *women* 'will be able to contribute fully to the historical process, no longer as a means only but also as an end of human evolution.'

1 Ruth Benedict, *Patterns of Culture* (London: Routledge & Kegan Paul, 1934), 33.

2 Jane Marcus, *Virginia Woolf and the Languages of Patriarchy* (Bloomington: University of Bloomington Press, 1987). Martha Carpentier writes: 'Unlike Frazer, [Jane Harrison] absorbed the other incipient sciences of the early twentieth century, psychology and sociology. Influenced by Freud's *Totem and Taboo* (1912), William James's studies of mysticism, Émile Durkheim's collectivism and Henri Bergson's *durée*, her interests expanded to consider the "common emotional factor that makes art and ritual in their beginnings well-nigh indistinguishable". This is a step Frazer never took, one that connects Harrison directly with modernism.' See Martha C. Carpentier, 'Jane Harrison and Ritual Theory', *Journal of Ritual Studies* 8:1 (1994), 11–26: 15.

3 Marija Gimbutas, *The Goddesses and Gods of Old Europe* (Berkeley: University of California Press, 1974); *The Language and the Goddess: Unearthing the Hidden Symbols of Western Civilization* (San Francisco: Harper & Row, 1989); and *The Civilization of the Goddess* (San Francisco: Harper, 1991). For posthumous appreciation of Gimbutas and her works see Joan Marder (ed.), *From the Realm of the Ancestors: An Anthology in Honor of Marija Gimbutas* (Manchester, CT: Knowledge, Ideas and Trends, 1997).

4 Claude Lévi-Strauss, *Les structures élémentaires de la parenté* (Paris: Presses Universitaires de France, 1955), trans. J. H. Bell, J. R. von Sturmer, and Rodney Needham as *Elementary Structures of Kinship* (Boston: Beacon Press, 1969).

5 Marcel Mauss, 'Essai sur le don: forme et raison de l'échange dans les sociétés archaïques', *L'année sociologique* 1923–4 (1925), 30–186, trans. Ian Cunnison as *The Gift: Forms and Functions in Archaic Societies* (London: Cohen & West, 1966).

6 For recent decolonizing feminist scholarship on this point, see Zainab Bahrani, 'The Iconography of the Nude in Mesopotamia', *Source: Notes in the History of Art* 12:2 (1993), 12–19; 'The Hellenization of Ishtar: Nudity, Fetishism and the Production of Cultural Differentiation in Ancient Art', *Oxford Art Journal* 19:2 (1996), 3–16; and the monograph *Women of Babylon: Gender and Representation in Mesopotamia* (London: Routledge, 2001).

7 Stella Kramrisch was already a professor of Indian Art at the University of Calcutta, publishing *Grundzüge der Indischen Kunst* (Hellerau bei Dresden: Avalun Verlag, 1924) and in English *Indian Sculpture: The Heritage of India Series* (Oxford: Oxford University Press, 1933). She made regular visits to lecture on Indian art at the Courtauld Institute and presented an exhibition of Indian art in photographs at the Warburg Institute, then housed in the Imperial Institute in Kensington before moving to the University of London in 1944. I am grateful to Jo Ziebritzki, who has published the monograph *Stella Kramrisch: Kunsthistorikerin zwischen Europa & Indien; Ein Beitrag zur Depatriarchalisierung der Kunstgeschichte* (Marburg: Büchner-Verlag, 2021). On the exhibition Kramrisch curated in London in 1940 see Sarah Victoria Turner, '"Alive and Significant": "Aspects of Indian Art", Stella Kramrisch and Dora Gordine in South Kensington c 1940', *Wasafiri* 27:2 (2012), 40–51.

8 Frederick Adam Wright, *Feminism in Greek Literature from Homer to Aristotle* (London: G. Routledge & Sons, 1923), 2.

9 Rona Goffen, *Titian's 'Venus of Urbino'* (Cambridge: Cambridge University Press, 1997); Paolo Tinagli, *Women in Italian Renaissance Art: Gender, Representation, Identity* (Manchester: Manchester University Press, 1997). This reading was first advanced by Shirley Moreno in *The Absolute Mistress: The Historical Construction of the Erotic in Titian's 'Poesie'* (MA thesis, University of Leeds, 1980).

10 Jac. Zwarts, *The Significance of Rembrandt's The Jewish Bride* (Amersfoort: G. J. van Amerongen & Co., 1929). Rosenau cites this booklet.

11 *Picture Post* 12:11 (1941). *Picture Post*, a pioneer in photojournalism, began in 1938 and ran until 1957. With a strong liberal, anti-fascist position, it was also

known for its denunciation of the persecution of Jews in Germany. The *Post*'s published plans for a welfare state are identified as a model for the plans William Beveridge introduced post-war. The photographs are now in the Hulton picture library, owned by Getty Images.

12 We might have to look to queer aesthetics to explore innovative formal arrangements of couples with shared intellectual interests and collaboration on projects. How to displace hierarchy becomes a formal question. In *Differencing the Canon*, I discuss this in relation to Man Ray's and Cecil Beaton's photographic portraits of Gertrude Stein and Alice B. Toklas and Lubaina Himid's painting series *Revenge* (1991), which features the partnership of two Black women as they negotiate the legacies of enslavement and empire. See Griselda Pollock, *Differencing the Canon: Feminist Desire and the Writing of Art's Histories* (London: Routledge, 1999), 182–4.

13 This discovery in a painting by Picasso may be ironic given what Picasso produced in 1907, namely the monumental image of a brothel *Les Demoiselles d'Avignon* (New York, Museum of Modern Art), which has become one of the canonical works of prostitutional modernism. See Leo Steinberg, 'The Philosophical Brothel', *October* 44 (1988), 7–74. It has also been a focus of feminist critique: Carol Duncan, 'Virility and Male Domination in Early Twentieth Century Vanguard Art', *Art Forum* (December 1973), 30–39, and 'MoMA's Hot Mamas', *Art Journal* 48:2 (1989), 171–8, both reprinted in *The Aesthetics of Power: Essays in Critical Art History* (Cambridge: Cambridge University Press, 1993), 81–108 and 189–210. The painting only entered the public arena and modernist art history with its purchase by the Museum of Modern Art in 1939, when it first went on view in an exhibition in New York: 'Picasso: Forty Years of His Art'. It is unlikely Rosenau would have ever seen it.

14 Helen Rosenau, 'The Prototype of the Virgin and Child in the Book of Kells', *Burlington Magazine* 83:486 (1943), 228–31.

15 Elaine Fantham, Helene Peet Foley, Natalie Boymel Kampen, Sarah B. Pomeroy, and H. Alan Shapiro, *Women in the Classical World: Image and Text* (New York: Oxford University Press, 1994); Suzanne Dixon, *Cornelia, Mother of the Gracchi* (London: Routledge, 2007).

16 Carl Einstein, *Negerplastik* (Leipzig: Verlag der weißen Bücher, 1915) is indicative of this hierarchical conjunction of terms such as 'primitive' and 'modern'. Einstein illustrates as plate 64 a similar sculpture of a mother holding a child. None of the plates are identified as to location, source, date, or maker.

17 'Eva Lewin Richter Meyerowitz', British Museum, n.d., https://www.britishmuseum.org/collection/term/BIOG126253, retrieved 18 March 2023. Rosenau references a beautifully illustrated article by E. L.-R. Meyerowitz, 'The Stone Figures of Esie in Nigeria', *Burlington Magazine* 82:479 (1943), 31–6, which the author illustrated with the photographs she had taken herself. A large collection of her photographs from 1936 to 1937 taken in Abomey (Republic of Benin), Umuahya (now Umuahia, Nigeria), and Techiman (Ghana) is in the Smithsonian. The online record notes: 'Individuals depicted include two wives of King Behanzin, Prince Justin Aho, and the only surviving Dahomey Amazon women warriors who had fought against the French in 1894' ('Eva L. R. Meyerowitz Photographs, EEPA 1987–009', Smithsonian, n.d., https://sova.si.edu/record/EEPA.1987–009, retrieved 18 March 2023). Her later publications include *The Akan of Ghana* (London: Faber & Faber, 1958), *The Divine Kingship in Ghana and Ancient Egypt* (London: Faber & Faber, 1962), and *At the Court of an African King* (London: Faber & Faber, 1962).

18 S. H. Steinberg, 'A Portrait of Constance of Sicily', *Journal of the Warburg Institute* 1:3 (1938), 249–51: 251.

19 See the study of the *Vierge Ouvrante* by Phyllis Chesler, *About Men* (New York: Simon & Schuster, 1978). Chesler found the concept itself quite shocking and susceptible to fascinating and troubling psychoanalytical analysis.

20 British Federation of University Women Special Cases minutes, 1939, Holocaust Survivors and Victims Database, United States Holocaust Memorial Museum, Washington, DC, https://www.ushmm.org/online/hsv/wexner/cache/1678113646-2412464-RG-59.026M.0001.00000160.jpg, retrieved 6 March 2023.

21 Alongside the recent academic research into German women art historians, for which Stella Kramrisch is one of the major projects, I noted this book: Kenneth X. Robbins & Marvin Tokayer (eds.), *Jews and the Indian National Art Project* (New Delhi: Niyogi Books, 2015). It documents the many inter-actions between Jewish men and women (as artists, writers, art historians, and collectors) and between historical and modern Indian art.

22 Sigrid Schade, *Schadenzauber und die Magie des Körpers: Hexenbilder der frühen Neuzeit* (Worms: Wernersche Verlagsgesellschaft, 1983). In this book, which might be translated as *Malign Spells and the Magic of the Body: Images of Witches in the Early Modern Times*, Schade traces this femicidal outbreak of violence against women in early modern Europe. Socialist–feminist Italian economist Sylvia Federici argues in *Caliban and the Witch: Women, the Body and Primitive Accumulation* (London: Penguin, 2021) for a doubled analysis of the transition to capitalism and a new form of the subordination of women in which the violent assault of women in witch hunting is also characterized as femicidal.

23 Letter from Paula Modersohn-Becker in Paris to her sister, Milly Rohland-Becker, May 1906, in Gunter Busch and Liselotte von Reinken (eds.), *The Letters and Journals of Paula Modersohn-Becker* (Chicago: Northwestern University Press, 1998), 286.

24 Gill Perry, *Paula Modersohn-Becker: Her Life and Work* (London: Harper & Row, 1979); Paula Modersohn-Becker, *The Letters and Journals of Paula Modersohn-Becker*, trans. and ann. J. Diane Radycki (London: Scarecrow, 1980); Marina Bohlmann-Modersohn, *Paula Modersohn-Becker: Eine Biographie mit Briefen* (Berlin: Knaus, 1997); Anne Higonnet, 'Making Babies, Painting Bodies: Women, Art, and

Paula Modersohn-Becker's Productivity', *Woman's Art Journal* 30:2 (2009), 15–21; J. Diane Radycki, *Paula Modersohn-Becker: The First Modern Woman Artist* (New Haven and London: Yale University Press, 2013); Sarah Lee and Dorothy Price, *Making Modernism: Paula Modersohn-Becker, Käthe Kollwitz, Gabrielle Münter and Marianne Werefkin* (London: Royal Academy, 2022).

25 Quoted in 'German Painter Erich Wolfsfeld's "Forgotten" Artwork to be Auctioned in Knutsford', *Knutsford Guardian*, 3 July 2009, https://www.knutsfordguardian.co.uk/news/4473383.german-painter-erich-wolfsfelds-forgotten-artwork-to-be-auctioned-in-knutsford, retrieved 18 March 2023.

26 The later twentieth century postcolonial critique of Orientalist art in French, German, and British painting produced during the period of the nine-teenth-century colonization of North Africa and the Middle East emerged in the wake of Edward Said's book *Orientalism* (London: Routledge & Kegan Paul, 1978). For feminist readings of both Orientalist paint-ing and the uncritical exhibitions of such works, see Linda Nochlin, 'The Imaginary Orient' [1983], in *The Politics of Vision: Essays on Nineteenth Century Art and Society* (London: Thames & Hudson, 1989), 33–59; Rana Kabbani, *Europe's Myths of the Orient: Devise and Rule* (Basingstoke: Macmillan, 1986); Jill Beaulieu and Mary Roberts (eds.), *Orientalism's Interlocutors: Painting, Architecture, Photography* (Durham: Duke University Press, 2002).

27 Julia Kristeva, 'Women's Time' [1979], in *The Kristeva Reader*, ed. Toril Moi (Oxford: Basil Blackwell, 1986), 187–213. Linear time is defined as the time of nations and production and monumental time as that concerned with life, death, birth, and the temporality of psychic life and the hinge between life (*zoe* in Greek) and meaning, hence the time of art and poetry.

28 Aby Warburg, 'Italienische Kunst und internation-ale Astrologie in Palazzo Schifanoia zu Ferrara' [Italian Art and International Astrology in Palazzo Schifanoia at Ferrara] [1922], in *Gesammelte Schriften* [Collected Writings], vol. 2, edited by Gertrud Bing and Franz

Rougemont (Leipzig: B. G. Teubner, 1932), 459–627. The brief reference Rosenau is citing here relates to the zodiac, in which Venus rules April and hence stands for spring and shapes the lives of those given to love, while those born under Aries, the woolly lamb, are likely to be weavers or wool traders.

29 *Aurora Leigh*, one of the major literary works of nineteenth-century British literature, was reclaimed for feminist studies by British-based US-American literary scholar Cora Kaplan. See Elizabeth Barrett Browning, *Aurora Leigh and Other Poems*, introduced by Cora Kaplan (London: Women's Press, 1978).

30 Griselda Pollock, 'Facing Sofonisba Anguissola', in *Sofonisba: History's Forgotten Miracle* (Niva: Nivaagaard Collection, 2022), 46–67. The artist signed herself 'Sophonisba' although many contemporary art historians prefer the spelling in this article's title.

31 In her handwritten notes on the back of her own copy of *Woman in Art*, Rosenau notes 'Portrait Artemisia Gentileschi Hampton Court'. This annotation has to have been added after 1962, when Michael Levey, later director of the National Gallery, published an article identifying a hitherto anonymous allegorical representation of *La Pittura* (Painting) as a signed work by Artemisia Gentileschi. See Michael Levey, 'Notes on the Royal Collection II: Artemisia Gentileschi's "Self-Portrait" at Hampton Court', *Burlington Magazine* 104:707 (1962), 79–81.

32 Hans Hildebrandt, *Die Frau als Künstlerin: mit 337 Abbildungen nach Frauenarbeiten bildender Kunst von den frühesten Zeiten bis zur Gegenwart* (Berlin: Rudolf Moss Verlag, 1928).

33 Olympe de Gouges, 'The Rights of Woman', 1791, https://pages.uoregon.edu/dluebke/301Modern Europe/GougesRightsofWomen.pdf, retrieved 4 April 2023.

34 These two terms are fundamental to Arendt's post-war analysis of the political sphere in the aftermath of its destruction by totalitarianism. She defined the political sphere as the space of action undertaken by singular beings who join to speak and act beyond the mere demands of economic need or expediency. Singularity and plurality define the human condition because of natality: each birth is a new possibility for all. Each is singular and this builds into the plurality of human possibilities, not a mass. See Hannah Arendt, *The Human Condition* (Chicago: University of Chicago Press, 1958).

35 Juliet Mitchell, *Psychoanalysis and Feminism* (London: Allen Lane, 1974).

Women's Time, Feminism's Time, Art's Time, Jewish Time

Our optimism, indeed, is admirable, even if we say so ourselves. The story of our struggle has finally become known. We lost our home, which means the familiarity of daily life. We lost our occupation, which means the confidence that we are of some use to the world. We lost our language, which means the naturalness of reactions, the simplicity of gestures, the unaffected expression of feelings. We left our relatives in the Polish ghettos and our best friends have been killed in concentration camps, and that means the rupture of our private lives. Nevertheless, as soon as we were saved – and most of us had to be saved several times – we started new lives.

> Hannah Arendt, 'We Refugees' (1943)[1]

Addressing the moment of writing *Woman in Art*, I ask what made it possible for Helen Rosenau to pose this subject *around 1940*? By focussing on the author, I have sought to understand the work as the product of a historically situated researcher, inflected by conditions of difference and possibility in equal proportions. Furthermore, in these essays, I ask what time-space do we encounter in Rosenau's *From … to*? What kind of Art History was she creating? What senses of time did her book encode? Was she thinking time in feminist terms, or in terms that reveal what a feminist thinking about art's and women's time might look like? Might she adumbrate some form of 'women's time'?

Time is a rather daunting issue. I am not concerned with the chronological itself. Art History, the discipline, variously produces temporalities for art's histories, be that nation, epoch, era, period, career, or artist's lifespan. We frame artists between dates of birth and decease and identify early work and that of maturity. In terms of dealing with cultures themselves, Art History often builds in notions of progression such as the timeline from primitive beginnings to developed realization, which is, in fact, the moment of writing a retrospective history of evolution that arrives at the present as a destination point. This is teleological time, as if the arrow of time moved in one direction, a *telos*, even as the record reveals rises and declines, emergences and disappearances, conquests and displacements, concurrences and co-existing

concepts of time, and many other factors shaping the remains with which the scholar reconstructs the past from the perspective of the writer's present.

In *Encounters in the Virtual Feminist Museum: Time, Space and the Archive*, I explored feminist time across the dialectic of the three elements of the subtitle, to escape the straitjacket of chronological time – linear progression plus filial succession – that twentieth-century Art History deployed both to repress non-linear concepts of time and to exile artist-women as valueless because they were positioned as mere 'followers' in the heroic model of formal advance.[2] I had to explore other possible logics that would enable other kinds of 'conversations' between artworks through which we might acknowledge and understand, through the study of art, cultural complexity and creative difference within which women's creativity could find its own belonging.

— Persistence: Aby Warburg's Time

In Hamburg during the first two decades of the twentieth century, the art historian Aby Warburg (1866–1929) challenged and interrupted the ideological trajectory of the victory of Christianity, and then of the bourgeoisie, as a line of historical inevitability. As a specialist in what was already recursively termed the Renaissance, rebirth, Warburg punctured the mythic fastening of mercantile, early capitalist, absolutist Christian societies in the fifteenth century to their classical forbears by observing that it was really rather odd, if not inexplicable, that a *Christian* culture should embrace the pagan imaginaries of the Antique, whose remnants were surfacing from their soil in excavations or came to the Italians of the fifteenth century via a 'migration' of images, and pagan, classical writings, preserved and translated from the Greek and Latin by Christian or Muslim scholars retrieving such texts from the great classical libraries.

Warburg disturbed a simple idea of descent in Art History by acknowledging how contradictory thought systems co-existed in the mentalities of the princes and merchants, the bankers and senators of the fifteenth-century city-states such as Florence or Papal Rome. Warburg's 'time' involved the uncanniness of *Nachleben* – persistence, afterlife, survival, and return. To these he added the proposition that images were like batteries, storing up psychic energies transmitted via the *pathos formulae* that he identified in images from classical art and literature.

Rosenau was studying in Hamburg just as Warburg established his transdisciplinary library on the principle of 'good neighbourliness', which produced often-unexpected encounters and deeper connections

than then standard disciplinary classification systems imagined. Rosenau was never a strictly Warburgian thinker, although I think she grasped the essence of his extraordinary project as profoundly enabling in terms of suggesting other logics and temporalities. Her 'time' was not that of survival. She crossed art's epochal time with anthropology's deeper, mythic time and history's time of change, rupture, and memory via the sociological as the site of modifications to deep structures – social and economic as well as mythic and psychological – in which differences could be discerned through the archaeological (she was involved in excavation) and the changing material forms of sculpture and painting and their encoding meaning as image.

The anthropological identifies social and psychic structures that constitute the institutions of culture that necessarily manage the reproduction of daily life – the economy and its labours – and reproduction of the society generationally – marriage and the family, sexuality and procreation. The sociological focusses on the interactions of structural and economic elements in changing configurations. The historical becomes an element, therefore, but not as a force of its own, but as the record of how the deep structures and the specific socio-economic configurations generate and negotiate breakdown, replacement, rupture, novelty, or the impact of conquest as victors were exposed to new worlds or as the conquered were forced into alien modes. By working with Karl Mannheim's (1893–1947) sociology of knowledge embracing foundational imaginative, social structures, and historical, generational, variation, Rosenau tracked historical shifts within the structuring of sexual difference, a central issue for all forms of human society from the earliest we can document to the most current society, the modern being in the making for four centuries at least – a point of crossover with Warburg, who defined the Renaissance not so much as a rebirth of a past as the emergence of 'the good European'.[3] Warburg's Art History was a psycho-archaeology of his own troubling imperialist, anti-semitic industrial present between 1900, the year of Rosenau's birth, and 1920, her coming of age intellectually.

What notion of time shaped Rosenau's thinking? To answer that, I read her 'little book' through thinkers who postdate her text, writing from a 'generational' position that marked the end of Warburg's modern. Shaped by the traumatic knowledge of horrors of Modernity – two world wars, the Holocaust, and Hiroshima, as well as the violence released by the struggle either to decolonize or to maintain empire – the 'postmodern moment' addressed the modern as its object of critical reappraisal from a point, if not entirely outside it, certainly on its unhappy borderline. The 'postmodern' was briefly both an internal critique of Modernity

and an intuition that there was no beyond, just the necessity to discern its lineaments and to disown its troubling legacies.

The two thinkers I want, therefore, to place in 'preposterous' (reversing time) dialogue with Helen Rosenau are Michel Foucault (1926–1984) and Julia Kristeva (b. 1941). In 'Women's Time', written on the cusp of the feminist intellectual revolution of the later twentieth century, Kristeva offered a feminist reflection on the time of sexual difference by distinguishing two temporalities, linear and monumental. Foucault does not address time or difference as directly. He countered the model of 'the history of…', in his case 'ideas', in our case in Rosenau's conjunction of 'woman' and 'art', with not a sociology but an archaeology of knowledge.

— The Archaeology of Knowledge: Michel Foucault's Time

With my concept 'the Virtual Feminist Museum', I defined Art History, as discipline, between three – Foucauldian – terms: *space*, *time*, and *the archive*.[4] As a historian of institutions and their experts, who generated new discourses on madness, criminality, sexuality, the body, and the self, Michel Foucault's theorization of the *archaeology* of knowledge complements Mannheim's *sociology* of knowledge. Foucault undertook a historical study of the formation, and effects, of statements, replacing the 'history of ideas' with the concept of 'discursive formations'. These are constituted by patterns of statements that form 'regularities' (like a regular verb) but not unities or consistencies. For instance, the 'body' is diversely produced in and across legal, medical, biological, anatomical, and philosophical discourses, according to each discourse's internal rules and focus, while accumulating a discursive field within which 'the body' is contested and, to some extent, lived. *Woman* is similarly not an entity or a being but the effect of 'being put into discourse' across multiple sites of being spoken, written, legislated, theologized, medicalized, philosophized, politicized, psychologized, and represented. The object of discourse does not pre-exist its articulation as discourse; the experts are themselves effects of the discursive arena. Yet these do not add up to a unity. At the heart of discursive formation is a contradiction:

> A discursive formation is not, therefore, an ideal, continuous, smooth *text* that runs beneath the multiplicity of contradictions, and resolves them in the calm unity of coherent thought; nor is it the *surface* in which, in a thousand different aspects, a contradiction is reflected that is always in retreat, but everywhere dominant. It is rather a *space of multiple dissensions*; a set of different oppositions whose levels and roles must be described. Archaeological analysis, then, erects the primacy of a contradiction that has its model in the simultaneous affirmation and negation of a single proposition.[5]

Furthermore, Foucault's 'archaeology' proposes a mode of inquiry into or for analysing histories of thought (and I include art as a thinking system) that opposes the typical unifying categories of individual author/ artist and oeuvre, and both comparison and unity at the level of the individual or epoch, period, or genre. Histories of philosophy, histories of art, and so forth are typically presented through the philosopher or artist and their works, which Foucault further disorients:

> The horizon of archaeology, therefore, is not a science, a rationality, a mentality, a culture; it is a tangle of interpositivities whose limits and points of intersection cannot be fixed in a single operation. Archaeology is a comparative analysis that is not intended to reduce the diversity of discourses, and to outline the unity that must totalize them, but is intended to divide up their *diversity into different figures*. Archaeological comparison does not have a unifying, but a diversifying, effect.[6]

I want to draw attention to his term 'figures', which has already served me in Part 1, Chapter 3, where I proposed that Helen Rosenau worked with figures such as *Temple*, *City*, *Jew*, and *Woman*. Foucault also explores the relations between discourse and what might be termed social and political determination, in a non-determined way that he defines as 'articulation' in the sense of jointing rather than expression:

> Archaeology also reveals relations between discursive formations and non-discursive domains (institutions, political events, economic practices and processes). These rapprochements are not intended to uncover great cultural continuities, nor to isolate mechanisms of causality. Before a set of enunciative facts, archaeology does not ask what could have motivated them (the search for contexts of formulation); nor does it seek to rediscover what is expressed in them (the task of hermeneutics); it tries to determine how the rules of formation that govern it – and which characterize the positivity to which it belongs – may be linked to non-discursive systems: it seeks to define specific forms of articulation.[7]

These suggestive formulations by Foucault, emerging two decades after Rosenau's Mannheimian intervention in the practice of a German-language Art History transplanted to and barely thriving yet in Britain in the 1940s, provide a vocabulary that I use to characterize the intervention, methodologically, theoretically, and politically, that the term 'feminist' enacts in its work on discursive formations and as one itself. The twin poles of the discourses of Art History are an artist-orientated, monographic construction of a 'subject' – agent – for art (the expressive unity of artist and oeuvre) and the hermeneutic focus on the meaning of images and the one-way relations between images and

their pre-texts termed 'iconography'. These are both traversed by a third focus on *form*, which yields a history of *style*, which in turn produces the expressive unities of period (in the case of Western Art – Classical, Medieval, Renaissance, Baroque, Modern) and nation, as in the national schools of art (Italian, German, French, British, American, Indian, Chinese, Nigerian, etc.).

Impinging upon them are the larger and different frames by which the discursive formations and statements that arise within medicine, theology, law, social institutions, and psychic life feed back into each of these individualist, formalist, iconographic models. How these are 'articulated' – in the sense of jointing and connecting, which may or may not be subject to (even determined by) structural material processes we term the economic and its social relations of production – is the site of a profound schism between idealists and materialists. Foucault, like Mannheim, stood outside that battle, while still focussing on how these many levels interact – are entangled – without unifying them. Their relations are complex and opaque and the level at which we can discern their effects is a close reading of a specific image or text in relation to the larger patterns of the discursive formations on the body, for instance, or on gender or sexuality, woman, or even difference itself.

In the case of proposing the topic of *Woman* in *Art*, Helen Rosenau worked with two 'figures' (Foucault's term) that do not produce a unity such as 'art reflects woman' or 'woman is expressed in art'. They diversify in the very process of the art historian seeking to plot out the specific forms of their articulation that then constitute their own historical deviations – not as developments, successions, progressions, or teleologies but as questions that require analysis of the terms of articulation in any particular painting, print, sculpture, or drawing – medium and materiality being also elements of art's non-discursive 'discoursing'. What govern their interactions are rules of their formation and intelligibility that the art historian seeks to discern through the range of the material covered and the specific focus on each instance and its internal rules of formation as a work, and a statement, we term 'art'.

— Women's Time: Julia Kristeva

Much of later twentieth-century retheorizing critiqued and transformed linear, chronological, or teleological models for art-historical temporality. Western art-historical time rehearses the linear history defined as the 'time of nations' in Julia Kristeva's important intervention on gender and theories of time, history, and revolution in her article 'Le temps des femmes' – 'Women's Time'.[8] Kristeva discerned two major concepts of time: *linear* – historical, progressive, teleological,

associated with the narratives of nations, production, and politics – and *monumental* – almost atemporal in terms of longevity and persistence, which she associates also with *cyclical* (recursive) time. Grasping the pair, monumental and cyclical, enables us to recognize as *historical* – even if so slow-moving and recurring as to appear atemporal – the time of the cultural, psycho-imaginary structures and relations that shape our psyches and sexualities, the sphere of what Kristeva terms *life* in its widest sense. While there is general acknowledgement of the long history of the struggle of women to become admitted as social agents and political subjects within linear, historical time through campaigns for the vote, for instance, the significance of monumental time as 'women's time' has not been fully recognized. Kristeva defines as monumental the temporalities of the patriarchal order determining social and psychic modalities of desire and the creation of life and the new in which women are deeply entangled as psycho-sexual *subjects* (the psychological sense) and as *subject to* patriarchal socio-symbolic and economic systems (the political-ideological sense). In monumental time, *woman* becomes the signifier and *women* the locus of psycho-sexual time even as we can argue that 'gender' and 'sexuality' are its typical terms, just as class and social relations of production are, according to Marx, the defining modes of linear time.

Refusing to unify 'women', Kristeva also thinks historically in generations, identifying a history of modern feminism in Mannheimian terms. Yet, for her, a generation is not a temporal location so much as a 'signifying space' – both a corporeal and a desiring mental space'.[9] Thus, Kristeva characterizes the campaigns for emancipation – to become a citizen – as women's struggle to be admitted to the time of nations and the political space. What marked the subsequent feminist generation post-1968 was, however, an engagement with monumental time that, according to Kristeva, risked idealizing the maternal and reifying difference between men and women, even falling prey to mysticism and religion in terms of over-investment in the Mother. Thinking of her own experience growing up in communist Bulgaria and then encountering the psycho-aesthetic trend among the Parisian feminists post-1968, Kristeva identifies two strands within her generation of feminism: the *socialist experiment* on the one hand, with its attempted political suspension of gender difference, and, on the other, the political–poetic embrace of the psycho-politics of *psychoanalysis* with an investment in sexual difference and the exploration of feminine subjectivity. Holding a third position open that might suspend this contradiction, Kristeva notes the specific investment of this second generation in art and literature, asking, 'Is it because, faced with social norms, literature reveals a certain knowledge

and sometimes the truth itself about an otherwise repressed, nocturnal, secret and unconscious universe?'[10] Rosenau's analysis addresses the visual arts as such a hermeneutic site. Kristeva also takes religious imaginaries seriously as records of cultural exploration of what defies the Logic of the Word, what touches what she terms the hinge between life, *zoé* and *bios* in Greek, and meaning – the semiotics of the unconscious. Kristeva also worries that an atheistic, political feminism disowns the necessity to acknowledge desire, the unconscious, and psycho-sexual formation, which were once 'spoken' through the language of religion and elaborated in art. She fears a politics without an acknowledgement of the unconscious, and she ponders if 'linear' feminism is trying to live without 'religion', while she also poses a third possibility that will liberate women from Woman in either discourse:

> Or is it, on the contrary, and as avant-garde feminists hope, that having started with the idea of difference, feminism will be able to break free of its belief in Woman, Her power, Her writing, so as to channel this demand for difference into each and every element of the female whole, and, finally, to bring out the singularity of each woman, and beyond this, her multiplicities, her plural languages, beyond the horizon, beyond sight, beyond faith itself?[11]

Kristeva defines religion as 'this phantasmatic necessity on the part of speaking beings to provide themselves with a representation (animal, female, male, parental etc.) in place of what constitutes them as such, in other words, symbolization – the double articulation of the syntactic sequence of language, as well as its preconditions or substitutes (thoughts, affects, etc.)'.[12] Religion, mythology, art, and literature are all instances of this necessity to find ways of figuring the subjective processes operating in monumental time that language and its syntax symbolize. Figuring connects thought and affect, life and meaning, while the aesthetic processes in the case of art, such as medium, material, colour, space, scale, become passageways between symbolization (the linguistic) and an aesthetic-psycho-affective register (akin to but not identical with a *pathos formula*). Sensitized to this register by its liberation from the religious–theological agenda and secular representational systems through the aesthetic practices of the avant-garde, Kristeva identified such levels already at work in pre-modern art through her analyses of the autonomous work of colour itself, the blue for instance in Giotto's (1267–1337) Arena (Scrovegni) Chapel frescoes and in the mournful and distracted Virgins we encounter in the paintings of Giovanni Bellini (1430–1516).[13]

Despite little overt theorization in Rosenau's 'little book', I am suggesting that Kristeva illuminates Rosenau's feminist project through

her analysis of practices such as religion, literature, and art, the first of these depending upon the other two for the work of symbolization of the thoughts and affects for which religion took it upon itself to create aesthetic forms, rituals, spaces, texts, and images. Furthermore, Kristeva's two temporalities, linear-historical and monumental-psycho-corporeal, help us to read Rosenau's writing of a history of art (the historical) by means of a focus on deep socio-temporally shaped and psychically charged structures such as 'marriage', sexuality, desire, law, and the double framing, social and affective, of 'motherhood', itself defined by Kristeva as the hinge between life-making and meaning, the body, psyche, and society. We might suggest that the juxtaposition on the cover can also be read in Kristevan terms on both a deep monumental time (the topic) and a historical time (the aesthetic form).

Kristeva identifies the aesthetic practices of the avant-garde, hence modern art, as a revolt against patriarchal–capitalist Modernity, which formed a modern trinity of Church–Family–State. Both generations of feminism were a product of, and indeed a critical mode within, this revolt. Feminism's two, often concurrent, generations – as evidenced by women's participation in the historical aesthetic avant-garde as much as in the political avant-gardes, left and right – generated a signifying space that transcended the terms of both political and psycho-aesthetic feminisms. Kristeva indicates a third signifying space untrammelled by the effects of both the systematic differentiation of gender in linear time and post-1968 feminism's troubled attempts to theorize sexual difference and the feminine. She thus proposes a third signifying space of which (just as Rosenau's book concluded with its exploration of women's creativities, namely interventions in the symbolic and imaginary through aesthetic practices) she writes:

> At this level of interiorization with its social as well as individual stakes, what I have called 'aesthetic practices' are undoubtedly nothing other than the modern reply to the eternal question of morality. At least this is how we might understand an ethics which, conscious of the fact that its order is sacrificial, reserves part of the burden for each of its adherents, therefore declaring them guilty while immediately affording them the possibility for *jouissance*, for various productions, for a life made up of both challenges and differences.[14]

I am not suggesting that Kristeva anticipates Rosenau or vice versa. I introduce a conversation between two feminist thinkers, with Rosenau writing and thinking in a signifying space, an intermediate generational position that I have argued has been lost in the narratives that leap from emancipatory struggle (1780–1930) to the post-1968 Women's Movement. Rosenau drew on the feminist thinkers of the later nineteenth and early

twentieth centuries to seed into a continuing feminist project during the 1920s–1940s that itself had generated a feminist cultural revolution. This cultural project was, however, halted, shattered, and dispersed by the rise of fascism and the world war and genocide it unleashed.

One purpose for this book as republication and commentary is to reopen that 'signifying space' to make it more legible to us by both recovering its conditions of possibility in first-generation feminist sociology and creating a thread to connect Rosenau's Art History in the 1920s–1940s to the second feminist cultural revolution in theory in the 1960s–1980s, a generation emerging from post-war communism and Cold War, and sensitized by and revolting against the traumas of decolonization wars, the Holocaust, and Hiroshima.

Kristeva's arguments in 'Women's Time', and other writings of that period in her thought, provide another vocabulary through which theoretically to situate Rosenau's book, whose economy risks her being misread even as it also reveals the synthetic brilliance of her capacity to create a single, book-length review of the history of art tracked through the figure of *Woman* and a history of gender and sexual difference tracked through the aesthetic practices of *Art*.

— Feminism, Art History, and My Generational Space

Sadly, my encounter with Helen Rosenau's book came very late in my academic career as a feminist scholar. Yet, had I read it in the 1970s, I would not then have been able to grasp its project or appreciate what it was doing. My feminist 'situation' begins in the moment of sheer excitement when, in 1973, riffling through the pages of the fledgling British feminist magazine *Spare Rib*, I came across a short article by journalist Rozsika Parker reporting on an astonishing exhibition researched and created by curators Ann Gabhart and Elisabeth Broun at the Walters Art Gallery in Baltimore, United States of America, and titled *Old Mistresses: Women Artists of the Past* (fig. 3.57). The exhibition's revelations burst upon my generation, made ignorant of what women had ever done and what feminist art historians had already written. The Baltimore curators also produced and sold to eager feminist art historians a pack of slides (photographic transparencies that used to be projected to illustrate lectures) with which we could then reveal to others the existence of these marvellous artist-women from Euro-American art history.[15]

Gabhart and Broun had easily identified works by artist-women in US-American museums or private collections, although sometimes in their stores and not on the walls. *Judith and Her Maidservant with the Head of Holofernes*, by the Italian seventeenth-century Roman painter Artemisia Gentileschi (1593–1653), is in the Detroit Institute of

Arts (fig. 3.58).[16] Ours – Rozsika Parker's and mine – was a generation inducted into a History of Art from which almost all women's names and works had been erased or disowned by the Gombriches and Jansons that were the widespread points of entry for the study of art history (as explained in Part 1, Chapter 3). Let me give an example. As a graduate student at the Courtauld Institute in 1971, my keen and competitive graduate student group were set a test by our professor of modern art. We had to identify the artist for ten images. Confidently we reeled off nine names but were all stumped by number ten. Clearly created in Paris between the 1890s and 1910s, it affirmed a radical understanding of new facture, new compositions, contemporary subject matter, and knowing conversations with other avant-garde artists. No name, however, popped into anyone's mind.

The work in question was by post-Impressionist and modernist Parisian painter Suzanne Valadon (1865–1938) (fig. 3.59). In a flash, I realized that none of us, even perhaps having heard of Valadon, had ever been trained to search our art-historical memory banks of artists for a *woman's* name. Had we even known to suggest her name, we would still have been perplexed because we did not anticipate that a woman might have painted the way Valadon did, nor what she had painted in terms

3.57 Rozsika Parker, review (showing fig. 3.58) in the British feminist magazine *Spare Rib* (1973) of the exhibition *Old Mistresses: Women Artists of the Past* at the Walters Art Gallery, Baltimore, 1972.

3.58 Artemisia Gentileschi (1593–1653), *Judith and Her Maidservant with the Head of Holofernes*, 1623–5, oil on canvas, 187.2 × 142 cm. © Detroit Institute of Arts / Gift of Mr Leslie H. Green / Bridgeman Images.

3.59 Suzanne Valadon (1865–1938), *The Blue Room*, 1923, oil on canvas, 90 × 116 cm. Paris: Musée nationale d'art moderne. Photo: Photo © Centre Pompidou, MNAM-CCI, Dist. RMN-Grand Palais / Jacqueline Hyde.

of subject matter and pose. There was no vocabulary for its analysis, no terms with which to see what her work was doing in its situatedness and what she was making in the specificity of class, gender, and sexual difference. These concepts themselves were unthinkable, even contaminating for a disinterested, scholarly Art History.

In 1971, the US-American art historian Linda Nochlin, teaching the 'first ever' university course on women artists at her prestigious women's college, Vassar, published a paradoxical but influential book chapter titled 'Why Are There No Great Women Artists?' – rehearsing a question posed to her by a contemporary art dealer and critic who wondered 'where *were* the great women of his own moment?'. Soon shortened for *Art News* in 1971, her long book chapter was also retitled in the past tense, 'Why *Have There Been* No Great Women Artists?' (my emphasis).[17] Nochlin's text was formative, and is now canonical, of a new phase of feminist

questioning of Art History (discipline) and art's histories (field). Yet its core paradox remains unexamined.

For, even as she illustrated her article with the names of many artist-women, Nochlin produced a negative, sociological explanation for the 'apparent' absence of women in art practice as a result of institutional obstacles – exclusion of women from workshops and academies that limited training, notably in the core grammar of Renaissance to modern art, the naked human body: the nude when a woman, the heroic or the divine when a man. She was also identifying a culprit in ideological definitions of women's incapacities for thought or creativity. Nochlin confidently anticipated that once institutional exclusion and social attitudes – rather than wombs accounting for women's apparently poor or limited showing in art – had been rendered obsolete by liberalizing modern thinking, discrimination would vanish in the inevitably progressive moment of a less prejudiced and post-emancipatory twentieth century. Women would now be free to create their own futures.

There is no doubt that during the twentieth century some privileged, and mostly white, women gained some degrees of economic freedom, political emancipation, and more access to education and the professions. As the century progressed and to this day, art schools became, and indeed still are, full of women. Yet the official gatekeepers and authorities – the exhibitions, the museums, the dealers, notably of modern art, and the Art History survey books and the monographs the presses published – became denuded or fell silent about women as artists. I do not believe we have yet grasped the real incongruity between the powerful hopefulness of nineteenth- and early twentieth-century feminism, comprising women's movements and fostering intellectual and creative production of art, literature, music, philosophy, historiography, sociology, and so on, and the vision presented by Nochlin's model – a historically thin line of few artist-women who had bravely overcome institutional and ideological obstacles and were now to be joined by untrammelled artist-women, free at last to produce whatever they wanted.[18]

Half a century later, liberal hopes and a sociological explanation alone have, however, been proven to be insufficient and misplaced. What Rozsika Parker and I argued instead was that we needed a structural analysis of systematic resistance on the part of *modern* patriarchal cultures and societies to equality and full participation, be that in terms of class, race, gender, or ability, because systemic hierarchies could never be wiped away by liberal hope alone. They have persisted and, in fact, become more and more deeply entrenched, mobilizing new forms of selective admission of women paralleled by 'quarantining' feminist

1971 **1972** **1974** **1976**

3.60

1971 The edition of *Art News* in which Linda Nochlin's article 'Why Have There Been No Great Women Artists?' appeared. Cover image: Marie-Denise Villers (1774–1821), *Mlle Charlotte D'Ognes*, 1801, oil on canvas, 161.3 × 128.6 cm. New York: Metropolitan Museum of Art. Mr and Mrs Isaac D. Fletcher Collection, Bequest of Isaac D. Fletcher, 1917.

1972 'Q' initial with self-portrait (?) and name from folio 64 of *The Claricia Psalter*, *c*.1200 (Walters Art Gallery, Baltimore), exhibited in *Old Mistresses: Women Artists of the Past* in 1972. Bridgeman Images.

1974 Eleanor Tufts, *Our Hidden Heritage: Five Centuries of Women Artists* (New York: Paddington Press, 1974). Cover image: Judith Leyster (1609–1660), *Self-Portrait at the Easel*, 1630, oil on canvas, 74.6 × 65.1 cm. Washington, DC: National Gallery of Art. Gift of Mr and Mrs Robert Woods Bliss. 1949.61.

analysis as alien to art's study as too sociological, too theoretical, and hence not proper Art History at all.

Women-starved proto-feminist Art History students eagerly lapped up the books that slowly appeared in English as fig. 3.60 reveals them. While offering archivally based documentation of artist-women throughout the centuries, these marvellously researched compendia remained within the discursive formation of Art History as a periodized, artist-centred story, still narrating heroic exceptions beset by obstacles. Women were thus catalogued in a category that structurally exiled them from being acknowledged as simply artists. Feminism valued the *woman* in the woman artist, but we were up against a culture that used that term as an implicit negation of creativity and imagination.

From 1975 to 1979, Rozsika Parker and I researched and wrote a book, originally destined to be published by Oresko Books, that we also titled, with acknowledgement, *Old Mistresses*, adding the subtitle *Women, Art and Ideology* (fig. 3.61b). Its publication was delayed until 1981.[19] The title acknowledged the gender hierarchies already embedded in and enacted by language. Great artists are *masters*. Language precludes comparable respect in the word *mistresses*, overloaded with sexual connotations as well as dark legacies of class and race relations. If we name a woman a *woman artist*, language itself confirms both the default masculinity of the single word, *artist*, and disqualifies women from being recognized within it if not preceded by the effectively disqualifying adjectival noun, *woman*.

We also challenged Linda Nochlin's diagnosis and her liberal hope of progress, which we sensed was bound to fail because of the deeper structures Julia Kristeva's analysis would soon explain to us. Hence the centrality in our subtitle of ideology, then a Marxist term, implying

1976 1978 1979

equal attention to the socio-economic structures of patriarchal, class, and raced societies.

On the original cover of the British edition (fig. 3.61b), we placed a work agonisingly titled *White Dreams* (fig. 3.61a), by a contemporary Venezuelan, New York-based artist-woman, Marisol Escobar (1930–2016). Her commentary on colour racism was performed by her own face cast holding a drooping white carnation, displacing the Hispanist, Carmen-like red rose, between her brown lips. This image and our choice so baffled the US-American publishers, Pantheon, that they replaced it with a realist painting by a white, late nineteenth-century US-American artist, showing a studio scene that represented women as dutiful art students learning to paint – in the academic tradition – the female nude! Their cover re-performed exactly the ideological bind of artist-centred Art History that our book sought to deconstruct on multiple levels. Using the bitter irony of Marisol's cast of her own Venezuelan face in earth-coloured clay under the title *White Dreams*, we had purposely 'differenced' the recurring tendency evidenced when we align the covers of the publications (fig. 3.60), each with a self-portrait as cover image.[20] Even as these books documented artist-women through Euro-American art history, they were modelled on the dominant paradigm of named individuals, on artists, organized by country and period, with short biographies and some works to suggest their topics and range of work.

I do not need to rehearse the difficulty of negotiating the double-bind of the notions of *recovery* or *re-discovery* of women artists. Artist-women were neither 'lost' through neglect nor passively forgotten, being fully documented by their contemporaries, archived, collected, listed in all the standard dictionaries of artists, sold at auction, and mentioned in many published surveys of art's history. Their names were, and are,

1976 Karen Petersen and J. J. Wilson, *Women Artists: Recognition and Reappraisal from the Early Middle Ages to the Twentieth Century* (New York: Harper & Row, 1976). Cover image: Suzanne Valadon (1865–1938), *The Blue Room*, 1923, oil on canvas, 90 × 116 cm. Paris: Musée nationale d'art moderne. Photo: Photo © Centre Pompidou, MNAM-CCI, Dist. RMN-Grand Palais / Jacqueline Hyde (see 3.60).

1976 Ann Sutherland Harris and Linda Nochlin, *Women Artists 1550–1950*, exhibition catalogue, Los Angeles County Museum of Art. Cover: Adrienne Marie Louise Grandpierre-Deverzy (1798–1869), *The Studio of Abel Pujol*, 1822, 1822, oil on canvas, 113.5 × 145.5 cm. Musée Marmottan Monet, Paris, France / Bridgeman Images.

1978 Elsa Honig Fine, *Women and Art: A History of Women Painters and Sculptors from the Renaissance to the 20th Century* (Montclair, NJ: Allanheld, Osmun & Co., 1978). Cover image: Artemisia Gentileschi (1593–1653), *Self-Portrait as the Allegory of La Pittura*, 1639, oil on canvas, 98.6 × 78.2 cm. Royal Collection Trust / © His Majesty King Charles III, 2023 / Bridgeman Images.

1979 Germaine Greer, *The Obstacle Race: The Fortunes of Women Painters and Their Work* (London: Secker & Warburg, 1979). Cover image: Élisabeth Vigée-Lebrun, *Self-Portrait*, 1791, oil on canvas, 99 × 81 cm. Ickworth House, Suffolk, UK National Trust Photographic Library / Bridgeman Images.

3.61a Marisol Escobar (1930–2016), *White Dreams*, 1968, plastic, wood and white carnation, 24.1 × 25.9 × 7.1 cm. Bequest of J. R. Wolf Class of 1951. Hood Museum of Art, Dartmouth, USA © DACS, London

3.61b Rozsika Parker and Griselda Pollock, *Old Mistresses: Women, Art and Ideology* (London: Routledge & Kegan Paul, 1981).

OLD MISTRESSES
Women, Art and Ideology

Rozsika Parker and Griselda Pollock

easy to find in all the normal records art historians typically use. The key question is: Why was it necessary, and why was it acceptable, for *twentieth-century* art historians systematically and consistently to deny women's evident and consistent existence as artists, certainly facing prejudice and gender-based discrimination, but never totally prevented from contributing, over long professional careers, to our understanding of art and what it does and who we are?

Woman in Art does not, therefore, belong in the same category as these post-1971 *rediscovery* compendia that focussed on the re-establishment of *women as artists* in standard art-historical format combining biography and career history with analysis of indicative artworks. *Woman in Art* is not about *artists* but about *art* investigated as a record of situated imagining and thinking in aesthetic forms. Within its pages, artist-women are frequently referenced without any fuss because the issue is not their exceptionality, their outsiderness, their obstacles, or their need to be reinserted. They are named because of the centrality within Rosenau's project of the questions that feminists in the nineteenth century and post-1968 termed *gender*, meaning a social hierarchy and differentiation of women from men. As a set of relations, gender enables us to examine the meaning of women and men, in history, framed by and inhabiting varied social structures and legal relations. Rosenau studied their representation formulated within or against different forms of ideological and cultural inscription in terms of what Anthropology and Sociology defined as both social positions and social, often also mythical, imaginaries. Artworks affirm both the social relations of gender and the visual formulations that are not reflections of the former but the mode of their formulation. They are fashioned as visible formulae. The image is both a mode of understanding and a projection of meaning for the invisible but lived social, erotic, emotional, legal, or political significance of the central institutions of gender relations: the lateral axis of the couple and the vertical axis of the intergenerational production of new life. These may seem unduly heavy-handed formulations for sex and family, but they are necessary to avoid the banal normalization of such terms as 'marriage' and 'motherhood' – used by Rosenau in her chapter headings even as she unsettled their normativity with her readings of historical shifts as changing situations.

If Anthropology studies deep structures and Sociology identifies specific social structures, History introduces the temporality of structures and hence change to both the deep and the specific. The key difference between the new feminist art histories post-1970 and the work of Helen Rosenau and the legacy she put to work to create her transformative study is her non-conscious alignment in advance, I suggest,

with Kristevan monumental time, a temporality that is also present in a way in Warburg's very different project of *Nachleben*, persistence. I read Rosenau's 'little book', therefore, as monumental art history, aligned with anthropological and psychoanalytical thought that springs us from the cage of linear, progressive, and hence Eurocentric, Christianocentric patriarchal art-historical modelling of history, art, and society.

Yet what of that subtitle *From Type to Personality*? *From… to…* is surely a progression. No. The prepositions are signifiers of change, certainly. The issue is Rosenau's resistance to a specific kind of modelling of time that sustains the canonical surveys of the history of Western art (and that thereby defined the eras of human history and its cultures from the centralized perspective of the Classical–Christian nations). Re-globalizing Art History and art's histories has been on the agenda for the embarrassed Western academy for a very short time. It is impeded by the challenges Westerners face when confronting the West's imperial restructuring of others' worlds. Imperial *worlding*, as Gayatri Spivak identified the process in her essay 'The Rani of Sirmur' (1985), always involved a complex plaiting of race, gender, and class power.[21] Neither Karl Marx (1818–1883) nor Sigmund Freud (1856–1939) can be left out of the study of racializing, imperializing, re-gendering worlding. Political economy and psychic economy coincide in mutual reinforcement across the body of women in the history of imperial plays of power.

My extended essays divert potential misrecognition of the significance of what Rosenau did because her terms might appear opaque to the intellectual generation of 1968, let alone of 1989 and certainly of 2007, or even 2023, the last two dates marking what has been termed 'post-feminism'. Placing Rosenau in conversation with and at a distance from the three theorists of time introduced here obviates this risk. We need, therefore, to push our historiographical probe deeper into a politics of knowledge that reached from the mid-1940s, when her book appeared, to the mid-1970s in order to understand, finally, how what Helen Rosenau proposed in her book became invisible less than thirty years later.

From the moment Adrian Rifkin reminded me not to forget Helen Rosenau's 'little book' to the invitation by Tamar Garb to lecture on the book at University College London in 2013, I have been on a much longer and deeper research journey than I had anticipated. The republication, the addition of full-colour images, and the analyses of each aspect that the book has prompted me to write have restored a far richer and wider field of pre-1940 feminist theory and research in which Helen Rosenau, the feminist scholar, was embedded and which she mobilized to formulate this study. Her unique and distinct engagement with Mannheim's

model; her parallel exploration of what Viola Klein (1908–1973) argued was modern anti-feminism and then later what Simone de Beauvoir (1908–1986) approached as deep cultural mythologies of the feminine as other; and her confident, scholarly, and transdisciplinary configuration of the art-historical project that was never trapped in either the formal or the iconological, never disloyal, but equally never obedient, to Marxist theories of class society and socio-economic determination, never confined to one cultural perspective be that geopolitical or in terms of gender – all these are compacted within and mobilized by the 'little book'.

Helen Rosenau's book is a key work of Art History in the twentieth century, *and for the present*, that should be as widely read as the conservative, masculinist texts that certain of her fellow refugee art historians and their exclusionary followers now sell in the millions of copies. Even as some new enthusiasts try to write yet another survey of art featuring only *women* artists, Rosenau has already modelled a feminist intervention in art's histories that is much more intellectually challenging and culturally relevant than works that popularize names for the market and so often without any real cultural or theoretical analysis.[22]

Yet, there is a sense in which the originality and scale of Rosenau's 'little book' could only become legible once another generation, cut off from its recent past, undertook a renewed, retheorized feminist and art-historical archaeology (in Foucault's sense), researching what we – I – discover is the much longer, sustained tradition of feminist thought and cultural analysis that, after the 1950s, was 'disappeared' by the narrowed conservative masculinization of the discipline and the stories of art it told and allowed to be heard.

The recent and expanded historiographical studies of the formation of the discipline of Art History have also contributed with the discipline's increasing interest in the Hamburg moment in the 1920s, in which Helen Rosenau participated but has not yet been included in the almost all-male cast of founding fathers. She can now also take her place, not as an acolyte, but as an originator of her own model and specific focus with its challenge to the exclusion of difference, gendered and ethnic–religious, and of the social–historical analysis of class. The elegance with which Rosenau plaits what post-1968 social–historical, feminist, postcolonial, queer, and Jewish studies struggled to articulate, let alone interrelate, has emerged for me as exemplary in this moment of the unfinished study of *woman* in *art*.

Notes to Essay 7

1 Hannah Arendt, 'We Refugees' [1943], in *The Jewish Writings*, ed. Jerome Kohn and Ron Feldman (New York: Schocken Books, 2007), 264–74: 265.

2 In *Encounters in the Virtual Feminist Museum: Time, Space and the Archive* (London: Routledge, 2007). The heroic model of artistic advance adopts the military metaphor of an avant-garde, identifying only the individual innovators, often on the basis of formal innovation alone, thus favouring one direction for art over a more complex understanding of culture's concurrent initiatives and diversifications. Culturally enriching difference resulting from position, situation, gender, race, class, sexuality have been systematically ignored or suppressed. The result is a selective and hierarchical account of art's linear progress composed of major leaders and minor others.

3 Warburg borrowed the ironic phrase 'the good European' from Friedrich Nietzsche's preface to *Beyond Good and Evil* (1886). See Aby Warburg, 'Italian Art and International Astrology in the Palazzo Schifanoia, Ferrara' [1922], in *The Renewal of Pagan Antiquity: Contributions to the Cultural History of the Renaissance*, ed. Kurt W. Foster, trans. David Britt (Los Angeles: Getty Research Institute for the History of Art and the Humanities, 1999), 563–92: 586.

4 Pollock, *Encounters in the Virtual Feminist Museum* and *After-Affects / After-Images: Trauma and Aesthetic Transformation in the Virtual Feminist Museum* (Manchester: Manchester University Press, 2013); Michel Foucault, *L'archéologie du savoir* (Paris: Gallimard, 1969), trans. A. M. Sheridan-Smith as *The Archaeology of Knowledge* (London: Tavistock, 1972). For a brilliant exploration of Foucault for Art History see Jennifer Tennant Jackson, *Evidence as a Problem: Foucauldian Approaches to Three Canonical Works of Art: Courbet's Atelier 1855; Velázquez's Las Meninas 1656; Botticelli's Venus ca. 1483* (PhD thesis, University of Leeds, 2001); 'Efficacity', in *Conceptual Odysseys: Passages to Cultural Analysis*, edited by Griselda Pollock (London: I. B. Tauris, 2007), 153–71; 'Courbet's *Trauerspiel*: Trouble with Women in *The Painter's Studio*', in *The Visual Politics of Psychoanalysis: Art and the Image in Post-traumatic Cultures*, edited by Griselda Pollock (London: I. B. Tauris, 2013), 77–101.

5 Foucault, *The Archaeology of Knowledge*, 155 (my emphasis).

6 Foucault, *The Archaeology of Knowledge*, 159–60 (my emphasis).

7 Foucault, *The Archaeology of Knowledge*, 162.

8 Julia Kristeva, 'Le temps des femmes', *34/44 Cahiers de recherche de sciences des textes et documents* 5 (1979), 5–19, trans. Alice Jardine and Harry Blake as 'Women's Time', in *The Kristeva Reader*, ed. Toril Moi (Oxford: Basil Blackwell, 1986), 187–213.

9 Kristeva, 'Women's Time', 209.

10 Kristeva, 'Women's Time', 207.

11 Kristeva, 'Women's Time', 208.

12 Kristeva, 'Women's Time', 208.

13 Julia Kristeva, 'Giotto's Joy' and 'Motherhood According to Bellini', in *Desire in Language*, ed. Leon Roudiez, trans. Thomas Gora, Alice Jardine, and Leon Roudiez (Oxford: Basil Blackwell, 1979), 210–36 and 236–70.

14 Kristeva, 'Women's Time', 211.

15 Elisabeth Broun and Ann Gabhart, *Old Mistresses: Women Artists of the Past*, Walters Art Gallery, Baltimore (April–June 1972). The catalogue of the exhibition was published as the entire edition of the *Walters Art Gallery Bulletin* 24:7 (1972).

16 The painting was donated in 1952 having been placed on the market only in that year. See E. P. Richardson, 'A Masterpiece of Baroque Drama', *Bulletin of the Detroit Institute of Arts* 32:4 (1952–3), 81–3. It came from the possession of an ancient Italian family and there is no other known provenance.

17 Linda Nochlin, 'Why Are There No Great Women Artists?', in *Woman in Sexist Society: Studies in Power and Powerlessness*, edited by Vivian Gornick and Barbara K. Moran (New York: Basic Books, 1971), 480–510; 'Why Have There Been No Great Women Artists?', *Art News*, January 1971, reprinted in *Art and Sexual*

Politics: Why Have There Been No Great Women Artists?*, edited by Thomas B. Hess and Elizabeth C. Baker (New York: Macmillan, 1973), 1–43; and *Why Have There Been No Great Women Artists?*, 50th anniv. ed. (London: Thames & Hudson, 2021).

18 Sharing this negative perspective of institutional and even psychological damage, Germaine Greer used the title *The Obstacle Race: Fortunes of Women Painters and Their Work* (London: Secker & Warburg, 1979), focussing more on psychological damage or structural discouragement than on institutional disadvantage.

19 Rozsika Parker and Griselda Pollock, *Old Mistresses: Women, Art and Ideology* (London: Routledge & Kegan Paul, 1981).

20 Concurrent research in Germany had produced Das Verborgene Museum (The Hidden Museum), founded in 1986, a still-existing project that 'resulted from an investigation carried out in Berlin museums (West) from 1984–1987, during which artworks by more than 500 artist-women – of whom only a small minority are still known – were *discovered* in archives and collections' (my emphasis): 'The Museum', Das Verborgene Museum, n.d., https://www.dasverborgen-emuseum.de/the-museum, retrieved 18 March 2023. See also works stemming from the project of reinstatement by research on women in the Nordic countries and across Europe: Anna Lena Lindberg and Barbro Werkmäster, *Kvinnor som Konstnärer* (Stockholm: LT, 1975); Anna Lena Lindberg (ed.), *Konst, kön och blick: feministiska bildanalyser från renässans till postmodernism* (Stockholm: Norstedt, 1995).

21 Gayatri Chakravorty Spivak, 'The Rani of Sirmur: An Essay in the Reading of Archives', *History and Theory* 24:3 (1985), 247–72. 'Worlding' involves the semiotic and ideological process Westerners produce in presenting their own world to the colonized in othering terms in which the colonized are obliged to inhabit their now colonially redesignated place and subject positions as the imposed reality of their colonizers. I have written about Spivak's influence on my own practice, drawing on her disowning of 'the global' by 'the planetary' as less tainted by total economic colonization, which she terms 'globalization', and her proposal for what she terms 'planetary subjectivity'. See Griselda Pollock, 'Whither Art History?', *Art Bulletin* 96:1 (2014), 9–23. For the concept of the planetary see Gayatri Chakravorty Spivak, *The Death of a Discipline* (New York: Columbia University Press, 2003).

22 I calculate that one third of the artists mentioned in *Woman in Art* are women: Hildegard of Bingen, Sophonisba Anguissola, Rosa Bonheur, Stella Bowen, Rosalba Carriera, Artemisia Gentileschi, Barbara Hepworth, Angelica Kauffman, Käthe Kollwitz, Marie Laurencin, Paula Modersohn-Becker, Vera Ignatievna Mukhina, Elisabet Ney, Renée Sintenis, Anna Dorothea Therbusch-Lisiewska, and Élisabeth Vigée-Lebrun.

Personal Afterthoughts

How did I arrive at the book and Helen Rosenau? In Part 3, Essay 7 I have mentioned Adrian Rifkin's prompt in 2013 but it began earlier, back to the 1990s, at a key but short-lived moment when a theoretical Jewish Cultural Studies flashed up upon the British intellectual scene. In 1995 the Centre for Jewish Studies, linked to the Department of Fine Art at the University of Leeds, was established by Adrian Rifkin, then Professor of Fine Art, and directed by a newly appointed Montagu Burton Fellow in Jewish Studies, art historian Eva Frojmovic. One of her first activities was to host the exhibition, just staged at the Barbican Concourse Gallery in London in 1996 and curated by Monica Bohm-Duchen and Vera Grodzinski, titled *Rubies and Rebels: Jewish Female Identity in Contemporary British Art*.[1] In 2019, Bohm-Duchen, a curator and art historian with a focus on modern Jewish artists, initiated a year-long project titled *Insiders/Outsiders: Refugees from Nazi Europe and Their Contribution to British Visual Culture*, at which Rachel Dickson spoke about Helen Rosenau, the conference culminating in the book of that title.[2] In 1997, to explore *Rubies and Rebels* as a hallmark exhibition of the intersection of Jewish and feminist art histories, Eva Frojmovic organized an international conference, *Portrait of the Artist as a Jewish Woman*, at Leeds that included curator Norman Kleeblatt speaking about his recent exhibition of Jewish contemporary artists engaging with their identities, *Too Jewish?*.[3]

Opening the conference, Adrian Rifkin performed a moving homage to the modern Jewish and feminist art historian Helen Rosenau, his unofficial MA supervisor during his studies in Art History. It was one of his spoken, unscripted *tours de force* that marked us all indelibly. A queer man speaking of the gesture of intellectual hospitality offered by a German Jewish refugee stranded in Manchester's Art History department (founded in 1961, although Rosenau had been teaching there since 1951) was personally affecting but also politically intriguing on so many levels: queer, feminist, Jewish, historiographical, biographical. Beyond the affectionate portrait by a former student, I discerned the significance of this man paying his own personal homage to his mentor, a woman intellectual. Helen Rosenau was the generous transmitter of her pre-war

intellectual world to a lost young thinker, opening a door from his enlivening exposure to Art History through lectures by another refugee art historian, Edgar Wind, during years at the University of Oxford, yet another link with the continental, intellectual traditions in Art History that were inflected by doubled perspectives of *outsiderness* and *marginality* – although Jewishness is for those within its embrace actually an inside, a world perhaps to be escaped a little, or certainly questioned and queered even as it enables an oblique gaze upon the Classical–Christian hegemony of the West. There is, however, a difference in the kind of *outsiderness* experienced specifically by intellectual women when they are caught in webs of multiple marginalities, in situations or institutions incapable of doubling or 'pivoting their centres'.[4] Helen Rosenau was battling not only with academic Britishness and Art History's increasing positivism. She was also being sidelined by fellow refugees, the continental boys, many deeply conservative and reactionary.

Rifkin not only introduced Helen Rosenau to the historical and theoretical field the conference was mapping as gender-inflected studies of Jewish and art-historical modernities. He also performed the link between an exiled generation we were studying in the conference and the current generation tentatively performing reclamation. Helen Rosenau was, however, not someone only from the pre-war world. She overlapped with those of us in the room. She had taught at the university I joined a few years after she had left, where both feminist and social histories of art were openly disdained by my colleagues. She spoke at the conferences of the Association of Art Historians, founded in 1974, we attended.

The project of the 1997 conference in Leeds resonated with the educational and intergenerational thinking of another displaced woman intellectual and German Jewish refugee, Hannah Arendt (1906–1975). In 'The Crisis in Education' (1954), she proposes:

> Education is the point at which we decide whether we love the world enough to assume responsibility for it and by the same token save it from that ruin which, except for renewal, except for the coming of the new and young, would be inevitable. And education, too, is where we decide whether we love our children enough not to expel them from our world and leave them to their own devices, nor to strike from their hands their chance of undertaking something new, something unforeseen by us, but to prepare them in advance for the task of renewing a common world.[5]

This ethics of transmission and renewal had marked one person, Adrian Rifkin, but it had not been given space institutionally and discursively. This publication is the monument to the possibility of transmission,

generally, and in a personal sense, from Adrian Rifkin to me. It is also an inquiry into what had made it impossible in the wider sense. Sharing both Rosenau's moment of writing and the process of learning to read her work now is our contribution to that 'task of renewing a common world' with something, if not unforeseen, being given new life as we wipe away the amnesia enshrouding what Rosenau put in the world for us all to use in 1944.

We heal a ruptured transmission of women's thinking, art, creativity, and the feminist-inspired cultural revolution in the first decades of the twentieth century that left us, in the post-1968 Women's Movement, orphaned thinkers, products of a silencing even while the women thinkers and artists who traversed the emancipatory discourses and cultures of the early twentieth century were still alive, just as were major twentieth-century artists whom I came to research in the 1990s were still alive when I first asked myself why, in 1970, I had been *made ignorant* of any history of women as artists by institutions tasked with teaching the History of Art. This will happen again if we do not heed Arendt's ethics of intergenerational transmission and do not equally refuse the destructive terms of conflicting waves and generational antagonism within the histories of feminism.[6]

This timely reprinting supplemented by my reflections as a post-1968 feminist social historian of art is not only an act of recovering missing feminist memories. This project has truly been a revelation. By close-reading *Woman in Art*, I want to position the book and its author not only in the history of Art History, but also as a link between very different 'generations' in the history of the intellectual project of the never-exhausted movements of women worldwide, and in the many chapters not only of 'women in art' but also of 'feminists in Art History'. As important is acknowledgement of both a Jewish art historian and a Jewish Studies scholar who also lost her place in the history of the 'cultural transfer' that resulted, tragically, from the forced exile of so many European Jewish intellectuals in the face of fascism. Many of the refugees were art historians.[7]

In 1942, under the auspices of the Free German League of Culture in Great Britain, Rosenau had published an article, 'Changing Attitudes towards Women'. She openly indicted Nazism's regressive gender ideology – *Kinder, Kirche und Küche* – reminding readers of the long, integrated history of feminist and egalitarian thought from the eighteenth century, when calls for legal equality between men and women were made by leading intellectuals such as Friedrich Schleiermacher (1768–1834).[8] Rosenau underlines the significant place of Jewish women in the Enlightenment, citing writer Rahel Levin Varnhagen (1771–1833) (see

fig. 2.43); novelist Dorothea Schlegel (1764–1839), the daughter of Moses Mendelssohn; and the Berlin salonnière Henriette Herz (1764–1847) (fig. 3.62), who taught Hebrew to the polymath Alexander von Humboldt (1769–1859) and was an influence on the theologian and feminist Schleiermacher, who wrote ten additional commandments for women, supporting their intellectual desire for education.[9] Rosenau concludes:

> Lastly, the suggestion to long for knowledge and culture is in contradiction to the Nazi policy of making entry into universities and the attainment of higher education difficult for women. Instead, the present regime in Germany crushes their independence and considers them primarily breeding machines for warriors. It is timely to remember that here speaks a German tradition [Schleiermacher and the three women cited] which was alive in the German feminist movement, a tradition overshadowed by recent events, but which we hope, may well rise again.[10]

Countering the tendency of the discipline of Art History only to revere founding fathers, it is time for it to become fully inclusive of women as equal contributors to its intellectual histories and methodological innovations. My fear, I must confess, is that the waters of oblivion will fold over my own moment of interrupting patriarchy and my own contributions, because the discipline, as a whole, does not yet accept that questions of 'woman in art', and women as artists and thinkers, are not a minor, specialist subdivision to be left to the tolerated but marginalized 'feminists'. These have been central questions for art and history. Thinking these questions should be as normalized as thinking those of the scholars whose *sexual indifference* has created an amnesiac history of our common worlds and its cultural forms.

If Helen Rosenau lived to witness the destruction of the 'German tradition', the feminist movement, the feminist intellectual revolution, and the very existence of the cultures of European Jewry as she had known it, nonetheless, she used her exile to sustain and entangle critical thinking and social–historical and feminist analysis with Jewish cultural inquiry as an act of political–historical defiance. During the toughest period of her career, as war raged and as Britain almost fell to the Third Reich in 1940, Rosenau devoted her time to amassing knowledge of many disciplines and histories of thought addressing gender and society, and she placed these histories of thought and their topics centrally in the field of contemporary Art History. Her 'little book' is thus no arcane relic of a lost moment in one career. It is a critical event in the history of Art History, whose story was so damaged by and then selectively reshaped after the disaster that overwhelmed 'the German tradition' in which Helen Rosenau and so many other influential art historians of the

twentieth-century Jewish and non-Jewish intellectual diaspora were themselves formed but that they also transmitted in their publications and teaching careers.

It is easy to forget and, in the headlong rush towards 'the new', to fail to respect the work that was involved in creating a new field of study, or ensuring the continuation of an intellectual dynamic that opened up new perspectives necessitated by a battle against the darkness of fascism and racism. Yet this case speaks to something deeper, to the willed and active erasure of women's thought and of art created by women that distorts the study of art and culture. And worse. We are all thereby distorted. The example of Helen Rosenau's big project, encased in its modest but aesthetically stylish format, is a timely reminder of how elegantly, thoughtfully, and brilliantly the question of woman and art was posed by this art historian.

After half a century of feminist denunciation, the 2020s may well be known

3.62 Dorothea Therbusch-Lisiewska (1721–1782), *Henriette Herz* (1764–1847), 1778, oil on canvas, 75 × 59 cm. Berlin: Altegalerie, Germany, AI 435. Photo: bpk-Bildagentur, Germany.

for an explosion of exhibitions featuring recovered or rediscovered artist-women. Journalists have recently been asked: 'Is this a good year for women artists?'.[11] The art market has discovered 'women artists' it seems, but at what price? Folded back into monographic studies, or collected as instances of movements or styles, celebrated as discoveries no longer hidden from history? Helen Rosenau's work does not foster financialization, market valuation, or promotion of artistic commodities ripe for speculative investment that the grand exhibitions will underwrite, however serious the curators may be in their scholarship. Her book is about thinking, *with* as well as *about* art, and thinking vital questions that she reveals art has always addressed – soliciting from us a comparable depth of thought.

La Pensée with 'a woman's shape' is now not just a sculptural idea but a force in the world. It must not be lost again.

Notes to Personal Afterthoughts

1 Monica Bohm-Duchen and Vera Grodzinski (eds.), *Rubies and Rebels: Jewish Female Identity in Contemporary British Art* (London: Lund Humphries, 1996).

2 Monica Bohm-Duchen (ed.), *Insiders/Outsiders: Refugees from Nazi Europe and Their Contribution to British Visual Culture* (London: Lund Humphries, 2019). See also the conversation with Monica Bohm-Duchen at 'Insiders/Outsiders: In Conversation with Monica Bohm-Duchen', Lund Humphries, 21 April 2020, https://www.lundhumphries.com/blogs/features/insiders-outsiders, retrieved 18 March 2023.

3 Norman Kleeblatt, *Too Jewish? Challenging Traditional Identities* (New Brunswick: Rutgers University Press, 1996).

4 The phrase is derived from Bettina Aptheker's *Tapestries of Life: Women's Work, Women's Consciousness and the Meaning of Daily Life* (Amherst: University of Massachusetts Press, 1989), where she seeks a 'grounding upon which the center could pivot' to include many women's experiences and 'the multiple, highly complex and ever-changing ensembles of social relations in which women are lodged' (12).

5 Hannah Arendt, 'The Crisis in Education' [1954], in *Between Past and Future: Eight Exercises in Political Thought*, edited by Jerome Kohn (London: Penguin, 2006), 170–93: 193. First published by Viking Press, New York, in 1961 with six essays, the book was extended to eight essays in 1968.

6 Griselda Pollock, 'Is Feminism a Trauma, a Bad Memory, or a Virtual Future?', *differences* 27:2 (2016), 27–61.

7 Peter Alter, 'Refugees from Nazism and Cultural Transfer to Britain', *Immigrants & Minorities* 30 (2012), 190–210. See also Charmian Brinson and Richard Dove with Anna Müller-Härlin, *Politics by Other Means: The Free German League of Culture in London 1939–1946* (London: Vallentine Mitchell, 2010).

8 Helen Rosenau, 'Changing Attitudes towards Women', in *Women under the Swastika* (London: Free German League of Culture in Great Britain, 1942), 26–7, https://jewish-history-online.net/source/jgo:source-234, retrieved 9 May 2022. See also Juliane Jacobi, 'Friedrich Schleiermachers "Idee zu einem Katechismus der Vernunft für edle Frauen": Ein Beitrag zur Bildungsgeschichte als Geschlechtergeschichte', *Zeitschrift für Pädagogik* 46:2 (2000), 159–74.

9 It is intriguing to note that Rahel Levin Varnhagen was the topic of Hannah Arendt's *Habilitation* thesis, written during her forced exile in France and completed in 1938 but lost after her incarceration in a French concentration camp and her subsequent escape from Europe to the United States. It was finally published in English translation as *Rahel Varnhagen: The Life of a Jewess* in 1957 with the 'first complete edition' later edited by Lilian Weissberg and trans. Clara and Richard Winston (Baltimore: Johns Hopkins University Press, 2000). One copy of Arendt's German manuscript had been sent to and saved by Gershom Scholem. Much of this research also fed into volume one (*Anti-semitism*) in her *Origins of Totalitarianism* (New York: Harcourt Brace, 1951).

10 Rosenau, 'Changing Attitudes towards Women', 27.

11 See, for example, Hettie Judah, 'Another Amazing Year for Women Artists', *The Guardian*, 14 December 2022, https://www.theguardian.com/artanddesign/2022/dec/14/amazing-year-female-artists-venice-biennale-turner, accessed 27 April 2023. Judah wrote: 'Burns and Halperin's new report will be published this month. So, was this a great year for women artists? "Put it this way: if these were the figures for male artists, they'd be viewed as a crisis," they say. "Overall, the data shows a systemic apathy and complete disengagement with the scope of the problem, especially among museums. The art market has seen a marked improvement for works by women in recent years, but they remain so deeply undervalued it will take generations to catch up."' Judah also interviewed me: 'I asked Pollock whether she thought it was a good year for women artists? That was not an

interesting question, she told me, but what did it say about our society that we still needed to ask it? "Think how much creativity has been stifled, how impoverished our world is if it's only one-sided. Behind the word 'women' lies this much more fascinating complexity: each one is a singular contribution to the accumulating wealth of what culture offers as a way of understanding our world."' Art editors Charlotte Burns and Julia Halperin initiated the *Burns Halperin Report* in 2018 to investigate the representation of Black American artists, female-identifying artists, and Black American female-identifying artists in US museums and the global art market. Its third edition was published in December 2022.

Bibliography of Helen Rosenau

Compiled by Griselda Pollock

1 · By Date

BOOKS

Der Kölner Dom, die Kölner Dombauhütte und ihre Ableitung aus Frankreich: Inaugural-Dissertation zur Erlangung der Doktorwürde der Hohen Philosophischen Fakultät Rheinischen Friedrich-Wilhelms-Universität zu Bonn [Cologne Cathedral, the Cologne Cathedral Builders' Lodge and Its Derivation from France: Inaugural Dissertation for the Award of the Doctorate of the Faculty of Philosophy at the Rheinische Friedrich-Wilhelms-Universität in Bonn submitted by Helen Rosenau from Bad Kissingen] (typescript, pre-1930, collection of Michael and Louise Carmi).

Der Kölner Dom: seine Baugeschichte und historische Stellung [Cologne Cathedral: Its Architectural History and Historical Context] [1930] (Cologne: Creutzer, 1931).

Design and Medieval Architecture (London: B. T. Batsford, 1934).

The Architectural Development of the Synagogue (PhD thesis, Courtauld Institute, University of London, 1939).

'Die Kunst unter dem Nationalsozialismus' [Art under National Socialism], authored with Heinz Worner, in *Der Fall Professor Huber*, edited by Hans Siebert (London: Free German League of Culture, 1943), n.p.

Woman in Art: From Type to Personality (London: Isomorph, 1944).

The Painter Jacques-Louis David (London: Nicholson & Watson, 1948).

A Short History of Jewish Art (London: J. Clarke, 1948).

Boullée, Etienne Louis, 'Treatise on Architecture': A Complete Presentation of Architecture; Essai sur l'art, edited by Helen Rosenau (London: Alex Tiranti, 1953).

The Ideal City in Its Architectural Evolution (London: Routledge & Kegan Paul, 1959).

Social Purpose in Architecture: Paris and London Compared, 1760–1800 (London: Studio Vista, 1970).

Boullée and Visionary Architecture (London: Academy Editions, 1976).

Vision of the Temple: The Image of the Temple of Jerusalem in Judaism and Christianity (London: Oresko Books, 1979).

ARTICLES

'Zur mittelalterlichen Baugeschichte des Bremer Domes' [On the Medieval Building History of Bremen Cathedral], *Bremisches Jahrbuch* 33 (1931), 2–37.

'Zur Baugeschichte der beiden Metropolitan-Kirchen des Erzbistums Hamburg-Bremen' [On the Building History of the Two Metropolitan Churches of the Archdiocese of Hamburg-Bremen], *Denkmalpflege* (1932), 26–35, 86–94.

'Die Aurea Camera des Kölner Domes' [The Aurea Camera of Cologne Cathedral], *Architectura: Zeitschrift für Geschichte und Aesthetik der Baukunst* 1 (1933), 96–103.

'Cathedral Designs of Medieval England', *Burlington Magazine* 66:384 (1935), 128–37.

'Synagogenarchitektur' [Synagogue Architecture], *Journal of the Palestine Exploration Society* 67 (1935).

'Note on the Relationship of Jews' Court and the Lincoln Synagogue', *Archaeological Journal* 93 (1936), 51–6.

'Some Aspects of the Pictorial Influence of the Jewish Temple', *Palestine Exploration Quarterly* 68 (1936), 157–62.

'The Early Synagogue', *Archaeological Journal* 94 (1937), 64–72.

'Synagogue and the Diaspora', *Palestine Exploration Quarterly* 69:3 (1937), 196–202.

Review of *The Excavations at Dura-Europos, Conducted by Yale University and the French Academy of Inscriptions and Letters; Preliminary Report of Sixth Season of Work, October 1932–March 1933*, by M. I. Rostovtzeff, A. R. Bellinger, C. Hopkins, and C. B. Welles, *Burlington Magazine* 73:424 (1938), 43.

'Women's Portraiture', *Contemporary Review* 155 (1939), 480–84.

'The Portrait of Isabella of Castille on Coins', *Journal of the Warburg and Courtauld Institutes* 3:1/2 (1939/40), 155.

'The Institution of Marriage as Seen in Art', *International Women's News* 35:1 (1940), 13.

'Motherhood as Seen in Art', *International Women's News* 35:2 (1940), 34.

'The Synagogue and Protestant Church Architecture', *Journal of the Warburg and Courtauld Institutes* 4:1/2 (1940/41), 80–84. Reprinted in *The Synagogue: Studies in Origins, Archaeology and Architecture*, edited by Joseph Gutman (New York: Ktav, 1975), 309–15.

'The Community of Women as Seen in Art', *International Women's News* 35:3 (1941), 55.

'Creativeness in Women', *Contemporary Review* 160 (1941), 111–15.

'Towards a New Synthesis', *International Women's News* 35:5 (1941), 97–9.

'Women Pioneers as Seen in Art', *International Women's News* 35:4 (1941), 74.

'Changing Attitudes towards Women', in *Women under the Swastika* (London: Free German League of Culture in Great Britain, 1942), 26–7.

'Some English Influence on Jan van Eyck', *Apollo* 36 (1942), 125–8.

'The Prototype of the Virgin and Child in the Book of Kells', *Burlington Magazine* 83:486 (1943), 228–31.

'Social Portraits of Princess Mary', *Burlington Magazine* 83:486 (1943), 207.

'Social Status of Women as Reflected in Art', *Apollo* 37 (1943), 94–8.

'A Note on English Church Planning in the Middle Ages', *Journal of the Royal Institute of British Architecture* 3:51 (1944), 206–7.

'A Study in the Iconography of the Incarnation', *Burlington Magazine* 85:496 (1944), 172–9.

'Synagogue Architecture: An Expression of Jewish Life', *Contemporary Review* 166 (1944), 49–51.

'The History of Town Planning', *Contemporary Review* 168 (1945), 180–83.

'Claude Nicolas Ledoux', *Burlington Magazine* 88:520 (1946), 163–8.

'Art and Society', *Contemporary Review* 171 (1947), 300–2.

'The Evolution of Jewish Art', *Contemporary Review* 173 (1948), 304–6.

'Some Drawings by Jacques-Louis David in the Victoria and Albert Museum', *Burlington Magazine* 90:545 (1948), 231–3.

'Architecture and the French Revolution: Jean Jacques Lequeu', *Architecture Review* 106 (1949), 111–16.

'Current Exhibitions', *Association of Jewish Refugees Information*, November 1949, 7.

'Boullée, Architect-Philosopher', *Architecture Review* 111 (1952), 396–402.

'The Humanism of Leonardo da Vinci', *Monthly Record* 57:8 (1952), 10–11.

'Notes on the Illuminations of the Spanish Haggadah in the John Rylands Library', *Bulletin of the John Rylands Library* 36:2 (1954), 468–83.

'Contributions to the Study of Jewish Iconography', *Bulletin of the John Rylands Library* 38 (1955/56), 466–82.

'A Note on Judeo-Christian Iconography', *Journal of Jewish Studies* 7 (1956), 79–84.

'Zum Sozialproblem in der Architekturtheorie des 15. bis 19. Jahrhunderts' [On the Social Problem in Architectural Theory from the 15th to the 19th Century], in *Festschrift Martin Wackernagel zum 75. Geburtstag* [*Festschrift* for Martin Wackernagel on the Occasion of His 75th Birthday] (Köln: Böhlau, 1958), 185–93.

'The Engravings of the Grands Prix of the French Academy of Architecture', *Architectural History* 3 (1960), 15–180.

'Problems of Jewish Iconography: Synopsis', *Gazette des Beaux-Arts* 102:56 (1960), 5–18.

'The Jonah Sarcophagus in the British Museum', *Journal of British Archaeological Association* 24 (1961), 60–66.

'Textual Gleanings on Jewish Art', *Cahiers de L'Archéologie* 13 (1962), 39–42.

'German Synagogues in the Early Period of Emancipation', *Year Book of the Leo Baeck Institute of the Jews from Germany* 8:1 (1963), 214–25.

'Antoine Petit und sein Zentralplan für das Hôtel-Dieu in Paris: Ein Beitrag zur Architektur-Typologie' [Antoine Petit and His Central Plan for the Hôtel-Dieu in Paris: An Essay on Architectural Typology], *Zeitschrift für Kunstgeschichte* 27 (1964), 228–37.

'Boullée and Ledoux as Town-Planners: A Reassessment', *Gazette des Beaux-Arts* 106 (1964), 173–90.

'The Menorah: A Contribution to Jewish Symbol Formation', in *Ben Uri: Fifty Years of Achievements in the Arts*, edited by Jacob Sonntag (London: Ben Uri Art Society, 1965), 10–11.

'השפעות יהודיות על אמנות נוצרית' [Some Jewish Influences on Christian Art], *Proceedings of the World Congress of Jewish Studies* 4 (1965), 137–8.

'Style and Visual Art', *British Journal of Aesthetics* 5 (1965), 73–4.

'The Functional and the Ideal in Late Eighteenth Century French Architecture', *Architecture Review* 140 (1966), 253–8.

'The Functional Element in French Neo-Classical Architecture', *Akten des 21. Internationalen Kongresses für Kunstgeschichte Bonn 1964* (1967), 1, 226–8.

'The Sphere as an Element in the Montgolfier Monuments', *Art Bulletin* 50:1 (1968), 65–6.

'A Latterday Temple Berlin', *Architectural Design* 39 (1969), 79–88.

'A Note on the Reconstruction of Salomon's Temple and Palace by Louis Mailelt', *Gazette des Beaux-Arts* 113 (1971), 307–12.

'The Menorah in Jewish Art', *Jewish Quarterly* 19:1/2 (1971), 35.

'Neo-classicism and Emancipation', *Jewish Quarterly* 20:3 (1972), 26–7.

'The Architecture of Nicolaus de Lyra's Temple: Illustrations on the Jewish Tradition', *Journal of Jewish Studies* 25 (1974), 294–304.

'The Arts of Islam', *Jewish Quarterly* 24:1/2 (1976), 33–4.

'The Architecture of the Synagogue in Neoclassicism and Historicism', in *The Visual Dimension:*

Aspects of Jewish Art [1977], edited by Clare Moore (London: Routledge, 1993), 82–104.

'The "Days of Creation" in the Sarajevo Haggadah', *Jewish Quarterly* 25:1 (1977), 26–7.

'Gottfried Semper and German Synagogue Architecture', *Leo Baeck Institute Year Book* 22 (1977), 237–44.

'Notes on Some Qualities of Architectural Seals during the Middle Ages', *Gazette des Beaux-Arts* 90 (1977), 77–84.

'Hebrew Iconography', *Jewish Quarterly* 27:1 (1979), 38.

'Sir Moses Montefiore and the Visual Arts', *Journal of Jewish Studies* 33:2 (1979), 233–44.

'Art That Survived', *Jewish Quarterly* 28:4 (1980), 42–3.

'Reflections on Moses Montefiore and Social Function in the Arts', *Journal of Jewish Art* 8 (1981), 60–67.

'Ledoux (1736–1806): An Essay in Historiography', *Gazette des Beaux-Arts* 101 (1983), 177–86.

'Ledoux's *L'Architecture*', in Haydn Mason (ed.), *Miscellany/Mélanges: Voltaire Foundation for Enlightenment Studies*, 230 (Oxford, 1985).

2 · By Subject Area
Architecture and Architects
BOOKS

Der Kölner Dom, die Kölner Dombauhütte und ihre Ableitung aus Frankreich: Inaugural-Dissertation zur Erlangung der Doktorwürde der Hohen Philosophischen Fakultät Rheinischen Friedrich-Wilhelms-Universität zu Bonn [Cologne Cathedral, the Cologne Cathedral Builders' Lodge and Its Derivation from France: Inaugural Dissertation for the Award of the Doctorate of the Faculty of Philosophy at the Rheinische Friedrich-Wilhelms-Universität in Bonn submitted by Helen Rosenau from Bad Kissingen] (typescript, pre-1930, collection of Michael and Louise Carmi).

Der Kölner Dom: seine Baugeschichte und historische Stellung [Cologne Cathedral: Its Architectural History and Historical Context] [1930] (Cologne: Creutzer, 1931).

Design and Medieval Architecture (London: B. T. Batsford, 1934).

The Architectural Development of the Synagogue (PhD thesis, Courtauld Institute, University of London, 1939).

Boullée, Etienne Louis, 'Treatise on Architecture': A Complete Presentation of Architecture; Essai sur l'art, edited by Helen Rosenau (London: Alex Tiranti, 1953).

The Ideal City in Its Architectural Evolution (London: Routledge & Kegan Paul, 1959).

Social Purpose in Architecture: Paris and London Compared, 1760–1800 (London: Studio Vista, 1970).

Boullée and Visionary Architecture (London: Academy Editions, 1976).

ARTICLES

'Zur mittelalterlichen Baugeschichte des Bremer Domes' [On the Medieval Building History of Bremen Cathedral], *Bremisches Jahrbuch* 33 (1931), 2–37.

'Zur Baugeschichte der beiden Metropolitan-Kirchen des Erzbistums Hamburg-Bremen' [On the Building History of the Two Metropolitan Churches of the Archdiocese of Hamburg-Bremen], *Denkmalpflege* (1932), 26–35, 86–94.

'Die Aurea Camera des Kölner Domes' [The Aurea Camera of Cologne Cathedral], *Architectura: Zeitschrift für Geschichte und Aesthetik der Baukunst* 1 (1933), 96–103.

'Cathedral Designs of Medieval England', *Burlington Magazine* 66:384 (1935), 128–37.

'Some Aspects of the Pictorial Influence of the Jewish Temple', *Palestine Exploration Quarterly*, 68 (1936), 157–62.

'The Synagogue and Protestant Church Architecture', *Journal of the Warburg and Courtauld Institutes* 4:1/2 (1940/41), 80–84. Reprinted in *The Synagogue: Studies in Origins, Archaeology and Architecture*, edited by Joseph Gutman (New York: Ktav, 1975), 309–15.

'A Note on English Church Planning in the Middle Ages', *Journal of the Royal Institute of British Architecture* 3:51 (1944), 206–7.

'Synagogue Architecture: An Expression of Jewish Life', *Contemporary Review* 166 (1944), 49–51.

'The History of Town Planning', *Contemporary Review* 168 (1945), 180–83.

'Claude Nicolas Ledoux', *Burlington Magazine* 88:520 (1946), 163–8.

'Some Drawings by Jacques-Louis David in the Victoria and Albert Museum', *Burlington Magazine* 90:545 (1948), 231–3.

'Architecture and the French Revolution: Jean Jacques Lequeu', *Architecture Review* 106 (1949), 111–16.

'Boullée, Architect-Philosopher', *Architecture Review* 111 (1952), 396–402.

'Zum Sozialproblem in der Architekturtheorie des 15. bis 19. Jahrhunderts' [On the Social Problem in Architectural Theory from the 15th to the 19th Century], in *Festschrift Martin Wackernagel zum 75. Geburtstag* [*Festschrift* for Martin Wackernagel on the Occasion of His 75th Birthday] (Köln: Böhlau, 1958), 185–93.

'The Engravings of the Grands Prix of the French Academy of Architecture', *Architectural History* 3 (1960), 15–180.

'German Synagogues in the Early Period of Emancipation', *Year Book of the Leo Baeck Institute of the Jews from Germany* 8: 1 (1963), 214–25.

'Antoine Petit und sein Zentralplan für das Hôtel-Dieu in Paris: Ein Beitrag zur Architektur-Typologie' [Antoine Petit and His Central Plan for the Hôtel-Dieu in Paris: An Essay on Architectural Typology], *Zeitschrift für Kunstgeschichte* 27 (1964), 228–37.

'Boullée and Ledoux as Town-Planners: A Reassessment', *Gazette des Beaux-Arts* 106 (1964), 173–90.

'The Functional and the Ideal in Late Eighteenth Century French Architecture', *Architecture Review* 140 (1966), 253–8.

'The Functional Element in French Neo-Classical Architecture', *Akten des 21. Internationalen Kongresses für Kunstgeschichte Bonn 1964* (1967), 1, 226–8.

'The Sphere as an Element in the Montgolfier Monuments', *Art Bulletin* 50:1 (1968), 65–6.

'A Latterday Temple Berlin', *Architectural Design* 39 (1969), 79–88.

'A Note on the Reconstruction of Salomon's Temple and Palace by Louis Mailelt', *Gazette des Beaux-Arts* 113 (1971), 307–12.

'The Architecture of Nicolaus de Lyra's Temple: Illustrations on the Jewish Tradition', *Journal of Jewish Studies* 25 (1974), 294–304.

'Gottfried Semper and German Synagogue Architecture', *Leo Baeck Institute Year Book* 22 (1977), 237–44.

'Notes on Some Qualities of Architectural Seals during the Middle Ages', *Gazette des Beaux-Arts* 90 (1977), 77–84.

'Ledoux (1736–1806): An Essay in Historiography', *Gazette des Beaux-Arts* 101 (1983), 177–86.

'Ledoux's *L'Architecture*', in Haydn Mason (ed.), *Miscellany/Mélanges: Voltaire Foundation for Enlightenment Studies*, 230 (Oxford, 1985).

Jewish Art and Architecture

BOOKS

The Architectural Development of the Synagogue (PhD thesis, Courtauld Institute, University of London, 1939).

A Short History of Jewish Art (London: J. Clarke, 1948).

Vision of the Temple: The Image of the Temple of Jerusalem in Judaism and Christianity (London: Oresko Books, 1979).

ARTICLES

'Synagogenarchitektur' [Synagogue Architecture], *Journal of the Palestine Exploration Society* 67 (1935).

'Note on the Relationship of Jews' Court and the Lincoln Synagogue', *Archaeological Journal* 93 (1936), 51–6.

'Some Aspects of the Pictorial Influence of the Jewish Temple', *Palestine Exploration Quarterly* 68 (1936), 157–62.

'The Early Synagogue', *Archaeological Journal* 94 (1937), 64–72.

'Synagogue and the Diaspora', *Palestine Exploration Quarterly* 69:3 (1937), 196–202.

Review of *The Excavations at Dura-Europos, Conducted by Yale University and the French Academy of Inscriptions and Letters; Preliminary Report of Sixth Season of Work, October 1932–March 1933*, by M. I. Rostovtzeff, A. R. Bellinger, C. Hopkins, and C. B. Welles, *Burlington Magazine* 73:424 (1938), 43.

'The Synagogue and Protestant Church Architecture', *Journal of the Warburg and Courtauld Institutes* 4:1/2 (1940/41), 80–84.

'Synagogue Architecture: An Expression of Jewish Life', *Contemporary Review* 166 (1944), 49–51.

'The Evolution of Jewish Art', *Contemporary Review* 173 (1948), 304–6.

'Notes on the Illuminations of the Spanish Haggadah in the John Rylands Library', *Bulletin of the John Rylands Library* 36:2 (1954), 468–83.

'Contributions to the Study of Jewish Iconography', *Bulletin of the John Rylands Library* 38 (1955/56), 466–82.

'A Note on Judeo-Christian Iconography', *Journal of Jewish Studies* 7 (1956), 79–84.

'Problems of Jewish Iconography: Synopsis', *Gazette des Beaux-Arts* 102:56 (1960), 5–18.

'The Jonah Sarcophagus in the British Museum', *Journal of British Archaeological Association* 24 (1961), 60–66.

'Textual Gleanings on Jewish Art', *Cahiers de L'Archéologie* 13 (1962), 39–42.

'German Synagogues in the Early Period of Emancipation', *Year Book of the Leo Baeck Institute of the Jews from Germany* 8: 1 (1963), 214–25.

'The Menorah: A Contribution to Jewish Symbol Formation', in *Ben Uri: Fifty Years of Achievements in the Arts*, edited by Jacob Sonntag (London: Ben Uri Art Society, 1965), 10–11.

'השפעות יהודיות על אמנות נוצרית' [Some Jewish Influences on Christian Art], *Proceedings of the World Congress of Jewish Studies* 4 (1965), 137–8.

'The Menorah in Jewish Art', *Jewish Quarterly* 19:1/2 (1971), 35.

'Neo-classicism and Emancipation', *Jewish Quarterly* 20:3 (1972), 26–7.

'The Architecture of the Synagogue in Neoclassicism and Historicism', in *The Visual Dimension: Aspects of Jewish Art* [1977], edited by Clare Moore (London: Routledge, 1993), 82–104.

'The "Days of Creation" in the Sarajevo Haggadah', *Jewish Quarterly* 25:1 (1977), 26–7.

'Hebrew Iconography', *Jewish Quarterly* 27:1 (1979), 38.

'Sir Moses Montefiore and the Visual Arts', *Journal of Jewish Studies* 33:2 (1979), 233–44.

'Art That Survived', *Jewish Quarterly* 28:4 (1980), 42–3.

'Reflections on Moses Montefiore and Social Function in the Arts', *Journal of Jewish Art* 8 (1981), 60–67.

Eighteenth-Century French Art and Architecture

BOOKS

The Painter Jacques-Louis David (London: Nicholson & Watson, 1948).

Boullée, Etienne Louis, *'Treatise on Architecture': A Complete Presentation of Architecture; Essai sur l'art*, edited by Helen Rosenau (London: Alex Tiranti, 1953).

The Ideal City in Its Architectural Evolution (London: Routledge & Kegan Paul, 1959).

Social Purpose in Architecture: Paris and London Compared, 1760–1800 (London: Studio Vista, 1970).

Boullée and Visionary Architecture (London: Academy Editions, 1976).

ARTICLES

'Claude Nicolas Ledoux', *Burlington Magazine* 88:520 (1946), 163–8.

'Some Drawings by Jacques-Louis David in the Victoria and Albert Museum', *Burlington Magazine* 90:545 (1948), 231–3.

'Architecture and the French Revolution: Jean Jacques Lequeu', *Architecture Review* 106 (1949), 111–16.

'Boullée, Architect-Philosopher', *Architecture Review* 111 (1952), 396–402.

'The Engravings of the Grands Prix of the French Academy of Architecture', *Architectural History* 3 (1960), 15–180.

'Boullée and Ledoux as Town-Planners: A Reassessment', *Gazette des Beaux-Arts* 106 (1964), 173–90.

'The Sphere as an Element in the Montgolfier Monuments', *Art Bulletin* 50:1 (1968), 65–6.

'Ledoux (1736–1806): An Essay in Historiography', *Gazette des Beaux-Arts* 101 (1983), 177–86.

Women in Art

BOOKS

Woman in Art: From Type to Personality (London: Isomorph, 1944).

ARTICLES

'Women's Portraiture', *Contemporary Review* 155 (1939), 480–84.

'The Portrait of Isabella of Castille on Coins', *Journal of the Warburg and Courtauld Institutes* 3:1/2 (1939/40), 155.

'The Institution of Marriage as Seen in Art', *International Women's News* 35:1 (1940), 13.

'Motherhood as Seen in Art', *International Women's News* 35:2 (1940), 34.

'The Community of Women as Seen in Art', *International Women's News* 35:3 (1941), 55.

'Creativeness in Women', *Contemporary Review* 160 (1941), 111–15.

'Towards a New Synthesis', *International Women's News* 35:5 (1941), 97–9.

'Women Pioneers as Seen in Art', *International Women's News* 35:4 (1941), 74.

'Changing Attitudes towards Women', in *Women under the Swastika* (London: Free German League of Culture in Great Britain, 1942), 26–7.

'The Prototype of the Virgin and Child in the Book of Kells', *Burlington Magazine* 83:486 (1943), 228–31.

'Social Portraits of Princess Mary', *Burlington Magazine* 83:486 (1943), 207.

'Social Status of Women as Reflected in Art', *Apollo* 37 (1943), 94–8.

General

'Some English Influence on Jan van Eyck', *Apollo* 36 (1942), 125–8.

'Die Kunst unter dem Nationalsozialismus' [Art under National Socialism], authored with Heinz Worner, in *Der Fall Professor Huber*, edited by Hans Siebert (London: Free German League of Culture, 1943), n.p.

'A Study in the Iconography of the Incarnation', *Burlington Magazine* 85:496 (1944), 172–9.

'Art and Society', *Contemporary Review* 171 (1947), 300–2.

'Current Exhibitions', *Association of Jewish Refugees Information*, November 1949, 7.

'The Humanism of Leonardo da Vinci', *Monthly Record* 57:8 (1952), 10–11.

'Style and Visual Art', *British Journal of Aesthetics* 5 (1965), 73–4.

'The Arts of Islam', *Jewish Quarterly* 24:1/2 (1976), 33–4.

Bibliography for Parts 1 and 3

ALTER, Peter. 'Refugees from Nazism and Cultural Transfer to Britain', *Immigrants & Minorities* 30 (2012), 190–210.

ANDERSON, Perry. 'Components of the National Culture' [1968], in *Student Power: Problems, Diagnosis, Action*, edited by Alexander Cockburn and Robin Blackburn (Harmondsworth: Penguin, 1969), 214–86.

ANON., 'Personalia', *AJR Information*, April 1951, 7.

ANTAL, Frederick. 'Remarks on Method of Art History' [1949], in *Classicism and Romanticism, with Other Studies in Art History* (London: Routledge & Kegan Paul, 1966), 175–89.

APTHEKER, Bettina. *Tapestries of Life: Women's Work, Women's Consciousness and the Meaning of Daily Life* (Amherst: University of Massachusetts Press, 1989).

ARCHER, W. G. and M. Archer, 'Santhal Painting', *Axis* 7 (1936), 27–8.

ARENDT, Hannah. 'Philosophie und Soziologie: Anlässlich Karl Mannheim, *Ideologie und Utopie*' [Philosophy and Sociology: On Karl Mannheim's *Ideology and Utopia*], *Die Gesellschaft* 7:1 (1930), 1631–76.

——. 'We Refugees' [1943], in *The Jewish Writings*, ed. Jerome Kohn and Ron Feldman (New York: Schocken Books, 2007), 264–74.

——. *Origins of Totalitarianism* (New York: Harcourt Brace, 1951).

——. 'The Crisis in Education' [1954], in *Between Past and Future: Eight Exercises in Political Thought*, edited by Jerome Kohn (London: Penguin, 2006), 170–93.

——. *Rahel Varnhagen: The Life of a Jewess* [1957], edited by Lilian Weissberg, translated by Clara and Richard Winston (Baltimore: Johns Hopkins University Press, 2000).

——. *The Human Condition* (Chicago: University of Chicago Press, 1958).

——. 'Philosophy and Sociology', in *Essays in Understanding 1930–1954*, edited by Jerome Kohn, translated by Robert Kimber and Rita Kimber (New York: Harcourt Brace, 1994), 28–43.

——. *The Jewish Writings*, edited by Jerome Kohn and Ron Feldman (New York: Schocken Books, 2007).

ASHLEY Montagu, M. F. *Marriage, Past and Present: A Debate between Robert Briffault and Bronisław Malinowski* (Boston: Porter Sargent, 1956).

AUDEN, W. H. *W. H. Auden: Collected Poems*, edited by Edward Mendelson (London: Faber & Faber, 1976).

AZATYAN, Vardan. 'Ernst Gombrich's Politics of Art History: Exile, Cold War and *The Story of Art*', *Oxford Art Journal* 33:2 (2010), 129–41.

BAEHR, Peter, 'Sociology and the Mistrust of Thought: Hannah Arendt's Encounter with Karl Mannheim and the Sociology of Knowledge', https://www.bard.edu/library/archive/arendt/kettler-mannhiem/SocioMistrust.pdf, retrieved 18 February 2023.

BAHRANI, Zainab. 'The Iconography of the Nude in Mesopotamia', *Source: Notes in the History of Art* 12:2 (1993), 12–19.

——. 'The Hellenization of Ishtar: Nudity, Fetishism and the Production of Cultural Differentiation in Ancient Art,' *Oxford Art Journal* 19:2 (1996), 3–16.

——. *Women of Babylon: Gender and Representation in Mesopotamia* (London: Routledge, 2001).

BAIN, Jennifer (ed.). *The Cambridge Companion to Hildegard of Bingen* (Cambridge: Cambridge University Press, 2021).

BAL, Mieke. *Reading Rembrandt: Beyond the Word–Image Opposition* (Cambridge: Cambridge University Press, 1991).

——. 'Recognition: Reading Icons, Seeing Stories', in *Reading Rembrandt: Beyond the Word–Image Opposition* (Cambridge: Cambridge University Press, 1991), 177–215.

——. *Quoting Caravaggio: Contemporary Art, Preposterous History* (Chicago: University of Chicago Press, 1999).

BARRETT Browning, Elizabeth. *Aurora Leigh and Other Poems*, introduced by Cora Kaplan (London: Women's Press, 1978).

BARTHES, Roland. 'Myth Today', in *Mythologies* [1957], translated by Annette Lavers (St Albans: Paladin, 1973), 109–59.

——. 'The Rhetoric of the Image' [1964], in *Image, Music, Text*, edited and translated by Stephen Heath (London: Fontana/Collins, 1977), 32–51.

BEARD, Mary Ritter. *Women as a Force in History: A Study in Traditions and Realities* (New York: Macmillan, 1946).

BEAULIEU, Jill and Mary Roberts (eds.). *Orientalism's Interlocutors: Painting, Architecture, Photography* (Durham: Duke University Press, 2002).

BEAUVOIR, Simone de. *Le deuxième sexe* [The Second Sex] (Paris: Éditions Gallimard, 1949).

——. *The Second Sex* [1949], translated by Constance Borde and Sheila Malovany-Chevalier (London: Vintage Books, 2011).

BENEDICT, Ruth. *Patterns of Culture* (London: Routledge & Kegan Paul, 1934).

BÉNÉZIT, Emmanuel. *Dictionnaire des peintres, sculpteurs, dessinateurs, et graveurs* [Dictionary of Painters, Sculptors, Draftsmen, and Engravers] (Paris: Éditions Gründ, 1911).

BERGHAN, Marion. *Continental Britons: German-Jewish Refugees from Nazi Germany* (London: Berghan, 1988).

BERGSON, Henri. *Matière et mémoire* [Matter and Memory] (Paris: Félix Alcan, 1896).

BERNAL, J. D. 'Foreword' to *Catalogue of Sculpture by Barbara Hepworth* [1937], in *Barbara Hepworth: A Pictorial Biography* (London: Tate Gallery, 1993), 36.

BERRYMAN, Jim. 'Frederick Antal and the Marxist Challenge to Art History', *History of the Human Sciences* 35:2 (2022), 55–7.

BILLINGTON-GREIG, Teresa. *The Non-violent Militant: Selected Writings of Teresa Billington-Greig*, edited by Carol McPhee and Ann Fitzgerald (London: Routledge & Kegan Paul, 1987).

BOAS, Frans. *Primitive Art* (Oslo: Institute for Comparative Culture Research; Cambridge, MA: Harvard University Press, 1927).

BOHLMANN-MODERSOHN, Marina. *Paula Modersohn-Becker: Eine Biographie mit Briefen* [Paula Modersohn-Becker: A Biography with Letters] (Berlin: Knaus, 1997).

BOHM-DUCHEN, Monica (ed.). *Insiders/Outsiders: Refugees from Nazi Europe and Their Contribution to British Visual Culture* (London: Lund Humphries, 2019).

—— and Vera Grodzinski (eds.). *Rubies and Rebels: Jewish Female Identity in Contemporary British Art* (London: Lund Humphries, 1996).

BOWEN, Stella. *Drawn from Life: Reminiscences by Stella Bowen* (London: Collins, 1941).

——. *Drawn from Life: Reminiscences by Stella Bowen* (London: Virago Books, 1984)

BRINSON, Charmian and Richard Dove with Anna Müller-Härlin. *Politics by Other Means: The Free German League of Culture in London 1939–1946* (London: Vallentine Mitchell, 2010).

BRITTAIN, Vera. *Testament of Youth* (London: Victor Gollancz, 1933).

——. *Testament of Friendship: The Story of Winifred Holtby* (London: Macmillan, 1940).

BRONFEN, Elisabeth. *The Knotted Subject: Hysteria and Its Discontents* (Princeton: Princeton University Press, 1998).

BROUN, Elisabeth and Ann Gabhart. 'Old Mistresses: Women Artists of the Past', *Walters Art Gallery Bulletin* 24:7 (1972).

BURCKHARDT, Jacob. *Die Kultur der Renaissance in Italien: Ein Versuch* [Renaissance Culture in Italy: An Attempt] (Basel: Schweighauser, 1860).

——. *Civilization of the Renaissance in Italy*, translated by S. G. C. Middlemore (London: George Allen & Unwin, 1878).

BUSCH, Gunter and Liselotte von Reinken (eds.). *The Letters and Journals of Paula Modersohn-Becker* (Chicago: Northwestern University Press, 1998).

BUTLER, E. M. 'Alkestis in Modern Dress', *Journal of the Warburg Institute* 1:1 (1937), 46–60.

CALLEN, Anthea. *Looking at Men: Art, Anatomy and the Modern Male Body* (New Haven and London: Yale University Press, 2018).

CAMPBELL, Nathaniel M. '*Imago expandit splendorem suum*: Hildegard of Bingen's Visio-theological Designs in the Rupertsberg *Scivias* Manuscript', *Eikón / Imago* 4:2 (2013), 1–68.

CAMPBELL, Olwen W. (ed.). *The Feminine Point of View* (London: Williams and Norgate, 1952).

CARPENTIER, Martha C. 'Jane Harrison and Ritual Theory', *Journal of Ritual Studies* 8:1 (1994), 11–26.

CARRIER, David. 'Gombrich and Danto on Defining Art', *Journal of Aesthetics and Art Criticism*, 54:3 (1996), 279–81.

CASSIRER, Ernst. *Philosophie der symbolischen Formen* [Philosophy of Symbolic Forms], 4 vols (Berlin: Bruno Cassirer, 1923).

——. *Philosophy of Symbolic Forms* [1923], translated by Steve G. Lofts, 3 vols (London: Routledge, 2020).

——. *An Essay on Man: An Introduction to a Philosophy of Human Culture* (New Haven: Yale University Press, 1944).

CAVARERO, Adriana. *Inclinations: A Critique of Rectitude*, translated by Adam Sitze and Amanda Minervini (Stanford: Stanford University Press, 2016).

CAVINESS, Madeline. 'Artist: "To See, Hear, and Know All at Once"', in *Voice of the Living Light: Hildegard of Bingen and Her World*, edited by Barbara Newman (Berkeley: University of California Press, 1998), 110–24.

CHESLER, Phyllis. *About Men* (New York: Simon & Schuster, 1978).

CLAYTON, Eleanor. *Barbara Hepworth: Art & Life* (London: Thames & Hudson, 2021).

CLÉMENT, Catherine and Julia Kristeva. *Le féminin et le sacré* [The Feminine and the Sacred] (Paris: Éditions Stock, 1998).

——. *The Feminine and the Sacred*, translated by Jane Marie Todd (New York: Cornell University Press, 2001).

CLEMENT, Claire Erskine. *Women in the Fine Arts from the Seventh Century B.C. to the Twentieth Century A.D.* (Boston: Houghton Mifflin, 1904).

——. *Women in the Fine Arts from the Seventh Century B.C. to the Twentieth Century A.D.* (Westwood, CT: Greenwood Press, 1981)

CODE, Lorraine. *What Can She Know? Feminist Theory and the Construction of Knowledge* (Ithaca: Cornell University Press, 1991).

COOKE, Jennifer. 'Frederick Antal: Connoisseur Turned Social Historian', in *Migrating Histories of Art: Self-Translations of a Discipline*, edited by Maria Teresa Costa and Hans Christian Hönes (Berlin: De Gruyter, 2018), 99–110.

COSTA, Maria Teresa, and Hans Christian Hönes (eds.), *Migrating Histories of Art: Self-Translations of a Discipline* (Berlin: De Gruyter, 2018).

CURTIS, Penelope. *Barbara Hepworth* (London: Tate Publishing, 1998).

DAHRENDORF, Ralf. *LSE: A History of the London School of Economics and Political Science 1895–1995* (Oxford: Oxford University Press, 1995).

DE ZEGHER, Catherine (ed.). *Inside the Visible: An Elliptical Traverse of Twentieth Century Art in, of, and from the Feminine* (Cambridge, MA: MIT Press, 1996).

DELEUZE, Gilles. *Bergsonism* [1988], translated by Hugh Tomlinson and Barbara Habberjam (New York: Zone Books, 1996).

DISPLACED German Scholars: A Guide to Academics in Peril in Nazi Germany During the 1930s [1936] (San Bernardino: Borgo Press, 1993).

DIXON, Suzanne. *Cornelia, Mother of the Gracchi* (London: Routledge, 2007).

DOUIE, Vera. *The Lesser Half: A Survey of the Laws, Regulations and Practices Introduced during This Present War that Embody Discrimination against Women* (London: Women's Publication Planning Association, n.d. [c.1940]).

——. *Daughters of Britain: An Account of the Work of British Women during the 2nd World War* (Oxford: Vincent Baxter Press, 1950).

DUNCAN, Carol. 'Virility and Male Domination in Early Twentieth Century Vanguard Art', *Art Forum*, December 1973, 30–39.

——. 'MoMA's Hot Mamas', *Art Journal* 48:2 (1989), 171–8.

——. *The Aesthetics of Power: Essays in Critical Art History* (Cambridge: Cambridge University Press, 1993), 189–210.

DYHOUSE, Carol. 'The British Federation of University Women and the Status of Women in Universities, 1907–1939', *Women's History Review* 4:4 (1955), 465–85.

EINSTEIN, Carl. *Negerplastik* (Leipzig: Verlag der weißen Bücher, 1915).

ELIAS, Norbert. *The Civilizing Process*, vol. 1: *The History of Manners*, translated by E. Jephcott (Oxford: Blackwell, 1969).

ELLER, Cynthia. *Gentlemen and Amazons: The Myth of Matriarchal Prehistory 1861–1900* (Berkeley: University of California Press, 2011).

ELSNER, Jaś. 'From Empirical Evidence to the Big Picture: Some Reflections on Riegl's Concept of Kunstwollen', *Critical Inquiry* 32 (2006), 741–66.

—— and Katharina Lorenz. 'The Genesis of Iconology', *Critical Inquiry* 38:3 (2012), 483–512.

ETTINGER, Bracha Lichtenberg. 'The Becoming Thresholds of Matrixial Borderlines', in *Travellers' Tales: Narratives of Home and Displacement*, edited by Jon Bird, Barry Curtis, Melinda Mash, Tim Putnam, George Robertson, and Lisa Tickner (London: Routledge, 1994), pp. 38–62.

——. 'Transgressing with-in-to the Feminine', in *Differential Aesthetics: Art Practices, Philosophy and Feminist Understandings* (Aldershot: Ashgate, 2000), pp. 185–209.

—— and Emmanuel Levinas. *Time Is the Breath of the Spirit* (Oxford: Museum of Modern Art, 1993).

EVANS, Richard J. *Eric Hobsbawm: A Life in History* (London: Little, Brown, 2019).

FANON, Frantz. *Peau Noire, Masques Blancs* [Black Skin, White Masks] (Paris: Éditions du Seuil, 1952).

FANTHAM, Elaine, Helene Peet Foley, Natalie Boymel Kampen, Sarah B. Pomeroy, and H. Alan Shapiro. *Women in the Classical World: Image and Text* (New York: Oxford University Press, 1994).

FARRELL, Bethany. 'How Our Tools Shape Us: Technology's Impact on Art History', Scholars Studio (Temple University), 19 February 2019, https://sites.temple.edu/tudsc/2019/02/19/how-our-tools-shape-us-technologys-impact-on-art-history, retrieved 27 April 2023.

FEDERICI, Sylvia. *Caliban and the Witch: Women, the Body and Primitive Accumulation* (London: Penguin, 2021).

FEIL, Katharina. *A Scholar's Life: Rachel Wischnitzer and the Development of Jewish Art Scholarship in the Twentieth Century* (New York: Jewish Theological Seminary, 1984).

FINE, Elsa Honig. *Women and Art: A History of Women Painters and Sculptors from the Renaissance to the 20th Century* (Montclair, NJ: Allanheld, Osmun & Co., 1978).

FLECKER, Uwe. *The Snake and the Lightning: Warburg's American Journey*, translated by Kevin Cook (Berlin: Hatje Cantz, 2023).

FORREST Weber, Catherine E. 'Mary Ritter Beard: Historian of the Other Half', *Traces of Indiana and Midwestern History*, 15:1 (2003), 5–13.

FORSTER, Kurt W. 'Aby Warburg: His Study of Ritual and Art on Two Continents', translated by David Britt, *October* 102:77 (1996), 5–24.

FOUCAULT, Michel. *L'archéologie du savoir* [The Archaeology of Knowledge] (Paris: Gallimard, 1969).

——. *The Archaeology of Knowledge* [1972], trans. A. M. Sheridan-Smith (London: Tavistock, 1972).

FREUD, Sigmund with Josef Breuer. 'Studies on Hysteria' [1893–5], *The Standard Edition of the Complete Psychological Works of Sigmund Freud*, edited by James Strachey with Anna Freud (London: Hogarth Press and the Institute of Psychoanalysis, 1953).

FREUDENTHAL, Margarete. *Gestaltwandel der städtischen, bürgerlichen und proletarischen Hauswirtschaft zwischen 1760 und 1910* [1933] (Frankfurt: Ullstein, 1986).

FREUND, Gisèle. *Photographie et société* [Photography and Society] (Paris: Éditions du Seuil, 1974).

——. *Photography and Society* [1974], translated by David R. Godine (Boston: David R. Godine, 1980).

FRIEDAN, Betty. *The Feminine Mystique* (New York: W. H. Norton, 1963).

GABHART, Ann and Elizabeth Broun. *Old Mistresses: Women Artists of the Past* (Baltimore: Walters Art Gallery, 1972).

GARB, Tamar. *Sisters of the Brush: Women's Artistic Culture in Late Nineteenth-Century Paris* (New Haven and London: Yale University Press, 1994).

GEHEIME Staatspolizei, *Die Sonderfahndungsliste GB* [The Black Book], Hoover Institution Library and Archives, Stanford University, 1940, https://digitalcollections.hoover.org/objects/55425/

die-sonderfahndungsliste-gb, retrieved 1 March 2023.

'GERMAN Painter Erich Wolfsfeld's "Forgotten" Artwork to be Auctioned in Knutsford', *Knutsford Guardian*, 3 July 2009, https://www.knutsfordguardian.co.uk/news/4473383.german-painter-erich-wolfsfelds-forgotten-artwork-to-be-auctioned-in-knutsford, retrieved 18 March 2023.

GIBSON, William. *Barbara Hepworth* (London: Faber, 1946).

GIMBUTAS, Marija. *The Goddesses and Gods of Old Europe* (Berkeley: University of California Press, 1974).

——. *The Language and the Goddess: Unearthing the Hidden Symbols of Western Civilization* (San Francisco: Harper & Row, 1989).

——. *The Civilization of the Goddess* (San Francisco: Harper, 1991).

GOFFEN, Rona. *Titian's 'Venus of Urbino'* (Cambridge: Cambridge University Press, 1997).

GOLDSCHEIDER, Ludwig. *Five Hundred Self-Portraits from Antique Times to the Present Day in Sculpture, Painting, Drawing and Engraving*, translated by J. Byam Shaw (Vienna: Phaidon; London: George Allen & Unwin, 1937).

GOMBRICH, Ernst. *The Story of Art* [1950] (London: Phaidon, 1962).

——. 'Arnold Hauser, *The Social History of Art*, 2 Volumes', *Art Bulletin* 35:1 (1953), 79–84.

——. *Art and Illusion: A Study in the Psychology of Pictorial Illusion* (London: Phaidon Press, 1960).

GOSSLING, Glenn. 'Sylvia Leith-Ross', Tavistock and Portman NHS Foundation Trust, 2019, https://100years.tavistockandportman.nhs.uk/sylvia-leith-ross, accessed 27 April 2023.

GOUGES, Olympe de. 'The Rights of Woman', 1791, https://pages.uoregon.edu/dluebke/301ModernEurope/GougesRightsofWomen.pdf, retrieved 4 April 2023.

GREER, Germaine. *The Obstacle Race: Fortunes of Women Painters and Their Work* (London: Secker & Warburg, 1979).

[GSELL, Paul] Rodin, Auguste. *L'Art: entretiens réunis par Paul Gsell* (Paris: Bernard Grasset, 1911).

HAMILTON, Peter. 'Editor's Foreword', in *Karl Mannheim*, by David Kettler, Volker Meja, and Nico Stehr (Chichester: Ellis Harwood; London: Tavistock, 1984).

HAMMACHER, A. M. *Barbara Hepworth* (Amsterdam: DeLange, 1958).

HARAWAY, Donna J. 'Gender for a Marxist Dictionary', in *Simians, Cyborgs and Women: The Reinvention of Nature* (London: Free Association Books, 1991), 127–48.

——. 'Situated Knowledges: The Science Question in Feminism and the Privilege of Partial Perspective', in *Simians, Cyborgs and Women: The Reinvention of Nature* (London: Free Association Books, 1991), 183–202.

HART, Joan. 'Erwin Panofsky and Karl Mannheim: A Dialogue on Interpretation', *Critical Inquiry* 19:3 (1993), 534–66.

HAUSER, Arnold. *The Social History of Art* (London: Routledge & Kegan Paul, 1951).

HAY, Denys. 'Burckhardt's Renaissance: 1860–1960', *History Today*, 10:1 (1960), 14–23.

HIGONNET, Anne. 'Making Babies, Painting Bodies: Women, Art, and Paula Modersohn-Becker's Productivity', *Woman's Art Journal* 30:2 (2009), 15–21.

HILDEBRANDT, Hans. *Die Frau als Künstlerin: mit 337 Abbildungen nach Frauenarbeiten bildender Kunst von den frühesten Zeiten bis zur Gegenwart* [Woman as Artist with 337 Images of Women's Work in the Visual Arts from Earliest Times to the Present] (Berlin: Rudolf Moss Verlag, 1928).

HILLS, Patricia. 'Art History Textbooks: The Hidden Persuaders', *Artforum* 14:10 (1976), 58–61.

HIRSCH, Felix E. 'Biographical Article: George Peabody Gooch', *Journal of Modern History* 26:3 (1954), 260–71.

HISCOCK, Karen Anne. *Axis and Authentic Abstraction in 1930s England* (PhD thesis, University of York, 2005).

HOFNER-KULENKAMP, Gabriele. 'Versprengte Europäerinnen: Deutschsprachige Kunsthistorikerinnen im Exil' [Dispersed Europeans: German-Speaking Women Art Historians in Exile], in *Frauen und Exil: Zwischen Anpassung und Selbstbehauptung* [Women and Exile: Between Adaptation and Self-Assertion], edited by Gesellschaft für Exilforschung (Munich: text+critik, 1993), 190–202.

HÖNES, Hans Christian. 'Warburg's Positivism: Confessions of a Truffle Pig', *Oxford Art Journal* 41:3 (2018), 361–79.

——. '"A Very Specialized Subject": Art History in Britain', in *Insiders/Outsiders: Refugees from Nazi Europe and Their Contribution to British Visual Culture*, edited by Monica Bohm-Duchen (London: Lund Humphries, 2019), 97–104.

HOOKS, bell. *Talking Back: Thinking Feminist – Thinking Black* (Boston: South End Press, 1989).

'INSIDERS/OUTSIDERS: In Conversation with Monica Bohm-Duchen', Lund Humphries, 21 April 2020, https://www.lundhumphries.com/blogs/features/insiders-outsiders, retrieved 18 March 2023.

IRIGARAY, Luce. 'Questions', in *This Sex Which Is Not One* [1977], translated by Catherine Porter with Carolyn Burke (Ithaca: Cornell University Press, 1985), 119–69.

——. 'The Age of the Breath', in *Key Writings* (London: Continuum, 2004), 165–70.

IVERSON, Margaret. *Alois Riegl: Art History and Theory* (Cambridge, MA: MIT Press, 2003).

JACOBI, Juliane. 'Friedrich Schleiermachers "Idee zu einem Katechismus der Vernunft für edle Frauen": Ein Beitrag zur Bildungsgeschichte als Geschlechtergeschichte' [Friedrich Schleiermacher's 'Idea for a Catechism of Reason for Noble Women': A Contribution to the History of Education as Gender History], *Zeitschrift für Pädagogik* 46:2 (2000), 159–74.

JANSON, H. W. *History of Art*, 3rd edition, revised and expanded by Anthony F. Janson (Englewood Cliffs, NJ: Prentice Hall, 1986).

—— with Dora Jane Janson. *History of Art* (New York: Abrams, 1962).

JAY, Martin. *The Dialectical Imagination: A History of the Frankfurt School and the Institute for Social Research* (Los Angeles: University of California Press, 1973).

JONES, Ernest. 'A Psycho-Analytic Study of the Holy Ghost', in *Essays in Applied Psycho-Analysis* (London: Psycho-Analytical Press, 1923), 415–30.

——. 'The Madonna's Conception through the Ear' [1923], in *Essays in Applied Psycho-Analysis* (London: Hogarth Press, 1951), 260–359.

JUDAH, Hettie. 'Another Amazing Year for Women Artists', *The Guardian*, 14 December 2022, https://www.theguardian.com/artanddesign/2022/dec/14/amazing-year-female-artists-venice-biennale-turner, accessed 27 April 2023.

KABBANI, Rana. *Europe's Myths of Orient: Devise and Rule* (Basingstoke: Macmillan, 1986).

KECSKEMETI, Paul. 'Introduction', in *Essays on the Sociology of Knowledge*, by Karl Mannheim (London: Routledge & Kegan Paul, 1952), 1–32.

KELLY, Mary. 'Sexual Politics and Art' [1977], in *Framing Feminism: Art and the Women's Movement 1970–1985*, edited by Rozsika Parker and Griselda Pollock (London: Pandora Books, 1995), 303–12.

KETTLER, David and Volker Meja. 'Their "Own Peculiar Way": Karl Mannheim and the Rise of Women', *International Sociology* 8:1 (1993), 5–55.

——, Volker Meja, and Nico Stehr. *Karl Mannheim* (Chichester: Ellis Harwood; London: Tavistock, 1984).

KINROSS, Robin (ed.). *Anthony Froshaug: Typography and Texts* (London: Hyphen Press, 2000).

KLEEBLATT, Norman. *Too Jewish? Challenging Traditional Identities* (New Brunswick: Rutgers University Press, 1996).

KLEIN, Viola. *Feminism and Anti-feminism: A Study of Ideologies and Social Attitudes* (PhD thesis, London School of Economics, 1944).

——. *The Feminine Character: History of an Ideology* (London: Kegan Paul & Co., 1946).

——. *The Feminine Character: History of an Ideology*, introduced by Janet Sayers (London: Routledge, 1989).

KRAMRISCH, Stella. *Grundzüge der Indischen Kunst* [Principles of Indian Art] (Hellerau bei Dresden: Avalun Verlag, 1924).

——. *Indian Sculpture: The Heritage of India Series* (Oxford: Oxford University Press, 1933).

[——]. 'Stella Kramrisch as Curator: Calcutta 1922 – London 1940 – Philadelphia 1968', Warburg Institute, 11 March 2022, https://www.youtube.com/watch?v=p2a0bB7Lny4, accessed 27 April 2023.

KREFT, Gerald. '"Dedicated to Represent the True Spirit of the German Nation in the World": Philipp Schwartz (1894–1977), Founder of the *Notgemeinschaft*', in *In Defence of Learning: The Plight*

Persecution and Placement of Academic Refugees 1933–1980s, edited by Shula Marks, Paul Weindling, and Laura Wintour (London: British Academy, 2011), 126–42.

KRISTEVA, Julia. 'Signifying Practice and the Mode of Production', trans. Geoffrey Nowell-Smith, *Edinburgh Magazine* 1 (1976), 64–76.

——. 'Giotto's Joy', in *Desire in Language*, ed. Leon Roudiez, trans. Thomas Gora, Alice Jardine, and Leon Roudiez (Oxford: Basil Blackwell, 1979), 210–36.

——. 'Le temps des femmes' [Women's Time] [1979], *34/44 Cahiers de recherche de sciences des textes et documents* 5 (1979), 5–19.

——. 'Women's Time' [1979], translated by Alice Jardine and Harry Blake, in *The Kristeva Reader*, edited by Toril Moi (Oxford: Basil Blackwell, 1986), 187–213.

——. 'Motherhood According to Bellini', in *Desire in Language*, ed. Leon Roudiez, trans. Thomas Gora, Alice Jardine, and Leon Roudiez (Oxford: Basil Blackwell, 1979), 236–70.

KUDOMI, Yoshiyuki. 'Karl Mannheim in Britain', *Hitotsubashi Journal of Social Studies* 28:2 (1996), 43–56.

LANGDON-DAVIES, John. *A Short History of Women* [1927] (New York: Viking Press, 1938).

LAWRENCE, Scotford. *Arnold Noach: Biography of a Friend* (Malvern: Aspect Design, 2021).

LEE, Sarah and Dorothy Price. *Making Modernism: Paula Modersohn-Becker, Käthe Kollwitz, Gabrielle Münter and Marianne Werefkin* (London: Royal Academy, 2022).

LEVEY, Michael. 'Notes on the Royal Collection II: Artemisia Gentileschi's "Self-Portrait" at Hampton Court', *Burlington Magazine* 104:707 (1962), 79–81.

LÉVI-STRAUSS, Claude. *Les structures élémentaires de la parenté* [The Elementary Structures of Kinship] (Paris: Presses Universitaires de France, 1955).

——. *Elementary Structures of Kinship* [1955], translated by J. H. Bell, J. R. von Sturmer, and Rodney Needham (Boston: Beacon Press, 1969).

——. *La pensée sauvage* [The Savage Mind] (Paris: Librairie Plon, 1962).

——. *The Savage Mind* (London: Weidenfeld & Nicolson, 1966).

LEVINE, Emily J. 'PanDora, or Erwin and Dora Panofsky and the Private History of Ideas', *Journal of Modern History*, 83:4 (2011), 753–87.

——. *Dreamland of Humanists: Warburg, Cassirer and Panofsky and the Hamburg School* (Chicago: University of Chicago Press, 2013).

LIDDINGTON, Jill. *The Road to Greenham Common: Feminism and Anti-militarism in Britain since 1820* (Syracuse: Syracuse University Press, 1989).

LINDBERG, Anna Lena (ed.). *Konst, kön och blick: feministiska bildanalyser från renässans till postmodernism* [Art, Gender and Gaze: Feminist Image Analyses from the Renaissance to Postmodernism] (Stockholm: Norstedt, 1995).

—— and Barbro Werkmäster. *Kvinnor som Konstnärer* [Women as Artists] (Stockholm: LT, 1975).

LONG, Sandra Salser. 'Arthur Schopenhauer and Elisabet Ney', *Southwest Review* 69:2 (1984), 130–47.

LYON, E. Stina. 'Viola Klein: Forgotten Émigré Intellectual, Public Sociologist and Advocate of Women', *Sociology* 4:5 (2007), 829–42.

——. 'Karl Mannheim and Viola Klein: Refugee Sociologists in Search of Social Democratic Practice', in *In Defence of Learning: The Plight, Persecution, and Placement of Academic Refugees, 1933–1980s*, edited by Shula Marks, Paul Weindling, and Laura Wintour (London: British Academy, 2011), 177–90.

MADOO Lengermann, Patricia and Gillian Niebrugge. *The Women Founders: Sociology and Social Theory, 1830–1930; A Text/Reader* (Boston: McGraw-Hill, 1998).

MANNHEIM, Karl. *Beiträge zur Theorie der Weltanschauungsinterpretation* [Commentary on the Theory of the Interpretation of Worldview] (Vienna: E. Hölzel, 1923).

——. 'On the Interpretation of *Weltanschauung*' [1923], in *Essays on the Sociology of Knowledge*, translated and edited by Paul Kecskemeti (London: Routledge & Kegan Paul, 1952), 33–83.

——. 'The Problem of Generations' [1927–8], in *Essays on the Sociology of Knowledge*, edited by Paul Kecskemeti (London: Routledge & Kegan Paul, 1952), 276–320.

——. *Ideologie und Utopie* [Ideology and Utopia] (Bonn: Friedrich Cohen Verlag, 1929).

——. *Ideology and Utopia: An Introduction to the Sociology of Knowledge* [1929], translated by Louis Wirth and Edward Shils (London: Routledge & Kegan Paul, 1936).

——. *Diagnosis of Our Time* (London: Kegan Paul, 1943).

——. *Essays on the Sociology of Knowledge*, edited by Paul Kecskemeti (London: Routledge & Kegan Paul, 1952).

——. 'Weltanschauung: Its Mode of Presentation', in *Essays on the Sociology of Knowledge*, edited by Paul Kecskemeti (London: Routledge & Kegan Paul, 1952), 33–83.

——. *From Karl Mannheim*, edited by Kurt Wolff, introduced by Volker Meja and David Kettler (New York: Routledge, 1971).

MARCUS, Jane. *Virginia Woolf and the Languages of Patriarchy* (Bloomington: University of Bloomington Press, 1987).

MARDER, Joan (ed.). *From the Realm of the Ancestors: An Anthology in Honor of Marija Gimbutas* (Manchester, CT: Knowledge, Ideas and Trends, 1997).

MARDER, Michael. 'Breathing "to" the Other: Levinas and Ethical Breathlessness', *Levinas Studies* 4 (2009), 91–110.

MARKS, Shula, Paul Weindling, and Laura Wintour (eds.). *In Defence of Learning: The Plight, Persecution, and Placement of Academic Refugees, 1933–1980s* (London: British Academy, 2011).

MARSHALL, Barbara L. and Anne Witz (eds.). *Engendering the Social: Feminist Encounters with Sociological Theory* (Maidenhead: Open University Press, 2004).

MARX, Karl. 'The Eighteenth Brumaire of Louis Napoleon' [1852], in *Karl Marx and Frederick Engels: Selected Works* (London: Lawrence and Wishart, 1970), 94–166.

MAUSS, Marcel. 'Essai sur le don: forme et raison de l'échange dans les sociétés archaïques' [Essay on the Gift: Form and Function of Exchange in Archaic Societies], *L'année sociologique* 1923–4 (1925), 30–186.

——. *The Gift: Forms and Functions in Archaic Societies*, translated by Ian Cunnison (London: Cohen & West, 1966).

MCPHEE, Carol and Ann Fitzgerald (eds.), *The Non-violent Militant: Selected Writings of Teresa Billington-Greig* (London: Routledge & Kegan Paul, 1987).

MENNELL, Stephen. 'A Sociologist at the Outset of Group Analysis: Norbert Elias and His Sociology', *Group Analysis* 30:4 (1997), 489–513.

METZGER, Mendel. 'Helen Rosenau', *Gazette des Beaux-Arts* 105 (1985), 30.

MEYEROWITZ, Eva L.-R. *The Akan of Ghana* (London: Faber & Faber, 1958).

——. *At the Court of an African King* (London: Faber & Faber, 1962).

——. *The Divine Kingship in Ghana and Ancient Egypt* (London: Faber & Faber, 1962).

[——]. 'Eva L. R. Meyerowitz Photographs, EEPA 1987–009', Smithsonian, n.d., https://sova.si.edu/record/EEPA.1987-009, retrieved 18 March 2023.

[——]. 'Eva Lewin Richter Meyerowitz', British Museum, n.d., https://www.britishmuseum.org/collection/term/BIOG126253, retrieved 18 March 2023.

MITCHELL, Claudine. 'Intellectuality and Sexuality: Camille Claudel, Fin de Siècle Sculptress', *Art History* 12:4 (1989), 419–47.

MITCHELL, Juliet. *Psychoanalysis and Feminism* (London: Allen Lane, 1974).

MODERSOHN-BECKER, PAULA. *The Letters and Journals of Paula Modersohn-Becker*, translated and annotated by J. Diane Radycki (London: Scarecrow, 1980).

MODJESKA, Drusilla. *Stravinsky's Lunch: Two Women Painters and Their Claims of Life and Art* (New York: Farrar, Straus and Giroux, 1999).

MOORE, Sylvia. 'An Interview with That Man Janson!', *Women Artists News* 4:1 (1978), 1, 8.

MORENO, Shirley. *The Absolute Mistress: The Historical Construction of the Erotic in Titian's 'Poesie'* (MA thesis, University of Leeds, 1980).

MOSSE, Werner E., Julius Carlebach, Gerhard Hirschfeld, Aubrey Newman, Arnold Paucker, and Peter Pulzer, *Second Chance: Two Centuries of German-Speaking Jews in the United Kingdom* (Tübingen: Paul Sieback, 1991).

NEMSER, Cindy. 'Barbara Hepworth', in *Art Talk: Conversations with 12 Women Artists* (New York: Charles Scribner's Sons, 1975), 13–34.

NEWMAN, Michael. *Ralph Miliband and the Politics of the New Left* (London: Merlin Press, 2002).

NITSCHKE-JOSEPH, Uta. 'A Fortuitous Discovery: An Early Manuscript by Erwin Panofsky Reappears in Munich', Institute for Advanced Study, 11 June 2013, https://www.ias.edu/ideas/2013/nitschke-joseph-panofsky, retrieved 22 February 2023.

NOCHLIN, Linda. 'Why Are There No Great Women Artists?', in *Woman in Sexist Society: Studies in Power and Powerlessness*, edited by Vivian Gornick and Barbara K. Moran (New York: Basic Books, 1971), 480–510.

——. 'Why Have There Been No Great Women Artists?', *Art News*, January 1971, reprinted in *Art and Sexual Politics: Why Have There Been No Great Women Artists?*, edited by Thomas B. Hess and Elizabeth C. Baker (New York: Macmillan, 1973), 1–43.

——. 'The Imaginary Orient' [1983], in *The Politics of Vision: Essays on Nineteenth Century Art and Society* (London: Thames & Hudson, 1989), 33–59.

——. *Why Have There Been No Great Women Artists?*, 50th anniversary edition (London: Thames & Hudson, 2021).

NYBURG, Anna. *Émigrés: The Transformation of Art Publishing in Britain* (London: Phaidon, 2014).

OBERMAIER, Hugo. *Urgeschichte der Menschheit, in Geschichte der führenden Völker I* [The Prehistory of Humankind amongst the Leading Peoples] (Freiberg: Herder Verlagsbuchhandlung, 1931).

OLIN, Margaret. *The Nation Without Art: Examining Modern Discourses on Jewish Art* (Lincoln: University of Nebraska Press, 2001).

PANOFSKY, Erwin. *Die theoretische Kunstlehre Albrecht Dürers* [The Art Theory of Albrecht Dürer] (Berlin: G. Reimer, 1914).

——. *Michelangelo's Design Principles Particularly Those in Relation to Raphael* [1920], edited and introduced by Gerda Panofsky-Soergel, translated by Joseph Spooner (Princeton: Princeton University Press, 2020).

——. *'Idea': ein Beitrag zur Begriffsgeschichte der älteren Kunsttheorie* (Leipzig: Teubner, 1924).

——. *Idea: A Concept in Art Theory* [1924] (Colombia: University of South Carolina Press, 1968).

——. *Perspective as Symbolic Form* [1927], translated by Christopher S. Wood (Princeton: Princeton University Press, 1997).

——. 'Zum Problem der Beschreibung und Inhaltsdeutung von Werken der bildenden Kunst' [On the Problem of Describing and Interpreting Works of the Visual Arts], *Logos* 21 (1932), 103–19.

——. 'On the Problem of Describing and Interpreting Works of the Visual Arts' [1932], translated by Jaś Elsner and Katharina Lorenz, *Critical Inquiry* 38:3 (2012), 467–82.

——. 'Jan Van Eyck's Arnolfini Portrait', *Burlington Magazine* 64:372 (1934), 117–19 and 122–7.

——. 'Three Decades of Art History in the United States: Impressions of a Transplanted European', *College Art Journal* 14:1 (1954), 7–27.

——. 'Iconography and Iconology: An Introduction to the Study of Renaissance Art', in *Meaning in the Visual Arts: Papers in and on Art History* (Garden City: Doubleday, 1955), 26–54.

PARKER, Rozsika and Griselda Pollock. *Old Mistresses: Women, Art and Ideology* (London: Routledge & Kegan Paul, 1981).

PAULI, Gustav. *Paula Modersohn-Becker* (Leipzig: Kurt Wolff, 1919).

PEACOCK, Martha Moffatt. 'Proverbial Reframing: Rebuking and Revering Women in Trousers', *Journal of the Walters Art Gallery* 57 (1999), 13–34.

PERRY, Gill. *Paula Modersohn-Becker: Her Life and Work* (London: Harper & Row, 1979).

PESMAN, Ros. '*Drawn from Life*: Stella Bowen and Ford Madox Ford', *International Ford Madox Ford Studies* 2 (2003), 221–38.

PETERSEN, Karen and J. J. Wilson. *Women Artists: Recognition and Reappraisal from the Early Middle Ages to the Twentieth Century* (New York: Harper & Row, 1976).

PHILO-LEXICON: Handbuch des jüdischen Wissens [Handbook of Jewish Knowledge] [1985] (Berlin: Suhrkamp Verlag, 1992).

PILCHER, Jane. *Social Change and Feminism: Three Generations of Women, Feminist Issues and the Women's Movement* (PhD thesis, University of Wales, 1992).

——. 'Mannheim's Sociology of Generations: An Undervalued Legacy', *British Journal of Sociology* 45:3 (1994), 481–95.

PINDER, Wilhelm. *Das Problem der Generation in der Kunstgeschichte Europas* [The Problem of

Generation in the History of European Art] (Berlin: Frankfurter, 1926).

POLLOCK, Griselda. 'Artists, Media and Mythologies, or Genius, Madness and Art History', *Screen* 21:3 (1980), 57–96.

——. *Vision and Difference: Feminism, Femininity and the Histories of Art* (London: Routledge, 1988).

——. '"With my Own Eyes": Fetishism and the Colour of the Labouring Body', *Art History* 17:2 (1994), 342–82.

——. 'Inscriptions in the Feminine', in *Inside the Visible: An Elliptical Traverse of Twentieth Century Art in, of, and from the Feminine*, ed. Catherine de Zegher (Cambridge, MA: MIT Press, 1996), 67–87.

——. *Differencing the Canon: Feminist Desire and the Writing of Art's Histories* (London: Routledge, 1999).

——. *Encounters in the Virtual Feminist Museum: Time, Space and the Archive* (London: Routledge, 2007).

——. 'Art History and Visual Studies in Great Britain and Ireland', in *Art History and Visual Studies in Europe: A Critical Guide*, edited by Matthew Rampley, Charlotte Schoell-Glass, Andrea Pinotti, Kitty Zijlmans, Hubert Locher, and Thierry Lenain (Leiden: Brill, 2012), 355–78.

——. *After-Affects / After-Images: Trauma and Aesthetic Transformation in the Virtual Feminist Museum* (Manchester: Manchester University Press, 2013).

——. 'Making Feminist Memories: The Case of Helen Rosenau and *Woman in Art*, 1944', University College London, London, 4 December 2014, https://www.youtube.com/watch?v=QhCLvdzPy10, retrieved 22 February 2023.

——. 'Whither Art History?', *Art Bulletin* 96:1 (2014), 9–23.

——. 'Is Feminism a Trauma, a Bad Memory, or a Virtual Future?', *differences* 27:2 (2016), 27–61.

——. *Charlotte Salomon in the Theatre of Memory* (New Haven and London: Yale University Press, 2018).

——. 'Abstraction? Co-creation?', in *Women in Abstraction*, edited by Christine Macel and Karolina Ziebinska-Lewandowska (Paris: Centre Pompidou, 2021), 25–30.

——. 'Facing Sofonisba Anguissola', in *Sofonisba: History's Forgotten Miracle* (Niva: Nivaagaard Collection, 2022), 46–67.

——. *Killing Men and Dying Women: Imagining Difference in 1950s New York Painting* (Manchester: Manchester University Press, 2022).

RADYCKI, J. Diane. *Paula Modersohn-Becker: The First Modern Woman Artist* (New Haven and London: Yale University Press, 2013).

RAMPLEY, Matthew, Charlotte Schoell-Glass, Kitty Zijlimans, Hubert Locher, and Thierry Lenain (eds.). *Art History and Visual Studies in Europe: A Critical Guide* (Leiden: Brill, 2012).

RAULFF, Ulrich. 'Nachleben: A Concept and Its Legacies', 150th Anniversary Conference at the Warburg Institute, London, 13–15 June 2016, https://warburg.sas.ac.uk/podcasts/ulrich-raulff-nachleben-a-warburgian-concept-and-its-origins, retrieved 15 March 2023.

READ, Herbert. *The Meaning of Art* (London: Faber & Faber, 1931).

——. *Barbara Hepworth: Carvings and Drawings* (London: Lund Humphries, 1952).

——. 'Art and the Evolution of Consciousness', *Journal of Aesthetics and Art Criticism* 12:2 (1954), 143–55.

'REDISCOVERING Stella Kramrisch's 1940 Photographic Exhibition of Indian Art at the Warburg Institute', Warburg Institute, n.d., https://warburg.sas.ac.uk/blog/rediscovering-stella-kramrischs-1940-photographic-exhibition-indian-art-warburg-institute, accessed 27 April 2023.

REITA, Rayna R. *Toward an Anthropology of Women* (New York: New Monthly Press, 1975), 157–210.

RICHARDSON, E. P. 'A Masterpiece of Baroque Drama', *Bulletin of the Detroit Institute of Arts* 32:4 (1952–3), 81–3.

RIEGL, Alois. *Stilfragen: Grundlegungen der Ornamentik* [Problems of Style: Foundations for a History of Ornament] (Berlin: G. Siemens, 1893).

——. *Late Roman Art Industry* [1901], translated by Rolf Winkes (Rome: Giorgio Bretschneider, 1985).

——. *Die spätrömische Kunst-Industrie nach den Funden in Österreich-Ungarn im Zusammenhange mit der Gesamtentwicklung der Bildenden Künste bei den Mittelmeervölkern* [The Late Roman Art Industry According to the Findings in Austria-Hungary in

the Context of the Overall Development of the Fine Arts among the Mediterranean Peoples] (Vienna: Kaiserlich und Königlichen Hof- und Staatsdruckerei, 1901).

RILEY, Denise. *The War in the Nursery* (London: Virago, 1983).

——. *Am I That Name? Feminism and the Category of 'Women' in History* (Basingstoke: Macmillan, 1988).

ROBBINS, Kenneth X. and Marvin Tokayer (eds.). *Jews and the Indian National Art Project* (New Delhi: Niyogi Books, 2015).

RUBIN, Gayle. 'The Traffic in Women: Notes on the "Political Economy" of Sex', in *Toward an Anthropology of Women*, edited by Rayna R. Reiter (New York: Monthly Review Press, 1975), 157–210.

SACHWEH, Jannik. *Brüche im bürgerlichen Wissenschaftsverständnis? Die Ausgrabungen Helen Rosenaus im Bremer Dom 1931* [Breaks in Bourgeois Understanding of Knowledge? Helen Rosenau's Excavations in Bremen Cathedral in 1931] (MA thesis, University of Bremen, 2016).

——. 'Helen Rosenau, Aspiring Art Historian and Archaeologist', translated by Insa Kummer, in *Key Documents of German-Jewish History*, 20 July 2021, https://jewish-history-online.net/article/jgo:article-281, retrieved 18 February 2023.

SAFRANSKI, Rüdiger. *Schopenhauer and the Wild Years of Philosophy*, translated by Ewald Osers (London: Weidenfeld & Nicolson, 1989).

SAID, Edward. *Orientalism* (London: Routledge & Kegan Paul, 1978).

SCHADE, Sigrid. *Schadenzauber und die Magie des Körpers: Hexenbilder der frühen Neuzeit* [Malign Spells and the Magic of the Body: Images of Witches in the Early Modern Times] (Worms: Wernersche Verlagsgesellschaft, 1983).

SCHOELL-GLASS, Charlotte. *Aby Warburg and Anti-semitism: Political Perspectives on Images and Culture* (Detroit: Wayne State University Press, 2008).

SCHOPENHAUER, Arthur. 'On Women', in *Parerga and Paralipomena: Short Philosophical Essays* [1851], vol. 2, edited and translated by Adrian del Caro (Cambridge: Cambridge University Press, 2015), 550–61.

SCOTT, Joan. 'Gender: A Useful Category of Historical Analysis', *American Historical Review* 91:5 (1986), 1053–75.

SEARS, Elizabeth and Charlotte Schoell-Glass. 'An Émigré Art Historian and America: H. W. Janson', *Art Bulletin* 95:2 (2013), 219–42.

SHERER, Daniel. 'Panofsky on Architecture: Iconology and the Interpretation of Built Form, 1915–1956', *History of the Humanities* 5:1 (2020), 189–224.

SHERMAN, Claire Richter (ed.) with Adele M. Holcomb. *Women as Interpreters of the Visual Arts, 1820–1979* (Westport: Greenwood Press, 1981).

SHILS, Edward. *'Ideology and Utopia* by Karl Mannheim', in 'Twentieth-Century Classics Revisited', edited by Stephen R. Graubard, special issue, *Daedalus* 103:1 (1974), 83–9.

SIMMEL, Georg. 'Das Relative und das Absolute im Geschlechter-Problem' [The Relative and the Absolute in the Problem of the Sexes] [1911], in *Georg Simmel: Schriften zur Philosophie und Soziologie der Geschlechter*, ed. H. J. Dahme and K. C. Köhnke (Frankfurt am Main: Suhrkamp, 1985), 200–23.

SIMMEL, Gertrud [as Marie Louise Enkendorff]. *Realität und Gesetzlichkeit im Geschlechtsleben* [Reality and Law in Sex/Gender Life] (Leipzig: Dunker & Humblot, 1910).

ŠKOF, Lenart. 'Ethics of Breath: Derrida, Lévinas and Irigaray', in *Breath of Proximity: Intersubjectivity, Ethics and Peace* (Dordrecht: Springer, 2015), 127–56.

SNOWMAN, Daniel. *The Hitler Émigrés: The Cultural Impact on Britain of Refugees from Nazism* (London: Chatto & Windus, 2002).

SPIVAK, Gayatri Chakravorty. 'The Rani of Sirmur: An Essay in the Reading of Archives', *History and Theory* 24:3 (1985), 247–72.

——. *The Death of a Discipline* (New York: Columbia University Press, 2003).

STEINBERG, Leo. 'The Philosophical Brothel', *October* 44 (1988), 7–74.

STEINBERG, S. H. 'A Portrait of Constance of Sicily', *Journal of the Warburg Institute* 1:3 (1938), 249–51.

STOCKS, Mary. *The Workers' Educational Association: The First Fifty Years* (London: Allen & Unwin, 1953).

TANNER, Jeremy. *The Sociology of Art: A Reader* (London: Routledge, 2003).

——. 'Karl Mannheim and Alois Riegl: From Art History to the Sociology of Culture', *Art History* 32:4 (2009), 755–84.

TARRANT, Shira. *When Sex Became Gender* (New York: Routledge, 2006).

TATE Gallery. *Barbara Hepworth: A Pictorial Biography* (London: Tate Gallery, 1970).

TENENTI, Alberto. 'Hauser, Arnold: art, histoire sociale et méthode sociologique' [Hauser, Arnold: Art, Social History and Sociological Method], *Annales: Économies, Sociétés, Civilisations* 12:3 (1957), 474–81.

TENNANT Jackson, Jennifer. *Evidence as a Problem: Foucauldian Approaches to Three Canonical Works of Art: Courbet's Atelier 1855; Velázquez's Las Meninas 1656; Botticelli's Venus ca. 1483* (PhD thesis, University of Leeds, 2001).

——. 'Efficacity', in *Conceptual Odysseys: Passages to Cultural Analysis*, edited by Griselda Pollock (London: I. B. Tauris, 2007), 153–71.

——. 'Courbet's *Trauerspiel*: Trouble with Women in *The Painter's Studio*', in *The Visual Politics of Psychoanalysis: Art and the Image in Post-traumatic Cultures*, edited by Griselda Pollock (London: I. B. Tauris, 2013), 77–101.

'THE Museum', Das Verborgene Museum, n.d., https://www.dasverborgenemuseum.de/the-museum, retrieved 18 March 2023.

THIEME, Ulrich and Felix Becker. *Allgemeines Lexikon der bildenden Künstler von der Antike bis zur Gegenwart* [General Dictionary of Artists from Antiquity to the Present], 37 vols (Leipzig: Verlag von Wilhelm Engelmann/Verlag E. A. Seemann, 1907–50).

THIMANN, Michael and Thomas Gilbhard (curators), 'The Library of Aby Warburg', translated by Eckart Marchand, Warburg Institute, n.d., https://warburg.sas.ac.uk/library/about-library/library-aby-warburg, retrieved 17 March 2023.

TIERTZ, Tabea. 'Marianne Weber and the Status of Women in Patriarchal Societies', in *SciHi Blog*, 2 August 2017, http://scihi.org/marianne-weber, retrieved 18 February 2023.

TINAGLI, Paolo. *Women in Italian Renaissance Art: Gender, Representation, Identity* (Manchester: Manchester University Press, 1997).

TUFTS, Eleanor. *Our Hidden Heritage: Five Centuries of Women Artists* (New York: Paddington Press, 1974).

——. 'Beyond Gardner, Gombrich, and Janson: Towards a Total History of Art', *Arts Magazine* 55:8 (1981), 150–54.

TURNER, Sarah Victoria. '"Alive and Significant": "Aspects of Indian Art", Stella Kramrisch and Dora Gordine in South Kensington c 1940', *Wasafiri* 27:2 (2012), 40–51.

VACHON, Marius. *La femme dans l'art: les protectrices des arts; les femmes artistes* [Women in Art: Patrons of the Arts; Women Artists] (Paris: J. Rouam & Cie, 1893).

VAN VUCHT Tijssen, Lieteke. 'De plaats van de vrouw in de moderne cultuur: Marianne Weber contra Georg Simmel' [The Position of Women in Modern Culture: Marianne Weber versus Georg Simmel], *Sociale wetenschappen*, 31:8 (1988), 83–101.

——. 'Women and Objective Culture: Georg Simmel and Marianne Weber', *Theory, Culture & Society* 8 (1991), 203–18.

VASARI, Giorgio. *Le vite de' più eccelenti pittori, sculptori et architettori* [The Lives of the Most Excellent Painters, Sculptors and Architects] (Florence: Giunti, 1558).

VENTRELLA, Francesco, 'Under the Hat of the Art Historian: Panofsky, Berenson and Warburg', *Art History* 34:2 (2011), 310–31.

W., L. Review of *The Painter J.-L. David*, by Helen Rosenau, *AJR Information*, December 1948, 6.

——. 'Refugee Scholar Honoured', *AJR Information*, August 1953, 4.

WARBURG, Aby. 'Italienische Kunst und internationale Astrologie in Palazzo Schifanoia zu Ferrara' [Italian Art and International Astrology in Palazzo Schifanoia at Ferrara] [1922], in *Gesammelte Schriften* [Collected Writings], vol. 2, edited by Gertrud Bing and Franz Rougemont (Leipzig: B. G. Teubner, 1932), 459–627.

——. 'Italian Art and International Astrology in the Palazzo Schifanoia, Ferrara' [1922], in *The Renewal of Pagan Antiquity: Contributions to the Cultural History of the Renaissance*, ed. Kurt W. Foster, trans. David Britt (Los Angeles: Getty Research Institute for the History of Art and the Humanities, 1999), 563–92.

—. *The Renewal of Pagan Antiquity: Contributions to the Cultural History of the Renaissance* [1932], introduced by Kurt Forster and translated by David Britt (Los Angeles: Getty Research Institute for the History of Art and Humanities, 1999).

—. 'A Lecture on Serpent Ritual', *Journal of the Warburg Institute* 2:4 (1939), 277–92.

WARBURG, Eric M. 'The Transfer of the Warburg Institute', in Warburg Institute, October 1953, https://warburg.sas.ac.uk/about-us/history-warburg-institute/transfer-institute, retrieved 15 March 2023.

WEBER, Gerhard W., Alexander Lukeneder, Mathias Harzhauser, Philipp Mitteroecker, Lisa Wurm, Lisa-Maria Hollaus, Sarah Kainz, Fabian Haack, Walpurga Antl-Weiser, and Anton Kern. 'The Micro-structure and the Origins of the Venus from Willendorf', *Scientific Reports* 12 (2022), 2926.

WEBER, Marianne. *Ehefrau und Mutter in der Rechtsentwicklung* [Wife and Mother in the Development of Law] (Tübingen: J. C. B. Mohr, 1907).

—. 'Die Frau und die objective Kultur' [Woman and Objective Culture], in *Frauenfrage und Frauengedanke: Gesammelte Aufsätze* [The Women Question and Women's Thought: Collected Writings] (Tübingen: J. C. B. Mohr, 1919), 95–133.

WEDEPOHL, Claudia. 'Mnemonics, Mneme, and Mnemosyne: Warburg's Theory of Memory', *Bruniana & Campanelliana* 20:2 (2014), 385–402.

WEIDMAN, Jeffrey. 'Many Are Culled but Few Are Chosen: Janson's History of Art, Its Reception, Emulators, Legacy, and Current Demise', *Journal of Scholarly Publishing* 38:2 (2007), 85–107.

WEISS, Andrea. *Paris Was a Woman: Portraits from the Left Bank* (London: Pandora Books, 1995).

WELCH, Stuart Carey and Diane M. Nelson, 'William G. Archer (1907–1979): Bibliographical Note', *Archives of Asian Art* 33 (1980), 109–111

WELTMANN, Lutz. 'Jewish Art', *AJR Information*, May 1949, 4.

WIGGERSHAUS, Rolf. *The Frankfurt School: Its History, Theories and Political Significance* (Cambridge: Cambridge University Press, 1994).

WILEY, Christopher. '"When a Woman Speaks the Truth about Her Body": Ethel Smyth, Virginia Woolf, and the Challenges of Lesbian Auto/Biography', *Music & Letters* 8:3 (2004), 388–414.

WILLIAMS, Raymond. *Marxism and Literature* (Oxford: Oxford University Press, 1977), 83–90.

WINCKELMANN, Johann Joachim. *The History of the Art of Antiquity* [1764], translated by Harry Francis (Los Angeles: Getty Research Institute, 2006).

WISCHNITZER, Rachel. *The Messianic Theme in the Paintings of the Dura Synagogue* (MA thesis, Institute of Fine Arts, New York, 1948).

WITZ, Anne. 'Georg Simmel and the Masculinity of Modernity', *Journal of Classical Sociology* 1:3 (2001), 353–70.

WOBBE, Theresa. 'Elective Affinities: Georg Simmel and Marianne Weber on Gender and Modernity', in *Engendering the Social: Feminist Encounters with Sociological Theory*, edited by Barbara L. Marshall and Anne Witz (Maidenhead: Open University Press, 2004), 54–68.

WOLFF, Janet. 'The Feminine in Modern Art: Benjamin, Simmel and the Gender of Modernity', *Theory, Culture & Society* 17:6 (2000), 33–53.

WOOLF, Virginia. *A Room of One's Own* [1929] (London: Penguin, 1945).

—. *Three Guineas* (London: Hogarth Press, 1938).

WRIGHT, Frederick Adam. *Feminism in Greek Literature from Homer to Aristotle* (London: G. Routledge & Sons, 1923).

ZIAREK, Ewa Płonowksa. *Feminist Aesthetics and the Politics of Modernism* (New York: Columbia University Press, 2013).

ZIEBRITZKI, Jo. *Stella Kramrisch: Kunsthistorikerin zwischen Europa & Indien; Ein Beitrag zur Depatriarchalisierung der Kunstgeschichte* [Stella Kramrisch: Art Historian between Europe and India; A Contribution to the Depatriarchalization of Art History] (Marburg: Büchner-Verlag, 2021).

ZWARTS, Jac. *The Significance of Rembrandt's* The Jewish Bride (Amersfoort: G. J. van Amerongen & Co., 1929).

3.63 Handwritten notes for an index on the back page of Helen Rosenau's personal copy of *Woman in Art* (London: Isomorph, 1944). Collection of Michael and Louise Carmi.

Index

Pearson, Marjory 259
Penrose, Roland 207
pensée sauvage (Lévi-Strauss) 250
Pergolesi, Giovanni Battista: *La Serva Padrona* (intermezzo) **158**
personality
— individualization in early modern period 300–01
— individualization of women in art
 Greek and Roman art **117, 119**
 Hals's distinguished women regents **146, 146**, 308
 medieval art and Naumberg sculptures **119–20, 119**, 292, 305
 Rembrandt and C17 art **124–5, 155–6**, 311–12
 Renaissance art **135, 140**, 300, 304–5, 309–10
— modernization and women as singular personalities 38, 87, 88, **104**
 modern marriages of individuals **128–9**, 228
— sociology of 57, 58
— Woman as type and shift to personality 52–3, 89, **104, 158**, 219–20, 304–12, 313
 ideas behind *Woman in Art* subtitle 87–8, 178–9, 252–3
perspective and HR's 'as seen in art' articles 226–7, 243
Petersen, Karen 38
— *Women Artists: Recognition and Reappraisal* 332, 333
Petit de Julleville, L. **120n.21**, 161, 267
Pevsner, Nikolaus 15, 51
Phaidon Verlag (publishers) 49–50, 169, 260
Philo-Lexicon: Handbuch des jüdischen Wissens (Handbook of Jewish Knowledge) 18
philology 192
philosophy and emergence of Art History as discipline 55–8, 204
Picasso, Pablo 301
— *The Kiss* (now *Lovers in the Road*) **129, 129**, 296
pictograph images and depiction of men **113**
Picture Post 295
Pietà imagery and motherhood **133–4, 134**, 210, 299, 302
Pilcher, Jane 72
Pinder, Wilhelm **120n.18, 127n.30, 161–2**, 269
Ping-Ying, Hsieh *see* Hsieh Ping-ying
pioneering women 18, 25, **148, 154**, 225, 230–31, 309–10
Planiscig, L. **162**, 268
Plato **159**
— *Republic* **116n.14**
— *Timaeus* **116n.14**, 266

Plekhanov, G. V. **127n.30, 162**, 272
poetry: women pioneers **148**, 309
point-of-view theory 62, 68
politics
— hostility towards left-wing views in Britain 51–2, 193–5
— movement for women in parliament 239–40, 243
— political dimensions of motherhood **133**, 298–9
— revolutionary movements and women **140n.50**, 151–2, 310–11
Pollock, Griselda
— *Encounters in the Virtual Feminist Museum* 320, 322
— 'Making Feminist Memories: The Case of Helen Rosenau and Woman in Art, 1944' (lecture) 13
— *Old Mistresses: Women, Art and Ideology* (with Rozsika Parker) viii, 93n.33, 276n.3, 332–3, 334
polygamy **121–3**, 227
— in medieval world **122–3**, 292
Polytechnic of Central London: lectures at School of Architecture 18
Popper, Karl 9, 50, 51
Portrait of the Artist as a Jewish Woman conference (Leeds, 1997) 341, 342
posters **137**
— war posters and proletarian heroines **149**
postmodern viewpoints and time and history 321–8
Power, Eileen **141n.52, 162**, 268, 274
prehistoric art and society
— aesthetic-symbolic practices 172, 173, 175
— cave art **142, 142**, 171–2, 212, 305–6
— 'gynaecodynamic' societies **111**, 282, 285
— new discoveries in C20 284–5
 and extension of art history 170–71, 172, 173
 as influence on modernist art and culture 172, 173, 175, 206
 and Hepworth's work 176, 177, 206
 and *Woman in Art* 279
— palaeolithic art and female figures **113, 130, 157**, 169–71, *172*, 208, 279, 284, 306
'preposterous' and HR in art history 23, 322
'primitive' art **137n.46**
— modernist projections and early art 172
— *see also* prehistoric art and society
Prior, Edward **120, 162**, 268
prostitution 210
— in ancient world **112, 115, 117, 119n.17**
 hetairai in ancient Greece **117**, 289

'sacred prostitution' **112, 115, 141**, 305
— in realist art of Toulouse-Lautrec **127, 127**, 293
— Vice and Virtue divisions in Middle Ages **144, 144**, 307
protecting goddesses in art **130–32, 131–2, 133, 142n.54**, 306
psychology and social psychology 54–5, 74, 192
— and Gombrich's *Story of Art* 193, 194
— HR's research and bibliographical sources 29, 30, 247, 249–50, 258, 260, 262–3, 264, 275
— HR's view of men and women in early societies 281
— and maternal instinct 304
— othering of social groups including women 238–9
— psychoanalytical theory 29, 30, 35, 260, 313
 and exchange systems 276n.5
 and gender 59
 Kristeva and time 325–6
— and women's development 77–8, 154, **158n.74**, 178, 179, 305, 312, 313
— *see also* Freud, Sigmund; personality
purdah and secluded life for women **141, 143**, 305
Pythia at Delphi **141**

race and racism
— anti-slavery feminism 78
— Nazi regime and Jewish people 33, 45, 47, 48, 66, 240, 253
— othering of social groups 238
— *see also* Jewish people
Ramolini, Laetitia **158**
Rank, Otto **137n.46, 162**, 271
Ranke, H. **114n.8, 162**, 272
Rao, T. A. Gopinatha *see* Gopinatha Rao, T. A.
Raphael (Raffael) **137n.46**
— *Lo Sposalizio* **118**, 291
Ravenna: mosaics of Empress Theodora and Justinian **119**
Read, Herbert 95n.58, 175, 207
realism in art
— Renaissance art **135**
— social intentions **127, 127, 129**
recluses and god-like lover for women **140**, 305
Reformation and art **135**, 300
religion
— 'Catholic' and 'Protestant' C17 art **123–5**, 293
— Kristeva and semiotics of the unconscious 326
— ritual and sexual acts in ancient world **115**

About the Authors

GRISELDA POLLOCK is professor emerita of Social and Critical Histories of Art and director of the Centre for Cultural Analysis, Theory and History at the University of Leeds and the 2020 Laureate of the Holberg Prize for the arts, humanities, law, and theology. In 2023, she was awarded a Lifetime Achievement Award for Writing on Art by the College Art Association. She has published extensively on nineteenth-century, modern, and contemporary art, cinema, and cultural theory. Her PhD, *Van Gogh and Dutch Art and His Concept of the Modern* (1980), was followed by (co-authored with Rozsika Parker) *Old Mistresses: Women, Art and Ideology* (1981, new editions 1996, 2013, and Bloomsbury Revelations, 2020). Her key works include *Vision and Difference: Feminism, Femininity and the Histories of Art* (1988); *Avant-Garde Gambits: Gender and the Colour of Art History* (1993); *Generations and Geographies in the Visual Arts: Feminist Readings* (1995); *Avant-Gardes and Partisans Reviewed* (1996), co-authored with Fred Orton; *Differencing the Canon: Feminist Desire and the Writing of Art's Histories* (1999); *Encounters in the Virtual Feminist Museum: Time, Space and the Archive* (2007); *After-Affects / After-Images: Trauma and Aesthetic Transformation in the Virtual Feminist Museum* (2013); *Charlotte Salomon in the Theatre of Memory* (2018); *Killing Men and Dying Women: Imagining Difference in 1950s New York Painting* (2022); and a revised edition of her 1995 monograph *Mary Cassatt* (2022). She has also edited, with Max Silverman, *Concentrationary Cinema: Aesthetics as Political Resistance in Alain Resnais's* Night and Fog (2009), *Concentrationary Memories: Totalitarian Terror and Cultural Resistance* (2011), *Concentrationary Imaginaries: Tracing Totalitarian Violence in Popular Culture* (2015), and *Concentrationary Art: Jean Cayrol, the Lazarean and the Everyday in Post-war Film, Literature, Music and the Visual Arts* (2019).

ADRIAN RIFKIN is professor emeritus of Art Writing at Goldsmiths University of London and formerly Professor of Fine Art at the University of Leeds (1992–9). He studied Art History with Helen Rosenau and prepared his PhD on Ingres at the University of Leeds, later published as *Ingres Then, and Now* (2000). His most recent publication is *Future Imperfect* (2021). Key works are *Street Noises: Parisian Pleasure 1900–1940*

(1993) and *Voices of the People: The Social Life of 'La sociale' in Second Empire Paris*, edited with Roger Thomas (1987). Edited works include *About Michael Baxandall* (1998); *Fingering Ingres*, edited with Susan Siegfried (2001); and *Other Objects of Desire: Collectors and Collecting Queerly*, edited with Michael Camille (2001). A collection of his writings appears in *Communards and Other Cultural Histories*, edited by Steve Edwards (2018), and a collection of responses to his work appeared as *Interdisciplinary Encounters: Hidden and Visible Explorations of the Work of Adrian Rifkin*, edited by Dana Arnold (2015).

RACHEL DICKSON is currently consultant editor at the Ben Uri Research Unit for the Study of the Jewish and Immigrant Contribution to the Visual Arts in Britain since 1900 (from 2021). Previously she was head of Curatorial Services at the Ben Uri Gallery and Museum (2011–20) and project curator (2002–11). Recent texts include the chapter '"Our Horizon Is the Barbed Wire": Artistic Life in the British Internment Camps' in *Insiders/Outsiders: Refugees from Nazi Europe and Their Contribution to British Visual Culture* (2019) and 'Helga Michie "A Little World in Art": An Investigation into Her Creative Practice 1963-1989' in *Between Departure and Arrival: Ilse Aichinger / Helga Michie*, edited by Geoff Wilkes (2021). Solo exhibition projects for Ben Uri include *The Inspiration of Decadence: Dodo Burgner 1907-1998* (2012), *Judy Chicago: A Transatlantic Narrative* (2012–13), *Art Out of the Bloodlands: A Century of Polish Artists in Britain* (2017), and the online exhibition *Midnight's Family: 70 Years of Indian Artists in Britain* (2020). Collaborations with co-curator/co-author Sarah MacDougall include *Whitechapel at War: Isaac Rosenberg and His Circle* (2008), *Forced Journeys: Artists in Exile in Britain c.1933–45* (Ben Uri and touring, 2009–10), *'Uproar!': The First 50 Years of the London Group, 1913-1963* (2013), *Out of Chaos: A Century of Ben Uri in London* (Somerset House, 2015), *Bomberg* (Ben Uri and touring, 2017–18), and *Jankel Adler: A 'Degenerate' Artist in Britain, 1940-1949* (2019).